CROSSING BOUNDARIES

Frontispiece: Professor Emeritus Richard N. Bailey, OBE: 'in medio duorum' (Photo: Alison Bailey)

CROSSING BOUNDARIES

Interdisciplinary Approaches to the Art, Material Culture, Language and Literature of the Early Medieval World

Edited by

ERIC CAMBRIDGE AND JANE HAWKES

Essays presented to Professor Emeritus Richard N. Bailey, OBE,
in honour of his eightieth birthday

OXBOW | books

Oxford & Philadelphia

Published in the United Kingdom in 2017 by
OXBOW BOOKS
The Old Music Hall, 106–108 Cowley Road, Oxford, OX4 1JE

and in the United States by
OXBOW BOOKS
1950 Lawrence Road, Havertown, PA 19083

Hardcover Edition: ISBN 978-1-78570-307-2
Digital Edition: ISBN 978-1-78570-308-9 (epub)

A CIP record for this book is available from the British Library

Library of Congress Cataloging-in-Publication Data

Names: Bailey, Richard N., honouree. | Cambridge, Eric, editor. | Hawkes,
 Jane (Medievalist), editor.
Title: Crossing boundaries : interdisciplinary approaches to the art,
 material culture, language and literature of the early medieval world :
 essays presented to Professor Emeritus Richard N. Bailey, OBE, on the
 occasion of his eightieth birthday / edited by Eric Cambridge and Jane
 Hawkes.
Other titles: Crossing boundaries (Oxbow Books (Firm))
Description: Philadelphia : Oxbow Books, 2016. | Includes bibliographical
 references and index.
Identifiers: LCCN 2016037221 (print) | LCCN 2016037784 (ebook) | ISBN
 9781785703072 (hardback) | ISBN 9781785703089 (epub) | ISBN 9781785703096
 (mobi) | ISBN 9781785703102 (pdf)
Subjects: LCSH: Arts, Medieval. | Civilization, Medieval.
Classification: LCC NX449 .C76 2016 (print) | LCC NX449 (ebook) | DDC
 709.02–dc23
LC record available at https://lccn.loc.gov/2016037221

Printed in Malta by Melita Press
Typeset in India by Lapiz Digital Services, Chennai

For a complete list of Oxbow titles, please contact:

UNITED KINGDOM
Oxbow Books
Telephone (01865) 241249, Fax (01865) 794449
Email: oxbow@oxbowbooks.com
www.oxbowbooks.com

UNITED STATES OF AMERICA
Oxbow Books
Telephone (800) 791-9354, Fax (610) 853-9146
Email: queries@casemateacademic.com
www.casemateacademic.com/oxbow

Oxbow Books is part of the Casemate Group

Front cover: Mosaic image of Edgar and the kings crossing the bar; modern public art in Edgar's Field Park, Chester (Photo: P. Everson)
Back cover: Taplow gold braid (Photo: Jane Hawkes)

Contents

Preface

It is a great pleasure to be able to put on record our thanks to the contributors to this volume, not only for their good humour, patience and sustained commitment to the project, but also for having the courage to seize the opportunity to approach their chosen topics from what are sometimes unorthodox angles. If the results occasionally court controversy, so be it: that is precisely what a volume of this kind should do. Their willingness to take risks, and the wide range of the subject-matter of their contributions, is also an apt reflection of the breadth of interests and learning, and the originality of approach, of the honorand, Professor Emeritus Richard Bailey, OBE. Far more than that, it is an eloquent testimony to the considerable affection and respect in which he continues to be held by friends, colleagues and pupils alike, all of whom have benefited from his wise advice and acute criticism, generously proffered, over many years. We are delighted to dedicate this volume to him as a token of our thanks and appreciation.

Though the response to our request for contributions has been overwhelming, it has inevitably proved impossible for a number of friends, colleagues and pupils of the honorand to participate who, in other circumstances, would very much have wished to do so. They would, nevertheless, like to join us in celebrating the occasion of his eightieth birthday. They include: Peter Addyman; Coleen Batey; Carol Farr; Roberta Franks; Signe Fuglesang; Luisa Izzi; Susan Mills; the late Jennifer O'Reilly; Steven Plunkett; Julian Richards; the late Charles Thomas; Ross Trench-Jellicoe; Sir David Wilson; and Susan Youngs.

Finally, we take this opportunity to place on record our warmest thanks to the anonymous readers, and to the publisher for its support and guidance in facilitating the production of what has proved to be a technically complex volume.

Eric Cambridge and Jane Hawkes
January 2016

List of Figures

Abbreviations

ASE	*Anglo-Saxon England*
ASPR	Anglo-Saxon Poetic Records
ASSAH	Anglo-Saxon Studies in Archaeology and History
BAA	British Archaeological Association
BAR	British Archaeological Reports
CASSS	Corpus of Anglo-Saxon Stone Sculpture
CBA	Council for British Archaeology
CCSL	Corpus Christianorum Series Latina
CSEL	Corpus Scriptorum Ecclesiasticorum Latinorum
DCMS	Department of Culture, Media and Sport
DLS	*De Locis Sanctis*
EEMF	Early English Manuscripts in Facsimile
EETS	Early English Text Society
HBS	Henry Bradshaw Society
HE	Bede, *Historia Ecclesiastica* in B. Colgrave & R.A.B. Mynors (ed. and trans.), 1969 *Bede's Ecclesiastical History of the English People* (Oxford)
JBAA	*Journal of the British Archaeological Association*
Med. Arch.	*Medieval Archaeology*
MGH	Monumenta Germaniae Historica
MOLA	Museum of London Archaeology
OAS	Oxford Archaeology South
OED	*Oxford English Dictionary*
ODNB	*Oxford Dictionary of National Biography*
OS	Ordnance Survey
PAS	Portable Antiquities Scheme
PASE	Prosopography of Anglo-Saxon England at www.pase.ac.uk
PCA	Pre-Construct Archaeology
PSAS	*Proceedings of the Society of Antiquaries of Scotland*
VCA	*Anonymous Life of Cuthbert* in B. Colgrave (ed. and trans.), 1940 *Two Lives of Saint Cuthbert: A Life by an Anonymous Monk of Lindisfarne and Bede's Prose Life* (Cambridge), pp 59–139
VCP	Bede, *Prose Life of St Cuthbert* in B. Colgrave (ed. and trans.), 1940 *Two Lives of Saint Cuthbert: A Life by an Anonymous Monk of Lindisfarne and Bede's Prose Life* (Cambridge), pp 141–307
RCAHMS	The Royal Commission on the Ancient and Historical Monuments of Scotland
VCH	Victoria County History

Introduction

Crossing Boundaries

Jane Hawkes

Interest in the early medieval has become increasingly interdisciplinary (an approach practised and fostered by the work of Richard Bailey), but in some cases what has been deemed 'interdisciplinary' has in fact been 'multidisciplinary', something that requires the inter-relatedness of the various disciplinary approaches presented to be intuited; the interdisciplinary effect of the multi-disciplinary study is cumulative rather than direct. With this in mind, the benefits of various combined approaches into the study of the Middle Ages presented in the essays brought together here will be explored in relation to the art, architecture, archaeology and texts of the medieval world.

The term 'interdisciplinary' seems to have emerged in the area of social sciences in the 1920s but in 1955 McCuskey and Jensen Conaway (of the American Association for Supervision and Curriculum Development) were still bemoaning the fact that: 'the word "interdisciplinary" is not in the dictionaries, and arrived in the Educational Index only in January 1955 [where] some sound advice is given. It says: "See Interprofessional Cooperation".'[1] Eventually provided with a dictionary definition, as an adjective 'pertaining to two or more disciplines or branches of learning; contributing to or benefiting from two or more disciplines',[2] the term is invoked with increasing frequency as an aspiration within universities. One such institution even claims that 'in the real world' (the area of science and politics) 'many of the world's great problems require an interdisciplinary approach in order to solve them'. It does, nevertheless, admit that an interdisciplinary approach is also relevant intellectually in exploring 'the relation between reasoning and emotion, the study of culture and identity', the criteria apparently defining the humanities.[3] Seeking to elucidate this, however, misapprehensions regarding such subject areas

are brought into play. The example given is that of an art historian working in the field of '*ancient*' art (italics added), who will pursue historical research by reading 'the necessary original texts, finding out which materials were used at the time, comparing other paintings of the same time' and undertaking 'chemical and spectroscopic analysis in a chemistry lab'. This will enable 'her' (the art historian) to find out not only the chemical details but also 'the origin of the canvas'. By such means, 'a deeper understanding of the life and work of a great artist' can be achieved by combining Art History, History, Chemistry and a foreign language. While those working in the area of medieval studies would certainly endorse the pursuit of evidence from these and other disciplines (such as archaeology, literature and linguistics) in order to reach a deeper understanding of the 'culture and identity' of a distant medieval past, they would probably not expect to encounter great artists, or even named artists, working on canvas (any more than would, perhaps, those working in the field of ancient art). One of the few identifiable artists of the early Middle Ages, Eadfrith, Bishop of Lindisfarne (the first named 'English' artist), for example, was both a scribe and a painter, who worked in the medium of vellum.[4]

Nevertheless, this scenario, although revealing some confusion, does highlight vividly the issues involved in practising interdisciplinarity, for in large part the misperceptions can be explained by the fact that individual disciplines represent dividing and classifying modes of thought which produce division and demarcation. And the origin of such segregation is of extremely long standing. It lies in the emergence of education (in the Western European tradition) in ancient Greece where several subjects were arranged in a hierarchical fashion, with theoretical, practical and productive fields

of knowledge being identified. Of these, the theoretical areas of philosophy, mathematics and physics were the most highly regarded, while the practical fields of ethics and politics were more valued than the productive areas of art, poetry and technology. However, within this hierarchy, theoretical subjects were understood to be a-disciplinary because they were considered to embrace other areas of knowledge and so were deemed universal; thus, philosophy developed as the highest universal 'discipline'. The roots of disciplinary and interdisciplinary approaches to knowledge are thus deeply entwined. And they remained so throughout the Middle Ages with the establishment of the universities in which the study of the so-called free arts – under the *trivium* and *quadrivium* – was the fundamental educational principle.[5] It seems that it was only with the conclusions drawn by Copernicus, Kepler, Galileo, Newton and others working in the field of 'natural science' that the culture of knowledge was transformed – with the understanding that nature could only be explained by the laws of mathematics and physics (rather than philosophy – or theology).

The compartmentalisation of knowledge and a qualitative assessment of its component parts has certainly persisted with ever-increasing specialisation leading to gaps in the level of comprehension, not only between individual disciplines but also within the disciplines themselves: between the ancient, medieval, early modern, modern and contemporary areas of history, literature and art history for instance. With the margins between disciplines being tightly drawn not only is the nature of each discipline concealed from those 'outside', cross- or inter-disciplinary work is rendered difficult at best.

Paradoxically, however, as Slavicek has observed, it seems that it is this very specialisation which has motivated a demand for interdisciplinarity – in order to close the ever increasing gaps between disciplines.[6] In seeking to elide the lacunae interdisciplinarity is usually visualised as inhabiting the space in which the different disciplines overlap; it is the overlapping areas that are deemed to be 'interdisciplinary'. However, without the need to change approaches within the various disciplines, change within them – a major requirement of interdisciplinarity – is not fulfilled. As a result the disciplinary approaches remain entrenched in their ways of thinking and problem solving, and 'multi-disciplinarity' – rather than inter-disciplinarity – is the result.[7]

In the area of medieval studies, however, interdisciplinary approaches are well established – almost of necessity. Working in an historical period where contemporary documents can be rare, 'the necessary original texts' have, inevitably, to be drawn from the purview of a variety of different disciplines, comprising as they do (for example), histories, exegetical tracts, charters, sermons, homilies and poetry, written in Latin and vernacular languages,

which each draw on late antique and early Christian traditions. For our hypothetical art historian therefore, working within the paradigm set out above, access to, and understanding of, the texts of history and literature, along with language skills, are of vital importance, as is an awareness of the contexts of production and potential audience receptions.[8] Furthermore, in the absence of a wide range of contemporary artistic evidence, knowledge and understanding of late antique, early Christian and later medieval works and their conditions of production are also necessary, as is access to information about a range of different media (contemporary, late antique, early Christian and later medieval): metalwork, sculpture, manuscript painting, ivory carving and textiles – the study of which increasingly involves a variety of theoretical, archaeological and technological approaches (including chemical and spectroscopic analyses). Indeed, this was the approach fostered (uncommonly) among undergraduates in the Department of English Language and Literature (later School), at the University of Newcastle upon Tyne by Richard Bailey and his medieval colleagues in the 1980s and 1990s. Here, under the influence of practices established in the Archaeology Department at Durham in the 1950s by Professor Dame Rosemary Cramp, where students of Anglo-Saxon archaeology were introduced to Anglo-Saxon art along with Old English (language and literature), undergraduates studying English Language and Literature learnt Old English in weekly seminars in their first year, read Old English literature in weekly tutorials, had weekly lectures on the art and archaeology of the Anglo-Saxons, and weekly seminars on early medieval palaeography, codicology and diplomatic. Under this regime understanding of Anglo-Saxon literature was inseparable from that of the material and visual culture of the period, and *vice versa*.

It is in this tradition that the essays drawn together here are presented, incorporating as they do more than one discipline in each essay: archaeology and art (Cramp, Webster, Graham-Campbell), art, history and literature (Stancliffe, Coatsworth, Edwards, Isabel Henderson, George Henderson), archaeology and runology (Hines) and antiquarianism (Morris), geography, history and archaeology (Everson and Stocker, Paterson), archaeology, history and contemporary visual culture (O'Sullivan), archaeology and history (Watts), archaeology, architecture and history (Cambridge, Parsons), art, early liturgy and exegesis (Ó Carragáin, Hawkes, Karkov), archaeology and liturgy (Gittos), history, and geography (Allason-Jones and Heslop), history, manuscript studies and linguistics (Doyle, Frankis, Moisl), linguistics and geography (Whaley), history and historiography (O'Brien), literature and archaeology (Owen-Crocker). In this way the essays collected here can be deemed interdisciplinary, crossing disciplinary boundaries, and focussing on the 'gaps' between distinct areas of disciplinary knowledge, breaking

down the gaps in fact, in the way they present their evidence and so elucidate their various areas of enquiry.

Notes

1 McCuskey & Jensen Conaway 1955, 395.
2 *OED.*
3 University College London website: http://www.ucl.ac.uk/ basc/faq/interdisciplinarity (Accessed 15 August 2015).
4 See London: British Library, Cottom MS Nero D. iv.
5 Logic, grammar and rhetoric were studied under the *trivium*, and arithmetic, geometry, astronomy and music under the *quadrivium*.
6 See Slavicek 2012; for further discussion see Clark 1960; Becher 1981; Moran 2010.
7 For further discussion, see Slavicek 2012, 111–12.
8 For a recent summary, see Foxhall Forbes 2013.

References

Becher, T., 1981 'Towards a Definition of Disciplinary Cultures', *Studies in Higher Education* 6(2), 109–22

Clark, B.R., 1960 *The Open Door College: A Case Study* (New York)

Foxhall Forbes, H., 2013 *Heaven and Earth in Anglo-Saxon England: Theology and Society in an Age of Faith* (London)

Maddern, C., 2013 *Raising the Dead: Early Medieval Name Stones in Northumbria* (Turnhout)

McCuskey, D. & Jensen Conaway, W., 1955 'The Interdisciplinary Approach', *Association for Supervision and Curriculum Development* (April 1955), 395–401: www.ascd.org/ ASCD/ pdf/journals/ed_lead/el_195504_mccuskey.pdf (Accessed 15 August 2015)

Moran, J., 2010 *Interdisciplinarity* (2 edn, New York)

Slavicek, G., 2012 'Interdisciplinary – A Historical Reflection', *International J. of Humanities and Social Science* 2(20), 107–13

Part I

New perspectives on Insular sculpture and art

The material culture of Britain, and in particular the form and iconography of its stone carvings, has been at the heart of Richard Bailey's research throughout his career. It is, therefore, entirely appropriate to begin a volume in his honour with a group of essays which offers a range of new perspectives on this important and distinctive material.

In a new reading of one of the most famous Northumbrian monuments, Clare Stancliffe considers the underlying exegetical background to the eclectic choice of images and texts on the Ruthwell cross. This prompts her to reassess its original context and purpose, and also its sources of inspiration, in which she suggests that early eighth-century Lindisfarne may have played a key role. A very different (and probably rather later) aspect of Lindisfarne's influence is argued for by Professor Dame Rosemary Cramp, who publishes here for the first time an important group of little-known aniconic Anglian cross-heads from sites in Bernicia. She suggests that this distinctive feature of their decorative repertoire reflects an association with the famous monastery. Elizabeth Coatsworth examines possible reasons for the comparative scarcity in Anglo-Saxon art of depictions of scenes of apostolic martyrdom. Her starting point is the way in which such scenes were portrayed on Northumbrian crosses, but she widens her enquiry to take in Carolingian Europe and later Anglo-Saxon England and suggests that these images should be seen as products of the rarified atmosphere of a learned monastic culture.

Nancy Edwards turns our attention to early medieval Wales, and in particular to the surprising variety of ways in which the Crucifixion was depicted in sculpture there. In tracing the iconographic sources of these portrayals she deftly places them in the context of the distinctive history and traditions of the Welsh Church while also drawing attention to the range of cultural contacts with its neighbours.

The final two papers in this section are devoted to the north of Britain, and focus on aspects of the art of Pictland and its relationships with the wider world in the later eighth and early ninth centuries, when the kingdom's artistic achievement was arguably at its height. George Henderson proposes innovative identifications of several iconographically problematic scenes on Pictish sculpture, suggesting that they may reflect an assertion by Pictish clerics of the orthodoxy of their own attitude to images in a contemporary world riven by increasingly bitter controversy over just that issue. In the process he reveals how well informed and well connected those churchmen were, and how sophisticated and innovative their contribution to the debate. The same period also saw the development of an intriguing artistic relationship between Pictish carvers and metalworkers and their counterparts in the kingdom of Mercia. These links are reviewed by Isabel Henderson nearly half a century after her own pioneering study first established their importance. If some aspects of the relationship have become more complex than they once seemed, in other ways the closeness of the cultural connexions between the two kingdoms has been startlingly vindicated by recent finds. What is more, she argues that this was not a case of one-way traffic, but rather a reciprocal, genuinely creative exchange between two societies at a particularly vibrant and innovative phase in their cultural history.

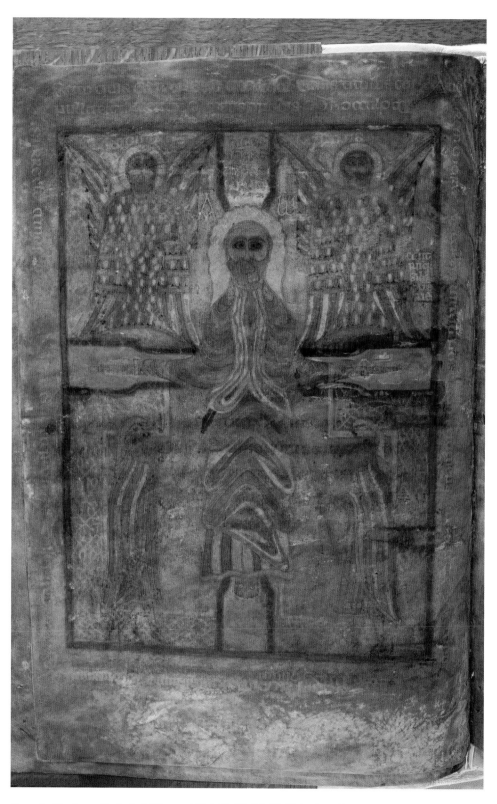

Fig. 1.1 Durham Gospels (Durham: Cathedral Library, MS A. II. 17, fol. 38 (3)v), Crucifixion surrounded on four sides by accompanying inscription: [TOP] Scito quis et qualis est qui talia cuius titulus cui / nulla est inuenta passus p(ro) nobis p(ro)p(ter) hoc culpa [RIGHT] Auctorem mortis deieciens uitam nostram restituens si tamen conpatiamur [LEFT] surrexit a mortuis [...] sedet ad dexteram d(e)i patris [BOTTOM] ut nos cumresuscitatos simul et regnare faciat ... (Photo: Copyright, Chapter of Durham Cathedral, reproduced with kind permission)

The riddle of the Ruthwell Cross: audience, intention and originator reconsidered[1]

Clare Stancliffe

Introduction

The Ruthwell Cross is a riddle in more than one respect: in its sophisticated selection of images and texts which link together to suggest overarching theological themes, but with puzzling twists or incongruities;[2] and equally because this cross, 'the most impressive single piece of surviving Anglo-Saxon sculpture,' comes not from a major church of the Northumbrian heartlands, but from a peripheral area in the west, and a site with no known historical context.[3] Ruthwell lies just north of the Solway Firth, between the rivers Annan and Nith. Today the cross stands within a post-medieval church, re-erected after being broken and buried at the Reformation. Its probable original context was revealed by aerial photography as a large ring enclosure of *c.*175m in diameter. Subsequent excavation produced evidence of iron working in Roman (or possibly post-Roman) times, and also 'a pecked cross grave marker of the sixth century and a piece of a drum capital from an eleventh-century building.'[4] This suggests that it was a British Christian site that was then taken over by the Anglo-Saxons, who erected the cross. Some 5 miles (8 km) to its north-east lies the better known site of Hoddom, another ecclesiastical site with evidence of a probable Anglian Church and some later eighth-century crosses. A link between the two sites is plausible, but unverifiable.

The cross stands over 5m tall, and was created in two sections (Fig. 1.2). The lower stone comprises most of the shaft, and includes the bottom three sculptured scenes on each broad side (excluding the later Crucifixion). The upper stone originally comprised the uppermost part of the shaft, containing one sculptured scene, and the cusped cross-head, also with images. The cross was badly damaged at the

Reformation, and what we see today is the reconstruction of Henry Duncan, minister at Ruthwell 1799–1843.[5] Apart from needing to reverse the uppermost stone of the cross-head,[6] Duncan's reconstruction is reasonably accurate: the positioning of the figure holding a lamb above Christ and the beasts, though questioned by Meyvaert, receives support from the identical positioning of similar scenes on the related Bewcastle Cross.[7] To do justice to all that has been published on the Ruthwell Cross would exhaust my allotted space.[8] Éamonn Ó Carragáin, for instance, has set a new standard for the interdisciplinary study of all the elements that went to the making of this remarkable monument, and the present contribution is retrograde in focussing solely upon the images and accompanying inscriptions on the two broader sides of the cross. My intention here is to build upon these earlier studies and to suggest that, in addition to the monastic audience and meanings already elucidated, there was also a British audience in mind; and, in the light of this, to probe its probable context and the mastermind behind it.

The iconography of the figural scenes

First, however, we need an overview of the cross (see Figs 1.2–3). The faces of the two broader sides contain figural carvings set in panels, each with an accompanying inscription in roman script (once in runes). In contrast the narrower sides contain an overall design of a tree of life or inhabited vine, with birds and animals feeding; and, squeezed into the margins, Old English verses on the Crucifixion in runic script. These correspond to parts of a poem preserved in a later form in the Vercelli Book,

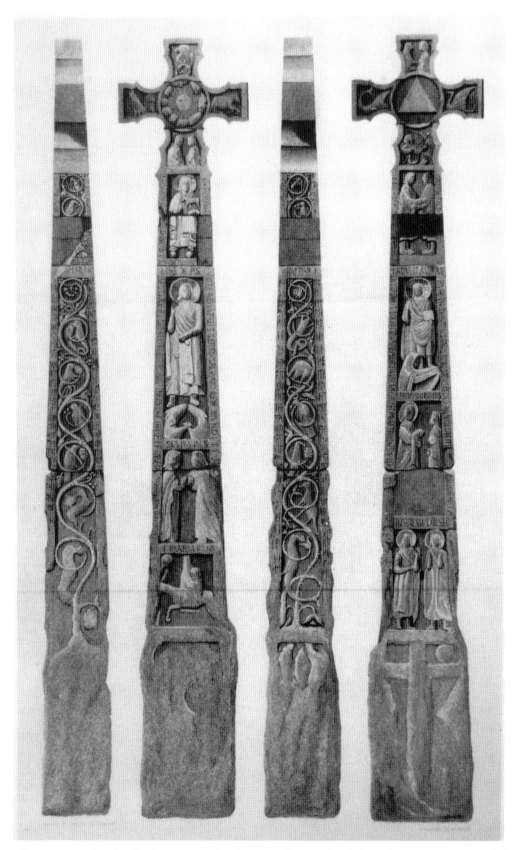

Fig. 1.2 Duncan's reconstructed Ruthwell Cross (1833), from W. Penny's engraving (Photo: Crown copyright RCAHMS. SC730096. Licensor www.rcahms.gov.uk)

The Dream of the Rood. The focus here will be on the figural scenes on the two broader sides:

North ('Desert') Side	South ('Salvation') Side
N1: John the Baptist with *agnus Dei*	S1: 'Mary and Martha'
N2: Christ above the beasts	S2: Jesus and the penitent Mary Magdalene
N3: Saints Paul and Antony	S3: Jesus healing the blind man
N4: Flight into Egypt	S4: Annunciation

The image which dominates the entire cross is N2, since Christ here is taller than any other figure on the cross (cf Figs 1.2–4). The accompanying inscription reads:

[top] +IHSXPS |
[right (1)] IVDEX:AEQVI*T*ATIS:
[left] BESTIAE:ET:DRACONES:COGNOUERVNT:INDE |
[right (2)] SERTO:SALVA[.]OREM:MVNDI: |
+ *Ie(su)s chr(istu)s iudex aequitatis. Bestiae et dracones cognoverunt in deserto salva(t)orem mundi*[9]

This well illustrates the riddling nature of the cross, since such an event is described nowhere in the Bible. The scholarly consensus is that it primarily refers to Jesus' forty days in the desert, which followed immediately on his baptism.[10] According to Mark 1:13, he was 'in the desert', 'with the beasts' (*cum bestiis*); and an uncommon interpretation, alluded to here, is that the beasts were not hostile forces trampled by Christ (as when this passage was conflated with Psalm 90:13), but rather creatures who recognised the Lord. This tradition is inspired by many passages in Isaiah, and recurs in apocalyptic and apocryphal writings and those about the desert fathers.[11] An additional resonance of this scene may have been that of Christ at the Transfiguration.[12]

The remaining three images on this side of the cross can best be understood as reflecting on, or drawing meaning out of, this primary scene. Above it (N1) is John the Baptist with the *agnus Dei* (Lamb of God), referring to the Baptist's words when he saw Jesus coming to be baptised.[13] Most of the inscription is now illegible, but [–]DORAMVS, *adoramus* ('we adore') survives, and points to a devotional context. This might refer to the *Agnus Dei* chant, introduced into the mass by Pope Sergius I (687–701),[14] although the *Gloria in excelsis*, which also figured in the mass, hails Christ in similar terms and includes the words '*adoramus te*.' At the bottom, the Flight into Egypt (N4) was probably chosen not just because the holy family fled through the desert, but because in the apocryphal Gospel of Pseudo-Matthew, when they stopped at a cave, many dragons came out and worshipped Jesus,[15] who reassured Mary and Joseph, 'Do not regard me

Fig. 1.3 Ruthwell Cross, north side: Christ above Beasts, Paul & Antony, Flight into Egypt; west side: Tree of Life (Photo: Clare Stancliffe)

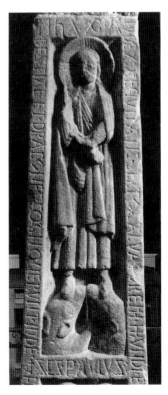

Fig. 1.4 Ruthwell Cross, north side, Christ above the Beasts (Photo: T. Middlemass, © Corpus of Anglo-Saxon Stone Sculpture)

as a baby, for I was and always am a perfect man, and it is necessary that I should make all wild creatures tame.'[16] Ruthwell's unusual frontal posture of the Virgin and Child on the donkey is reminiscent of an icon, and this, together with Christ's distinctive (and rare) triple cruciform halo, tallies with this reading of the panel as portraying Christ manifest on earth in his divinity, rather than Jesus the baby.[17] Meyvaert noted evidence for knowledge of this Pseudo-Matthew episode in a contemporary psalm commentary copied by a Northumbrian named Edilbericht in the eighth century. This paraphrases Pseudo-Matthew with the words, 'dragons came and worshipped their feet', which aptly describes the posture of the adoring beasts on the Ruthwell Cross.[18] The inscription is damaged, but began +MARIA:ETIO[–], + *Maria et Io(seph ...)* ('Mary and Joseph') (Fig. 1.5), which confirms the allusion to Pseudo-Matthew where they are named in that order,[19] whereas in (canonical) Matthew the initiative lies with Joseph, and Mary is not mentioned.[20] Finally, the significance of Paul and Antony sharing a loaf (N3; Fig. 1.5) has been elucidated by Ó Carragáin, drawing out its eucharistic symbolism,[21] and by Haney, emphasising the significance of the desert as the place of encounter with God, and noting that Jerome's *Vita Pauli* includes a passage where a desert creature asks Antony 'to pray for us to our common Lord, whom we recognise has come to save the world',[22] using words which are echoed in the Ruthwell inscription around Christ and the beasts.

To the wealth of informed comment I would add that the figure of Christ above the beasts is indeed Jesus in the desert, but seen through the lens of the prophecies in Isaiah (to which all four Gospels allude);[23] note the scroll in Christ's

hand. Particularly pertinent is Isaiah 11:1–9,[24] foretelling the flower that would arise from the stem of Jesse: 'the spirit of the Lord will rest upon him' tallies with the spirit of God descending on Jesus at his baptism immediately before his sojourn in the desert;[25] 'he will judge the poor with justice, and reprove with equity on behalf of the meek of the earth' is paraphrased by the title, '*iudex aequitatis*'; [26] and this is followed by the description of how 'the wolf will dwell with the lamb' and all creatures and mankind will be at peace – a reference closely paralleled by Pseudo-Matthew in a passage just after that discussed above.[27]

Scholarly opinion is divided over whether the overarching theme of this side of the cross should be identified as 'desert', which fits all four scenes, and is specifically mentioned in the two surviving inscriptions;[28] or 'eucharist', which fits N1 and N3 well, and has been argued for the other scenes also;[29] or 'recognition of Christ', which fits N1 and N2 well, but is less obvious for N3 and N4.[30] Given that the designer appears to have thought in terms of multivalent images, all three meanings are probably intended, although 'desert' predominates.

The south side is dominated by Christ standing, while the penitent woman, widely identified at that time as Mary Magdalene,[31] dries his feet with her hair (S2; Fig. 1.6). S2 to S4

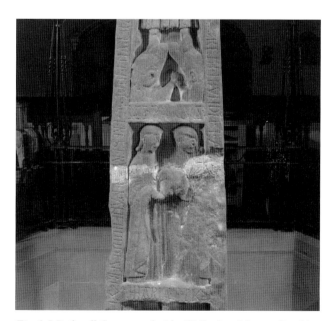

Fig. 1.5 Ruthwell Cross, north side, SS Paul and Antony Breaking Bread (Photo: T. Middlemass, © Corpus of Anglo-Saxon Stone Sculpture)

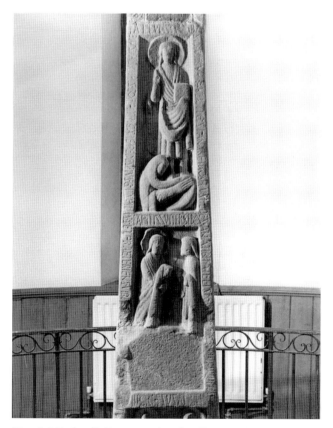

Fig. 1.6 Ruthwell Cross, south side, Christ and Penitent Mary Magdalene; Christ healing Blind Man (Photo: T. Middlemass, © Corpus of Anglo-Saxon Stone Sculpture)

are all straightforwardly identified by their accompanying inscriptions, which reproduce relevant quotations from the Gospels. They make excellent sense if read from the bottom, beginning with the Annunciation, then Christ Healing a Blind Man, followed by Christ and Mary Magdalene. At the top is a depiction of two women embracing (S1), which was long interpreted as a Visitation. But the surviving part of the inscription, this time, exceptionally, in runes, may be read:

[right] '+dominnæc'
[left] 'marþa'
[top] 'mari[.*m*]'[32]

Perhaps: '+Dominae c([–] Martha Mari(*a*)(*m*-))' ('+ ladies … Martha Mary …'). It is therefore likely primarily to portray Martha and her sister Mary, perhaps representing the active and contemplative lives, and this fits well immediately above the penitent Mary.[33] Confirmation also comes from the fact that neither woman here is haloed, unlike the Virgin Mary in S4. Nonetheless, this scene may be deliberately multivalent, recalling the Visitation as well: note how the figure on the right puts her hand on the other's belly (Fig. 1.2).[34]

The scenes on this side fit together when viewed against the exegetical tradition. The Annunciation stood for the Incarnation as a whole, being identified by Bede as 'the starting point of our salvation'.[35] Jesus healing the blind man was interpreted by Augustine as Jesus enlightening and then baptising the human race, and Bede gives a similar interpretation.[36] The depiction of Christ and the penitent Mary Magdalene symbolises penitence and forgiveness, neatly balancing the role of Christ as *iudex aequitatis* in N2. Finally, Bede expounds how we must begin with penitence and the active virtues before rising to contemplation of God. If we may accept the figures in S1 as the sisters Martha and Mary, their embrace might then symbolise the interlocking nature of the active and contemplative lives, while the recurring figure of Mary Magdalene would link S1 and S2 together, showing how a repentant sinner can aspire to the heights of contemplation.[37]

A British audience?

Whereas the 'Desert' side of the cross is suited to a monastic community, this 'Salvation' side implies a wider audience.[38] This is plausible: priests based in *monasteria* were responsible for the pastoral care of the surrounding population. We should, then, be thinking of both a monastic community (perhaps a double monastery under an abbess, given the prominence of women on the cross),[39] and the surrounding lay population. In the Ruthwell area, however, the latter are likely still to have been British in speech and ethnicity at the time the cross was erected (probably between *c.* 690 and 750).[40] This putative British audience may account for the selection of some of the more unusual scenes on the cross. Let us begin

by considering Christ and the penitent Mary Magdalene (S2; Fig. 1.6). This is very uncommon; indeed, the Ruthwell carving is the earliest surviving representation of this scene.[41] Why, then, was it chosen? A British context would explain this, as canonical texts emanating from Archbishop Theodore show that he regarded British Easter practice and tonsure as at best schismatic, and at worst heretical, requiring repentance and lengthy periods of penance.[42] The prominent image of the penitent at Christ's feet would have sent a strong message to the Britons. This hypothesis is strengthened when we consider the juxtaposition of this scene with S3 (Christ Healing the Blind Man; Fig. 1.6). John's Gospel itself interprets this as an occasion 'that the works of God might be manifested in him',[43] and Augustine and Bede both stressed the theme of enlightenment. This message acquired particular relevance in relation to the Britons in two miracles recounted in Bede's *Ecclesiastical History*. One tells how saints Germanus and Lupus confuted Pelagian teachings in Britain, and then vindicated their catholic teaching by healing a blind girl: 'Her eyes were immediately delivered from darkness and filled with the light of truth … From that day the evil doctrine was so utterly banished … that they thirsted eagerly after the teaching of the bishops.'[44] In the second one the Roman missionary Augustine attempted to convince representatives of the British Church to abandon their traditional Easter practice and join him in evangelising the English, and then 'proved' the rightness of his case by healing a blind Englishman. At this, 'all acknowledged Augustine to be a true herald of the heavenly light. Then the Britons confessed that they realised that it was the true way of righteousness which Augustine preached.'[45] In circles where this story was remembered, and particularly where Bede's *History* was known, the image of Christ healing a blind man beneath that of his forgiving a penitent sinner would have had a particular resonance.

There may well be a message implicit in the inhabited vine-scroll on the narrower sides of the cross (Fig. 1.3), since it symbolises 'the incorporation of all the faithful members of the Church into the sacramental and the glorified body of Christ';[46] but this will not be pursued here since it was a common motif elsewhere. In contrast, the representation of Paul and Antony breaking bread together (N3) is perhaps the earliest representation of this event,[47] and certainly the only scene illustrated that does not come from the Bible. (Its source is Jerome's *Vita Pauli*.) Why, then, was it chosen? God's care for his people in the desert could have been illustrated by Elijah and the Raven, or, with eucharistic connotations, by the Feeding of the Five Thousand. Alternatively the Supper at Emmaeus would have emphasised the themes of eucharist and recognition. If, however, we look closely at the scene (Fig. 1.5), we note that the sculptor omitted the miraculous element in Jerome's story (the raven bringing the bread), and focussed instead on the two hermits sharing the loaf. Ó Carragáin has shown how the sculptor adjusted the scene to suggest a eucharist, rather than a simple meal,[48] and the

inscription (albeit damaged) confirms this. These details imply concelebration of the eucharist, which could not have been represented by any biblical scene.[49] In the context of a neighbouring British population, at a period when British and Northumbrian priests were not in communion with each other, the message is clear: there is a need for humility and mutual respect (as with Paul and Antony), and above all to be in communion with each other.[50]

As well as the panels discussed here, Schapiro noted that the concentration on the desert theme would have had a particular appeal to British Christians, who appear to have valued the eremitical life highly.[51] My suggestion, then, is that the Ruthwell Cross is in part a 'charm offensive' directed at the Britons. The images we have discussed on the 'Salvation' side of the cross focussed on their need to recognise their error, repent and be restored, while those on the 'Desert' side highlighted what the two traditions had in common in the desert tradition, and emphasised the need for mutual humility, recognition and unity within the body of Christ, his Church. This audience would explain why such a major monument occurs in an area peripheral to Northumbrian rule. It was created there because a publicly accessible monument that used images (in addition to words) stood a good chance of engaging with local (disaffected?) Brittonic speakers.

For this suggestion to carry conviction we need to address two questions: why, if the cross envisaged a British audience, were the verses on the narrower sides in a language, Old English, and a runic script, which would have excluded them?[52] And how might this fit into the general pattern of Anglo-British relations? The first question can be dealt with summarily. I am not arguing that Britons formed the only audience for the Ruthwell Cross, but simply adding an additional audience to that of the monastic community at Ruthwell, which presumably was linguistically Anglian, even if it incorporated some Britons. It is also possible that those responsible for the cross sought to encourage the assimilation of the Britons, which might have been furthered by the use of English.

The question of how the Ruthwell Cross might fit into the pattern of Anglian and British relations is tricky since we know little about these, particularly for the area around Ruthwell. My working hypothesis is that up to and including Oswiu's reign (642–70), a British kingdom(s) in modern Cumbria (Rheged?) acknowledged Bernician overlordship, but retained its own king(s); and that it was only incorporated into Northumbria under King Ecgfrith (670–85).[53] Well to the north of Ruthwell, the area covered by the later counties of Ayr and Renfrew either belonged to the British kingdom of Alclud (later Strathclyde), or – perhaps for Cunningham and the land to its south – was reclaimed by it from Northumbria following Ecgfrith's downfall in 685 after a brief period of Northumbrian overlordship.[54] As regards Whithorn, well to the west of Ruthwell, Bede notes, from the perspective of 731, that it lies within Bernicia,[55] and that the number of believers there has

nuper ('recently') increased to such an extent that it now has its own bishop.[56] Since the Britons of this area had long since been Christian, this must mean either that it had only recently been taken over by Northumbria, which had enforced its own brand of Christianity there; or, if it had been technically under Northumbrian overlordship for some time, it was nonetheless only recently that the Britons there had adopted the Easter practice and tonsure favoured by the Northumbrians. As for Ruthwell, given the ambition of Ecgfrith's conquests, it seems likely that Annandale was conquered by him as well as lands south of the Solway. But was it sufficiently firmly incorporated into Northumbria to remain in Northumbrian hands after the defeat of Nechtansmere, or had the local nobility just switched allegiances and then, perhaps, reverted?[57] And was control of it such that Northumbria was able to enforce conformity on the Easter question from *c.* 680 onwards? Or did such control only become a reality in the 720s, as with the areas to its west?

Two archaeologists have recently reconsidered the British polities in the west. They agree that the Cumbrian lowlands, on the one hand, and the Rhinns and Machars (later Wigtownshire), on the other, probably formed the heartlands of different kingdoms, but differ as regards the Ruthwell area. McCarthy doubts whether it belonged to the same kingdom as Cumbria.[58] Toop, however, argues that the land north of the Solway Firth and east of the river Nith shares with Cumbria the occurrence of *eccles* place-names, but no British tradition of public monuments in stone, in both respects contrasting with the area west of the Nith, where, in addition, Irish influence is much in evidence.[59] Her mapping of *eccles* place-names is incomplete: some apparently do occur in the Loch Ryan and Rhinns area.[60] But the distribution of *caer* names would confirm her view,[61] and we may tentatively accept that the area east of the Nith appears to have been more closely related to Cumbria than to Galloway and the Rhinns to its west, though we need not assume that it formed part of a unitary kingdom with the Cumbrian area. Since Ruthwell is close to the Solway, just five miles east of the Nith estuary, the implication would be that from Ecgfrith's reign it was within Anglian or Anglian-affiliated territory, but close to its westernmost extremity. In view of Bede's comments in 731 on the 'recent' increase in converts, the British population west of the Nith is likely to have been integrated into Bernicia and the Northumbrian Church only around the 720s. In this scenario, the Anglian takeover of Ruthwell might have been linked to a concern to consolidate their control in a marginal area.

Who was responsible for the Ruthwell Cross?

Let us now consider which church might have instigated the creation of such a sophisticated monument. We may agree that it is likely to have been 'one of the major monastic houses of Northumbria.'[62] Beyond this, we should consider four criteria: historical context (are there any known or plausible links between the two churches?); the evidence

of the stone carving; the layout, lettering, and content of the inscriptions; and the overall scheme of the images on the cross, already discussed. As we go, we need to bear in mind that the overall architect of the cross is likely to have been a different person from the craftsmen who carried out his designs,[63] and that the two need not necessarily be from the same church. In other words, we may be dealing with a collaboration between different churches.

As regards the first criterion, our knowledge is scanty, but two points are relevant. First, from the time of its conquest until the establishment of Whithorn as a separate diocese *c.* 730 (and possibly beyond, if the Nith continued as a boundary), Ruthwell was probably in the diocese of Lindisfarne, despite being more readily accessible from Hexham.[64] Secondly, the churches at both Ruthwell and at Bewcastle, where there is a related cross, have dedications to the Lindisfarne patron, St Cuthbert, which are likely to predate Ruthwell's absorption into Strathclyde in the ninth or tenth century.[65]

As regards the evidence of the stone carving, the earliest centres in Bernicia with such skills were Hexham and Wearmouth-Jarrow. Ruthwell differs from the early sculpture at Hexham, but Cramp has made a strong case for Wearmouth-Jarrow, based on parallels between the inhabited vine-scroll from both places.[66] The issue becomes more complicated when we also take the Bewcastle Cross into account. That has two figural scenes which are closely paralleled on the Ruthwell Cross (Christ above the beasts immediately below John the Baptist with the *agnus Dei*) as well as an inhabited vine-scroll on its eastern side, which is closely related to that at Ruthwell. However, Bewcastle's north and south sides carry panels of ornament, with one motif (the chequers) that may look to Hexham, while others look to a broader Insular tradition. Indeed, the overall scheme of panels of interlace is similar to what one finds in manuscripts like the Lindisfarne Gospels, and one panel at Bewcastle is paralleled (though not uniquely) in that Gospel-book.[67] This alerts us to the fact that we may be seeing influences from more than one centre coalescing; and in that connection we should note that Cramp agrees with Saxl in seeing a strong relationship between the Ruthwell figure of Christ (S2; Fig. 1.6) and that on the Cuthbert coffin-reliquary made at Lindisfarne in 698 (see Fig. 8.8).[68] Further, the double cusped shape of the cross-head at Ruthwell is of a type found at Lindisfarne.[69]

We turn now to the evidence of the inscriptions around the images on the broad sides of the cross. First, while one is in runes, the other seven use roman script. This casual mix of scripts, without any discernible rationale, is typical of the Cuthbert coffin-reliquary.[70] Secondly, there is the form of the roman lettering used: many letter forms tally with those of the display script of the Lindisfarne Gospels, which is also found on the name stones from Lindisfarne. Although this display script does occur elsewhere,[71] it probably emerged at a centre where there was a strong cross-over between manuscripts and epigraphy, and that centre might well have

been Lindisfarne.[72] Higgitt notes the formal cutting of the Lindisfarne name stones, with their lettering kept between guidelines; and that formality, together with seriffing and the actual forms of many letters, appears also on the Ruthwell Cross (Figs 1.4–5). In addition, Baldwin Brown noted a precise parallel between the way that the Mary Magdalene inscription on Ruthwell ended, with an 'a' being placed vertically above a 't' (Fig. 1.6), and the identical treatment of these letters in the Lindisfarne Gospels, folio 211r.[73]

Additional evidence for a link between the inscriptions on the Ruthwell Cross and one from Lindisfarne comes from their length, layout and intention. Cramp has commented on the Ruthwell Cross: 'it is unique in Anglo-Saxon cross sculpture to have inscriptions which surround the whole of each image, instead of being just a label across or a single long inscription.'[74] One interesting parallel was drawn by Kitzinger,[75] who compared the static, hieratic figure of Christ above the beasts with that of icons from St Catherine's, Sinai. Some of these were surrounded by inscriptions on all four sides, like the Ruthwell panels, which were arranged in the same way as at Ruthwell. They begin horizontally along the top of a scene, turn down the right-hand side, then run from top to bottom down the left-hand side, and horizontally along the bottom. The longest inscription at Ruthwell, around Jesus and Mary Magdalene, follows this precisely; the others adopt a shortened form (Figs 1.5–6), which is also found on a seventh-century icon at Santa Maria in Trastevere, Rome.[76] There is, however, one interesting difference. The lettering around the icons runs vertically down the two sides, whereas that round the Ruthwell Cross panels must be read sideways.[77] Now we find a precise parallel to the Ruthwell arrangement in the inscription which surrounds the crucifixion image in the Durham Gospels (Durham Cathedral Library, MS A. II. 17), folio 38 (3)v, a manuscript probably produced at Lindisfarne *c.* 700 (Fig. 1.1).[78] Here, the sideways-on inscription down the two sides makes good sense, as someone contemplating the manuscript image could turn it to facilitate reading the inscription down the two sides. This arrangement seems, at this period, unique to Ruthwell and the Durham Gospels. The closest parallel I am aware of is a damaged name stone from Billingham; but here the writing on the left-hand side, though sideways on, runs from bottom to top, not vice versa.[79]

In addition to this unusual layout, there are other parallels between the Ruthwell and the Durham Gospels' inscriptions. Both that on the manuscript and those on the cross are exceptional in their length. Further, the inscriptions operate in a similar way. They are not simply labels; rather, the viewer is being drawn into the meaning of what is portrayed, and urged to respond.[80] O'Reilly has commented on *ekphrasis*, *apropos* of her discussion of the Durham Gospels' crucifixion: '[it] brings the larger context or significance of the subject before the inner eye, engaging the attention of the viewer and eliciting a response, sometimes by presenting a puzzle, wordplay or paradox, and especially by calling to mind other

images, texts and ideas already in the viewer's memory.'[81] That would be an excellent description of the 'Desert' side of the Ruthwell Cross. Arguably, that side too was designed to elicit a response of engagement and adoration from the viewer. As well as the fragmentary 'adoramus' round N1, the implication of N2 is that if Christ was recognised even by the beasts, then surely humankind should follow suit.[82] Compare the Durham Gospels' inscription, which stimulates the onlooker to contemplate who it is who is dying for us, and to suffer alongside Christ: 'Casting down the author of death, restoring our life, if however we suffer along with him'.[83] Thematically, also, there are parallels between the two inscriptions. The Gospels' inscription just quoted is summarised by the *salvatorem mundi* of Ruthwell. More significantly, for both a central theme is to 'know who and of what kind he is, who suffered such things for us'.[84] The words come from the Durham Gospels, but the same concern is evident on the 'Desert' side of the cross, with its interest in the beasts who 'recognised … the saviour of the world'. It is even more apparent in the verses on the narrower sides of the cross.[85] Finally, in the Durham Gospels the alpha and omega beside Christ's head, and *initium* and *et finis* above the heads of the attendant seraphim, point to its crucified and reigning Christ also representing the Christ who will come in judgment,[86] thus tallying with Ruthwell's *iudex aequitatis*. Given that the two images primarily represent different aspects of Christ, the numerous overlaps between the two inscriptions are noteworthy.

The final criterion for trying to elucidate which monastery might have been responsible for the Ruthwell Cross is its choice of iconographic themes. Various commentators have rightly stressed the relevance of Bede's exegesis.[87] But Meyvaert, while recognising this, has also pointed out that certain features could not have stemmed from Bede himself, notably its interpretation of the beasts accompanying Christ in the wilderness as friendly, rather than hostile, as in Bede's exegesis; and its apparent reference to the apocryphal Gospel of Pseudo-Matthew, whereas Bede never admits apocryphal works.[88] One can go further and argue that the significance given to the desert tradition on the 'Desert' side of the cross tallies with the spirituality of Lindisfarne, rather than that of Bede. The basis for this statement is the divergent ways in which St Cuthbert's anachoretic leanings are presented in the Anonymous *Life of St Cuthbert* from Lindisfarne, on the one hand, and in that by Bede, on the other.[89] Cuthbert's original attempt at anachoresis and his attitude to the episcopate are treated very differently by the two authors.[90] Further, Haney has brought out how the central panel (N2), illustrating Christ being recognised by the beasts *in the desert*, belongs in the Desert tradition, where a special relationship with God is associated with solitude in the desert – and, we might add, the paradisal relationship between man and animals is restored.[91] The Anonymous *Life* echoes this tradition in interpreting the otters who licked Cuthbert's feet dry after

the manner of the lions, who 'served' Daniel in the Old Testament.[92] (This reading probably depended on Jerome's interpretation of this event in his epistle 1:9,[93] and belongs with his image of the friendly lions in his *Vita Pauli*, which lick St Antony's hands and feet.[94]) Haney rightly compares Jerome's letter 3 on how Bonosus has taken himself off to a rocky island 'as if a new colonist of paradise.' Totally alone, 'but with Christ's companionship not alone, he sees the glory of God, which even the apostles had not seen *except in the desert*.'[95] As Sulpicius Severus explained, describing an Egyptian anchorite who avoided all human contact, 'he who is frequented by men cannot be frequented by angels.'[96] This tradition is echoed in the Anonymous *Life*, when Cuthbert, near the end of his life, resigned his bishopric and withdrew back to Farne, where 'he remained alone, content with the converse and ministry of angels.'[97] Bede, on the other hand, says nothing of angels, and talks rather of how his contrition might supplant worldly cares.[98]

When we review all four criteria, the significance of links to Lindisfarne stands out.[99] Ruthwell apparently belonged to that diocese up to *c.* 725, and possibly stayed there; so, if I am right to suggest that the cross was intended in part for a British audience, the Bishop of Lindisfarne would have been pastorally responsible for them, and the person most obviously likely to commission such a monument. The themes portrayed on the cross, the roman and runic lettering, the inscriptions around the panels, and even some features of the cross like its figure of Christ and its double cusped shape would all fit here. Nonetheless, we need to heed Cramp's comment: 'it is difficult to believe that these crosses [Ruthwell and Bewcastle] were carved by Lindisfarne masons since there is no surviving stone carving at Lindisfarne which is anything like them in motifs or style of cutting.'[100] At the same time her case for a sculptural parallel with carvings from Wearmouth-Jarrow remains significant. As regards this final riddle posed by the Ruthwell Cross, I suggest that the answer lies in a collaboration between the two monasteries of Lindisfarne and Wearmouth-Jarrow. Perhaps the Ruthwell Cross was conceived by a Lindisfarne monk-bishop, albeit one who probably knew Bede and his exegesis, and might well have discussed the design of the cross with him. (That might explain how the image of Christ healing the blind man came to form part of his appeal to the Britons, even though the cross may just predate publication of Bede's *Ecclesiastical History* in 731.) This Lindisfarne churchman planned the sequence of scenes on the north and south faces, in part to engage with the local British population, persuading them to repent of their separatist traditions and unite with the Northumbrian Church, which was in many respects so similar to their own. He was also responsible for composing the inscriptions accompanying each scene.[101] Yet Lindisfarne, while fully aware of the role of art as a vehicle for embodying and synthesising the diverse Christian traditions in Northumbria,[102] lacked craftsmen with the skills to create such a public sculptured monument, which was needed if the

Britons were to be reached. He therefore commissioned it from Wearmouth-Jarrow, which had such craftsmen.

This, of course, is pure hypothesis; but besides making sense of all the aspects already discussed, it receives support from two independent facts. First, other major collaborations between Lindisfarne and Wearmouth-Jarrow are attested around just this time, with Wearmouth-Jarrow loaning the exemplar for the Lindisfarne Gospels,[103] and with Lindisfarne commissioning Bede to write a new *Life* of St Cuthbert *c.*720.[104] Secondly, Symeon of Durham, writing between *c.* 1105 and 1115 but informed by a contemporary inscription, records that Æthilwald, Bishop of Lindisfarne from *c.* 724–40, 'had had embellished by the work of craftsmen a stone cross, and in memory of the saint [Cuthbert] he had his name inscribed on it.'[105] According to Symeon the cross had been brought to Durham along with St Cuthbert's relics, and stood in the cemetery there; and the further detail that it had been broken but skilfully mended with lead suggests that Symeon was indeed thinking of a real cross with a real inscription on it. We thus have independent evidence that the bishop of Lindisfarne was commissioning at least one stone cross with accompanying inscription during precisely the period to which the Ruthwell Cross is most plausibly ascribed. Æthilwald in his youth had been Cuthbert's personal attendant, and will thus have been imbued with the way in which that saint had blended Lindisfarne's eremitic ideals with deep pastoral concern.[106] Further, according to Aldred's colophon Æthilwald was responsible for binding the Lindisfarne Gospels, suggesting his involvement in the artistic products of Lindisfarne's scriptorium.[107] That Æthilwald also commissioned the Ruthwell Cross must remain a hypothesis, but it is one that is surely worth pondering.

Notes

1 For Richard, who first introduced me to the Northumbrian crosses.

2 Bailey 1996, 61–5.

3 McKinnell 2003, 629 (quotation); Cramp 1961, 11 (peripheral location).

4 Crowe 1987, 41.

5 Farrell & Karkov 1992, 35–47; Cassidy 1992b, 15–19; Meyvaert 1992, 95–102.

6 Saxl 1943, 6, n. 1; Cramp 1978, 8–22; Farrell 1978b, 96–9.

7 Meyvaert 1982; 1992, 112–25; *contra*, Henderson 1985; Bailey 1993.

8 In addition to Saxl 1943 and Schapiro 1944, note Haney 1985, Cassidy 1992a (particularly Meyvaert 1992), Ó Carragáin 2005 and Orton & Wood 2007, with full bibliographies.

9 Jesus Christ, Judge of justice. Beasts and dragons recognised in the desert the Saviour of the world (McKinnell 2003, 627 slightly adapted; my translation).

10 Ó Carragáin 1986, 381; Meyvaert 1992, 125–7.

11 E.g. Isaiah 11:1–9, 40:3–5, 43:19–21, 51:3; Schapiro 1944; Williams 1962, 10–46.

12 Bailey 2011, building upon Ó Carragáin 1986.

13 Ecce agnus Dei (John 1:29). In the Gospels this immediately preceded Jesus's sojourn in the wilderness, depicted in the panel below.

14 Ó Carragáin 2005, 247–60.

15 Gijsel 1997, 449, 451 implying that a flight into Egypt, rather than a return from Egypt, is depicted.

16 Ps-Matt. 18(2): Nolite me considerare quia infantulus sum; ego enim semper uir perfectus fui et sum, et necesse est ut omnia genera ferarum mansuescere faciam (Gijsel 1997, 451).

17 Hawkes 2015, 86–94.

18 uenerunt dracones et laudauerunt pedes eorum (McNamara 1986, 308; Stancliffe forthcoming); Meyvaert 1992, 125–9.

19 Gijsel 1997, 451, 453.

20 Matthew 2:13–23.

21 Ó Carragáin 2005, 153–60.

22 … quem in salutem mundi venisse cognovimus (Haney 1985, 219); the edition by Morales & Leclerc 2007, 160 omits the 'quem in' (*Vita Pauli* 8.3).

23 Sawyer 1996, 26–8 and *passim*.

24 Cf Schapiro 1944, 235; Henderson 1985, 5.

25 Et requiescat super eum spiritus Domini (Isaiah 11:2).

26 Sed iudicabit in iustitia pauperes, et arguet in aequitate pro mansuetis terrae (Isaiah 11:4).

27 Habitabit lupus cum agno (Isaiah 11:6); cf Ps-Matt. 19(2) (Gijsel 1997, 455, 457).

28 E.g. Saxl 1943, 1–5; Haney 1985; Ó Carragáin 2005, 151; cf Meyvaert 1992, 125–40.

29 E.g. Ó Carragáin 2005, 150–64, 201–9; Henderson 1985; Bailey 1996, 63.

30 E.g. Haney 1985, 227; Bailey 1996, 63.

31 Ward 1987, 10–25.

32 McKinnell 2003, 627.

33 Howlett 1974; Meyvaert 1992, 138–40.

34 Ó Carragáin 2005, 95–107.

35 *Homelia* 3 (Hurst 1965, 14). The Annunciation lection was normally read shortly before Christmas: Ó Carragáin 2005, 85–6; Lenker 1997, 342–3.

36 Meyvaert 1992, 110; Bede, *In Lucae evangelium expositio* II (on Luke 4:23) (Hurst 1960, 105–6).

37 Meyvaert 1992, 111–12; Howlett 1992, 80–1; see also below, 7.

38 Meyvaert 1992, 105–6, 124–5.

39 Cf Farr 1997.

40 Cf Cramp in Bailey & Cramp 1988, 19–22; Cramp 1995, n. 3.

41 Hawkes 2003, 624.

42 Cf Finsterwalder 1929, 248, 249, 270, 323–4 and 257–8, 295–7; Stancliffe 2003.

43 ut manifestentur opera Dei in illo (John 9:3).

44 Bede, *HE* I, 18: quos [oculos] statim euacuatos tenebris lumen ueritatis impleuit … post quam diem ita … iniqua deletum est, ut sacerdotum doctrinam sitientibus desideriis sectarentur (Colgrave & Mynors 1969, 58–9).

45 Bede, *HE* II, 2: uerus summae lucis praeco ab omnibus praedicatur Augustinus. Tum Brettones confitentur quidem intellexisse se ueram esse uiam iustitiae quam praedicaret Augustinus (Colgrave & Mynors 1969, 136–7); Hanning 1966, 80–1; Stancliffe 1999, 124–34, 2007, 7–8. Cf Schapiro 1944, 244–5.

46 O'Reilly 2003, 153.

47 Schapiro 1944, 236, 239; Haney 1985, 220, n. 25.

48 Ó Carragáin 2005, 154–6.

49 Cf Acts 20:7 and 11; Adomnán, *Vita Columbae* I, 44 (Anderson & Anderson 1961, 304); Ó Carragáin 2005, 176–7, n. 170.

50 Cf 1 Corinthians 10:16–17; Finsterwalder 1929, 249, 270, 324.

51 Schapiro 1944, 243; cf Bede, *HE* II, 2 (Colgrave & Mynors 1969, 138–9).

52 Cf Wood in Orton & Wood 2007, 124–5.

53 Smyth 1984, 22–9. For the dearth of archaeological and place-name evidence for Anglian settlement in the west before the eighth century see McNeill & MacQueen 1996, 61 and Laing & Longley 2006, 167–8; cf Charles-Edwards 2013, 10–13 (on Rheged), 326–7 (on the varieties of sub-kingship).

54 Charles-Edwards 2013, 8–10, 432–5.

55 Bede, *HE* III, 4 (Colgrave & Mynors 1969, 222–3).

56 Bede, *HE* V, 23 (Colgrave & Mynors 1969, 558–61).

57 Edmonds' (2015, 62–3, 47) suggestions re Strathclyde's later expansion south would, *mutatis mutandis*, fit Ecgfrith's expansion north.

58 McCarthy 2011, esp. 21.

59 Toop 2011.

60 Hough 2009, 111; James 2009, 139–40. Also Wilson 1978. On links to Ireland, Edmonds 2009, 7–17 and n. 15; McNeill & MacQueen 1996, 58–60.

61 McNeill & MacQueen 1996, 51.

62 Cramp 1965, 10.

63 See n. 101 below.

64 Stancliffe 2013, 32; cf the later archdeaconry of Teviotdale (McNeill & MacQueen 1996, 350–1).

65 Meyvaert 1992, 148–50.

66 Cramp 1965, 6–12.

67 Cramp in Bailey & Cramp 1988, 19–22, 61–72.

68 Cramp 1965, 10; Saxl 1943, 19. See further below, 78–89.

69 Cramp 1984, xvi, 9, citing Lindisfarne 15, 16 and 38.

70 Cf above, 7 and n. 32; Page 1989.

71 Including, rather exceptionally, Wearmouth-Jarrow: Higgitt 1990, 157–8.

72 Ibid., esp. 155–8; cf also Higgitt 1979, 359–64, 367; Brown 1921, 175–82; Maddern 2013, 65–71.

73 Brown 1921, 178, 176.

74 Cramp 2013, 414.

75 Kitzinger 1993, 8–9.

76 Ó Carragáin 2005, 240–1 and pl. 8.

77 Kitzinger 1993, 8–9; Meyvaert 1982, 12–14, 23–4.

78 Verey 1980, 59, 107; O'Reilly 2007; Meyvaert 1982, 23–4 notes this parallel and also compares Codex Amiatinus fols IIv–IIIr; but the latter is a plan with labelling, not a continuous inscription.

79 Cramp 1984, 51–2 and pl. 17.

80 Cf Pulliam 2011, 257.

81 O'Reilly 2007, 316.

82 Cf Haney 1985, 219.

83 Auctorem mortis deiciens uitam nostram restituens si tamen conpatiamur.

84 Scito quis et qualis est qui talia … passus p(ro) nobis.

85 McKinnell 2003, 628.

86 Revelation 1:7–8 and 22:12–13; O'Reilly 2007, 305.

87 E.g. Howlett 1992, 79–81.

88 Meyvaert 1992, 125–7, 164 and 132 n. 140.

89 See Stancliffe 1989, esp. 36–41.

90 Ibid., 31–3.

91 Haney 1985, 219–26; Schapiro 1944, 236–7.

92 *VCA* II, 3 (Colgrave 1940, 80–3).

93 Hilberg 1910, 6.

94 *Vita Pauli* 16, 5 (Morales & Leclerc 2007, 178).

95 quasi quidam nouus paradisi colonus insedit … Solus ibi, immo iam Christo comitante non solus, uidet gloriam dei, quam etiam apostoli nisi in deserto non uiderant. (Hilberg 1910, 15–16); Haney 1985, 225; see also Williams 1962, 21–7, 34, 38–46.

96 *Dialogus* I, 17: qui ab hominibus frequentaretur, non posse ab angelis frequentari (Halm 1866, 170).

97 *VCA* IV, 11: Conloquio et ministerio angelorum contentus … solus manebat (Colgrave 1940, 128; my translation).

98 *VCP* 36 (Colgrave 1940, 266–7).

99 Lindisfarne has previously been mooted by Meyvaert 1992, 164, and tentatively by Brown 2011, 109 and 169, n. 279.

100 Cramp 1989, 225.

101 Higgitt 1990, 150–2 on the separate roles of designing and cutting inscriptions.

102 Brown 2000, 24–5; Charles-Edwards 2000, 331–4, 337–8, 341–2.

103 Brown 2003, 153–76, 187; Gameson 2013, 45–7.

104 *VCP* Prologue (Colgrave 1940, 142–7; cf 16).

105 Fecerat iste de lapide crucem artifici opere expoliri, et in sui memoriam suum in eo nomen exarari (Rollason 2000, 60–1). On Æthilwald's dates, Stancliffe 2013, 25–7. Note Rollason's (correct) translation: the cross was carved in memory of Cuthbert, not Æthilwald, and there is therefore no reason to ascribe it to the end of Æthilwald's life; cf Cramp 1984, 4–5 and n. 9.

106 *VCA* IV, 4 (Colgrave 1940, 116–17); Bede, *VCP*, 30 (Colgrave 1940, 254–5).

107 Newton et al. 2013, 107–9.

References

Anderson, A.O. & Anderson, M.O. (ed. and trans.), 1961 Adomnán, *Vita Sancti Columbae,* in *Adomnan's Life of Columba* (1 edn, London & Edinburgh)

Bailey, R.N., 1993 'The Ruthwell Cross: a non-Problem', *Antiquaries J.* 73, 141–8

Bailey, R.N., 1996 *England's Earliest Sculptors* (Toronto)

Bailey, R.N., 2011 '*In Medio Duorum Animalium*: Habakkuk, the Ruthwell Cross and Bede's Life of St Cuthbert' in Mullins & Scully 2011, pp 243–52

Bailey, R.N. & Cramp, R. 1988 *Cumberland, Westmorland and Lancashire North-of-the-Sands* CASSS 2 (Oxford)

Bonner, G., Rollason, D. & Stancliffe, C. (ed.), 1989 *St Cuthbert, his Cult and his Community to AD 1200* (Woodbridge)

Brown, G. Baldwin, 1921 *The Arts in Early England, 5: The Ruthwell and Bewcastle Crosses the Gospels of Lindisfarne, and other Christian Monuments of Northumbria* (London)

Brown, M.P., 2000 '*In the beginning was the Word': Books and Faith in the Age of Bede,* Jarrow Lecture (Jarrow)

Brown, M.P., 2003 *The Lindisfarne Gospels: Society, Spirituality and the Scribe* (London)

Brown, M.P., 2011 *The Lindisfarne Gospels and the Early Medieval World* (London)

Cassidy, B. (ed.), 1992a *The Ruthwell Cross* (Princeton, NJ)

Cassidy, B., 1992b 'The Later Life of the Cross: From the Seventeenth Century to the Present' in Cassidy 1992a, pp 3–34

Charles-Edwards, T.M., 2000 *Early Christian Ireland* (Cambridge)

Charles-Edwards, T.M., 2013 *Wales and the Britons 350–1064* (Oxford)

Cramp, R., 1961 'The Anglican [*sic*] Sculptured Crosses of Dumfriesshire', *Trans. Dumfriesshire and Galloway Natural History and Antiquarian Soc.* 3 ser. 37, 9–20

Cramp, R., 1965 *Early Northumbrian Sculpture*, Jarrow Lecture (Jarrow)

Cramp, R., 1978 'The Evangelist Symbols and their Parallels in Anglo-Saxon Sculpture' in Farrell 1978a, pp 118–30

Cramp, R., 1984 *County Durham and Northumberland*, CASSS 1 (Oxford)

Cramp, R., 1989 'The Artistic Influence of Lindisfarne within Northumbria' in Bonner et al. 1989, pp 213–28

Cramp, R., 1995 *Whithorn and the Northumbrian Expansion Westwards*, Third Whithorn Lecture for 1994 (Whithorn)

Cramp, R., 2013 'Editorial Addendum' to Paul Meyvaert, 'Necessity Mother of Invention: A Fresh Look at the Rune Verses on the Ruthwell Cross', *ASE* 41, 414–16

Crowe, C., 1987 'Excavations at Ruthwell, Dumfries, 1980 and 1984', *Trans. Dumfriesshire and Galloway Natural History & Antiquarian Soc.* 3 ser. 62, 40–7

Edmonds, F., 2009 *Whithorn's Renown in the Early Medieval Period: Whithorn, Futerna and Magnum Monasterium*, Sixteenth Whithorn Lecture (Whithorn)

Edmonds, F., 2015 'The Expansion of the Kingdom of Strathclyde', *Early Medieval Europe* 23, 43–66

Farr, C.A., 1997 'Worthy Women on the Ruthwell Cross: Woman as Sign in Early Anglo-Saxon Monasticism' in C.E. Karkov, M. Ryan & R.T Farrell (ed.), *The Insular Tradition* (Albany, NY), pp 45–61

Farrell, R. (ed.), 1978a *Bede and Anglo-Saxon England*, BAR: British Series 46 (Oxford)

Farrell, R.T., 1978b 'The Archer and Associated Figures on the Ruthwell Cross – A Reconsideration' in Farrell 1978a, pp 96–117

Farrell, R.T. with Karkov, C., 1992 'The Construction, Deconstruction, and Reconstruction of the Ruthwell Cross: some Caveats' in Cassidy 1992a, pp 35–47

Finsterwalder, P.W. (ed.), 1929 *Die Canones Theodori Cantuariensis und ihre Überlieferungsformen* (Weimar)

Gameson, R., 2013 *From Holy Island to Durham: The Context and Meanings of the Lindisfarne Gospels* (London)

Gijsel, J. (ed. and trans.), 1997 *Pseudo-Matthaei Evangelium, textus et commentarius*, part 1 of J. Gijsel & R. Beyers (ed. and trans.), *Libri de Nativitate Mariae*, Corpus Christianorum Series Apocryphorum 9 (Turnhout)

Halm, C. (ed.), 1866 Sulpicius Severus, *Dialogi*, in *Sulpicii Severi Libri qui supersunt*, CSEL 1 (Vienna), pp 152–216

Haney, K.E., 1985 'The Christ and the Beasts Panel on the Ruthwell Cross', *ASE* 14, 215–31

Hanning, R.W., 1966 *The Vision of History in Early Britain* (New York)

Hawkes, J., 2003 'Ruthwell Cross § 1: The Cross' in J. Hoops, *Reallexikon der Germanischen Altertumskunde* 25, rev. edn (ed.), H. Beck, D. Geuenich & H. Steuer (Berlin & New York), pp 622–5

Hawkes, J., 2015 '"Hail the Conquering Hero": Coming and Going at Ruthwell: *adventus* and Transition' in M. Boulton & J. Hawkes with M. Herman (ed.), *The Art, Literature and Material Culture of the Medieval World* (Dublin), pp 80–96

Henderson, G., 1985 'The John the Baptist Panel on the Ruthwell Cross', *Gesta* 24, 3–12

Higgitt, J., 1979 'The Dedication Inscription at Jarrow and its Context', *Antiquaries J.* 59, 343–74

Higgitt, J., 1990 'The Stone-Cutter and the Scriptorium: Early Medieval Inscriptions in Britain and Ireland' in W. Koch (ed.), *Epigraphik 1988: Fachtagung für mittelalterliche und neuzeitliche Epigraphik*, Österreichische Akademie der Wissenschaften, philosophisch-historische Klasse, Denkschriften 213 (Vienna), pp 149–62

Hilberg, I. (ed.), 1910 Jerome, *Epistulae*, in *Sancti Eusebii Hieronymi Epistulae, pars 1: Epistulae I–LXX*, CSEL 54 (Vienna)

Hough, C., 2009 'Eccles in English and Scottish Place-Names' in E. Quinton (ed.), *The Church in English Place-Names*, English Place-Name Society extra ser. 4 (Nottingham), pp 109–24

Howlett, D., 1974 'Two Panels on the Ruthwell Cross', *J. Warburg and Courtauld Institutes* 37, 333–6

Howlett, D., 1992 'Inscriptions and Design of the Ruthwell Cross' in Cassidy 1992a, pp 71–93

Hurst, D. (ed.), 1960 Bede, *In Lucae Evangelium Expositio* in D. Hurst (ed.), *Bedae Venerablilis Opera, pars II: Opera Exegetica, 3*, CCSL 120 (Turnhout), pp 1–425

Hurst, D. (ed.), 1965 Bede, *Homeliae Evangelii* in D. Hurst (ed.), *Bedae Venerablilis Opera, pars III: Opera Homiletica*, CCSL 122 (Turnhout), pp 1–403

James, A.G., 2009 '**Eglēs / Eclēs* and the Formation of Northumbria' in E. Quinton (ed.), *The Church in English Place-Names*, English Place-Name Society extra ser. 4 (Nottingham), pp 125–50

Kitzinger, E., 1993 'Interlace and Icons: Form and Function in Early Insular Art' in R.M. Spearman & J. Higgitt (ed.), *The Age of Migrating Ideas: Early Medieval Art in Northern Britain and Ireland* (Edinburgh), pp 3–15

Laing, L. & Longley, D., 2006 *The Mote of Mark: A Dark Age Hillfort in South-West Scotland* (Oxford)

Lenker, U., 1997 *Die westsächsische Evangelienversion und die Perikopenordnungen im angelsächsischen England* (Munich)

Maddern, C., 2013 *Raising the Dead: Early Medieval Name Stones in Northumbria* (Turnhout)

McCarthy, M. 2011 'The Kingdom of Rheged: A Landscape Perspective', *Northern History* 48, 9–22

McKinnell, J. 2003 'Ruthwell Cross § 2: The Inscriptions' in J. Hoops, *Reallexikon der Germanischen Altertumskunde* 25, rev. edn (ed.), H. Beck, D. Geuenich & H. Steuer (Berlin & New York), pp 625–9

McNamara, M. (ed.), 1986 *Glossa in Psalmos: The Hiberno-Latin Gloss on the Psalms of Codex Palatinus Latinus 68*, Studi e Testi 310 (Vatican City)

McNeill, P.G.B. & MacQueen, H.L. (ed.), 1996 *Atlas of Scottish History to 1707* (Edinburgh)

Meyvaert, P., 1982 'An Apocalypse Panel on the Ruthwell Cross', *Medieval and Renaissance Studies* 9, 3–32

Meyvaert, P., 1992 'A New Perspective on the Ruthwell Cross: Ecclesia and Vita Monastica' in Cassidy 1992a, pp 95–166

Morales, E.M. & Leclerc, P. (ed. and trans.), 2007 Jerome, *Vita Beati Pauli Monachi Thebaei* in *Jérôme, Trois vies de moines (Paul, Malchus, Hilarion)*, Sources Chrétiennes 508 (Paris), pp 144–83

Mullins, E. & Scully, D. (ed.), 2011 *Listen, O Isles, unto Me: Studies in Medieval Word and Image in Honour of Jennifer O'Reilly* (Cork)

Newton, F.L., Newton, F.L. Jr & Scheirer, C.R.J., 2013 'Domiciling the Evangelists in Anglo-Saxon England: A Fresh Reading of Aldred's Colophon', *ASE* 41, 101–44

Ó Carragáin, É., 1986 'Christ over the Beasts and the Agnus Dei: Two Multivalent Panels on the Ruthwell and Bewcastle Crosses' in P.E. Szarmach (ed.), *Sources of Anglo-Saxon Culture* (Kalamazoo, MI), pp 377–403

Ó Carragáin, É., 2005 *Ritual and the Rood: Liturgical Images and the Old English Poems of the Dream of the Rood Tradition* (London)

O'Reilly, J., 2003 'The Art of Authority' in T.[M.] Charles-Edwards (ed.), *After Rome* (Oxford), pp 140–89

O'Reilly, J., 2007 '"Know who and what he is": The Context and Inscriptions of the Durham Gospels Crucifixion Image' in R. Moss (ed.), *Making and Meaning in Insular Art* (Dublin), pp 301–16

Orton, F. & Wood, I. 2007 *Fragments of History: Rethinking the Ruthwell and Bewcastle Monuments* (Manchester & New York)

Page, R.I., 1989 'Roman and Runic on St Cuthbert's Coffin' in Bonner et al. 1989, pp 257–65

Pulliam, H., 2011 '"The Eyes of the Handmaid": The Corbie Psalter and the Ruthwell Cross' in Mullins & Scully 2011, pp 253–62

Rollason, D. (ed. and trans.), 2000 *Symeon of Durham Libellvs de Exordio atqve Procvrsv istivs, Hoc est Dvnhelmensis Ecclesie* (Oxford)

Sawyer, J.F.A., 1996 *The Fifth Gospel: Isaiah in the History of Christianity* (Cambridge)

Saxl, F., 1943 'The Ruthwell Cross', *J. Warburg and Courtauld Institutes* 6, 1–19

Schapiro, M., 1944 'The Religious Meaning of the Ruthwell Cross', *Art Bulletin* 26, 232–45

Smyth, A.P., 1984 *Warlords and Holy Men: Scotland AD 80–1000* (London)

Stancliffe, C., 1989 'Cuthbert and the Polarity between Pastor and Solitary' in Bonner et al. 1989, pp 21–44

Stancliffe, C., 1999 'The British Church and the Mission of Augustine' in R. Gameson (ed.), *St Augustine and the Conversion of England* (Stroud), pp 107–51

Stancliffe, C., 2003 *Bede, Wilfrid, and the Irish*, Jarrow Lecture (Jarrow)

Stancliffe, C., 2007 *Bede and the Britons*, Fourteenth Whithorn Lecture (Whithorn)

Stancliffe, C., 2013 'Disputed Episcopacy: Bede, Acca, and the Relationship between Stephen's *Life of St Wilfrid* and the Early Prose Lives of St Cuthbert', *ASE* 41, 7–39

Stancliffe, C., forthcoming 'The Irish Tradition in Northumbria after the Synod of Whitby' in R. Gameson (ed.), *The Lindisfarne Gospels: New Perspectives* (Leiden)

Toop, N.J., 2011 'Northumbria in the West: Considering Interaction through Monumentality' in D. Petts & S. Turner (ed.), *Early Medieval Northumbria: Kingdoms and Communities, AD 450–1100* (Turnhout), pp 85–111

Verey, C.D., 1980 (with T.J. Brown & E. Coatsworth), *The Durham Gospels*, EEMF 20 (Copenhagen)

Ward, B., 1987 *Harlots of the Desert: A Study of Repentance in Early Monastic Sources* (Kalamazoo, MI)

Williams, G.H., 1962 *Wilderness and Paradise in Christian Thought* (New York)

Wilson, P.A., 1978 'Eaglesfield: The Place, the Name, the Burials', *Trans. Cumberland & Westmorland Antiquarian and Archaeological Soc.* 78, 47–54

2

Heads you lose

Rosemary Cramp

As Richard Bailey himself has noted,[1] although Anglo-Saxon England is rich in the survival of its pre-Conquest stone crosses there is a poor survival rate for whole monuments. This particularly applies to major monuments of the seventh to ninth centuries in northern Britain. So often at sites, even those with many fragments of sculpture, heads and shafts are separated and, save for a few of the important monuments such as Rothbury,[2] few joins can be made between the shaft fragments and the heads. This is unfortunate since it is the form and decoration of the head which so often provides the evidence for the affiliation and dating of a monument. The fact that so many Anglian cross-heads are separated from their shafts is partially explained by the practical fact that the cross-head entire is usually carved separately from the shaft rather than with the lower arm emerging as part of the shaft,[3] and so can easily be broken off, but also the shaft fragments can be more easily reshaped for re-use. In addition the head of the cross most clearly proclaims its devotional significance and so can attract the most fervent iconoclasm or, on the other hand, could be the most important element to save from desecration.

In the Viking Age, where Richard Bailey has made such a significant contribution, more complete monuments survive, but this paper is concerned with a group of largely unpublished individual heads from northern Britain, dating from a period loosely defined as eighth to ninth century. Unfortunately not only are there no identified shafts for these heads, but also not one is complete, and only the centres and parts of the arms survive. This may be because, since their common feature is a very prominent boss in the centre of each face, that made their reuse difficult, or because bosses were seen as particularly significant. Yet even in their maimed state these heads convey that they were once part of major monuments. Amongst the large monumental crosses of the seventh to ninth centuries in Northumbria, the surviving heads can be either historiated, often with figures of Christ in the centre as, for example, the Rothbury, Hoddom, Otley and (probably) Ruthwell crosses, or are decorated in a way which, in their original painted state, would resemble metalwork, such as those at Hexham and Ripon.[4] The relationship of stone crosses to their metal counterparts has often been commented on and is cogently summarised by Bailey,[5] and the cross-heads under discussion belong to the latter group.

The first to be considered is a cross-head from Duddo in Northumberland. This piece was identified as Anglian and brought to my attention by Roger Miket, and has not yet been published. It was found on Stackyard Field at Duddo farm in Northumberland in 1990.[6] The head is of yellowish sandstone, which could be local, and it measures 360 × 390mm with a thickness of 190<200mm. The diameter of the boss from its outer ring is 190mm and its height about 60mm. It is flat-topped and the inner ring is 100mm in diameter.

The piece is very damaged: what survives is the central boss and a small part of one arm, and only on one face does the ornament survive (Fig. 2.1a); the opposite face has been cut away leaving only the outline of the central boss and part of its outer moulding (Fig. 2.1b–c). Most of the damage on this face appears to be ancient and a deliberate attempt to obliterate the central carving. The curve under the arms was decorated with a panel framed by double roll mouldings, and there are traces of burning. On the main surviving face there is ancient damage where the arms have been cut away and what appears to be more recent plough damage where part of the central boss has been sheared off. Nevertheless enough survives to demonstrate that this was a very richly decorated piece. In the centre of the boss is a four-petalled, star-like flower, with a tiny hole in the middle, and small bosses in the intersections of the petals. This is enclosed in

Fig. 2.1 Duddo cross-head: (a) main decorated face; (b) reverse, mutilated, face; (c) profile view showing evidence of burning (Photos: Jeff Veitch, by kind permission of Mr and Mrs Dakin)

a beaded ring, encircled by a twisted band and then a double roll moulding, which on each arm connects into a central spine of ornament. Each arm on this face is outlined with a fine double roll moulding and the spine running down each arm appears to be decorated. The carving throughout is delicate and assured.

The nearest parallel to the Duddo cross-head is another fragmentary head with a prominent boss, discovered in 1983 in the garden of 47 West Street, some 200m from Norham church in Northumberland (Fig. 2.2a).[7] It is carved from a reddish sandstone, apparently local, and measures 310 × 270mm with a thickness of 105mm. Two faces of this head survive, and one is clearly more important than the other since the whole surface is decorated (Face A, Fig. 2.2a). There is a prominent central boss, 115mm wide and 75mm in height. The boss is thimble shaped; the rounded tip is plain and surrounded by a ring with projections to form a zone of four panels enclosing tiny bush scrolls with a bud at each tip. Viewed directly from in front the ring and panel divisions form a cross. On the flat surface below is an encircled ring of two strand twist and on the arms a complex interlace pattern terminating in two pointed knots, which cleverly follow the lines of the mouldings of the boss and arms. The arms are framed with a double roll moulding. The opposite face of the cross is smoothly dressed and plain save for a central boss surrounded by two bold rings (Fig. 2.2b). This boss is less prominent and flatter than on the decorated face, built up in a series of layers, and its diameter is 130mm, and height 60mm (Fig. 2.2c). A side view of this head was published in 1988 when the little tree scrolls were compared with some on an inscribed cross-head from Carlisle,[8] but it has never been fully illustrated or discussed.

Also to be considered are two unpublished bosses which have survived, having been chipped from their heads. The first, now in the Lindisfarne collections (Fig. 2.3), appears to have been found during Peers' work on the site but has only recently been identified in the English Heritage collections.[9] It is formed of yellowish sandstone and is flat-topped with a roughly cut triangular hole in the centre (which could be secondary). Its diameter at the base is 152mm and its height 115mm. It is decorated with three rings of bold pellets, increasing in size towards the base, and framed by plain roll mouldings. A boss, which could have been this one, was recorded as lost in the Corpus of Anglo-Saxon Stone Sculpture, County Durham and Northumberland, but some problems remain.[10] Peers, after his analysis of the major pieces from Lindisfarne, noted that 'A few pieces of cross heads remain', mentioning fragments of cross-arms, and that 'There is *also* a boss from the middle of a cross head, having a fret round it' (emphasis added). This in no way fits the description of the boss illustrated here, but no other exists today in the Lindisfarne store, so that either there was once another boss or Peers wrote from memory. In many ways this is the most 'classical', and least influenced

by Insular art, of all the bosses under discussion, and it is a surprising find from Lindisfarne. It fits none of the other surviving shaft fragments from the site, but, once, must have been part of an imposing monument.

In addition, a recent excavation at Beckermet St Bridget in Cumbria has produced another disengaged boss of the thimble-like form and decorated with eight rather irregular ridges radiating from a small sunken circle in the centre (Fig. 2.4).[11] It measures 120 × 140mm and is 85mm in height. Although its form and ornament are different from the eastern group the location on the west coast of Cumbria in an area in close proximity to Ireland and southern Scotland may be significant.

Taken together, what light can these remnants throw on the wider scene of Northumbrian sculpture? Although smaller plain, single or multiple bosses, usually surrounded by interlace, are very common on the Hiberno-Saxon and Viking-age monuments in Northumbria, cross-heads with

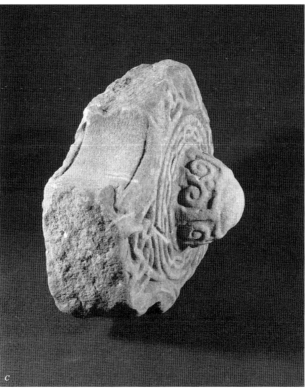

Fig. 2.2 Norham cross-head: (a) main decorated face; (b) reverse plain face; (c) profile view showing the panels of tree scrolls, and the relative depth of the two bosses (Photos: Tom Middlemass, © Corpus of Anglo-Saxon Stone Sculpture)

such prominent decorated bosses in their centres are not as common in Northumbria as they are in parts of Scotland and Ireland. And of particular relevance to these Northumberland pieces are two other heads from places now in southern Scotland, but which, at the time they were carved, could have been in the land holdings of Lindisfarne.[12] The first is the central part of a head from the church of Abercorn in West Lothian. On one face it has a boss about 200mm in diameter which has been built up on three decreasing discs to a height of 63mm with the topmost carved with

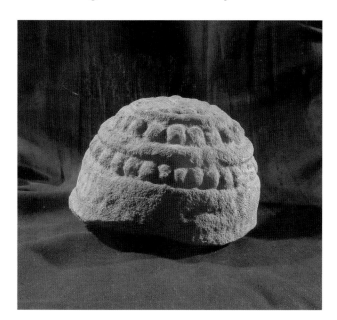

Fig. 2.4 Two views of the ridged boss as excavated at Beckermet St Bridget churchyard, Cumbria: (a) top view; (b) side view (Photo: Dan Ellsworth, with his permission)

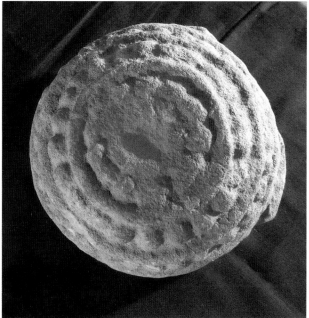

Fig. 2.3 Boss with rings of pellets from the Lindisfarne collection of English Heritage: (a) top view; (b) side view (Photo: Rosemary Cramp, by kind permission of English Heritage)

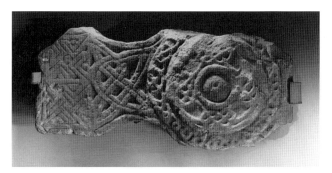

Fig. 2.5 Jedburgh cross-head, main face (Photo: Tom Middlemass, © Corpus of Anglo-Saxon Stone Sculpture)

an eight-petalled flower.[13] On the opposite face is a 'flatter single disc, 7½ inches [190.5mm] in diameter, with a projection of only ⅜ of an inch [9.5mm] above the face'.[14] In the centre of the head is an encircled eight-petalled rosette. It has been reconstructed as the head of a shaft formed from two large fragments decorated on the narrow faces with plant trails and on the surviving broad face with a repertoire of interlace, interlaced beasts, inhabited and uninhabited plant-scrolls, all Anglian motifs. A central rosette, with twelve petals, also occurs on the cross at Thornhill in Dumfriesshire the shaft of which is also decorated with Anglian ornament.[15]

More Insular in its motifs is a decorated cross-head from Jedburgh which has not had much discussion since I published it in 1983,[16] but which is of some relevance here (Fig. 2.5). One arm and the central boss of the head survive. The arm is 245mm long and 102mm wide whilst the boss and its surrounding rim of interlace is 244mm in diameter. The whole span of the head would then have been about 610mm. On the only face presently visible there is a composite boss consisting of a small plain central boss surrounded by a plain ring and in the centre a small hole (which originally I considered marked the compass point for drawing out the encircling ornament). In the next encircling zone four Carrick-bend knots, linked by two strands, form the shape of a cross. The recessed zone which surrounds this is filled with Stafford knots linked by two glides. A bold six-strand knot and two panels of key pattern decorate the end of the arm.

On the back, as described in the Roxburgh Inventory, 'one arm of a large cross is set on a plain background and the arm ends in a small boss with a six-petalled flower'.[17] The interlace cross between the small bosses on a cross-head is found also on an often-cited metalwork-type cross-head from Northallerton, Yorkshire,[18] also on one face of the very worn head from Edzell, Angus. Here, the other face has a large central boss covered with interlace the height of which (about 40mm) is more comparable, however, to those bosses which occur on some of the major cross-slabs of Pictland rather than the free-standing crosses under discussion.[19]

The location of all of the pieces, except that from Beckermet, in areas most probably under Lindisfarne lordship does seem to be significant. How closely comparable are they in form and ornament? All, where more than the boss survives, are free-armed heads with a wide curve; and this separates them from the Dalriadan group at Iona, and Kildalton, Islay, which are ringed. The double curved type of cross-head (D11 in CASSS terminology)[20] is characteristic of Lindisfarne.[21] In addition Norham, Duddo, Abercorn and Jedburgh have a more prominent and more elaborate boss on one of the faces, implying that this was the more significant view.

Decorative bosses are part of the repertoire of Insular ornament, particularly in metalwork, but may once have been more common in other media. In Ireland, where wooden crosses are attested in literary sources,[22] a wooden boss which is almost certainly from the centre of a cross-head was preserved in the Wood Quay site in Dublin and was published by James Lang.[23] Although found in a later context, Lang sees this as 'leading back to Insular, often ecclesiastical models … It has the size and shape of a boss from a high cross and asserts the hitherto speculative supposition that wooden crosses existed alongside their stone counterparts'.[24] It measures 260mm in length, with a width of 183mm and a height of 112mm. The dome is covered by deeply cut median-incised interlace composed of three linked triquetrae, one of which is nearly worn away. The pointed loops meet in the centre of the boss. Since we know that the earliest crosses mentioned in Northumbria were of wood,[25] it seems possible that similar bossed crosses in wood could have co-existed there also. George and Isabel Henderson have stressed: 'It is an essential fact about Insular art that book painting, stone sculpture, and metalwork shared exactly the same design precepts and motifs, and that we can legitimately supplement gaps in the one by what we know from the other'.[26]

In my previous discussion of Jedburgh I noted: 'There is an obvious link with metalwork techniques in the manner of building up the centre of the cross in successively raised zones with a jewel-like boss in the centre', and compared the head with similar 'metal-work treatment' in both the ornament of the Iona school of crosses and a cross-head from Northallerton already mentioned.[27] More recently there has been considerable discussion of the metalwork parallels for painted crosses, and also for how stone crosses could have been copying those of wood which were encased in sheet metal and enriched by jewelled or glass settings, such as the well-known cross from Bischofshofen.[28] The tiny hole in the centre of the four-pointed 'flower' on the top of the decorated face of Duddo, or that of Jedburgh, may have held an embellishment, but on the whole it is the nature of the ornament itself, with its beading and twists like filigree, which on these heads reflects the metalwork tradition. The star-like flower in the centre of the boss from Duddo is unique in sculpture, but is curiously like the motifs which occur on the base of Kentish glass vessels, and which have been discussed by Owen-Crocker and Stephens as Christian emblems.[29] The five-pointed star shapes have been considered as deriving from the Chi-Rho, but the four-pointed star at Duddo more obviously forms a cross with the hole in the centre probably holding glass or a coloured stone, which would have made the focus on the cross at the heart of the head the more intense.

Crosses within crosses are an important hidden element in Hiberno-Saxon art as Robert Stevenson pointed out and, once looked for, the cross as the central focus of a pattern appears often in sculpture especially in the patterns of

interlace.[30] More obviously within the arms of the Duddo and Abercorn crosses are other crosses which, seemingly, are like the spine and boss motifs first discussed by Collingwood and developed further by Bailey who has given them the additional title of 'cruciform head pattern'.[31] We do not know how the 'spine' ended on Duddo but it could have terminated in a circular ring or boss.

A central boss surrounded by interlace is one of the commonest forms of decoration on surviving cross-heads from Northumbria; Cumbrian crosses sometimes have a prominent ring surrounding the boss, or there may be multiple small bosses which can be in the shape of a cross or arranged in fives or sevens. Often the five bosses have been interpreted as a reference to Christ's five wounds, but Éamonn Ó Carragáin in his discussion of the Kells Cross of St Patrick and St Columba, east face, puts forward a eucharistic interpretation for the feeding of the five thousand and for the centrepiece:

The seven bosses recall Christ's second Eucharistic feeding in the desert, when he fed four thousand people with seven loaves and 'a few fish' (Matt. 15:32–9; Mark 8:1–10). The bosses of course are not realistic representations of loaves. The designer was primarily interested, not in realism but the numerical contrast between "five" and "seven".[32]

Similarly eucharistic in their reference are the vine-scrolls which cover the shafts of many of the crosses which have metalwork-derived types of head as at Abercorn, Hexham, Ripon, Northallerton, and perhaps the tiny fruiting plants which surround the central boss on the face of the Norham head are to be seen as 'Trees of Life' or vine-scrolls. Norham, unlike Lindisfarne, has substantial remains of a shaft with vine-scrolls, but in the same style of cutting and detail as part of a cross-head from the site, and there seems no obvious shaft fragment from the Norham collection which would fit the new head.

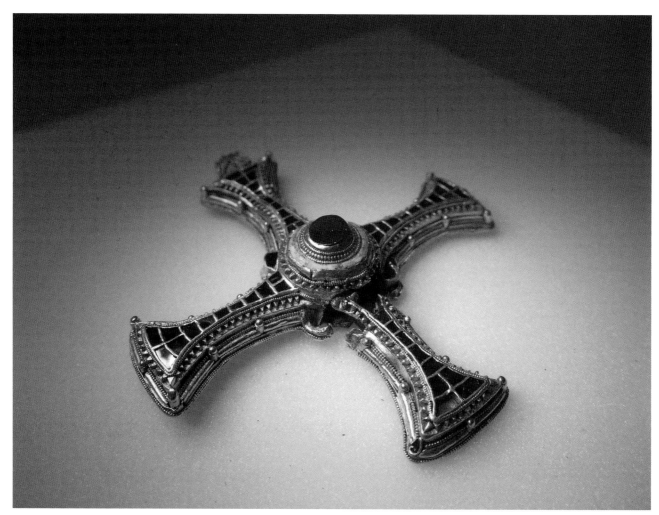

Fig. 2.6 St Cuthbert's pectoral cross, profile view (Photo: Francesca dell'Acqua, by kind permission of the Dean and Chapter of Durham Cathedral)

These newly discovered parts of cross-heads, when considered with others in northern Britain, do seem to indicate that there were major monuments in an Insular eighth- to ninth-century style, which were perhaps promoted through Lindisfarne. Just as the distinctive name stones which occur at Lindisfarne, Hartlepool and Wearmouth are comparable with name stones at Iona and Ireland, but in their form and epigraphy reflect the influence also of continental memorials and books,[33] so these heads, with their prominent bosses, find parallels in Iona and Ireland but also with other monuments in Northumbria. As a further hint that the promotion of these monuments was through Lindisfarne it should be noted that the prevailing shape of the incised crosses on the Lindisfarne name stones is to terminate in a circular boss, whilst at Hartlepool the half circular terminals are the commonest, and the prevailing cross shape from Wearmouth-Jarrow, for all of its monuments, is with square terminals.

We cannot, unfortunately, say where these crosses stood to proclaim their message. They belong to a category of monument which treats the cross as a sacred object in itself, like the great gold altar crosses mentioned in the literature of the time,[34] or, more symbolically, as a reminiscence of the great jewelled cross which once stood at Golgotha, or the *crux gemmata,* capable of conveying by its cosmic form the full significance of the Passion and Resurrection, with the good news which is the New Testament. They are different from those which are like an open-air iconostasis with historiated shafts and heads, in which Christ reigns in the centre of the head. Both types can emphasise by plant forms the sacred Tree of Life, the True Vine, the eucharistic blood of Christ. Given the fact that these bosses take the position of the figure of Christ or the Agnus Dei on the historiated heads, could they also have a sacral significance? As on the pectoral cross of St Cuthbert, where the central jewel is raised above the background (Fig. 2.6), possibly for a relic to be enclosed there, were these bosses meant to imply that Christ was there in symbolic form? This may, however, be asking too much from these poor lost heads.

Notes

1 Bailey 1996, 4–5.
2 Cramp 1984, fig. 20.
3 Kelly 1993, 220–1.
4 Rothbury: Cramp 1984, ills 1206, 1207; Hoddom: RCAHMS 1920, fig. 75; Otley: Coatsworth 2008, ills 597, 600; Hexham: Cramp 1984, ill 902; Ripon: Coatsworth, 2008, ill. 637.
5 Bailey 1996, 119–24.
6 I am grateful to the present owners, Mr and Mrs Dakin, for permission to photograph and publish it.
7 It was given to the Durham University Museum, by Mr and Mrs Smith, and is now is now on display in their collections (accession number DURHA.1986.173.1).

8 Bailey in Bailey & Cramp 1988, 85–6, ills 203, 205.
9 Peers 1923–4, 269. I am grateful to Susan Harrison for drawing it to my attention.
10 Cramp 1984, 251.
11 I am grateful to Dan Ellsworth for allowing me to record this before it has been cleaned and conserved.
12 Morris 1977; Johnson South 2002, 46–7.
13 Calder 1937–8, fig. 1.
14 I have not been able to measure this piece myself; the measurements are taken from its publication in Calder 1937–8, 222, fig. 2.
15 Collingwood 1927, 54, fig. 68.
16 Cramp 1983, 270–3.
17 RCAHMS 1956, 208.
18 Lang 2001, ills 672–5.
19 Stevenson 1958–9, 42–43, pl. vi.
20 Cramp 1999, 8.
21 Peers 1923–4, pl. liv, fig. 5; Cramp 1984, ills 195, 1099–1102 and 201, 1135.
22 Mac Lean 1995.
23 Lang 1988, 4, fig. 1, 49, pl. 1.
24 Ibid., 4.
25 Bede, *HE* III, 2 (Colgrave & Mynors 1969, 214–17); Mac Lean 1997.
26 Henderson & Henderson 2004, 224.
27 Cramp 1983, 272, figs 115 and 116.
28 Bailey 1996; 2009, 26–7; Webster 2012, 106, pl. 71.
29 Owen-Crocker & Stephens 2008, 140–9.
30 Stevenson 1981–2.
31 Collingwood 1927, 93–8; Bailey & Cramp 1988, 33–4.
32 Ó Carragáin 2011, 163.
33 Maddern 2013, 37–51.
34 Bede, *HE* II, 20 (Colgrave & Mynors 1969, 126); see also Wood 2006.

References

Bailey, R.N., 1996 *England's Earliest Sculptors* (Toronto)

Bailey, R.N., 2009 'Anglo-Saxon Art: Some Forms, Orderings and their Meanings' in S. Crawford & H. Hamerow, with L. Webster (ed.), *Form and Order in the Anglo-Saxon World, AD 600–1100*, ASSAH 16 (Oxford), pp 18–30

Bailey, R.N. & Cramp, R., 1988 *Cumberland, Westmorland and Lancashire-North-of-the-Sands*, CASSS 2 (Oxford)

Calder, C.S.T., 1937–8 'Three Fragments of a Sculptured Cross of Anglian Type now Preserved in Abercorn Church, West Lothian' *PSAS* 72, 217–23

Coatsworth, E., 2008 *Western Yorkshire*, CASSS 8 (Oxford)

Collingwood, W.G., 1927 *Northumbrian Crosses of the Pre-Norman Age* (London)

Cramp, R., 1983 'The Anglian Sculptures from Jedburgh' in A. O'Connor & D.V. Clarke (ed.), *From the Stone Age to the 'Forty-Five, Studies Presented to R.B.K. Stevenson* (Edinburgh), pp 269–84

Cramp, R., 1984 *County Durham and Northumberland*, 2 vols, CASSS 1 (Oxford)

Cramp, R., 1997 'The Insular Tradition: An Overview' in Karkov et al. 1997, pp 283–99

Cramp, R., 1999 *Grammar of Anglo-Saxon Ornament: a General Introduction to the Corpus of Anglo-Saxon Stone Sculpture*, repr. (Oxford)

Hawkes, J., 2008 'Constructing Salvation: the Figural Iconography of the Iona Crosses' in C.E. Karkov & H. Damico (ed.), *Aedificia Nova* (Kalamazoo, MI), pp 198–225

Henderson, G. & Henderson, I., 2004 *The Art of the Picts: Sculpture and Metalwork in Early Medieval Scotland* (London)

Hinde, H. (ed.), 1868 *Symeonis Dunelmensis Opera et Collectanea* 1, Surtees Society 51 (Durham)

Johnson South, T. (ed.), 2002 *'Historia De Sancto Cuthberto': a History of Saint Cuthbert and a Record of his Patrimony* (Woodbridge)

Karkov, C., Ryan, M. & Farrell, R.T. (ed.), 1997 *The Insular Tradition* (Albany, NY)

Kelly, D., 1993 'The Relationship of the Crosses of Agyll: the Evidence of Form' in R.M. Spearman & J. Higgitt (ed.), *The Age of Migrating Ideas* (Edinburgh), pp 209–18

Lang, J.T., 1988 *Viking-Age Decorated Wood. A Study of its Ornament and Style* (Dublin)

Lang, J.T., 2001 *Northern Yorkshire*, CASSS 6 (Oxford)

Mac Lean, D., 1995 'The Status of the Sculptor in Old-Irish Law and the Evidence of the Crosses', *Peritia* 9, 125–55

Mac Lean, D. 1997 'King Oswald's Wooden Cross at Heavenfield in Context' in Karkov et al. 1997, pp 79–98

Maddern, C., 2013 *Raising the Dead: Early Medieval Name-Stones in Northumbria* (Turnhout)

Morris, C.D., 1977 'Northumbria and the Viking Settlement: the Evidence for Land-holding', *Archaeologia Aeliana* 5 ser. 11, 81–103

Ó Carragáin, É., 2011 'High Crosses, the Sun's Course, and Local Theologies at Kells and Monasterboice' in C. Hourihane (ed.), *Insular and Anglo-Saxon Art and Thought in the Early Medieval Period* (Princeton, NJ), pp 149–74

Owen-Crocker, G.R. & Stephens, W., 2008 'The Cross in the Grave: Design or Divine?' in K. Jolly, C.E. Karkov & S. Larratt (ed.), *Cross and Culture in Anglo-Saxon England, Studies in Honor of George Hardin Brown* (Morgantown, WV) pp 118–52

Peers, C.R., 1923–4 'The Inscribed and Sculptured Stones of Lindisfarne', *Archaeologia* 74, 255–70

RCAHMS 1920 *Dumfries and Galloway* (Edinburgh)

RCAHMS 1956 *Roxburgh* (Edinburgh)

Stevenson, R.B.K., 1958–9 'The Inchyra Stone and Other Unpublished Early Christian Monuments', *PSAS* 92, 33–55

Stevenson, R.B.K., 1981-2 'Aspects of Ambiguity in Crosses and Interlace', *Ulster J. Archaeology* 3 ser. 44-5, 1-27

Webster, L., 2012 *Anglo-Saxon Art: a New History* (London)

Wood, I.N., 2006 'Constantinian Crosses in Northumbria' in C.E. Karkov, S.L. Keefer & K.L. Jolly (ed.), *The Place of the Cross in Anglo-Saxon England* (Woodbridge), pp 3–13

Depiction of martyrdom in Anglo-Saxon art and literature: contexts and contrasts[1]

Elizabeth Coatsworth

The few overt scenes of martyrdom from Anglo-Saxon England have survived only in sculpture and manuscript illumination. None has survived in wall paintings;[2] nor are there contemporary accounts among the descriptions of (now lost) wall paintings and panels, such as those from late seventh–century Monkwearmouth.[3] Documentary and literary sources, however, attest to the depth of interest in martyrs and martyrdom in the life of the Church.

Surviving depictions of martyrdom in Anglo-Saxon art from the eighth to eleventh century

The surviving scenes are not only few in number but also limited in subject. There is at least one scene of unspecified saints martyred by decapitation on folio 59 of the Harley Psalter, a Canterbury manuscript of the first half of the eleventh century,[4] which illustrates Psalm 115:6 ('Precious in the sight of the Lord is the death of his saints');[5] ministering angels with veiled hands attend the martyrs. The remainder are usually clearly identifiable (though in the first example there is some doubt as to the original intentions of the sculptor), and these are discussed below in broadly alphabetical then chronological order.

St Andrew

Possibly the earliest representation of the crucifixion of Andrew (Fig. 3.1) is on a late eighth- to early ninth-century cross in the church of St Andrew, sometimes called St Andrew Auckland, at South Church, Bishop Auckland, Co. Durham.[6]

Apart from the scene in question on Face A, and the probable evangelist symbol on the head,[7] the remaining panels on C and the base of the cross have only pairs or triplets of haloed figures.[8] Both are representations of saints: the triplets on the base when complete probably represented the twelve apostles, while the paired figures could be evangelists. Broadly, these figures bear witness to the Life and Resurrection of Christ, the first group by faithfully carrying on his teaching in their lifetime, in many cases to their death; the second, overlapping, group by recording that life and resurrection for posterity.

Face A has two surviving panels. The upper, complete and with an arched frame, is an Annunciation scene, similar in many of its details to that on the eighth-century ivory book-cover from Genoels-Elderen, Belgium.[9] This shows

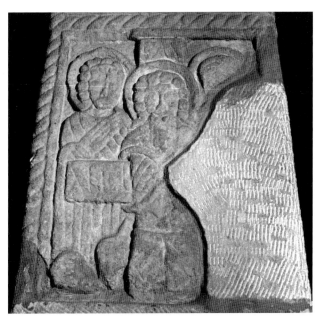

Fig. 3.1 Crucifixion, St Andrew's, South Church, Bishop Auckland, Co. Durham (Auckland St Andrew 1), cross-shaft, Side A (Photo: © E. Coatsworth)

Mary as faithful to the will of God and a witness to the life of her son. If the scene below is that of the Crucifixion of Christ, this is the central event of Christ's life to which Mary, apostles and evangelists are the faithful witnesses. But what if it is the crucifixion of Andrew, apostle and martyr?

The central, bearded and robed, figure does not have a cruciform nimbus, and is roped to the cross, his arms tied behind the cross-beam. Contemporary evidence shows that victims of crucifixion could be nailed, or bound and nailed to the cross.[10] A late second- to early third-century amulet possibly from Syria, now in the British Museum, shows Christ with outstretched hands tied to the cross-beam.[11] A silver-gilt paten from Central Asia, now dated to the ninth to tenth centuries, has a robed Christ with arms extended but bound to the cross with bands crossing his breast.[12] Examples where the thieves crucified with Christ are represented with their arms tied behind the cross-beam are more numerous.[13] On the other hand, Andrew was depicted crucified with arms outstretched but unbound, fastened with nails, as in the ninth-century Byzantine manuscript

of the Homilies of Gregory Nazianzen (fol. 32v),[14] or with neither ropes nor nails visible, as in the Carolingian Drogo Sacramentary, Metz (fol. 98v (p. 206)), also ninth century.[15]

On the sculpture, the figures behind the crucified are, on his right, a nimbed, robed figure gesturing towards the cross; and on his left the nimbed head of a female figure. These could be the witnessing John and Mary, although it is usually Mary who is on Christ's right; but they could also possibly be the witnesses Stratocles and Maximilla from some of the apocryphal accounts of Andrew's martyrdom, though the haloes rather count against this.[16] There is only one attendant (male) figure in the martyrdom image in the Homilies of Gregory Nazianzen, and none in the Drogo Sacramentary. Similarly, it is probable from the position and stance that the figure beneath the cross-arm is the spear-bearer piercing Christ's side, though Cramp suggested it could be a figure pulling on the ropes which bound Andrew to the cross.[17] The gesturing male figure in the image in the Homilies of Gregory Naziansen is another possibility. There are two twelfth-century examples (both with outstretched

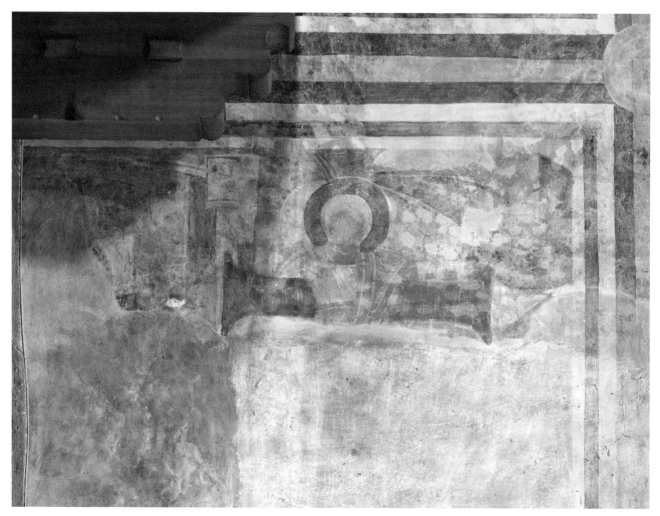

Fig. 3.2 Crucifixion of St Andrew, Müstair (Photo: © Stiftung Pro Kloster Sankt Johann in Müstair & Michael Wolf, Foto: Michael Wolf)

arms) which have been cited as indicating the possibility for earlier, now lost, images of a roped Andrew.[18] Roping by attendant figures is found earlier in depictions of the martyrdom of Peter,[19] and these could have influenced the rare later depictions of Andrew bound by ropes.[20]

The inscription on the upper arm of the cross reads 'PAS' (possibly an abbreviation of *passio*), while that on the surviving horizontal arm of the cross reads 'AND'. Suggested interpretations include reading 'PAS' as an abbreviation for *passio Christi* (assuming a lost abbreviation for *Christi* on the shaft of the cross or an arm): *passus est*, *Christus passus*, and *passio Andreas*.[21] Cramp corrected my initial suggestion of *Andreas* to the genitive, surmising that perhaps the missing right arm had 'REAE' (therefore *passio Andreae*: 'the passion of Andrew').[22] Calvert suggested that multiple meanings were part of the intention of this scene from the start;[23] but this creates difficulties with the scene above. I have suggested that the 'AND' seemed less certainly carved and was possibly an addition,[24] but even if added not much later it might signal discomfort about the suitability of this image as a representation of the Crucifixion of Christ, or at least with the ambiguity of the scene.

A new publication of the series of wall paintings from St Johann at Müstair, Switzerland, has not quite eliminated its ambiguity in providing an excellent illustration of a ninth-century panel which may have been of Andrew (Fig. 3.2); the authors are more tentative in this ascription than Ataoguz, saying that if it is, it is unique.[25] It clearly shows a crucified figure, of which only the upper part survives, wearing a white undergarment, probably with long sleeves, and an over-garment which drapes across his left shoulder and folds around his waist. There are no other extant figures – nothing survives beneath the cross-arms – and there is no evidence of ropes or other fastenings. The figure's arms are pulled back behind the cross, however, so it is a more convincing parallel than the twelfth-century examples noted above.

The Anglo-Saxon cross panel would be unique as a Crucifixion of Christ because of the position of the central figure's arms. In the light of Müstair it could possibly be one of two depictions of Andrew with his arms behind the cross, though the evidence of roping is confined to the sculpture. One should never assume the impossibility of innovation and experimentation in the development of iconography, but if these were experiments, they were unsuccessful, neither having any followers; nor is there any evidence of connection between these two images (the figures' garments differ). If the sculpture is of Andrew, the overall programme of the cross still suggests witness, but with no surviving evidence of the life of Christ apart from the Annunciation, which then seems oddly placed.[26] Given that dedications to Andrew are attested early in Anglo-Saxon England,[27] it is possible the scene was reinterpreted as a crucifixion of Andrew, with the addition of the inscription on the left horizontal arm of the cross, perhaps when the rendering

of Christ crucified wearing a robe was less familiar, and roping his arms behind the cross was seen as odd way of making an awkwardly proportioned scene fit a cross-shaft panel.[28] Renewed interest in this cross could account for its influence on a later cross with Peter's martyrdom at Aycliffe, Co. Durham.[29]

St Peter

At Aycliffe, Peter is represented in a carving on the late tenth- or early eleventh-century cross, Aycliffe 1 (again in a church dedicated to Andrew).[30] Apart from this scene, the only other identifiable image is of the Crucifixion of Christ on Face A; a further panel on A, and three on C have figural iconography with identical figures in pairs or triplets; despite the variety of attributes held by those on C, none can be identified.

The crucifixion of Peter is on narrow face D, to the left of the main face A. It has no accompanying figures, but is unmistakable. It shows a frontal figure without a halo, in a loincloth or belted tunic, crucified upside down (Fig. 3.3). No nails or ties of any kind are visible. Cramp linked this cross in its style of carving and ornamental repertoire with a

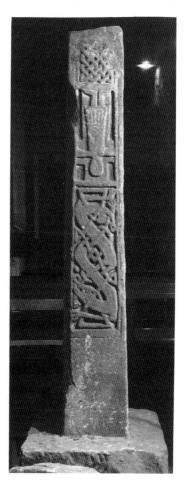

Fig. 3.3 Crucifixion of St Peter, Aycliffe, Co. Durham (Photo: T. Middlemass, © Corpus of Anglo-Saxon Stone Sculpture)

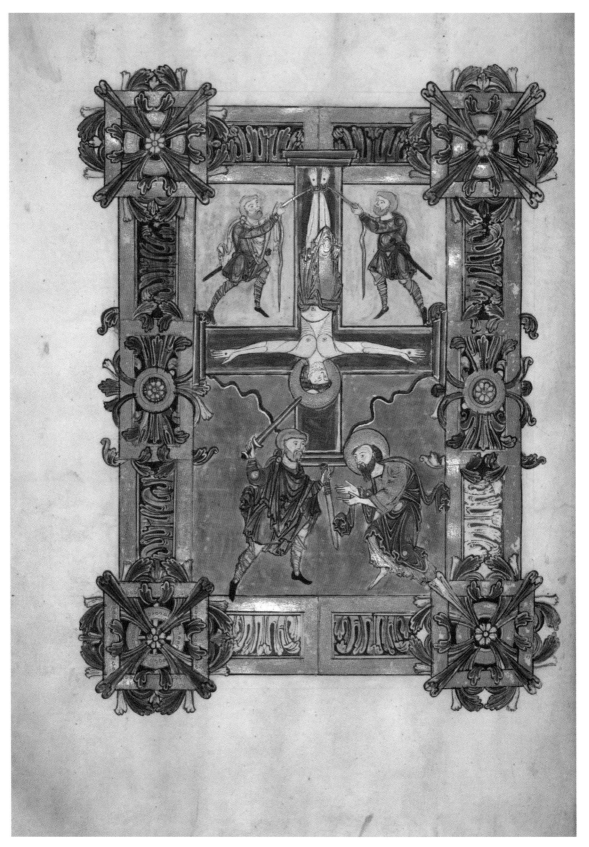

Fig. 3.4 Benedictional of St Æthelwold. London: British Library, MS Add. 49598, fol. 95v (Photo: © British Library Board, all rights reserved)

Lindisfarne-Durham tradition, also found at Chester-le-Street, associated with the movements of the Cuthbert Community. She also agreed with Richard Bailey that the iconography of the paired and tripled figures, though not their flat figural style, was derived from those on the much earlier cross-shaft of St Andrew Auckland.[31] These then can also be interpreted as apostles or martyrs witnessing to the Crucifixion of Christ and its significance, but without the conflation between the iconography of Christ and Andrew possible there.

St Peter with St Paul or with St Paul and St Laurence; St Laurence

Apart from Aycliffe, there is no other scene in which Peter's crucifixion appears alone, but it features twice in Anglo-Saxon manuscripts accompanied by the martyrdom of Paul, and in the second image, with Laurence as well. Laurence also appears once alone. The earliest example is found on folio 95v of the Benedictional of Æthelwold (Fig. 3.4). Here Peter, in the upper register, is portrayed upside down on a Latin cross with stepped terminals complete with a roll moulding, reminiscent of sculptured and metalwork examples of the period.[32] He is nimbed and wears a loincloth draped and knotted at the waist like that of the crucified Christ on folio 43 in the tenth-century Sherborne Pontifical, probably made in Canterbury.[33] His head is turned to his right, with short hair, a tonsure and light beard. His feet and hands are nailed to the cross, but his ankles are also tied with ropes, at which two executioners, the only accompanying figures, are pulling. The foot of the cross extends into the upper frame of the scene; the cloud-like edging under the upper arm interlocks with the landscape background against which Paul, on the right, bows forward as he awaits his martyrdom. His executioner holds the scabbard of his sword in his left hand, his right arm with the sword raised above his head ready to strike.

This dual arrangement is similar to that in the mid-ninth-century Drogo Sacramentary (fol. 86r (p. 181)).[34] This has, however, accompanying witnesses to both scenes, on the left in each case. There are no ropes tying Peter's feet, his executioners are in the act of fixing nails in his hands and feet; nevertheless the head of the cross reaching into clouds echoes the motif of the cloud-like wave which links it to Paul's martyrdom in the Benedictional. The executioner in the Sacramentary stands on the left of Paul with his sword raised in his right hand, and seizes and pulls the tonsured head of Paul forward with his left hand; another man stands behind Paul holding another sword or the scabbard. The executioner's sword pierces Peter's halo in the scene above, and one of his feet dances into the lower frame, linking both scenes and also drawing in the viewer. Deshman noted late tenth- and eleventh-century western parallels with the theme of roping, and sometimes nailing, Peter's feet,[35] but the similarities with the Drogo Sacramentary suggest that most of its elements had been around for some time.

This is also apparent in the eleventh-century Harley Psalter,[36] definitely based on its ninth-century Carolingian model, the Utrecht Psalter, dated to 820–30.[37] In the Harley illustration of Psalm 33 (34): 7–8, on folio 19, Peter is shown upside down on a tall cross: two executioners reach up to hammer nails into his hands (Fig. 3.5). To his left Paul kneels before the sword-wielding executioner (in this case standing to the right of Paul) who holds the scabbard in his other hand. To the left, two executioners again stretch Laurence on his gridiron. Angels hover protectively over all three scenes. This is identical in detail to the rendering in the Utrecht Psalter, folio 19. The tiny miniature in the Drogo Sacramentary (fol. 89 (p. 187)),[38] conveys more detail of Laurence's martyrdom, in this case of the structure of the gridiron and its fire; and the accompanying witnesses and torturers. This amount of detail is found, however, in an eleventh-century troper,[39] which has a full-page miniature on folio 25 (Fig. 3.6), with two scenes from the martyrdom of Laurence. Above is his confrontation with Decius, with his torture below, and an angel flying down to receive his soul, this last detail echoing the Utrecht and Harley Psalters.

St Stephen

The Benedictional of Æthelwold also has, on folio 17v, an image of the stoning of the protomartyr, Stephen (Fig. 3.7). Deshman compared this with the scene in the Drogo Sacramentary, folio 27r (p. 63),[40] in that both scenes are overseen by a full-length standing figure of Christ – above the scene in a mandorla supported by angels in the Benedictional, and in the stem of the initial D in the Sacramentary, where angels attend on the Hand of God within the bowl of the letter. Both scenes depict Stephen's vision as recorded in Acts 7:56: 'Behold, I see the heavens opened, and the Son of Man standing at the right hand of God.'[41] Western images of the ninth to tenth centuries vary, some with a kneeling figure of Stephen (sometimes on the right, or as in Drogo on the left), but always with the executioners in a tight group.[42] Only one Carolingian example appears to have standing figures as in the Benedictional, a wall painting from the crypt of the former abbey of St Germain in Auxerre (Yonne, France), although the disposition of the figures (with Stephen on the right but facing away from his killers), is again different.[43]

The Bury Psalter of around the second quarter of the eleventh century, folio 87v,[44] has Stephen, tonsured, kneeling in the right margin, away from his executioners, who stand in a group of four in the left margin, one with stones in the skirt of his tunic; Stephen is shown struck by a stone. The image illustrates the first three verses of Psalm 79 (Vulgate), especially verse 3: 'they have poured out their blood like water round about Jerusalem'.[45]

The surviving images which show the method of martyrdom in Anglo-Saxon art are not only few in number,

Ecce oculi dni super timen
tes eum . sperantes aute
in misericordia eius . ut
eripiat amorte animas
eorum . & alat eos in
fame

Anima autem nostra
sustinet dnm . quo adiu
tor & protector noster
est . & inipso laetabitur
cor nostrum . & inno
mine sco eius sperabim

Fiat dne misericordia
tua super nos . quem
admodum sperauim
inte

PSALMVS DD CVM MVTAVIT FACIEM SVAM CORAM ABIMELEH XXXIII.

BENEDICAM
dnm in omni tem
pore . semper laus eius
inore meo
In dno laudabitur ani
ma mea . audiant man
sueti & letentur
Magnificate dnm mecum .
& exaltemus nomen eius
in inuicem
Inquisiui dnm & exau

diuit me . & ex omnibus
tribulationibus meis
eripuit me
Accedite adeum & in
luminamini . & uultus
uri nonerubescent
Iste pauper clamauit
& dns exaudiuit eum
& ex omnibus tribulati
onibus eius liberauit
eum

In mitt & angelum dni
incircuitu timentium
eum . & eripiet eos
Gustate & uidete quo suauis
est dns . beatus uir qui
sperat ineum
Timete dnm omnes sci
eius . quo nihil de est
timentibus eum
Diuites eguerunt & esuri
erunt . inquirentes aute

Fig. 3.5 Harley Psalter. London: British Library, MS Harley 603, fol. 19 (Photo: © British Library Board, all rights reserved)

therefore, but are confined to a narrow range of subjects: the proto-martyr Stephen, the apostles Peter, Paul and Andrew, and Laurence, deacon of Sixtus II. Although the restriction to these figures must relate at least partly to the accidents of survival, it may be that there is evidence in the non-visual sources to show why these were among the most likely to have been chosen for depiction.

Martyrdom in literature and other non-visual sources

Much of the scholarly discussion of martyrdom in Anglo-Saxon literature is concerned with sources and their transmission. Here I am only concerned with the literary and documentary contexts in which martyred saints appeared. Details which could be reproduced visually are obviously of interest but, as

will become clear, martyrologies with such details were well established by the seventh to eighth centuries.

Martyred saints in church dedications from the sixth to eleventh century

Discussion of such contexts must include contemporary accounts of historical figures and their interest in martyrs. For example, we know that Bede dedicated his *Commentary on the Acts of the Apostles* to Acca, bishop of Hexham (709–32; d. 740), of whom he said, in his *Ecclesiastical History*, that:

> He took great trouble ... to gather relics of the blessed apostles and martyrs of Christ from all parts and to put up altars for their veneration ... He has also built up a very large and most noble library, assiduously collecting histories of the passions of the martyrs as well as other ecclesiastical books.[46]

Visits of Wilfrid and Benedict Biscop to Rome in the 650s and 660s are recorded in Bede's *Historia Abbatum*; their interest in the tombs of the apostles and veneration of their remains are both remarked on.[47] This found expression in the naming of Benedict Biscop's two foundations: St Peter at Monkwearmouth and St Paul at Jarrow, the latter recorded on a dedication slab still in the church.[48] Wilfrid dedicated his foundation at Ripon to Peter, and those at Hexham and Oundle to Andrew.[49] Stephen, Wilfrid's biographer, records that, when in Rome, Wilfrid dedicated himself to his vocation in 'the oratory dedicated to St Andrew the Apostle'.[50]

While most are lost to us, surviving church dedications at least give some indication of the importance attached to specific saints. Levison, using documentary sources, compiled a list of seventh- and eighth-century church dedications he believed to be the earliest.[51] He found that the highest numbers were dedicated to Peter (20), Mary (19), Paul (5) Peter and Paul jointly (6) and Andrew (6). After this comes Laurence (3), while only one or two were dedicated to Martin, Michael (the archangel), John the Baptist, Alban, Bartholomew (also an apostolic martyr),[52] Holy Saviour (Christ Church), Matthias, the Four Crowned Martyrs, and (jointly) to Cuthbert and Oswald. This list is interesting (if the Virgin is excepted) because of the preponderance of dedications to the apostolic saints Peter, Paul and Andrew above all others, and also because Stephen (alone of those figuring in illustrations) is absent, though Bede mentions a church dedicated to Stephen in Faremoûtier-en-Brie, associated with an Anglo-Saxon royal female saint.[53] Later, Richard Morris looked at church dedications from before the end of the seventh century, also mainly from documentary sources, especially Bede.[54] He confirmed only Peter (1), Mary (7), Andrew (3), Paul (2),

Peter and Paul together (3), along with one to the Four Crowned Ones, one to Holy Saviour (Christchurch), one to Martin, and one to (the archangel) Michael, confirming Levison's distribution, but also showing how many more churches there were with unknown dedications.

Mary Clayton, interested in dedications to the Virgin, produced her own lists for the whole period, based on the work of Knowles and Hadcock:[55] although these used evidence only from cathedrals, monasteries and nunneries, she checked their results against Levison for the seventh and eighth centuries (Table 3.1). The final list seems to follow the same conservative pattern, with (excluding Mary), Peter, Paul and Andrew, alone or in various combinations remaining ahead of all other saints. Peter is clearly in the majority, with Paul (including Peter and Paul together) and Andrew far behind, but well ahead of the remainder. Laurence is represented. Stephen is again conspicuous by his absence. Of the rest, little is known about Ruman and Melor, although Melor was venerated as a martyr; Edmund and Kenelm were both royal martyrs. The table also shows a considerable change in naming practices in the tenth century, for example in a renewed interest in early Anglo-Saxon royal female saints. I have put foundations and tenth-century re-foundations together, but the reforms of the tenth century were certainly important here. Nevertheless Peter, Paul and Andrew all had new dedications in the tenth century, and Peter and Andrew in the eleventh.

Martyrs in Anglo-Saxon literature from the eighth to eleventh centuries

Dedications of churches, and altars within churches, were celebrated in the poetry of Aldhelm (d. 709 or 710), in his *Carmina ecclesiastica* (although it is not known whether these were for real or ideal churches). There are five poems, but it is the fourth which is of particular interest: *On the Altars of the Twelve Apostles*, apparently in one church.[56] The order of the apostles' names follows the list in the prayer *Communicantes* ('In communion with those whose memory we venerate, especially ... we ask that through their merits and prayers, in all things we may be defended'),[57] from the Roman Canon of the Mass.[58] According to Lapidge and Rosier, Aldhelm's main source was *De ortu et obitu patrum* (On the lives and deaths of scriptural figures), by Isidore of Seville (*c.* 560–636), though O'Leary also thought *Passiones* of the apostles known in early Anglo-Saxon England were an important source for at least six apostles in Aldhelm's poem.[59] The order in *Communicantes* clearly indicates order of importance, so it may be significant that the first three (Peter, Paul, and (?) Andrew) are also the only apostles portrayed as martyrs in surviving Anglo-Saxon art.[60] Aldhelm's references to the physical actuality of the martyrdoms implies a knowledge of the more detailed texts on which

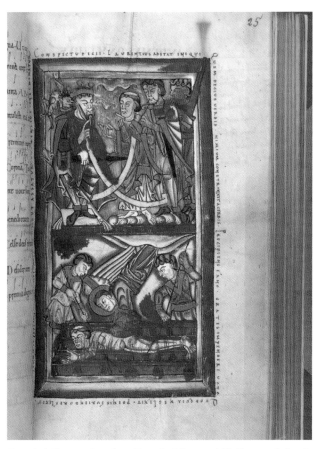

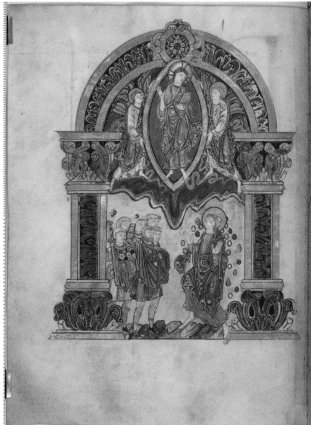

they are based, amplifying Isidore's account of Peter's death by drawing on Jerome,[61] but without describing the distinctive feature of his crucifixion. On Paul the description is even slighter but clearly indicates decapitation.[62] The brief description of Andrew's martyrdom makes clear that this was a death on the cross, the emphasis on hanging implying a difference from the Crucifixion of Christ.[63] O'Leary is also clear that the *Passiones* of the apostles known to Aldhelm in the late seventh century were known in Northumbria by the early eighth century.[64]

Lapidge hypothesised that the author of the first English martyrology was Acca of Hexham.[65] Bede (*c.* 673–735) said of himself in his *Ecclesiastical History* that he had written a 'martyrology of the festivals of the holy martyrs, in which I have diligently tried to note down all I could find about them, not only on what day, but also by what sort of combat and under what judge they overcame the world',[66] a work now only available in a reconstruction stripping out additions and interpolations known to be later in date.[67] This version contains none of the martyrdoms under consideration here except for Laurence (10 August): 'roasted on an iron griddle'.[68] It is unlikely, however, that the original did not contain apostolic martyrs such as Peter,

Paul and Andrew, though later changes may have made the form of the originals uncertain. The main point is, however, that details of the martyrdoms which could be portrayed graphically were available throughout the period.

Bede's interest in veneration of the apostles and martyrs is well attested in his writings, for example, his discussion of the death of Stephen in his *Commentary on Acts*.[69] He also showed considerable unease about the validity of some of the sources for Passion narratives,[70] though whatever his scruples, he also wrote hymns for the feasts of Peter and Paul, John the Baptist, and Andrew which refer to their deaths in ways which show his interest in, and familiarity with, apocryphal *passiones*. That for Andrew, for example, includes a prayer by the saint, in chains, from the cross.[71]

The influence of apocryphal texts of martyrdom is fully apparent in the ninth-century Book of Cerne, a private devotional work, which Michelle Brown has shown to be concerned with overarching themes such as the Communion of Saints.[72] It includes seventy-one prayers (nos 4–74) on folios 43r–87v, 'forming a protracted act of invocation', 'addressed in order to the saints, the angels, the Virgin, the apostles, saints, confessors and martyrs ... (the Church Triumphant), whose intercession for fellow members of the

Table 3.1 Dedications of cathedrals, monasteries and nunneries (after Clayton 1990, 122–30)

Dedications	6th	7th	8th	9th	10th	11th
Mary		8 +?2	3	1	5	3 + ?1
Mary and Bartholomew				1	2	
Mary and Benedict					1	
Mary and Ruman					1	
Mary and Kenelm					1	
Mary and **Peter**					2	
Mary and Æthelthryth					1	
Mary, **Peter and Paul**					1	
Mary and Melor					1	
Mary, **Andrew** and Eadburgh						1
Mary, **Peter** and Osburg						1
Peter		12	4		1	2
Peter and Paul	1	4/5	1	2	1	
Paul		2				
Peter, Paul and Andrew					1	
Andrew		4	1		1	
St Swithun (later Christ Church)	1					
Christ and **Peter**?					1	
Saviour, Mary and All Saints					1	
Holy Cross and **Peter**					1	
Michael			2			
Alban			1			
Benedict			1			
Laurence			1			
Æthelberht					1	
Cuthbert					1?	
Germanus					1	
Edmund						1

communio sanctorum was particularly beneficial'.[73] The 'Prayers with apocryphal content' include an address by Andrew to the cross (fol. 81r); and a prayer of Peter as he went to his crucifixion (fol. 87r), clearly influenced by the apocryphal literature of martyrdom.[74]

In a detailed study of *The Old English Martyrology*, Christine Rauer argued that its primary purpose would have been to inform its readers on the lives, and where appropriate, the martyrdom, of both native and foreign saints.[75] Its earliest forms are thought to date from the late eighth or early ninth century, while the earliest manuscripts confirm its existence before 900.[76] It includes a very extensive list of saints' lives and passions arranged in calendrical order, including many early Christian and later Anglo-Saxon martyrs. Among these, it of course has Stephen (26 December);[77] the martyrdoms of Peter and Paul (both had other days associated with them) commemorated jointly (29 June);[78] St Laurence (10 August);[79] and Andrew, including the named witnesses Stratocles and Maximilla (30 November).[80]

The poems attributed to Cynewulf have been dated from the mid-ninth century to the monastic revival of the tenth.[81] The long poem *Andreas* (which may not be by Cynewulf) covers much of Andrew's story but not his martyrdom. This is found, along with accounts of the deaths of all the other apostles, in the poem which succeeds it in the Vercelli manuscript,[82] *The Fates of the Apostles*.[83] This begins with Peter, Paul and Andrew, in the same order as in Aldhelm's *Carmina ecclesiastica*, and was therefore also possibly influenced by the *Communicantes* prayer from the liturgy of the Mass.[84] James Cross noted of Andrew that his place of death (Achaia) and its manner (he was 'stretched on the gallows'),[85] both suggested an early apocryphal passion of Andrew as a likely source; but that for Peter and Paul only

a few bare details found in all early accounts were used: namely, that they were martyred in Rome by Nero.[86]

The remaining literary accounts of the martyrdoms are to be found in collections of homilies, notably those attributed to Ælfric, and the Blickling Homilies, of the tenth century. Ælfric's *Lives of the Saints* has no texts on martyrs represented in surviving Anglo-Saxon art. It has, however, lives of the royal Anglo-Saxon martyr-saints, Oswald and Edmund.[87] His homilies include a number of saints and martyrs, and among them are (in the First Series), Stephen, Peter and Paul (together), Laurence, and Andrew. Stephen and Peter and Paul also figure in the Second Series, but not in connection with martyrdom; that for Stephen for example is concerned with miracles associated with his relics after his death.[88] The account of Stephen's martyrdom in the First Series is elaborated on that in Acts (6:5–15; 7:51–60); that of Peter and Paul is based on a tradition which had the two apostles meeting their martyrdom on the same day, with Paul decapitated on the Ostian Way while Peter was crucified upside down in the Circus of Nero on the Vatican.[89] The *passio* of *Andreas* includes the account of his continued preaching while on the cross, a detail which might justify the inclusion of witnesses to the scene in a visual rendering.[90] The Blickling Homilies have only Peter and Paul (combined) and Andrew: the first contains the usual details which could be rendered visually, such as Peter's request to be crucified head down to differentiate it from Christ's, though that of Andrew, like the poem *Andreas*, ends before his martyrdom.[91]

Conclusions

The martyrologies and homiletic literature contain an extensive programme of lives (and sometimes deaths) of apostles and other saints. They are evidence of interest in the theme, but not of the limited selection in the art. Church dedications go some way to demonstrating the relative popularity of (after the Virgin Mary) the apostles Peter, Paul, Andrew and Laurence, though not of Stephen, but do not in themselves explain this popularity.

It is not necessary to explain the primacy among apostles occupied by Peter and Paul from the earliest times. In all the Gospels, Andrew, brother of Simon (Peter) is seen as being particularly close to Christ and in John's Gospel he is mentioned as the disciple of John the Baptist who was first to recognise Christ as Messiah, bringing his brother to meet him (John 1: 35–42). The importance of Laurence, martyred in the Valerian persecution of 258, is attested by the five basilicas dedicated to him in Rome, including San Lorenzo fuori le Mura built over his tomb. The extent of the cults of Andrew and Laurence in Rome and their importance in early medieval Europe, including England, has been demonstrated by several scholars.[92] The earliest dedication of a church to Andrew in England was that by

King Æthelberht at Rochester in Kent *c*. 604.[93] Relics of Laurence were among those sent by Pope Vitalian to King Oswiu of Northumbria later in the seventh century.[94] The church of St Laurence in Bradford on Avon was (cautiously) said by William of Malmesbury (early twelfth-century) to have been built by Aldhelm,[95] although the surviving church is believed to be eleventh century.[96] The supposed tomb of Stephen, deacon and protomartyr, was discovered in 415, and this news and the spread of associated relics had a major and continuing impact across the Christian world. The relics were believed to have been sent to Rome and buried alongside his fellow deacon Laurence. The *Translatio Sancti Stephani*, which recounts this transfer, has been dated to the eighth century, and seems to be asserting Rome as the equal of Byzantium where the relics had been kept in a church dedicated to Laurence: a proposed exchange of the remains of Stephen for those of Laurence was miraculously prevented – and this same story may also be a riposte to Charlemagne and Alcuin who had wanted remains of Paul to be sent from Rome to Aachen. The issue was alive in eighth-century Europe and in Rome, witnessed by several churches dedicated to Stephen at this period.[97]

The Roman cults of these saints clearly connect with the liturgical evidence,[98] and support the significance of those few whose depictions have survived; in particular the Roman Canon of the Mass can account for the interest in all five saints represented in Anglo-Saxon art, including Stephen and Laurence. Laurence is also listed in the *Communicantes*,[99] and Stephen appears in the post-communion prayer beginning *Nobis quoque peccatoribus, famulis tuis*.[100]

There is a more mundane reason for both the relative rarity of overt depictions of martyrdom, and the limited number of martyrdoms represented, in early medieval art. Martyrologies and other sources indicated that many saints met martyrdom, and that many met similar deaths. This is illustrated by the miniature in the Homilies of Gregory Nazianzen, noted in connection with Andrew.[101] On folio 32v, the deaths of all twelve apostles are shown. Philip is shown crucified upside down as is Peter; Simon and Bartholomew were crucified upright as is Andrew – and all are nailed to the cross. In the absence of inscriptions there was clearly a problem of identification, leading to confusion – in the case of upright crucifixions, with that of Christ as well as other saints – even for the literate. Peter and Paul's primacy over all other saints would have extended to their association with particular methods of execution. The means by which Stephen and Laurence met their end were sufficiently distinctive – but Andrew remained a problem until he became associated with the saltire cross, far beyond the end of our period.

The relative infrequency of Anglo-Saxon examples in any visual media makes the contexts in which they appear of considerable interest. Ataoguz emphasised the monastic context in which the Carolingian wall paintings of Müstair

were likely to have been displayed and used: the apostolic mission to preach linking to the monastic present and the preaching role of the monks.[102] Both surviving sculptures with martyrdoms appear to show an interest in apostles or martyrs and evangelists in the context of witness, and recent work has demonstrated other examples of monastic sculpture which suggest a concern to represent the work and worship of a monastic community.[103] The appearance of such scenes in manuscripts providing material for the conduct of worship at specific points in the Church calendar – which effectively covers all genres except for the poetry and the private prayers – is not surprising, but illustrations of overt martyrdom never appear in books of homilies and there appear to be none in martyrologies. In fact they appear in deluxe books made for specific institutions or individuals of particular importance (the Psalters, the Benedictional and the troper) – placing them in relation to the liturgy certainly, but also to similar contexts of ecclesiastical life and meditation as the sculptures and the (Carolingian) wall paintings.

Notes

1 Richard Bailey's contribution to the study of the iconography of Anglo-Saxon stone sculpture, always in awareness of its broader context in the history, art and thought of the period, has been an inspiration to many – not least because of the incisive wit and humour with which he engages in scholarly debate. I was conscious of following in a giant's footsteps as a fellow but later student of Rosemary Cramp, and am glad to acknowledge the benefit of his advice for the first piece I ever wrote for publication, as well as on many occasions since. An iconographical study and its literary context seems an appropriate tribute to one who has shown how much is possible in this area.
2 Cather et al. 1990.
3 Dodwell 1982, 84–8; Gem 1990.
4 London: British Library, MS Harley 603; Harley (Electronic Resource).
5 Pretiosa in conspectu Domini mors sanctorum eius.
6 Coatsworth 1979; 2000, 159–63; Cramp 1984, 37–40, ills 1–5.
7 Cramp 1978.
8 For a detailed description and illustrations, see Cramp 1984, 37–8, ills 1–14.
9 Webster & Backhouse 1991, 180–3, cat. 141; Coatsworth 1998, esp. 17–20.
10 Cook 2015, 423–6.
11 British Museum, Department of Prehistory and Europe, MME 1986.05–01.1.
12 Leningrad: State Hermitage Museum, Inv. No. Ꞓ154; Cormack & Vassilaki 2008, pl. 286.
13 Coatsworth 2000, 162.
14 Paris: Bibliothèque Nationale de France, MS grec. 510; Mandragore (Electronic Resource).
15 Paris: Bibliothèque Nationale de France, MS lat. 9428; Drogo (Electronic Resource).
16 James 1924, 357–63.

17 Cramp 1984, 40, pls 1, 6.
18 Calvert 1984, esp. 545, fig. 4.
19 See below, 25–7.
20 The problem of distinguishing crucified figures other than Christ is discussed below, 32.
21 Coatsworth 1979, 124; summarised in Coatsworth 2000, 160.
22 Cramp 1984, 39.
23 Calvert 1984.
24 Coatsworth 1979, 124; 2000, 160–1; Okasha 1971, 54 gives both the same date.
25 Goll et al. 2007, panel 78k; Ataoguz 2013, 98.
26 See above, 23–4.
27 See below, 29 and Table 1.
28 Coatsworth 2000, 161.
29 See Bailey 1980, 191–4; and below, 27 and Fig. 3.4.
30 For a detailed description and illustrations, see Cramp 1984, 41–3, ills 25–8.
31 Bailey 1980, 191–4; Cramp 1984, 42–3.
32 Coatsworth 1997, 174–5, 181–2, pls iiia–b.
33 Paris: Bibliothèque Nationale de France, MS lat. 943 (Temple 1976, pl. 134).
34 Drogo (Electronic Resource).
35 Deshman 1995, 115–7, pl. 31, figs 112–16.
36 London: British Library, MS Harley 603.
37 Utrecht: Universiteitsbibliotheek, MS 32.
38 Drogo (Electronic Resource).
39 London: British Library, MS Cotton Caligula A. xiv (Alexander 1984, 86, cat. 3, pl. on 17; see also Temple 1976, 113–15, cat. 97, pls 293–5).
40 Drogo (Electronic Resource).
41 Ecce video coelos apertos, et filium hominis stantem a dextris Dei.
42 Deshman 1995, figs 107–8, 110.
43 Ibid., fig. 111.
44 Rome: Biblioteca Apostolica Vaticana, Reg. lat. 12; Ohlgren 1992, pl. 3.34; Bury (Electronic Resource).
45 Effuderunt sanguinem eorum, tamquam aquam, in circuitu Jerusalem.
46 Bede, *HE* V, 20: Dedit namque operam … ut adquisitis undecumque reliquiis beatorum apostolorum et martyrum Christi in uenerationem illorum poneret altaria … Sed et historias passionis eorum, una cum ceteris ecclesiasticis uoluminibus, summa industria congregans, amplissimam ibi ac nobilissimam bibliothecam fecit' (Colgrave & Mynors 1969, 530–1). See below, 30.
47 Bede, *Historia Abbatum*, 1–2 (Grocock & Wood 2013, 22–7).
48 Bede, *Historia Abbatum*, 4, 7 (ibid., 30–1, 36–9); Cramp 1984, 113–14, pl. 98, 524.
49 Thacker 2000, 260, 267–70; Stephen, *Vita Wilfridi*, 22, 55 (Colgrave 1927, 44–6, 120).
50 Stephen, *Vita Wilfridi*, 5: in oratorio sancto Andreae apostolo dedicato (Colgrave 1927, 12–13); see Ó Carragáin 1994, 7 for discussion of its possible location.
51 Levison 1946, 259–65.
52 Rauer 2013, 166–7, no. 162.
53 Bede, *HE* III, 8 (Colgrave & Mynors 1969, 238–40).
54 Morris 1983, 34–8.
55 Clayton 1990, 122–30; Knowles & Hadcock 1971.
56 Lapidge & Rosier 1985, 50–8.

57 communicantes et memoriam venerantes in primis ... quorum meritis precibusque concedas, ut in omnibus protectionis tuae muniamur auxilio (Hänggi & Pahl 1968, 430–1). The apostolic martyrs are listed in the order Peter, Paul, Andrew, James [the Great], John, Thomas, James [the Less], Philip, Bartholomew, Matthew, Simon, Thaddeus [Jude].

58 Lapidge & Rosier 1985, 42.

59 Ibid., 42–4; O'Leary 2003, 107.

60 See above, 23–7.

61 Lapidge & Rosier 1985, 50, 239, n. 43.

62 Ibid., 51.

63 Ibid., 52.

64 O'Leary 2003, 112–13.

65 See above, 29; Lapidge 2005, esp. 44, 57–8, 66–9, for a discussion of the role of Acca and Bede in gathering and transmitting martyrological literature.

66 Bede, *HE* V, 24: Martyrologium de nataliciis sanctorum martyrum diebus, in quo omnes, quos inuenire potui, non solum qua die uerum etiam quo genere certaminis uel sub quo iudice mundum uicerint (Colgrave & Mynors 1969, 570–1).

67 McCulloh 2000, 69; for the reduced text, see Lifshitz 2001.

68 Ibid., 189; Quentin 1908, 17–119, at 79: craticula ferrea assatus.

69 Martin 1989, 65–7.

70 Ibid., 23–4.

71 O'Leary 2003, 114; for the texts see Fraipont 1955, 405–70, and 437–8 for the hymn to Andrew.

72 Brown 1996, 19, 150.

73 Ibid.

74 Ibid., 138–9.

75 Rauer 2013; Herzfeld 1890 for previous edition and translation of full text.

76 Rauer 2013, 1–3; see discussion of Acca of Hexham above, 29.

77 Ibid., 38–9, 231.

78 Ibid., 126–7, 269.

79 Ibid., 158–9, 280–1.

80 Ibid., 222–3, 308. For a history of the reception of the apostles in the early Christian Church, see Burnett 2014.

81 McCulloh 2000, 70; Conner 1996.

82 Vercelli: Biblioteca Capitolare, CXVII.

83 Krapp & Dobbie 1932, 3–51 (*Andreas*); 51–4 (*The Fates of the Apostles*).

84 See above, 29.

85 Line 22b: gealgan þehte (Krapp & Dobbie 1932, 51).

86 Cross 1979, 170 (Peter) and 170–1 (Andrew); McCulloh 2000, 82–3 also suggested that the latter poem had a passionary, rather than a martyrology, as a likely source.

87 Skeat 1966, i, 124–43 (Oswald); 314–33 (Edmund); 398–425 (Thomas).

88 Clemoes 1997, iii, 198–205; xxvi, 388–99; xxix, 418–28; xxxviii, 507–19; Godden 1979, ii, 12–18; xxiv, 221–9.

89 Godden 2000, 21–8, 209–21.

90 Ibid., 318–29.

91 Morris 1880, 170–93, esp. 189–90, 228–49.

92 Farmer 1997, 296; Farmer 2011, 18, 263; Godden 2000, 238–47; and see above, 29.

93 Bede, *HE* II, 3 (Colgrave & Mynors 1969, 142).

94 Bede, *HE* III, 29 (ibid., 318).

95 Winterbottom 2007, 198.1–2 at 522–3; see also 225.7 at 568–9.

96 Fernie 1983, 145–50.

97 Costambeys & Leyser 2007, esp. 277–85.

98 See above, 29.

99 Hänggi & Pahl 1968, 430.

100 Ibid., 436.

101 See above, 24.

102 Ataoguz 2013, esp. 91–8.

103 Hawkes 2007; Coatsworth 2008, 142; Pickles 2009.

References

Alexander, J.J. G., 1984 'Manuscripts' in G. Zarnecki, J. Holt & T. Holland (ed.), *English Romanesque Art 1066–1200: Hayward Gallery, London 5 April–8 July 1984* (London), pp 82–133

Ataoguz, K., 2013 'The Apostolic Ideal at the Monastery of St John in Müstair, Switzerland', *Gesta* 52(2), 91–112

Bailey, R.N., 1980 *Viking Age Sculpture in Northern England* (London)

Brown, M.P., 1996 *The Book of Cerne: Prayer, Patronage and Power in Ninth-Century England* (London, Toronto & Buffalo)

Burnet, R., 2014 *Les Douze Apôtres: Histoire de la réception des figures apostoliques dans le christianisme ancien* (Turnhout)

Calvert, J., 1984 'The Iconography of the St Andrew Auckland Cross', *Art Bulletin* 66(4), 543–55

Cather, S., Park, D. & Williamson, P. (ed.), 1990 *Early Medieval Wall Painting and Painted Sculpture in England,* BAR: British Series 216 (Oxford)

Clayton, M., 1990 *The Cult of the Virgin Mary in Anglo-Saxon England* (Cambridge)

Clemoes, P. (ed.), 1997 *Ælfric's Catholic Homilies. The First Series. Text,* EETS supp. ser. 17 (Oxford)

Coatsworth, E., 1979 'The Iconography of the Crucifixion in Pre-Conquest Sculpture in England' (PhD, 2 vols, University of Durham)

Coatsworth, E. 1997 'Late Pre-Conquest Sculptures with the Crucifixion' in B. Yorke (ed.), *Bishop Æthelwold: his Career and Influence* (Woodbridge), pp 161–93

Coatsworth, E., 1998 'Clothmaking and the Virgin Mary in Anglo-Saxon Literature and Art' in G. Owen-Crocker & T. Graham (ed.) *Medieval Art: Recent Perspectives* (Manchester), pp 8–25

Coatsworth, E., 2000 'The "Robed Christ" in pre-Conquest Sculptures of the Crucifixion', *ASE* 29, 153–76

Coatsworth, E., 2008 *Western Yorkshire,* CASSS 8 (Oxford)

Colgrave, B. (ed. and trans.), 1927 *The Life of Bishop Wilfrid by Eddius Stephanus* (Cambridge)

Conner, P.W., 1996 'On Dating Cynewulf' in R.E. Bjork (ed.), *Cynewulf: Basic Readings* (New York), pp 27–55

Cook, J., 2015 *Crucifixion in the Mediterranean World.* Wissenschaftliche Untersuchungen zum Neuen Testament 327 (Tübingen)

Cormack, R. & Vassilaki, M. (ed.), 2008 *Byzantium 330–1453* (London)

Costambeys, M. & Leyser, C., 2007 'To be the Neighbour of St Stephen: Patronage, Martyr Cult, and Roman Monasteries. *c.* 600–*c.* 900' in K. Cooper & J. Hillner (ed.), *Religion, Dynasty, and Patronage in Early Christian Rome* (Cambridge), pp 262–87

Cramp, R., 1978 'The Evangelist Symbols, and their Parallels in Anglo-Saxon Sculpture' in R.T. Farrell (ed.), *Bede and Anglo-Saxon England*, BAR: British Series 46, pp 118–30

Cramp, R., 1984 *County Durham and Northumberland*, CASSS 1 (Oxford)

Cross, J.E., 1979 'Cynewulf's Traditions about the Apostles in *Fates of the Apostles*', *ASE* 8, 163–75

Deshman, R., 1995 *The Benedictional of Æthewold* (Princeton, NJ)

Dodwell, C.R., 1982 *Anglo-Saxon Art. A New Perspective* (Oxford)

Farmer, D.H., 1997 *Oxford Dictionary of Saints*, 4 edn (Oxford)

Farmer, D.H., 2011 *Oxford Dictionary of Saints*, 5 edn rev. (Oxford)

Fernie, E.C., 1983 *The Architecture of the Anglo-Saxons* (London)

Fraipont, J. (ed.), 1955 *Bedae Venerabilis Opera, Pars IV: Opera Rhythmica*, CCSL 122 (Turnhout)

Gem, R., 1990 'Documentary References to Anglo-Saxon Painted Architecture' in Cather et al. 1990, pp 1–16

Godden, M. (ed.), 1979 *Ælfric's Catholic Homilies. The Second Series. Text*, EETS supp. ser. 5 (London & New York)

Godden, M., 2000 *Ælfric's Catholic Homilies Introduction, Commentary and Glossary*, EETS supp. ser. 18 (Oxford)

Goll, J., Exner, M. & Hirsch, S., 2007 *Müstair: die mittelalterlichen Wandbilder in der Klosterkirche* (Munich)

Grocock, C. & Wood, I.N. (ed. and trans.), 2013 *Abbots of Wearmouth and Jarrow...* (Oxford)

Hawkes, J., 2007 'Gregory the Great and Angelic Mediation: The Anglo-Saxon Crosses of the Derbyshire Peaks' in A. Minnis & J. Roberts (ed.), *Text, Image, Interpretation: Studies in Anglo-Saxon Literature and its Insular Context in Honour of Éamonn Ó Carragáin* (Turnhout), pp 431–48

Hänggi, A. & Pahl, I., 1968 *Prex Eucharistica Textus e Variis Liturgiis Antiquioribus Selecti* (Fribourg)

Herzfeld, G. (ed. and trans.), 1890 *An Old English Martyrology*, EETS orig. ser. 185 (London)

James, M.R., 1924 *The Apocryphal Gospels, Acts, Epistles and Apocalypses with Other Narratives and Fragments* (Oxford)

Knowles, D. & Hadcock, R.N., 1971 *Medieval Religious Houses: England and Wales* (London)

Krapp, G.P. & Dobbie, E.V.K. (ed.), 1932 *The Vercelli Book*, ASPR 2 (New York)

Lapidge, M., 2005 'Acca of Hexham and the Origin of the *Old English Martyrology*', *Analecta Bollandiana* 123, 29–78

Lapidge, M. & Rosier, J.L. (trans.), 1985 *Aldhelm: The Poetic Works* (Cambridge)

Levison, W., 1946 *England and the Continent in the Eighth Century* (Oxford)

Lifshitz, F., 2001 'Bede, Martyrology' in T. Head (ed.), *Medieval Hagiography. An Anthology* (New York & London), pp 168–97

McCulloh, J.M., 2000 'Did Cynewulf use a Martyrology? Reconsidering the Sources of the Fates of the Apostles', *ASE* 29, 67–83

Martin, L.T (trans.), 1989 *The Venerable Bede: Commentary on the Acts of the Apostles* (Kalamazoo, MI)

Morris, R. (ed.), 1880 *The Blickling Homilies of the Tenth Century*, EETS orig. ser. 58, 63, 73 (London)

Morris, R.K., 1983 *The Church in British Archaeology*. CBA Research Report 47 (London)

Ó Carragáin, É., 1994 *The City of Rome and the World of Bede*, Jarrow Lecture (Jarrow)

Ohlgren, T.H., 1992 *Anglo-Saxon Textual Illustration: Photographs of Sixteen Manuscripts with Descriptions and Index* (Kalamazoo, MI)

Okasha, E., 1971 *Hand-List of Anglo-Saxon Non-runic Inscriptions* (Cambridge)

O'Leary, A., 2003 'Apostolic *Passiones* in Early Anglo-Saxon England' in K. Powell & D. Scragg (ed.) *Apocryphal Texts and Traditions in Anglo-Saxon England* (Cambridge), pp 103–19

Pickles, T., 2009 'Angel Veneration on Anglo-Saxon Stone Sculpture from Dewsbury (West Yorkshire), Otley (West Yorkshire) and Halton (Lancashire): Contemplative Preachers and Pastoral Care', *JBAA* 162, 1–28

Rauer, C. (ed. and trans.), 2013 *The Old English Martyrology. Edition, Translation and Commentary* (Cambridge)

Quentin, H., 1908 *Les Martyrologes Historiques du Moyen Âge: étude sur la formation du martyrologe romain* (Paris)

Skeat, W.W., 1966 Ælfric's Lives of the Saints: Being a Set of Sermons on Saints' Days Formerly Observed by the English Church, edited from British Museum Cott. MS. Julius VII, with Variants from other Manuscripts by Walter W. Skeat, 2 vols. Reprinted from EETS orig. ser. 76 (1881), 82 (1885) [vol. 1]; 94 (1890), 114 (1900) [vol. 2] (London)

Temple, E., 1976 *Anglo-Saxon Manuscripts: 900-1066* (London)

Thacker, A., 2000 'In Search of Saints: the English Church and the Cult of Roman Apostles and Martyrs in the Seventh-Eighth Centuries' in J.M.H. Smith (ed.), *Early Medieval Rome and the Christian West. Essays in Honour of Donald H. Bullough* (London), pp 247–77

Webster, L. & Backhouse, J., 1991 *The Making of England. Anglo-Saxon Art and Culture AD 600-900* (London)

Winterbottom, M. with R.M. Thompson (ed.) 2007 *William of Malmesbury: Gesta Pontificum Anglorum (The History of the English Bishops)*, 2 vols (Oxford)

Electronic Resources

Bury: Biblioteca Apostolica Vaticana, fol. 87v: http://digi.vatlib.it/view/MSS_Reg.lat.12/0001?page_query=87v&navmode=struct&action=pagesearch&sid=982b090ec0046a776cee6792790f8cac (Accessed 23 January 2015)

Drogo: http://www.wdl.org/en/item/590/ (Accessed 17 January 2014)

Harley: http://www.bl.uk/catalogues/illuminatedmanuscripts/ILLUMINBig.ASP? size= big&IllID=15338 (Accessed 24 January 2014)

Mandragore: http://mandragore.bnf.fr/jsp/rechercheExperte.jsp: use search term search term Grec 510 (Accessed 19 June 2014)

Crucifixion iconography on early medieval sculpture in Wales

Nancy Edwards

Introduction

Over 570 pieces of early medieval stone sculpture are now known from Wales including, from the late eighth century onwards, free-standing crosses and cross-slabs carved in relief with a range of ornament and sometimes complex Latin inscriptions. Yet representations of biblical iconography are remarkably rare and the only scene which may be securely identified is the Crucifixion.[1] Several different types of image may be identified. This study will examine in more depth the various representations and set them in their wider Insular context.

Christ crucified

There is a handful of monuments which simply show the image of Christ crucified unaccompanied by other figures. These demonstrate considerable variety and span a lengthy period, probably from the late eighth or early ninth century up until the late eleventh or early twelfth. They will be discussed according to region, beginning with south-west Wales.

The first example is on a pillar from an otherwise historically unattested site in Llanychaer parish in northern Pembrokeshire.[2] The other three faces and the top of the monument are carved with elegantly executed crosses, one of which has a circular recess in the centre which may once have held a metal or other inset.[3] The image of Christ (Fig. 4.1) is now very weathered but clearly shows him face on, his head and body erect, his arms outstretched. Traces of his hairline are visible and he is shown beardless with open lentoid eyes joined to his nose and a half oval mouth. He is clad in a knee-length garment with two short vertical bands at the neck, suggesting priestly dress.[4] His arms are foreshortened with prominent hands and an indication of his legs, but not his feet, can be seen below the hem of his

garment. Although Nash-Williams shows a cross outlined in chalk behind the figure, the present state of weathering means that it is unclear whether this actually exists.[5] The image may be compared with a second likely representation on a cross-slab from St Dogmaels parish, also in northern Pembrokeshire. This is carved with an encircled equal-arm cross below which are traces of a face-on robed figure with outstretched arms.[6]

The simple representation on the Llanychaer pillar does not depict the crucified Christ as suffering or dead. Instead the image is intended to be multivalent: Christ is shown alive with his arms outstretched in the priestly *orans* position,[7] thereby also representing his triumphant victory over death and the Second Coming (*parousia*).[8] On the Irish 'Scripture' crosses separate scenes of the Crucifixion, Resurrection and Second Coming (as well as the Last Judgement) are frequently shown in careful juxtaposition to each other.[9] However, in this case details of the multivalent Llanychaer image have more in common stylistically with representations on Irish metalwork. For example, the stylised facial features of Christ on the Llanychaer image are reminiscent of Christ on the St John's Rinnagan Crucifixion plaque, Co. Westmeath, which (though he is accompanied by seraphim and the spear and sponge bearers) also shows the living Christ in the priestly *orans* position and dressed in a priestly robe; this has been variously dated to the eighth or ninth centuries.[10] On art-historical grounds a late eighth- or ninth-century date also seems likely for both the Llanychaer pillar and the St Dogmaels cross-slab.[11]

A third, broadly contemporary representation from Llanddewibrefi, Cardiganshire,[12] is, as far as I am aware, unique. The monument consists of a shaped slab, one face of which is incised with a linear cross with trifid terminals on the upper and horizontal cross-arms, while the stem divides part way down, and each end terminates in an outward,

Fig. 4.1 Crucifixion, Llanychaer, Pembrokeshire (Photo: Crown copyright: Comisiwn Brenhinol Henebion Cymru/Royal Commission on the Ancient and Historical Monuments of Wales)

depicted: the trifid terminals on the upper and horizontal cross-arms represent Christ's head and outstretched hands, whilst the vertical, bifurcated stem indicates his body and legs. This dual image and almost abstract simplicity are, however, also captured on a gilt copper-alloy mount from St Arvans, Monmouthshire,[13] most likely of seventh- to early ninth-century date, which consists of an encircled cross with a chi-rho hook and face-masks in the cross-arm terminals which also seem to represent the figure of Christ on the Cross.

Turning to north-west Wales, a small cross-head from Llanfachraith, near Holyhead, Anglesey, is carved in relief with an incomplete and unaccompanied figure of Christ shown face on with his head and body erect.[14] He is probably wearing a loincloth. His remaining outstretched hand is enlarged. This image immediately recalls similar Crucifixion figures with enlarged hands which are a feature of several representations on the Irish 'Scripture' crosses, for example, those at Monasterboice, Co. Louth, and there are particularly close parallels with a small cross-head from that site.[15] In this case there is also written evidence suggesting a connection with this part of Ireland, since the foundation of Cell Mór Mochop, Co. Meath, mentioned *c.* 1200 in the life of St Cybi, was closely linked to the major church of Caer Gybi at Holyhead.[16]

A likely further example from Bardsey Island off the Llŷn Peninsula is on a cross-shaft. Only the lower half of a figure clad in a pleated, calf-length garment with outward pointing feet survives.[17] The head and arms probably originally occupied the cross-head, now missing. The slab-shaped cross and the stone from which it is carved, Anglesey arenite,[18] as well as the letter-forms of the inscription all indicate a date in the tenth or eleventh century. The pleated garment might be similar to that Christ is wearing on the twelfth-century cross at Dysart O'Dea, Co. Clare.[19] There is, however, a parallel closer to home on the runic cross from Michael on the Isle of Man dated *c.* 925–60.[20] This shows Christ in a long pleated loincloth and with outward pointing feet.

There are two representations on the Welsh borders. The first is an image of Christ Crucified carved in false relief on a panel at Llanveynoe St Peter in the Olchon Valley, now just in Herefordshire. This is quite different from the representations discussed so far. It consists of Christ on the Cross and, although his short arms are straight, his body appears slightly twisted with both feet turned to the right. Furthermore, his head is tilted to the left to symbolise his suffering, but his surviving eye appears open. He is beardless and wears a plain loincloth with a waistband. A tenth- or eleventh-century date has been suggested.[21] Since the representation is so simple it is difficult to draw parallels, but those made by Redknap and Lewis with images of Christ in a loincloth on late Irish crosses are not convincing.[22] Rather, the geographical location of the monument might suggest links with Anglo-Saxon sculpture. A number of possible

slightly upward pointing line. This may be interpreted as an almost abstract representation of the figure of Christ on the cross. The linear cross-symbol is the first thing you see, but if you look again, it is clear that a figure is also being

parallels have been noted, including with the fragmentary Crucifixion from North Cerney, Gloucestershire,[23] though in all cases the figure on the cross appears upright, but that on the slab from Newent, also in Gloucestershire, which is otherwise much more complex, shows a beardless Christ still alive on the Cross but with his head tilted to the left.[24]

Fig. 4.2 Cross-slab with Crucifixion, Meifod, Montgomeryshire (Photo: Crown copyright: Comisiwn Brenhinol Henebion Cymru/ Royal Commission on the Ancient and Historical Monuments of Wales)

The second is on the cross-slab from Meifod, Montgomeryshire.[25] This is an ambitious monument (Fig. 4.2) dominated by an interlace-decorated Latin cross surmounted by a ring-cross with bosses in the quadrants on which the figure of Christ is shown. He is face on, his enlarged head and body erect, his eyes open. He is beardless. There are nail marks in both his outstretched palms and his feet, which point downwards. There are possible traces of a loincloth and a depression may indicate the wound in his right side. Again the image is very simple but in this case seems most likely to have been derived from a metalwork Crucifixion figure, such as the unprovenanced Romanesque example from St Mel's College, Co. Longford which, unusually, shows Christ upright with his head erect.[26] The form of the main expanded cross may be compared with that on the reverse of the late eleventh- or early twelfth-century cross-slab St Davids 8, which is dated by inscription.[27] The Meifod cross-slab may be of a broadly similar date and denote the patronage of the rulers of Powys who rose to importance during this period.[28] Indeed, it has recently been plausibly argued that Daniel ap Sulien (d. 1127), archdeacon of Powys, commissioned the monument. He was the son of Sulien of Llanbadarn Fawr (d. 1091) who was twice bishop of St Davids, thereby indicating a route by which influences from the south-west may have arrived in this part of Wales.[29]

The small number of definite and probable images of Christ Crucified unaccompanied by other figures thus demonstrates both considerable variety and longevity, since together they span approximately the late eighth or early ninth century to the late eleventh or early twelfth. They are all simple representations but some clear regional differences emerge. As might be expected Llanychaer and probably St Dogmaels in the south-west demonstrate links with representations in Ireland, both on sculpture and in metalwork, and connections across the Irish Sea are also evident in the north-west. This draws attention to the continuing importance of cultural links to the west throughout the period. At Llanveynoe on the Welsh borders, however, the iconography is suggestive of cultural links to the east. The Crucifixion image on the Meifod cross-slab, since it appears to have parallels with St Davids, at first looks anomalous but may be accounted for by the personal connections outlined above.

Christ crucified with Stephaton and Longinus

Remarkably, there is only one example of the Crucified Christ with additional figures known from early medieval Wales, in this case Stephaton and Longinus, both of whom are characteristic of many Irish representations. This is depicted on the cross-head of a fragmentary disc-headed cross at St Canna's Church, Llan-gan in the Vale of Glamorgan in south Wales (Fig. 4.3).[30] The carving is in relatively poor

condition since the local Pennant sandstone from which it is made is badly laminated. Christ is shown alive, his head and body erect. His head is large: there seem to be traces of short, curly(?) hair and he has sunken lentoid eyes with raised irises and drilled pupils, prominent ears and a faintly smiling mouth. His beard is delineated by short vertical lines. He has thin, outstretched arms and a stocky body. He is wearing a form of loincloth which may be comparable with that shown on the crucified Christ on Muiredach's Cross, Monasterboice,[31] and his feet face outwards. There are no traces of a cross behind him, only the shape of the cross-head itself. Squashed into the available space on either side of Christ are the figures of Stephaton, the sponge-bearer, on the left, and Longinus, who is about to pierce Christ's left side with his spear, on the right. Nothing of the form of the sponge or cup held by the former survives. However, the fact that Longinus is shown on the right makes a specific connection with Irish representations since these frequently also show him piercing Christ's left side rather than his right, as is the norm on early medieval representations of the Crucifixion elsewhere.[32] The two figures are dressed in tunics and the spear bearer has long upward-curling hair. Irish sculptural parallels may be exemplified by representations of the Crucifixion on a number

of the 'Scripture' crosses, including the North and South Crosses, Duleek, Co. Meath, which provide comparisons for the layout of the image as a whole.[33] It has been suggested that, as with some other Irish examples,[34] there might once have been an angel on either side of Christ's head on the cross at Llan-gan, but there is no visible evidence for this; nor can anything be seen on the late nineteenth-century cast.[35]

The fact that the Llan-gan depiction shows Christ with a beard is not, however, a characteristic of representations on the Irish 'Scripture' crosses which were drawing on models showing a beardless Christ probably derived from imported ivories or other portable objects.[36] Nevertheless, there are a number of Irish metalwork Crucifixion plaques, which were probably once affixed to wooden crosses, most recently dated to between *c*. 1000–1150, that show Christ crucified accompanied by the spear- and sponge-bearers and two angels;[37] some of these do depict a bearded Christ, sometimes clad in a loincloth as, for example, the stocky figure on the Kells plaque.[38] The majority also show the spear- and sponge-bearers with long upward-curling hair. However, similar depictions are not confined to Ireland. The image of a bearded Christ accompanied by Stephaton and Longinus and angels is also found at a much earlier date in Northumbria in the late seventh- or early eighth-century Durham Gospels.[39] There is a further example on the probably tenth-century carved stone plaque from Penrith, Cumbria, which shows a bearded Christ in a robe with angels, the spear-bearer (on Christ's left) and the cup-bearer and a further figure on his right. Richard Bailey has plausibly suggested that this representation is also derived from Irish models and has likewise compared it with Irish metalwork Crucifixion plaques.[40]

The figure below the Crucifixion on the Llan-gan cross seems to be holding a now incomplete sword and a drinking horn,[41] suggesting he is a member of the secular elite, most likely the patron who commissioned the monument shown with objects indicating his power, prestige and generosity.[42] He may be compared with the two secular figures with swords and a drinking horn on the early tenth-century 'Cross of Scriptures' at Clonmacnoise, Co. Offaly.[43] By being placed immediately below the Crucifixion, the Llan-gan figure was demonstrating his continuing piety and the expectation of prayers for his soul after death.[44] The juxtaposition of a cross with a prominent named patron portrait is also found on Llandyfaelog Fach, Breconshire.[45]

The Crucifixion iconography on the Llan-gan cross-head seems, therefore, to have been broadly based on an Irish model, probably derived from metalwork. Comparisons have also been made with Irish sculpture dating to the second half of the ninth and first half of the tenth centuries and these links have most recently led to the Llan-gan cross-head being dated to the late ninth or early tenth centuries and being seen as early in the disc-head cross series,[46] though a slightly later date is also possible.

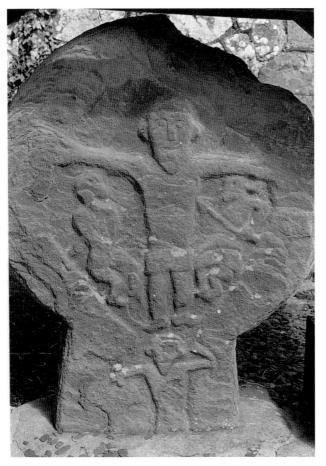

Fig. 4.3 Crucifixion, Llan-gan, Glamorgan (Photo: Nancy Edwards)

The empty cross with the Virgin Mary and St John the Evangelist

Three representations from south and south-east Wales demonstrate elements of Crucifixion iconography which, like Llanveynoe, suggest the influence of Anglo-Saxon models. Intriguingly, however, these images do *not* include the figure of Christ on the Cross. The first is on an incomplete disc-headed slab cross (Fig. 4.4), one of an important collection of early medieval sculpture from the vicinity of the Cistercian abbey of Margam, west Glamorgan, indicating that this was the site of a major early medieval church.[47] One broad face is dominated by a Latin ring-cross with square terminals and a central boss carved in relief and decorated with plait-work and simple interlace.

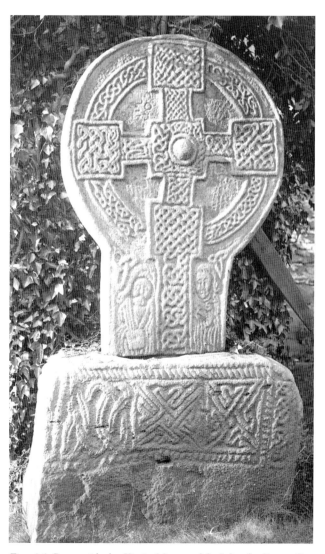

Fig. 4.4 Cross with the Virgin Mary and St John the Evangelist, Margam, Glamorgan (Photo: Amgueddfa Cymru – National Museum Wales)

Its form and ornament suggest a metalwork model and it may once have been painted in colours which would have underlined this. On either side of the shaft is a figure, each of which turns slightly towards the Cross. These may be clearly identified as St John the Evangelist on the left and the Virgin Mary on the right. St John is shown robed and bearded with indications of hair and perhaps a sprawling halo above. He either holds a book or, more likely, since no hand is shown grasping it, a book satchel hangs from his shoulders,[48] thereby identifying him as the Evangelist. The Virgin Mary also has long robes, the folds of which she may catch in her hand, and a veil or halo. The two triquetra knots acting as ornamental fillers, may also have been intended as symbols of the Trinity.[49] Uniquely, the dedicatory Latin inscription is incised vertically down the upper and lower left-hand quadrants of the cross-head and reads 'Conbelin set up this cross for the soul of Ric…',[50] though the end of the inscription is not now legible.

There is a second probable example depicted on the pillar found on the site of a chapel at Nash Manor, Llanblethian, in the Vale of Glamorgan (Fig. 4.5).[51] Like Margam, the face is carved in relief with a Latin ringed cross featuring a sunken central roundel with a boss and was once decorated with interlace thereby recalling a metalwork model. Two small figures stand on the plinth on either side of the cross. Nash-Williams suggested that they represented 'the Blessed Virgin and St John'.[52] Recently, however, this has been rejected and it has been argued that they are ecclesiastics or saints.[53] Nevertheless Nash-Williams' original identification seems more likely. The two figures are shown in profile facing the cross and reaching out to touch it, thereby suggesting their role as witnesses at the Crucifixion. The slim upright robed figure on the left may hold a book in his right hand, thereby indicating he is St John the Evangelist, whilst the smaller bowed figure in more voluminous robes on the right suggests a representation of the Virgin Mary expressing her grief. Although it has been pointed out that the Virgin does not usually touch the cross, a comparison can be made with the grieving Mary touching the cross on the memorial tablet from Newent, though the positions of the two figures are reversed.[54]

The third representation is on a smallish, incomplete, poorly executed cross-slab in Llanhamlach Church, Breconshire (Fig. 4.6). Again, the identification of the two *orans* figures, one on either side of the cross, has caused some debate. Most recently the female figure on the right has tentatively been identified as St Eiliwedd, a local saint.[55] However, there is no tradition of the depiction of local saints on early medieval sculpture in Wales. On the other hand Nash-Williams suggested that these figures also represent St John the Evangelist and the Virgin Mary and this certainly makes more sense of what is shown.[56] The robed figure on the right has prominent breasts with radiating lines beneath

which serve to signify flowing milk, thereby identifying her as the Virgin Mary and drawing attention to her role as the Mother of Christ. It may also allude to Luke 11:27: 'Blessed is the womb that bore thee, and the paps that gave thee suck'.[57] In support of this, an important comparison may be drawn with the image of the Virgin and Child in the Book of Kells, in which the forms of her breasts and

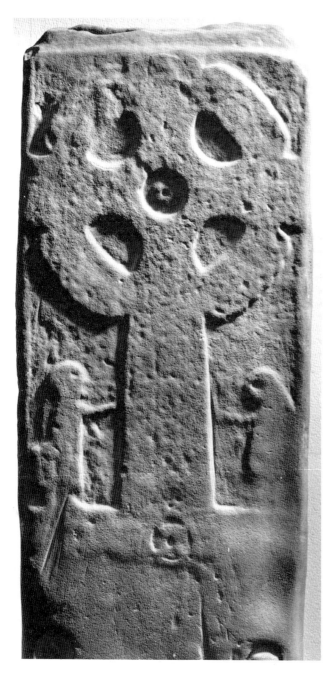

Fig. 4.5 Upper part of cross-slab showing the Virgin Mary and St John the Evangelist, Llanblethian, Glamorgan (Photo: Amgueddfa Cymru – National Museum Wales)

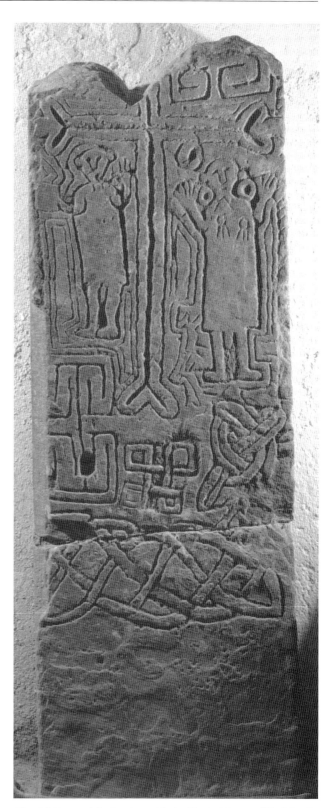

Fig. 4.6 Cross-slab showing with the Virgin Mary and St John the Evangelist, Llanhamlach, Breconshire (Photo: Crown copyright: Comisiwn Brenhinol Henebion Cymru/Royal Commission on the Ancient and Historical Monuments of Wales)

nipples are clearly delineated beneath her imperial purple over-garment.[58] Heather Pulliam has also suggested that the groupings of three white dots on the Virgin's robe may represent her breast milk, as well as her purity. She was unable to find a parallel for the depiction of the Virgin's breasts in this image,[59] but Llanhamlach provides one. The three 'doughnut-like' features, one on either side of the Virgin's head and one above might represent celestial bodies or possibly, as has been suggested for similar shapes on the Anglo-Saxon memorial slab from Newent, skeuomorphs of metal rivets.[60] The figure on the left clearly holds a book in his right hand and, like the Margam cross, this aids his identification as St John the Evangelist. One of the two inscriptions on the adjacent face also reads *(I)ohannis* which may be interpreted as dedicatory, meaning '[The cross] of John', which likewise supports the identification; the other reads 'Moridic raised this stone' and presumably refers to the patron.[61]

Like the representation of Christ crucified with Stephaton and Longinus at Llan-gan, the images on these three monuments, showing the Virgin Mary and St John the Evangelist as witnesses standing on either side of the cross, are derived from the account in St John's Gospel.[62] Superficially, their presence suggests the influence of late Anglo-Saxon Crucifixion models but in practice it is more complex. In southern Anglo-Saxon England Crucifixion scenes are characteristic from the second half of the tenth century and now mainly survive in manuscripts and on ivories,[63] though sculptured representations, including roods,[64] are also known. They usually show the suffering Christ, bearded and dressed in a loin-cloth, accompanied by the Virgin Mary on the left and St John the Evangelist on the right, sometimes with a pair of angels flying above the cross-arms and some other features, such as the hand of God (*dextera Dei*) above Christ's head.[65] An increasing interest in the cult of the Virgin in Anglo-Saxon England can also be traced from this time as part of the Benedictine Monastic Reform movement.[66] In Crucifixion images in late Anglo-Saxon manuscripts and ivories the Virgin and St John are more commonly shown without emotion, standing as witnesses on either side of the cross, as, for example, in the Sherborne Pontifical,[67] and the Ahrenberg Gospels,[68] both of which date to the end of the tenth century. They may gesture towards the cross,[69] or the Virgin is sometimes shown in an *orans* pose, which has its origins in early Christian representations, and St John may be depicted likewise.[70] He frequently holds a book emphasising his role as both witness and Evangelist.[71] Barbara Raw has suggested that the inclusion of the praying figure of Mary underlines her faith and her role as an intercessor, as well as indicating the divine nature of Christ.[72] Sometimes, however, the Virgin, but less often St John, are shown grieving, as in BL Harley 2984, which has been dated to the last quarter of the tenth century,[73] and the early eleventh-century Sacramentary of

Robert of Jumièges.[74] On sculpture the grieving Virgin is also found on the Newent memorial tablet, which has been dated to the first half of the eleventh century.[75]

Nevertheless there are significant differences between these southern Anglo-Saxon images and those on the monuments at Margam, Llanblethian and Llanhamlach. In the late Anglo-Saxon representations the Virgin is always shown on the left, St John the Evangelist on the right, but on the Welsh images this is reversed. There may, however, have been an older type which was available in both the northern half of Anglo-Saxon England and in Wales. On a cross from Sandbach, Cheshire, which has been dated to *c.* 800, a more complex image with the Crucified Christ, the sun and moon, and the evangelist symbols also depicts the Virgin on the right and St John on the left. It has been argued that this representation was assembled from a number of different models which were ultimately derived from early Christian prototypes which may have been transmitted via Carolingian intermediaries.[76] In addition, Kirby Wharfe 1, West Yorkshire, dating to the tenth century, provides the only certain example of a slender but empty cross clasped by two figures, St John on the left and the Virgin on the right.[77]

Two features on the Welsh images, however, appear to be unique: the delineation of the Virgin's breasts on Llanhamlach (thereby drawing particular attention to the relationship between mother and son), and the likely inclusion of St John with a book satchel on Margam. No angels or other accompanying features are included and, above all, there is no figure of Christ on the cross. Instead we see the cross as a symbol signifying Christ's victory over death, and in two cases this is elaborately decorated so as to emulate metalwork, thereby ultimately recalling the *crux gemmata*, the cross that will appear in the heavens at the end of time depicted in a fifth-century mosaic at Santa Pudenziana in Rome, which also references the gemmed cross set up in the chapel erected over the site of Golgotha by Emperor Theodosius in 417.[78]

Barbara Raw has demonstrated that the purpose of the late Anglo-Saxon Crucifixion images, both public and private, was devotional. Through meditation on the Cross supplicants sought protection, both in life, and particularly at death, and continuing prayer by others thereafter would secure the welfare of the soul in purgatory.[79] The representations at Margam, Llanblethian and Llanhamlach should be regarded likewise and the presence of inscriptions on Margam and Llanhamlach also indicates a wish for the continuing remembrance of those named. Indeed the form of the latter is comparable with slightly smaller panels depicting the Crucifixion at Romsey, Hampshire, and St Dunstan's, Stepney, in London[80] which, it has been suggested, may have acted as foci for private prayer.[81]

Therefore, although the images at Margam, Llanblethian and Llanhamlach suggest some access to models available in late Anglo-Saxon southern England depicting the

Crucifixion with figures of the Virgin Mary and St John the Evangelist, and had a similar devotional purpose, they also have parallels with representations on a small number of monuments in northern England which might have their origins in the pre-Viking period. Nevertheless they also display features which clearly demonstrate the ability to construct images, probably ultimately derived from a number of models, to reflect their own religious outlook.

In this context it should also be noted that there has been some disagreement concerning dating. Redknap and Lewis have recently dated the Margam cross to the late ninth or early tenth century,[82] though Nash-Williams preferred the late tenth or eleventh.[83] On the other hand, Nash-Williams dated Llanblethian to the ninth century, while Redknap and Lewis suggested the tenth or eleventh. There has, however, been agreement on a tenth- or eleventh-century date for Llanhamlach,[84] where the ornament includes a ring-knot. If the figures of the Virgin Mary and St John do indeed reflect cultural influences from late Anglo-Saxon England, a date between the mid-tenth and earlier eleventh century would seem most likely for all three.

Conclusion

This discussion has indicated that there are remarkably few surviving representations of the Crucifixion on early medieval sculpture in Wales spanning a period from the late eighth or early ninth centuries to the late eleventh or early twelfth. Unaccompanied figures of Christ Crucified predominate and the varying regional iconography largely reflects a variety of cultural links with Ireland in the west and England in the east. More complex images are confined to the single representation of Christ Crucified with Stephaton and Longinus on the cross at Llan-gan, suggestive of connections with Ireland, while representations of the Virgin Mary and St John the Evangelist are indicative of the influence of models also present in Anglo-Saxon England, though there the inclusion of an empty cross is very rare. The almost abstract representation at Llanddewibrefi, however, appears unique. Portable models, particularly in the form of metalwork crosses and crucifixes, are most likely to have provided inspiration but there is also evidence for the construction of images to respond to the preferences of patrons and religious ideology.

In my recent examination of iconography on early medieval Welsh sculpture more generally I noted that figural imagery of any kind is comparatively rare and argued that this could not be entirely explained by subsequent losses, nor as a consequence of the limited economic resources available.[85] Rather, it seems to reflect a deliberate choice, in which religious and ideological considerations were important and the fact that most examples of figural iconography on Welsh sculpture more generally seem to date art-historically to the tenth or eleventh centuries might support this contention. In this regard Thomas Charles-Edwards has recently re-emphasised the growing rift between British Christians, who traced their origins back to the Roman past, and the Anglo-Saxon Church with its increasing adherence to Rome,[86] as well as its enthusiastic adoption of figural iconography. This is seen above all in Wales in the very late acceptance of the Roman Easter in 768.[87] Wendy Davies has also underlined the conservatism of the Welsh early medieval Church.[88] More specifically, there is some evidence of a continuing interest in Pelagius in Wales up to the eighth century,[89] and Michael Herren and Shirley Ann Brown have argued that continuing adherence to aspects of Pelagianism in Celtic Britain and Ireland led to 'strictures against luxury combined with [a] literal interpretation of the scriptural injunctions against imagery'[90] – in other words an adherence to the second commandment concerning the prohibition of graven images.[91] This suggests that there may have been a deliberate rejection of figural iconography by elements in the Welsh Church rather than simply a lack of familiarity with models that were becoming available in other parts of the Insular world. From the late eighth century Wales was gradually drawn back into a wider Insular world as the result of Anglo-Saxon and Viking incursions. Nevertheless it is possible that a deeply entrenched traditional reluctance towards depicting the human image died hard. It is against this background that we need to see the unique representation at Llanddewibrefi, and the unusual images at Margam, Llanblethian and Llanhamlach which show the Virgin Mary and St John on either side of the cross but *without* the figure of Christ. It is possible that the Virgin Mary and St John were human so they might be depicted but Christ, as a divine being, the son of God, could not.[92] The cross-form, often decorated with abstract ornament recalling the *crux gemmata*, should be seen as a symbol of Christ and his victory over death which also acted as a focus for prayer and devotion.

Acknowledgements

I am grateful to the editors for suggestions which have greatly improved this article.

Notes

1 For my recent extended analysis of iconography on early medieval sculpture in Wales and why texts and abstract patterns may have been preferred, see Edwards 2015.
2 Edwards 2007, P49.
3 See Bailey 1996, 7–8 for Anglo-Saxon examples.
4 Schiller 1972, ii, figs 329–32.
5 Nash-Williams 1950, pl. lxix(2).
6 Edwards 2007, P116.
7 O'Reilly 2013, 58.
8 Veelenturf 1997, 69, 121–50.
9 For a recent discussion, see Ó Carragáin 2013.
10 Youngs 1989, 140–1; Murray 2013, 194.

11 Edwards 2007, 366, 470.
12 Ibid., CD11.
13 Redknap 2009, 354–5, fig. 19.3.
14 Edwards 2013, AN11.
15 Harbison 1992, i, no. 179; ii, figs 504–5.
16 Wade-Evans 1944, 240–1; Charles-Edwards 2013, 607.
17 Edwards 2013, CN12.
18 Ibid., 111–13.
19 Harbison 1992, i, 384; ii, fig. 261.
20 Michael 129 (101), Wilson 2008, 67, fig. 37.
21 Bryant 2012, 288–9, ills 512–13; Redknap & Lewis 2007, H5.
22 Ibid., 535.
23 Bryant 2012, 240, ills 413–14.
24 Ibid., ill. 402.
25 Edwards 2013, MT6.
26 Ó Floinn 1987, 169.
27 Edwards 2007, P97.
28 Edwards 2013, 445–6.
29 Stephenson 2015, 5–8.
30 Redknap & Lewis 2007, 115–17, G43.
31 Harbison, 1992, iii, fig. 894; the loincloth has the appearance of baggy shorts (Harbison 2011, 134).
32 O'Reilly 2013, 66.
33 Harbison 1992, ii, figs 243, 246.
34 E.g. North and South Crosses, Castledermot, Co. Kildare (ibid., ii, figs 101, 107).
35 Redknap & Lewis 2007, 338–9.
36 Eclectic use of Carolingian models derived from ivories and manuscripts has most recently been discussed in Harbison 2011; the influence of late Roman and late antique models, some of which were possibly mediated through Carolingian art, is also highly likely (see Stalley 1990; 2014, 7).
37 Murray 2013. The probably eighth-century St John's Rinnagan plaque, see n. 10, demonstrates that the practice in Ireland of making metalwork representations of the Crucifixion has a longer history. See also the fragmentary Insular representation of a bearded Crucified Christ from Hofstad, Norway (Wamers 1985, no. 44, pl. 19.1).
38 Murray 2013, 298, no. 7, ill. 15.11.
39 Durham: Cathedral Library, MS A. II. 17, fol. 38^3v (Alexander 1978, no. 10, pl. 202; Coatsworth 1980, 58–62, pl. II; O'Reilly 2013, 57–64, pl. 1); see Fig. 1.1 above.
40 Bailey 1986; Bailey in Bailey & Cramp 1988, 140–2, ills 524–31.
41 For various suggestions, none very convincing, see Redknap & Lewis 2007, 339.
42 Neuman de Vegvar 1995; a drinking-horn terminal was found on the late ninth- or early tenth-century royal crannog at Llangors, Breconshire (Redknap 2004, 178).
43 Stalley 2014, 20–2.
44 Raw 1990, 64.
45 Redknap & Lewis 2007, B16.
46 Ibid., 115–16, 339.
47 Ibid., G79, 576–7.
48 Ibid., 419–20.
49 Henry 1965, 154; cf St Vigeans 11, Angus: Henderson & Henderson 2004, fig. 220.
50 Conbelin posuit hanc crucem pro anima Ric; for transcription and discussion, see Redknap & Lewis 2007, 417.
51 Ibid., G34, 579.
52 Nash-Williams 1950, no. 250, 157.
53 Redknap & Lewis 2007, 318.
54 Bryant 2012, 238, ill. 402.
55 Redknap & Lewis 2007, B32, 213, who follow Ettlinger 1961, 290–4.
56 Nash-Williams 1950, 77.
57 Beatus venter, qui te portavit, et ubera, quae suxisti.
58 Dublin: Trinity College, MS 58, fol. 7v (Meehan 2012, 46–7).
59 Pulliam 2011, 66–9, 72–5.
60 Bryant 2012, 238, ill. 402.
61 Moridic sur(r)exit hanc lapidem (Redknap & Lewis 2007, 212–13).
62 John 19.
63 Raw 1990.
64 E.g. Breamore and Headbourne Worthy, Hants, but these are now fragmentary (Tweddle et al. 1995, 251–3, 259–60, pls 425–8, 448–50).
65 Raw 1990.
66 Clayton 1990, 158–78.
67 Ibid., 173–4; Paris: Bibliothèque Nationale, MS lat. 943, fol. 4v (Temple 1976, no. 35, pl. 134).
68 New York: Pierpont Morgan Library, MS 869, fol. 9v (Temple 1976, no. 56, pl. 171).
69 See, for example, on late Anglo-Saxon ivories, Cambridge: Fitzwilliam Museum, no. M24–1938 and London: British Museum, MLA 1980, 12–1,1 (Beckwith 1972, no. 38, pl. 72; Backhouse et al. 1984, no. 126).
70 Raw 1990, 100–2; e.g. the Ahrenberg Gospels and the Sherborne Pontifical (Temple 1976, pls 134, 171).
71 E.g. the Ahrenberg Gospels, ibid., pl. 171.
72 Raw 1990, 100–5.
73 London: British Library, MS Harley 2904, fol. 3v (Temple 1976, no. 41, pl. 142).
74 Rouen: Bibliothèque Municipale, MS Y.6 (274), fol. 71v (ibid., no. 72; Raw 1990, pl. xv).
75 Bryant 2012, 236–9, ill. 402.
76 Sandbach, Market Cross 1: Bailey 2010, 108, ill. 265; Hawkes 2002, 38–44.
77 Coatsworth 2008, 186, ill. 440. Further possible examples are Halton St Wilfrid 1, Lancashire, and Burton in Kendal 1, Cumbria: Bailey 2010, 180, ill. 465; Bailey in Bailey & Cramp 1988, 82, ill. 180.
78 Maddern 2013, 214, pl. 3.
79 Raw 1990, 60–3.
80 Tweddle et al. 1995, 229–30, 261–3, pls 354, 453, 455.
81 Raw 1990, 58.
82 Redknap & Lewis 2007, 115, 420. The only disc-headed cross dated other than by art-historical means is Llantwit Major 1, which is mid- to late ninth century (ibid., 373).
83 Nash-Williams 1950, 152.
84 Ibid., 77; Redknap & Lewis 2007, 213.
85 Edwards 2015, 17–18.
86 Charles-Edwards 2013, 396–410.
87 Dumville 2002, *s.a.* 768.
88 Davies 1992, 18, 21.
89 Dumville 1985; Charles-Edwards 2013, 618; pers. comm. Alison Bonner.
90 Herren & Brown 2002, 18.
91 Exodus 20:4.
92 Herren & Brown 2002, 186.

References

Alexander, J.J.G., 1978 *Insular Manuscripts, 6th to 9th Century* (London)

Backhouse, J., Turner, D.H. & Webster, L. 1984 *The Golden Age of Anglo-Saxon Art* (London)

Bailey, R.N., 1986 'A Crucifixion Plaque from Cumbria' in J. Higgitt (ed.), *Early Medieval Sculpture in Britain and Ireland* (Oxford), pp 5–21

Bailey, R.N., 1996 *England's Earliest Sculptors* (Toronto)

Bailey, R.N. 2010 *Lancashire and Cheshire*, CASSS 9 (Oxford)

Bailey, R.N. & Cramp, R., 1988 *Cumberland, Westmorland and Lancashire North-of-the Sands*, CASSS 2 (Oxford)

Beckwith, J., 1972 *Ivory Carvings in Early Medieval England* (London)

Bryant, R., 2012 *The Western Midlands*, CASSS 10 (Oxford)

Charles-Edwards, T.M., 2013 *Wales and the Britons 350–1064* (Oxford)

Clayton, M., 1990 *The Cult of the Virgin Mary in Anglo-Saxon England* (Cambridge)

Coatsworth, E., 1980 'The Decoration of the Durham Gospels' in C.D. Verey, T.J. Brown & E. Coatsworth (ed.), *The Durham Gospels* (Copenhagen), pp 53–63

Davies, W., 1992 'The Myth of the Celtic Church' in N. Edwards & A. Lane (ed.), *The Early Church in Wales and the West* (Oxford), pp 12–21

Dumville, D.N., 1985 'Late-Seventh- or Eighth-Century Evidence for the British Transmission of Pelagius', *Cambridge Medieval Celtic Studies* 10, 39–52

Dumville, D.N. (ed. and trans.), 2002 *Annales Cambriae A.D. 682–954: Texts A–C in Parallel* (Cambridge)

Edwards, N., 2007 *A Corpus of Early Medieval Inscribed Stones and Stone Sculpture in Wales, 2: South-West Wales* (Cardiff)

Edwards, N., 2013 *A Corpus of Early Medieval Inscribed Stones and Stone Sculpture in Wales, 3: North Wales* (Cardiff)

Edwards, N., 2015 *The Early Medieval Sculpture of Wales: Text, Pattern and Image*, Kathleen Hughes Memorial Lectures 13 (Cambridge)

Ettlinger, E., 1961 'Contributions Towards an Interpretation of Several Stone Images in the British Isles', *Ogam* 13, 286–304

Harbison, P., 1992 *The High Crosses of Ireland*, 3 vols (Bonn)

Harbison, P., 2011 'An Irish Stroke of European Genius: Irish High Crosses and the Emperor Charles the Bald' in Hourihane 2011, pp 133–48

Hawkes, J., 2002 *The Sandbach Crosses. Sign and Significance in Anglo-Saxon Sculpture* (Dublin)

Henderson, G. & Henderson, I., 2004 *The Art of the Picts* (London)

Henry, F., 1965 *Irish Art in the Early Christian Period (to 800 A.D.)* (London)

Herren, M. & Brown, S.A., 2002 *Christ in Celtic Christianity* (Woodbridge)

Hourihane, C. (ed.), 2011 *Insular and Anglo-Saxon Art and Thought in the Early Medieval Period* (Princeton, NJ)

Maddern, C., 2013 *Raising the Dead: Early Medieval Name Stones in Northumbria* (Turnhout)

Meehan, B., 2012 *The Book of Kells* (London)

Mullins, J., Ní Ghrádaigh, J. & Hawtree, R. (ed.), 2013 *Envisioning Christ on the Cross: Ireland and the Early Medieval West* (Cork)

Murray, G., 2013 'Irish Crucifixion Plaques: a Reassessment' in Mullins et al. 2013, pp 286–317

Nash-Williams, V.E., 1950 *The Early Christian Monuments of Wales* (Cardiff)

Neuman de Vegvar, C., 1995 'Drinking Horns in Ireland and Wales' in C. Bourke (ed.), *From the Isles of the North, Early Medieval Art in Britain and Ireland* (Belfast), pp 81–7

Ó Carragáin, É., 2013 'Recapitulating History: Contexts for the Mysterious Moment of Resurrection on Irish High Crosses' in J. Hawkes (ed.), *Making Histories, Proceedings of the Sixth International Conference on Insular Art* (Donington), pp 246–61

Ó Floinn, R., 1987 'Irish Romanesque Crucifix Figures' in E. Rynne (ed.), *Figures from the Past, Studies on Figurative Art in Christian Ireland in honour of Helen M. Roe* (Dun Laoghaire), pp 168–88

O'Reilly, J., 2013 'Seeing the Crucified Christ: Image and Meaning in Early Irish Manuscript Art' in Mullins et al. 2013, pp 52–82

Pulliam, H., 2011 'Looking at Byzantium: Light, Color, and Cloth in the Book of Kells' Virgin and Child Page' in Hourihane 2011, pp 59–78

Raw, B.C., 1990 *Anglo-Saxon Crucifixion Iconography and the Art of the Monastic Revival* (Cambridge)

Redknap, M., 2004 'Llangors Crannog', *Archaeology in Wales* 44, 177–8

Redknap, M., 2009 'Early Medieval Metalwork and Christianity: a Welsh Perspective', in N. Edwards (ed.), *The Archaeology of the Early Medieval Celtic Churches* (Leeds), pp 351–73

Redknap, M. & Lewis, J.M., 2007 *A Corpus of Early Medieval Inscribed Stones and Stone Sculpture in Wales, 1: Breconshire, Glamorgan, Monmouthshire, Radnorshire, and geographically contiguous areas of Herefordshire and Shropshire* (Cardiff)

Schiller, G., 1972 *Iconography of Christian Art, 2: The Passion of Christ*, trans. J. Seligman (London)

Stalley, R., 1990 'European Art and the Irish High Crosses', *Proc. Royal Irish Academy* 90C, 135–58

Stalley, R., 2014 'Irish Sculpture of the Early Tenth Century and the Work of the "Muiredach Master": Problems of Identification and Meaning', *Proc. Royal Irish Academy* 114C, 1–39

Stephenson, D. 2015 'The Meifod Cross-slab: Origin and Context', *Montgomeryshire Collections* 103, 1–8

Temple, E., 1976 *Anglo-Saxon Manuscripts 900–1066* (London)

Tweddle, D., Biddle, M. & Kjølbye-Biddle, B., 1995 *South-East England*, CASSS 4 (Oxford)

Veelenturf, K., 1997 *Dia Brátha, Eschatological Theophanies and Irish High Crosses* (Amsterdam)

Wade-Evans, A.W. (ed. and trans.), 1944 *Vitae Sanctorum Britanniae et Genealogiae* (Cardiff)

Wamers, E., 1985 *Insularer Metallschmuck in wikingerzeitlichen Gräbern Nordeuropas* (Neumünster)

Wilson, D.M., 2008 *The Vikings in the Isle of Man* (Aarhus)

Youngs, S. (ed.), 1989 *'The Work of Angels': Masterpieces of Celtic Metalwork, 6th–9th Centuries AD* (London)

Pictish relief sculpture: some problems of interpretation

George Henderson

The attentive student of eighth-century Pictish art has ample opportunity to recognise visual proofs of contact with wide-flung contemporary or near contemporary European culture, contacts not recorded in any other form. Perhaps the best known of these is the commemorative inscription in raised lettering carved on the narrow side of a demolished cross-slab, found in around 1880 built into the wall of the Manse garden at Tarbat, Ross-shire.[1] John Higgitt in 1982 pointed out that these bands of raised letters looked very like dedicatory inscriptions put up on Roman churches in the early eighth century during the pontificate of John VII.[2] Those Roman inscriptions, though, belong to an older tradition. Similar relief lettering is a dramatic feature of friezes carved on the great sixth-century palace church of St Polyeuktos, excavated from the 1960s in Istanbul.[3]

The Tarbat fragment bearing the inscription is one of a large number of broken carvings, widely dispersed in and around the site of the present parish church. Another portion of the same demolished cross-slab was recovered from the fabric of the crypt of the church during excavations carried out by archaeologists from the University of York in the 1990s. This shows three frontal figures identifiable as apostles, one of them a shaggy-headed St Andrew, standing in a row flanking an almost completely lost seated figure of Christ.[4] They are markedly flat in their handling, suggesting that their model was a panel painting. Quantities of other sculptured fragments, in pristine condition as to surface finish and detail, came to light in the course of excavations beyond the churchyard, under a layer of burnt debris. The deliberate breaking of sacred representations, evidently soon after their creation, is a curious phenomenon which has been attributed either to alien invasions, by the pagan Vikings, or to some unrecorded 'early religious reform'. In an exploratory paper published in 2011 Kellie Meyer hinted that the destruction of the material culture of the

community at Tarbat could have been regarded by locally-based 'Celtic'-inclined clergy as divine judgement on their too-Romanising brethren.[5]

A parallel for the destruction at Tarbat of a recently executed work of art is provided by the relief sculpture of an angel at Lichfield, broken into three pieces and buried, perhaps under a layer of burnt debris, but remarkably preserving surface detail, including colour.[6] On the analogy of the apparition of the archangel Michael, as psychopomp, to St Wilfrid, recorded in his *Life* by Stephen of Ripon, I have suggested that the lost right half of the panel at Lichfield, deliberately cut off from the image of the archangel, represented St Chad receiving his summons to heaven, recorded by Bede.[7] The Lichfield Angel is generally supposed to be part of the shrine of St Chad, and to date *c.* 800. Its destruction has been very tentatively ascribed to the Vikings 'wintering' at Repton in 873–4. It is interesting that the Lichfield Angel, in its unique display of scooped, clinging, banded drapery, anticipates the grand style of the twelfth-century Bury Bible,[8] and so might reflect a much earlier lost phase of that particular Byzantine idiosyncrasy, the 'damp fold' style. The same wave and impetus of Eastern influence as reached Mercia, brought to neighbouring Pictland the relief lettering of the Tarbat inscription and the icon-like row of apostles. The artistic campaigns of which these objects are prime chance survivors were drastically terminated, within a very few years.

The destruction of images of saints and angels was exactly what Pope Gregory II and his successors argued against in their missives to the iconoclast Byzantine Emperors Leo III and Constantine V.[9] Rumours of the Iconoclastic Controversy and its implications for the role of the visual arts in the service of religion certainly reached the West, at different levels of authority. The clear-cut response of Bede as to what it was right and fitting to have

represented was guided by the principles of typology, with its core argument that Christ himself likened the raising up of the brazen serpent in the desert (Numbers 21:9; John 3:14) to his own exaltation on the Cross for the healing of souls.[10] In respect of images of the apostles, and their preaching mission, Bede confirms the Greek concept that painting is 'living writing'.[11] The full devotional force of such an interpretation is seen in Æthelwulf's *De Abbatibus* where the scribe Ultan is said to have achieved his high art of manuscript illumination because the Creator Spirit (no less) had taken control of his fingers and fired his dedicated mind to 'travel to the stars'.[12] The bones of Ultan's hands, after his death, were treasured relics, guarded by heavenly birds, and a source of miraculous healing.[13] This text encapsulates the spirit of Insular sacred art, widely recognised as multi-layered visual exegesis. While the Carolingian position may have been different, no imagined barriers between 'carnal' and 'spiritual' exist in, for example, the Crucifixion page in the Durham Gospels (see Fig. 1.6), which I have called 'the most metaphysically charged of all surviving Insular works of art'.[14]

Bede's and Æthelwulf's positive approach to the focussing effect of images could very well have been shared by patrons and artists in Pictland. A Pictish cleric attended a Church Council convened in Rome by Pope Gregory II in 721.[15] There is no evidence that the Pictish nation was more culturally isolated in, say, 780, than in 721. Alas, Pictish illuminated Gospel books have not survived, but Pictish theological adventures are amply displayed in the large-scale sculptured cross-slabs. These seem open to iconoclastic disapproval by the extent to which they fuse the stone medium with spiritual values. They are conceptual in form and content, for example the cross-slab, Meigle 2 (see Fig. 6.5), where we see, carved, the extraordinary image of the redemption of the soul from Hell, the practical rescue, like that of a Chilean miner, taking place up the narrow shaft under the left segment of the ring of the cross, where Christ's side was pierced.[16] This is just where the disc of the Host is segmented, wounded, in the unique and precocious representation of the ritual of the Mass, in the Paul and Antony scene in the pediment of the front of the Nigg cross-slab.[17] On the back of Meigle 2 (Fig. 5.1) the monumental frontal figure flanked by four lions represents Daniel cast into the lions' den, a traditional type of Christ's Passion and Resurrection. Another familiar type, Jonah and the whale, appears on a number of Pictish sculptures, but wholly original typology is also displayed, for example on the broken Tarbat cross-slab, where the contrasted layers of animal imagery and human figures can be understood to refer to Jewish ritual observances on the one hand and the New Covenant witnessed by the apostles on the other.[18] The same contrast, vain ritual slaughter of bulls and goats alongside the symbol of Christ's once-for-all sacrifice in the bringing of the bread from heaven to Paul and Antony,

on the cross-slab, St Vigeans 7, shows visual art pressing home deep spiritual truths, unconfined in its scope as an exegetical agent.[19]

As well as Paul and Antony, other monastic saints are represented in Pictish sculpture, a subject condemned by iconoclast opinion, and also the banned subject, representations of angels, regularly four-winged cherubim, sometimes oddly randomly placed, on the roam as it were, which bring to mind the great images called down from the wall of the Temple to go as messengers for Christ in the Anglo-Saxon poem *Andreas*.[20] Other Pictish cherubim attend the cross, as they do in the Durham Gospels (see Fig. 1.1). On the Aberlemno roadside cross-slab they turn in towards the cross and bow in veneration to it (Fig. 5.2). They hold out books in their hands, as they do on a sixth-century Syrian glass vessel in Dumbarton oaks representing the jewelled cross of Calvary, itself recalling the eschatological *crux gemmata*.[21] The jewelled cross, raised on a stepped platform, is a standard early Christian image, but it had a special vogue in Pictland in the eighth century, seen markedly in the northern province, with spectacular variants

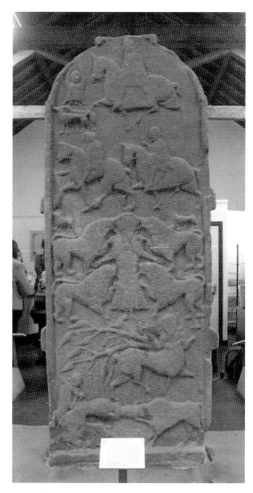

Fig. 5.1 Meigle 2, Perthshire, cross-slab: reverse (Photo: Tasha Gefreh)

at Shandwick, Edderton, Rosemarkie and Hilton of Cadboll. At all these places, the special sanctity of the image of the speaking, healing, fabric of the True Cross, as envisaged in the contemporary Anglo-Saxon poem, *The Dream of the Rood*, is publically purveyed as a link with orthodox Christianity in the East as well as in the West.

Another such link is the emergence in Pictland of the royal name, Constantine, in 789. The bearer of it, Constantin son of Uurguist, was presumably born, and christened, *c.* 750.[22] The adoption of this name, with its imperial and historic Christian resonances, coincides with a manifest influx of exotic models, the impact of which is seen notably in modifications introduced to the image of the Pictish rider, a standard feature of the sculptured scenes of the hunt displayed on the backs of cross-slabs. On the Elgin cross-slab, unique in Pictish art in its affirmation of the theme of Gospel harmony (on its front the cross is shown accompanied as in book painting by the evangelists together with their symbols), the rider on the back, despite the blurring effect of the special crystalline stone selected by the sculptor, has a grand grave profile, like an emperor's head on a coin, and is equipped above his shoulder by a large bird, not a falcon, in size more that of an eagle, giving another Roman imperial flavour to the whole.[23] The mounted huntsman with his left hand gripping a falcon and with his sword raised to smite a rampant lion on the St Andrews Sarcophagus (Fig. 5.3) reflects a model similar to the engraved silver dish, now in the British Museum, conventionally attributed to Sasanian Iran and dating between the fifth and the eighth centuries.[24] It is a curious coincidence, if nothing more, that the rather later, blundering, recollections of the chroniclers place the reception in Scotland of other exotic imports, namely the corporeal relics of the Apostle Andrew, patron saint of Constantinople, just at the time when the cult of the saints, their shrines and images, were under official disfavour in the capital of the Eastern Empire, and at the time when the art of the Picts, under impressive external stimulus, was reaching its height both conceptually and technically.[25] Such material contacts argue travel, observation, acquisition and general awareness of the European scene. It would seem not quite out of the question that a backwash from Iconoclasm was making itself felt in Scotland, and that a creative attitude to Christian orthodoxy and the imperial ideal, symbolised by the royal name Constantine, was not merely nostalgic but indicative of interest in, and loyalty to, values currently being debated.

A peculiar feature of Pictish relief figural sculpture is the juxtaposition, which we see conspicuously on the St Andrews Sarcophagus, of iconic sacred imagery with the overtly secular imagery of huntsmen and hunting. On the back of the Nigg cross-slab the heroic figure of David, with his identifiers, harp, ram, lion, is set half way down the figural panel, with huntsmen and hunted deer and running

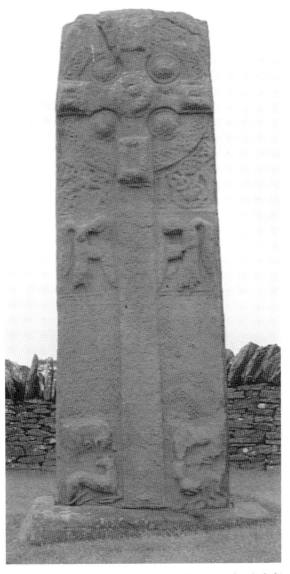

Fig. 5.2 Aberlemno roadside cross-slab (Photo: Tasha Gefreh)

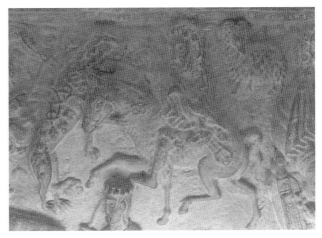

Fig. 5.3 St Andrews Sarcophagus, detail: Rider (Photo: Jane Hawkes)

hounds above and below him. The figure at the bottom left of the panel lifting up one disk and lowering another has been associated either with David, as one of David's fellow musicians, a cymbal player, or as a beater, rousing the quarry in the hunt.[26] An alternative interpretation that weighs in heavily on the side of the sacred content of the panel as a whole sees the figure of the 'cymbal player' as an outstanding example of Pictish literal illustration of scripture, comparable to that of Meigle 27 which perfectly caught the tone and content of St James's Catholic Epistle 2:2–3.[27] The 'cymbal player' at Nigg can be connected with the figure of David holding up the disk that bears his name on folio 172v of the Durham Cassiodorus,[28] and can further be seen as illustrating Psalm 101, the text of which immediately follows the David portrait, at verse 11, which reads 'for having lifted me up thou hast thrown me down'.[29] This interpretation is supported by the indisputable fact that the design of the frame of the figural scene on the back of the Nigg cross-slab closely matches the form and motifs used in the frames of the two David portraits in the Durham Cassiodorus, folios 81v and 172v.[30] The illuminator and the sculptor were clearly in touch with one another.

Another Pictish monumental sacred figure, the Daniel on the back of Meigle 2 (Fig. 5.1), is, like the Nigg David, placed half-way down the panel, preceded by seemingly secular imagery, a grandiloquent cavalcade, the lower group of horsemen given bold cameo treatment. The uppermost single horseman is presumably the core image on this area of the sculpture, and his path is blocked, or else consecrated, by the presence of a multi-winged seraph or cherub. If the cherub is an obstruction, one thinks of Balaam's encounter with the menacing 'angel of the Lord' in Numbers 22. But the Meigle horseman's magnificent mount is no timorous talking ass. Elsewhere I have suggested that the Meigle cherub alludes to the *initium* of St Mark's Gospel, 'Behold I send my angel before thy face, who shall prepare the way before thee',[31] and have seen this portion of the Gospel as helping to explain the complex meaning of the Daniel figure, as a type of Christ suffering Temptation in the desert.[32] In his contribution to a recent National Museums Scotland publication, Martin Goldberg states 'We can point with some confidence' to this same scriptural text as the source of the Meigle rider with angel precursor.[33] He goes on, however, to widen the meaning of the image, recognising it as a formal Adventus, as in Roman images of the triumphant Emperor preceded by the winged figure of Victory. That the sculptor could have drawn on such an antique model is indeed feasible, since one such model, namely the 'Two Emperors' coinage, clearly lies behind the figural compositions of the cross-slabs at Lethendy, Aldbar, and St Vigeans 11.[34] Goldberg recognises an Adventus again in the looser composition of Meigle 1, and argues that the Adventus theme offers the key to the meaning of a coherent central group of Pictish cross-slabs. They take on the dignity

of liturgical objects, having the role as gateways to the Christian faith, both by where they are physically stationed and by having in their imagery a complex reference to the celebration of the feast of Easter.[35]

Goldberg goes beyond the generally accepted interpretation of the hunt, in a Christian context, as an allegory of conversion, the putting down of vices by virtues. He interprets the harrying of the hinds and stags in Pictish sculpture as a symbol of baptism, taking his cue from Psalm 41:1, chanted as the baptismal ceremony on Holy Saturday begins, with the bringing in of the Paschal Candle: 'As the hart panteth after the fountains of water; so my soul panteth after thee, O God'.[36] The hart here is a devout convert, about to be born again by Baptism. The stags peacefully lapping the waters, for example at the bottom of the apse mosaic of San Clemente in Rome,[37] look very different from the Pictish scenes of fleeing and harried deer, at what Goldberg maintains is 'the moment of the hunt which Psalm 42 [*sic*] … describes perfectly with reference to Baptism'.[38] Pictish hunting scenes do not support the idea that the harried deer now has occasion to refresh itself. Rather its death knell is on it, if it is not actually dead. The deer at the bottom left on the back of the Aberlemno roadside cross-slab has collapsed, its legs folded under it. The running deer at the bottom left of the back of the Hilton of Cadboll cross-slab has a spear lodged fatally in its flank (Fig. 5.4). On the front

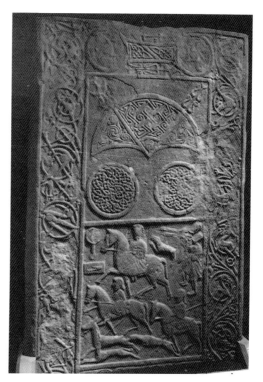

Fig. 5.4 Hilton of Cadboll cross-slab, upper portion of the reverse (Photo: © RCAHMS SC1460617 (E71856) Tom and Sybil Gray Collection. Additional permission sought from NMS. Licensor: www.rcahms.gov.uk)

of the cross-slab, Kirriemuir 2, the horseman has run down the stag with his horse, and is about to cast his spear to kill it. On the back, the recumbent stag is dead, with its tongue lolling out and already preyed upon by a carrion bird.[39]

Still with his sights firmly on the Easter significance and function of the cross-slabs, Goldberg argues that the principal rider in the Hilton of Cadboll hunting scene should be recognised as Christ riding into Jerusalem (Matt. 21:9), in specific illustration of the scriptural reading on Palm Sunday (Figs 5.4–5).[40] His reasoning here is the frontal position of the figure, sitting athwart the horse, the feature which has hitherto consistently signalled the figure to be that of a woman. Though in Western iconography of Christ's Entry into Jerusalem, as we see it, for example, at the very foundation of Insular Gospel imagery on folio 125 of St Augustine's Gospels, Christ is seated across the back of the ass, the Eastern tradition is different, and shows Christ seated frontally, with both his legs hanging down, for example on folio 1v of the Rossano Gospels.[41] The adoption of exotic eastern Christian models is a marked feature of eighth-century Pictish sculpture, as already noted. But interesting as Goldberg's suggestion is, namely that the Hilton of Cadboll rider illustrates a specific sacred person and incident, not merely allegorical or simply secular, the rider's lack of identifying attributes other than the frontal pose is worrying. In all the Greek scenes of the Entry into Jerusalem Christ clearly raises his hand in blessing. He rides on a long-eared ass. Other details from the scriptural narrative are the norm, the city gate, the citizens in front welcoming the rider, the apostles accompanying behind, the garments flung under the feet of the ass, branches being

Fig. 5.5 Hilton of Cadboll cross-slab, spiral panel on the reverse (Drawing: © RCAHMS SC1461817. Drawing by Ian G. Scott. Licensor: www.rcahms.gov.uk)

cut from the overhanging trees. At Hilton of Cadboll there is starkly nothing but the frontality of the rider to shift the meaning of the scene from that of the standard Pictish hunt, and it is hard to understand, therefore, why the sculptor should make so little of the subject matter of Palm Sunday if he was moved to intensify the devotional content of his image. Fatal, however, to the identification of the Hilton rider as Christ is the second accompanying horseman, in cameo relation to the principal rider. Christ always is, and must be, the single mounted figure in scenes of the Entry into Jerusalem.

It seems reasonable to revert to the conventional interpretation of the principal rider on the Hilton of Cadbol cross-slab as a woman (Fig. 5.4). In the past, she has been variously identified, for example as the portrait of a local aristocratic woman, accompanied by her groom, the identification stolidly favoured by the National Museum which houses her, until the advent of Goldberg's proposal in the Museum's own publication. Then again, she has been recognised as some echo of the ancient Celtic goddess Epona. She has also been identified as the Virgin Mary, a Pictish version of the Maria Regina image favoured by the eighth-century iconophile Popes. Here also, the accompanying horseman frustrates the interpretation. Neither St Joseph nor his young son St James (the Less) could take on such a role. In *The Art of the Picts* we wondered whether the Hilton sculptor could be responding to the hunting scene in Virgil's *Aeneid*, Book IV, where the Punic Queen Dido wears a buckle of gold clasping her purple mantle, and is accompanied by Aeneas.[42] In a closely argued analysis of the Hilton of Cadboll cross-slab, Isabel Henderson has surveyed and assessed the various options, and she judges that the Hilton of Cadboll female rider is probably best seen as a timeless personification of female nobility, virtue, and wisdom. She states also: 'Unfortunately there is little scope for speculative specific attribution to a historical powerful woman.' Very fairly, however, she illustrates the representation of such a powerful woman, made in Mercia in the last decade of the eighth century, the coin portrait of King Offa's wife, Cynethryth.[43]

I am tempted to add to conjecture regarding a specific identification of the Hilton rider, if only to balance possibilities against Goldberg's proposal that the rider is Christ, which in its novelty seems to have earned some popular approval. I have suggested above that, in the second half of the eighth century, the Pictish rider image takes on an imperial connotation. An outstanding personality in the political and religious history of the period is the Byzantine Empress Irene, by whose official initiative East and West were reconciled by the enactments of the Second Council of Nicaea in 787, which reaffirmed the traditional value of images in the devotional life of Christians.[44] As Pope Hadrian 1 noted in his letter to the empress and her son, the return to Nicaea was effective as evoking the memory

of the First Council of Nicaea and so associating her son, Constantine VI, with Constantine the Great, and Irene herself with Helena, and thereby with the cult of the True Cross.[45] The frontal female rider at Hilton of Cadboll, with her shadowy male companion, could be seen as reflecting the disposition of power between these co-rulers of Byzantium, as known or rumoured in the West in the last decades of the eighth century.[46]

A curious pointer towards recognising contemporary references in the figures depicted on the Hilton of Cadboll cross-slab is one of the fragments from the back of the cross-slab excavated at Hilton in 2001. It is catalogued as No X.IB 355.7 and described as a truncated human figure adjacent to the haunch of an animal.[47] This little figure is special in itself. It is rare, if not unique, among the productions of Insular art in the sumptuous dress, the shirt flounced at the waist, and the elaborately embroidered lower part of the tunic.[48] Judged by his narrative context and by his dress, he is a specific person, and he is in Hell, surged round by monstrous dragons.[49] So is he Dives, the rich man clothed in purple and fine linen, damned for his selfish luxury in the parable of Dives and Lazarus (Luke 16)? He might well be. We have seen the sculptor of Meigle 27 take a discerning view of the discrepant merits of 'fine apparel' (*veste candida*) versus 'mean attire' (*sordido habitu*).[50] However, another interpretation seems possible. The animal's haunch, attached to the man and in natural proportion to him, is that of a lion. The neat small scale of the lion clearly differentiates it from the huge monsters which represent the denizens of Hell. In the reconstruction of the Hilton of Cadboll cross-slab, recently erected on or near the site of the original, the man and the lion are fancifully re-located within the stem of the cross, and there contrived to represent David wrestling with the lion. Their true relationship however has, I suggest, the feeling of a rebus. The rebus is a device 'ten a penny' in secular personal seals in the late Middle Ages, for example Thomas de Muscamp's fine seal in the Durham Cathedral archives which shows a field of flies, *campus muscarum*.[51] In our own period we can reasonably turn to the Book of Kells. I have interpreted the large fly with open wings in the initial F on folio 63 to allude to the reference in Matthew 12:24, to the name 'Beelzebub the prince of the devils'.[52] (In the Kells list of Hebrew names Beelzebub is glossed as *vir muscarum* (leader (or Lord) of flies).[53] So the image illustrates the word. The *rebus non verbis* at Hilton of Cadboll would then be the lion, Leo, to gloss the princely figure who is in Hell. It was to Hell that the anathemas of Pope Gregory III assigned the notorious iconoclast, the Emperor Leo III.[54] The iconoclast is dropped into Hell, below, at the bottom right of the grand symbolic Calvary Cross on its great step base, the eternal source of redemption to the orthodox Christian.

On the back of the cross-slab, then, the reigning Empress Irene, recent restorer of orthodoxy, might be seen celebrated in the characteristically Pictish manner – reinventing its own imagery with a difference, in the form of the female rider, glamorised appropriately by her festive cohort of trumpeters. A nice touch, to complete the picture, is the discovery by Ian G. Scott, through painstaking scrutiny and alignment of carved fragments from the back of the cross-slab, that at the very centre of the grand square sun-burst of spirals below the hunting scene, the sculptor had placed a miniature equal-armed ringed cross of typically Pictish design, readily evoking Constantine the Great's conversion vision of a cross of light in the heavens, above the sun.[55] The Hilton of Cadboll cross-slab, like so much Pictish sculpture the victim of many vicissitudes, and to worse vandalism than many, once stood up proudly on the coast of the Tarbat Peninsula as a triumphant unifying Christian symbol, a strong iconophile gesture by the late eighth-century Pictish Church.

Whatever the specific sense of the principal rider, the recovery in 2001 of the lower portion of the Hilton of Cadboll cross-slab has substantially enriched our inheritance of Pictish and Insular art. The preservation in pristine condition of the carving on both faces, front and back, is revelatory, comparable to the fine surface detail so admired in the Lichfield Angel and on an incomparably grander scale. That the upper portion, with its scalped and desecrated front face, continues to be separated from the richly informative lower portion is deeply regrettable, leading to neglect and indifference in both provincial Hilton/Balintore and metropolitan Edinburgh. The relation of the two portions, and what the multifarious detached fragments further suggest, should be borne in mind continually, and their content and layout scrupulously observed and respected by new scholars attracted into the challenging field of Insular art and iconography.[56]

Notes

1 Allen & Anderson 1993, 2(iii), 94.
2 Higgitt 1982.
3 Harrison 1989, pls 31, 34, 86–9.
4 Henderson 2005; 2007.
5 Meyer 2011, 181, n. 16.
6 Rodwell et al. 2008.
7 Stephen, *Vita Wilfridi* 56 (Colgrave 1927, 122–3); Bede, *HE* IV, 3 (Colgrave & Mynors 1969, 340–5). A version of my letter proposing this interpretation of the Lichfield Angel, mistitled and misleadingly pruned, appeared in *Current Archaeology*, Issue 209, 18(5) (May–June 2007), 53. Richard Bailey pointed out (pers. comm.) that the Lichfield angel's arm pose and gesture are not those that normally appear in the scene of the Annunciation.
8 Cambridge, Corpus Christi College, MS 2.
9 For the standard view of the attitude to images of Gregory II and Gregory III, see e.g., Farmer 1997, 219–20; for radical reappraisal, see Brubaker & Haldon 2011. These writers are at pains to demote the controversy and the emotions which it

might have aroused. For the practical effects of eighth-century iconoclasm in Byzantium, see the mutilated relief sculptures of Christ and the apostles from St Polyeuktos, in Harrison 1989, pls 135–42.

10 Bede, *De Templo* II (Hurst 1969, 212–13; trans. Connolly 1995, 90–2); the same argument occurs in the letter of Pope Hadrian I to Irene and Constantine VI, for which see Noble 2009, 151–2.

11 Bede, *De Templo* II: Nam et pictura Graece ζωγραφία, id est uiua scriptura, uocatur (Hurst 1969, 213; trans. Connolly 1995, 91).

12 Æthelwulf, *De Abbatibus* VIII, lines 214–15: cum digitos sanctus iam spiritus auctor / rexit, et accendit sacratam ad sidera mentem (Campbell 1967, 18–19).

13 Æthelwulf, *De Abbatibus* VIII, lines 235–262 (Campbell 1967, 20–3).

14 Henderson 1999, 144. Noble sees a fundamental gap between carnal and spiritual as the standard Carolingian attitude to the role of the visual arts, epitomised by the theologian Theodulf of Orleans' 'principled indifference to art' (Noble 2009, 220–4). Noble himself contrasts the disciplined decoration in Carolingian Gospel books with supposed distractions from the text offered by 'some of the more disconcerting achievements of insular art' (ibid., 228).

15 Fraser 2009, 336 and n. 46.

16 Henderson & Henderson 2004, 138, pl. 199.

17 Henderson 2013, 225.

18 Henderson & Henderson 2004, 142, pl. 206.

19 Ibid., 140–2, pls 204, 205.

20 Henderson 2011, 273; see also discussion in Brubaker & Haldon 2011, 776.

21 Henderson & Henderson 2004, 151, pls 218–19.

22 For Constantin, see Broun 1998, 77–83; for other instances of the name in Insular contexts, see Macquarrie 2012, 346–7; also Macquarrie 1994, 31–2.

23 Henderson & Henderson 2004, 129, pl. 188, and 148–50, pl. 216; see also Henderson 1998, 158.

24 Henderson 1998, 135, fig. 40, and 157–9.

25 For Scottish interest in the cult of St Andrew and its disputed date see Fraser 2009, 362 and Woolf 2007, 65–7.

26 Henderson & Henderson 2004, 131, pl. 192.

27 Ibid., 156–7, pl. 230.

28 Durham: Cathedral Library, MS B. II. 30.

29 quia elevans allisisti me; Henderson 2005, 16–17.

30 Alexander 1978, cat. 17, pls 74, 75; for the Durham Cassiodorus images of David as type of Christ, see Bailey 1978.

31 Ecce ego mitto angelum meum ante faciem tuam, qui praeparabit viam tuam ante te (Mark 1:2).

32 Henderson & Henderson 2004, 133–4, pl. 194.

33 Goldberg 2012, 157.

34 Kent & Painter 1977, 172, nos 504, 506, 529; Gannon 2003, 84–7; compare Henderson & Henderson 2004, pls 193, 209, 210.

35 Goldberg 2012, 154–8.

36 Quemadmodum desiderat cervus ad fontes aquarum: ita desiderat anima mea ad te, Deus.

37 Krautheimer 1980, pl. 118.

38 Goldberg 2012, 154.

39 Henderson & Henderson 2004, pls 186, 187, 183. For analysis of the Hilton of Cadboll hunting scene, see Henderson 2008a, 178–89.

40 Goldberg 2012, 157–8. For Goldberg's specific example, the wooden lintel of the Al-Muallaqa church in Cairo, see Peers 2007, 25–46.

41 For St Augustine's Gospels (Cambridge: Corpus Christi College, MS 286), see Wormald 1954; for the Rossano Gospels (Rossano: Diocesan Museum, MS Purpureus Rossanensis) and other examples of Eastern and Western versions of the scene, see Deshman 1995, pls 71–7, 79.

42 Henderson & Henderson 2004, 136.

43 Henderson 2008a, 183–9 and 187 (ill. 5.50); for Cynethryth, see Gannon 2003, 40–1.

44 For a critical assessment of the Empress Irene's role and reputation, see Brubaker & Haldon 2011, 260–86.

45 Noble 2009, 150.

46 The Empress Irene's level of control varied as consort, regent, joint ruler, joint ruler with precedence, and sole ruler. The arrangement of the riders on the Hilton of Caboll cross-slab could depict all of these except the first and last and could generally reflect an impression of her status formed from the years 780–800.

47 Henderson 2008b, 84–5, and 108 (ill. 4.15, bottom left illustration).

48 For possible parallels see Bourke 1986, 116–21 and pl. 16a–f; the closest analogy is 16e, the phallic warrior on fol. 200 of the Book of Kells (Dublin: Trinity College Library, MS 58) who, unlike the others' tatoo effect, is actually clothed, in tunic and hose, the latter decorated with spirals. The clothing of the Hilton of Cadboll figure, however, is more realistic, loose fitting and voluminous.

49 Henderson 2008b, 78, 83 (ill. 4.4a), 84–5.

50 James 2:2; see above, n. 27.

51 Durham: University Library, Special Collections Catalogue, reference code: GB.0033-DCD, 'Medieval Seals in the Durham Cathedral Muniments'; Thomas de Muscamp, no. 1851; see Hunter Blair 1910, pl. viii, no. 5.

52 Beelzebub principe daemoniorum.

53 Henderson 2001, 159.

54 Even Leo IV would fit, if we were to invoke later impressions of him also as an evil iconoclast.

55 Henderson 2008b, 79, 83 (ill. 4.4b), 175 (ill. 5.38), 201.

56 In admiration and friendship, I offer to Richard Bailey this brief summary of thoughts on the potential meanings of some Pictish sculptured monuments. He himself is notable for his enquiring first-hand approach to a very wide range of historical and art-historical problems and for his readiness to communicate and share his observations and insights with other people.

References

Alexander, J.J.G., 1978 *Insular Manuscripts 6th to the 9th Century* (London)

Allen, J.R. & Anderson, J., 1993 *The Early Christian Monuments of Scotland*, 2 vols, paperback repr. (Balgavies)

Bailey, R.N., 1978 *The Durham Cassiodorus*, Jarrow Lecture (Jarrow)

Bourke, C., 1986 'A Panel on the North Cross at Clonmacnoise', *J. Royal Soc. of Antiquaries of Ireland* 116, 116–21

Broun, D., 1998 'Pictish Kings 761–839: Integration with Dal Riata or Separate Development?' in Foster 1998, pp 71–83

Brubaker, L. & Haldon, J., 2011 *Byzantium in the Iconoclast Era ca 680 – ca 850, a History* (Cambridge)

Campbell, A. (ed.), 1967 *Æthelwulf De Abbatibus* (Oxford)

Colgrave, B. (ed. and trans.), 1927 *The Life of Bishop Wilfrid by Eddius Stephanus* (Cambridge; paperback repr. 1985)

Connolly, S. (trans.) 1995 *Bede: On the Temple* (Liverpool)

Deshman, R.,1995 *The Benedictional of Æthelwold* (Princeton, NJ)

Farmer, D., 1997 *Oxford History of the Saints*, 4 edn (Oxford)

Foster, S.M. (ed.), *The St Andrews Sarcophagus: a Pictish Masterpiece and its International Connections* (Dublin)

Fraser, J.E., 2009 *From Caledonia to Pictland. Scotland to 795* (Edinburgh)

Gannon, A., 2003 *The Iconography of Early Anglo-Saxon Coinage: Sixth to Eighth Centuries* (Oxford)

Goldberg, M., 2012 'Ideas and Ideologies' in D. Clarke, A. Blackwell & M. Goldberg, *Early Medieval Scotland: Individuals, Communities and Ideas* (Edinburgh), pp 141–203

Harrison, M., 1989 *A Temple for Byzantium* (London)

Henderson, G., 1999 *Vision and Image in Early Christian England* (Cambridge)

Henderson, G., 2001 'The Barberini Gospels (Rome, Vatican, Biblioteca Apostolica Barberini Lat. 570) as a Paradigm of Insular Art' in M. Redknap, N. Edwards, S. Youngs, A. Lane & J. Knight (ed.), *Pattern and Purpose in Insular Art, Proceedings of the Fourth International Conference on Insular Art Held at the National Museum & Gallery, Cardiff 3–6 September 1998* (Oxford & Oakville, CT), pp 157–68

Henderson, G., 2005 'Insular Art: Influence and Inference' in A. Bovey (ed.), *Under the Influence: The Concept of Influence in the Study of Illuminated Manuscripts* (Turnhout), pp 11–20

Henderson, G., 2007 'The Representation of the Apostles in Insular Art, with special Reference to the new Apostles Frieze at Tarbat, Ross-shire' in A. Minnis & J. Roberts (ed.), *Text, Image, Interpretation: Studies in Anglo-Saxon Literature and its Insular Context in Honour of Éamonn Ó Carragáin* (Turnhout), pp 473–94

Henderson, G., 2011 'Cherubim and Seraphim in Insular Literature and Art' in E. Mullins & D. Scully (ed.), *Listen, O Isles unto Me: Studies in Medieval Word and Image in Honour of Jennifer O'Reilly* (Cork), pp 263–77

Henderson, G., 2013 'Raven into Dove: Assimilation and Conflation in the Making of a Sacred Image' in J. Hawkes (ed.), *Making Histories, Proceedings of the Sixth International Conference on Insular Art* (Donington), pp 215–28

Henderson, G. & Henderson, I., 2004 *The Art of the Picts: Sculpture and Metalwork in Early Medieval Scotland* (London; paperback repr. 2011)

Henderson, I., 1998 '*Primus inter Pares*: the St Andrews Sarcophagus and Pictish Sculpture' in Foster 1998, pp 97–167

Henderson, I., 2008a 'The Art-historical Context of the Hilton of Cadboll Cross-slab' in James et al. 2008, pp 127–204

Henderson, I., 2008b 'The Cataloguing of the Hilton of Cadboll Cross-slab' in James et al. 2008, pp 75–126

Higgitt, J., 1982 'The Pictish Latin Inscription at Tarbat in Ross-shire', *PSAS* 112, 300–21

Hunter Blair, C., 1910, 'The Armorials of Northumberland: an Index and an Ordinary', *Archaeologia Aeliana* 3 ser. 6, 89–189

Hurst, D., 1969, 'De Templo' in *Bedae Venerabilis opera, Pars II, Opera Exegetica, 2A*, CCSL 119A (Turnhout), pp 141–234

James, H.F., Henderson, I., Foster, S. & Jones, S., 2008 *A Fragmented Masterpiece: Recovering the Biography of the Hilton of Cadboll Pictish Cross-slab* (Edinburgh)

Kent, J.P.C. & Painter, K.S. (ed.), 1977 *Wealth of the Roman World AD 300–700* (London)

Krautheimer, R., 1980 *Rome: Profile of a City, 312–1308* (Princeton, NJ)

Macquarrie, A., 1994 'The Historical Context of the Govan Stones' in A. Ritchie (ed.), *Govan and its Early Medieval Sculpture* (Stroud), pp 27–32

Macquarrie, A. (ed.), 2012 *Legends of Scottish Saints: Readings, Hymns and Prayers for the Commemoration of Scottish Saints in the Aberdeen Breviary* (Dublin)

Meyer, K., 2011 'Saints, Scrolls and Serpents: Theorising a Pictish Liturgy on the Tarbat Peninsula' in S.T. Driscoll, J. Geddes & M.A. Hall (ed.), *Pictish Progress: New Studies on Northern Britain in the Early Middle Ages* (Leiden & Boston, MA), pp 169–200

Noble, T.F.X., 2009 *Images, Iconoclasm, and the Carolingians* (Philadelphia, PA)

Peers, G., 2007 'Vision and Community among Christians and Muslims', *Arte Medievale* 6, 25–46

Rodwell, W., Hawkes, J., Cramp, R. & Howe, E., 2008 'The Lichfield Angel: a Spectacular Anglo-Saxon Painted Sculpture', *Antiquaries J.* 88, 48–108

Woolf, A., 2007 *From Pictland to Alba 789–1070* (Edinburgh)

Wormald, F., 1954 *The Miniatures in the Gospels of St Augustine* (Cambridge)

Reviewing the relationship between Pictish and Mercian art fifty years on

Isabel Henderson

Introduction

The twenty-first century has been a time of great change in perceptions of Mercian art; the discovery of the Staffordshire hoard, with its evidence, albeit enigmatic, for a hitherto unsuspected corpus of early deluxe metalwork, and the spectacular addition to its later Christian figure sculpture of the Lichfield Angel, alighting on the scene with an almost theatrical presence. The same period has brought a significant increase of the range of Pictish sculpture. Numerous additions to the high quality sculpture already recorded in the nineteenth century from Portmahomack, Tarbat, have been recovered belonging to diverse formats appropriate to its newly perceived monastic context. The discovery in its entirety of the missing lower portion of the well-known Hilton of Cadboll slab, together with thousands of fragments from its vandalised cross-bearing face, comprises the most significant single addition to Pictish sculpture since the nineteenth century.

The claim made in *The Picts*, published in 1967, that Pictish sculpture was part of mainstream Insular art is no longer controversial and, in spite of some discredited analogies, the view expressed there that the form, subject matter and art of the St Andrews Sarcophagus, and by extension other major Pictish sculptures, should be withdrawn from any 'ill-defined Northumbrian context' and associated fully with 'artistic developments centred on Mercia in the last quarter of the eighth century' is still referred to for general purposes in the literature. The 'artistic developments' focussed on the degree of experimentation in funerary monuments apparent in both regions, and on sculpture where both the decorative and figural styles of Mercia seemed closer to those of the Picts than did the heavier, more plastic styles of Northumbrian work.

The argument was conceived as a reaction to the paper of Cecil Curle (née Mowbray) on Eastern influence on the St Andrews Sarcophagus and Nigg, where many of her analogies seemed too remote in place and time to be relevant.[1] I welcome this opportunity to review the evidence for the relationship, which I believe has been strengthened since 1967.

Recent changes proposed in the political geography of the Picts, now widely accepted, have also transformed our perceptions of the geography and internal dynamic of the Pictish kingdoms. The northern kingdom, centred in Moray and probably extending northward into Ross-shire, is now generally accepted as having been the region named in early sources as Fortriu and not, as had been previously thought, Strathearn to the south of the Mounth.[2] There the density of sculpture-bearing sites may reflect the political domination of the southern Picts by the northern kingdom, a development paralleled by the density of Mercian ecclesiastical patronage in dependent territories rather than in the Mercian heartland.[3] That Pictland north of the Mounth played a central part in shaping the development of the Pictish Church and state from the seventh century is now unequivocal.[4]

I am aware that many of the publications referred to will be familiar to the honorand of this volume and to many of its readers, so I will address selected themes covering sculpture and metalwork only. The expected Corpus volume covering the monuments of eastern Mercia will inevitably provide a new perspective and a number of forthcoming publications on Pictish art will further refine the relationship.[5]

Shrines and funerary monuments

In 1967 the St Andrews Sarcophagus was claimed as 'the most ambitious of the various, historically connected, attempts to reconstruct the sarcophagus shape, such as the early Mercian coped tombstone at Wirksworth, Derbyshire'.[6]

The choice on the long panel of a frontal standing David, with adjacent narrative scenes on a smaller scale is certainly compatible with emulation of the classical forms of a sarcophagus. A similar resemblance to early Christian sarcophagus layout is evident on Wirksworth.[7] Charles Thomas placed the form of the Sarcophagus firmly in an Insular context as 'perhaps the culminating example, of a class of Insular stone monuments whose content has been gradually enlarged by fresh discoveries, but whose origin must remain uncertain.'[8]

The interdisciplinary studies devoted to the Lichfield Angel published in 2008 conclude that the fragments belonged to a panel of a gabled box-shaped shrine, so adding to the already diverse types of surviving Mercian funerary monuments.[9] An earlier claim that the complete shrine would have closely resembled the St Andrews Sarcophagus is rejected.[10] In a subsequent publication it has been allowed that the idea of a stone shrine that lay behind the Sarcophagus 'may have been adopted from Mercian examples, such as that at Lichfield'.[11] The Lichfield reconstruction proposed in 2008 is composite, described as a 'shrine box', something which may have contained a coffin. The disputes as to the outward form and internal arrangements of the St Andrews Sarcophagus are charted in Sally Foster's chapter in the 1998 monograph on the Sarcophagus.[12] Further research is under way that claims to support the view that the surviving elements of the Sarcophagus in fact formed part of a chancel screen.[13]

This ambiguity between screen or shrine panel has been confronted in the British Academy Corpus publication of six related fragments from South Kyme, Lincolnshire.[14] Because these include sections of panels with key and spiral pattern, something rare in southern sculpture, but common in Pictish sculpture, they have frequently appeared in discussions of Pictish sculpture and were part of the 1967 case. The authors of the new publication set out the argument for the fragments belonging to a screen or a shrine. They opt for a shrine because the fine detail of the ornament is unsuited to a screen. More significantly the presentation within panels of a range of decorative motifs can be closely compared to the miniature, finely carved shrine-shaped Gandersheim Casket. The Casket has been the subject of recent intensive research including independent studies by Richard Bailey and by Leslie Webster who came to the same conclusion that it was most likely a product of Peterborough dating to the late eighth or early ninth century.[15] The Casket has become a key artefact in the understanding of the sculpture and fine metalwork of Anglo-Saxon Insular art. In 1967 the Franks Casket was taken to be the only relevant representative of this type of artefact likely to have influenced the St Andrews Sarcophagus.[16]

The Lichfield Angel publication includes a preliminary list of Mercian funerary monuments which shows how significant their number has become, but still without any standard form or scheme of decoration emerging.[17] The only comparable number of roughly contemporary funerary monuments is to be found in Pictland.[18] Thomas surmises that the Pictish monument types could have been introduced from Northumbria, composite stone box structures being one of a range of formats, which would also include chancel screens, made at the time of the instruction of the Picts in building in stone by masons from Wearmouth-Jarrow.[19]

The Picts and the Mercians share two basic types of funerary sculpture: box-shaped composite monuments; and monuments made from a solid block of stone. The distinctive grooved corner-post composite construction is confined to Pictland, with the important exception of Iona, where a number of posts described as shrine posts have survived.[20] The primary function of the box-shaped monument was presumably to contain substantial associative relics or venerable remains. There is a fragment of a panel from a second decorated composite monument at St Andrews, and a solid house-shaped shrine of the same type as the Peterborough 'Hedda Stone'.[21]

A uniquely Pictish type of funerary monument shares features of the basic types, being both composite and solid. It is often referred to simply as a recumbent, but there is little doubt that it functioned as an elaborately carved grave-cover. These impressive monuments, though never house-shaped, should be part of the discussion of the range of Insular funerary monument types.[22] They comprise body-length substantial solid blocks of stone carved in high relief with images and decoration wholly compatible with the repertoire of Pictish symbol-bearing cross-slabs. They are composite to the extent that typically there is a slot at one end to hold a second element which may have been a miniature cross-slab. These slots have never been the subject of a separate study or tested by replication. Conjecturally, the slots on special days could have contained minor associative relics, perhaps sealed with a metal embellishment on analogy with other such attachments to sculpture.[23] The type site is Meigle in Perthshire, where the finest examples are found, which together give a strong impression of belonging to a royal mausoleum (Figs 6.1–2).

More understanding of these hybrid Pictish funerary monuments can be expected in imminently forthcoming publications. Martin Carver's monograph on the Portmahomack excavations will include descriptions of grooved corner-posts, a flat carved sarcophagus lid, a section of a frieze and a screen panel with a rounded upper edge. In his preliminary publication this newly recovered sculpture is attributed to an archaeological context radiocarbon dated to no earlier than 780 and no later than about 820.[24] Jane Geddes' major contribution to the forthcoming interdisciplinary publication of the sculpture at St Vigeans, Angus, promises to offer a coherent context and interpretation of this large collection, which includes

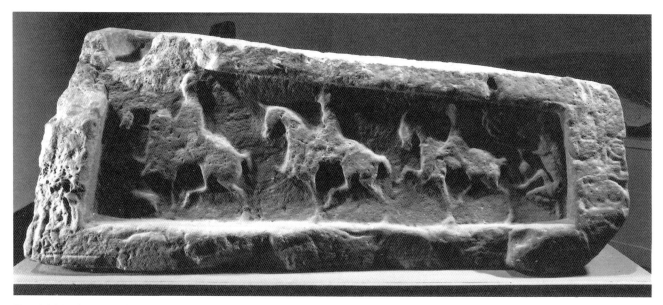

Fig. 6.1 Meigle 11, Perthshire, left side of recumbent grave-marker: three riders move away from a naked demon, towards the slotted end (Photo: Crown copyright RCAHMS. B 1603. Licensor www.rcahms.gov.uk)

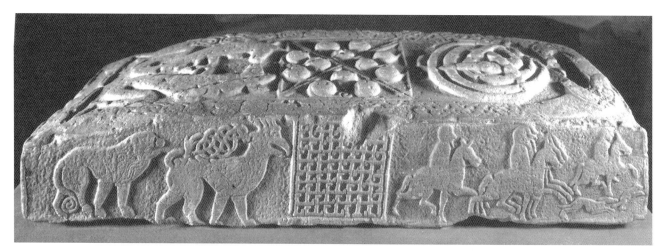

Fig. 6.2 Meigle 26, Perthshire, right side of recumbent grave-marker: five riders move towards the slotted end (Photo: Crown copyright: RCAHMS. B 1559 CN [SC 397544]. Licensor www.rcahms.gov.uk)

a number of recumbent grave-markers, and centres on her identification of one of the monuments as a solid shrine.[25]

Fragments of relief-carved decorated shrine and corner-slab monuments were also found in association with the massive Pictish fortification of Burghead overlooking the Moray Firth, and along the coast on the site of the early medieval foundation at Kinneddar.[26] Both sites have substantial collections of Pictish sculpture. In 1989 the entire collection of Pictish sculpture in Groam House Museum, Rosemarkie, a site on the northern shore of the Moray Firth, was catalogued for the Scottish Cultural Resources Access Network by Susan E. Seright and myself. A number of the panels were found to be grooved on the reverse, and other sculptures showed signs of belonging to architectural or

monumental composite constructions. Rosemarkie is an historically attested early foundation and has an extensive collection of finely carved sculpture, all of which deserves further study.[27] In the churchyard of Kincardine parish church, at the southern edge of Sutherland, within easy reach of Portmahomack, is the most northerly recumbent grave-cover, carved with David iconography and Breedon-style squatting creatures on either side of a plant.[28]

This brief account of the funerary sculpture located at a succession of coastal sites gives a summary impression of the content, some of it new, of the spread of Pictish shrine production proposed by Thomas. He tentatively suggests that initiation in southern Pictland, probably in the early eighth century, was followed by 'an east-coast diffusion

northward to the Moray Firth and then the Northern Isles during that century; a limited but undateable diffusion to Iona; and more such shrines during the ninth century'. He dates his 'culminating example', the St Andrews Sarcophagus, allowing for other factors, to *c.* 800 to 850.[29]

Stephen Plunkett's paper in the 1998 Sarcophagus monograph extended this model for diffusion with a start further south, from Peterborough. His view is based not on form but on exact comparative stylistic analysis, in particular of animal ornament, backed up by practical considerations of 'routes of communication between centres of power' running up the whole length of the east coast.[30] This allows for his cautiously expressed acceptance of a Mercian-Pictish connection, and for the role of Northumbria which, *pace* my arguments in 1967, he thought it would be perverse to deny. The recognition of the close relationship between Pictish sculpture and the Rothbury cross, unmentioned in 1967, in itself justifies this modification.[31]

The patron of the Sarcophagus was clearly not satisfied with the prevailing native funerary monument types. Something physically along the lines of Meigle 11 (Fig. 6.1) might have been thought worthy of consideration, but awareness of the experimentation going on for elite commissions in the south, whether in Mercia or Northumbria, could have motivated his looking for something innovatory. The final form chosen for the Sarcophagus involved a radical increase of the breadth of the native corner-posts so that there could be scope for a display of elaborate ornament in high relief framing and referring to the subject matter of the long side panel.

Recent research in both Pictland and Mercia has resulted in significant additions to the corpora of shrines and funerary monuments in both kingdoms, revealing a greater diversity of types and decoration that was known in 1967. Though artistic connections between these two kingdoms were fundamentally important, it is also clear that this category of material cannot be fully understood without considering the products of other parts of the Insular world, notably Northumbria.

High relief carving

In 1967 the most striking analogy for the drapery and general proportions of the monumental figure of David on the Sarcophagus was said to be the Breedon angel.[32] The date of this sculpture remains controversial but a plausible case can still be made for the late eighth to early ninth century.[33] Then, however, this independent robust figure carved in high relief did not relate readily to the other Mercian full-length figures with their delicate forms and sensitive inclination of posture. Looking for a model for the specific image of David killing the Lion on the St Andrews Sarcophagus the closest parallel remains that in the bowl of the initial of Psalm 52 in the Vespasian Psalter,[34] but this fails to account for the three-

dimensional model which, it was generally accepted, must lie behind the St Andrews figure. After lengthy discussion in the Sarcophagus monograph I concluded that the figure style *per se* was more convincingly paralleled in the Italo-Byzantine ivory carving of the evangelists and St John the Baptist on the front of Maximian's throne in Ravenna, attributed to the sixth century.[35] I was sceptical, however, of the Picts being able to achieve the tight composition of the figure's engagement with the lion and had to hypothesise, in addition, the existence in a Pictish treasury of a model with this theme.

The observation by Ian G. Scott, hitherto unremarked, that the damaged near-side limbs of two creatures on the long panel of the Sarcophagus had originally been carved clear of the stone surface strongly supported an ultimate origin in the techniques of ivory carving. This technical device is used, in both instances, where exotic creatures, a griffin and a monkey-like quadruped, are astride the backs of native depictions of a foal and a deer respectively. The pinioning of the griffin portrays, in a classical animal metaphor, no doubt much appreciated by the Picts, the destructive power of death. The image is prominently positioned on the panel in high relief and would have been given maximum impact by the use of this daring technical treatment (Figs 6.3–4).[36]

Such daring carving, achieved by the skillful use of a drill, has been singled out as a marked feature of the work of the sculptors of the Breedon friezes, testifying to the extent to which foreign models in ivory were being reproduced, perhaps under instruction by trained masons.[37] Other aspects of the relief of the St Andrews Sarcophagus imply knowledge of the spatial conventions used in ivory carving: varying levels of shallow relief are used to express recession in the fall of drapery; where carved surfaces are superimposed on each other the relief is skillfully gradated, notably for the carving of the spray of foliage lying across the back of the lion that leaps up at the rider. The expressive turn into space of the head, and the rounded hindquarters of the centrally-placed horse are also new in an otherwise standard portrayal of a profile stepping Pictish horse (Fig. 6.3).

The Pictish transition from incision to low relief carving has often been explained as being part of the transfer of skills made possible by the example of the eighth-century Northumbrian masons, but Pictish sculptors' later level of skill in high relief is unexpected, and can only be explained as either the product of home grown talent learning with expert eyes from the techniques of the new models, or more probably as the result of subsequent direct contact with sculptors experienced in high relief carving. In Pictish decoration one has to account for feats of deep carving into the stone exemplified in the celebrated fragment of spiral pattern from Portmahomack,[38] virtually tubular key-pattern, and intermingling of interlace, spiral and key-pattern on the surface of a single boss, all of which are found on Easter Ross monuments which give an impression of a relatively

Fig. 6.3 St Andrews Sarcophagus, Fife. Detail of the Lion Hunt from the long panel showing different levels of relief-carving. The near-side legs of the quadruped sitting backwards astride a deer were originally drilled free of the surface of the stone (Photo: Crown copyright Historic Scotland reproduced courtesy of Historic Scotland. www.historicscotlandimages.gov.uk)

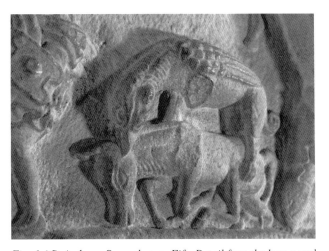

Fig. 6.4 St Andrews Sarcophagus, Fife. Detail from the long panel of a griffin biting the neck of a mule. The damage on the griffin's left fore leg shows that it was originally carved free of the surface of the stone (Photo: Crown copyright Historic Scotland reproduced courtesy of Historic Scotland. www.historicscotlandimages.gov.uk)

sudden rise in technical competence. These skills could originate from Northumbria or Mercia but it is Mercian sculpture which accounts for associated motifs, such as the crouching creatures on the long side and complete end panel of the Sarcophagus, and specifically for the free-standing carving described above.[39]

In southern Pictland sculptors at Meigle were carving figures on a miniature scale, expressing muscular exertion in a style significantly different from the anatomically correct but profile figures carved in incision and low relief found regularly on earlier Pictish sculpture.[40] The naked figure perched on the volute at the top of the shaft of the great Meigle 2 cross-slab is rounded, reaching down to haul up by the wrist an exhausted figure whose head is lowered and back arched, feet braced against the lateral moulding as he is about to tumble into the jaws of a fierce beast (Fig. 6.5). This vignette recalls the three individual portrayals of classically inspired naked figures inhabiting vine-scroll in the Breedon broad frieze. The crouching spearman, his torso twisted round, with one shoulder raised and jaw jutting out the better to drive his spear into his quarry, is the most expressive, but all three are miniature studies of muscular tenseness.[41] These representations of physical force at Breedon and Meigle are unlikely to be directly related, but both represent a closely shared interest in portraying movement. The figure of the cymbal player at Nigg is another example of the depiction of muscular exertion.[42] His head is bent at an angle, held low to accentuate the force of the downward clash of the cymbal. The physically awkward craning of the heads of the apostles to stare at the Ascension of Christ on the Rothbury cross belongs to this same category of the ambition to portray physical action in order to enhance narrative.[43] A small but notable detail in the uniformly expressive style used for the narratives on the Wirksworth slab is the slightly backward leaning stance of the leading stretcher bearer in the funeral procession of the Virgin Mary as he takes the weight of her body.[44]

The discovery of the Lichfield Angel merits reconsideration of a possible connection between the St Andrews David and the Breedon Angel. We now have three figures in similarly arranged classical dress, carved in high relief, who share bodily proportions, fleshy facial types (two with moustaches) and elaborately dressed shoulder-length hairstyles. All three place their weight on the left leg with the foot turned outwards in profile. The shared contrapposto stance is animated in the Mercian figures by the right leg being carved so as to portray movement. This physical freedom is further emphasised in the Breedon figure by the blessing hand being shown outside the arcade. Only the David figure stands firmly within the ground-line with the elegant bend of the right knee echoing the Ravennate pose. Some independent access – or independent responses – to similar models must surely underlie the composition of these substantial figures.

So far no further examples of carving clear of the stone surface have been detected on Pictish sculpture other than on the Sarcophagus, but the wider context of acquiring that skill could be direct instruction from Mercian sculptors in achieving high relief carving which was applied to figural and ornamental themes alike in order to achieve a virtually

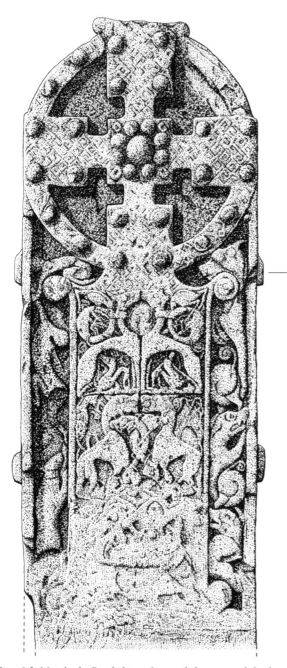

Fig. 6.5 Meigle 2, Perthshire, front of the cross-slab showing redemptive imagery in the background to the left of the cross-shaft; a figure kneeling on the volute of the shaft hauls up an exhausted naked man who is tumbling into the jaws of a beast (Photo: Crown copyright: RCAHMS DC 25233 [SC 394838]. Licensor www. rcahms.gov.uk)

three-dimensional effect with an impact on the viewer vastly different from the neat naturalism of the earlier low-relief Pictish figure style.

Recent discoveries and research have transformed our knowledge of this aspect of Insular carving. A number of Pictish carvings in exceptionally high, even three-dimensional

relief have been identified and analysed. They are most plausibly explained as imitation of imported (and perhaps classical) models, probably ivory carvings. The closest analogues for the production of deep relief carving and for a dependence on exotic models are again to be found in Mercian art, where recent finds reinforce the connections with Pictland.

Insular art and foreign models

It is accepted that much in eighth-century Insular art, both in manuscripts and sculpture, can be accounted for by a common new assimilation of eastern Christian models. A notable example is the combination on the broad frieze at Breedon of Insular vine-scrolls with exotic themes. Richard Jewell acknowledges the problem of how models of the fifth and sixth century were available for use at Breedon.[45] Of course date of acquisition and the subsequent use of such models need not tally and it is necessary to be aware of the possibilities of a looser creative process where the sources for forms, content and styles are drawn on as circumstances require. This calls for a much more subtle unpicking of the intentions behind the commissioning of the work of art. While the identification of these foreign models as closely as possible is fundamental, to attempt to detect the circulation of models within Insular art is perhaps a means of getting closer to them and to reduce their number. We may have such a possibility in the three high-relief figures discussed above.

It has been strongly argued that a fragment of a cross carved with a rider, found at Repton in 1979, portrays Æthelbald, the bellicose long-reigning king of Mercia, who is associated with the royal mausoleum at Repton.[46] The accoutrements of the king are those of an Imperial figure but incorporate Anglo-Saxon weaponry – identification with a glorious past is combined with recognisable signs of contemporary power. Exactly the same convention is deployed on the St Andrews Sarcophagus where the salvatory figure of David of the Old Testament is keyed in to contemporary values of kingship by the form of his Anglo-Saxon or continental hunting knife. Similarly the notion of upgrading the Pictish aristocratic deer hunt to a lion hunt was almost certainly taken from possession of a Sasanian model but with the costuming of the hunter on horseback made to conform to that of David. The familiar Pictish foot-hunter is given matching classical dress. All that remains of the Pictish hunting scene is the depiction of the horse, although here given a narrative quality by the spatial relationships, described above, made possible by the high relief. The possibility of a relationship between the manipulation of rider iconography on the front of the Repton fragment and the eschatological iconography of the fate of the damned on its edge, with similar conventions and themes common in Pictish sculpture, has not been pursued, although an awareness of these northern sculptures could account for its acknowledged uniqueness in the corpus of Mercian sculpture.[47]

It has been argued that the native Pictish hunting scene embodied symbolism of important social responsibilities and to convert this to a lion hunt makes a compellingly heightened statement. Although the Sarcophagus lion has broken free of its cover running animals and exotic beasts continue to inhabit the undergrowth which bears a close resemblance to vine-scroll conventions (Fig. 6.3). Ian G. Scott drew the tree and its inhabiting creatures, some native, but others, like the crouching creatures elsewhere on the Sarcophagus, more at home in Mercia, for illustration in the St Andrews monograph, demonstrating how in essence the iconography of the Sarcophagus panel is achieved by the same creative mix of native, Insular and exotic models as that of the Breedon broad frieze and the Repton rider.[48]

The analysis of the reinterpretation of traditional Insular forms in terms of exotic foreign models has been transformed since 1967 by detailed analyses of the Breedon friezes and the St Andrews Sarcophagus as well as by the discovery of the important carving from Repton, which exemplifies a similar process of the classical re-presentation of an essentially Germanic warrior figure. It is possible that this reflects Pictish influence rather than the other way round.

Animal ornament

I have published in detail the art-historical context of the animal ornament surrounding the stepped base carved on the front face of the newly recovered massive lower portion of the Hilton of Cadboll cross-slab and will not repeat this here.[49] In summary its high relief carving provides a missing link between the fine-style carving of related animal ornament on the Nigg cross-slab and its heavier counterpart on the St Andrews Sarcophagus. The sculpture at Hilton as well as Nigg can now be associated with the repertoire of the Sarcophagus. Unlike Nigg, the Hilton ornament is unstructured and unpanelled, conveying a narrative of a tangle of fierce beasts lying immediately under a probable scene from a Last Judgement. This use of animal ornament to construct a Hell scene is paralleled on the Rothbury cross although there the symmetrical arrangement of panelled ornament is maintained.[50] In terms of the Mercian relationship the significant feature is the detail of the twisted mane expressed in parallel curves on the neck of the animal on the extreme left edge of the Hilton base. A mane of this type is exactly paralleled on an animal on one of the fragments at South Kyme.[51] The convention also occurs frequently in animal designs on the Gandersheim Casket.[52] The segmented head of a scaly creature to the left of the base is also present on the Casket, as is the positioning of a head seen from above on a profile body – a characteristic of the animal ornament in the Rothbury Hell panel.

Manes, though not of the twisted variety, are a feature of quadrupeds on the broad frieze at Breedon and heavily curled manes articulate the shoulders of the symmetrically arranged ornamental lions on the corner slab to the right of the side panel of the Sarcophagus. Many of the traits of the new Hilton animal ornament belong to styles current in Insular art but it is the twisted mane that suggests a direct relationship with Mercian art.

Turning briefly to the many fragments of animal ornament belonging to the front of the Hilton upper portion, sufficient heads have survived to define the style. Although more delicate, smaller in scale and in much lower relief than the animals on either side of the base, they share the rounded skull with pricked ears, the fanged head with a lolling tongue set on an extended neck. This type of animal ornament relates closely to the animal style of the Mercian Beckley pommel.[53] Whether this ornament, essentially decorative, had an internal structure composed of groups of animals within panels, or was free flowing in the fields created by the cross-shape, or indeed on the shaft itself, has still to be determined.

The recent recovery of sculpture missing from the Hilton of Cadboll cross-slab has greatly enhanced our knowledge of Pictish depictions of animals. Though there are undoubted comparisons to be made with Northumbrian carvings, notably the Rothbury cross, again the closest stylistic comparanda are Mercian, reinforcing the connections first identified in 1967.

Vine-scroll

The vine-scroll on the reverse of the Hilton of Cadboll cross-slab has long featured in the literature as being closely comparable to Northumbrian examples, notably that on a section of a shaft at Croft on Tees, North Yorkshire, itself surely a reflex of Mercian influence.[54] As a result of the new discoveries at Hilton in 2001 the complexity of the vine-scroll can now be appreciated. In 2004 we described it as 'the Pictish masterpiece in the vine-scroll tradition' along with an illustration of the reverse of the lower portion,[55] but it was not until 2008 when the whole scroll had been reconstructed and described that its unique organisation was understood.[56] The recovery of the bottom edge revealed that the Hilton slab, like the closely related fragment of a slab at Portmahomack, was edged with a three-sided frame. On the Hilton reverse the gently curving S-scroll on the right edge of the frame is a typical Northumbrian scroll type. A different influence is evident on the left edge of Hilton in the zig-zag, trellis-like arrangement of the stems. This could be derived from the Northumbrian tree-scroll but it appears in identical form on folio 8r of the Book of Kells and takes its place as one of the many quotations from its repertoire, or from that of closely related books, long recognised in the sculpture of Easter Ross. To add to this mix is now the lively composition used

on the bottom edge. On the related Portmahomack fragment the creatures on the bottom edge are conventionally placed facing one another on either side of a simple root-like growing point for the lateral S-scrolls.[57] On Hilton they are addorsed on either side of an elegantly wide sweeping growing point set on a plinth from which independent intertwining shoots emerge. The creatures' heads are in profile, both facing left, although both eat berries from stems originating from the growing point. The treatment of the conventional image of the nourishing vine has been radically modified to allow the central creatures to lead with their outstretched fore legs, chasing, as it were, the creatures moving up the differentiated scrolls with only a backward glance to peck a berry by the creature on the right.[58] This vigorous movement has its only consonance in Insular sculpture on the Breedon broad frieze, where hounds are depicted moving forward with their hind legs outstretched in an ambiguous relationship with a central plant.[59] Another closer parallel with Mercian work is the method used to depict the wings of the Hilton quadrupeds on either side of the growing plant, where the smaller scapular feathers are indicated by well-spaced round bosses - a feature also used on the wing of the griffin on the St Andrews Sarcophagus (Fig. 6.4).[60] Bailey notes that this convention, although a distinctive feature of the winged creatures on the Gandersheim Casket (which, as we have seen, is probably associated with Peterborough), is confined in English sculpture to near-by Castor.[61] The only difference in the Pictish examples is that the bosses are set on a pad of relief rather than arranged within a panel.

The vine-scroll frame on the reverse of Hilton as now seen in its complete form draws on three different scroll organisations, Northumbrian, Kellsian and Mercian, with a style of inhabitants inserted in all of them that relate to Mercian art. The concealed asymmetry of the animal decoration on the Nigg cross-arms escapes the Hilton sculptor but the principle of 'same but different' controls his border. He goes his own way in avoiding the conventional alternation of quadruped and bird within the scrolls, something already blurred by the presence of winged quadrupeds, and, as we have seen, he abandons the conventional lay-out of the tree of life image. In so far as the change of scroll type to right and left is often unnoticed, the sculptor achieved his aim of 'same but different' on the lateral edges, but the unconventional arrangement on the lower edge, so long concealed, was surely made under the inspiration of Mercian work, deliberately chosen to attract attention. It certainly did so at the moment of disinterment.

A diversity of models underlying the development of Pictish vine-scroll ornament has been further confirmed by recent discoveries; though the Pictish scrolls reveal links both to Northumbrian sculpture and to the Book of Kells, again the closest detailed stylistic connections are with Mercian art.

Abstract ornament

The key pattern at South Kyme has a distinctive median line which is paralleled on the Breedon broad frieze. Of the surviving fragments of decorative repertoire from the front of the Hilton slab key-pattern is predominant and those carved in rounded high relief in patterns similar in their open structure to Breedon examples would repay closer comparison.[62] The crosses sunk into a bed of interlace on panels on the St Andrews Sarcophagus and on a related new find at Portmahomack have been regarded as inspirational to the prominent use of the motif in the St Petersburg Gospels on the grounds that such a motif, because its effectiveness depends on physical recession, has a natural origin in sculpture.[63] To my knowledge it does not occur in precisely this form elsewhere in Insular sculpture.

The incomplete fragment of neatly carved triple spirals at South Kyme has now been confidently associated with the Gandersheim Casket.[64] On the Casket the encircled seven spiral panel has lizards emerging from its periphery. A roundel filled with seven spirals sometimes occurs at the crossing of the arms of crosses on the front faces of Pictish sculpture so its importance, though not so iconographically charged as on the Casket, was recognised.[65] The emergence of creatures from a roundel made up of their bodies belongs with the more prevalent so-called snake bosses, also symbolic, found on Pictish sculpture and at Iona, where at least one such boss, on the St John's Cross, has an emerging reptile with a head seen from above and the fore legs of a lizard. It would seem that the Gandersheim spiral motif is at least related to the concept of the Pictish snake-boss and its metalwork analogues, and that the comparatively rare examples of Mercian spiral work are most plausibly ultimately derived from knowledge of this ornament prevalent on Pictish and Ionan sculpture.[66]

The newly discovered key pattern at Hilton of Cadboll again seems to link most closely to Mercian examples; and while the trumpet-spirals of Pictish art were seen as derived from Mercian examples in 1967, it now seems possible that the rare Mercian examples of this motif may be an example of Pictish (or possibly Ionan) influence travelling in the other direction.

The St Ninian's Isle hoard, Shetland

The most lively debate on the relationship between Pictish and Mercian art has been focused on the silver military fitments in the St Ninian's Isle hoard; the sword pommel and two scabbard chapes, the larger of which is inscribed (Fig. 10.8c). David Wilson drew attention to the similarities of their decoration to southern metalwork animal styles, but considered these to be without significance for their place of origin, being evidence merely for the repertoire of Insular metalworkers of the late eighth century. On the

other hand he found that a shared predominance of animal ornament with extended bodies and closely coiled rolled haunches in Pictish sculpture, particularly on the Nigg cross-slab, localised the style. He quoted with approval the claim, made in 1967 in *The Picts*, that Pictish art should not be regarded as 'a late or provincial reflection of the main developments of Hiberno-Saxon art'.[67] Leslie Webster, in a series of publications dating from the 1991 *Making of England* catalogue took the opposite view; in particular she felt the rolled haunched animal was a period motif and the southern similarities close enough to suggest strongly that the pommel and chapes were imports,[68] a view reinforced by their similarities to the recently discovered Beckley pommel.[69] These correspondences include the new animal ornament from the front face of the Hilton of Cadboll cross-slab and were featured in my 2007 and 2008 publications.[70]

The invocation on the inscribed chape is consonant with that on the York helmet and, as Webster has demonstrated, is part of a long-standing tradition of the Christianisation of weaponry going back to the Anglo-Saxon gold and garnet pommels of the seventh century.[71] The uninscribed chape, with its cross flanked by animals at the centre of the front face, reflects this simpler, earlier tradition.[72] The interpretation of the inscription on the larger chape has been the subject of much debate and the issues, which have a crucial role in determining the Pictishness of the hoard, were reviewed in detail by Katherine Forsyth at the conference in Shetland, as yet unpublished, celebrating the fiftieth anniversary of the finding of the hoard.[73] On that occasion I made the case for a Pictish origin for all the silver items, on the basis of the unparalleled virtuosity of the decoration flowing over the surfaces of the conical mounts, the friezes of animals on silver bowls nos 2 and 3, and more generally, on the grounds that details of the animal style, in spite of the evident Southumbrian connections, are coherent with those found on the St Ninian's Isle brooches which also appear on Pictish sculpture. Webster concludes her recent balanced account of the southern connections by offering two scenarios, one that the Picts were copying Anglo-Saxon originals and the other, 'perhaps more plausibly', that the pommel and the chapes were imports, part of 'an Anglo-Saxon weapon suite which made its way to the extreme north'. Either, she felt, could explain the productive contacts between Pictland and Mercia in the eighth century.[74] The existence of such imports would certainly bring with them an extension of the Pictish decorative repertoire and other significant connections, but in my view it can still be argued that the evidence in the hoard suggests that the Picts had assimilated, rather than copied, aspects of the southern repertoire as a result of a more general exposure to it. Either way, what emerges unambiguously is the closeness of the specifically Mercian connection with Pictland

Though recent re-evaluation of this spectacular metalwork hoard has left the origin of a number of key pieces controversial as between Mercia or Pictland, the very fact of that controversy serves to underline the closeness of the stylistic connections between the two kingdoms in the decades either side of 800.

The historical context

The alliance between Onuist son of Uurguist (ruled 729–761) and Æthelbald of Mercia (ruled 716–757) was presumably founded on Mercian intelligence becoming aware of the expansionist successes of the Pictish king, and of a shared desire to control the Northumbrians and Britons, at least to the extent of keeping them within their boundaries. Onuist first established his position in Pictland, north and south, and then took over the kingdom of Dalriada to the west. He played an essential part in the North British diplomatic scene and his coordinated relationship with the equally belligerent Æthelbald must have been established as a result of his reputation for being able to deploy significant military resources, something which has implications for Pictish state formation.[75] Further insight into the mechanisms of Pictish-Mercian relations can be expected from ongoing work by historians into the career of Onuist, and from archaeologists of the University of Aberdeen who have just launched a five-year project to investigate the archaeology of Fortriu, one aim of which is to set the sites of sculptural production in a specifically social context. A productive comparison with the views of Driscoll in the St Andrews monograph and the results of the Strathearn Environs and Royal Forteviot (SERF) project will eventually be possible.[76]

The eighth century, in Mercia and Pictland, saw long periods of stability and successful expansion by their leaders that easily account for the keen interest they would have taken in aspects of each other's use of monumental and architectural propaganda. In the design of elite sculpture the last thing one should expect is conformity. The Pictish king did not share the violent end of his Mercian ally but died in his bed. If indeed the St Andrews Sarcophagus is to be associated with Onuist then his patronage need not have been for a self-aggrandising funerary monument but could have been a devotional tribute to the memory of Naiton who, thanks to the support of Northumbrian churchmen, created the beginnings of an independent Pictish Church which required a distinctive physical presence. Nonetheless, the prominently placed classical image of the griffin and its prey, carved to impress, in the new technology of high relief, and symbolic of the destructive power of death, supports the view that the Sarcophagus was planned as a funerary monument. There can be little doubt that it was the outward-looking Onuist who made it possible to continue, spectacularly, the development and enrichment of Pictish sculpture begun in the early eighth century by the equally outward-looking but peaceful contact of Naiton with Northumbria. The aspirations and wide contacts of Onuist

are ideally suited to lay the foundation of a second wave of inspiration for the exceptionally responsive Pictish sculptors of the next generation. Much of Pictish sculpture still calls for interdisciplinary explanation and the increasing range of Mercian sculpture and metalwork over fifty years continues to provide a significant part of that explanation.[77]

Notes

1 Mowbray 1936; Henderson 1967, 149–54 (quotations above at 151).
2 Woolf 2006.
3 Woolf 2001.
4 See further below, 62–3.
5 Hawkes & Sidebottom forthcoming 2017. For the benefit of less specialist readers each section concludes with a brief summary supplied by the editors. I welcome this opportunity to acknowledge the care they that have taken editing an unwieldy topic which has considerably improved its presentation and clarity.
6 Henderson 1967, 149–50.
7 Hawkes 1995, 273.
8 Thomas 1998, 84–6 at 84.
9 Rodwell et al. 2008.
10 Hawkes 2008, 64 & n. 57.
11 Webster 2012, 144.
12 Foster 1998a, 56–62.
13 Clarke 2012, 95 & n.79.
14 Everson & Stocker 1999, 248–51.
15 Bailey 2000, 43–51; Webster 2000, 63–71.
16 Henderson 1967, 150.
17 Hawkes 2008, 65–6.
18 Thomas 1998, 96; Scott & Ritchie 2009, 18–25.
19 Thomas 1998, 90–2; Bede, *HE* V, 21 (Colgrave & Mynors 1969, 532–5).
20 RCAHMS 1982, 216–18.
21 Henderson 1998, 165–7.
22 Henderson & Henderson 2004, 197–205; Lang 1972–4, 211 (for 'Fife' read 'Angus').
23 Bailey 1990, 2; Henderson 1994, 91–2.
24 Carver 2008, 64, 138; Carver et al. 2016, 138, ill. 5.3.25, 148–9.
25 Harden 2010, 67; Clancy et al. forthcoming.
26 Henderson & Henderson 2004, ills 299 & 300; Dransart 2001.
27 Henderson 1991; Seright 2007.
28 Trench-Jellicoe 1997, 168–70, ill. 5.
29 Thomas 1998, 95.
30 Plunkett 1998, 225–6.
31 Mac Lean 1998, 194–5.
32 Henderson 1967, 152; illustrated in Plunkett 1998, fig. 68.
33 Plunkett 1998, 219.
34 Henderson 1967, 152; 1998, fig. 29.
35 Henderson 1998, fig. 33.
36 Henderson 1998, colour pl. 10.
37 Jewell 1986, 100–9.
38 Henderson & Henderson 2004, ill. 54.
39 Mac Lean 1998, 199–201; Henderson 1998, 124–6.

40 For the possibility that this earlier Pictish figure style is also related to Mercian figure sculpture, see Hawkes 2001, 233–4.
41 Jewell 1986, pl. xlv, a, d & e.
42 Henderson & Henderson 2004, ill. 192.
43 Hawkes 1996, fig. 4.
44 Hawkes 1995, 261–2, fig. 6.
45 Jewell 1986, 109 & n. 126.
46 Biddle & Kjølbye-Biddle 1985.
47 Henderson 1997, 44–50. On p. 49 the Hell motif is mistakenly said to be carved on the reverse. See also Hawkes 2011. For comparison between the weapons slung from the waists of David and the Repton Rider, see Henderson 1998, 162–3. Further work needs to be undertaken on this subject.
48 Ibid., 111, fig. 24.
49 Henderson 2007; 2008a; 2008b.
50 Hawkes 1996, 88.
51 Everson & Stocker 1999, ill. 345.
52 Webster & Backhouse 1991, 177–9, cat. 138.
53 Henderson 2008a, 106–7, ills 4.13 & 4.14; 2008b, 145, ill. 5.15(a); for Webster on the Beckley pommel, see further below, 97–111.
54 See e.g. Lang 2002, 91.
55 Henderson & Henderson 2004, 53, ill. 61.
56 Henderson 2008b, 192, ill. 5.52.
57 Ibid., 190, ill. 5.51.
58 Henderson 2008a, 79, ill. 4.5.3; a finished drawing on a larger scale is in a pocket on the back board of James et al. 2008.
59 Henderson 2008b,197, ill. 5.57.
60 Henderson 2007, 210, ill. 10; see above, 55.
61 Bailey 2000, 47.
62 Jewell 1986, 103, pl. xlvii, a & c; Henderson 2008a, 88–90, ills 4.5–6.
63 Plunkett 1998, 215.
64 Everson & Stocker 1999, 250, ill. 343.
65 E.g. at Aberlemno (Henderson & Henderson 2004, ill. 36).
66 Fisher 2001, 19–20.
67 Wilson 1973, i, 127–8.
68 Webster & Backhouse 1991, 223–4, cat. 177, 178a, b; Webster 2001a; 2001b.
69 Webster 2012, 145; see also Webster below, 97–111.
70 Henderson 2007; 2008a; 2008b.
71 Webster 2012, 31, fig 12; see also Webster below, 105–6.
72 Graham-Campbell 2003, 32; see also Webster below, 106.
73 Forsyth forthcoming; Henderson forthcoming.
74 Webster 2012, 145–6; and below, 105–6.
75 Broun 2013.
76 Noble et al. 2013; Driscoll 1998; 2011, 270–4.
77 I offer this contribution to Richard, in admiration of his expertise, art-historical, exegetical, technical and antiquarian. Always perspicacious, often light-hearted, his combination of authority with an engaging style has, over many years, made his publications both profitable and a pleasure to read.

References

Bailey, R.N., 1990 *The Meaning of Mercian Sculpture*, Vaughan Paper 34 (Leicester)
Bailey, R.N., 2000 'The Gandersheim Casket and Anglo-Saxon Stone Sculpture' in Marth 2000, pp 43–52

Biddle, M. & Kjølbye-Biddle, B., 1985 'The Repton Stone', *ASE* 14, 233–92

Broun, D., 2013 'State-formation in Scotland before the twelfth Century' (unpublished lecture, O'Donnell Lecture Series Early Medieval Scotland, Faculty of English, University of Oxford, Oxford, 10 May 2013)

Brown, M.P. & Farr, C.A. (ed.), 2001 *Mercia: an Anglo-Saxon Kingdom in Europe* (London & New York)

Carver, M., 2008 *Portmahomack: Monastery of the Picts* (Edinburgh)

Carver, M., Garner-Lahire, J. & Spall, C., 2016 *Portmahomack on Tarbat Ness. Changing Ideologies in North-east Scotland, Sixth to Sixteenth Century AD* (Edinburgh)

Clancy, T.O., Geddes, J. & Taylor, S., forthcoming *Early Medieval Sculpture at St Vigeans, Angus, Interpretation and Context* (Edinburgh)

Clarke, D., 2012 'Communities' in D. Clarke, A. Blackwell & M. Goldberg, *Early Medieval Scotland: Individuals, Communities and Ideas* (Edinburgh) pp 69–139

Cramp, R.J., 2008 'The Art-historical Context of the Carved Decoration' in Rodwell et al. 2008, pp 66–75

Dransart, P., 2001 'Two Shrine Fragments from Kinneddar, Moray', in M. Redknap, N. Edwards, S. Youngs, A. Lane & J. Knight (ed.), *Pattern and Purpose in Insular Art* (Oxford & Oakville, CT), pp 233–40

Driscoll, S.T., 1998 'Political Discourse and the Growth of Christian Ceremonialism in Pictland: the Place of the St Andrews Sarcophagus' in Foster 1998b, pp 168–78

Driscoll, S.T., 2011 'Pictish Archaeology: Persistent Problems and Structural Solutions' in S.T. Driscoll, J. Geddes, & M.A. Hall (ed.), *Pictish Progress. New Studies on Northern Britain in the Early Middle Ages* (Leiden), pp 245–79

Everson, P. & Stocker, D., 1999 *Lincolnshire*, CASSS 5 (Oxford)

Fisher, I., 2001 *Early Medieval Sculpture in the West Highlands and Islands* (Edinburgh)

Forsyth, K., forthcoming 'Language and Literacy in pre-Viking Shetland: the Evidence from St Ninian's Isle' in Smith forthcoming

Foster, S.M. 1998a 'Discovery, Recovery, Context and Display' in Foster 1998b, 36–62

Foster, S.M. (ed.), 1998b *The St Andrews Sarcophagus: a Pictish Masterpiece and its International Connections* (Dublin)

Graham-Campbell, J., 2003 *Pictish Silver: Status and Symbol*, H.M. Chadwick Memorial Lectures 13 (Cambridge)

Harden, J., 2010 'Guide to St Vigeans' in [J. Harden] *The Picts. Including Guides to St Vigeans' Museum and Meigle Museum*, ed. A. Burnet, Discover Scottish History Series (Edinburgh), pp 62–9

Hawkes, J., 1995 'The Wirksworth Slab: an Iconography of *humilitas*', *Peritia* 9, 246–89

Hawkes, J., 1996 'The Rothbury Cross: an iconographic Bricolage', *Gesta* 35, 73–90

Hawkes, J., 2001 'Constructing Iconographies: Questions of Identity in Mercian Sculpture', in Brown & Farr 2001, pp 230–45

Hawkes, J., 2008 'The Monument Form' in Rodwell et al. 2008, 64–6

Hawkes, J., 2011 'The Road to Hell: the Art of Damnation in Anglo-Saxon Sculpture' in E. Mullins & D. Scully (ed.), *Listen, O Isles, Unto Me: Studies in Medieval Word and Image in Honour of Jennifer O'Reilly* (Cork), pp 230–42

Hawkes, J. & Sidebottom, P., forthcoming 2017 *Derbyshire and Staffordshire*, CASSS 13 (Oxford)

Henderson, G. & Henderson, I., 2004 *The Art of the Picts: Sculpture and Metalwork in Early Medieval Scotland* (London)

Henderson, I., 1967 *The Picts* (London)

Henderson, I., 1991 *The Art and Function of Rosemarkie's Pictish Monuments* (Rosemarkie, Groam House Museum (repr.)

Henderson, I., 1994 'The Insular and Continental Context of the St Andrews Sarcophagus' in B. Crawford (ed.), *Scotland in Dark Age Europe* (St Andrews), pp 71–103

Henderson, I., 1997 Pictish Monsters: Symbol, Text and Image, H.M. Chadwick Memorial Lectures 7 (Cambridge)

Henderson, I., 1998 '*Primus inter pares*: the St Andrews Sarcophagus and Pictish Sculpture' in Foster 1998b, pp 97–167

Henderson, I., 2007 'New animal Ornament on the Cross-slab from Hilton of Cadboll, Ross & Cromarty, Scotland' in R. Moss (ed.), *Making and Meaning in Insular Art: Proceedings of the Fifth International Conference on Insular Art held at Trinity College Dublin, 25–28 August 2005*, Research Studies in Irish Art 1 (Dublin), pp 198–214

Henderson, I., 2008a 'The Cataloguing of the Hilton of Cadboll Cross-slab' in James et al. 2008, pp 75–126

Henderson, I., 2008b 'The Art-historical Context of the Hilton of Cadboll Cross-slab' in James et al. 2008, pp 127–204

Henderson, I., forthcoming 'The Pictishness of the Art of the St Ninian's Isle Treasure' in Smith forthcoming

James, H.F., Henderson, I., Foster, S.M. & Jones, S., 2008 *A Fragmented Masterpiece: Recovering the Biography of the Hilton of Cadboll Pictish Cross-slab* (Edinburgh)

Jewell, R.H.I., 1986 'The Anglo-Saxon Friezes at Breedon-on-the-Hill, Leicestershire', *Archaeologia* 108, 95–115

Lang, J.T., 1972–4 'Hogback Monuments in Scotland', *PSAS* 105, 206–35

Lang, J.T., 2002 *Northern Yorkshire*, CASSS 6 (Oxford)

Mac Lean, D., 1998 'The Northumbrian Perspective' in Foster 1998b, pp 179–201

Marth, R. (ed.), 2000 *Das Gandersheimer Runenkästchen. Internationales Kolloquium, Herzog Anton Ulrich-Museum, Braunschweig 24.–26. Marz 1999* (Brunswick)

Mowbray, C.L., 1936 'Eastern Influence on Carvings at St Andrews and Nigg, Scotland', *Antiquity* 10, 428–40

Noble, G., Gondek, M., Campbell, E. & Cook, M., 2013 'Between Prehistory and History: the Archaeological Detection of Social Change among the Picts', *Antiquity* 87, 1136–50

Plunkett, S.J., 1998 'The Mercian Perspective' in Foster 1998b, pp 202–26

Rodwell, W., Hawkes, J., Howe, E., & Cramp, R.J., 2008 'The Lichfield Angel: a Spectacular Anglo-Saxon Painted Sculpture', *Antiquaries J.* 88, 48–108

RCAHMS 1982 *Argyll: An Inventory of the Monuments, 4: Iona* (Edinburgh)

Scott, I.G. & Ritchie, A., 2009 *Pictish and Viking Age Carvings from Shetland* (Edinburgh)

Seright, S.E., 2007 'Rosemarkie's Pictish Sculpture: assemblage and record' (unpublished lecture, Tarbat Historic Trust, Portmahomack, 27 July 2007)

Smith, B. (ed.), forthcoming *The St Ninian's Isle Treasure Sixty Years On*, Shetland Amenity Trust, Shetland Heritage Publications (Lerwick)

Thomas, C., 1998 'Form and Function' in Foster 1998b, pp 84–96

Trench-Jellicoe R., 1997 'Pictish and Related Harps: their Form and Decoration' in D. Henry (ed.), *'The Worm, the Germ and the Thorn' Pictish and Related Studies presented to Isabel Henderson* (Balgavies), pp 159–72

Webster, L., 2000 'Style and Function of the Gandersheim Casket' in Marth 2000, pp 63–72

Webster, L., 2001a 'The Anglo-Saxon Hinterland: Animal Style in Southumbrian Eighth-century England, with Particular Reference to Metalwork' in M. Müller-Wille & L.O. Larson (ed.), *Tiere-Menschen-Götter. Wikingerzeitliche Kunststile und ihre neuzeitliche Rezeption*, Veröffentlichen Joachim-Jungius-Gesellschaft des Wissenschaften Hamburg 90 (Göttingen), pp 39–62

Webster, L., 2001b 'Metalwork of the Mercian Supremacy' in Brown & Farr 2001 (London & New York), pp 263–77

Webster, L., 2012 Anglo-Saxon Art: a New History (London)

Webster, L. & Backhouse, J. (ed.), 1991 *The Making of England: Anglo-Saxon Art and Culture AD 600–900* (London)

Wilson, D.M., 1973 'The Treasure' in A. Small, C. Thomas & D.M. Wilson, *St. Ninian's Isle and its Treasure*, Aberdeen University Studies 152, 2 vols (Oxford), i, pp 45–148

Woolf, A., 2001 'The Verturian Hegemony: a Mirror in the North' in Brown & Farr 2001 (London & New York), pp 106–12

Woolf, A., 2006 'Dun Nechtain, Fortriu and the Geography of the Picts', *The Scottish Historical Review* 85, 182–201

Part II

Objects and meanings

In the second section of the volume our attention moves from stone carvings to the analysis and interpretation of artefacts in a range of other media, reflecting the wide range of Richard Bailey's own interests, shown by his publication of a series of fundamental studies of a number of key artefacts in wood, ivory, metal, and vellum.

We begin with reinterpretations of the iconography of two of the most famous wooden artefacts to have survived from late antiquity and the early Middle Ages. Éamonn Ó Carragáin reveals a hitherto unsuspected dimension of the iconography of one of Christendom's earliest surviving crucifixion images, carved on the great doors of the basilica of Santa Sabina in Rome, and offers a remarkable insight into the factors which shaped the beginnings of what would become the most emblematic of all Christian images. Jane Hawkes takes as her point of departure the pioneering identification by Richard Bailey of the fragments of a cross-inscribed board found in St Cuthbert's grave in the nineteenth century as probably the base of the saint's coffin; she proceeds to reconstruct a ground-breaking three-dimensional iconography of the whole deposit which relates the body of the saint to the reliquary in which it was enclosed.

Manuscripts are represented by Catherine Karkov's analysis of a well-known Canterbury manuscript of the late pre-Conquest period, the Harley Psalter. She probes the enigmatic iconography of its opening image of the Trinity, identifying a complex interaction, not only between text and image, but also between that initial image and others later in the manuscript and proposes a subtle contextualisation of the iconography in the concerns of the patrons who commissioned the work and of the community and the team of scribe-artists who produced it.

The remainder of this section is concerned with finds of metalwork from England ranging in date from the late eighth to the twelfth century. Leslie Webster provides the first full publication of a recently discovered piece of Mercian metalwork of spectacularly high quality. In a compelling analysis she probes issues of its symbolic significance as well as its practical function as a sword pommel, and argues that early medieval master smiths endowed high-status swords with a distinctive and sophisticated iconography of their own which we are only just beginning to understand and appreciate.

The next two papers are concerned with Viking-age finds from the Danelaw. A unique example in gold of a lozenge brooch from Norfolk forms the subject of James Graham-Campbell's study. The type clearly originates from Denmark, but he draws attention to an accumulating body of evidence for production sites in East Anglia, the only known place of manufacture outside of Scandinavia. This pattern can be paralleled in other types of personal adornment and is transforming our understanding of the manufacture and distribution of such items in the area of the Viking settlement in Britain. John Hines considers a very different type of artefact, a lead spindle-whorl from Lincolnshire, which preserves a remarkable runic inscription. He argues that this provides a hitherto wholly unsuspected insight into the survival of pagan beliefs which challenges conventional wisdom on the nature of Christianity in the late Viking Danelaw.

For the final paper in this section we move into the post-Conquest period with Helen Gittos, who scrutinises a group of enigmatic inscribed lead plaques, probably of twelfth-century date, from the abbey of Bury St Edmunds. She decodes the text borne by these objects to suggest that they performed a liturgical function in rituals associated with dying monks, and perhaps also with their burial. As documentary evidence of such practices is lacking we are entirely reliant on interpreting the objects themselves, so her analysis has arguably also given birth to a new sub-discipline, the archaeology of liturgy.

The Santa Sabina crucifixion panel: 'between two living creatures you will be known' on Good Friday, at 'Hierusalem' in fifth-century Rome

Éamonn Ó Carragáin

Among his many services to scholarship, Richard Bailey has written an excellent paper on the early medieval interpretations of the Old Latin text of the Canticle of Habakkuk.[1] He makes good use of vernacular glosses to confirm how the Canticle was interpreted in Anglo-Saxon England. He argues, convincingly, that Bede refers to the Canticle and to its use at Lauds on Fridays in his prose *Life* of Cuthbert. Bede tells how Cuthbert, staying at Coldingham, was observed by one of the brethren going down to the sea-shore to stand up to his neck in the sea for an all-night vigil of prayer. At daybreak, Cuthbert returned to the shore, knelt down, and resumed his prayer. While he knelt in prayer, 'two four-footed creatures which are commonly called otters' came out of the sea. Lying down on the sand before the kneeling saint, they 'began to warm his feet with their breath and sought to dry him with their fur'. When they had finished their service to Cuthbert, 'they received his blessing and slipped away into their native waters'.[2] Unlike the other lives of Cuthbert, Bede's prose *Life* specifies that, directly after the beasts had recognised and warmed him, Cuthbert 'forthwith returned home and sang the canonical hymns with the brethren at the appointed hour'.[3] At the hour of sunrise, the appointed liturgical office would have been Lauds; and, as Bede himself points out in his commentary *In Habacuc*, it was customary to recite the Canticle at Lauds, the 'morning praises', each Friday, the day in which Christ's Passion was accomplished.[4] Bailey agreed that the Canticle of Habakkuk, as interpreted by Bede, is relevant, not only to our understanding of this episode in the prose *Life* of Cuthbert, but also to the Bewcastle and Ruthwell crosses. On each of these eighth-century monuments there is a panel representing Christ acclaimed by two animals.

The inscription to the Ruthwell panel calls them 'beasts and dragons',[5] and says that they 'recognised in the desert the saviour of the world'.[6] But they are anonymous beasts, in the sense that scholars have not been able to identify them with any particular species. They 'recognise the Saviour of the world' by crossing their paws to form the symbol (*Chi*) for the title 'Christ'. This iconography is highly original, and is found nowhere else except on those two related Northumbrian monuments. The two beasts are placed under the feet of the majestic Christ, in a clear reminiscence of the widespread iconography of Psalm 90:13.[7] However they are not the evil beasts (asps, basilisks, lions or dragons) of Psalm 90; instead, they acclaim Christ as the Messiah by forming with their paws the first letter of his messianic title in Greek, '*Christos*' ('the anointed one'). Their acclamation of Christ is consistent with the helpful cosying up of the otters (in Bede's prose *Life* of Cuthbert), to the saint who has been chilled by his long vigil. It is reasonable to suppose that Bede's account of Cuthbert's otters, and the sculptors at Ruthwell and at Bewcastle, were each independently inspired by the same ideas and texts.[8] In effect, the Bewcastle and Ruthwell sculptors have converted their beasts from evil to good; this highly original transformation seems designed to fuse a recollection of Psalm 90 with a recollection of the 'two living creatures' (*dua animalia*) of the Old Latin version of the Canticle of Habakkuk.[9]

At the beginning of his paper, Bailey writes that 'the sceptic might also observe that, if this [*in medio duorum animalium innotesceris*] were such a popular concept, why is there seemingly no evidence for it in continental art?'[10] Here I argue that a libretto, partially based on the opening verses of the Canticle of Habakkuk, and sung at the ninth hour on

Good Friday as a tract or responsory chant,[11] also provides a context within which one of the earliest surviving Roman representations of the Crucifixion may be understood. This is a panel at the top left-hand corner of the wooden door at Santa Sabina on the Aventine Hill in Rome (Fig. 7.1).

At present placed at the top left-hand corner of the wooden door, the Santa Sabina crucifixion panel appears as the first of a row of four small panels; together these span the width of the door. Directly underneath, there is a series of four larger (that is, taller) panels. This pattern is then repeated: the panels of the third row on the door are small; those of the fourth row are large. A final pair of small figural panels, placed at present on the left and right sides of the door with two blank panels between them, completes the present arrangement of figural panels. Directly under this row comes a row of four blank large panels, and then, at the bottom of the door, a row of four blank small panels. The door now has eighteen figural panels in all, eight large and ten small. Towards the bottom, there are ten blank panels, four large and six small. It is certain that originally there were more figural panels, which presumably became damaged and had to be replaced by blanks; in her standard study of the door, Gisela Jeremias argues convincingly that originally there was a Jonah cycle, now lost.[12] Thus the present arrangement of panels on the door, even that of the top row of small panels, is possibly not the original one. However, it is also possible that the present arrangement may partly preserve the original one. We shall return to this question later.

In the crucifixion panel, Christ is a majestic and heroic figure: a mature and well-built man, naked except for a narrow loin-cloth. He has a full beard and long flowing hair, like that of the bearded philosopher-Christ in the early fifth-century apse of Santa Pudenziana, Rome.[13] The artist has expressed his importance by making him much taller than the two younger-looking, beardless men, each

Fig. 7.1 Crucifixion, door panel, Santa Sabina, Rome (Photo: Jane Hawkes)

clad in a narrow loin-cloth, who flank him to left and right. The background of the panel is filled with rectangles clearly intended to represent the stones of a wall. A raised structure is embedded in the wall, but does not otherwise interfere with our view of it. The structure has three peaks, shaped so as to suggest three gable ends; on the 'gable' to the viewer's left, a small curved arch suggests a window. By superimposing the outlines of gable ends on the wall, the artist has emphasised the parallelism between the two thieves: each of them is, like Christ himself, framed by a separate gable. He has also emphasised the contrast between Christ and the two thieves: Christ is so tall as to fill the central gable, while the head of neither thief reaches to the lower horizontal border of his gable. Christ's greater size was appropriate: in early Christian narrative and exegesis, Christ, because he embodied divine and human natures, was seen as *ut gigas* ('like a giant'), who 'rejoices to run his course'.[14] All three men seem fully alive, with open eyes. Their faces show no signs of suffering; Christ in particular seems calm and majestic.[15] The small young man on Christ's left hand (on the viewer's right), who is slightly taller than his fellow to the viewer's left, seems positively joyful. In the panel, there is no reference to the other human figures recorded by the Gospels, and in later tradition, as being present at the Crucifixion. There is no wound on Christ's side (as he is fully alive, he could not yet have been wounded by the spear; that wound was inflicted to ensure, and demonstrate, his death).[16] There is no sign of a spear-bearer, nor a sponge-bearer, nor the other women or men in the fifth-century British Museum ivory or in the late sixth-century Rabbula Gospels.[17] All three figures look somewhat to their right, towards what, from the onlooker's perspective, appears as the left side of the door. All three also have their arms extended to left and right; but the arms are bent, not strained or stretched out. This is in striking contrast to the fifth-century British Museum ivory, where the triumphant Christ has his arms stretched out rigidly by the nails which pierce his open hands. Were it not for the clear references to crucifixion, which we will now examine, scholars might well have interpreted the pose of all three figures (arms extended to left and right, but bent and not rigidly stretched out) as the *orans*-pose, the classic ancient attitude of prayer. Indeed, scholars have recently suggested that the Santa Sabina artist may have been partially inspired by early Christian depictions, in the catacombs and on sarcophagi, of the Hebrew children in the fiery furnace: threefold *orantes*, male figures, and types of the death and Resurrection of Christ.[18]

Whatever the sources of its inspiration, there is no doubt that this is a crucifixion panel. The designer and carver have provided unmistakeable references to the Crucifixion, though they have not attempted any realistic representation of it. The open palm of Christ's left hand is nailed to a very short horizontal plank, but the plank is not continued to fill the

space over his bent left arm (between his left shoulder and left hand). The same is true of Christ's right side; his right palm is nailed to an exiguous plank, which is lower than, and thus not in line with, the plank behind Christ's left hand. The artist has made no effort to angle the two tiny planks, to which his hands appear to be nailed, so as to represent a convincing cross-piece. There is no sign of the upright of a cross above Christ's bearded head, which is framed by the central 'gable'. Christ seems to stand on the ground, not to hang on a cross. There are no signs of nails in his feet; however, just under Christ's feet, a slight wedge-mark in the lower border of the panel may refer to the upright of his cross. It would seem that the artist primarily intended to emphasise Christ's gesture of prayer, and that he has sacrificed any effort to represent a realistic crucifixion to this concern.

The references to crucifixion are more definite in the case of the two young men who flank Christ. The uprights of their crosses are visible behind their heads: the upright is particularly plain over the head of the smaller of these figures (to the left of the panel, on Christ's right hand). Their feet, like Christ's, are at ground-level. However, the wedge-like marks under their feet, on the lower border of the panel, are clearer than that under the feet of Christ, and may well have been intended to refer to the uprights of their crosses or to *suppedanea*. Their cross-pieces are also more convincing than in the case of Christ; however, the plank to which one palm of each flanking figure is nailed never forms a straight line with the plank to which his opposite palm is nailed. In the case of all three figures, we have references to crucifixion rather than a convincing representation of it.

Which of these young men is the good thief, and which the bad? In her careful examination of the panel, Jeremias does not even raise the question.[19] Dina Tumminello is equally meticulous, but her approach is different. She rejects, as inappropriate to these malefactors, any suggestion that the gestures of the thieves should be seen as gestures of prayer.[20] She makes a detailed case that the figure on Christ's left (to the right of the panel) is the good thief: he is the taller of the two flanking figures; he looks towards Christ; and the gesture of his arms is closer to that of Christ. Tumminello emphasises that, on Christ's right (to the left of the panel), the bad thief obstinately looks away from Christ; she sees his gaze as 'filled with hatred'.[21] I do not wish to challenge these careful observations; Tumminello has demonstrated that the two flanking figures are not identical, but are contrasted to a certain degree. She may be correct in arguing that the more cheerful young figure to the right of the panel is the good thief. But I doubt that the sculptor intended the distinction between good and bad thieves to be an important feature of his panel. Against Tumminello's interpretation, it might be objected that the 'good thief' is on Christ's left, not on his right; and that Christ looks away from the 'good thief' and towards the 'bad thief'. The artist seems more intent on emphasising that both thieves face the same way as

Christ (somewhat towards the left of the panel) than on accentuating the contrasts between the two thieves. Jeremias has convincingly argued that the Santa Sabina artist probably had few models, if any, to go on. She suggests that the commissioner, and the artist, were unsure of how to proceed, and were experimenting with concepts for which they did not know any accepted and traditional iconography.[22] After all, Luke's Gospel is the only one to describe a sharp contrast in attitudes between the 'good' (repentant) thief and the 'bad' (unrepentant) one.[23] Mark simply relates that Christ was crucified between two thieves, one to his left and the other to his right (15:27–8). Matthew states that both of the thieves cursed Christ (27:38, 44), and makes no distinction between them. John does not refer to the thieves at all. In the final years of the fourth century, in other words, one, or at most two, generations before the Santa Sabina door was made, Jerome reconciled the apparent contradiction between Matthew, where both thieves curse Christ, and Luke, where the good thief repents, by arguing that both thieves at first cursed Christ, but that then the good thief was converted to believe in Christ by the darkness over all the earth, and the miracles that took place while Christ was on the Cross.[24]

Tumminello interestingly suggests that the artist intended the wall with rectangular 'stones', which covers the back of the panel, to emphasise that Calvary, where the crucifixions took place, was just outside the walls of Jerusalem.[25] If the designer or artist intended to emphasise the walls of Jerusalem, they may possibly have intended the panel to recall such passages as Hebrews 13:12–14:

> Wherefore Jesus also, that he might sanctify the people by his own blood, suffered without the gate. Let us go forth therefore to him without the camp, bearing his reproach. For, we have not here a lasting city: but we seek one that is to come.[26]

Whether that is so, we shall see that to recall Jerusalem, in relation to Calvary, had a precise significance in terms of the liturgical landscape of fifth-century Rome.

At the end of the fourth century, Jerome commented on the phrase *In medio duorum animalium cognosceris* ('you will be known in the midst of two living creatures'), a phrase from Habakkuk 3:2 in the Old Latin translation of the Greek Septuagint.[27] Jerome himself, working directly from the Hebrew, had translated the phrase differently: '*in medio annorum notum facies*' ('in the midst of the years thou shalt make it [thy work] known'). However Jerome, aware that the older Latin translation from the Greek had been consecrated by many years of Christian devotional and liturgical use, saw it too, and not just the Hebrew original, as inspired. He therefore provided a rich and multi-layered interpretation of the Old Latin phrase:

> And so, disturbed by wonder, I burst out in fear in praise of you, saying 'you will be known in the midst

of two living beings'. These are interpreted as the
two Seraphim in Isaiah [6:2], and the two cherubim
described in Exodus [25:18], who look towards each
other, and who have the [place of] oracle between
them, in Isaiah [cf 6:2] veiling the Lord's head and
feet. [It is said that] in the present age these fly, and
that one calls out the mystery of the Trinity to the
other; and that one of them who is called 'burning' is
sent, and comes to earth, and cleanses the lips of the
prophet, and says 'I am come to cast fire on the earth.
And what will I, but that it be kindled?' [Luke 12:49].
This is how others interpret it, and use many texts of
scripture to justify that interpretation. But the simple
interpretation, and the opinion of the common people,
understands it as referring to the Saviour, who may be
recognized as crucified between two thieves. Those
who interpret the text better, say that the Saviour is
to be understood and believed in [the midst of] the
primitive Church, which was called together from
the circumcision [i.e., from the Jews] and from the
foreskin [i.e., from the Gentiles], [Christ] surrounding
himself on this side and on that by two peoples. There
are those who understand the two living creatures
as the two Testaments, Old and New, who are truly
living and full of life, who [can be said to] breathe
[the Spirit], and in the midst of which the Lord may
be known.[28]

The most striking thing about Jerome's interpretation is
that he cites the 'opinion of the common people (*opinio
uulgi*)'. Why should the common people have any such
opinion? Furthermore, Jerome agrees that their opinion,
even if a simple one, is basically correct. Jerome preferred
to see more historically wide-ranging dimensions in the
phrase, but these interpretations also concentrate on how
the Saviour is to be recognised in history: in the midst of
the primitive Church called out from Jews and Gentiles,
and in the correspondences between the [Hebrew] Old
Testament and the [Greek] New; it is by relating those two
complementary revelations that the Lord is to be known
and believed.

In the early fifth century, a few decades before the
construction of the Santa Sabina door, St Augustine would
once more record this popular interpretation. Unlike Jerome,
Augustine would place the various interpretations on the
same level; he evidently saw them as equally valid:

> Again, in his prayer, combined with a song, to whom
> but the Lord Christ is Habakkuk speaking when
> he says, 'Lord, I heard your discourse, and I was
> afraid: Lord, I considered your works, and I was
> filled with dread'? For can this represent anything
> but the indescribable amazement aroused by the
> foreknowledge of a new and sudden salvation for

mankind? 'Between the two living creatures you
will be recognized' can surely only mean between
the two covenants, or between the two thieves, or
between Moses and Elijah conversing with him on
the mountain.[29]

The popular interpretation, Jerome's *opinio uulgi* (which to
Jerome seemed merely a *simplex interpretatio*, but caused no
difficulty to Augustine), was firmly based on the liturgical
praxis of the Western Latin Church. In Rome, from the
fourth century (and probably well before) a closely related
phrase, '*in medio duorum animalium innotesceris*', was sung
on Good Friday, at the beginning of the solemn ceremony
commemorating the moment of the Lord's death on the
Cross between two thieves. Liturgical historians generally
accept that the most solemn liturgical occasions are the most
conservative: thus it is likely that the readings and chants for
Good Friday are very ancient. There was no Mass on Good
Friday, because the ceremonies at the moment of Christ's
death preserved the customs of a time before the Eucharist
was celebrated on weekdays. Instead, at the ninth hour on
Good Friday, the traditional hour for the commemoration
of Christ's death, people came together in the various
ancient churches of the city, for services of readings and
prayer: the word '*synaxes*' (gatherings) is used for such non-
eucharistic services. Of these gatherings, the most important
was naturally the *synaxis* at which the Bishop of Rome,
the Pope, presided. By tradition, the pope presided at the
basilica of 'Hierusalem', which in modern times has come
to be known as 'Santa Croce in Gerusalemme'. 'Hierusalem'
stood within the imperial property known as the Sessorian
Palace. The basilica was particularly associated with Helena,
the mother of Constantine, who was believed to have
brought back to Rome relics of the Passion and of the True
Cross, and deposited them in this basilica; hence the name
'Hierusalem'.[30] The basilica came to be seen as the symbolic
counterpart, in Rome, of Calvary.[31]

Detailed accounts of the papal Good Friday ceremony
at 'Hierusalem' have survived, not from the fifth century,
but from the eighth.[32] Scholars agree that the readings
and chants of that ceremony are unlikely to have changed
much since the fourth and fifth centuries; indeed, because
the ceremonies on the most solemn feasts were usually the
most conservative, the readings and chants may predate the
time of Constantine. The papal ceremony of readings at
'Hierusalem' began abruptly. There was no entrance chant
or *introit*. A subdeacon ascended the ambo and, without even
identifying the book to be read, began to intone a passage
from the prophet Hosea (6:1–6). When read on Good Friday,
the opening verses must have been seen to emphasise the
unity of the sacred Triduum, the three days (Good Friday,
Holy Saturday, Easter Sunday) which culminated in Christ's
Resurrection. The lection implies that, by repentance and by
participation in the Triduum, the whole congregation, now

gathered at 'Hierusalem', will partake not only in Christ's death, but also in his rising to new life:

Come, let us return to the Lord;
For it is he who has torn, and he will heal us:
He has struck down, and he will bind us up.
After two days, he will revive us,
On the third day he will raise us up that we may live before him.[33]

After this first reading, the choir intoned a tract or responsory chant, once more taken from the prophets. The libretto of the chant was loosely based on the opening verses of the Old Latin version of the Canticle of Habakkuk, but also diverged somewhat from it;[34] liturgical scholars are agreed that this chant (which may have originated outside of Rome) is probably one of the most ancient surviving Latin chants of the Western Church:[35]

RESP[ONSORY] (GRAD[UAL]): Lord, I heard your tidings and was afraid
I considered your works and grew fearful.
V[ERSICLE]: Between two living beings you will become known
When the years draw nigh you will become known,
When the time comes you will be revealed.
V[ERSICLE]: When my soul is deeply troubled by him,
I will remember mercy.
God will come from Lebanon,
And the holy one from the shaded, thickly-wooded mountain.
V[ERSICLE]: His majesty has covered the heavens,
And the earth is full of his praise.[36]

It is likely that Jerome's *opinio uulgi*, and Augustine's recording of the tradition, are both inspired by this chant, sung at the most solemn moment of the liturgical year, the moment of Christ's death on the Cross. It is equally likely that our Santa Sabina panel was primarily designed to recall what Jerome called the '*opinio uulgi*'. The designer and artist were not primarily concerned with realism; that is, with representing the details of the Gospel narratives. It is possible that, as Tumminello has argued, one of the thieves was intended to be seen as 'good' and the other as 'bad'. However, the way in which the panel is designed suggests that the designer and artist subordinated such considerations to a more central intention: to recall the Good Friday chants, and with them the *opinio uulgi* (an opinion shared by Augustine and well-known to Jerome), that, between the two thieves, the natures of Christ were revealed, and he was to be recognised. Designer and artist seem to have been careful to ensure that any individuation of the two thieves should not interfere with their essential similarity, as it were; that even if the designer and artist wished to recall Luke's vivid scene of the repentant thief,

they ensured that such a recollection would not overshadow Isaiah's prophecy recalled, not only in Luke's Gospel, but also in the Vulgate text of Mark:

And with him they crucify two thieves: the one on his right hand, and the other on his left. And the scripture was fulfilled, which saith: *And with the wicked he was reputed.*[37]

To conclude: modern art historians have been fascinated with the Santa Sabina crucifixion panel because it is among the earliest surviving representations of Christ's Crucifixion. As we shall see, this fascination has led them to interpret the panel too much in isolation from the neighbouring small panels on the top row of the door, and to concentrate on the ways in which the panel anticipates, or fails to anticipate, features of later crucifixion scenes (such as representations of the good and bad thieves). This concentration has prevented them from appreciating how the panel, placed as it is at the opening of the iconographic programme, suggests a perspective within which the whole door may be read. The designer of the Santa Sabina door, and the artist who sculpted the panel, were primarily interested in the Crucifixion, not as an event to be literally described by piling on details from the Gospel narratives, but as an epiphany of how Christ's nature, as God and as man, was revealed 'in the midst of two living creatures' at the very moment in history when 'he was reputed with the wicked'. The panel refers to the Crucifixion indeed; but the artist sees Christ's death primarily in the terms in which it was made present to Christian communities in fifth-century Rome – through the communal actions and the liturgical chants of the Easter Triduum. In the fifth century, as we have seen, the Good Friday readings and chants placed the commemoration of Christ's death firmly within that wider context. It was in the whole Easter Triduum, enacted and experienced as a unified event, that Christ's nature and triumph was understood to be revealed.

The present position of the panel, at the beginning of the iconographic programme of the door, is appropriate, and may possibly be original. Famously, Christianity is a religion of the codex, and it is normal to begin reading the page of a book at the top left-hand corner. In the top row of small panels on the Santa Sabina door, our crucifixion panel (at the left corner) is balanced by a panel representing Christ as acclaimed by, and between, two disciples (the fourth small panel, at the right corner). Jeremias has convincingly identified those two disciples as Peter and Paul (Fig. 7.2).[38] What is of great interest is the similarity of design between this panel, at the top right corner of the door, and the crucifixion panel at the top left corner. Each of the panels is a 'figure of three'; the three 'gable ends' in the crucifixion panel, which emphasise the relationships between Christ and the two malefactors, have a close visual parallel in the palm trees which mark out the spaces between Christ and the flanking disciples, Peter and

Fig. 7.2 Christ between Peter and Paul, door panel, Santa Sabina, Rome (Photo: Jane Hawkes)

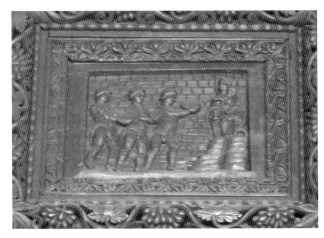

Fig. 7.4 Adoration of the Magi, door panel, Santa Sabina, Rome (Photo: Jane Hawkes)

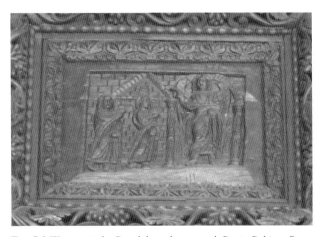

Fig. 7.3 Women at the Sepulchre, door panel, Santa Sabina, Rome (Photo: Jane Hawkes)

of scriptural symbolism than most modern scholars, who sometimes have that sort of imaginative agility trained out of them. We have seen how both Jerome and Augustine, in their interpretations of the '*in medio duorum animalium*' phrase, thought nothing of jumping, in what to most of us would seem an arbitrary fashion, between what we are trained to think of as widely different situations and ideas. The same fifth-century flexibility in linking various levels of symbolism together is implied at the basilica of Santa Sabina, in close proximity to the great wooden door. On the interior of the entrance wall, that is, just over the inner side of the great wooden door, the famous mosaic dedicatory inscription is placed: it consists of seven lines of verse.[42] The fourth and central line has seven words, and the fourth or central word in that line is the name 'PETRVS'. This name primarily refers to the priest Peter of Illyria who founded the basilica with its decorations 'which you admire'.[43] The inscription states that, through his Christian virtues ('he was generous to the poor and harsh on himself'), Peter of Illyria was 'worthy of such a great name':[44] the inscription explicitly compares the generous priest to St Peter himself. But that is not all. To the left of the inscription stands a lady, entitled 'the Church from the Circumcision'.[45] To the right of the inscription a matching lady is entitled 'the Church from the Gentiles'.[46] This is the very theme to which, as we have seen, Jerome refers when interpreting '*in medio duorum animalium*': 'those who interpret the text better, say that the Saviour is to be understood and believed in [the midst of] the primitive Church, which was called together from the circumcision [i.e., from the Jews] and from the foreskin [i.e., from the Gentiles], [Christ] surrounding himself on this side and on that by two peoples'.[47] The two ladies add an essential layer of symbolism to the verse inscription placed between them. The flanking ladies add a further, wider implication to the poem's explicit comparison between Peter of Illyria and his great namesake: they imply that in the life and death of

Paul. The two small panels at the centre of the top row are thematically relevant to these flanking panels at the upper corners of the door. The panel immediately to the right of the crucifixion panel refers to the Resurrection: on Easter morning, the holy women encounter the angel at the empty tomb of Christ (Fig. 7.3).[39] Together, these two panels represent the Easter Triduum, from Good Friday to Easter Sunday: the progression from the first to the second recalls the first Good Friday lection from Hosea, which we have already quoted: 'after two days, he will revive us, on the third day he will raise us up that we may live before him'.[40] The third panel in the first row of small panels represents the Epiphany: the three wise men from the East acclaim Christ, shown forth to them by his mother Mary (Fig. 7.4).[41] In short, if the crucifixion panel implies a discussion of the ways in which Christ is revealed and recognised, this discourse is continued and developed in the other three panels of the top row on the door.

The audience in fifth-century Rome is likely to have been more responsive to the rich and complementary levels

Fig. 7.5 Early Medieval Rome Study Group, Rome, September 1994 (Photo: Niamh Whitfield)

Peter of Illyria, who 'fleeing the joys of this life, deserved to hope for the future [life]',[48] as in the life and death of St Peter, and in the basilica 'which you admire',[49] and where the people of God can now gather, Christ is to be known: as he was to be seen at the moment of his heroic death on the Cross, and also in the primitive Church, which, through the Spirit, he called together out of the Jews and the Gentiles.

The present argument suggests that the crucifixion panel, properly placed at the beginning of a whole 'page' of sculpted images in which Christ is to be known, functions as the initial 'sentence' of a fitting prologue to the whole Santa Sabina door. The prologue is now provided by the close progression between the four small panels at the top of the door. It is possible that this prologue, which announces a major theme in the panels of the door, was designed already in the fifth century. However, it would appear that this theory is now impossible to prove, and must remain a speculation. It is beyond the scope of the present paper to explore the ways in which the theme of epiphany or recognition is developed throughout the figural panels of the door, though it is of interest to note in passing that the panels include a representation of the Prophet Habakkuk.[50]

But future scholars of the door might, when exploring its iconography, take as their motto a further sentence of Jerome's interpretation of *in medio duorum animalium*: 'There are those who understand the two living creatures as the two Testaments, Old and New, who are truly living and full of life, who [can be said to] breathe [the Spirit], and in the midst of which the Lord may be known'.[51] After all, Christ himself had famously proclaimed that 'I am the entrance door, the way in'.[52]

Envoi (Fig. 7.5)

I hope that this contribution will remind Richard of a sunny afternoon in September 1994, when a group of (generally) vigorous, fit and (in varying degrees) distinguished medievalists trudged up the Aventine Hill. We had just visited the basilica of Santa Maria in Cosmedin in the Schola Graeca, which was once a *xenodochium* (building intended for the reception of pilgrims), between the Tiber and the Palatine hill. There, Rosemary Cramp had startled and delighted us by pointing out that the dimensions and layout of that early medieval basilica were similar to those of the monastic church

at Jarrow. Fortified by such authoritative evidence of how relevant the city of Rome could be to the world of Bede, the group then skirted the Circus Maximus and trudged up the Aventine to the basilica of Santa Sabina, where we admired and discussed the famous fifth-century wooden entrance door, and the splendid interior. That week, and subsequent publications (not least those of Richard Bailey) which built on the experience of Rome, were helpful in forming the modern scholarly consensus among Anglo-Saxonists that to understand the ecclesiastical cultures of Anglo-Saxon England, and in particular that of eighth-century Northumbria, the fascination in these cultures with the churches and liturgies of Rome needs to be taken into account.[53]

Notes

1 Bailey 2011.
2 Bede, *VCP* 10: duo ... quadrupedia quae uulgo lutraeae uocantur ... anhelitu suo pedes eius fouere coeperunt ... percepta ab eo benedictione patrias sunt relapsa sub undas (Colgrave 1940, 188–91).
3 Bede, *VCP* 10: canonicos cum fratribus ymnos hora competente compleuit (Colgrave 1940, 190–1).
4 Bede, *In Habacvc,* Incipit (Hudson 1983, 381; trans. Connolly 1997, 65).
5 bestiae et dracones.
6 cognoverunt in deserto salvatorem mundi.
7 Quacquarelli 1975.
8 Henderson 1999, 206; see Stancliffe above, 3–14, Fig. 1.1.
9 See Ó Carragáin 1986; 2005, 201–8.
10 Bailey 2011, 244; phrase from Habakkuk added. I offer this short paper in gratitude for Richard's presentation of important new evidence to confirm that the Canticle is relevant to Northumbrian art and hagiography, and for his continued support and friendship over many years.
11 Hornby 2009, 118–19.
12 Jeremias 1980, 16, 47.
13 Tiberia 2003, 26–33.
14 Psalm 18:6: In sole posuit tabernaculum suum et ipse tamquam sponsus procedens de thalamo suo exultavit ut gigas ad currendam viam suam. The motif is discussed by Ó Carragáin (2013, 257–60).
15 Jeremias 1980, 61. See also Foletti & Gianandrea 2015.
16 Cf John 19:34; Hausherr 1963.
17 Such early crucifixion scenes are reproduced in Tumminello 2003, 10–12.
18 Sheckler & Leith 2010.
19 Jeremias 1980, 60–3.
20 Tumminello 2003, 13.
21 Ibid., 14.
22 Jeremias 1980, 62–3.
23 Luke 23:33, 39–43.
24 Jerome, *In Mathevm* IV, 27, 44 (Adriaen & Hurst 1969, 272–3). This and other passages in Jerome and Ambrose are discussed by Courtray 2009, 105–16. Kelly (1975, 222), dates the commentary to AD 398.
25 Tumminello 2003, 14.

26 propter quod et Iesus ut sanctificaret per suum sanguinem populum extra portam passus est. Exeamus igitur ad eum extra castra inproperium eius portantes. Non enim habemus hic manentem civitatem sed futuram inquirimus.
27 The meaning of the phrase is discussed by Bailey 2011, 245–8; see also Ward 1993. Kelly (1975, 161), dates Jerome's translation of, and commentaries on, the Old Testament to AD 392–406.
28 Jerome, *In Abacvc* II, iii, 2: Vel certe admiratione turbatus, in laudes tuas trepidus erumpo dicens: *In medio duorum animalium cognosceris* ... Quae quidem et duo Seraphim in Esaia [6:2], et duo Cherubim, scribi interpretantur in Exodo [25:18], quae contra se respiciunt, et in medio habent oraculum; et in Esaia velantia caput et pedes Domini [cf 6:2], in praesenti tantum saeculo uolent, et alter ad alterum mysterium inclament Trinitatis, et mittatur unus de Seraphim, quod interpretatur ardens, et ueniat in terram et mundet prophetae labia, et dicat: *Ignem ueni mittere super terram, et quam uolo ut ardeat* [Luke 12:49]. Hoc aestimant alii, et ad hanc interpretationem multis scripturarum utuntur testimoniis. Porro simplex interpretatio, et opinio uulgi de Saluatore intellegit, quod inter duos latrones crucifixus agnitus sit. Qui autem melius, hoc dicunt, quod in prima Ecclesia quae de circumcisione fuit, et de praeputio congregata, duobus populis se hinc inde cingentibus, intellectus sit Saluator et creditus. Sunt qui duo animalia, duo intellegant testamenta, nouum et uetus, quae uere animantia sint, quae uitalia, quae spirent et in quorum medio Dominus cognoscatur (Adriaen 1970, 620–1; my translation).
29 Augustine, *De Civitate Dei* XVIII, 32: In oratione autem sua cum cantico cui nisi Domino Christo dicit: *Domine, audiui auditionem tuam, et timui; Domine, consideraui opera tua, et expaui?* Quid enim hoc est nisi praecognitae nouae ac repentinae salutis hominum ineffabilis admiratio? *In medio duorum animalium cognosceris* quid est nisi aut in medio duorum testamentorum, aut in medio duorum latronum, aut in medio Moysi et Heliae cum illo in monte sermocinantium? (Dombat & Kalb 1955, 623; trans. Bettenson 1972, 800). The passage is discussed in Bailey 2011, 382, n. 623.
30 On the basilica, see now Cavallaro 2009 and the essays in Cassanelli & Stolfi 2012.
31 See Baldovin 1987, 136, 148, 155.
32 On these Good Friday ceremonies, see Ó Carragáin 2005, 180–222.
33 Hosea 6:1–3: venite et revertamur ad Dominum. Quia ipse cepit et sanabit nos percutiet et curabit nos vivificabit nos post duos dies in die tertia suscitabit nos et vivemus in conspectu eius...
34 See Righetti 1959–69, 2, 221–31; Bernard 1996, 142–52; McKinnon 2000, 282, 288; and Hornby 2009, 17–22, 118–27.
35 On the early dating, see Righetti 1959–69, 2. 222–3; McKinnon 2000, 357–8; Hornby 2009, 9–11.
36 RESP. GRAD. Domine audivi auditum tuum et timui consideravi opera tua et expavi. V. In medio duorum animalium innotesceris dum adpropinquaverint anni cognosceris dum advenerit tempus ostenderis. V. In eo dum conturbata fuerit anima mea misericordiae memor ero. Deus a Libano veniet et sanctus de monte umbroso et condenso. V. Operuit caelos majestas ejus et laudis ejus plena est terra. (Hesbert 1985, 94–5, No. 78a; my translation).

37 Mark 15:27-28: Et cum eo crucifigunt duos latrones unum a dextris et alium a sinistris eius. Et adimpleta est scriptura quae dicit et cum iniquis reputatus est. Verse 28, with its prophecy based on Isaiah 53:12, is an interpolation from Luke 22:37. The interpolation, and hence the prophecy, was accepted in the Vulgate text of Mark.

38 Jeremias 1980, 77–80, pl. 67.

39 Ibid., 63–5, pl. 53.

40 Cf Hosea 6:2, quoted above, n. 33.

41 Jeremias 1980, 48–50, pl. 41.

42 The verse inscription is quoted, translated and analysed in Ó Carragáin 2008, 53–4. See Brandenburg 2005, 174–7, 301, figs 92a–b; Higgitt 2003.

43 haec qvae miraris.

44 pauperibvs locvples sibi pavper; vir nomine tanto dignvs.

45 ec[c]lesia ex circvmcisione.

46 ec[c]lesia ex gentibvs.

47 Above, n. 28.

48 praesentis fvgiens mervit sperare fvtvrvm.

49 Above, n. 43.

50 Jeremias 1980, 45–7, pl. 38.

51 Jerome, *In Abacvc* II, iii, 2 (quoted above, n. 28). I have inserted the words 'the Spirit' into my translation, because Jerome's punning phrase *quae spirent* is clearly intended to be read as multivalent: Jerome sees that the Old and New Testaments are alive and 'can be said to breathe' precisely because the Holy Spirit speaks through them.

52 John 10:9: ego sum ostium.

53 For a fine recent example, see Tinti 2014. The 1994 group included Richard Bailey, Rosemary Cramp and the late Jim Lang; also Jennifer and Terry O'Reilly, Damian Bracken, Jane Hawkes, Charles Doherty, Niamh Whitfield, Pat Wallace, Siobhán Cuffe Wallace and Tomás Ó Carragáin.

References

Adriaen, M. (ed.), 1970 *S. Hieronymi Presbyteri Opera, Pars I, Opera Exegetica 6, Commentariorvm in Abacvc Prophetam ad Chromativm,* in *Commentarii in Prophetas Minores,* CCSL 76A, pp 579–654 (Turnhout)

Adriaen, M., & Hurst, D. (ed.), 1969 *S. Hieronymi Presbyteri Opera, Pars I, Opera Exegetica 7, Commentariorvm in Mathevm Libri IV,* CCSL 77 (Turnhout)

Bailey, R.N., 2011 'In medio duorum animalium: Habakkuk, the Ruthwell Cross and Bede's life of St Cuthbert' in E. Mullins & D. Scully (ed.), *Listen, O Isles, unto Me. Studies in Medieval Word and Image in Honour of Jennifer O'Reilly* (Cork), pp 243–52

Baldovin, J., 1987 *The Urban Character of Christian Worship: the Origins, Development and Meaning of Stational Liturgy* (Rome)

Bernard, P., 1996 *Du chant romain au chant grégorien* (Paris)

Bettenson, H. (trans.), 1984 *St Augustine: Concerning the City of God against the Pagans* (Harmondsworth)

Brandenburg, H., 2005 *Ancient Christian Churches of Rome from the Fourth to the Seventh Centuries: the Dawn of Christian Architecture* (Turnhout)

Cassanelli, R. & Stolfi, E. (ed.), 2012 *Gerusalemme a Roma: la basilica di Santa Croce e le reliquie della Passione* (Milan)

Cavallaro, A., 2009 *Santa Croce in Gerusalemme* (Rome)

Connolly, S. (trans.), 1997 *Bede on Tobit and on the Canticle of Habakkuk* (Dublin)

Courtray, R., 2009 'La Figure des Deux Larrons chez Jérôme' in A. Cain & J. Lössl (ed.) *Jerome of Stridon: his Life, Writings and Legacy* (Farnham), pp 105–16

Dombat, B. & Kalb, A. (ed.) 1955 *Sancti Avrelii Avgvstini de civitate Dei libri I–X,* CCSL 48 (Turnhout)

Foletti, I. & Gianandrea, M., 2015 *Zona liminare: il nartice di Santa Sabina a Roma, la sua porta e l'iniziazione Cristiana* (Rome & Brno)

Hausherr, R., 1953 *Der Tote Christus am Kreuz: zur Ikonographie des Gerokreuzes* (Bonn)

Henderson, G., 1999 *Vision and Image in Early Christian England* (Cambridge)

Hesbert, R.-J., 1985 *Antiphonale Missarum Sextuplex* (Rome)

Higgitt, J., 2003 'Design and Meaning in Early Medieval Inscriptions in Britain and Ireland' in M. Carver (ed.), *The Cross goes North: Processes of Conversion in Northern Europe, AD 300–1300* (York & Woodbridge), pp 327–38

Hornby, E., 2009 *Medieval Liturgical Chant and Patristic Exegesis: Words and Music in the Second-Mode Tracts* (Woodbridge)

Hudson, J.E. (ed.), 1983 *Bedae Venerabilis Opera, Pars II: Opera Exegetica; in Habacvc,* CCSL 119B (Turnhout)

Jeremias, G., 1980 *Die Holztür der Basilika S. Sabina in Rom* (Tübingen)

Kelly, J.N.D., 1975 *Jerome: his Life, Writings, and Controversies* (London)

McKinnon, J.W., 2000 *The Advent Project: the Later-Seventh-Century Creation of the Roman Mass Proper* (Berkeley, CA)

Ó Carragáin, É., 1986 'Christ over the Beasts and the Agnus Dei: Two Multivalent Panels on the Ruthwell and Bewcastle Crosses' in P. Szarmach (ed.) *Sources of Anglo-Saxon Culture* (Kalamazoo, MI), pp 377–403

Ó Carragáin, É., 2005 *Ritual and the Rood: Liturgical Images and the Old English Poems of the 'Dream of the Rood' Tradition* (London & Toronto)

Ó Carragáin, É., 2008 'Who then Read the Ruthwell Poem in the eighth Century?' in C. Karkov & H. Damico (ed.) *Aedificia Nova: Studies in Honour of Rosemary Cramp* (Kalamazoo, MI), pp 43–75

Ó Carragáin, É., 2013 'Recapitulating History: Contexts for the Mysterious Moment of Resurrection on Irish High Crosses' in J. Hawkes (ed.) *Making Histories* (Donington), pp 246–61

Quaquarelli, A., 1975 *Il leone e il drago nella simbolica dell'età patristica* (Rome & Bari)

Righetti, M., 1959–69 *Manuale di storia liturgica,* 4 vols (Milan)

Sheckler, A.V. & Leith, M.J.W., 2010 'The Crucifixion Conundrum and the Santa Sabina Doors, *Harvard Theological Review* 103(1), 67–88

Tiberia, V., 2003 *Il mosaico di Santa Pudenziana a Roma* (Montelupino)

Tinti, F., 2014 *England and Rome in the Early Middle Ages: Pilgrimage, Art, and Politics* (Turnhout)

Tumminello, D., 2003 *La Crocifissione del portale di S. Sabina e le origini dell'iconologia della Crocifissione* (Rome)

Ward, B., 1993 'In Medio Duorum Animalium. Bede and Jerome on the Canticle of Habakkuk', *Studia Patristica* 25, 189–93

The body in the box: the iconography of the Cuthbert Coffin

Jane Hawkes

Introduction

It is not too excessive a claim to suggest that the Cuthbert Coffin (Fig. 8.1) is, for many reasons, central to our understanding of the art and archaeology of Anglo-Saxon and Viking-age England, presenting, as it does, an almost unique survival of carved wood that can be dated firmly (in itself an unusual phenomenon for the period) to the late seventh century, or more specifically, to the translation of the saint at Lindisfarne in 698.[1] It thus also presents us (again unusually in the context of Anglo-Saxon England), with an identifiable provenance. As Richard Bailey's work on the reliquary and its contents makes clear,[2] study of the Coffin is inherently interdisciplinary – something central to his approach to all aspects of the early medieval. The manufacture of the Coffin is recorded in the historical past

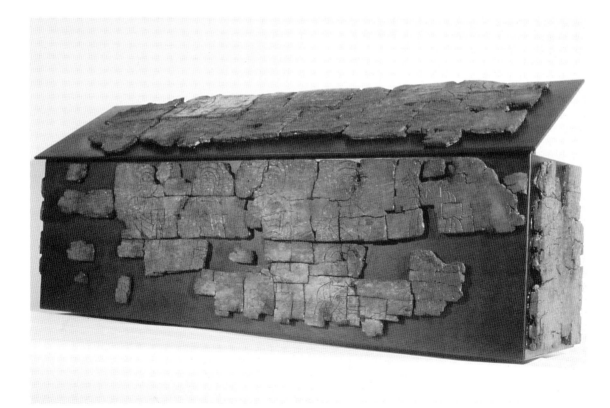

Fig. 8.1 Wooden coffin of St Cuthbert, 698 (Photo: by kind permission of the Dean and Chapter of Durham Cathedral)

by means of literary genres, the saint's *vitae* and historical chronicle,[3] as are its survival and travels through the north of England in the tenth century;[4] it re-emerged archaeologically in the early nineteenth century when it was excavated from under the floor of Durham Cathedral;[5] it has been presented epigraphically, linguisitically and art-historically following Raine's account of it in 1828,[6] Greenwell's subsequent study in 1899,[7] and the collection of essays brought together by Colonel Battiscombe in 1956 in an impressively large single volume that seems to come close to replicating the weight of the reliquary itself.[8] In this respect, the Cuthbert Coffin presents an object that reflects subjects central to the scholarship of Richard Bailey – and his students.

Historiography

Here, the Coffin will be re-assessed in the light of just one of these areas of study: art history – itself perhaps one of the most interdisciplinary of the discrete modern academic disciplines. Having said this, it is notable that this was not an aspect of the reliquary that concerned its makers or those venerating the remains of the saint within it in the late seventh and eighth centuries. As is usual in this period, no 'art' is discussed or presented in the historical sources recounting the death, burial, translation, relocation, representation and eventual entombment of Cuthbert in the sixteenth century, and as Richard Bailey has reconstructed the event, it was certainly not a great concern for those disinterring the remains in 1827.[9] Only Reginald of Durham, writing a generation after the 1104 translation of the coffin into the Norman Cathedral, mentions the fact that the original reliquary was 'engraved with most wonderful carving ... [in] fine in craftsmanship, [of] manifold forms of animals and flowers and the likenesses of men';[10] no other detail is forthcoming, and the absence of 'flowers' from the wooden coffin suggests that his account may not have been a record made from first-hand observation. Indeed, his account of the twelfth-century translation of the relics in the newly founded Norman Cathedral at Durham makes it clear that the late seventh-century coffin was wrapped in a 'coarse linen cloth soaked in wax',[11] which was placed in a second wooden container covered by hides and bound by iron,[12] with the two containers then being placed in a third, outer coffin decorated with gold and precious stones (*auro et gemmis*).[13] While (unsurprisingly) no such embellishment of the outer coffin was recovered at the time of the nineteenth-century excavation, evidence of the hides covering the second coffin were recovered, and pieces of coarse linen saturated in wax were found adhering to the innermost, original coffin.[14] It is extremely unlikely that Reginald was able to access the carving decorating that inner coffin; rather, his elucidation of the craftsmanship as being 'more consistent with a state of ecstasy than the knowledge or resources of a sculptor'[15] strongly suggests

that his account was inspired by the sanctity of the reliquary and its contents, rather than concern for 'art-historical' exactitude or relevance.

In fact, despite the extraordinarily long textual history of the Coffin,[16] its 'art history' was of little concern before Ernst Kitzinger's almost forensic reconstruction of the Coffin;[17] his analysis of the lightly engraved 'graffiti' on its surfaces constituted the first of the (relatively few) examinations of the coffin devoted to its art-historical aspects.[18] It was undertaken, for the most part, in keeping with the formalist (typological) art-historical approaches current at the time,[19] but through his impressively detailed examination of the stylistic features of the engravings (which he sourced in a variety of Mediterranean artistic traditions), he situated his findings within what was the first iconographic and iconological explanation of the coffin in keeping with the approach most famously set out by Panofsky in the 1950s.[20] By these means Kitzinger identified the possible iconographic sources for the schemes covering the coffin in (again) variously Eastern and Western Mediterranean depictions of the Magi and the *Majestas* of the Apocalypse.[21]

In the course of this extended excursus his greatest concern was perhaps the ways in which the Anglo-Saxon engravings failed to conform to what were then regarded as mainstream early Christian iconographic types. Thus, while he considered the evangelist symbols on the coffin lid to demonstrate access to 'one basic [iconographic] type ... of Latin art, made probably not earlier than the sixth century',[22] he deemed the central figure of Christ to have been adapted from 'scenic contexts', articulated by means of a 'classicism' of the 'dry, flat and academic kind which could be reduced easily to a linear design',[23] a style he located in 'Greek' art of the fifth and sixth centuries (Fig. 8.8).[24] In other words, he considered the scheme as a whole unlikely to have been inspired by a single model, largely because the symbols are set out in a way unrelated to each other or the figure of Christ.[25] Almost as an afterthought he postulated that the scheme, as a whole, could be explained as having derived from a model like that lying behind the Codex Amiatinus *Majestas*, but this, he considered to be 'of so hybrid a nature that the sources ... are hard to determine'.[26] Likewise, he tried to explain the iconographic sources of the Virgin and Child at the foot of the Coffin (Figs 8.2, 8.7), in the light of the miniature preserved in the Book of Kells, produced some two centuries later.[27] These he considered 'so similar in composition and detail' that it is 'well nigh impossible to deny the ... historical link between them', emerging as they do from an Insular context of 'the same period'.[28] In the light of the (perhaps inevitable) differences between the two schemes, Kitzinger deemed the manuscript image to reproduce the original prototype more faithfully than the Coffin engraving,[29] and, discounting any role of the icon types later identified as the *Eleousa* and *Hodegetria* in the formulation of the Mother and Child, he saw this model

reflected in that lying behind a miniature depicting the Adoration of the Magi preserved in an eleventh-century copy of Beatus' Commentary on the Apocalypse which shows the Child turned towards his mother.[30] He thus identified the iconographic prototype as an image of the Magi with likely Coptic origins, characterised by 'classical and realistic qualities' which the 'hard and barbaric "façade"' of the Insular versions 'should not prevent us from recognising'.[31] Furthermore, unable to defend the 'monotonous and stereotyped representation' of the apostles on one side of the Coffin (Figs 8.2, 8.4),[32] Klitzinger deemed them to have been adapted from the figures of the archangels at the head of the Coffin and down the other side (Figs 8.2, 8.5a, 8.6). Here, however, he noted that the engraving of Gabriel 'violated the rules of Mediterranean iconography' by holding a book in his left hand, rather than his right, while the staff-bearing central archangel on the long side was 'contrary to the rules of Early Christian iconography' because the staff was the almost exclusive attribute of Gabriel.[33] Yet, lying behind this 'unprepossessing appearance' of the archangels he saw evidence for a 'Mediterranean' iconographic model of 'classical character', which although 'definitely barbaric and probably Irish' had been transformed into 'pictorial translations of litanies', making them 'the most distinct Nordic feature in the imagery of the Coffin'.[34] Having identified the sources most likely to have influenced the Anglo-Saxon engravings, but faced with such consistent iconographic inconsistencies, Kitzinger concluded they were adapted to present a visual litany, based on his analysis of the inscriptions and ordering of the apostles and archangels on the long sides of the Coffin, that was intended to invoke protection for the relics contained within.

Addressing the iconographic inconsistences that had so taxed Kitzinger, Higgitt examined the portrayal of Peter on the coffin in an essay contributed to the 1987 conference proceedings commemorating the 1300th anniversary of the death of Cuthbert in 687.[35] Pointing to the depiction of the apostle (Fig. 8.4) as clean-shaven and tonsured, when the 'predominant, almost universal type' in early Christian art represented him as bearded with a full head of hair,[36] he demonstrated that the tonsured, clean-shaven figure was the 'universal type' in Anglo-Saxon (and indeed, Insular) art, apparently being selected to signify the alignment of the Church in the region to that of Rome, for whom Peter was *arbiter orbis*.[37] Building on Kitzinger's observations, Higgitt was able to show that, in this respect at least, the Coffin engravings demonstrate the tendency, apparent elsewhere in Anglo-Saxon art, for those responsible for ecclesiastical art works to create their own iconographic variations in keeping with the perceived needs of their own visual constructs.[38] Most recently Ní Ghrádaigh and Mullins have followed this line of questioning by focussing on the inscriptions and the litanies of the saints in the early Irish world to argue

that the Coffin can be understood as an Insular construct designed to act as a 'sacred vessel' of all the saints.[39]

While it is undoubtedly true that the engravings covering the surfaces of the Coffin do situate Cuthbert within a wider conceptual and potentially liturgical framework, it remains the case that it was made first and foremost as the container of Cuthbert's incorrupt body. It is with this in mind that the decoration will be examined further here, exploring the ways in which the engravings situate the body within, enclosing and enfolding the saint internally, through the low relief carvings applied externally over the surfaces of the three-dimensional object of the box.

The decoration of the coffin and its iconographic significances

It is, of course, now generally accepted that, at the time of its translation in 698, the incorrupt body of Cuthbert was placed in a light wooden chest (*levis theca*; Fig. 8.1),[40] on a base-board engraved with a stepped-base cross (Figs 8.2–3),[41] and covered by a board presenting an iconographic scheme with an apocalyptic frame of reference (Fig. 8.8), but which also referenced the apostolic mission to the four corners of the world of bearing witness to Christ and his salvation (by means of the Gospels of the four evangelists). Around his body were gathered the Virgin and Child, on the foot-board (Fig. 8.7), the two archangels, Michael and Gabriel, on the head-board (Fig. 8.5a), with another five on his right (Fig. 8.6), and the twelve apostles on his left (Fig. 8.4), with Peter and Paul by his head (Fig. 8.2).

Considered in this way, in the light of the body upon, and surrounded by, such 'wonderful carving', it is worth turning first to consider the engraving with which the saint was in almost immediate contact: the stepped-base cross (Figs 8.2–3) lying under the body, placed so that the head and shoulders figuratively lay over the *eaxlespanne* of the cross and the feet at its stepped base.[42] In this respect, the body of Cuthbert can be considered as having been laid on the cross in death, his incorrupt body *in imitatione Christi*, assuming the place of Christ's body on the Cross of the Crucifixion. Yet, as Bailey has pointed out,[43] the form of this particular cross, being stepped-based, functions not just as a sign of the Crucifixion, but also of the True Cross – the cross on which Christ died (historically), surrendering his human body for the sins of humanity. Taking this form, the stepped-base cross, perhaps inspiring compunction with more immediacy than might otherwise be the case, informs contemplation of the salvation and possibility of eternal life with a greater potency than that afforded by the general symbol of the cross.[44] The stepped-base cross was certainly a recognisable leitmotif of early religious who thought of themselves as bearing the Cross within their breast – not just upon it.[45] In this respect it is notable that Cuthbert's pectoral cross (Fig. 2.6) was borne next to his

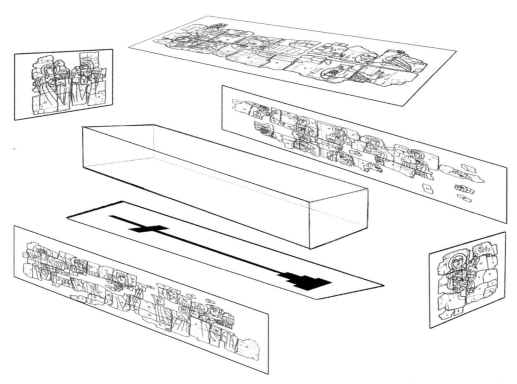

Fig. 8.2 Coffin of St Cuthbert, diagram showing relationship of carved panels to body within (Drawing: Heidi Stoner)

breast, under the winding cloths, so that when the remains were recovered in the nineteenth century it had come to bear the marks of the decaying body, in effect becoming subsumed into the saint.[46] Whether this was a personal possession, or donated later in the Anglo-Saxon period,[47] its position in relation to the body of Cuthbert points to the iconographically significant nature of the red garnets which are set in the cross without the hatched foil, with the result that they present a darker red, closer to blood, than is achieved by the cloisonné technique where the gold foil refracts light through the garnets, producing a bright and lightly shimmering faceted effect. Thus, although likely understood to be synonymous with the carbuncle of the Bible and late antique and early medieval lapidaries, which was understood to shine in the dark 'like a burning coal',[48] the garnets are presented in the pectoral cross as if they were sardonyx, the stone 'most like blood'.[49]

Regardless of such considerations, the stepped-base form of the outline cross engraved on the base-board of the Coffin would, apart from denoting the True Cross, also have been understood to have alluded to the jewelled cross set on the altar of the True Cross in Jerusalem by Theodosius in 417 – itself intended to reference the Cross of Calvary, the site it marked metaphorically in the complex established by Constantine to mark the Holy Sepulchre. Known in the Anglo-Saxon world through accounts of the *loca sancta* of Jerusalem,[50] this complex

was understood to stand at the notional centre of the world, a cross-topped column to the north marking the site where Christ would return at the time of the Second Coming; it thus marked the site of the General Resurrection of the dead at the end of time.[51] Through this matrix of associations the stepped-base cross 'supporting' the body of Cuthbert would thus have signified, through its invocation of the earthly (and therefore the heavenly) Jerusalem, not only the Crucifixion of Christ in the historic past, enacted by Cuthbert in death in the continual present of his incorrupt earthly existence, but also the future fulfilment of the salvation made possible by Christ's sacrifice, when time would cease to exist and Cuthbert would be seen confirmed in the community of saints.

Lying on the wooden cross, the material symbolically echoing the wood of the Crucifixion and actualising the past history of the earthly Crucifixion and Jerusalem, Cuthbert's body is situated in a vertical relationship with the jewelled pectoral cross on his breast, the jewelled cross itself bearing associations of the *crux gemmata* of the Second Coming, while above, on the lid, are the figures of Christ resurrected and the living creatures of the Apocalypse, and surrounding him is a sacred iconography of angels and apostles. He is thus caught between the past, earthly Crucifixion and the future, coming Judgement and the heavenly Jerusalem, lying literally between past and future references to salvation and their material and symbolic significances.[52]

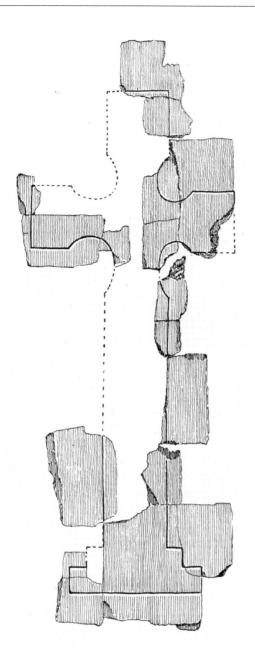

Fig. 8.3 Base panel of coffin of St Cuthbert with stepped-base cross (after Haverfield & Greenwell 1899, pl. 6)

Considering the body of Cuthbert thus laid out on the cross engraved on the base of the Coffin it is clear, as has long been recognised,[53] that he was placed physically within the community of saints in death, flanked on his left by the twelve apostolic saints (Figs 8.2, 8.4), and on his right and at his head, by the archangels of heaven (Figs 8.2, 8.5a, 8.6). Much has been made of the ways in which the arrangement of the apostles reflects litanies invoking their names in early Roman and early Irish liturgies,[54] but it is also worth noting that, far from being 'monotonous and stereotyped', the figures adopt poses marked by subtle variation: they half turn in different directions, right and left; some have their hair arranged with central partings while others do not; and each gestures towards the book held in his veiled left hand in slightly different ways, with some holding their hands open, others pointing to the book, and others still blessing them (Fig. 8.4). The way in which the nose of each figure is delineated indicates that John and Andrew are half-turned towards each other, as is the pair below them; likewise, Bartholomew and James incline their heads towards each other, as does the pair below them. The overall effect is one of gentle and constant movement oscillating backwards and forwards along the length of the panel. It is a movement, however, contained by the two pairs of apostles at each end who turn away from the others to face the ends of the Coffin: thus Peter and Paul turn in the direction of the archangels on the head-board, and the other two, possibly Simon and Thaddeus,[55] turn towards the Virgin and Child on the foot-board (Fig. 8.2). In this way Cuthbert is not only flanked by the apostles on his right, but they are arranged in such a way as to include the figures set at his head and feet, in a subtle but clear manner that transforms them from a single, discrete group, into a part of a greater community encircling and containing the body of the saint.

Here, it is notable that Peter and Paul are set at his head. As the considerable body of scholarship on the concept of wisdom in the early Middle Ages has demonstrated,[56] this was understood to be accessed through the eye, or eyes of the mind (*oculus (oculi) mentis*),[57] by means of reading and learning the authority of the scriptures and the writings of the Church Fathers. However, the setting of these two apostles also serves to point to association with the angelic

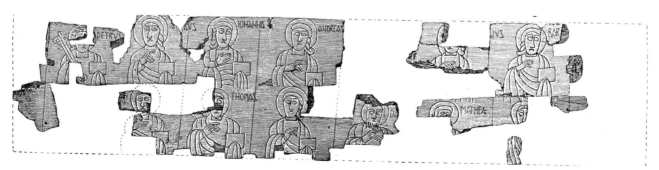

Fig. 8.4 Side panel of coffin of St Cuthbert with apostles (after Haverfield & Greenwell 1899, pl. 3)

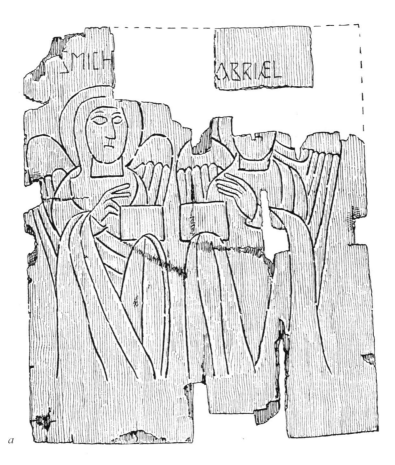

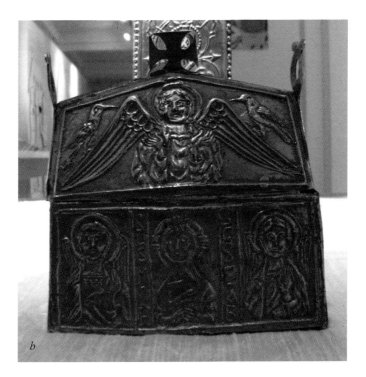

Fig. 8.5 (a) Head-board of coffin of St Cuthbert with Archangels Michael and Gabriel (after Haverfield & Greenwell 1899, pl. 4); (b) front panel of Mortain Casket (replica) showing Christ flanked by Archangels Michael and Gabriel (Photo: Jane Hawkes)

hosts of Heaven: with Gabriel, Michael and Raphael – this latter archangel placed to the right of Cuthbert's head, complementing Peter and Paul on his left, and, like the foremost of the apostles, Raphael turns in the direction of the head-board, as do all the archangels (Figs 8.2, 8.6). While the apostles hum with movement and variation, the archangels turn in unison towards the head of the Coffin, although their gestures, as far as can be determined, did vary in relation to the books held in their veiled left hands. But, further distinguishing the archangels on the side panel, not only from the apostles, but from all the other figures on the Coffin, the eyes of all five are punctuated with pupils; their gaze is accentuated. While this has the effect of signifying their role as witnesses,[58] it also serves to emphasise the angelic nature of sight, wisdom and bearing witness in relation to that borne by the apostles and evangelists. As has been discussed elsewhere,[59] the angels were unique in God's creation in being understood to combine the spiritual with the earthly; they resided in heaven where they functioned as attendants on the heavenly throne and were there able to gaze on the Divine, gaining wisdom from its source, but significantly, they also shared the gift of free will with humanity on earth. For Gregory the Great this unity between the human and angelic lay in the shared ability to contemplate the Divine, important because it was 'through the grace of contemplation [that men and angels] yearn to taste eternal blessedness'.[60] It involved 'awakening the perception of the mind by understanding that is moved from within',[61] and so enabled 'the spirit … to fix its eyes of faith on the single light of the Creator, because the God who created all things, brings to life'.[62] By this means the angels, 'in gazing always on the Unchangeable, are changed into immutability';[63] this was the nature of all the angelic hosts.

Yet, while discussion of the archangels has tended to focus on the litanies potentially circulating in the early Insular world,[64] universal to the early Church, and perhaps likely in the context of their setting on the Coffin in relation to the body within, was the understanding of Gabriel as the archangel of the Annunciation, the angel who, according to Luke 1:28–38, announced Christ's human incarnation to the Virgin and the forthcoming salvation that would be made possible through this event. Likewise, Michael was understood from an early period to be the angel of the Second

Coming, the angel of the Apocalypse, present at the Last Judgement, while Raphael was considered to be the angel of the Resurrection.[65] On the Coffin (Figs 8.2, 8.5a), Michael and Gabriel turn to face each other, Gabriel, continuing the directional gaze of Peter and Paul towards the centre of the head-board, Michael, continuing that of Raphael towards the same point, behind which lay Cuthbert's head, the site of the *oculi mentis*. The revealing gaze of the archangels, and the direction in which the foremost apostles are turned, all serve to focus on this point between Michael and Gabriel who, like book-ends, signify the beginning of human salvation and its fulfilment (the alpha and omega of a Christological history). In an analogous manner, bearing the host rather than books in their veiled hands, they flank the figure of Christ on the eighth-century house-shaped Mortain Casket (Fig. 8.5b), likely made to enshrine the eucharistic host, the body of Christ; as on the Coffin, Michael is on the viewer's left and Gabriel on the right.[66] At the head of the Coffin, they flank the head of Cuthbert in a casket enshrining the incorrupt body of the saint which itself bears witness to life everlasting made possible by means of the Incarnation. Furthermore, their setting at Cuthbert's head also serves to highlight that which is manifest in an ecclesiastic whose life has been lived according to a *regula pastoralis*, such as that set out by Gregory the Great – and the Cuthbert *vitae* demonstrate that this was the example of his life. According to this tradition wisdom (attained through the *oculi mentis*) was primary: wisdom which was intrinsically connected with prayer,[67] teaching and ministry (demonstrating a responsibility to be 'useful' to their fellows),[68] and the balance maintained between action and contemplation,[69] through 'chastity, abstinence, learning, forbearance, humility, bravery, compassion, benevolence and righteousness'.[70] The clustering of Michael and Gabriel, along with Raphael, Peter and Paul at the site of Cuthbert's head, together implies that attention was being deliberately drawn to this matrix of ideas both in relation to the individual (Cuthbert), and in terms of what his example could itself teach others.

Complementing this, at the feet of the saint who lived his life in this exemplary manner, are the full-length figures of the Virgin and Child, denoting the human, earthly aspect of Christ in bodily form (Figs 8.2, 8.7). As was outlined by Kitzinger, this was the symbolic function of the scheme,

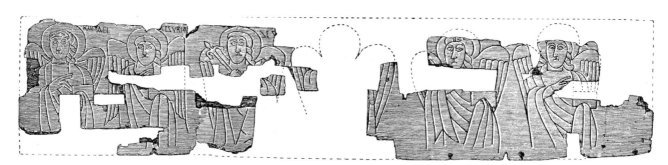

Fig. 8.6 Side panel of coffin of St Cuthbert with archangels (after Haverfield & Greenwell 1899, pl. 2)

even if, in his opinion, it failed to denote the humanity of the Child as successfully as was achieved in the Kells miniature, the forwards-facing aspect of the heads of the Virgin and Christ on the Coffin 'merely [conforming] to a great many other representations of the Christ Child in early medieval art'.[71] As I have argued elsewhere,[72] however, the *contraposto* arrangement of the bodies of mother and child do articulate the humanity of Christ achieved through the Virgin, while the forwards-facing pose of the Child (again denoted by the delineation of the nose, this time viewed face on) speaks to his Divine nature, enthroned as he is on his mother's lap while she, also gazing outwards rather than turning towards him, further underlies the supra-human nature of the Child. The way in which the lower half of the bodies are entwined together while the torsos turn away from each other successfully signifies the relationship between the two, denoting Christ's human condition, born of the Virgin in order to suffer under Pontius Pilate and die on the cross, while at the same time signifying his future Resurrection from the dead and Ascension into heaven.

The manner in which they are posed also continues the movement of the engraved figures encircling Cuthbert, while marking its starting and end point (Fig. 8.2). As noted, the two apostles at the foot of the Coffin turn in the direction of the foot-board, their gaze directed towards the human Child by Cuthbert's left foot; the manner in which the Child's body is turned in profile continues the direction of that movement. At Cuthbert's right foot, adjacent to the archangels who

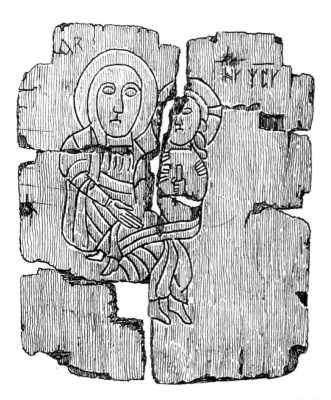

Fig. 8.7 Foot-board of coffin of St Cuthbert with Virgin and Child (after Haverfield & Greenwell 1899, pl. 5)

turn towards the head of the saint's body, is the Virgin, the lower half of whose body turns towards the apostles, the disciples of his human ministry, but who was informed of the Incarnation by Gabriel, set at the right of Cuthbert's head. Thus, while the earthly bodies of the Virgin and Child continue the directional movement of figures around the saint within, their gaze remains static, assuming the aspect of that presented in figural images known as icons, most familiarly painted on (but not limited to),[73] the wooden boards set up within churches. In these contexts it has long been accepted that the function of such images was to inspire the viewer to contemplation of that represented by the figure (or action) displayed before them – to contemplate the spiritual and immaterial which lies beyond the material surface of the image – and by this means achieve understanding of, and spiritual union with, the Divine.[74]

Sharing this aspect is the figure of the *Majestas*, Christ Resurrected, on the lid (Figs 8.2, 8.8), whose body overlies that of Cuthbert below, his head notionally above that of the saint. While Kitzinger was unable to identify a single iconographic source for the scheme depicted on the board covering the 'light chest' containing Cuthbert, it can be understood to depict the visionary appearance of Christ in heaven, who will rule in eternity in future at the end of time when heaven is re-established on earth, the beasts of the heavenly throne circling his throne and forever praising him with the angelic anthem: 'Holy, Holy, Holy'.[75] The naming of these winged and haloed beasts, however, along with their books, makes clear their shared identity as symbols of the human evangelists, while their placement in the corners of the panel further calls to mind the mission to the apostles to bear witness to Christ's salvation to the far corners of the world. This was a mission that was considered to have particular relevance to the Insular world. Recent work by Diarmuid Scully, for instance, has demonstrated the early medieval currency of the idea of the islands of Britain as existing on the northern edge of the known world,[76] with the concomitant understanding that the incorporation of these islands into the Church would make it truly universal and thus bring the world to a state of preparation for the Second Coming; it is an idea long recognised in the work of Bede in his commentary on Genesis.[77] Situated over the body of Cuthbert, priest and bishop of the Church in Anglo-Saxon England and thus, according to Bede, a pillar of the Church,[78] the iconographic scheme of the Coffin lid not only alludes to the General Resurrection at the end of time, when the body of Cuthbert will be reunited with his spirit, as was demonstrated by the Resurrection of Christ, it also refers to his role within the Church that would bring about that consummation.

Summary

The manner in which the engraved motifs and inscriptions are placed around the body of Cuthbert, above and below him, situates him in a three-dimensional space and,

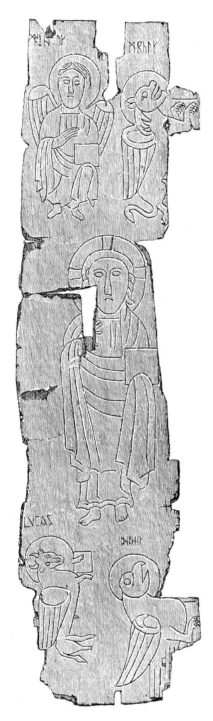

Fig. 8.8 Lid of coffin of St Cuthbert with Christ in Majesty and four evangelist symbols (after Haverfield & Greenwell 1899, pl. 1)

which enabled this was made possible by his birth through the Virgin, foretold by the Archangel Gabriel, celebrated by the angelic hosts over Bethlehem; resurrected bodily he was borne into heaven at the Ascension: 'from whence he will come to judge both the quick and the dead'. In other words, Cuthbert is set at the centre of the salvific history of the world. Vertically, the carved decoration situates Cuthbert temporally within a past history and a future time; surrounding him, the implications of this are explored in relation both to the saint himself and to humanity generally.

Furthermore, because of the way in which the iconographic references of the carving are situated in three dimensions, Cuthbert can also be understood as being placed within a container in a manner that echoes the way in which world was perceived. At its centre lay Jerusalem, and in the middle of that city was the site of both Christ's Crucifixion, marked by a stepped-base cross, and of his Resurrection and that of all humanity at the end of time. Around this point were the regions of the created world, those furthest removed from Jerusalem being 'at the corners', while encircling this world were the heavens, the region inhabited by the stars, God and his angels – the site of the heavenly Jerusalem 'not made by human hands',[80] into which the faithful will be subsumed at the time of the Second Coming, and in whose company is, and will be, Cuthbert.

The lightly engraved decoration of the *levis theca* constructed to contain Cuthbert thus situates and presents him, locally and temporally, but also universally and eternally, enabling the confines of the container to be transcended. Furthermore, despite its 'graffito' technique, the engraved decoration comments on the human saint as the *locus* through which all humans may access the uncontained space of eternal life. In this way the saint becomes the 'image' (*icon*), the 'living writing' (*viva scriptura*), as Bede put it in his defence of images in *De Templo*,[81] through which understanding of the Divine is accessed and made possible.

Abbreviations

H.Ez: Gregory the Great, *Homiliae in Hiezechihelem Prophetam* (Adriaen 1971)

Libellus: Reginald of Durham, *Reginaldi Dunelmensis Libellus de Admirandis Beati Cuthberti Virtutibus* (Raine 1835)

RP: Gregory the Great, *Regula Pastoralis* (Rommel 1992)

Notes

1 *VCA* IV, 14 (Colgrave 1940, 130–3); *VCP* 42–3 (Colgrave 1940, 290–7); Battiscombe 1956b, 22; Higgitt 1987, 268; although see Cronyn & Horie 1989, 256; Cambridge 2015, 115.

2 Bailey 1989; 1995.

3 E.g. *VCA* (Colgrave 1940, 59–139); *VCP* (Colgrave 1940, 141–307); *HE* IV, 29–30 (Colgrave & Mynors 1969, 438–45).

metaphorically, at the centre of the history of salvation played out around his mortal remains: Cuthbert died as a human being; as a saint he is presented in communion with the apostolic saints and angelic hosts in heaven;[79] a phenomenon made possible by Christ's death on the Cross, a way that Cuthbert chose to follow in life, and was presented as such in death; while Christ's human condition

4 Simeon of Durham, *Libellvs de Exordio atqve Procvrsv Istivs, hoc est Dvnhelmensis, Ecclesie* II, 5–III, 4 (Rollason 2000, 87–155).

5 Raine 1828, 180–216; Austen 1929.

6 Raine 1828, 180–216.

7 Haverfield & Greenwell 1899, 133–56; see also Fowler 1900.

8 Battiscombe 1956a (the volume weighs 4.5kg); see also Kitzinger 1950; for the most recent study, concentrating on the inscriptions, see Ní Ghrádaigh & Mullins 2013.

9 Bailey 1989; Battiscombe 1956b, 2.

10 *Libellus* XLIII: … praemirabili caelatura desculpitur … minuti ac subtilissimi operis … diversa bestiarum, florum, sive ymaginum … videntur inseri … (Raine 1835, 90), written between 1165 and 1172; Anonymous account of 1104 (Hodgson-Hinde 1868, 188–97); Battiscombe 1956b, 3, 99–114; Ní Ghrádaigh & Mullins 2013, 76.

11 *Libellus* XLII: … pannus tertius, totus undique cera infusus, praeminebat … (Raine 1835, 89); see also Haverfield & Greenwell 1899, 136; Battiscombe, 1956b, 6; Ní Ghrádaigh & Mullins 2013, 87.

12 *Libellus* XLIII (Raine 1835, 90); Battiscombe 1956b, 3.

13 *Libellus* XLIII (Raine 1835, 90); Battiscombe 1956b, 3.

14 Ibid., 5–7.

15 *Libellus* XLIII: plus stupori quam scientiae aut possibilitati sculptoris convenire credatur. (Raine 1835, 90). This is not to say that he could have known personally, and accurately recorded the recollections of, those who had witnessed the 1104 translation.

16 See also Rollason 1989, 51–4.

17 Kitzinger 1956, 203–17.

18 Graffiti is the term used by Kitzinger 1956, 298; cf Ní Ghrádaigh & Mullins 2013, 77.

19 Battiscombe 1956b, 15.

20 Panofsky 1955. It had, nevertheless, been put into practice earlier by Saxl, with whom Kitzinger (1956, 202) consulted in the course of preparing his study of the Coffin, and Schapiro in the 1940s in relation to other Anglo-Saxon carvings: namely, the crosses at Ruthwell (Dumfriesshire) and Bewcastle, Cumberland (Saxl 1943; Schapiro 1944).

21 Kitzinger 1956, 242–80, esp. 278; 1950 [unpaginated].

22 Kitzinger 1956, 241.

23 Ibid., 244.

24 Ibid., 248.

25 Ibid., 245.

26 Florence: Biblioteca Medicea Laurenziana, MS Amiatinus I, fol. 796v: Kitzinger 1956, 247; see further, Bruce-Mitford 1967; Nordhagen 1977.

27 Dublin: Trinity College Library, MS 58, fol. 7v: Meehan 2012, 19–21; see also Kitzinger 1956, 249–62.

28 Ibid., 261.

29 Ibid., 250.

30 Turin: Biblioteca Nazionale, MS Lat. 93, fol. 14v; ibid., 252, and 256, where he drew attention to another eleventh-century manuscript illustration of the Magi preserved in the Bristol Psalter (London: British Library, Add. MS 40731, fol. 115v).

31 Ibid., 260.

32 Ibid., 266.

33 Ibid., 275.

34 Ibid., 278–9.

35 Higgitt 1987.

36 Jameson 1890, i, 187–8.

37 Bede, *HE* V, 19 (Colgrave & Mynors 1969, 528).

38 See further e.g., Bailey 1996, 59–76, 117–24; Hawkes 1993; 1996; 1997.

39 Ní Ghrádaigh & Mullins 2013.

40 *VCP* 42 (Colgrave 1940, 294); Battiscombe 1956b, 1–22; Kitzinger 1956, 221–3; Cronyn & Horie 1985, 1–8.

41 Bailey 1989, 238–43; Cronyn & Horie 1989, 247.

42 *Dream of the Rood*, line 9 (Swanton 1970, 89). Given the narrow dimensions of the Coffin (460mm high, 410>380mm wide, and 1.69m long), it is generally assumed that the body itself was set in it at a slight angle.

43 Bailey 1989, 241–3.

44 Baker 2011, 81–139.

45 Maddern 2013; Fleming 1966.

46 Raine 1828, 211; Kendrick 1937, 283; Battiscombe 1956b, 15–18; Bruce-Mitford 1956, 309, 315; Coatsworth 1989, 296.

47 Cambridge 2015, 118–19; see further below, Gittos 131.

48 *Old English Lapidary*, line 12: carbunculus … is bymende glede gelic (Kitson 1978, 32).

49 *Old English Lapidary*, lines 7–8: sardius … is luttran blode gelic (ibid., 32). See further, Bede, *In Genesim*, I (Jones 1967, 49–50); see also Isidore, *Etymologiae* XVI, xvi.1 (Barney et al. 2002, 326); Augustine: *De Doctrina Christiana* xvi (Martin 1962, 50); for discussion see Kitson 1978, 22, 32–3; 1983; Garrett, 1909.

50 Adomnán, *DLS* I, 5 (Meehan 1958, 48–9; Bede, *DLS* II, 2 (Fraipont 1965, 256); Bailey 1996, 46–7; Wood 2006, 8–11; Maddern 2013, 214.

51 See, e.g. Hawkes 2006; O'Loughlin 2012; Delano-Smith 2012.

52 I am grateful to my colleague, Dr Meg Boulton, for discussion on this topic.

53 See, e.g. Kitzinger 1956, 265–80; Higgitt 1989, 284–5; Ní Ghrádaigh & Mullins 2013.

54 Kitzinger 1956, 265–80; cf 1950; Ní Ghrádaigh & Mullins, 2013.

55 Kitzinger 1956, 269; Ní Ghrádaigh & Mullins 2013, 86.

56 For summary, see Kempshall 2001.

57 *RP* I, 9; I, 11; III, 35; IV, 1 (Rommel, 1992, 158; 164; 512; 538). For the impact of this text in late seventh- to early eighth-century Northumbria, see, e.g. Bede, *Epistola ad Ecgbertum* (Grocock & Wood 2013, 123–61); *HE* II, 17–18 (Colgrave & Mynors 1969, 194–6); see also general discussion in Pulliam 2013; and Kempshall 2001 for its influence in contemporary Irish literature.

58 Ní Ghrádaigh & Mullins 2013, 80.

59 Mayr-Harting 1998; Hawkes 2007, 441–2.

60 *H.Ez.* I, iv, 4: per contemplationis gratiam aeternam iam beatitudinem degustare concupiscunt (Adriaen 1971, 50; trans. Gray 1990, 43).

61 *H.Ez.* I, viii, 12: Sicut auditus corporis excitatur uoce, ita sensus mentis excitatur intellectu, qui de interioribus agitur (Adriaen 1971, 108; trans. Gray 1990, 83).

62 *H.Ez.* I, viii, 16: In solo Creatoris sui lumine fidei oculos figat, quod unus uiuificet omnia qui creauit Deus (Adriaen 1971, 109; trans. Gray 1990, 84).

63 *H.Ez.* I, viii, 15: aspicientes semper incommutabilem mutati sint in incommutabilitatem (Adriaen 1971, 109; trans. Gray 1990, 84).

64 Kitzinger 1956, 269–79; Ní Ghrádaigh & Mullins 2013, 80.

65 On Raphael in this context, see Ní Ghrádaigh & Mullins 2013, 80.

66 For summary of scholarship see Webster & Backhouse 1991, 175–6, cat. 137.

67 *RP* II, 1, 7, 11 (Rommel & Morel 1992, 174, 218–30, 252).

68 *RP* I, 1, 5, 6; II, 4; III, 25 (Rommel & Morel 1992, 128–32, 144–8, 150, 186–204, 428–38).

69 E.g., *RP* I, 9; II, 5; III, 28, 32, 34 (Rommel & Morel 1992, 158–60, 200, 464, 492, 508); see also Proverbs 23:34; Stancliffe 1989.

70 Kempshall 2001, 115.

71 Kitzinger 1956, 262.

72 Hawkes 1997.

73 See e.g. Hawkes 2013.

74 E.g., Belting 1994, 11; for summary see e.g. Hawkes 2013, 45–50.

75 E.g., Ezekiel 1; Revelation 4, *passim*; see Cronin 1995; Baker 2011, 30–5.

76 Scully 2009; 2011a; 2011b; 2015; see also Bracken 2009.

77 Jones 1967; 1969.

78 *De Templo* II (Hurst 1969, 198–9; trans. Connolly 1995, 74–5); see also Deshman 1986, 273–8; O'Reilly 1994; O'Reilly 1995, xliv–xlvi.

79 See further, Gameson 2015, 129.

80 Hebrews 9:11–12:24; see discussion in O'Reilly 1995, xx.

81 *De Templo*, II (Hurst 1969, 213; trans. Connolly 1995, 91–2).

References

Adriaen, M. (ed.), 1971 *Sancti Gregorii Magni Homiliae in Hiezechihelem Prophetam*, CCSL 142 (Turnhout)

Ashbee, J. & Luxford, J. (ed.), 2013 *Newcastle and Northumberland: Roman and Medieval Architecture and Art*, BAA Conference Trans. 36 (Leeds)

Austen, Rev. Chancellor, 1929 'The Story of Saint Cuthbert', *Yorkshire Herald*, 23 July (n.p.)

Bailey, R.N., 1989 'St Cuthbert's Relics: Some Neglected Evidence' in Bonner et al. 1989, pp 231–46

Bailey, R.N., 1995 'St Oswald's Heads' in C.E. Stancliffe & E. Cambridge (ed.), *Oswald: Northumbrian King to European Saint* (Stamford), pp 195–209

Bailey, R.N., 1996 *England's Earliest Sculptors* (Toronto)

Baker, N., 2011 'The Evangelists in Insular Culture, *c.*600–*c.*800 AD' (PhD, 2 vols, University of York)

Barney, S.A., Beach, J.A. & Berghof, O. (trans.), 2002 *The Etymologies of Isidore of Seville* (Cambridge)

Battiscombe, C.F. (ed.), 1956a *The Relics of Saint Cuthbert* (Oxford)

Battiscombe, C.F., 1956b 'Introduction' in Battiscombe 1956a, pp 1–114

Belting, H., 1994 *Likeness and Presence. A History of the Image before the Era of Art* (Chicago, IL)

Bonner, G., Rollason, D. & Stancliffe, C. (ed.), 1989 *St Cuthbert, his Cult and his Community to AD 1200* (Woodbridge)

Bracken, D., 2009 'Rome and the Isles: Ireland, England and the Rhetoric of Orthodoxy' in Graham-Campbell & Ryan 2009, pp 75–98

Breay, C. & Meehan, B. (ed.), 2015 *The St Cuthbert Gospel: Studies on the Insular Manuscript of the Gospel of John (BL, Additional MS 89000)* (London)

Bruce-Mitford, R.L.S., 1956 'The Pectoral Cross' in Battiscombe 1956a, pp 308–25

Bruce-Mitford, R.L.S., 1967 *The Art of the Codex Amiatinus*, Jarrow Lecture (Jarrow)

Cambridge, E., 2015 'Reconsidering Cuthbert's Relics' in Breay & Meehan 2015, pp 115–27

Coatsworth, E., 1989 'The Pectoral Cross and Portable Altar from the Tomb of St Cuthbert' in Bonner et al. 1989, pp 287–302

Connolly, S. (trans.), 1995 *Bede: On the Temple* (Liverpool)

Cronin, J., 1995 'The Evangelist Symbols as Pictorial Exegesis' in C. Bourke (ed.), *From the Isles of the North: Early Medieval Art in Ireland and Britain: Proceedings of the Third International Conference on Insular Art held in the Ulster Museum, Belfast, 7-11 April, 1994* (Belfast), pp 111–17

Cronyn. J.M. & Horie, C.V., 1985 *St Cuthbert's Coffin: the History, Technology and Conservation* (Durham)

Cronyn, J.M. & Horie, C.V., 1989 'The Anglo-Saxon Coffin: Further Investigation' in Bonner et al. 1989, pp 247–56

Delano-Smith, C., 2012 'The Exegetical Jerusalem: Maps and Plans for Ezekiel Chapters 40–48' in Donkin & Vorholt 2012, pp 41–76

Deshman, R., 1986 'The Imagery of the Living Ecclesia and the English Monastic Reform' in P.E. Szarmach (ed.), *Sources of Anglo-Saxon Culture* (Kalamazoo, MI), pp 261–82

Donkin, L. & Vorholt, H. (ed.), 2012 *Imagining Jerusalem in the Medieval West* (Oxford)

Fleming, J.V., 1966 'The Dream of the Rood and Anglo-Saxon Monasticism', *Traditio* 22, 43–72

Fowler, J.T., 1900 'On an Examination of the Grave of St Cuthbert in Durham Cathedral Church', *Archaeologia* 57, 11–28

Fraipont, J. (ed.), 1965 *Bedae Venerabilis De Locis Sanctis* in *Itineraria et alia geographica*, CCSL 175 (Turnhout), pp 245–80

Gameson, R., 2015 'History of the Manuscript to the Reformation' in Breay & Mehan 2015, pp 129–36

Garrett, R.M., 1909 *Precious Stones in Old English Literature* (Leipzig)

Graham-Campbell, J. & Ryan, M. (ed.), 2009 *Anglo-Saxon/Irish Relations before the Vikings: Proceedings of the British Academy and Royal Irish Academy Joint Symposium, 10–12 October, 2005*, Proc. British Academy 157 (Oxford)

Gray, T. (trans.), 1990 *The Homilies of Saint Gregory the Great on the Book of the Prophet Ezekiel* (Etna, CA)

Grocock, C.W. & Wood, I.N. (ed. and trans.), 2013 *The Abbots of Wearmouth and Jarrow: Bede's Homily i. 13 on Benedict Biscop, Bede's History of the Abbots of Wearmouth and Jarrow, the Anonymous Life of Ceolfrith, Bede's Letter to Ecgbert, Bishop of York* (Oxford)

Haverfield, F.J. & Greenwell, W., 1899 *A Catalogue of the Sculptured and Inscribed Stones in the Cathedral Library* (Durham)

Hawkes, J., 1993 'Mary and the Cycle of Resurrection: the Iconography of the Hovingham Panel' in M. Spearman &

J. Higgitt (ed.), *The Age of Migrating Ideas* (Edinburgh), pp 254–60

Hawkes, J., 1996 'The Rothbury Cross: an Iconographic Bricolage', *Gesta* 35, 73–90

Hawkes, J., 1997 'Columban Virgins: Iconic Images of the Virgin and Child in Insular Sculpture' in C. Bourke (ed.), *Studies in the Cult of Saint Columba* (Dublin), pp 107–35

Hawkes, J., 2006 'The Anglo-Saxon Legacy' in E. Hartley, J. Hawkes & M. Henig (ed.), *Constantine the Great: York's Roman Emperor* (London), pp 104–14

Hawkes, J., 2007 'Gregory the Great and Angelic Mediation: the Anglo-Saxon Crosses of the Derbyshire Peaks' in A. Minnis & J. Roberts (ed.), *Text, Image, Interpretation: Studies in Anglo-Saxon Literature and its Insular Context in Honour of Éamonn Ó Carragáin* (Turnhout), pp 431–48

Hawkes, J., 2013 'Stones of the North: Sculpture in Northumbria in "The Age of Bede"' in Ashbee & Luxford 2013, pp 34–53

Higgitt, J., 1987 'The Iconography of St Peter in Anglo-Saxon England, and St Cuthbert's Coffin' in Bonner et al. 1987, pp 267–86

Hodgson-Hinde, J. (ed.), 1868 *Symeonis Dunelmensis Opera et Collectanea* 1 (Durham)

Hurst, D. (ed.), 1969 *Bedae Venerabilis De Templo in Bedae Venerabilis Opera, Pars II, Opera Exegetica 2A*, CCSL 119A (Turnhout), pp 141–234

Jameson, Mrs A., 1890 *Sacred and Legendary*, 2 vols (London)

Jones, C.W. (ed.), 1967 *Bedae Venerabilis Opera. Pars II, Opera Exegetica, 1: Libri qvatvor in principivm Genesis vsqve ad nativitatem Isaac et eiectionem Ismahelis adnotationvm*, CCSL 118A (Turnhout)

Jones, C.W., 1969 'Some Introductory Remarks on Bede's Commentary on Genesis', *Sacris Erudiri* 19, 115–98

Kempshall, M., 2001 'No Bishop, No King: the Ministerial Ideology of Kingship and Asser's *Res Gestae Aefredi*' in R. Gameson & H. Leyser (ed.), *Belief and Culture in the Middle Ages: Studies presented to Henry Mayr-Harting* (Oxford), pp 106–27

Kendrick, T.D., 1937 'St Cuthbert's Pectoral Cross, and the Wilton and Ixworth Crosses', *Antiquaries J.* 17, 283–93

Kitson, P., 1978 'Lapidary Traditions in Anglo-Saxon England: Part I, the Background; the Old English Lapidary', *ASE* 7, 9–60

Kitson, P., 1983 'Lapidary Traditions in Anglo-Saxon England: Part II, Bede's *Explanatio Apocalypsis* and Related Works', *ASE* 12, 73–123

Kitzinger, E., 1950 *The Coffin of Saint Cuthbert* (Oxford)

Kitzinger, E., 1956 'Coffin Reliquary' in Battiscombe 1956a, pp 203–304

Maddern, C., 2013 *Raising the Dead: Early Medieval Name Stones in Northumbria* (Turnhout)

Martin, J. (ed.), 1962 *Sancti Avrelii Avgvstini de doctrina Christiana; de vera religione*, CCSL 32 (Turnhout)

Mayr-Harting, H., 1998 *Perceptions of Angels in History* (Oxford)

Meehan, B., 2012 *The Book of Kells* (London)

Meehan, D. (ed.), 1958 *Adamnan's De Locis Sanctis*, Scriptores Latini Hiberniae 3 (Dublin)

Ní Ghrádaigh, J. & Mullins, J., 2013 'Apostolically Inscribed: St Cuthbert's Coffin as Sacred Vessel' in Ashbee & Luxford 2013, pp 73–89

Nordhagen, P.J., 1977 *The Codex Amiatinus and the Byzantine Element in the Northumbrian Renaissance*, Jarrow Lecture (Jarrow)

O'Loughlin, T., 2012 'Adomnán's Plans in the Context of his Imagining "the most famous City"' in Donkin & Vorholt 2012, pp 15–40

O'Reilly, J., 1994 'Exegesis and the Book of Kells: the Lucan Genealogy' in F. O'Mahony (ed.), *The Book of Kells* (Aldershot), pp 344–97

O'Reilly, J., 1995 'Introduction' in Connolly 1995, pp xvii–lv

Panofsky, E., 1955 *Iconography and Iconology: an Introduction to the Study of Renaissance Art* (New York)

Pulliam, H., 2013 'Eyes of Light: Colour in the Lindisfarne Gospels' in Ashbee & Luxford 2013, pp 54–72

Raine, J., 1828 *St Cuthbert, with an Account of the State in which his Remains were found upon the Opening of his Tomb in Durham Cathedral, in the Year 1827* (Durham)

Raine, J. (ed.), 1835 *Reginald of Durham, Libellus de Admirandis beati Cuthberti Virtutibus quae novellis patratae sunt Temporibus,* Surtees Society 1 (Oxford)

Rollason, D., 1989 *Saints and Relics in Anglo-Saxon England* (Oxford)

Rollason, D. (ed. & trans.), 2000 *Symeon of Durham: Libellvs de Exordio atqve Procvrsv Istivs, hoc est Dvnhelmensis, Ecclesie* (Oxford)

Rommel, F. & Morel, C. (ed. and trans.), 1992 *Grégoire le Grand Règle pastorale*, Sources Chrétiennes 381–2 (Paris)

Saxl, F., 1943 'The Ruthwell Cross', *J. Warburg and Courtauld Institutes* 6, 1–19

Schapiro, M., 1944 'The Religious Meaning of the Ruthwell Cross', *Art Bulletin* 26, 232–45

Scully, D., 2009 'Bede's *Chronica Maiora*: Early Insular History in a Universal Context' in Graham-Campbell & Ryan 2009, pp 47–73

Scully, D., 2011a 'Proud Ocean has become a Servant: a Classical *Topos* in the Literature on Britain's Conquest and Conversion' in E. Mullins & D. Scully (ed.), *Listen, O Isles, Unto Me: Studies in Medieval Word and Image in Honour of Jennifer O'Reilly* (Cork), pp 3–15, with notes at pp 313–18

Scully, D., 2011b 'Location and Occupation: Bede, Gildas and the Roman Vision of Britain' in J. Roberts & L. Webster (ed.), *Anglo-Saxon Traces* (Tempe, AZ), pp 243–72

Scully, D., 2015 'Ends of Empire and the Earth: Themes of Transition and the Orkney Islands from Antiquity to Bede', in M. Boulton & J. Hawkes (ed.), *The Art, Literature and Material Culture of the Medieval World: Transition, Transformation and Taxonomy* (Dublin), pp 125–37

Stancliffe, C., 1989 'Cuthbert and the Polarity between Pastor and Solitary' in Bonner et al. 1989, pp 21–44

Swanton, M. (ed.), 1970 *The Dream of the Rood* (Manchester)

Webster, L. & Backhouse, J. (ed.), 1991 *The Making of England: Anglo-Saxon Art and Culture, AD 600–900* (London)

Wood, I., 2006 'Constantinian Crosses in Northumbria', in C.E. Karkov, S.L. Keefer & K.L. Jolly (ed.), *The Place of the Cross in Anglo-Saxon England* (Woodbridge), pp 3–13

9

Reading the Trinity in the Harley Psalter

Catherine E. Karkov

The Harley Psalter is one of the great manuscripts and yet also one of the great puzzles of Anglo-Saxon art.[1] Scholarship has focussed on its place in the development of English psalter illumination, its scribes and artists, its vivid outline drawings, the sequence of its production, its relationship to the Carolingian Utrecht Psalter,[2] and its place in the so-called Utrecht Tradition.[3] For all that, however, we still do not know why or for whom it was begun, why it suffered times of neglect and was worked on sporadically by such a varied team of artists and scribes working in markedly different styles and hands, or why it was ultimately abandoned unfinished. This paper proposes to answer none of these questions;

rather it will concern itself with the manuscript's remarkably understudied opening image of the Trinity, the work of the artist responsible for this image and the contribution of both to the way in which we might read the manuscript.

The Harley Psalter was begun at either Christ Church or St Augustine's Canterbury *c.* 1020 probably, in the view of many scholars, for or in honour of one of the four early eleventh-century archbishops: Ælfric (995–1005); Alphege (1005–12); Lyfing (1012–20); or Æthelnoth (1020–38). Heslop, however, has suggested that the manuscript may have been commissioned by Æthelnoth for presentation to the pope.[4] Whatever the case, the manuscript never left Canterbury

and, indeed, became very much a repository for Canterbury concerns and traditions, points which will be discussed further below. As such, it would also have a significant influence on post-Conquest manuscript production at Canterbury, most notably on the mid-twelfth-century Eadwine Psalter, the second of the surviving manuscripts produced in the Utrecht tradition. The Harley Psalter is a grand and learned book, but one that could never have been used either for liturgical celebrations or for private devotions, not least because of its eccentric mix of the Gallicanum and Romanum psalter texts. It has been suggested that the manuscript's makers were more interested in its illustrations than they were in its text,[5] but the way in which the artists frequently managed both to illustrate and to subvert the text, to use the images to clarify the text, and to relate the images not only to the text of the psalms but also to contemporary monastic life at Canterbury,[6] indicate that it was the relationship between the two that must have been paramount. Yet, grand and literate as it was, and in spite of work continuing on it for over a century, it was ultimately abandoned unfinished. Perhaps its importance was superseded by the planning and production of the far grander and more ornate Eadwine Psalter, with its much more explicit interest in Canterbury history.[7]

The Harley Psalter is now believed to have been the work of ten artists, two of whom were also scribes, and two additional scribes. William Noel has divided their work into two campaigns: an early phase in which work progressed rapidly, and a later phase in which work progressed much more slowly and sporadically.[8] The Trinity belongs to this second phase, and thus may not have been a part of the manuscript's original conception. Nevertheless, the artists of the second phase did look carefully at the work of their predecessors, sometimes adding to or referring back to it, and there is no doubt that the image was an important part of what must have been a developing conception of what the manuscript was to be.

The Trinity (Fig. 9.1) is an iconographically unusual and art-historically somewhat controversial image. It is the work of the artist Noel has labelled 'Artist I', an artist who was also responsible for the historiated Beatus initial to Psalm 1 and the display capitals that follow it (Fig. 9.3), as well as the large decorated initial to Psalm 101 (fol. 50r).[9] Artist I's work is universally considered to be substandard in comparison to that of the other artists who worked on the manuscript. Janet Backhouse described his hand as 'less talented but distinctive'.[10] Noel labelled the drawing 'lacklustre' and 'crude' in its architectural details, although he thought that the archbishop in the Beatus initial was 'rather accomplished'.[11] Richard Gameson, however, was in no doubt that Artist I's work was 'crude, unattractive and gloomy'. 'One wonders', he asked, 'why he was ever allowed near this fine book.'[12] Of course, Gameson's criteria for the success of the Harley 603 artists were based on how well they managed to 'produce facsimiles of the illustrations in Utrecht',[13] and Artist I was adding to the Harley Psalter images that did not exist in, and thus could not be directly

modelled on, those of Utrecht. Whatever its technical shortcomings, however, the image is a powerful expression of the meaning of the Trinity, and an image that sets the scene in many ways for the pages that follow.

This is not the usual Anglo-Saxon version of the Trinity, typically a triumphant image based on the first two verses of Psalm 109, and showing the three persons of the Trinity seated beside each other, an enemy at their feet, as in the illustration to Psalm 109 in Harley 603 (fol. 56v), the image of the Quinity in Ælfwine's Prayerbook (fol. 75v),[14] or on the eleventh-century ivory seal of Godwine and Godgytha now in the British Museum.[15] Nor does it resemble the uniquely Anglo-Saxon representation of the Trinity as or in Creation that survives in the Tiberius Psalter (fol. 7v),[16] the Royal Bible (fol. 1v)[17] and the Bury Psalter (fol. 68v),[18] the latter of which has a number of close connections with Harley 603.[19] In the Harley Psalter Trinity, Artist I has depicted God the Father seated and holding the Son in his lap, a pose clearly based on that of the seated Virgin and Child as they appear, for example, in the roughly contemporary ivory of the Virgin and Child now in the Victoria and Albert Museum,[20] itself possibly produced in Canterbury, or the image of the Quinity in Ælfwine's Prayerbook noted above. In the Harley Psalter image God the Father presses the Son's face against his own in an unusual expression of emotion. As Barbara Raw has noted, the pose both symbolises the 'eternal birth of Christ', and 'Christ's birth from his Father before time',[21] a symbolism also central to the more usual image of the Trinity as or in Creation. But the pose in Harley 603 also allows the artist to convey the inseparable nature of the Father and Son by showing their two identical faces not only gazing intently into one another's eyes, but also seeming to merge into one being on the page. This is furthered, perhaps unintentionally, by the difficulty in establishing at first glance which hands belong to which figure. In addition to holding his Son's head, God the Father, holds a blank scroll (perhaps an inscription was to be added) that unrolls across his body, a symbol of the Word in the beginning, while the Son holds an orb in his left hand, representative of his eternal kingship. The dove of the Holy Spirit presses its beak close to the Father's ear as if whispering into it. Both of the feet of the dove, just to the right hand of the Son, also grasp the Father's scroll, establishing both the physical union of the three and their union in and through the Word. The eyes of the angels supporting the mandorla that enclose the three persons of the Trinity are fixed firmly upon them, centering our attention on the image as a focus of contemplation. Raw observes that the image is unique amongst Anglo-Saxon representations of the Trinity in its focus on the inner relations of the three figures as opposed to their actions in relation to the world, as well as in its suggestion of a kind of contemplation of the Godhead that was described at length in the devotional writings of authors such as Augustine, Benedict of Aniane, and John of Fécamp.[22] The image does also engage with the actions of the Trinity in the world, however, to the extent that it engages with, and presents a model for, the contemplation of the Godhead in the

human heart and mind, and specifically within the hearts and minds of the Canterbury community, as is made clear through its relationship to the larger programme of illumination, and especially in its relationship to the illustration and historiated initial that introduces Psalm 1.

The figures are drawn in brown ink, uniting them to the text of the psalms that follow – the Word united with the word. A wash of green ink has been used as an overall background for the page, to fill in the mandorla and the cross within the nimbus of the Father, as well as to cover details of the figures themselves, most obviously Christ's drapery. The green is suggestive simultaneously of Paradise and of the world, as well, perhaps, of Christ's presence in both eternity and the world.[23] A silver coloured ink has been used to fill in the legs of the throne on which the Trinity sits, and to outline the lower portion of the Father's body, a detail to which I will return below.

The emphasis placed on the Word in the Trinity is, perhaps, not all that unusual in late Anglo-Saxon manuscript illumination. As I have argued elsewhere, later Anglo-Saxon scribes and artists were keenly interested in the relationship between Word and word, and the spiritual meaning of the acts of writing and reading.[24] This is especially true of manuscripts associated with the Canterbury scribe Eadwig Basan (one of the scribes who worked on the Harley Psalter), and perhaps with the scribal and artistic traditions of Canterbury more generally. The Harley Psalter, however, makes this interest manifest in unique and consistent ways, and in so doing establishes a model that would have a profound impact on later manuscripts, most notably, perhaps, on the Eadwine Psalter.

Noel has demonstrated how deeply self-referential the manuscript is, a phenomenon created in large part by the ways in which the later artists who worked on it modelled their drawings not just on Utrecht or other manuscripts, but on the work of the earlier Harley 603 artists. So, Artist-Scribe E, who was responsible for the illustrations on folios 15v, 53r, 58v, 61r–62v, 72v, and 79r–v, as well as for completing the illustration on folio 15,[25] borrowed from the work of Artists A, B, C and D, and both clarified aspects of, and borrowed motifs from, Artist F.[26] Artist G, on the other hand, went back through the manuscript adding details to the work of the other artists.[27]

Other details also reveal the artists' desire to update the manuscript. In the illustration to Psalm 2 (which is placed beneath the text of Psalm 1 in Fig. 9.3), what were originally spear-bearing angels in the upper left of the corresponding drawing in Utrecht have been humanised in Harley through the removal of their wings and the addition of genitals.[28] This is probably a reflection of the Anglo-Saxon interest in the relationship between humanity and the fallen angels that was especially prominent following the monastic reform of the tenth century, although Noel has interpreted it as reflecting a more general Anglo-Saxon interest in demonology.[29] Artist F has introduced a group of monks gathered around a chalice to the illustration to Psalm 132 (fol. 68v). The same artist, has

also introduced the figure of a monk plucking a quill from a goose to the illustration to Psalm 116 (fol. 59v), presumably as a reference to the work of the monastic scriptorium.[30] The words of Psalm 116 might be read as encapsulating one of the primary messages of the Psalter, and one of the primary reasons for its production: 'O praise the Lord all ye nations, praise him all ye people. For his mercy is confirmed upon us: and the truth of the Lord remaineth for ever'.[31] Neither of these latter two artistic details is included in the Utrecht illustrations.

With the work of these artists in integrating the Psalter with its producers and readers in mind, we can return now to the opening pages of the manuscript and the work of Artist I. The visual narrative of the psalms begins with the image of the blessed man hunched over his book in contemplation of the opening words of Psalm 1 that are written in miniature on its pages: *Beatus vir qui non abiit in con ...* (Fig. 9.2). The image is, once again, a departure from Utrecht, in which the blessed man appears to be writing rather than reading, and the pages of his book are filled with dots symbolic of writing rather than with legible words.[32] The look of puzzlement on the Harley figure's face and the hand held nervously to his brow suggest that he is deeply engrossed in meditation on the law of the Lord, just as the words of Psalm 1 state that he should be. Celia Chazelle suggests that the contrast between the blessed man meditating on his book and the wicked man with his large sword and angry expression may be meant to convey an 'anti-military message against Swein and Cnut'.[33] While an anti-military message against Swein is certainly possible as it was during the last of Swein's raids against England that Archbishop Alphege was martyred, an anti-Cnut statement is less likely as it was Cnut who had Alphege's remains translated to Canterbury – although of course the Psalter could have been begun long before that translation took place. The idea that a reference to the slaying of the archbishop was intended is supported by Artist H basing an illustration that refers directly to this event on the wicked man of Psalm 1 (see below).

Certainly the godly work of the blessed man is repeated in the figure of the archbishop in the historiated initial to Psalm 1 (Fig. 9.3), whose pose, hunched over the end of a scroll at the feet of Christ, provides a mirror image (or book-end) to that of the blessed man hunched over his book. The archbishop is thus the second of the manuscript's blessed men.[34] The figure of Christ in the initial has been badly rubbed, but his right hand appears to have been raised in blessing, and he is presumably blessing not just the archbishop at his feet, but also the reader who meets his frontal gaze. A blank scroll (again, an inscription may have been intended) extends from his left hand, which also holds an open book, and is grasped with both hands by the archbishop. Both scroll and book are objects on which words are written and from which words are read. Here they suggest that it is through the words of the psalms and their prayers addressed to God that Christ and his faithful archbishop communicate from their separate spaces. The

archbishop in the Psalter's first full opening is thus united with, but also distinct from, both the blessed man of Psalm 1 and Christ. He is situated in an eternal present that incorporates both the biblical past in which the psalms were originally written, the contemporary world in which they were now being written and read, and the future in which the archbishop will be united with Christ in heaven. The mandorla in which Christ stands, as well as the scroll used to unite his figure with that of the archbishop, connect the image with that of the Trinity on folio 1r.

Colour, as well as books and scrolls, has been used to reinforce these connections. The little figure of the archbishop has been surrounded by a wash of the same silver colour that is used to outline the letters 'ea' of *beatus*; he is, in other words *beatus*, one with the reading figure on the facing page, as well as with the throne of the Trinity into whose presence he hopes to be brought on the day of judgment. The green that has been used to fill the outer border of the initial B, Christ's nimbus, and other details of the initial (as well as the words '*vir qui*') helps to connect its figures with those of the Trinity.

Noel has pointed out that, in the Eadwig Psalter,[35] the Beatus page is prefaced by a prayer expressing the hope that the Trinity will receive the psalms of the sinners who read or recite them.[36] The Eadwig Psalter is almost exactly contemporary with Harley 603, and a product of the same Canterbury scriptorium. It is not surprising therefore that the two manuscripts should express similar devotional hopes and practices. It is also possible that the Harley Psalter's Trinity was designed as a pictorial replacement for texts such as the Eadwig Psalter prayer, in keeping with the manuscript's general privileging of image over text.[37] However, to assume this is the only reason for its presence is to understand the image primarily in terms of its possible textual sources, and not in term of its visuality, materiality, or its larger role within the manuscript. Artist I's Trinity, even though a relatively late addition to the manuscript, establishes the framework through which the rest of it is to be read, both in terms of its contents and in terms of its physical and spiritual connection between reader, Word and book. It presents us with the birth and eternal nature of Christ the Word, whose body literally becomes a part of the Psalter's first word, *Beatus*. The scroll that unites the three figures of the Trinity is a multivalent symbol expressive of the Word before and in time, of the inseparability of the Trinity, and of the textual technology that unites the Trinity and Creation with the patron or reader of the Psalter and its creation. The united yet separate nature of the Trinity's three figures in the Word also prepares us for the united yet separate nature of the archbishop, the blessed man of Psalm 1, and the figure of Christ through the opening words of the Psalter. This second union of figures is, of course, not as intimate as that of the Trinity, but it is crucial to the manuscript's conception and use. In this regard, we might also note the hand gestures that lead the eye through the opening three pages. Even though enclosed in a mandorla, the fingers of Christ's left hand in the Trinity miniature gesture

out towards the edge of the page, inviting us to turn it. The sweeping gesture of the angel standing behind the blessed man on folio 1v, far more expansive and expressive than that of its Utrecht model, helps move the eye from the Trinity, across the figure of the reading man and towards the opening words of the psalm on the facing page. The motion is then stopped by the figure of the archbishop, who faces back towards Christ and the illustration to Psalm 1, and directed out at the reader through the frontal eyes and blessing hand of Christ, as well as by the open book that he holds. (In addition to the Trinity and the Beatus initial to Psalm 1 and the display capitals which follow it, Artist I was also responsible for the large decorated initial to Psalm 101, which opens the third of the traditional three divisions of the Psalter. The Psalm 101 initial contains neither book- nor scroll-holding figures, but it does repeat the distinctive foliage patterns of the Beatus initial.)

The importance of Artist I's work and his fusion of contemporary (or historical) figures with the words of the psalms can be gauged by the way in which Artist H refers back to his work in some of his most significant drawings. Artist H based the style of his drawings on that of Artist G,[38] but seems also to have based the content of some of his drawings on the work of Artist I. Artist H, who worked in the twelfth century, is believed to have been responsible for the historiated initial to Psalm 51 (fol. 29r), which opens the second of the traditional divisions of the Psalter.[39] Artist H's initial (Fig. 9.4) may well refer back to details of Artist I's work – in fact he might be described as reading the work of Artist I, along with that of other of the earlier artists, in composing his own images. The initial has been inserted into a blank space left by the scribe Eadwig Basan (presumably) for an enlarged decorative initial and opening line of text similar to those of Psalm 1. Artist H omitted the four opening words of the psalm, filling the space instead with just the initial Q. The bowl of the initial is composed of Christ surrounded by a mandorla and seated in majesty holding an open book. The tail of the letter is formed by an angel which grasps and supports the mandorla, a head personifying a wind at its feet. Although the figure of Christ is seated, his frontal stare and general pose, with blessing right hand and book-holding left hand, recalls that of the Christ in the initial to Psalm 1. The angel supporting the mandorla, the rainbow on which Christ is seated and, perhaps, the head of the wind adjacent to the angel's feet, all indicate that this is a heavenly setting, like that of the Trinity, rather than the coming together of the heavenly and earthly realms represented in the Beatus initial. While the Beatus initial introduces the blessed man, personified by the archbishop, this initial introduces the workers of inequity and malice of the opening verses of Psalm 51. This is a much less approachable and more judgmental image of Christ, as is appropriate to the text it accompanies. Both initials, however, are equally concerned with words and with language. The scroll that connects the archbishop and the figure of Christ in the Beatus initial suggests the prayers directed from the one to the other that identify the archbishop as blessed, and that will

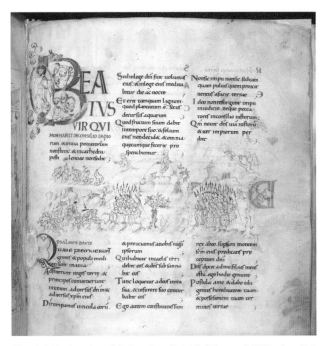

ultimately bring him into the presence of the Trinity and the Word. In contrast, this initial asks the reader to think about false words and malicious speech. The curve of the angel's body and, especially, the open mouth of the wind, direct our attention to the second column of text. The lines that issue from the wind's mouth direct the reader's eyes specifically to the fourth verse of the psalm, which reads, 'Thou hast loved all the words of ruin, O deceitful tongue'.[40]

The connection back to, and contrast with, the blessed figure of Psalm 1 (and the opening images of the manuscript) is continued in the illustration to Psalm 52 at the bottom of the page. This is one of two references (both the work of Artist H) to the martyrdom of Archbishop Alphege generally accepted as having been worked into the illustrations for both Psalms 52 and 59 (fol. 32v). Thus, like the opening pages of the manuscript, it makes direct reference to an archbishop of Canterbury, if not the same archbishop of Canterbury. Alphege had been ransomed by the invading Danes who captured Canterbury in September of 1011. After refusing either to pay the ransom or to allow it to be paid for him he was pelted with bones and other objects before being dispatched with the butt of an axe. He was buried in St Paul's in London, but his body was later enshrined in Canterbury by Cnut. In the illustration to Psalm 52 a figure being

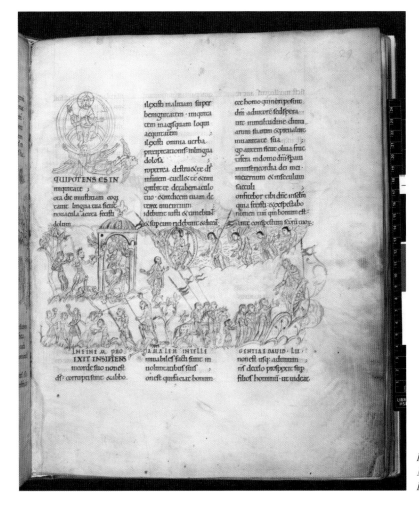

stoned at the left is believed to refer to the martyrdom of Alphege himself.[41] In this case, not only is the scene far more gruesome than its Utrecht model, it has also been changed significantly. In Utrecht, the figure being attacked is being sawn in half rather than stoned, and the corrupt king who sits above him (the fool who denied God, Psalm 52:1) has been changed from a classical ruler to a king in contemporary dress. Moreover, he is depicted as a military leader holding a sword and being counselled by a demon. The image clearly echoes that of the sword-wielding wicked man of Psalm 1 who is surrounded by his military retinue on one side and accompanied by a snake-wielding demon on the other. Gameson connects the Psalm 52 illustration as a whole with that of Psalm 13,[42] but the connections with the illustration to Psalm 1 are particularly clear in the case of the seated figure. If Artist I's archbishop can personify the blessed man, the slayer of an archbishop, possibly the same archbishop, could be made to personify the wicked man.

The illustration to Psalm 59 depicts an attack on a city and is modelled largely on the illustration to the same psalm in the Utrecht Psalter; however it is far more frenzied and violent than its model. A figure at the left of the page throws up his arms in either a prayer or a plea for mercy as he is about to be beheaded. In the siege at the centre of the page the attackers are far more violently assaulted with spears and rocks, one sticking out his tongue as he dies, a detail that can be paralleled in the images of the violent deaths of those who offend the Church in the twelfth-century St Albans Psalter. The drawing clearly seems to have had a special resonance for the manuscript's producers and readers. The idea that it was understood as a reference to the Danish siege of Canterbury is reinforced by its having served as a model for that scene in the twelfth-century St Alphege window in Canterbury Cathedral.[43]

In conclusion, the integration of patron and reader, scribe and artist, community and text in the meaning and message of the manuscript is a phenomenon of late Anglo-Saxon manuscripts, especially those associated with Canterbury and Eadwig Basan in particular,[44] and it was a phenomenon that was to have a deep and enduring influence on post-Conquest manuscript production at Canterbury. While the text of the prefatory prayer in the Eadwig Psalter cited above may provide a textual source (or parallel) for the prefatory image in the Harley Psalter, the two manuscripts also share an interest in uniting contemporary or historical figures from the community, especially those of the manuscripts' patrons and producers, with those of the biblical or historical figures depicted in their images, and with the meaning of their texts. In the Eadwig Psalter this is achieved primarily through the use of inscribed scrolls and books, and through the merging or juxtaposition of the spaces the figures inhabit. The most famous example of this type of complex space is seen in the image of Eadwig and the monks of Canterbury presenting their book to St Benedict on folio 133r. The figure generally identified as Eadwig himself in the miniature also provides a parallel for that of the archbishop in the Harley Psalter's Beatus initial. The

Eadwig Psalter images are artistically more accomplished than those of the Harley Psalter, and the use of scrolls and books within its images is more complex and consistent; nevertheless, the Harley Psalter, and especially the work of Artist I, provides an important example of how widespread this practice was becoming at early eleventh-century Canterbury. Its union of Word and word, biblical figures and contemporary users also provides an important precedent, if not a model, for the Eadwine Psalter, a manuscript that may well represent the pinnacle of this tradition, with its complex mirroring of the blessed man on folio 5v and the scribe Eadwine at the end of the manuscript (fol. 283v), and its mining of Canterbury history.[45] One wonders if the similarities between the two manuscripts might not have been even closer had the Harley Psalter ever been completed – or indeed whether Harley 603 was abandoned because the Eadwine Psalter was seen in effect as taking its place. The psalter text in Eadwine was originally prefaced by a series of formulaic narrative illustrations that both paralleled the lives of David and Christ, and mapped the chronological movement from Creation to the time in which the manuscript itself was created.[46] The Harley Psalter's Trinity might be said to accomplish similar work, but in a far more economic and even mystical format. It requires us to read not a sequential narrative, nor even a typological one, but to read the manuscript spiritually and personally through the union of Word and body that it presents. In so doing it establishes a spiritual model for the union of the bodies of the Canterbury community (or those who would threaten it) with the textual and pictorial narratives of the psalms that follow.

Notes

1 London: British Library, MS Harley 60.
2 Utrecht: Rijksuniversiteit Bibliotheek, MS 32.
3 The other two surviving manuscripts in the Utrecht tradition are the mid-twelfth-century Cambridge: Trinity College, MS R.17.1, and Paris: Bibliothèque Nationale, MS Lat. 8846, produced *c.* 1180–90.
4 Heslop 2008.
5 Noel 1995, 189; Horst et al. 1996, 148, 151.
6 Noel 1995, 91, 191; Horst et al. 1996, 153.
7 On the Eadwine Psalter see Gibson et al. 1992; Karkov 2015.
8 Noel 1995, 186.
9 Noel's Artist I was previously identified as Artist E by Francis Wormald (1952, 70); Wormald's identification was followed by Backhouse 1984 and Gameson 1990.
10 Backhouse 1984, 98.
11 Noel 1995, 122.
12 Gameson 1990, 33.
13 Ibid., 30.
14 London: British Library, Cotton MS Titus D. xxvii.
15 London: British Museum, Acc. No. M&ME 1881,4-4,1.
16 London: British Library, Cotton MS Tiberius C. vi.
17 London: British Library, Royal MS I. E. vii.
18 Vatican: Biblioteca Apostolica, MS Reg. lat. 12.

19 On the Creation/Trinity, see Heimann 1966; on the importance of the Bury Psalter and its models for Harley 603, see Noel 1995, 150–69.

20 London: V&A Museum, Acc. No. A.5-1935.

21 Raw 1997, 168.

22 Raw 1997, 15–18, 168. See Augustine, *De Trinitate* I.i.1; VII. vi.12 (Mountain 1968, 27; 267); Benedict of Aniane, *Forma fidei* (Leclercq 1948, 28–53); John of Fécamp, *Confessio theologica* (Leclercq & Bonnes 1946, 182–3).

23 The effect is furthered unintentionally by the way in which the colour has bled through the vellum and tinted the background of the drawing that prefaces Psalm 1 (Fig. 9.2). On the colour green in Anglo-Saxon landscapes see Kabir 2001, 144–6, 161, 175.

24 Karkov 2006; 2007; 2015.

25 Noel 1995, 19; on the work of this hand see also Duffey 1977.

26 Artists A, B, C and D were responsible for the early phase illustrations, which make up the bulk of the manuscript; Artist F was responsible for the illustrations in quires 10 and 11, and the illustration at the bottom of fol. 59r; see Noel 1995, 18–19.

27 Gameson 1990, 100.

28 The image is the work of Artist A.

29 Gibson et al. 1992, 126.

30 Noel 1995.

31 Laudate Dominum, omnes gentes: laudate eum, omnes populi: Quoniam confirmata est super nos misericordia eius: et veritas Domini manet in aeternum.

32 Chazelle (2004, 341) describes the Utrecht figure as 'contemplating rather than writing, but he does appear to be holding a stylus in his right hand'.

33 Ibid.

34 Noel 1995.

35 London: British Library, Arundel MS 155.

36 Noel 1995, 194

37 See Noel 1995, 194; Haney 1986, 50; Henderson 1992, 243; Kantorowicz 1947; Wormald 1984, 106–8; Raw 1997, 15–18.

38 Noel 1995, 113.

39 Artist H is also responsible for the illustration of fols 29r–35r, and the initials to Psalms 53 and 57; on his work see Gameson 1993.

40 dilexisti omnia verba praecipitationis lingua dolosa.

41 Noel 1995, 193.

42 Gameson 1993.

43 Noel 1995, 141.

44 See n. 35 above.

45 See further Karkov 2015.

46 See Gibson et al. 1992.

References

Backhouse, J., 1984 'The Making of the Harley Psalter', *British Library J.* 10(2), 97–113

Chazelle, C., 2004 'Violence and the Virtuous Ruler in the Utrecht Psalter' in F. Büttner (ed.), *The Illustrated Psalter: Studies in the Content, Purpose and Placement of its Images* (Turnhout), pp 337–48

Duffey, J., 1977 'The Inventive Group of Illustrations in the Harley Psalter' (PhD, University of California, Berkeley)

Gameson, R., 1990 'The Anglo-Saxon Artists of the Harley (603) Psalter', *JBAA* 143, 29–48

Gameson, R., 1993 'The Romanesque Artist of the Harley Psalter, *English Manuscript Studies 1100–1700* 4, 24–61

Gibson, M., Heslop, T.A., & Pfaff, R.W. (ed.), 1992 *The Eadwine Psalter: Text, Image, and Monastic Culture in Twelfth-century Canterbury* (London)

Haney, K., 1986 *The Winchester Psalter, an Iconographic Study* (Leicester)

Heimann, A., 1966 'Three Illustrations from the Bury St Edmunds Psalter and their Prototypes', *J. Warburg and Courtauld Institutes* 29, 39–59

Henderson, G., 1992 'The Idiosyncracy of Late Anglo-Saxon Religious Imagery' in Carola Hicks (ed.) *England in the Eleventh Century*, Harlaxton Medieval Studies 2 (Stamford), pp 239–49

Heslop, T.A., 2008 'The Implications of the Utrecht Psalter in English Romanesque Art' in C. Hourihane (ed.), *Romanesque Art and Thought in the Twelfth Century: Essays in Honor of Walter Cahn* (Princeton, NJ), pp 267–89

Horst, K. van der, Noel, W. & Wüstefeld, W.C.M. (ed.), 1996 *The Utrecht Psalter in Medieval Art: Picturing the Psalms of David* ('t Goy)

Kabir, A.J., 2001 *Paradise, Death and Doomsday in Anglo-Saxon Literature* (Cambridge)

Kantorowicz, E.H., 1947 'The Quinity of Winchester', *Art Bulletin* 29, 73–85

Karkov, C.E., 2006 'Writing and Having Written: Word and Image in the Eadwig Gospels' in A.R. Rumble (ed.), *Writing and Texts in Anglo-Saxon England* (Manchester & Woodbridge), pp 44–61

Karkov, C.E., 2007 'Evangelist Portraits and Book Production in Late Anglo-Saxon England' in S. Panayotova (ed.) *The Cambridge Illuminations: the Conference Papers* (London), pp 55–63

Karkov, C.E., 2015 'The Scribe Looks Back: Anglo-Saxon England and the Eadwine Psalter' in M. Brett & D.A. Woodman (ed.), *The Long Twelfth-Century View of the Anglo-Saxon Past* (Farnham), pp 289–306

Leclercq, J. (ed.), 1948 'Les Munimenta fidei de Saint Benoit d'Aniane', *Studia Anselmiana* 20, 21–74

Leclercq, J. & Bonnes, J.-P. (ed.), 1946 'Un maître de la vie spirituelle au Xie siècle: Jean de Fécamp', *Etudes de théologie et d'histoire de la spiritualité* 9 (Paris), 110–83

Mountain, W.J. (ed.), 1968, *Sancti Avrelii Avgvstini De Trinitate Libri XV*, 2 vols, CCSL 50, 50A (Turnhout)

Noel, W., 1995 *The Harley Psalter* (Cambridge)

Raw, B.C., 1997 *Trinity and Incarnation in Anglo-Saxon Art and Thought* (Cambridge)

Wormald, F., 1952 *English Drawings of the Tenth and Eleventh Centuries* (London)

Wormald, F., 1984 'Late Anglo-Saxon Art: Some Questions and Suggestions', in F. Wormald, *Collected Writings*, 1 (Turnhout), pp 105–10

Wundorsmiþa geweorc: a Mercian sword-pommel from the Beckley area, Oxfordshire[1]

Leslie Webster

Introduction

The silver-gilt sword pommel which is the subject of this paper is unlike any other (Figs 10.1a–c, 10.2). It is the work of a virtuoso smith, a *wundorsmiþa geweorc,* to use the words which praise the hilt from the famous sword with which Beowulf beheaded the monstrous Grendel and killed his mother (*Beowulf,* line 1681).[2] In its elegant and intricate virtuosity, and the extreme conceits of its design, the Beckley pommel is utterly *sui generis.* But exceptional as its form and decoration are, it is nonetheless linked closely to some distinctive strands within the early medieval art of Britain, and raises questions about the transference of motifs and ideas in this period, and expressions of cultural identity. This paper will examine the meaning and context of this extraordinary object, and its wider implications.[3]

Find history

The pommel was first shown to the British Museum by the finder, William Stowell, on 1 July 1993; he said he had discovered it while detecting on farmland near Beckley, Oxfordshire. On first inspection, it seemed to be made of copper alloy, so thickly encrusted was it with green corrosion products (Fig.10.1d); these obscured the decoration to such a degree that it was briefly thought that the pommel might be Swedish, as it seemed to recall Vendel-style animal ornament of the seventh to early eighth centuries.[4] Examination and conservation in the Museum's (then) Department of Conservation, Documentation and Science quickly revealed the case to be quite different, and even more remarkable. The pommel emerged from its carapace of verdigris as gilded silver, Insular in origin, and immediately recognisable as a piece of major importance. At a coroner's inquest held at Oxford on 16 March 1994, the pommel was declared not to

be Treasure Trove under the pre-1996 law, since it appeared to be an accidental loss, and returned to the finder. It was subsequently purchased from him by the British Museum (reg. no. P&E1994,0407.1).

At the inquest, the finder confirmed in his statement that he had found the pommel on land at Royal Oak Farm, in the parish of Beckley, on the north side of the B4027 road, about 5km north-east of Oxford. He also identified the approximate find-spot on the local Ordnance Survey map. It lies on the edge of Stow Wood, an ancient woodland remnant. Some considerable time after the inquest and the attendant press publicity, rumours apparently emanating from the metal-detecting fraternity began to circulate in Oxford, suggesting that the pommel may actually have been found elsewhere in the area, possibly near Woodeaton, some 6km to the north-west of Beckley. Enquiries made by Professor John Blair and others at the time were unable to substantiate this, however, or to add any further information. Though a note of uncertainty will perhaps never quite be dispelled, the finder's sworn statement to the inquest remains currently the best available information as to the pommel's find-spot.

Description

The pommel (max height 59mm, max length 99mm, max thickness 16.5mm, weight 90.79g) is cast in two pieces which are soldered and riveted together; the upper piece is the pommel proper, the curving lower element forming the pommel-bar, or upper guard. From its underside protrudes the stump of the iron tang which, originally encased in wood, horn, ivory (or even metal), formed the core of the hand-grip. XRF analysis of the metal content gave a reading for silver of approximately 72%, higher than many eighth-century artefacts, but significantly below the high silver

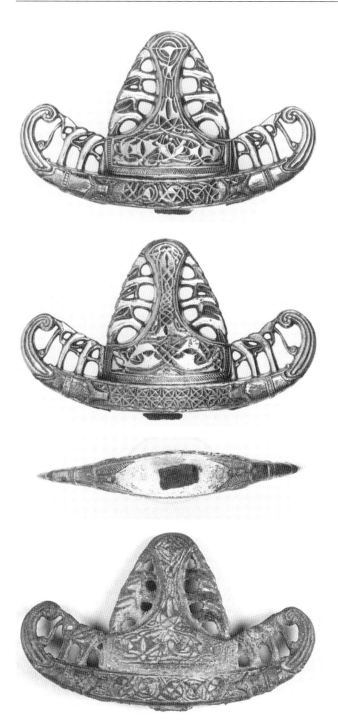

Fig. 10.1 The Beckley area pommel: (a) Side A; (b) Side B; (c) underside; (d) the pommel before conservation, Side A (Photos: © The British Museum)

content of late eighth- and early ninth-century coinage, typically over 90%.[5]

The pommel is divided structurally into two elements (Fig. 10.1a–b). The arched central element consists of an inverted tau-shape with curving sides, its stem bordered by an openwork procession of four downward-gaping animal

heads, diminishing in size towards the crest of the pommel. The two topmost creatures are conjoined by a curving band which runs over the crest. From the back of each of the lower three heads a lappet flows back into the gaping jaws of the animal behind, where they give the ambiguous appearance of being tongues. The main body of the tau element has highly attenuated animal decoration on both sides. On Side A (Fig. 10.1a) the transverse arm of the tau has four interlacing leggy creatures, three of which have duck-billed jaws relating them to the friezes of gaping animals down each side; the fourth has a wholly schematic head (Fig. 10.3a–b). The two animals with heads which cross over in the centre of the motif have more elaborate heads with lolling tongues and thread-like lappets (Fig. 10.3a). All have schematised kite-shaped bodies which resemble a skate's egg-purse, their legs, tails and necks reduced to mere threads. Above these, extending up the vertical arm of the tau, are two pairs of even more schematic beasts with similar bodies and legs, the upper pair terminating in a spiral formed of the tail (or possibly fore leg) of one animal, which enmeshes a headless partner, which is reduced to a body with tail and two extended limbs (Fig. 10.3c). The design on Side B, which is less well preserved, is similarly compressed, but differs in detail (Fig. 10.1b). Here four highly stylised interlacing creatures again occupy the transverse arm of the tau; two are relatively straightforward constructions with duck-billed heads and skate-purse bodies, like the larger animals on the other face (Fig. 10.4a); the other pair are more elaborate, with arching bodies, elaborately interlacing tails, and almost abstract heads, their intertwining jaws extending up the vertical arm to merge seamlessly into the legs of two spindly beasts at the top of the arm (Fig. 10.4b). Each side of the tau is bordered by a frame, ribbed diagonally on its lower three sides.

The other element is the separately-cast and attached pommel-bar. This curves gently upwards, terminating at each end in an open-jawed, fish-like, head with a ribbed collar, from the mouth of which protrudes a huge upward-curling deeply grooved tongue, which simultaneously gives the appearance of a bird of prey's beak (Figs 10.1a–b, 10.2, 10.5a). The grooves of the tongue terminate in a triple-lobed whorl. Along the upper edge of the pommel-bar, and flanking the tau-shaped central element, are two short openwork animal processions, each consisting of three creatures with gaping jaws, identical to the downward pointing creatures that flank the central tau (Figs 10.1a–b, 10.2, 10.5a). The inner two face inward and have long necks, the second biting at the lappet of the innermost, but the third faces outward, springing from the back of the head of the second animal; its gaping head and extended lolling tongue confronts the curving beak-like tongue of the terminal fish-like creature. A decorative panel occupies the central part of the pommel-bar. On Side A (Figs 10.1a & 10.3c) this consists of a highly schematic version of

BECKLEY POMMEL
1994 4-7 1

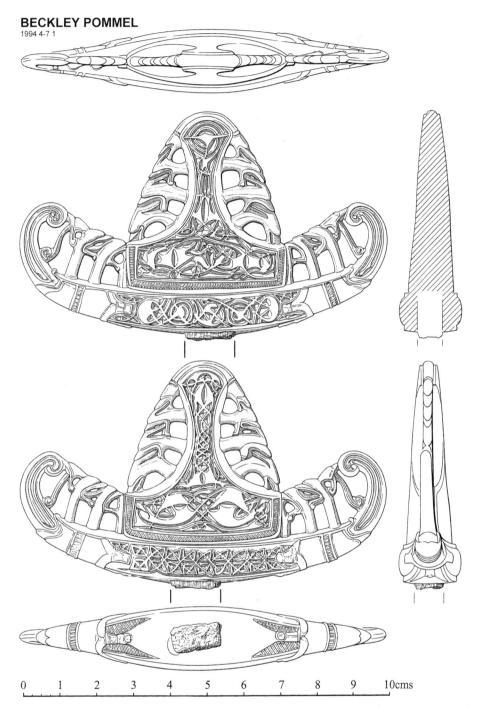

0 1 2 3 4 5 6 7 8 9 10cms

Fig. 10.2 The Beckley area pommel, composite drawing (Drawing: James Farrant, Stephen Crummy, British Museum)

an inhabited vine, formed of three stylised creatures enmeshed in a running scroll which terminates at each end in a pelta-shaped motif, possibly zoomorphic; they have sub-triangular bodies and thread-like legs resembling those of the animals on the tau element. Beyond each end of the scroll, a pair of Stafford knots wraps around an arched element. On Side B (Figs 10.1b, 10.2, 10.4b) the entire panel is filled with a regular interlaced knot scheme

of Stafford knots. Separating these two panels from the collared creatures at the end of the pommel-bar on each side is an arched moulding which wraps right around the pommel-bar (Figs 10.1c, 10.2, 10.5a–b). On the outer faces it emerges to give the impression of a cicada-like creature with stubby head and spread wings; and on the underside, the hint of animal life in this arcading is reinforced by the addition of two pairs of sub-triangular diagonally

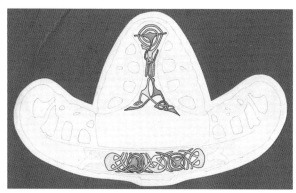

Fig. 10.3 The Beckley area pommel, Side A: (a) larger paired animals; (b) paired animals; (c) four upper animals and inhabited scroll (Drawings: James Farrant, British Museum)

Fig. 10.4 The Beckley area pommel, Side B: (a) lower paired animals; (b) four upper animals and interlace (Drawings: James Farrant, British Museum)

hatched elements, resembling wings, or perhaps, given their proximity to the fish-heads, pectoral fins (Figs 10.1c, 10.2, 10.5b). The heads of the two rivets which attach the pommel-bar are visible between these fin-like features.

A remarkable feature of this design is that, when the pommel is inverted (as it would have been when the sword was drawn from its scabbard and raised), these elements coalesce to display a horned and threatening animal mask (Fig. 10.6).

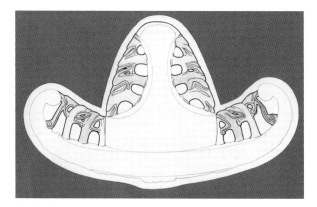

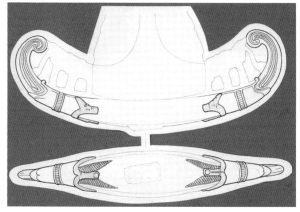

Fig. 10.5 The Beckley area pommel: (a) processing animal heads; (b) pommel-bar fish-head terminals and underside (Drawings: James Farrant, British Museum)

Morphology

The form of the pommel, as well as its decoration (discussed below) is exceptional. Its large size and unusual structure set it apart from related Anglo-Saxon sword hilts. However, it can be seen that the pommel's overall form, and its tau-shaped central element, ultimately derive from the classic 'cocked hat' pommel type characteristic of the sixth and seventh centuries, and typified by the well-known examples from Sutton Hoo (Suffolk) Mound 1, Crundale Down (Kent), and most of the sword pommels from the Staffordshire hoard. The type continued on into the eighth century, when it developed into a version where a decorated central arched element was given greater prominence, and was often flanked by two stylised animal heads; these beast-head terminals derive from the earlier pommel tradition, exemplified by the seventh-century examples from Hög Edsten, Sweden, and, nearer home, the remarkable pommel with Christian iconography from Dinham, near Ludlow, Shropshire.[6] To date, nine pommels with this distinctive form are currently recorded, from: St Ninian's Isle (Shetland); Fetter Lane (London); Windsor (Berkshire); the Thames at Chiswick Eyot (Middlesex); Chelmondiston (Suffolk); Mouldsworth (Cheshire); Woodford and Lowick (both Northamptonshire);[7] and an unprovenanced example (Fig. 10.7a–b).[8] The finest of these, in common with other high-status metalwork of the eighth century, are of silver or silver-gilt, rather than copper alloy, and all have straight pommel-bars (or upper guards), like their seventh-century predecessors. By contrast, the curving form of the bar on the Beckley pommel suggests that it is an intermediate form between this eighth-century group and the fully-fledged ninth-century Petersen L-type sword hilts, with their steep pommels and curved pommel-bar and guard.[9] The only other hybrid pommel which combines a curving L-type pommel-bar with an element similar to earlier pommels is a large unprovenanced iron example, inlaid with silver scroll and geometric ornament, now in the Metropolitan Museum in New York.[10] This has a large central arched feature, evoking those of the eighth-century pommel type, but in overall appearance and effect it is quite different from the Beckley pommel, and appears to belong to a specifically East Anglian ornamental tradition. L-type sword pommels are also characteristically made of iron, and often embellished with silver sheeting decorated with niello inlays, again, very different in appearance from the Beckley pommel. Morphologically, the Beckley piece therefore stands between, but also somewhat apart from, these two groups. This may, of course, reflect its

Fig. 10.7 (a) Silver-gilt sword-hilt from Fetter Lane, London, side with spread-eagled animal (Photo: © The British Museum); (b) Silver-gilt pommel with animal decoration from Mouldsworth, Cheshire (Photo: © PAS)

Fig. 10.6 The pommel inverted to reveal a horned animal mask (Photo: © The British Museum)

exceptional status as much as its dating. However, a late eighth-century terminal which might possibly be from a curving iron pommel-bar, discussed below,[11] hints at other intermediate hilts of this period.

Decoration

Idiosyncratic as it is, much of the pommel's distinctive decorative grammar and vocabulary nevertheless has general parallels in other high-status metalwork of the later eighth and early ninth centuries; most of this is Southumbrian, and exhibits a concentration of provenances within the wider zone of Mercian hegemony, at its peak during this period. Parallels with Southumbrian manuscript and sculptural ornament are also apparent, though different conventions and techniques of execution in the different media mean that comparisons are often less direct than in metalwork.

In terms of the decorative grammar which shapes the pommel's signature, four features are particularly distinctive. The first is the striking use of three-dimensional openwork, seen in the processing beast heads that seem to defend the outer edges of the pommel; similar examples of openwork animal decoration can be seen on a silver pin from Flixborough (Linconshire),[12] and a silver mount of uncertain function from Babingley (Norfolk).[13] To a lesser degree, it is a feature of weapon chapes, appearing on examples from the Thames at Westminster, the Ridgeway near Newbury, Berkshire (Fig. 10.8a–b),[14] and on both sword chapes from the St Ninian's Isle (Shetland) hoard (Fig. 10.8c).[15] Low relief openwork is a recurrent feature on brooches of the period, continuing into the ninth century; early versions appear on the smallest brooch and the 'Mercian-style' brooch pair in the Pentney (Norfolk) hoard, dated to the late eighth and early ninth centuries respectively,[16] while the flatter openwork typical of ninth-century Trewhiddle-style metalwork occurs on the three remaining brooches in that hoard, which are in the fully developed Trewhiddle style.[17]

A second signature element is the use of three-dimensional animal heads, including the creatures with beak-like tongues which protrude from the pommel-bar, as well as the processing heads. A number of other Anglo-Saxon high-status silver fittings reflect this trend. These include the seax chape fragment from Newbury (Fig. 10.8b) and a mount of uncertain function from West Ilsley (Berkshire),[18] another unprovenanced fitting,[19] and the snarling creature which terminates the Thames runic scabbard chape (Fig. 10.8a). Three-dimensional sculptural versions of these beast heads survive at St Mary's Church, Deerhurst (Gloucestershire) where they are dated to the early ninth century.[20] The quartet of upright heads encircling the central animal inside the lost River Witham (Lincolnshire) hanging bowl is also relevant here;[21] these, and a 2003 metal-detector find of a similar, single, head from Kilham (East Yorkshire), recall the long-necked upright heads of the pommel.[22] The exceptions to this

largely Southumbrian distribution are from the St Ninian's Isle treasure, the terminal heads on the two chapes relating closely to the animal heads on the Newbury and Thames seax chapes (Fig. 10.8c).

The Beckley pommel's emphasis on sequences or processions of elements, seen in the processing heads, also features in Southumbrian metalwork, albeit less prominently: for example, in sequences of bird-head and scroll features on both sides of the central arched element of the Fetter Lane pommel.[23] But the closest parallel to the Beckley processions is once again to be found on the St Ninian's Isle inscribed chape (Figs 10.7a, 10.8c).

The final signature element is the pommel's highly manneristic treatment of the animal forms, stretched and distorted to the bounds of legibility (Figs 10.1a–b, 10.2–4,). The minimalist creatures on the tau element and Side A of the pommel-bar can only be read with difficulty by someone without a prior knowledge of traditions of eighth-century zoomorphic ornament. All the normal aids to identification – representations of musculature, fur, feathers, features and even, sometimes, heads – are absent here.[24] However, these eccentrically constructed creatures are encrypted versions of the exaggeratedly etiolated or otherwise contorted animals which surface elsewhere in high-status Mercian metalwork, manuscripts and sculpture of this period. To take just a few examples, consider the spread-eagled creature on the Fetter Lane sword hilt, the highly reduced animals on the left-hand pin from the River Witham pin-set, and the tortured beasts engulfed in interlace on a recently discovered fitting from Cranfield (Bedfordshire).[25] Plentiful examples can be found among the pin-heads and hooked tags of Brandon (Suffolk) and Flixborough.[26] These playful contortions and buried images are not the result of misunderstanding or incompetence, which we can certainly find elsewhere in Anglo-Saxon art, but have to do with the deeply embedded Anglo-Saxon concept of the hidden image which must be teased out, and understood.[27] At its most dramatic and extraordinary, this is seen in the pommel's glowering beast mask, only revealed when it is inverted (Fig. 10.6).

Turning to the decorative vocabulary of the pommel, a similar pattern of comparisons emerges. The very distinctive duck-billed or shovel-snouted mouths or muzzles which appear on the processing beast heads and the creatures on the tau-shaped element, and which I have elsewhere characterised as typical of Southumbrian, mostly Mercian, high-status metalwork, have many parallels.[28] They include the gaping head of the spread-eagled creature on the Fetter Lane hilt, another on a horn terminal from the Thames at Lambeth,[29] and similar heads on a key from Gloucester and on a number of decorated pin-heads from Brandon and Flixborough.[30] One of the Flixborough pin-heads closely resembles an example from Titchmarsh (Northamptonshire) and an otherwise unprovenanced example from Nottinghamshire, suggesting an east midlands

origin for the pin type.[31] A number of fragments of late eighth-century Anglo-Saxon objects found in ninth-century Viking graves in Norway also exhibit this feature, and are to be associated with the raiding activities of the great Viking armies during the middle years of the ninth century, when they rampaged across the English south and midlands.[32] Close parallels again occur within the St Ninian's Isle treasure: they appear on the lively beasts on the sword pommel,[33] and most prominently, on the animal head terminals and the processing heads which frame the outer edge of the inscribed chape (Fig. 10.8c). Related animal heads have also been identified in the repertoire of three Pictish objects in the hoard, with the suggestion that this supports a local manufacture for all these pieces.[34] They comprise the small dumpy heads protruding from the terminals of penannular Brooch 20, and extremely small ones in the interlace on the terminals of Brooch 17 and on the internal mount from Hanging Bowl 6.[35] In fact parallels for these small versions of the shovel-snouted heads also exist in Southumbrian metalwork; for instance on a pin-head from Brandon, and on the Windsor sword pommel.[36] Significantly, the same distinctive snouts also appear on two dies for manufacturing impressed foils, one from Canterbury, the other from East Lindsey,[37] lending further support to the case for the principal focus of manufacture of objects with this motif lying within the Mercian orbit. Manuscript parallels for these shovel-snouted heads also seem to be particularly associated with manuscripts thought to have been made in Mercian centres; early examples occur in the gaping head of the creature which frames the text on the Chi-Rho page of the mid-eighth-century Lichfield Gospels (fol. 5), and on the throne of St Mark in the same manuscript (fol. 142).[38] Animals such as these, with their lolling tongues, large muzzles and head lappets, are the likely inspiration for the adaptation of the motif into metalwork. The Barberini Gospels, now thought possibly to have been made at *Medeshamstede* (Peterborough) in the late eighth or early ninth century, contains many beasts with similar enlarged snouts, for example in ornamental details on folios 18, 51, 80 and 125.[39] Another manuscript of possible Mercian origin, the St Petersburg Gospels, features similar gaping heads with lolling tongues in the initials of all its Gospel openings, as well as in some of the canon tables.[40] By contrast, this particular motif is uncommon in Anglo-Saxon sculpture, perhaps because weathering has made such detail less clear, or perhaps because it was regarded rather as appropriate to media other than stone; a rare example occurs on Side B of cross-shaft 2 at Otley (West Yorkshire), dated by Coatsworth to the early ninth century.[41]

With their short necks and open jaws, the unsighted 'fish' heads, with their grossly curving tongues, are close relatives of these shovel-snouted beasts, and recall similar creatures on the external mount on the base of the lost hanging bowl from the River Witham, some of which also seem to be eyeless.[42] Their tongues, however, resemble the curling grooved beak on the West Ilsley object (see above), which concludes in a double spiral, very similar to the triple spiral in which the grooved tongues of the Beckley creatures terminate. The grooved and curving element on the damaged Babingley fitting is almost certainly from a similar head, also ending in a triple spiral.[43] A recent find of an animal head terminal from Croydon Parish (Cambridgeshire), provides an even closer parallel (Fig. 10.8d).[44] This is a gilded silver socketed fitting in the shape of a bird-like head, which at first sight appears to have a long curved beak; but closer inspection reveals that the 'beak' is in fact composed of downward-curling jaws, the ends of the lips clearly defined, with a protruding tongue which curves back to touch the underside of the jaw. In size it is very close to that of the 'fish' heads on the pommel, and the presence of corroded iron in its rectangular socket and the stump of an iron attachment rivet on its underside raise the possibility that this might have been attached to the end of an iron pommel-bar – a different kind of construction from the Beckley pommel-bar, and unparalleled, but given the dearth of sword pommels from this period, perhaps not impossible.

The shovel-snouted animals which appear on the pommel's central tau also have highly eccentric bodies, shaped like skate egg-purses, from the corners of which spindly necks, legs and tails protrude. These elliptical forms are rare, and uniquely prolific on the pommel. The best known parallel is the spread-eagled creature on the Fetter Lane hilt, which is a large-scale version of the type, its slender limbs and coiling, thorny tail emerging from the flattened body with a fourfold spiral, which dominates this panel. It is this image which enables us to decode the much more schematised bodies on the Beckley pommel, and others like them, such as the rudimentary animals on a stylus head from Alton (Hampshire),[45] and on a possible sword belt fitting from a 'productive' site at Grossenwiehe, Schleswig-Holstein, Germany (Fig. 10.9a–b).[46] Similarly bodied animals are even rarer outside metalwork, but can be seen, for example, on the topmost panel of the east face of the ninth-century Nith Bridge cross-shaft at Thornhill, Dumfriesshire, which, as Kendrick argued,[47] shows the influence of southern Northumbrian sculpture, such as the ninth-century cross-shaft 3 at Ilkley (West Yorkshire),[48] and in the decoration of its lower panels, of Southumbrian animal style in general.

The even more schematic animals on the upper part of the tau element and pommel-bar on Side A (Fig. 10.3c) are clearly part of the same genus, and also share the tight double coil of the scrolls which encircle them with some of this metalwork. More naturalistic versions of creatures enmeshed in this distinctive double scrollwork can be seen in Mercian sculpture at Breedon (Leicestershire) and on the Hedda stone at Peterborough (Cambridgeshire),[49] but a closer parallel to the delicate ellipses of the inhabited

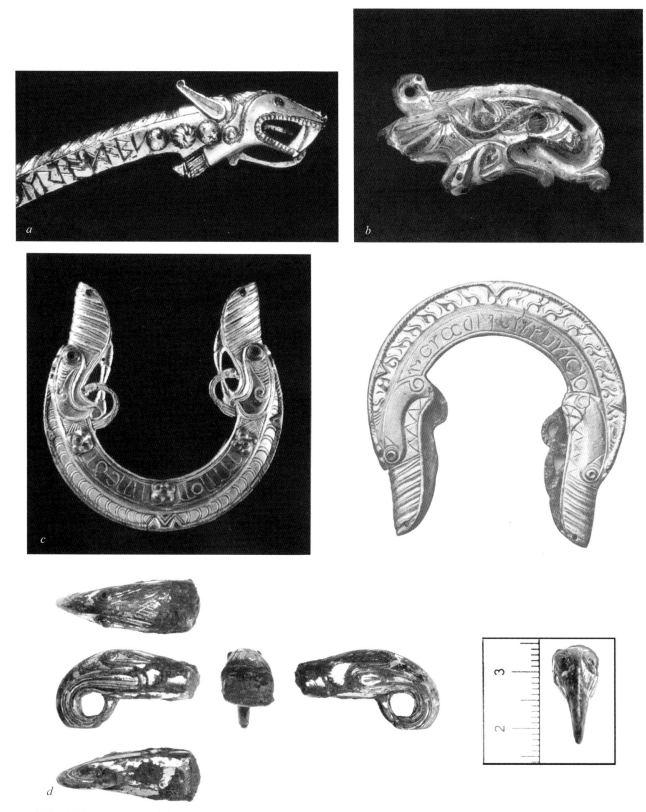

Fig. 10.8 (a) Silver-gilt seax with beast-head terminal, from the Thames at Westminster, detail (Photo: © David Wright); (b) Silver-gilt seax chape with beast-head terminal, from the Ridgeway near Newbury, Berkshire (Photo: © Messrs Christies); (c) Silver-gilt sword chape with inscription, from the St Ninian's Isle hoard, composite view (i–ii) (Photo: © National Museums of Scotland); (d) Silver-gilt fitting in the form of a tongued animal head, Croydon Parish, Cambridgeshire, composite view (Photo: © PAS)

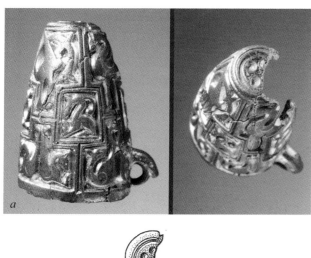

Fig. 10.9 Silver-gilt sub-conical sword fitting (?) from Grossenwiehe, Schleswig: (a) composite view; (b) analytical drawing (Photo and drawing: © Archäologisches Landesamt Schleswig)

pommel-bar scroll occurs in two Pictish stone monuments from the Tarbat peninsula (Ross-shire). Though extremely schematised, the Beckley scroll seems to echo the elegant coiling plants with strutting creatures which grace the back of the Hilton of Cadboll cross-slab (especially those in the left-hand border), and the lower part of a cross-slab found to the east of Tarbat Old Church, at near-by Portmahomack, the site of a seventh- to eighth-century Pictish monastery (Tarbat no.1).[50]

The final characteristic animal element in the pommel's vocabulary, seen on both its sides, is an ingenious attenuation of the animal bodies, necks and limbs to create a playful and eye-teasing pattern. This idea is widespread in Insular art, in various regional versions. Anglo-Saxon examples of these stretched and twisted animals occur amongst the Southumbrian metalwork from Viking graves in Norway,[51] and have been noted earlier in the elongated half-hidden animals on the Cranfield mount. The same principle, though in a less abstract version, is visible on the St Ninian's Isle pommel, where the stringy bodies of speckled duck-billed beasts loop and twist before rejoining their distant hind legs, and Pictish versions of the motif occur elsewhere in the hoard.[52] It is a motif with an active life in manuscripts; again, the Lichfield and Barberini Gospels supply some of the closest parallels.[53]

The remaining decorative components of the pommel offer little diagnostic information. The Stafford knot interlace on Side B of the pommel-bar (Fig. 10.3b) belongs to Cramp's 'simple pattern' group,[54] a widespread type in Anglo-Saxon eighth- and ninth-century art. More difficult to place are the arcaded elements which encircle the pommel-bar at each end, and the curious grooved fin-like decoration on the underside, which would not normally be visible (Fig. 10.4a–b). As suggested above, these might be read as belonging to the collared fish-like heads with curving beak-like tongues, which terminate the pommel-bar; the paired 'fins' are depicted at the back of the fish-heads, very approximately where the two pectoral fins might be expected.

Meaning

Such exceptional, and superbly crafted, decoration on a sword hilt invites a number of questions about its purpose and meaning. Beyond mere ornament, and the display of wealth and power, costly and intricate decoration on swords and other items of very personal war-gear, such as helmets, can be seen to carry other messages, indeed, sometimes even texts. The presence of a rich visual iconography is also part of what Sue Brunning has persuasively argued is the personality of the sword, entwined with that of its owner.[55] The particular role of inscriptions on swords and sword fittings, as well as on other prestige fighting equipment, is suggestive here. Inscriptions on metalwork of the period between *c.* 750 and 850 occur predominantly on gold

finger-rings, where they normally consist of personal name formulae, and very rarely on other object types.[56] Inscriptions on high-status battle-gear are very different in character, and much less common – though this disparity may reflect differential kinds of loss, rather than a difference in real life, rings being rather more easily lost than helmets or swords.

From the late eighth- to early ninth-century horizon, three extensive inscriptions from arms and armour are known; two from scabbard chapes and one from a helmet. The Latin inscription on the late eighth-century York helmet runs over the crown in the form of a cross, and is in the form of a short prayer invoking divine protection for the wearer, named as Oshere: it has been translated as 'In the name of our Lord, Jesus Christ, the Holy Spirit (and) God: and to all we say Amen. Oshere'.[57] The cruciform construction of this inscription is itself an image, annexing the role of the traditional dragon-headed crest which protected the crown and reinforcing the words of the text, the shape of the cross itself protecting the wearer's head. At the same time, there are other elements in the decoration of the helmet which clearly belong to an older Anglo-Saxon zoomorphic apotropaic tradition, and which continue as a live iconography into the middle Saxon decorative tradition. Dragon-, bird- or snake-like animal heads at either end of a yoking element, or encircling an image (as on some bracteates and cloisonné pendants) are a common element in sixth- to seventh-century prestige metalwork, where they have a protective function.[58] On the York helmet, the fierce creatures which protect the brows and terminate the crest, framing the ends of the inscription, are wholly in this tradition, seen much earlier on the Sutton Hoo helmet. The owner of this helmet is presented as both a Christian warrior, and a warrior discreetly guarded by the same protective animal symbols as his sixth-century forbears.[59] This is a theme repeated on one of the scabbard chapes from the St Ninian's Isle hoard, where two yoked and snarling animal heads curve around the end of the scabbard, protecting the sword blade both physically and magically (Fig. 10.8d). Similar conjoined animal heads curve around the end of the other chape from the hoard, but the first example, like the York helmet, is accompanied by a Latin inscription, engraved on both sides of the chape. This can be translated as 'in the name of God the Highest Father, and of God the Son, of the Holy Spirit, Ω'.[60] Like the prayer on the York helmet, this seems to be another case of double indemnity, whereby the written message is enshrined in a form – the fierce embrace of beast heads – which reinforces the protective power of the Christian invocation.

Unlike these two Latin texts, the third apotropaic inscriptions, on the seax scabbard mount from the River Thames at Westminster, is in runes (Fig. 10.8a). We cannot know what decorated the missing end, which has been broken off in antiquity, but the other terminates in a snarling dragon head, so it clearly fits the emerging pattern. The text

is clear, but has not been satisfactorily interpreted; however it is apparent that it begins, and appears to end, with the same reversed letters, and that elements of the text seem to echo letter sequences in an Anglo-Saxon charm against theft.[61] A talismanic function seems more than likely, echoing what we have already seen on the St Ninian's Isle chape.

It is noteworthy that all three of these high-status items of fighting equipment, intended to defend or protect the user, are inscribed with prayers or charms which also have a protective function, associated with decoration which also contains traditional motifs of a talismanic nature. The fact that such combinations are not seen in other secular metalwork of the period, such as brooches, dress pins, or finger-rings, strongly suggests that it no accident that fighting gear has a particular and distinctive iconography. The very personal nature of weapons and armour, intimately associated as they are with their owner's safety and well-being, power and fame, could be seen to encourage specifically protective forms of embellishment.

What does this all mean for our understanding of the Beckley pommel? Though it has no talismanic inscription, it uses a very similar iconographical lexicon to those seen on the helmet and chapes. The conjoined pairs of animal heads, across the very top of the pommel and linking both ends of the pommel-bar, and the bristling framework of open-jawed beast heads, are clearly part of the same family, and surely also have an apotropaic function. It is also likely that the other images on central part of the pommel were intended to convey a message. It is now widely accepted that in the earlier Anglo-Saxon period, the ornament of high status metalwork, including weaponry, carried powerful meanings, and that this is a tradition which continued after the Conversion period and was indeed assimilated to Christian ideas.[62] The sword from *Beowulf* with which this study opened bears images of the biblical Flood which carry a message about divine and earthly power, good and evil, which resonates within the poem (lines 1687–93);[63] it is an elaborate fictional creation, but it can only make sense in the poem if the Anglo-Saxon audience knew that the decoration on their own swords could be 'read'. Some pommels which tell a story have survived, like the Dinham example with an image of Golgotha, supporting the possibility that the decoration of others may have been intended to convey meaning, even though this may remain impenetrable to us.[64]

But what is arguably the pommel's most powerful image is certainly a more accessible one. Brunning has convincingly argued that early medieval swords were treated as if they had developed identities, with human characteristics, even, sometimes, names.[65] They can be read as if the hilt were the 'face' of the sword, and the blade the 'body'. Richly decorated hilts such as those from Fetter Lane and Beckley were intended to engage the eye, and gave the sword a particular identity. But the exceptional trick, whereby the Beckley pommel presents a very different

visage when the sword is held upright, the pommel inverted, shows that a sword could have more than one aspect to its personality. Seen this way, the sword's face delivers an unequivocal threat (Fig. 10.6). It is a glowering beast mask that the enemy sees as the blade descends, not the apotropaic creatures that bring protection to the wielder. The message is: this sword is a ferocious killer.

Inverted, other things are also emphasised. The gaping fish-heads spew out monstrous tongues, and the fin-like decoration on the underside of the pommel is visible. But these creatures also form the horns of the sinister beast head which appears in this inverse orientation. It is hard to know how to interpret these strange composite beings, whose gaping jaws link them to the processing heads on the pommel, and whose prominent tongues also have parallels in this period.[66] Are they fierce creatures capable of destruction, as the association with the horned beast may also suggest? Or should they be seen in the long Anglo-Saxon tradition of dual-headed protective animals which avert harm?[67] It is also noteworthy that the panel that connects the two fish-like heads carries a version of the inhabited vine-scroll – elsewhere a specific reference to the eucharistic sacrifice which redeems the faithful. If this were indeed read by its contemporary audience in this way, it would situate the pommel among those items of battle discussed above, which identify their owners as Christian warriors through their inscriptions. The Beckley pommel is possibly not alone in this; the equally prestigious Fetter Lane hilt may also carry a Christian meaning, its fourfold spiral of whirling snakes possibly symbolising the Resurrection, as has been suggested for snake motifs in manuscripts, and on Anglo-Saxon and Pictish Christian sculpture.[68]

Date and origin

The form of the pommel, a transitional type between the eighth-century pommels and the Petersen L-type hilt, with its characteristically curving pommel-bar and lower guard, also places it in the same chronological bracket. The dating for the L-type swords rests largely on the Trewhiddle-style decoration of a number of examples which suggests that they begin towards the middle of the ninth century, continuing into its later decades.

Stylistically, as we have seen, the decoration of the pommel places it in the later eighth or conceivably early ninth century, with parallels, particularly in metalwork and manuscripts, that suggest Southumbrian manufacture within the sphere of Mercia, then at the height of its power. It is notable that this is also the period from which a number of particularly fine items of high-status military accoutrements survive, indicative of the flourishing elite warrior culture suggested by the written records.

Linked with this, the pommel's striking relationship to prestige Pictish weapon fittings and sculpture with similar decoration and related iconography raises issues about stylistic identities and the transference of ideas which merit a brief digression. I have tentatively suggested elsewhere that the St Ninian's Isle sword pommel and chapes might be of Mercian origin, perhaps entering Pictland as prestigious gifts (though I would now exclude the uninscribed chape from this scenario).[69] The political context and sculptural reflexes of this contact are reviewed in detail by Isabel Henderson elsewhere in this volume.[70] But political contacts provide just one prestige context for gift-exchange and trade, amongst many other possible vectors by which exotic goods from Southumbria, and further afield, could reach the Pictish heartlands. One might nevertheless be more hesitant about suggesting that the St Ninian's Isle pommel and inscribed chape were Mercian imports, were it not that their most numerous and closest surviving stylistic and iconographic parallels are found in Southumbrian, rather than Pictish, metalwork. And although, as noted above,[71] small animal heads of duck-billed type appear on two Pictish brooches from the hoard, and on the internal mount of Hanging Bowl no. 6, the fact that there is nothing else like them to be found on brooches and other metalwork from Pictland strengthens the case for an Anglo-Saxon origin for the two weapon fittings.[72]

Picts and Anglo-Saxons certainly shared a common heritage in the Insular artistic tradition, which, Isabel Henderson has argued,[73] accounts for the many stylistic similarities between the St Ninian's Isle weapon fittings and Southumbrian metalwork; however, this cannot easily explain the remarkable closeness between, for instance, the processions of duck-billed heads on the inscribed chape and on the Beckley pommel, or the chape's very Anglo-Saxon apotropaic iconography; or, as just noted, the virtually complete absence of this type of decoration on indigenous Pictish metalwork. The fact that the same kind of superbly crafted prestige weapons were prized by both peoples testifies to another hallmark of a shared Insular heritage, but it does not preclude their moving between kingdoms; indeed, swords and other weapons are more likely to travel from their place of origin than most other prestige artefact types, given the exigencies of warfare, and the travels of royal entourages.

Context and aftermath

No other objects were found in the vicinity of the pommel. It had clearly become detached from the rest of the sword hilt and blade long before it was discovered, probably even before it entered the earth. The stump of the tang is quite cleanly broken off, suggesting that the pommel may have been deliberately removed from the hilt, rather than remaining attached to the rest of the sword, which then decayed *in situ*. An entire sword could conceivably have been broken up and redistributed in the course of ploughing,

but the absence of recent (or, indeed, any) damage to the pommel, and the clean break in the tang, suggest otherwise. The lower guard, and possibly the grip as well, are likely to have been as lavishly decorated as the pommel, their absence adding to the likelihood that the sword was disassembled long ago. That is not unlikely; there is some archaeological evidence for the re-use of fine pommels, presumably when the blade was damaged beyond repair. Equally, the silver pommel may have been removed for melting down, rather than re-use. How it came to be deposited in the ground is another matter; there are several possible explanations, of varying plausibility. As a substantial and precious item, casual loss seems the least likely, though not impossible. It could, alternatively, have been buried for safe keeping. A third possibility is that the sword had been deliberately put beyond use, by destroying it and disposing of the parts. There is good evidence for Anglo-Saxon swords and other weapons being thrown into rivers and other watery places, often after being deliberately twisted or otherwise damaged. In England, this practice is well attested in the tenth and eleventh centuries, but no doubt went back earlier; the broken scabbard mount from the Thames may represent deliberate damage and discarding, as may the eighth-century pommel from the Thames foreshore at Chiswick Eyot. The Beckley pommel was not associated with a wet site, though that need not rule out intentional destruction and disposal of the sword.

The find-spot itself may be of no significance; but it is less than 500m from a Roman road which runs north from Dorchester, and which probably continued to be an active thoroughfare in Anglo-Saxon times. Professor John Blair has pointed out to me that it also lies within an area which also had significant royal associations in the eleventh century.[74] Beckley was royal land until around 1006–11, when Æthelred II sold it for a pound of silver to a Dane, Toti, to help pay the Danegeld. The find-spot lies 2.5km north of Headington, which by 1066 was one of the six main royal manors of Oxfordshire;[75] Æthelred issued a charter there in 1004.[76] It also lies on the edge of the last surviving fragment of the ancient forest of Stowood, which, together with nearby Shotover, was listed among the *dominice foreste regis* in Domesday Book.[77] It seems more than likely that royal ownership of land in this area goes back to *c.* 800, when this part of England was under Mercian control, and that the presence of kings and their courts near by lies behind the deposition of the pommel within what was once a royal hunting forest. Whatever the circumstances of the pommel's disposal, the owner of this magnificent artefact must have been a member of the powerful Mercian elite around the end of the eighth century. But ownership of such a subtle, fierce and complex object implies something more – a skilled and subtle mind that could appreciate such a rare and extravagant conceit, and read its secrets.[78]

Notes

1. Although much of Richard Bailey's extensive published work has been on more northerly subjects, he has been known to make excursions elsewhere, including some very illuminating ones into Mercia, so I hope that this paper will not seem inappropriately foreign territory. In touching on Mercian contacts with much further north, and on questions of iconography and the Anglo-Saxon interest in highly condensed images, it also deals with matters on which Richard has greatly enlightened our understanding, and I offer it here as a modest tribute to a remarkable lifetime's achievement.

2. Klaeber 1950, 63.

3. I have discussed aspects of the pommel briefly elsewhere, notably in Webster 2001a, 56–7; 2001b, 272–3; 2003, 18; and 2012, 35–6, 145–6. Marzinzik 2013, 136–7, has excellent photographs of the sword.

4. For example, the curved jaws or beak and openwork animal crestings of the drinking horn terminal from Valsgärde grave 7 (Arwidsson 1977, no. 682, pl. 29), and the brooch from Kaästa, Uppland, with its extraordinarily extended animals and egg-purse shaped elements (Salin 1904, fig. 2).

5. A systematic programme of metal analysis of eighth-century silver artefacts is still awaited, but there is a growing number of pointers to low silver content in non-numismatic objects; for example in this survey, the seax chape fragment from Newbury (Berkshire) has a silver content of 42%, while that of the St Ninian's Isle (Shetland) inscribed chape is 25%. See below, 102 for further discussion of these chapes.

6. Webster 2005, 32–3.

7. Small et al. 1973, ii, cat. 11, pls xxvi d, xxviii a; Webster & Backhouse 1991, cat. 177; Wilson 1964 cat. 41, Webster & Backhouse 1991, cat. 173; Hinton 1974, cat. 36, Webster & Backhouse 1991, cat. 180–1; Plunkett 2005, 165; DCMS 2005 (*Treasure Annual Report*) no.119; PAS nos. NARC177, SUSS-589730.

8. Hammond 2010, 78, fig. 1.8.3–c.

9. Petersen 1919, 112–6, figs 94–7.

10. Acc. no. 2005.344; images on New York Metropolitan Museum of Art website (http://www.metmuseum.org/collection).

11. See below, 103.

12. Evans & Loveluck 2009, no. 680, fig. 1.29.

13. DCMS 2005 (*Treasure Annual Report 2003*) no. 127. The crescentic element described in this entry may in fact represent the curving beak or tongue of another creature.

14. Webster & Backhouse 1991, cat. 179. For the Newbury mount, see Christie's, London, 25 October 2006, lot 66; *Fifty-third Report of the Reviewing Committee on the Export of Works of Art and Objects of Cultural Interest 2006-07*, DCMS: London 2007, Case 26, 73-4, pl. 20 (text based on report of Expert Adviser); it was denied an export permit; Graham-Campbell forthcoming.

15. Small et al. 1973, ii, pl. xxix; Webster & Backhouse 1991, cat. 178a.

16. Webster & Backhouse 1991, cat. 187f, c and d.

17. Webster & Backhouse 1991, cat. 187a, b and e.

18. West Ilsley: PAS no. BERK-07A2A4.

19. Webster 2012, 143, fig. 102.

20 As Richard Bailey has convincingly argued (Bailey 2005, 5–7); see also Gem et al. 2008, 114 and figs 16–23, 7–9, and Bryant 2012, 177–85, especially 178–9.

21 Graham-Campbell 2004, figs 1, 2, 6.

22 DCMS 2005, no. 129.

23 Webster 2012, 139, fig. 95.

24 For more coherent versions of the animals in question, with speckled fur and more conventional anatomy, see typical examples from East Norfolk (PAS no. PAS-E90054) and Melton, Leicestershire (PAS no. LEIC-15A132).

25 River Witham: Webster 2012, 139, fig. 95; Cranfield: PAS no. BH-E811E5.

26 E.g. Webster & Backhouse 1991, cat. 66f, h, and 69e, f.

27 Webster 2012, 13–41.

28 Webster 2001a, 55–8, fig. 7; 2001b, 267–73.

29 PAS no. LON-EFCF31.

30 Webster & Backhouse 1991, cat. 176, 66f, 69e, p.

31 Evans & Loveluck 2009, no. 680, fig. 1.29; Titchmarsh: PAS no. RAH1481; Hammond 2010, 95, fig. 1.10-s.

32 E.g. Bakka 1963, figs 4,7, 56–7.

33 Small et al. 1973, ii, fig. 31, pl. xxviii a.

34 Wilson 1973, 91, 133; Henderson & Henderson 2004, 99; see also Henderson above, 61–2.

35 Small et al. 1973, ii, pls xxii b, xxxi, xxvi c; Henderson & Henderson 2004, 97, 99, 111.

36 Webster & Backhouse 1991, cat. 66f; Hinton 1974, cat. 36; Webster & Backhouse 1991, cat. 181.

37 Webster & Backhouse 1991, cat. 174; Webster 2001a 56–7.

38 Lichfield: Cathedral Library MS 1 (Alexander 1978, cat. 21, pls 76, 80). The origin of the Gospels has been much debated, but recent scholarship favours a Mercian, probably Lichfield, origin for the manuscript: Brown 2007, 49, 52.

39 Rome, Vatican City: Biblioteca Apostolica, MS Barberini Lat. 570. The key contributions to the identification of the Barberini Gospels as a likely product of *Medeshamstede* or one of its colonies are the important papers of Farr 2000 and Bailey 2000, which respectively highlight the close stylistic relationship of the Gospels to the Gandersheim casket, and the equally close relationship of the casket to sculpture from the vicinity of Peterborough. See also Brown 2007, 52–3.

40 St Petersburg: National Library of Russia, MS F.v.I.8; Alexander 1978, cat. 9, figs 190–5; Brown 2007, 52, 58.

41 Coatsworth 2008, 219-221, ills 570, 572.

42 Graham-Campbell 2004, figs 1, 7.

43 DCMS 2005, no. 127.

44 PAS no. CAM-511D9F. I am very grateful to Dr Sue Brunning for bringing this new-found object to my attention, just in time for it to be included here.

45 PAS no. SUR-6015C7.

46 I am very grateful to Dr Astrid Tummuscheit of the Archäologisches Landesamt Schleswig-Holstein for allowing me to refer to this piece in advance of her own publication, and to Dr Martin Segschneider for bringing it to my attention.

47 Kendrick 1938, 203–4.

48 Coatsworth 2008, 171, ills 361, 363–4.

49 E.g. Plunkett 1998, fig. 65a, e. The significance of these and other links with Pictish artefacts is examined below, 107.

50 Henderson & Henderson 2004, figs 62, 187; Henderson 2007.

51 E.g. Bakka 1963, figs 32–3, 41, 43b, d.

52 Notably on the uninscribed chape, on conical Mount 12, and on Bowls 2 and 3: Henderson & Henderson 2004, 113.

53 See e.g. the animal uprights of St Mark's throne on fol. 142 of the Lichfield Gospels, the decorative initial on fol. 51 of the Barberini Gospels, and the initial S on fol. 27 of the Blickling Psalter (New York: Morgan Library, MS M.776): Alexander 1978, cat. 21, 36 and 31.

54 Cramp 1984, xli, fig. 23, Type E (top).

55 Brunning 2013, 14 and *passim*.

56 I know of no inscriptions on brooches from this period; but there are two examples of a runic *futhorc* inscribed on the heads of dress pins, presumably as good luck charms (from Brandon, Suffolk (Webster & Backhouse 1991, cat. 66b), and from Malton, North Yorkshire (BM 2000,0508.1). The Flixborough silver ring with an alphabetic text, and the possibly rather later Greymoor Hill (near Carlisle, Cumbria) ring with a runic charm also fall into this talismanic category (Webster & Backhouse 1991, cat. 69b; Wilson 1964, cat. 27).

57 IN NOMINE : DNI : NOSTRI : IHV : SCS : SPS : DI : ET : OMNIBVS : DECEMVS : AMEN: OSHERE : XPI (Tweddle 1992, figs 446, 448–51).

58 Speake 1980, 86, fig. 11, pl. 2 a–h; Webster 2001a, 15, 16, 18; 2003, fig. 6.

59 Webster 2003, 18–9, fig. 6c–e.

60 From reconstruction provided by Howlett (2002, 473): IN NOMINE D[EI] S[UMMI] | [PAT]RES AC D[EI] FILI SP[IRIT]US S[AN]C[T]I O.

61 Page 1964, 77–9; Storms 1948, 311, no. 86 (*wiþ þeofte*).

62 Dickinson 2005; Webster 2012, 29–32.

63 Klaeber 1950, 63.

64 See Webster 2005, 29–36.

65 Brunning 2013, 233.

66 See Henderson above, 60.

67 See Henderson above, 61–2.

68 Henderson 1998, 116; see also Webster 2005, 32 for further exploration of the iconography of the Fetter Lane hilt.

69 Webster 2001b, 272; 2012, 143–4. With regard to the second chape (which, unlike the inscribed chape, shows no signs of wear or gilding, and differs from that and the pommel in several stylistic respects), I now accept James Graham-Campbell's argument (2003, 32) that this seems to be a reinterpreted version of the first, and was probably a local product.

70 See Henderson above, 62–3, and also Henderson 1994, 80; 2007; Webster 2012, 144–5.

71 See 103.

72 In discussing these Wilson (1973, 93) points out, in connexion with Brooch 20, that 'such a feature is unparalleled in the entire corpus of Celtic penannular brooches'; Henderson & Henderson 2004, 99.

73 See further Henderson above, 54–65, and also Henderson & Henderson 2004, 113; Henderson 2007, 214.

74 Pers. comm. This discussion draws considerably on Professor Blair's comments.

75 Great Domesday (National Archives E 31/2/1/5887, fol.154v); entry illustrated at Open Domesday (http://domesdaymap. co.uk/; Accessed 10 December 2015) Oxfordshire, 2; Morris 1978, 1, 2.

76 The Electronic Sawyer, S909.

77 Great Domesday (National Archives E 31/2/1/5887, f.154v); entry illustrated at Open Domesday (http://domesdaymap. co.uk/; Accessed 10 December 2015) Oxfordshire, 2; Morris 1978, 1, 10.

78 My thanks to Isabel and George Henderson, James Graham-Campbell, John Blair, Michelle Brown, Sue Brunning and David Wilson, and the British Museum illustrators, Stephen Crummy and Jim Farrant, who have all in different ways contributed to the gestation of this paper. The faults, of course, are all mine. And as this paper has been a long time in the writing, I would particularly like to thank the editors for their patience, as well as for their constructive suggestions which have undoubtedly improved this text.

References

Alexander, J.J.G., 1978 *Insular Manuscripts, 6th to the 9th Century* (London)

Arwidsson, G., 1977 *Valsgärde 7*, Acta Musei Antiquitatum Septentrionalium Regiae Universitatis Upsaliensis 5 (Uppsala)

Bailey, R.N., 2000 'The Gandersheim Casket and Anglo-Saxon Stone Sculpture' in Marth 2000, pp 43–52

Bailey R.N., 2005 *Anglo-Saxon Sculptures at Deerhurst*, Deerhurst Lecture 2002 (Deerhurst)

Bakka, E., 1963 'Some English Decorated Metal Objects found in Norwegian Viking Graves. Contribution to the Art History of the 8th century A.D.', *Årbok for Universitetet i Bergen, Humanistik Serie* 1, 4–66

Brown, M.P., 2007 *Manuscripts from the Anglo-Saxon Age* (London)

Brunning, S.E., 2013 'The "living" Sword in Early Medieval Northern Europe: an Interdisciplinary Study' (PhD, 2 vols, Institute of Archaeology, University College London)

Bryant, R., 2012 *The Western Midlands*, CASSS 10 (Oxford)

Coatsworth, E., 2008 Western Yorkshire, CASSS 8 (Oxford)

Cramp, R.J., 1984 *Grammar of Anglo-Saxon Ornament. A General Introduction to the Corpus of Anglo-Saxon Stone Sculpture* (Oxford; repr. 1991)

DCMS, 2005 *Treasure Annual Report 2003* (London)

Dickinson, T.M., 2005 'Symbols of Protection: the Significance of Animal-ornamented Shields in Early Anglo-Saxon England', *Med. Arch.* 49, 109–63

The Electronic Sawyer: Revised Catalogue of Anglo-Saxon Charters (Available: http://www.esawyer.org.uk. Accessed 10 December 2015)

Evans, D.H. & Loveluck, C. (ed.), 2009 *Life and Economy at Early Medieval Flixborough, c. AD 600–1000, the Artefact Evidence*, Excavations at Flixborough 2 (Oxford)

Farr, C.A., 2000 'The Gandersheim Casket compared with Anglo-Saxon Manuscripts' in Marth 2000, pp 53–62

Foster, S.M. (ed.), 1998 *The St Andrews Sarcophagus: A Pictish Masterpiece and its International Connections* (Dublin)

Gem, R. & Howe, E., with Bryant, R., 2008 'The Ninth-century Polychrome Decoration at St Mary's Church, Deerhurst', *Antiquaries J.* 88, 109–64

Graham-Campbell, J., 2003 *Pictish Silver: Status and Symbol*, H.M. Chadwick Memorial Lectures 13 (Cambridge)

Graham-Campbell, J., 2004 'On the Witham Bowl', *Antiquaries J.* 84, 358–71

Graham-Campbell, J., forthcoming 'The St Ninian's Isle Treasure: Contents and Context' in B. Smith (ed.), *The St Ninian's Isle Treasure: Reflections after Fifty Years* (Lerwick)

Hammond, B., 2010 *British Artefacts, 2: Middle Saxon and Viking (AD 650–950)* (Witham)

Henderson, G. & Henderson, I., 2004 *The Art of the Picts: Sculpture and Metalwork in Early Medieval Scotland* (London)

Henderson I., 1994 'The Insular and Continental Context of the St Andrews Sarcophagus' in B. Crawford (ed.), *Scotland in Dark Age Europe* (St Andrews), pp 71–103

Henderson I., 1998 '*Primus inter pares*: the St Andrews Sarcophagus and Pictish Sculpture' in Foster 1998, pp 97–167

Henderson I., 2007 'New animal Ornament on the Cross-slab from Hilton of Cadboll, Ross and Cromarty, Scotland' in R. Moss (ed.) *Making and Meaning in Insular Art* Proceedings of the fifth international Conference on Insular Art held at Trinity College Dublin, 25–28 August 2005, Research Studies in Irish Art I (Dublin), pp 198–214

Hinton, D., 1974 *A Catalogue of the Anglo-Saxon Ornamental Metalwork 700–1100 in the Department of Antiquities, Ashmolean Museum* (Oxford)

Howlett, D., 2002 'St Ninian's Isle: the Inscription on the Chape', *Peritia* 16, 472–3

Kendrick, T.D., 1938 *Anglo-Saxon Art* (London, repr. 1972)

Klaeber, F. (ed.), 1950 *Beowulf and The Fight at Finnsburg,* 3 edn (Boston, MA & London)

Marth, R. (ed.), 2000 *Das Gandersheimer Runenkästchen. Internationales Kolloquium, Herzog Anton Ulrich-Museum, Braunschweig 24.–26. Marz 1999* (Brunswick)

Marzinzik, S., 2013 *Masterpieces: Early Medieval Art* (London)

Morris, J. (ed. and trans.), 1978 *Domesday Book, 14: Oxfordshire* (Chichester)

Page, R.I., 1964 'The Inscriptions' in Wilson 1964, pp 67–90

Petersen, J., 1919 *De Norske Vikingesverd: En Typologisk-Kronologisk Studie Over Vikingetidens Vaaben* (Oslo)

Plunkett, S., 1998 'The Mercian Perspective', in Foster 1998, pp 202–26

Plunkett, S., 2005 *Suffolk in Anglo-Saxon Times* (Stroud)

Salin, B., 1904 *Die Altgermanische Thierornamentik* (Stockholm)

Small, A., Thomas, C. & Wilson, D.M., 1973 *St Ninian's Isle and its Treasure*, Aberdeen University Studies 152, 2 vols (Oxford)

Speake, G., 1980 *Anglo-Saxon Animal Art and its Germanic Background* (Oxford)

Storms, G., 1948 *Anglo-Saxon Magic* (The Hague)

Tweddle, D., 1992 *The Anglian Helmet from Coppergate*, The Archaeology of York: The Small Finds 17/8 (London)

Webster, L., 2000 'Style and Function of the Gandersheim Casket', in Marth 2000, pp 63–72

Webster L., 2001a 'The Anglo-Saxon Hinterland: Animal Style in Southumbrian Eighth-century England, with Particular Reference to Metalwork', in M. Müller-Wille & L.O. Larsson (ed.), *Tiere-Menschen-Götter: Wikingerzeitliche Kunststile und ihre neuzeitliche Rezeption*, Veröffentlichen

Joachim-Jungius-Gesellschaft des Wissenschaften Hamburg 90 (Hamburg), pp 39–62

Webster, L., 2001b 'Metalwork of the Mercian Supremacy' in M.P. Brown & C.A. Farr (ed.), *Mercia, an Anglo-Saxon Kingdom in Europe* (Leicester), pp 263–77

Webster, L., 2003 'Encrypted Visions: Style and Sense in the Anglo-Saxon Minor Arts, A.D. 400–900' in C.E. Karkov & G.H. Brown (ed.), *Anglo-Saxon Styles* (Albany, NY), pp 11–30

Webster, L., 2005 'Visual Literacy in a Protoliterate Age' in P. Hermann (ed.), *Literacy in Medieval and Early Modern Scandinavian Culture*, Studies in Northern Civilization 16 (Viborg), pp 21–46

Webster, L., 2012 *Anglo-Saxon Art, a new History* (London)

Webster, L. & Backhouse, J. (ed.), 1991 *The Making of England: Anglo-Saxon Art and Culture AD 600–900* (London)

Wilson, D.M., 1964 *Anglo-Saxon Ornamental Metalwork 700–1100 in the British Museum*, Catalogue of Antiquities of the Later Saxon Period 1 (London)

Wilson, D.M., 1973 'The Treasure', in Small et al. 1973, i, pp 45–148

A Scandinavian gold brooch from Norfolk

James Graham-Campbell

A recent (2013) metal-detector find of a fragmentary 'lozenge brooch', from near Attleborough, Norfolk, is the first example of its type to have been discovered made of gold, with filigree decoration (Figs 11.1–3).[1] 'The openwork lozenge brooch, with a raised central rosette and four arms terminating in moulded Borre-style animal heads, is a ninth-century Scandinavian brooch type which is found with some frequency in the eastern counties of England'.[2] In addition, a simplified Anglo-Scandinavian variant, local to the Norwich area, has been recognised by Jane Kershaw.[3] These brooches are, however, characteristically cast in copper-alloy, with a few being of lead-alloy (Fig. 11.4) and one of silver (see below).

Description

Gold composite openwork lozenge brooch, now in four conjoined pieces but with one terminal missing and some distortion and damage to the broken edges (Figs 11.2–3).[4] The brooch is made from two sheets of gold, with filigree

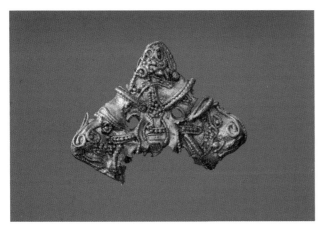

Fig. 11.1 Gold filigree-decorated lozenge brooch from near Attleborough, Norfolk. (Photo: © Norfolk County Council)

decoration on its upper face. It has slightly concave sides with rounded terminals, each in the form of an animal head. There were originally four circular holes between the arms of the central cross. The edge of the flat back-plate is folded over the rim of the convex front-plate, forming a hollow brooch. The back-plate is plain, except for the remains of the catch-plate on one terminal, in the form of a rectangular gold strip, originally folded in the centre to form the catch itself, but now broken flush with the surface. The pin-attachment would have been on the reverse of the missing terminal. The upper plate is shaped by hammering so as to provide a rounded base for each of the four animal heads. The filigree decoration on the front face is formed from beaded and twisted wires with granulation, but the workmanship is of poor quality and some details are obscure from over-heating and flooding with solder, with the result that some of the granules, which are of uneven size, have become detached and are missing. There is some evidence of wear.

The central element in the design consists of a cross with its arms bound together by a central ring consisting of two concentric circles of twisted wire (Fig. 11.1). The vertical cross-arms are formed from a row of granules bordered by twisted wire; the surviving horizontal arm has an expanded lozengiform terminal of twisted wire filled with a cluster of small granules. Each cross-arm overlaps with a C- or V-shaped transverse bar, consisting originally of a thick beaded wire bordered by twisted wires. These form the backs of the animal-head terminals and, in turn, overlie the V-shaped brows of the animal heads themselves, consisting of a row of granules bordered by twisted wires. The brows are linked together and would have formed a second (outer) circle had it not been broken on the forehead of the lower animal head, where the design is somewhat confused (as is that of the left-hand face). Each animal-head terminal has a border of twisted wire, with its ends bent back and extended to run parallel with the edge to terminate in opposing scrolls which

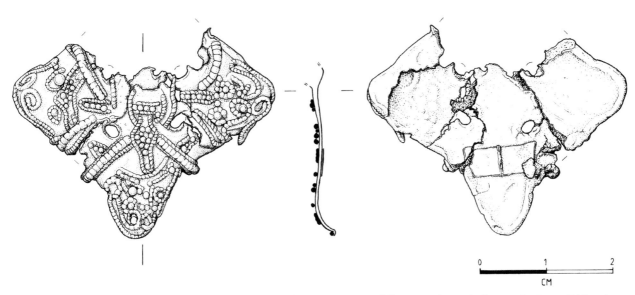

Fig. 11.2 Front and back of the Attleborough lozenge-brooch fragments. (© Norfolk County Council; drawing by Jason Gibbons)

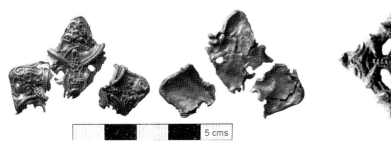

Fig. 11.3 Front and back of the Attleborough lozenge-brooch fragments. (Photo: © Norfolk County Council)

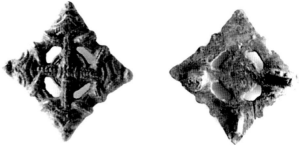

Fig. 11.4 Cast lead-alloy lozenge brooch (Type I/II) from Elsham, Lincolnshire. Scale 1:1 (Photo: © Kevin Leahy)

form the snout. The eyes are unevenly executed, but formed from single granules each surrounded by an oval or circle of beaded and twisted wire. Those of the lower face are in the place of the missing brows, so creating a space below. This is filled to one side by the addition of a Z-shaped scroll, with a single granule contained in its inner loop; the other side has an enlarged snout scroll. The faces appear to have been filled with granules, most of which are now missing, in contrast with the inner area which seems to have been left plain. Overall length: *c.* 39mm; weight: 5.5g.

Discussion

The great majority (thirty-two out of thirty-six) of the copper-alloy lozenge brooches from Scandinavia and northern Germany that have been published to date are from Viking-age Denmark, there being just one on record from Norway and three from Uppland in Sweden, including one from Birka.[5] A recent addition to the Danish corpus is an exceptional example in cast silver found during metal-

detecting at Lejre (Sjælland).[6] There is clear evidence for serial production at Hedeby in the form of twenty-three brooches, two patrices and a mould.[7] More widespread production is, however, indicated by finds of four further patrices for lozenge-brooch moulds, from Tissø and Lejre (Sjælland), Gudme (Fyn) and Dalshøj (Bornholm).[8]

In addition, there is an atypical lozenge brooch (not in openwork) from Norway that is of particular relevance to the Attleborough gold filigree brooch because it is made of silver with filigree decoration; this forms part of the substantial Tråen hoard, Buskerud,[9] deposited *c.* 1000.[10] Somewhat larger in size is a cast silver lozenge brooch from Rinkaby, Skåne (Length 68mm), but its design is far more elaborate, with the terminal heads facing inwards and the spaces between the beaded arms being filled with Borre-style 'gripping-beasts'.[11] This is, however, unique and appears to owe its inspiration as least as much to the design of such elaborate Borre-style disc brooches as that in the Swedish silver hoard from Vårby, Huddinge, Södermanland, deposited *c.* 940,[12] as it does to the lozenge-brooch series.

The cast lozenge brooches have been divided into two main types (Types I and II) distinguished from each other by the treatment of the cruciform arms, with those of Type I being filled with a row of 'cast pellets' (or beading), and Type II having 'paired ridges'.[13] In fact, the finest examples, including two of those from England – 'East Anglia' (no. 14) and Elsham, Lincolnshire (no. 15; Fig. 11.4)[14] – combine these decorative features, having a row of beading placed between the ridges, in direct imitation of the classic filigree arrangement to be seen on the Attleborough brooch (Fig. 11.1). They have therefore been classified here as Type I/II.

It is evident that Type I and II cast brooches demonstrate simplification in their decoration by utilising just one or other of these decorative features. In addition, the two Type I/II brooches (nos 14 and 15) share a significant design element, which they have in common with two Type II brooches from England (nos 16 and 19), that relates them even more closely to the Attleborough example, with its central 'ring-knot' (Fig. 11.1), in likewise having a central ring at the crossing of the arms, although in these cast versions it is simplified to 'a circular plate' underlying 'the central rosette' (Fig. 11.4).[15]

The imitation beaded-wire decoration of the Type I/II brooches (in particular), combined with the fact that a couple of the copper-alloy examples from England (for example) show signs of having been gilded (nos 9 and 26), strongly suggest that it was gold filigree-decorated jewellery which formed the immediate inspiration for the cast lozenge-brooch series in Scandinavia. This is as suggested for much standard Borre-style ornamental metalwork, including the Borre mounts themselves.[16]

The design of four masks set cross-wise is a common motif in ornament of the middle Viking period (both inward- and outward-facing) and has been traced back to the design of a gold filigree-ornamented pendant in the ninth-century Hoen hoard from Norway.[17] It appears not only on brooches and pendants, but also on harness-mounts,[18] including several examples from Hedeby and the surrounding area.[19] It was on such cast ornaments that the Borre style will have been introduced into Britain and Ireland,[20] although the presence of at least some Scandinavian-trained metalworkers producing Borre-style filigree-decorated jewellery in tenth-century England is attested by the separate discovery of two copper-alloy dies and a lead patrix used in the production of cruciform pendants of the so-called 'Hiddensee-Rügen type', with bird-headed suspension loops.[21] Yet, despite this accumulating evidence for their manufacture here, no actual pendant has yet been found in Britain or Ireland, although there is one stray-find of silver from Iceland.[22]

The only example from outside eastern England of the thirty-seven lozenge brooches known from the Viking West is from Dublin – there being none on record from either Scandinavian Scotland or Iceland (Fig. 11.5). This Type I copper-alloy brooch (Length 25mm), from the Winetavern Street excavations,[23] was identified as 'unfinished' by Ingmar Jansson and thus as 'evidence of casting of standard [Scandinavian] bronze jewellery' in Dublin.[24] It was subsequently described by the present author, more correctly, as 'a faulty casting' with the comment that it 'may have been imported for some secondary use (for example, as a pendant), or simply scrap metal'.[25] Indeed, the fact of it being a faulty (and thus unfinished) casting is not sufficient in itself to demonstrate its production in Dublin, if only because no other evidence has been found there for the manufacture of such small dress ornaments of the Scandinavian types now known to have been so common – and copied – in eastern England. In addition, the distribution pattern (Fig. 11.5) does not suggest the existence of any other production centre for lozenge brooches in the Viking West other than 'the single workshop' proposed by Kershaw, most probably in Norwich, responsible for a homogeneous group of eight brooches, with 'a common design fault: the elongation of the terminal bearing the single pin-lug, resulting in a distorted asymmetrical lozenge shape'.[26]

The overall distribution pattern of the lozenge brooches known to have been found outside Scandinavia (Fig. 11.5) is comparable to that of the fourteen Scandinavian Jellinge-style disc brooches of Jansson's Type I A1 from the Viking West,[27] with eleven brooches known from England (including the one from Attleborough),[28] none from Scotland and one from Dublin,[29] where it had been re-used as a pin-head, with the addition of a single example from Iceland, from Hofstaðir in Garðabær.[30] In Scandinavia, these brooches likewise have a restricted distribution, the majority also being known from Viking-age Denmark (nine, including three from Hedeby), with the others consisting of three from Sweden (including one from Birka) and a single outlier from Saxony-Anhalt.[31]

In addition to the gold lozenge brooch which forms the subject of this paper, the metal-detector site on the edge of a common pasture near Attleborough, Norfolk,[32] has produced a number of other Scandinavian or Anglo-Scandinavian items of Viking-age date, including the Jellinge-style disc brooch of Jansson's Type I A1 mentioned above. Other such near-by finds include two Borre-style disc brooches of Jansson's Type II A,[33] two lead Thor's hammers, two 'truncated spherical' weights and a dirham fragment.[34] In addition, there are two coins of Edgar, two of Cnut and one of Edward the Confessor, from a little further away to the south-east, but the settlement failed to survive into the post-Conquest period.[35]

The Attleborough lozenge brooch was a find 'waiting to be made', even if others of superior workmanship must surely follow, in southern Scandinavia at least. Likewise, it can only be a matter of time before an example of a filigree-decorated pendant of Hiddensee-Rügen type is metal-detected somewhere in eastern England.

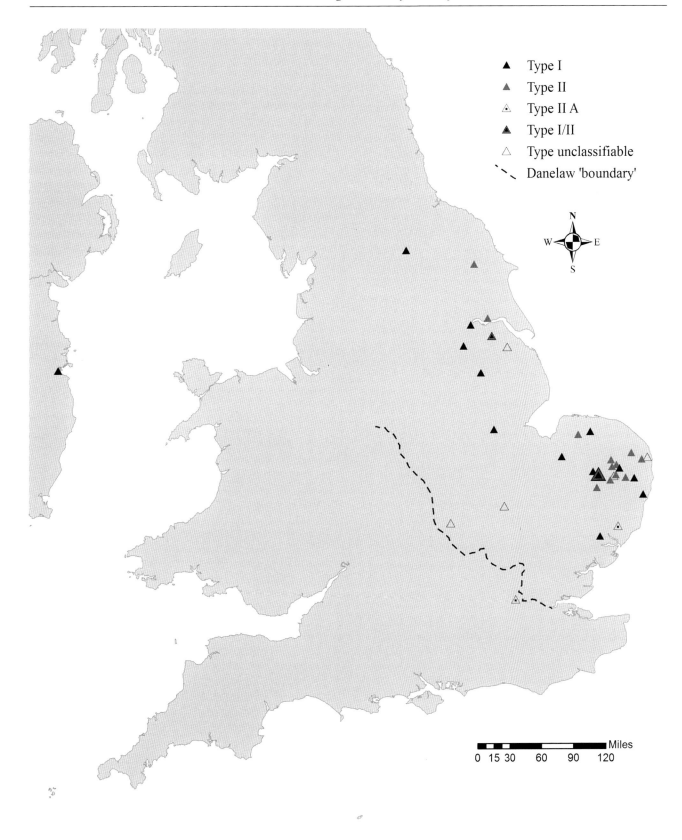

Type I
Type II
Type II A
Type I/II
Type unclassifiable
Danelaw 'boundary'

Miles
0 15 30 60 90 120

Fig. 11.5 Lozenge brooches in Britain and Ireland of known provenance; enlarged symbol: Attleborough, Norfolk. (Drawing: Jane Kershaw)

Notes

1 I am grateful to Andrew Rogerson (Norfolk Historic Environment Service) for bringing the Attleborough brooch to my attention (28 March 2013) and providing the photographs (Figs 11.1–3), and drawing (Fig. 11.2, by Jason Gibbons) as part of the Treasure process (2013 T185), and to Tim Pestell for giving permission for its publication, on behalf of Norwich Castle Museum and Art Gallery. During the preparation of this paper I have also benefited from discussions with Caroline Paterson, Leslie Webster and David Wilson, but in particular with Jane Kershaw who has also kindly provided the distribution map (Fig. 11.5) and assisted me with compiling the Appendix (117), on which it is based.

2 Kershaw 2013, 43; cf. Paterson in Leahy & Paterson 2001, 194–5.

3 Kershaw 2013, 47–8, fig. 3.5; see above, 114.

4 I am grateful to Erica Darch (Finds Liaison Officer, Norfolk) for a copy of her detailed preliminary description of the brooch which forms the basis for my own (see also PAS database: NMS-73CD11).

5 Kershaw 2013, 251, Appendix A, lists 1 and 2, map 3.1.

6 Recorded at Roskilde Museum; information from Jane Kershaw.

7 Capelle 1968, pls 9.2-3, 10.2; Hilberg 2009, 95, fig. 11.

8 Kershaw 2013, 251, appendix A, list 3.

9 Brøgger 1917, 258 (c); Grieg 1929, 214, no. 17c, fig. 47 (C.21858).

10 Skaare 1976, 136, no. 36; deposited 'after *c.* 991'.

11 Graham-Campbell 1980, no. 490; 2013, 67, pl. 65; Wilson 1995, 87, pl. 54.

12 Wilson 1995, 94, 96, pls 70 and 72: Graham-Campbell 2013, pl. 99.

13 Kershaw 2010, 107–8, following Richardson 1993, 18; see also Paterson in Leahy & Paterson 2001, 194, and Kershaw 2013, 45.

14 Leahy & Paterson 2001, 194–5, pl. 10.5; Hadley 2006, 123, fig. 14; Kershaw 2010, ii, no. 15; 2013, fig. 3.4.

15 Kershaw 2013, 47.

16 Wilson in Wilson & Klindt-Jensen 1966, 89; Graham-Campbell 2013, 65.

17 Fuglesang 2006, 89–90, no. 8, pl. 5; 2013, 826, 830, fig. 2.

18 Paterson in Leahy & Paterson 2001, 194; Kershaw 2013, 44.

19 Müller-Wille 1977, fig. 3,2–3; 1987, pls 76, 77,1 and 102,1–4.

20 For the introduction of the Borre style into Britain and Ireland, see Wilson 1976; Bailey 1980, 54–5, 71–2; Graham-Campbell 1987; Richardson 1993; Paterson 2002; Kershaw 2013.

21 See Kershaw 2009 for general discussion and the die from Swinhope, Lincolnshire (ibid., fig. 5,b); the second – and more elaborate – die is a recent find from the Askham area, Nottinghamshire (PAS database: DENO-698D71), which I am grateful to Jane Kershaw for having brought to my attention. The lead patrix is an old find from York (Roesdahl et al. 1981, YMW13).

22 Eldjárn & Friðriksson 2000, 382–3, figs 295–6.

23 Ó Ríordáin 1971, 77; Anon 1973, 24, no. 9 (E81:4681).

24 Jansson 1981, 9 (n. 4), 16, fig. 6 (map).

25 Graham-Campbell 1987, 151; cf Richardson 1993, 138; Kershaw 2013, 132. One terminal is incomplete (face missing); on the reverse, the catch-plate is a solid lump and there are no pin-attachment lugs.

26 Kershaw 2013, 47–8, fig. 3.5; as listed in the Appendix (Type II(2)).

27 Jansson 1984, 60, fig. 8.2, I A1.

28 Pestell 2004, 70, pl. 4; Kershaw 2010, ii, no. 481.

29 Kershaw 2013, 104–8, figs 3.54–6, map 3.19.

30 Eldjárn & Friðriksson 2000, 370, figs 266, 603.

31 Kershaw 2013, 254, list 1.3, map 3.18.

32 Pestell 2004, 70–2.

33 Kershaw 2010, ii, nos 39–40.

34 Pestell 2004, 71–2, pl. 4; 2013, 240, 241–2; additional information from Jane Kershaw and Tim Pestell. The two weights are Norfolk HER 36681 and 29895 (the latter being in Norwich Castle Museum: 2009.208); the second lead Thor's hammer is now NCM 2013.60. The dirham fragment was found in 2004 (Norfolk HER 36681).

35 Information from Andrew Rogerson and Tim Pestell.

References

Anon, 1973 *Viking and Medieval Dublin: National Museum Excavations, 1962–1973* (Exhibition Catalogue, National Museum of Ireland)

Bailey, R.N., 1980 *Viking Age Sculpture in Northern England* (London)

Brøgger, A.W., 1917 *Universitetets Oldsaksamlings Tilvekst 1904–1914*, Oldtiden 6 (Kristiania)

Capelle, T., 1968 *Der Metallschmuck von Haithabu* (Neumünster)

Fuglesang, S.H., 2006 'The Scandinavian Pendants' in S.H. Fuglesang & D.M. Wilson (ed.), *The Hoen Hoard: A Viking Gold Treasure of the Ninth Century*, Norske Oldfunn 20 (Oslo), pp 83–92

Fuglesang, S.H., 2013 'Copying and Creativity in Early Viking Ornament' in A. Reynolds & L. Webster (ed.), *Early Medieval Art and Archaeology in the Northern World: Studies in Honour of James Graham-Campbell* (Leiden), pp 825–41

Graham-Campbell, J., 1980 *Viking Artefacts: a Select Catalogue* (London)

Graham-Campbell, J., 1987 'From Scandinavia to the Irish Sea: Viking Art Reviewed' in M. Ryan (ed.), *Ireland and Insular Art, A.D. 500–1200* (Dublin), pp 144–52

Graham-Campbell, J., 2013 *Viking Art* (London)

Grieg, S., 1929 'Vikingetidens skattefund', *Universitetets Oldsaksamlings Skrifter* 2, 177–311

Eldjárn, K. & Friðriksson, A., 2000 *Kuml og haugfé: úr heiðnum sið á Íslandi* (Reykjavík)

Hadley, D.M., 2006 *The Vikings in England: Settlement, Society and Culture* (Manchester)

Hilberg, V., 2009 'Hedeby in Wulfstan's Days: a Danish Emporium of the Viking Age between East and West' in A. Englert & A. Trakadas (ed.), *Wulfstan's Voyage: the Baltic Sea Region in the Early Viking Age as seen from Shipboard* (Roskilde), pp 79–113

Jansson, I., 1981 'Economic Aspects of Fine Metalworking in Viking-Age Scandinavia' in D.M. Wilson & M. Caygill (ed.), *Economic Aspects of the Viking Age*, British Museum Occasional Paper 30 (London), pp 1–19

Jansson, I., 1984 'Kleine Rundspangen' in G. Arwidsson (ed.), *Birka II:1. Systematische Analysen der Gräberfunde* (Stockholm), pp 58–74

Kershaw, J.F., 2009 'Swinhope' in J. Naylor, K. Leahy, & G. Egan, 'Medieval Britain and Ireland in 2008: Portable Antiquities Scheme Report', *Med. Arch.* 53, 327–46, at 337

Kershaw, J.F., 2010 'Culture and Gender in the Danelaw: Scandinavian and Anglo-Scandinavian Brooches, 850–1050' (DPhil, 2 vols, University of Oxford)

Kershaw, J.F., 2013 *Viking Identities: Scandinavian Jewellery in England* (Oxford)

Leahy, K. & Paterson, C., 2001 'New light on the Viking Presence in Lincolnshire: the Artefactual Evidence' in J. Graham-Campbell, R. Hall, J. Jesch & D. Parsons (ed.), *Vikings and the Danelaw: Selected Papers from the Proceedings of the Thirteenth Viking Congress* (Oxford), pp 181–202

Müller-Wille, M., 1977 'Krieger und Reiter im Spiegel früh- und hochmittelalterlicher Funde Schleswig-Holsteins', *Offa* 34, 40–74

Müller-Wille, M., 1987 *Das Wikingerzeitliche Gräberfeld von Thumby-Bienebek*, 2 vols (Neumünster)

Ó Ríordáin, B., 1971 'Excavations at High Street and Winetavern Street, Dublin', *Med. Arch.* 15, 73–85

Paterson, C., 2002 'From Pendants to Brooches: the Exchange of Borre and Jellinge style Motifs across the North Sea', *Hikuin* 29, 267–76

Pestell, T., 2004 *Landscapes of Monastic Foundation. The Establishment of Religious Houses in East Anglia c. 650–1200* (Woodbridge)

Pestell, T., 2013 'Imports or Immigrants? Reassessing Scandinavian Metalwork in Late Anglo-Saxon East Anglia' in D. Bates & R. Liddiard (ed.), *East Anglia in the North Sea World* (Woodbridge), pp 230–55

Richardson, C., 1993 'The Borre Style in the British Isles and Ireland' (MLitt, University of Newcastle upon Tyne)

Roesdahl, E., Graham-Campbell, J., Connor, P. & Pearson, K. (ed.), 1981 *The Vikings in England and in their Danish Homeland* (London)

Skaare, K., 1976 *Coins and Coinage in Viking-Age Norway* (Oslo)

Wilson, D.M., 1976 'The Borre Style in the British Isles' in B. Vílhjálmsson, J. Kristjánsson, T. Magnusson & G. Kolbeinsson (ed.), *Minjar og Menntir* (Reykjavík), pp 502–9

Wilson, D.M., 1995 *Vikingatidens Konst* (Lund)

Wilson, D.M. & Klindt-Jensen, O., 1966 *Viking Art* (London)

Appendix: Hand-list of Borre-style lozenge brooches from Britain and Ireland (Fig. 11.5)

James Graham-Campbell and Jane Kershaw

Lozenge brooches from Britain and Ireland (by country)
England: 36; Ireland: 1; Scotland: 0; Wales: 0
Total: 37

Lozenge brooches from Britain and Ireland (by type)
For further details, see Kershaw 2010, ii, nos 1–32 (with additions), and the on-line catalogue for England hosted by the Archaeological Data Service, doi:10.5284/1012709:http://dx.doi.org/1.5284/1012709

Type I (nos 1–13 & Dublin, Ireland): with beaded arms
5 Lincolnshire: Adlingfleet, Aisthorpe, Epworth, Laughton, unprovenanced (Scandinavian; copper-alloy)
5 Norfolk: Kirby Cane, Little Snoring, Marham, Rockland St Peter (Scandinavian: copper-alloy; now NCM 2003.119); Stoke Holy Cross/Caistor St Edmund (Anglo-Scandinavian: lead-alloy; NCM 1985.403)
2 Suffolk: Wangford, Wenham Parva (Scandinavian: copper-alloy)
1 North Yorkshire: Snape with Thorpe (Scandinavian: copper-alloy)
1 Dublin: Winetavern Street (Scandinavian: copper-alloy)
Total: 14

Type I/II (nos 14–15 & Attleborough, Norfolk): with beaded and ridged arms
1 East Anglia: unprovenanced (Scandinavian: copper-alloy)
1 Lincolnshire: Elsham (Scandinavian: lead-alloy)
1 Norfolk: Attleborough (Scandinavian: gold)
Total: 3

Type II (nos 16–26 & Woodbastwick, Norfolk, and Swanland, Yorkshire East Riding): with ridged arms
Type II(1) = Scandinavian (5 brooches: nos 16, 19, 26; Woodbastwick, Norfolk, and Swanland, Yorkshire East Riding); Type II(2) = Anglo-Scandinavian (8 brooches: nos 17–18 and 20–5)
1 Lincolnshire: unprovenanced (II(1): copper-alloy)
10 Norfolk: Keswick, Woodbastwick (II(1): copper-alloy); Aslacton, Bawburgh, Ketteringham, North Lopham, Stokesby with Herringby, Tasburgh, Tattersett, Woodton (II(2): copper-alloy)
1 Yorkshire, East Riding: Swanland (II(1): copper-alloy)
1 North Yorkshire: Thorpe Bassett (II(1): copper-alloy)
Total: 13

Type II A (nos 27–8): with ridged arms and schematic heads
1 London: Bull Wharf, Queenhithe (Scandinavian: copper-alloy)
1 Suffolk: Hasketon (Scandinavian: copper-alloy)
Total: 2

Unclassifiable (nos 29–32 & Tharston and Hapton, Norfolk): uncertain
1 Cambridgeshire: Southoe and Midloe (copper-alloy)
1 Lincolnshire: Swallow (copper-alloy)
2 Norfolk: Mautby, Tharston and Hapton (copper-alloy)
1 Northamptonshire: Towcester (copper-alloy)
Total: 5

12

A glimpse of the heathen Norse in Lincolnshire

John Hines

A new find

Evidence of religious allegiance and practices amongst the Scandinavians who invaded and eventually settled in England in the Viking Period has always been elusive – even though these people are definitively and pejoratively labelled as 'heathens' in English sources such as the *Anglo-Saxon Chronicle* and Wulfstan's homilies. One source which does provide both figuratively and literally hard information on a knowledge and use of myths associated with the traditional gods and goddesses amongst this population is the Anglo-Scandinavian sculpture that Richard Bailey has done so much to make accessible and more comprehensible to students and scholars. In the space created by what is largely an absence of evidence, it has been possible to consider, quite reasonably, whether there had been a rapid assimilation of the Scandinavian incomers – however few or many they may have been – to local culture, which may have included their prompt conversion to Christianity.[1] An alternative view may be that the nature of traditional religious practice in Viking-period Scandinavia was of a materially indistinct character which would inevitably render it largely invisible. Whichever the case, but particularly in the latter view, an inscribed artefact found in the parish of Saltfleetby St Clement, Lincolnshire, in the summer of 2010 is important, not only as a rare find but also as an unusually informative one.

In recent years, responsible metal-detecting has contributed many new archaeological finds and has, in some cases, truly transformed our understanding of topics, areas and periods. This is not least so in the case of the pre-Conquest, early Middle Ages, and especially true of the historic county of Lincolnshire.[2] The object on which a full report is published here for the first time was found by Mrs Denise Moncaster, a local detectorist who regularly searches the fields in the Saltfleetby area (see Fig. 12.1).

Recognising the unusual character and interest of the object, she reported it promptly to the county Finds Liaison Officer, Adam Daubney, who, in preparing a record of the find for the Portable Antiquities Scheme database, asked me to comment on it because of what appeared to be a runic inscription that it bore. The identification of the inscribed marks as runes could be confirmed instantly; equally immediate was excitement and even incredulity at what could first be read.

The inscribed object is a lead spindle-whorl, weighing 49.8g. Lead spindle-whorls are typically cast and finished by paring with a knife. Its outline, viewed from above or below, can be described as more of a curved triangle than

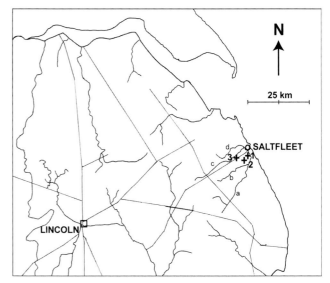

Fig. 12.1 The location of Saltfleetby, Lincolnshire, showing the relative positions of the three parish churches of Saltfleetby and the local rivers referred to in the text. Key: 1. Saltfleetby St Clement; 2. Saltfleetby All Saints; 3. Saltfleetby St Peter (a) Great Eau; (b) Long Eau; (c) Greyfleet Drain; (d) South Dike (J. Hines)

as circular; this shape may have assisted spinning by finger when on the spindle. Its maximum width is 28.5mm and its maximum height 16.5mm. In profile its body has a vertical walled part and a conical part (Fig. 12.2). Experts in hand-spinning advise that it should have been used with the flat face uppermost and the conical face downwards. There is a vertical hole through the whorl for the spindle with a diameter of 7–8mm.

A reading of the inscription

The runes are in two rows, one around the vertical wall of the whorl and the other in a ring around the spindle hole on the flat (upper) face (Fig. 12.3a–b). The runes had been cut into the soft lead of the object with a knife; some deliberately formed points in the inscription clearly preserve the shape of the knife tip in cross-section. A simple, but not readily identifiable, curvilinear motif has also been cut into one side of the sloping face of the conical part of the whorl (Fig. 12.3c).

The runes themselves are immediately identifiable as the forms of the 'long-branch' variant of the later Scandinavian fuþark, including forms which show that the script available had already started to expand from the reduced, sixteen-character

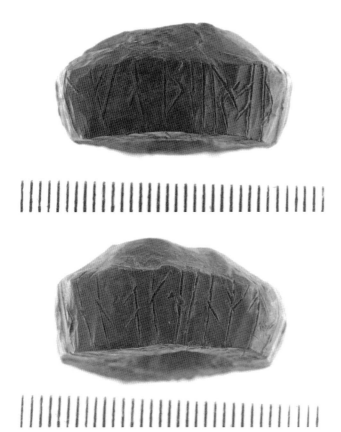

Fig. 12.2 The Saltfleetby spindle-whorl, width 28.5mm (Photo: John Morgan, Cardiff University)

'younger fuþark' that had been adopted by the beginning of the Viking Age towards a character set of twenty-four or more graphs of the Scandinavian Christian Middle Ages which mirrored the Latin alphabet. The Saltfleetby inscription includes two new rune-forms of this kind: there are six instances of a dotted rune ᛂ representing **e**, phonologically the middle front vowel. The script and spelling system also distinguishes the low and middle back vowels **a** and **o** as ᛆ and ᛅ respectively: rune-forms which are interpreted as descendants of the original **jāra* rune ᛡ and **ansuz* rune ᚠ.[3] The inscription has been written so that the tops of the runes around the side wall are at the edge between the wall and the cone, while the tops of the runes on the flat face are at the outer edge.

There is one point in the inscription where the identity of the runes cut is not immediately legible (discussed below). Typical long-branch runic forms include a **t** rune that retains its early form ᛏ as opposed to a reduced ᛌ. **b** is also represented by the original form ᛒ rather than ᛕ or ᛓ. This set of graphs is thus a somewhat more conservative version of the younger fuþark, and on the whole is more characteristic of inscriptions from Denmark than from Norway or Sweden. The form of the **n** rune, which occurs twice on the Saltfleetby whorl, however, is much more like the reduced 'short-twig' ᚿ rather than ᚾ. All the same, the by-stave on the Saltfleetby **n** definitely crosses the vertical stave in both instances, and we should not make too much of this one graphic form as an apparently 'un-Danish' feature.

The inscription around the side wall of the spindle-whorl is fully legible, and it transpires that this is – as near to certainty as is practically possible – the beginning of the text. In this sequence, individual words are divided by single or double dots, while at one point a small saltire cross **x** can be found at mid-height on the wall. This cross has been overcut by the rune immediately to its left; it would appear that, having inscribed the runes around the wall, the inscriber had not left quite enough space to fit in the last rune of the final word here, an **r**, which therefore, a little clumsily, obscures the cross.

The transliteration of the text on the side wall is:

x oþen . ok . einmtalr . ok : þalfa . þeir

Several Old Norse lexemes are immediately identifiable here, especially *ok*, 'and', and *þeir*, 'they' (in this case the masculine form). **oþen** was the first sequence of letters read, and the cause of immediate interest because it is a known runic spelling of the name of the god, normalised as Óðinn in Old Norse.

The inscription on the face of the whorl presents greater problems and uncertainties. There are three clear, or at least reasonably clear, dividing marks, in the form of single knife-points, as on the wall; a possible fourth dividing mark can at best have been very lightly and carelessly cut, and could indeed be no more than small patch of accidental damage on the face of the object. This mark, however, not only lies directly below the initial

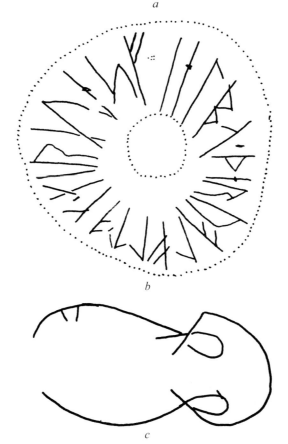

Fig. 12.3 The inscription on the Saltfleetby spindle-whorl: (a) side wall, in a single row; (b) face; (c) the motif on the conical side (J. Hines)

cross **x** on the wall, but also precedes what would serve perfectly, in syntactic terms, as the first word of the second line of the inscription.

If this place is correctly identified as the beginning of the second line, it is immediately to its left, in the last four or five graphs of the inscription, that the identity of the runes becomes unclear. Interpreted in terms of normal rune-forms of the 'long-branch' version of the younger fuþark, we can disentangle these by postulating that we begin with **iu**, |ᚢ, with the vertical main stave of the ᚢ cutting over | at the bottom; the curved right-hand stave of the u also joins the bottom of the next rune ᛁ, **e**. There is next a poorly cut long-branch **s**, ᚴ, followed by **f**, ᚠ.

With these identifications, and starting our reading in line with the cross on the side wall, we have:

(.) ielba . þeruolflt . ok. kiriuesf

The inscription, therefore, consists altogether of forty-nine runes, with nine or ten dividing marks, most of which separate readily identifiable words. There are twenty-five

runes on the side wall and twenty-four around the flat face. It is really only the final eight runes, **kiriuesf**, that stubbornly defy interpretation.

Starting on the side wall, with the saltire cross and what can only reasonably be taken as the name of Óðinn, we would appear to have the sequence:

Óðinn and [noun or name] and [noun or name] they...

The **e** in the second, unstressed syllable in **oþen** can be explained in terms of regular sound-change either as the 'harmonisation' of the unstressed vowel to the middle back vowel [o:] in the first syllable or as reduction of [i] to [ə] under low stress.[4] The two sequences **einmtalr** and **þalfa**, linked to **oþen** by the repeated conjunctions **ok** and preceding **þeir**, are also more readily interpretable as proper names than common nouns. The *regular* runological interpretation of **einmtalr** is as the name of another familiar god in the Norse pre-Christian pantheon, Heimdallr. In this case, we would have omission of initial *h*- before a vowel in a stressed syllable – a common

phenomenon.[5] The apparently intrusive **n** before **m** could be explained as marking a nasalisation of the vowel before the nasal consonant **m**, or, alternatively, simply as insecure spelling. It is of interest to note here that the originally palatalised masculine nominative singular ending -*r*, historically written with a distinct rune transliterated as ʀ or *z*, has fallen together with [r] generally. This is common in later Viking-period inscriptions: the great Jelling stone inscription in Jutland, for instance, retains a single conservative ʀ in **haraltr.kunukʀ**: *Haraldr konungr*, 'King Harald'.[6]

As a name **þalfa** cannot be identified so directly, and we are compelled to adopt a more speculative approach. The sequence **þalfi** occurs on one Swedish rune-stone, from Södermanland,[7] where it is interpreted as a male personal name *Þjálfi*. *Þjálfi* is a reasonably common male personal name in Swedish inscriptions, usually spelt **þialfi** or **þelfi**, and sometimes occurring in the accusative case (once in the genitive) as *Þjálfa*. The syntactic context of the form in the Saltfleetby inscription does not, however, support that interpretation of **þalfa**.

Þjálfi is also known as a Norse mythological character, but not a god: he appears in the tenth-century skaldic *Þórsdrápa*, the eddic *Hárbarðsljóð*, and Snorri's Prose Edda, *Gylfaginning* Chapters 44–7, as the servant boy, *skósveinn*, of the god *Þórr*. He is accompanied in that story by his sister, *Rǫskva*. We should be careful not to be too readily influenced by the interpretation of the sequence **þalfi** on the Södermanland rune-stone and the mythological association that could lead to. Three diphthongs would appear to have been carefully and fully spelt out in the Saltfleetby inscription, in **einmtalr**, **þeir** and later in **ielba** (see below); there is no good reason why the carver could not have written **þialfa**. A personal name ending in -*a* will usually be a weak (*n*-stem) feminine. There are masculine names in Old Norse of this declension, e.g. *Sturla*, but these are rare. If, however, **þalfa** is a feminine name, we should expect the personal pronoun 'they' to be the neuter form *þau* for a mixed group rather than the masculine *þeir*. The Germanic and Norse lexicons do not help us towards a credible solution. The etymology of the mythological name *Þjálfi* is uncertain and disputed;[8] that of the Modern Icelandic verb *þjálfa*, 'to train', 'to tame', is similarly obscure.[9] Perhaps all we can, all we should, and indeed all we *need* to conclude is that **þalfa** appears to be a personal name, which grammatically may be feminine despite the use of *þeir*, and that, although unidentifiable from our sources, it must represent a character of the background and status to appear in subject position alongside two major gods, Óðinn and Heimdallr.

The inscription on the side wall thus seems to give us a perfectly formed noun phrase, inflected as the subject of a sentence: 'Óðinn and Heimdallr and Þálfa, they...'. If we continue reading on the face directly underneath

the sequence **x oþen**, we proceed with an appropriately formed third person plural present indicative verb, **ielba**, interpreted as *hjelpa*, normalised Old Norse *hjálpa*: 'help', 'are helping'. The use of the original **b** rune for the voiceless counterpart of the voiced stop [b], [p], is standard practice with the younger fuþark. The omission of initial *h*- in this word would match that in **einmtalr** for *Heimdallr*; the spelling **ialbi** occurs for the subjunctive *hjálpi* in many medieval Christian inscriptions, especially in Sweden. The representation of the diphthong of the first syllable as **ie** is phonologically interesting rather than really problematic. In Icelandic the erstwhile -*ja*- diphthong here, from **e* by breaking before *a* in the following syllable, was lengthened before *l* followed by certain consonants to give *hjálpa*. In the mainland Scandinavian languages the second element has, however, been raised through progressive *j*-umlaut, to give Danish *hjælpe*, Norwegian *hjelpe* and Swedish *hjälpa*, and it would appear that the Saltfleetby inscription provides unusually, but not implausibly, early evidence for this shift.[10]

Old Norse *hjálpa* – and indeed Old English *helpan* – treat the person helped as an indirect object denoted by the dative case, and the following **þer** in this inscription is the dative, *þér*, of the second person singular personal pronoun *þú*, 'thou'. We might then expect a word-divider after **þer**, but there is none. This is probably best explained merely by the fact that it is from around this point that the inscription starts to include abbreviations, and so becomes more difficult to follow; the inscriber simply omitted a divider. It is probable, though, that the 'thou/thee' referred to, and indeed addressed by, the inscription is named in the immediately following sequence, and that a division between the personal pronoun and the personal name when both refer to the same person was considered unnecessary.

The suggested interpretation of the sequence to the next word-divider, **uolflt**, is as a feminine personal name *Ulfljót*. This name is familiar in the masculine form, *Ulfljótr*, as the name of the first law-speaker of the Icelandic Alþingi, a Norwegian settler in Iceland. Both *Ulf*- as first element and -*ljót* as second element are recorded in women's names in early Icelandic sources such as *Landnámabók*. **uo**, however, is an unusual runic spelling. Where it does appear in the runic corpus it usually represents the sequence [vo]. In the element *ulf*- ('wolf') it can be suggested that what is spelt as a diphthong represents a glide between [u] and [lf], a development anticipating the twelfth-century lengthening of the vowel to [uː], *ú*, in Old Norse. After this putative personal name, the inscription proceeds with a further conjunction **ok**, 'and', but then, regrettably, ends in an irresolvably obscure sequence, transliterated as **kiriuesf**.

Frustratingly, **kir** and indeed **kiri** are quite familiar sequences in Viking-period and later Norse runic inscriptions, identifiable most simply as forms of the verb *gøra*, 'to do', 'to make', e.g. *gøri*, third person singular or plural present

subjunctive; or the male personal name *Geirr* (also a common noun, meaning 'spear'), which is *Geiri* in the dative singular. The representation of [g] by **k** is standard younger fuþark practice, and quite what would be expected in this inscription. With, however, the otherwise consistent use of dotted ᛁ for **e** and apparently regular spelling of diphthongs, the use of ᛁ alone for *e* or *ei* to spell either this verb or this name here would be out of keeping with the remainder of the inscription.

The sequence **uesf** which follows **kiri** sheds no clear light. There are no word-dividers, but at this end of the inscription that tells us nothing. **ues** could be the imperative singular of the verb *vesa*, 'to be'. The final **f** would then have to be a single letter standing for a lexeme – e.g. *frændi*, 'kinsman', or *fjándi*, 'enemy' – but of course the available choice is colossal. *-sf* cannot terminate a word in Old Norse. **ues** could also be the genitive singular of the neuter noun *vé*, 'shrine'; a noun which is also the name of an otherwise thoroughly obscure brother of Óðinn.[11] A *Vés f[rændi]* could then refer either to Óðinn or any other close relative of theirs. The sequence *-ju* can terminate a word, and indeed **kirikiu** appears as an oblique case (genitive and dative) of the feminine noun *kirkja* (church), in two medieval Swedish inscriptions. There is no basis for proposing that as a reading in the case of Saltfleetby. **kiri** also, in fact, appears in a runic version of the liturgical phrase *Kyrie eleison*, and twice in spellings of the name of Christ and the term Christianity (Old Norse *kristni*). Less implausibly **kiri** might be read as *kyrri*, on the root *kyrr*, 'calm': either the adjective itself, nominative singular masculine, weak declension, or again the third person singular or plural present subjunctive of the verb *kyrra*, 'to calm'. It would even be possible to interpret **kiriues** as the genitive case of a personal name *Gǫrvir*, 'one who makes'. There are thus several possible lexical identifications, but none of them leads to a reading that can be recommended.

Altogether, we are able to read more than eighty per cent of this inscription with confidence. In normalised Old Norse this would read: *Óðinn ok Heimdallr ok Þalfa, þeir hjálpa þér Ulfljót ok...*, and in translation: 'Óðinn and Heimdallr and Þalfa: they are helping you, Ulfljót, and ...'. Even though some conjecture is required towards the end of this sequence to read the personal name *Ulfljót*, the unproblematic character of this section makes it all the more puzzling that the final eight runes should be so obscure. That can partly be attributed to the abbreviation of syllables, perhaps even of words, which first appears in **uolflt**. For such a practice to be introduced towards the end of an inscription for which there was limited space might seem quite self-explanatory but, on this object, these final runes also look considerably less carefully cut and are unusually large. The inscriber was not just running out of space. We can assume that the final sequence was meaningful, but must also then infer that what it encodes in this effectively cryptic form can only have been known to the person who wrote the text and to anyone with whom he or she chose to share that information.

The context and significance of the find

This text is a charm that has been inscribed on to an everyday, practical object, itself one quite distinctively associated not only with productive household activity, but also with the female sphere. The charm invokes the aid and support of Norse gods from the pre-Christian Scandinavian religious tradition that Late Anglo-Saxon churchmen such as Ælfric and Wulfstan identified and denounced as 'heathenism'. Grammatically, it is worthy of note that the verb used in the charm is present indicative, not subjunctive: 'they help' or 'they are helping' rather than 'may they help'. We can imagine that the action of spinning the whorl on which this charm was written was conceived of as a movement that activated the text and so made the statement a reality; it enacted the charm.

The form of the spindle-whorl on which this charm was inscribed is familiar in England – both in material and in shape – and not least in Anglo-Scandinavian contexts. It represents Form A1 in the typology of spindle-whorls classified by shape devised by Penelope Walton Rogers in her analysis of the textile-producing equipment from Anglo-Scandinavian York, based initially on specimens from Yorkshire and Lincolnshire.[12] It is not impossible that the item had been brought to England from Scandinavia, where it had been inscribed, but a spindle-whorl showing this combination of material and shape really would have been quite unusual in Scandinavia in any relevant period.[13] Form A1 is dated by Walton Rogers primarily to the long period *c.* 600–1000, and the lead whorls in York are predominantly from tenth-century layers. Penelope Walton Rogers has confirmed to me that this form would be unusual in an eleventh- or twelfth-century context.[14]

The runic forms, conversely, with the introduction of two forms new to the Viking-period younger fuþark, ᛁ = **e** and ᚭ = **o**, would be expected to represent a slightly later date, in the eleventh century at the earliest. The dotting of runes does appear in Denmark, and possibly on the Isle of Man too, by the last two decades of the tenth century.[15] It is at present impossible to date the regular and general use of ᚭ for **o** any earlier than the second quarter of the eleventh century.[16] The archaeological and runological datings thus point in opposite directions, although they are not hopelessly at odds with one another. A durable and serviceable spindle-whorl could continue to be available for inscribing some time after the type itself had been superseded. It is also possible that these are peculiarly early examples of the runes in question. Specifically English influence on the development of the practice of dotting runes and the use of ᚭ for **o** has been proposed,[17] although my own judgement concurs with Barnes' scepticism on

this point: English influence is simply unnecessary as an explanation, and the chronological gap between the widespread use of runes in England and the emergence of these details in Scandinavian-Norse runic practice renders such a relationship implausible.[18] Nevertheless, dotting certainly represents the assimilation of runic writing to roman script traditions, and Viking-period Britain and Ireland was a context in which the contact preconditions for that development were abundantly provided.

There are other explicit charms such as this written in runes, although they are not copious in number. In the large collections of runic material from later medieval urban sites in Norway, in fact, conventional Christian prayers, especially the *Ave Maria* and *Pater Noster* are numerically predominant. The direct invocation of Óðinn is quite rare in any runic inscription and, remarkably, is unknown from the Viking Period. A particularly striking example, however, is the charm on a fragment of human skull from the Jutlandic coastal trading site of Ribe, datable to the eighth century. This has been read in several different ways, but for the purpose of reference here a reliable edited form may be cited as:

Ulfúrr ok Óðinn ok Hótýr. Hjalp Buri er viðr þeima verki, ok dverg unninn. Burr.

for which I would suggest the translation : 'Ulfúrr and Óðinn and Hótýr. [This] is a help to Búrr against that affliction, and the dwarf [is] overcome. Búrr'.[19] Here, we should note especially how the Saltfleetby inscription uses a triple invocation formula that is quite regular in a charm tradition.[20] We can also both compare and contrast the Saltfleetby spindle-whorl and charm with a set of so-called runic amulets found across the late Viking world, now from Orkney to Russia: on these, the texts are very obscure, and are in many cases concluded to be deliberately meaningless, although well-informed attempts at interpretation have been made.[21]

There are also parallels for the inscribing of runes on a spindle-whorl, although again nothing with a text that is truly comparable in character to that from Saltfleetby.[22] An eleventh-century soapstone whorl from Hoftun, Aust-Agder, Norway, for instance, reads **kunitr kerþsnalt**, interpreted as *Gunnhildr gerði snáld*: 'Gunnhildr made the spindle-whorl'. Both chronologically and geographically a closer parallel to the Saltfleetby specimen may be a whorl found in Lurk Lane, Beverley, East Yorkshire, which is inscribed with rune-like marks or graphs, but not such as to form a legible text.

Altogether, the evidence for the use of Norse runes in England is both sparse and fragmented. The relative wealth of evidence for later Viking-period runic literacy on the Isle of Man is not immediately reflected in the areas of north-west England and south-west Scotland bounding the Irish Sea, except perhaps in a short-twig sixteen-character **fuþark** inscription on a silver penannular brooch from Penrith; a local runic writing tradition only appears here in some half

a dozen inscriptions dated to the twelfth century.[23] There is a similar number of inscriptions from southern England, a majority of which certainly, and all of which probably, reflect the presence of a Scandinavian elite associated with the conquest and reign of Cnut. In Lincolnshire, besides Saltfleetby, there are two eleventh-century inscriptions from the city of Lincoln itself, both on bone objects: one a comb-case now in the British Museum and the other a fragment of a cattle rib from a layer excavated in St Benedict's Square.[24] The former has an inscription in long-branch runes, but differs distinctly in detail from the Saltfleetby whorl. The latter has short-twig runes.

Alongside this, it should be noted that the Anglo-Saxon/ Old English runic writing tradition, whose roots date from the very beginning of Anglo-Saxon England in the fifth century and which enjoyed a real flourishing in the eighth century, shrank radically and in many respects withered away in the ninth century – to the extent that it appears only to survive as a scholarly curiosity in manuscript runes in restricted contexts in the tenth century. It is tempting to explain its striking demise in terms of the negative connotations of a style of writing that could be associated with the Scandinavian Viking enemies of the Anglo-Saxons in the ninth century, and so also with their heathenism. There is, however, no explicit or direct evidence to show that this was the case.

It is a matter of considerable interest, therefore, that there is no reason why the Saltfleetby spindle-whorl should not have been inscribed very close to, if not actually at, the place where it was found. Materially, it is completely at home there, especially if the artefact is detectably earlier than the form of the inscription: an obsolete functional object is more likely to have survived where it was commonest rather than where it was a rarity. If this is correct, the implications for this site on the North Sea coast, probably in the reign of Cnut or later, are truly remarkable. At least some people were using the Old Norse language there, in as correct and standard a form as we could ever expect to find in any contemporary Scandinavian inscription. There would have been a woman with a fully Norse name present, Ulfljót; if so, she could, of course, have been newly arrived from Scandinavia. The practices of Norse runic literacy were fully up to date: the dominant long-branch rune forms hint at a Danish rather than a Norwegian connection. Above all, of course, the inscription shows a continuing allegiance to the pre-Christian Norse religious tradition, despite the dominant Christianity of England and, indeed, the effective establishment of Christianity in both Denmark and Norway by the third decade of the eleventh century.

The first of the Norse gods invoked is Óðinn: famously, the high one (*Hár*) of the Norse pantheon in Ásgarðr, and *Alfǫðr*, 'father of all'. The mythological sources we have concerning Óðinn are profuse and the modern scholarly

(and, indeed, less scholarly) analyses and discussions of the figure are even more overwhelming in quantity. In *De falsis diis* Ælfric, and Wulfstan following him, refer to *Oðon* as they rather summarily seek to demonstrate that Germanic and Norse 'paganism' conforms to a consistent and classical pattern of untrue religious beliefs and adherence. The centrality of Óðinn to the Norse religious cosmos of the Viking period is undeniable: this is evidenced equally in England and the Isle of Man, where Óðinn appears on the Andreas I cross-slab, while the full iconographic and typological significance of the portrayal of Víðarr on the Gosforth Cross depends upon the recognition that Víðarr is the son of Óðinn, All-father.[25] The only reflex of Norse pre-Christian religion we have in a place-name in England is Rosebery Topping, Yorkshire (< *Othenesberg* [AD 1119]), but, despite a few direct parallels in Scandinavia, a colourful folk-name for a conspicuous landmark is scarcely evidence of an active cult of Óðinn in Viking-period England. Amongst the many roles and aspects of this character, he was a war god, and a god associated both with rune lore and magic spells: an epithet that appears for him in eddic poetry is *galdrs faðir*, 'father of the spell'.[26] Óðinn is invoked in charms with some regularity – at least as far as our very sparse empirical evidence can show.[27] There would appear, then, to have been a deep-rooted and real belief that calling upon Óðinn would give efficacy to a charm or prayer.

If not necessarily more important, Heimdallr is perhaps rather more interesting in this context. Heimdallr is a much more elusive figure in our evidence for pre-Christian Norse religion.[28] A range of mythological sources implies that he was a god of genuinely high status and importance within that pantheon, but the evidence for his cult, in the form, for instance, of place-names or images, does not match this. This leaves us with an altogether mysterious character: it is impossible, for instance, to know whether the tradition that led to his portrayal in the works of Snorri Sturluson in the thirteenth century had systematically suppressed information that would have provided a full and coherent portrayal of Heimdallr, or whether this god has been artificially raised in interest and importance through the post-conversion interpretation and rationalisation of merely fragmentary scraps and traditions.

Heimdallr is also linked to the genre of charm in Norse tradition, at least through the reported existence of a poetic *Heimdallargaldr*, from which Snorri quoted a couple of lines.[29] Snorri also refers to him as a son of Óðinn. He is famously the watchman of the gods, ready to sound Gjallarhorn when the forces of chaos break loose and the apocalyptic battle of Ragnarøk is imminent. This figure is identified on the Gosforth cross.[30] A number of sources associate him with aspects of fertility and human reproduction. Fantastically, he is referred to as the son of nine mothers – nine virgin mothers according to the

lines quoted by Snorri from *Heimdallargaldr*: 'níu em ek meyja mǫgr'. The prose introduction to *Rígsþula* in Codex Wormianus identifies Rígr, a name derived from Old Irish *rí*, 'king', as Heimdallr: he sleeps with successive human women, and begets children representing three classes (*jarlar*, *karlar* and *þrællar*) of society; 'sons of Heimdallr', *megir Heimdallar*, is given as a kenning for humankind in *Vǫluspá* (stanza 1).[31] His fight with Loki for *Brísinga men*, the goddess Freyja's necklace, in Úlfr Uggason's *Húsdrápa*, supposedly describing the narrative carved panels in Olaf the Peacock's house at Hjarðarholt, Laxárdalur, Iceland, has been interpreted as a battle over a fertility token.[32] He is also the ruler of 'shrines' (*Grímnismál*, stanza 13).[33]

It is frustrating, in consequence, that we cannot at present say anything more about the third figure involved, *Þalfa*. Perhaps the one detail that it is worth considering further, even if speculatively of necessity, is the reasonable presumption that this is a feminine name and therefore a female figure, alongside the two gods. Even with some information on Freyja, Iðunn and Frigg, the mythological traditions of the Norse goddesses are sparse indeed compared to those portraying the gods. Supernatural female handmaidens and para-divine figures such as valkyries and *dísir*, by contrast, are familiar. The spindle-whorl pertains to and represents the female sphere of activity and experience, and it is not unreasonable to suggest that the aid it asserts, and was supposed to enact, was also specifically for the female sphere: possibly even the *biargrúnar* (birth-runes; *Sigrdrífumál*, stanza 9) to protect a woman in childbirth.[34]

At Saltfleetby on the Lincolnshire coast, diverse cultural traditions had met at a date very late in the Viking Period, and this inscribed spindle-whorl was one tangible product of their interaction. It gives us a truly unique insight into a serious, and thoroughly Norse, cultural expression within this complex and hybrid context. Perhaps Saltfleetby was a particularly propitious site for this. The metal-detecting at Saltfleetby has identified substantial Roman-period occupation and activity towards the western, inland end of the low ridge of land. The Saltfleetby area is a ridge of slightly raised land, running approximately WSW–ENE towards the broad coastal salt marshes with the Greyfleet Drain on the northern side and the Rivers Long Eau and Great Eau ('Eau' from Old Norse *á*, 'river') to the south (see Fig. 12.1). A Roman road from Lincoln and Louth is identified as running the length of the ridge to the coast, presumably to provide access and transport to and from coastal saltings. At the confluence of the South Dike, Greyfleet Drain and Long and Great Eau on the coast, Saltfleet was established as a small harbour in the Middle Ages, surviving as a regular local market site to the end of the eighteenth century, when it was superseded by the larger centres of Louth, Grimsby and Mablethorpe.[35] The

Domesday Survey records that the taking of toll from ships calling at Saltfleet had started between the Conquest and 1087.[36] Between the Roman period and the high Middle Ages, however, there is no sign of Anglo-Saxon occupation or activity in Saltfleetby except for two stirrup-strap mounts of the type dated to the eleventh century from the same area as where the spindle-whorl was found,[37] which undoubtedly represent one and the same, relatively distinguished and successful, settlement or homestead.

In the high Middle Ages the district manifestly prospered. The dispersed strip settlement of Saltfleetby had no fewer than three parish churches, two of them now redundant: from west to east, Saltfleetby St Peter, Saltfleetby All Saints, and Saltfleetby St Clement parishes. As Barbara Crawford has explored in detail, there is a close association between church dedications to St Clement and Scandinavian coastal trading communities.[38] It is no surprise therefore that St Clement's church is that at the coastal end of the site.[39] The spindle-whorl and strap-mounts were found within the bounds of the parish of Saltfleetby St Clement. The name Saltfleetby is probably best explained as the *býr* (= homestead or settlement) defined by its proximity to the creek and harbour of Saltfleet. Equally, it is reasonable to postulate that Saltfleetby was a prosperous local landholding or estate centre, represented by the strap-mounts and spindle-whorl, which sub-divided into the three parishes of the high Middle Ages.

Archaeologically, it would be very surprising if the Saltfleetby inscription had been made as late as the post-Conquest period when Saltfleet's status as a port appears to have advanced, although both runographically and philologically that would be a very comfortable dating. Nothing, however, is quite as surprising as this evidence for a genuine ritual adherence to the pre-Christian deities in any part of the late Anglo-Scandinavian world. It is very welcome for a small new find to turn up and create such astonishment. The object and its inscription may represent individuality and non-conformity – possibly distinctly female – rather than a hitherto unsuspected, general cultural cleft in that context. If so, however, that was a form of individuality that was both striking and brave – and therefore presumably especially meaningful for the person who wanted this charm carved onto a spindle-whorl.

Acknowledgements

Warmest thanks to Adam Daubney, Finds Liaison Officer for Lincolnshire, and Mrs Denise Moncaster for going out of their way to assist in my study of this fascinating object. Sincere thanks too to Michael Barnes, James Knirk, Judith Jesch and Henrik Williams for discussion and advice on the inscription that was simultaneously informative, challenging and supportive, and to Penelope Walton Rogers and Ingvild Øye for expert advice on spinning and spinning equipment.

I profited much from the opportunity to present and discuss this find at a seminar at Miðaldarstofnun, University of Iceland, in March 2014. Responsibility for the use made of all this invaluable support must, of course, remain my own.

Notes

1 Abrams 2000; 2001; Hadley 2006, 192–236, especially 224–6.
2 Leahy & Paterson 2001.
3 Spurkland 2005, 81.
4 Seip 1955, 128, 132–7.
5 Spurkland 2005, 76–7.
6 Düwel 2008, 105–11.
7 Sö194. The *Samnordisk runtextdatabas* is a convenient corpus of Scandinavian runic inscriptions, ordered by these reference numbers *http://www.nordiska.uu.se/forskn/samnord. htm* (Accessed 23 June 2014).
8 Simek 1993, 31.
9 Magnússon 1989, 1181, s.v. ÞJÁLFA.
10 Seip 1955, 122–3, 246.
11 Simek 1993, 362, s.v. VILI.
12 Walton Rogers 1997, 1731–45.
13 Pers. comm., Ingvild Øye, Bryggen Museum, Bergen.
14 Pers. comm.
15 Düwel 2008, 93, 102–5.
16 See Spurkland 2005, 96–103.
17 Barnes 2012, 92–4; 2015.
18 See further below, this page.
19 Cf Stoklund 1996; Macleod & Mees 2006, 25–6.
20 Macleod & Mees 2006, 15–19.
21 Steenholt Olesen 2010. A further specimen has recently been identified from the Broch of Deerness, Orkney.
22 Cf Macleod & Mees 2006, 50–1.
23 Barnes & Page 2006.
24 Page 1999, 205–6. The accession number of the comb-case is BM 1867,0320.12. An image can be viewed on *http://www. britishmuseum.org/research/collection_online/collection_ object_details.aspx?objectId=65237&partId=1* (Accessed 20 June 2014). For the rib fragment, see McKinnell 1995.
25 Bailey 1980, 127–9; Bailey in Bailey & Cramp 1988, 100–3.
26 *Baldrs Draumar*, stanza 3 (Neckel, rev. Kuhn, 1962, 277–9).
27 Macleod & Mees 2006; cf Jolly 1996, 125–8; Raudvere 2002, 92–4.
28 Cöllen 2015.
29 Turville-Petre 1964, 147–55.
30 Bailey 1996, 87–91.
31 Neckel, rev. Kuhn, 1962, 1–16 at 1.
32 Simek 1993, 44–6.
33 Neckel, rev. Kuhn, 1962, 56–68, at 59–60.
34 Neckel, rev. Kuhn, 1962, 189–97, at 191.
35 Wright 1982, 20–1.
36 Sawyer 1998, 21–2.
37 PAS LIN-EA2E51 and LIN-820011: *http://finds.org.uk/ database* (last accessed 23 June 2014); cf Williams 1997.
38 Crawford 2008, esp. 107–8 and 126–30.
39 The present, closed, church is not on its original site: in the nineteenth century a new church was constructed here a few hundred metres north of the original church.

References

Abrams, L., 2000 'Conversion and Assimilation' in D. Hadley & J.D. Richards (ed.), *Cultures in Contact: Scandinavian Settlement in England in the Ninth and Tenth Centuries* (Turnhout), pp 135–53

Abrams, L., 2001 'The Conversion of the Danelaw' in Graham-Campbell et al. 2001, pp 31–44

Bailey, R.N., 1980 *Viking Age Sculpture in Northern England* (London)

Bailey, R.N., 1996 *England's Earliest Sculptors* (Toronto)

Bailey, R.N. & Cramp, R. 1988 *Cumberland, Westmorland and Lancashire North-of-the-Sands*, CASSS 2 (Oxford)

Barnes, M.P., 2012 *Runes: a Handbook* (Woodbridge)

Barnes, M.P., 2015 'Norse-English Runic Contacts', in J.O. Askedal & H.F. Nielsen (ed.), *Early Germanic Languages in Contact*, NOWELE Supplement Volume (Amsterdam), pp 187–202

Barnes, M.P. & Page, R.I., 2006 *The Scandinavian Runic Inscriptions of Britain*, Runrön 19, Institutionen för nordiska språk, Uppsala Universitet (Uppsala)

Cöllen, S. 2015 *Heimdallr – Der rätselhalfte Gott: Eine philologischer und religionsgeschichtliche Untersuchung* (Berlin)

Crawford, B., 2008 *The Churches Dedicated to St Clement in Medieval England: a Hagio-Geography of the Seafarer's Saint in 11th Century North Europe*, Axiöma (St Petersburg)

Düwel, K., 2008 *Runenkunde*, 4th ed. (Weimar)

Graham-Campbell, J., Hall, R., Jesch, J. & Parsons, D. (ed.), 2001 *Vikings and the Danelaw: Papers from the Proceedings of the Thirteenth Viking Congress, Nottingham and York, 21st–30th August 1997* (Oxford)

Hadley, D.M., 2006 *The Vikings in England: Settlement, Society and Culture* (Manchester)

Jolly, K.L., 1996 *Popular Religion in Late Anglo-Saxon England: Elf Charms in Context* (Chapel Hill, NC)

Leahy, K. & Paterson, C., 2001 'New light on the Viking presence in Lincolnshire: the Artefactual Evidence' in Graham-Campbell et al. 2001, pp 181–202

McKinnell, J., 1995 'A Runic Fragment from Lincoln', *Nytt om Runer* 10, 10–11

Macleod, M. & Mees, B. 2006 *Runic Amulets and Magic Objects* (Woodbridge)

Magnússon, Á.B., 1989 *Íslensk Orðsifjabók* (Reykjavík)

Neckel, G, rev. Kuhn, H. 1962 *Edda: Die Lieder des Codex Regius nebst verwandten Denkmälern 1. Text* (Heidelberg)

Page, R.I., 1999 *An Introduction to English Runes*, 2 edn (Woodbridge)

Raudvere, C., 2002 '*Trolldómr* in early medieval Scandinavia' in K. Jolly, C. Raudvere & E. Peters, *Witchcraft and Magic in Europe: The Middle Ages* (London), pp 73–171

Sawyer, P., 1998 *Anglo-Saxon Lincolnshire*, A History of Lincolnshire 3 (Lincoln)

Seip, D.A., 1955 *Norsk Språkhistorie til omkring 1370*, 2nd ed. (Oslo)

Simek, R., 1993 *Dictionary of Northern Mythology* (Cambridge)

Spurkland, T., 2005 *Norwegian Runes and Runic Inscriptions* (Woodbridge)

Steenholt Olesen, R., 2010 'Runic Amulets from Medieval Denmark', *Futhark* 1, 161–76

Stoklund, M., 1996 'The Ribe cranium inscription and the Scandinavian transition to the younger futhark' in T. Looijenga & A. Quak (ed.), *Frisian Runes and Neighbouring Traditions*, Amsterdamer Beiträge zur älteren Germanistik 45 (Amsterdam), pp 199–209

Turville-Petre, E.O.G., 1964 *Myth and Religion of the North* (London)

Walton Rogers, P., 1997 *Textile Production at 16–22 Coppergate*, The Archaeology of York: The Small Finds 17/11 (York)

Williams, D., 1997 *Late Saxon Stirrup-Strap Mounts: a Classification and Catalogue*, CBA Research Report 111 (York)

Wright, N.R., 1982 *Lincolnshire: Towns and Industry 1700–1914*, A History of Lincolnshire 3 (Lincoln)

13

Archaeological evidence for local liturgical practices: the lead plaques from Bury St Edmunds[1]

Helen Gittos

Introduction

Reading through the 2004 supplement to the *Hand-list of Anglo-Saxon Non-Runic Inscriptions* I was intrigued to come across a group of lead plaques from Bury St Edmunds, Suffolk.[2] It was the text of their inscriptions that struck me: *crux xpi triumphat, crux xpi pellit hostem* ('the cross of Christ triumphs, the cross of Christ drives away the enemy'). I recognised these as the words to be said by a bishop at the moment when he enters a church during its dedication ceremony.[3] My heart leapt because I thought they were a cache of church consecration crosses, for which there is good liturgical but not material evidence from late Anglo-Saxon England.[4] But it seems clear that they were found in association with burials and so a different explanation is required.[5]

The lead plaques from Bury St Edmunds

Several lead plaques have been discovered from the site of the medieval abbey at Bury St Edmunds, Suffolk (Figs 13.1–3). There has been confusion about their number and whereabouts but there are at least eight extant.[6] Six of these are in the form of small crosses with inscriptions on one face:

BURY ST EDMUNDS, MOYSE'S HALL MUSEUM, BSEMS 1976.276[7]
132mm high × 98mm wide. Intact.
BURY ST EDMUNDS, MOYSE'S HALL MUSEUM, BSEMS 1976.280[8]
104mm high × 80mm wide. Intact.
LONDON, BRITISH MUSEUM, DEPARTMENT OF MEDIEVAL AND LATER
 ANTIQUITIES, 1867, 0711.14[9]
186mm high × 145mm wide. Damaged; inscription hard
 to read.
LONDON, SOCIETY OF ANTIQUARIES OF LONDON, LDSAL 372.1[10]
102mm high × 85mm wide. Broken and bent.

LONDON, SOCIETY OF ANTIQUARIES OF LONDON, LDSAL 372.2[11]
83mm high × 76mm wide. Broken into three pieces and
 bent. The left, right and top ends of the cross-arms are
 concave in shape; the bottom limb has a rectangular tang.
LONDON, SOCIETY OF ANTIQUARIES OF LONDON, LDSAL 373[12]
154mm high × 139mm wide. Broken and badly damaged.

Okasha's *Handlist* also records two more crosses that were described and illustrated in the *Antiquaries Journal* in 1855 and included in the 1903 catalogue of Moyse's Hall Museum but which are now lost.[13] The illustrations show that they are identical to Society of Antiquaries LDSAL 372.1 and 372.2 so it would appear that they were never returned to Bury after having been displayed at the Antiquaries. Another inscribed cross is reported to have been in the possession of James Reeve, curator of Norwich Museum, in 1892.[14] There are also two other surviving crosses that have been found at Bury St Edmunds and are similar in scale but different in shape and lacking inscriptions (Fig. 13.3):

BURY ST EDMUNDS, MOYSE'S HALL MUSEUM, BSEMS 1976.279[15]
75 × 55mm A cross pattée with very wide triangular arms.
LONDON, SOCIETY OF ANTIQUARIES OF LONDON, LDSAL 372.3[16]
77mm × 77mm Maltese cross with expanding terminals.
 Broken into two pieces.

Additionally, the 1903 catalogue of Moyse's Hall Museum, Bury St Edmunds lists another Maltese cross which now appears to be lost.[17]

These crosses were all found in the late eighteenth to early twentieth centuries and little is known about the archaeological contexts in which they were discovered. Where details of their find spots are given, they are often said to have been found in the Abbey cemetery and the southern and eastern parts of the precinct are densely packed with

A) Bury St Edmunds, Moyse's Hall Museum, 1976.276

B) Bury St Edmunds, Moyse's Hall Museum, 1976.280

C) London, BM, Dept. of Medieval and Later Antiquities 1867, 0711.14

D) London, Soc. of Ant., 372.1 (BMG)

E) London, Soc. of Ant., 372.2

F) London, Soc. of Ant., 372.3

Fig. 13.1 Inscribed lead crosses from Bury St Edmunds (A and B, reproduced by kind permission of St Edmundsbury Heritage Service, Photos: Brian and Moira Gittos; C, © the Trustees of the British Museum; D–F, reproduced by kind permission of the Society of Antiquaries of London, Photos: Brian and Moira Gittos)

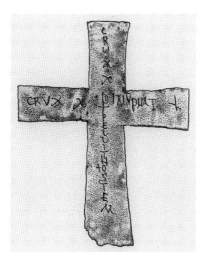

A) Bury St Edmunds, Moyse's Hall Museum, BSEMS 1976.276

B) Bury St Edmunds, Moyse's Hall Museum, BSEMS 1976.280

C) London, B. M., Dept. of Med. and Later Antiquities 1867, 0711.14

D) London, Soc. of Ant., LDSAL 372.1

E) London, Society of Ant., LDSAL, 372.2

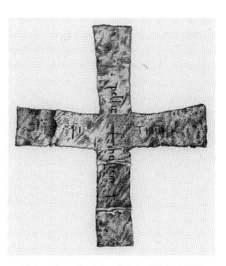

F) London, Society of Ant., LDSAL 373

Fig. 13.2 Drawings of the inscribed lead crosses from Bury St Edmunds (Drawings: © Maggie Kneen)

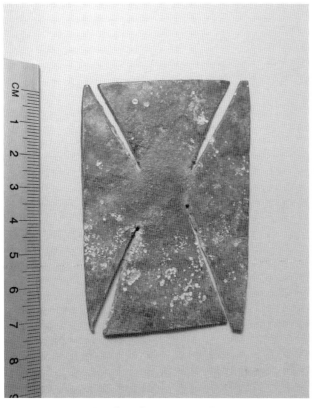

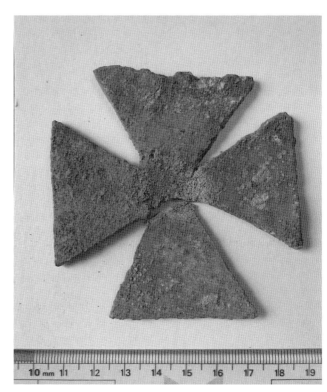

A) Bury St Edmunds, Moyse's Hall, 1976.279 *B) London, Soc. of Ant., LDSAL 372.3*

Fig. 13.3 Uninscribed lead crosses from Bury St Edmunds (A, reproduced by kind permission of St Edmundsbury Heritage Service; B, reproduced by kind permission of the Society of Antiquaries of London, Photos: Brian and Moira Gittos)

eighteenth- and nineteenth-century burials. Most probably turned up in the course of grave digging. The earliest published reference to such crosses seems to have been in the *Bury Post* of 16 November 1791 which reports:

> Thursday last, in digging a grave opposite the hospital in our church-yard, two stone coffins were discovered, of great antiquity, in each of which were found a leaden crucifix, inscribed on one side *Crux Xpi triumphat*, and on the reverse *Crux Xpi pellit hostem*. Many doubts having arose respecting the above, from their being found so near the surface of the earth, and that place of interment not being thought sufficiently antient, we are enabled to say, that the late Mr Hall, of Angel-hill, who was proprietor of the abbey-lands, in clearing a part of the grounds ... in the year 1720, found several stone-coffins, which he caused to be reinterred in the church-yard, in the same state in which he found them; and there is little doubt but the coffins now discovered were a part of those he then dug up.[18]

In 1855, Samuel Tymms displayed three crosses at the Society of Antiquaries which he said had been found 'on the breasts of skeletons in that part of the Cemetery of St Edmund,

known, I believe, as the Cœmeterium Fratrum', adding that 'in every instance within my own observation the body on which it was found appeared to have been buried without a coffin'. He also reported that 'Similar crosses from the same churchyard are now to be found in many private Collections in the county, and the Museum of the Suffolk Institute of Archaeology has several specimens of a larger size than those now sent, but the Inscription in every instance appears the same.'[19] In 1903, excavations in what was considered to be the medieval chapter house at Bury St Edmunds uncovered a line of stone coffins, interpreted as being the burials of abbots recorded as being there in a late medieval register of the Abbey. The coffin lids had been removed, but although the coffins were full of earth, the bones were intact and in two of them, thought to be the burials of abbots Samson (d. 1211) and Edmund de Walpole (d. 1256), were found, respectively, 'a broken Maltese cross of lead' and 'a perfect Maltese cross of lead, uninscribed'.[20] So, in each case where find spots are given, the crosses are said to have been lying on or near the bodies, whether in coffins or not.

The crosses seem to have been made by being cut from sheets of lead and then inscribed in a rather informal way, with a hard point stylus, much as one would write on a wax tablet.[21] Each is different. For example, they vary in size: the

largest, British Museum 1867, 0711.14, measures 186mm high × 145mm wide, the smallest, Society of Antiquaries 372.2, is 83mm high × 76mm wide. One, London, Society of Antiquaries 372.2, has a somewhat different shape from the others, with a small tang at the end of the shaft for fitting into something and bow-shaped ends to the other arms. There are some differences in the way the inscriptions are laid out: some have crosses at all four corners and the centre, others have none; some are laid out so that the '*p*'s in '*xpi*' meet in the centre of the cross; some have the vertical text facing left, others facing right.[22] There is also considerable variation in the letter forms. Two have marks on the back: one has a simple, inscribed cross, the other appears to have an 'N', whilst the rest seem to have been left blank.[23] These differences indicate that, despite the similarities between them, the crosses were not mass produced and were probably made over a period of time.

Various dates have been suggested for these objects. Their most diagnostic feature is the form of the letters in the inscriptions which Okasha describes as 'insular minuscule'.[24] She tentatively suggests they are eleventh or twelfth century on the basis of palaeographic comparisons and similarities with other lead crosses also thought to date roughly from this period, although there is not space in the *Handlist* to explain these in detail.[25] However, in an earlier publication she considered them to be twelfth or thirteenth century and Roberta Gilchrist and Barney Sloane have also suggested the later date, though in neither case are any reasons given.[26] The script on these objects is hard to date so it is not surprising that such a range has been suggested. My discussions about them with Julia Crick, T.A. Heslop and Teresa Webber suggest that they are likely to be twelfth century. Most are written in a minuscule script with a few capital letter forms. This is the case with London, British Museum 1867 0711.14 and Bury St Edmunds 1976.280 and Teresa Webber suggests that the way the second limb of the 'h' in '*triumphat*' curves round to the left on both of these is unlikely to have been used before the twelfth century. And the lack of Gothic and cursive features suggests that they are unlikely to belong to the thirteenth century. Other examples are written mostly in capitals, as is the case with Bury St Edmunds 1976.276, and the possible date range for these is even wider – potentially ranging from the late eleventh to the early thirteenth centuries.[27] The range of letter forms used adds to the other indications that these crosses were produced over an extended period.

Medieval inscribed lead crosses associated with burials

Uninscribed crosses, with or without suspension loops for hanging as pendants, were placed on bodies throughout the Middle Ages. These were often made of lead but could be of more precious metals, or of wax or wood: the pectoral cross

from Cuthbert's tomb is one of the most famous (Fig. 2.6). Examples are known from the graves of people of all kinds of status.[28] However, the group of inscribed crosses from Bury St Edmunds seems to belong to a class of material of a rather narrower date range.

Inscribed metal crosses associated with burials (rather than inscribed plaques such as have been found at Flixborough, Lincolnshire and Kirkdale, Yorkshire) tend to date from the eleventh to twelfth centuries and have been found in parts of continental Europe as well as England.[29] Gilchrist and Sloane identified three broad groups of them:[30]

Absolution crosses

These record the text of a formal absolution of the sins of the dead person.[31] A rare surviving well-dated English example is a lead cross found in the cathedral cloisters at Chichester inscribed with a papal absolution for Bishop Godfrey of Chichester who died in 1088 (Fig. 13.4).[32] It is comparable in size with the largest of the Bury St Edmunds crosses, though the arms of the cross are much broader and the inscription is written in a conventional way as a single block of text and on ruled lines. The script is also not closely comparable with the Bury examples. Absolution crosses similar to Bishop Godfrey's, thought to date from the twelfth century, have been excavated from burials in the cemetery of Bouteilles in Normandy (Fig. 13.4) and others have been found elsewhere in northern France.[33]

Commemorative crosses

These record the names of the deceased and tend to be from the eleventh to thirteenth centuries.[34] One of the most famous is the late twelfth-century cross found at Glastonbury, allegedly from the tomb of King Arthur.[35] Of this type, the closest comparison with the Bury examples is, interestingly, from another Benedictine monastery: St Augustine's, Canterbury, Kent (Fig. 13.4). This commemorates the burial of Wulfmaeg (d. 1063), sister of Abbot Wulfric II and was discovered in 1924 close to the remains of a lead box and some bones deep below the south aisle of the Norman church. Its inscriptions read:

[Side 1] V IDVS MAR MIGRAVIT EX HAC VITA WLFMÆG SOROR WLFRICI ABBA ANNO MLXIII (On 11 March 1063, Wufmaeg, sister of Abbot Wulfric, departed from this life.)

[Side 2] A XṔI EX HOC Ω SIGNO CUNABULA [C]UN[CT]A[..] ([Perhaps] By this alpha and omega of Christ I mark all resting places.)[36]

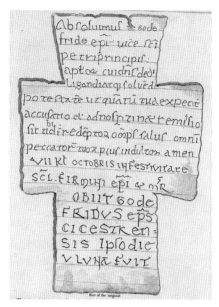

A) Absolution cross of Godfrey, bishop of Chichester

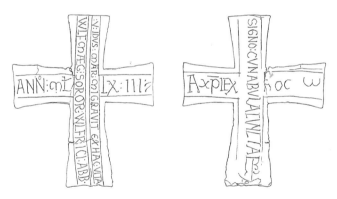

B) Cross of Wulfmaeg from St Augustine's, Canterbury: front and back

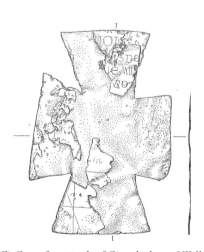

C) Cross from tomb of Giso, bishop of Wells *D) Cross from Bouteilles, Normandy*

Fig. 13.4 Comparative examples of inscribed lead crosses (A, from an engraving by Thomas King, made 1831 (West Sussex Record Office, PD. 2193B), reproduced by permission of the West Sussex Record Office; B, reproduced by kind permission of the Society of Antiquaries of London from Potts 1924, pp. 423–4, © reserved; C, reproduced by kind permission of the Society of Antiquaries of London and Warwick Rodwell (from Rodwell 1979, fig. 5), © reserved; D: reproduced from Cochet, 1857b, 38)

Okasha suggests that the style of writing, with its Gothic elements, means that it is likely to have been placed in the casket when the bones from the old church were moved into the new one in 1091 rather than when Wulfmaeg died in 1063.[37] It is similar in size and form to the largest of the Bury examples and the inscription is also written down the length of the cross (with the letters facing to the left) and horizontally along the cross-arms. In content, the second of its inscriptions bears comparison with the ones from Bury in its emphasis on the power of the sign of the cross. However, the letter forms are dissimilar, there are inscriptions on both sides of the cross, and they are set within ruled lines.

Protective crosses

Gilchrist and Sloane place the Bury St Edmunds crosses amongst a less homogeneous set which they define as being for 'protective' purposes.[38] Other examples that they include with them, and which have some affinities with the Bury group, include:

PUMP ROOM, BATH ABBEY, SOMERSET, BATRM 1983.88[39]
This is a circular lead disc with a cross and inscriptions on both sides. It is similar in size to the Bury examples. It was found in excavations in 1898 close to Bath Abbey. It is damaged and is hard to read but the inscription on the cross on the front face is a prayer to Christ to cleanse the deceased person's sins. The inscription on the back of the cross records the death of a nun called Eadgyvu. This is an interesting object because it bears some similarities with the ones from Bury St Edmunds, especially in terms of the layout of the text being arranged facing downwards on the horizontal arms and to the left on the vertical one.

WORCESTERSHIRE ARCHAEOLOGICAL SERVICE, HWCM 3899
A very small lead cross-shaped plaque (52 × 28 × 0.5mm). The badly deteriorated text is laid out over each cross-arm with the letters facing the centre of the cross. It reads:

SENTIO AELF [.INE] [A]R[T...] FVID[:]
([perhaps] I perceive (or think of) Ælf[w]ine (who) was a [craftsman].)[40]

This does not look like a particularly useful comparison for the Bury examples given its size and the content of the inscription.

Two other examples of inscribed protective crosses are also worth considering:

CUMBERWORTH, LINCOLNSHIRE (PRIVATE COLLECTION)
Found during excavation in St Helen's church. This is comparable in size but not shape to the Bury examples and has on it a Latin inscription set out conventionally to be read from top to bottom:

+XPI EX HOC SIGNO [*c*. 15 letters illegible] EXPIATUM [P..]COR EXIGUUM SQUALOREM M[..T] [U]OLUTUM QU[I] IN UIRT[UTE] [CR] UCIS MUNDUM DE MORTE RED[EM]IT TA[R] TARA DISRUPIT AUT CELESTIA PANDIT.
(Okasha suggests the beginning and end may be translated: '+ through this sign of Christ [...] he who by the power of the cross redeemed the world from death, shattered hell and threw open heaven.')[41]

It is possible that this is akin to the continental examples that have been gathered together by Robert Favreau which have on them various types of affirmation of faith.[42]

WELLS CATHEDRAL, SOMERSET
Found in 1978 inside the tomb of Bishop Giso (d. 1088; Fig. 13.4). It is useful because it is reasonably well dated although the inscription is now illegible. In terms of the shape of the cross, and the placement of the inscription, it is akin to the absolution cross of Bishop Godfrey of Chichester, who also died in 1088. A small scrap of material adhering to the cross indicates that it may have been placed on the body.[43]

So, this third category contains a wide variety of material which shares some characteristics with the Bury group, but I have found no close comparisons for the Bury St Edmunds texts.

It is clear, though, that the Bury crosses should be considered as part of a vogue for the placing of small inscribed lead crosses in the graves of high status and ecclesiastical people in the eleventh and twelfth centuries in England and elsewhere in north-western Europe.[44] Some have absolution formulae, some commemorate the names of the deceased, some are statements of faith, and a small number of others have texts that refer to the protective power of symbols: the cross in the case of the ones from Bury, the alpha and omega in the case of the ones from St Augustine's, Canterbury and perhaps also Bath Abbey. Amongst these objects, the ones from Bury St Edmunds stand out as being a coherent group, all found in one place, and with few close comparisons. In this respect they are akin to other collections of lead crosses and plaques that closely resemble one another such as have been found within the cemetery at Bouteilles or at Christ Church, Newgate Street, London.[45]

The inscriptions

The inscribed crosses from Bury St Edmunds all have this text written on them (with a few minor differences discussed below):

[On the horizontal cross-arms, reading from left to right]
CRVX XP̄I TRIŪPHAT

(The cross of Christ triu[m]phs.)
[On the shaft of the cross, with each letter facing to the left]
CRVX PELLIT HOSTEM
(The cross of Christ drives away the enemy.)[46]

However, as one can see from the drawings in Fig. 13.2, the texts are not presented in an identical fashion.

BURY ST EDMUNDS, MOYSE'S HALL MUSEUM, BSEMS 1976.276
The text on the vertical inscription faces to the right. The 'P' of 'XPI' is in the centre of the cross with the 'I' placed within the 'P'. There appear to be crosses after *triumphat* and beside the 'o' in *hostem*.

LONDON, BRITISH MUSEUM, DEPARTMENT OF MEDIEVAL AND LATER ANTIQUITIES, 1867, 0711.14
There are crosses at each end of the horizontal cross-arms.

LONDON, SOCIETY OF ANTIQUARIES OF LONDON, LDSAL 372.1
There appear to be four crosses, one at the end of each of the arms.

LONDON, SOCIETY OF ANTIQUARIES OF LONDON, LDSAL 372.2
The usual positioning of the two texts on the shaft and arms is reversed. There seem to be crosses at the ends of the terminals and in the centre.

LONDON, SOCIETY OF ANTIQUARIES OF LONDON, LDSAL 373
This is very damaged but there are crosses in the centre and at the bottom of the vertical shaft.

So, the principal differences are in the way that the texts are laid out and whether there are crosses, rather than in the words themselves.

Discussion

As mentioned at the beginning, these words are only otherwise known, so far as I have found, in the context of *ordines* for the consecration of a church in English, or English-influenced, manuscripts. After the initial parts of the ceremony, which were to take place outside the church, the bishop entered the building and stood holding a cross in his hand, saying *Crux pellit hostem. Crux christi triumphat*. The instruction to do this is first found in Anglo-Saxon pontificals that contain a dedication rite which I have suggested was put together in Canterbury *c.* 1000.[47] The details are slightly different in a later version of this rite, which I have proposed was written in Canterbury in the early eleventh century. In this case, these words were to be said whilst the bishop traced a cross over the length and breadth of the floor of the church saying *Crux christi expellat hinc hostem. Crux christi triumphet hic in aeuum.*[48] The practice of saying these words continued to

be included in British dedication rites into the later Middle Ages, for example it is found in the pontificals of David de Bernham (Bishop of St Andrews 1240–53) and of Anian Sais, Bishop of Bangor (1309–28).[49] In summary, so far as I have been able to discover, the words on the Bury crosses are identical to those used in some church dedication rites and are not found in any other contexts.[50]

Although it may appear at first sight that the words on the Bury crosses are unremarkable given that they refer to the salvific and protective powers of Christ's Cross, I think that the manuscript evidence suggests otherwise. The extremely restricted use of these words in a particular liturgical context strongly indicates that the crosses themselves are related to a liturgical ceremony, in this case presumably one associated with burial. This would fit well with the evidence that they seem to have been produced over a period of time on an *ad hoc* basis. It would also fit with the other inscribed crosses to which they most obviously relate that contain absolution or commemorative texts, because they are also closely connected with liturgical rituals. In the central Middle Ages there was a custom of placing an absolution cross or scroll on the breast of the body once it had been lowered into the grave. These were usually made of parchment but sometimes took the form of lead crosses.[51] In some cases it has been possible to match up the inscribed texts with ones in liturgical books, as with some of the examples from Bouteilles.[52] We have seen that some of the commemorative crosses have words on them that resemble prayers, such as the ones from Bath Abbey and probably Cumberworth. Those found within graves were presumably placed there during the burial rite. The cross from St Augustine's recording the burial of Wulfmaeg was probably placed there in the context of the ceremony in which her bones were translated.[53] The question is: what ceremony may the Bury crosses have been associated with?

In trying to answer this question one immediately comes up against a surprising problem. Despite the huge amount of work that has gone into understanding attitudes towards, and customs relating to, death and burial in the Middle Ages, no detailed research seems to have been conducted into the evidence that English liturgical sources contain for rites for the dying and for burial.[54] This is presumably at least partly because of the paucity of work on later medieval liturgical rites in general; few sources have been edited and some of the most accessible texts that have been published, such as the 'Sarum Manual', have been based on early printed books rather than manuscript sources.[55] Because of this, it is not easy to find out whether these words were also used in rites associated with burial. Ideally, one wants a rite for the care of the dying and burial of the dead from a manuscript used at Bury St Edmunds in the central Middle Ages. So far I have not been able to identify such a text.[56] The closest I have found is London: British Library, Harley MS 5334, which is a manual (a priest's book) containing almost all of the rite for visiting the sick,

vigils for the dead, the commendation of the soul (fols 1–66v) and then an *ordo* for the burial of the dead (fols 66v–94).[57] The manuscript dates from the fourteenth or fifteenth century and the presence of distinctive Bury saints in the litanies, as well as a fifteenth-century *ex libris* inscription recording the gift of the book to the Abbey by one of its monks, indicate that it was made to be used by a monk of Bury.[58] It does not, though, include anything that might provide a context for the deposition of the crosses, but this may simply be because it is so much later in date than the crosses themselves.

There is, however, evidence in some burial rites from the central Middle Ages that would be consistent with the placing of crosses on the dead as part of the rituals associated with dying and death. A burial rite in an eleventh-century north Italian priests' book says that a wax cross should be placed on the breast of a dead person when they are buried. It gives a diagram of the cross: a rectangle with lines running from corner to corner, a cross and the alpha and omega in the centre and the opening words of each Gospel in each of the four triangles.[59] So here we have a contemporaneous reference to a similar type of object, albeit a plaque rather than a cross, made of wax not lead and with different inscriptions. Bernard of Cluny mentions something similar in his monastic customary, which was written for Cluny *c.* 1085. When a monk was in the final stages of dying, after having been anointed and given communion, 'the priest brings him a cross so that he may adore it and kiss it'.[60] A little later, when death is thought to be imminent, 'a servant' was to be:

> assigned to him whose only duty is to care for the sick man. But at night all the servants who are in the infirmary keep watch attentively so that his death does not happen unexpectedly. A cross is laid upon his face and candles are kept lit until daylight.[61]

This is also not an exact parallel for the Bury St Edmunds practice because Bernard does not say that the cross placed on the man's face should have an inscription on it – and he had such an eye for detail that, if he thought it should have done, he would have said so. Another difference is that the antiquarian references to find spots record the Bury crosses as having been found on the *bodies* of the dead rather than their faces. It does, though, suggest that Bernard thought that the monks of Cluny should be practising a rite that would be reasonably consistent with the archaeological evidence from Bury. Perhaps the Benedictine monks at Bury were also provided with such crosses when they were dying, and these were then placed in their graves after their death, as comforting, supplicatory, and protective objects. There are further indications that this may be a Benedictine practice. The late thirteenth-century customary of Westminster Abbey, and the mid-fourteenth-century customary of St Augustine's, Canterbury, give instructions about the objects that should be placed in the grave of an abbot. They included a wax cross (*cum cruce de candellis facta*)

and a lead plaque inscribed with his name and the year of his death (*et epitaphium plumbeum continens annum in quo moriebatur et eius nomen*) which was to be placed on his chest.[62] The fact that some of the best written parallels come from Benedictine customaries suggests that the Bury crosses should probably be understood as a specifically Benedictine tradition.

So, it is possible that the Bury crosses were used in rituals associated with dying and then subsequently placed in the grave during burial. However, given the links between the texts inscribed on them and rites for consecrating churches, it is worth considering another ritual context: the practice of blessing graves. This was an idea rooted in antiquity when only the graves themselves were specially protected and not the cemeteries in which they were located.[63] There are early medieval rites for blessing a coffin or burial, though little indication about whether, and how, they were used.[64] It is much more common, though, to find grave blessings integrated into burial rites. Examples of these can be found in manuscripts originating from France, Germany and Italy from the late ninth century onwards, including the Cluniac customary previously discussed.[65] This practice was often, but not universally, included in English burial rites. Provision for it is made amongst some of the surviving eleventh-century burial rituals from England, such as the mid-eleventh-century Red Book of Darley and Lanfranc's late eleventh-century *Constitutions*.[66] It was also part of the ceremony in the 1543 edition of the Sarum Manual. After the body had been brought to the cemetery, 'Then let there be a blessing of the grave', two blessings and a prayer follow, the tomb was to be sprinkled with holy water, incensed, and then the body placed within it.[67] The blessing asks for God to bless and sanctify the tomb and body to protect them from harm, just as he had blessed the burials of Abraham, Isaac and Jacob. In some cases the priest was to make the sign of the cross over the burial after it had been closed over.[68] So it is conceivable that the Bury St Edmunds crosses may have been markers to indicate that these tombs had been blessed, akin to consecration crosses on churches.

Conclusions

The crosses from Bury St Edmunds are interesting because they are evidence for a local burial custom practised repeatedly over a period of time. It seems likely that they are evidence for a part of the monastery's liturgy for which no written texts survive. Precisely what this was is difficult to recover but they were probably related either to rituals associated with dying, or with the blessing of graves or, conceivably, both. They are of wider significance in that they add to our knowledge about the variety of local burial practices and also provide an example of how evidence for liturgical practice can be recovered even in the absence of written liturgical rites.[69] Perhaps even more importantly, they

are a reminder of how little research has yet been conducted on the manuscript evidence for burial rites in England in the later Middle Ages.[70]

Notes

1 I am grateful to Keith Cunliffe and Ron Murrell at Moyse's Hall Museum, Lloyd de Beer at the British Museum and Anooshka Rawden at the Society of Antiquaries for their assistance with viewing the crosses in the care of their respective institutions. Moira and Brian Gittos generously took the time to photograph most of the crosses and discuss them with me. I am also grateful to John Blair, Eric Cambridge, Julia Crick, Sarah Foot, T.A. Heslop, Tom Licence, Richard Sharpe, Teresa Webber, Leslie Webster and James Willoughby for various kinds of help and advice, and to Maggie Kneen for her expert drawing of some very difficult objects. Thanks to Jane Hawkes and Eric Cambridge for their invitation to be part of this collection, their comments on this chapter, and their patience.

2 Okasha 2004, 229–33 (nos 213–17).

3 See n. 47–9 below.

4 Gittos 2013, 220–1, 230, 240–1; for late eleventh- and early twelfth-century painted examples see Park 1990, esp. 230, 238 (n. 71, 72), 241.

5 This exploration of them is offered to Richard Bailey, my undergraduate tutor and supervisor, in great gratitude to him for his gentle guidance, inspiration and encouragement.

6 Okasha 2004 lists the two inscribed ones in Moyse's Hall, and identifies another three as now being lost; Campbell (1998, 73) says eight survive but that seven of these are in Moyse's Hall, one in the British Museum; Gilchrist & Sloane (2005, 91) say that seven survive.

7 Okasha 2004, no. 213.

8 Ibid., no. 214.

9 British Museum 1907, 40.

10 Tymms 1855; Waterton 1863.

11 Tymms 1855; Waterton 1863.

12 Tymms 1855; Waterton 1863.

13 Tymms 1855, 165–7; Barker 1903, 24; Okasha 2004, 231–2 (nos 215, 217).

14 Beloe 1892, 313–14, pls 1, 4.

15 Barker 1903, no. 24.

16 This seems to be the one sent by Samuel Tymms to the Society in 1855 (Tymms 1855).

17 Barker 1903, 24. The dimensions given in the catalogue indicate this is not the same as London, Soc. of Ant., LDSAL 372.3.

18 *The Bury and Norwich Post*, 16 Nov 1791, 2.

19 Tymms 1855, 165–7. He also displayed these to the Suffolk Institute of Archaeology on 10 January 1856 in Bury St Edmunds (Tymms 1856). These appear to be London, Society of Antiquaries LDSAL 372.1–3 and the ones said to have been lost from Moyse's Hall in Okasha 2004, 231–2 (nos 215, 217).

20 Barker 1907, 53–8, esp. 57, 58.

21 For the use of lead in this way see Favreau 1999, esp. 45.

22 Okasha 2004, 230.

23 Moyse's Hall 1976.276 has a cross on the back; BM 1863, 0411.25 seems to have an 'N'.

24 Okasha 2004, 229–33.

25 Ibid., 229.

26 Okasha 1996, 68; Gilchrist & Sloane 2005, 91, fig. 51.

27 Tessa Webber, pers. comm. 8 July 2014. James Willoughby, pers. comm. 30 July 2014 thinks the inscription on this cross 'could be described as a debased Rustic capital, of a sort one sees in manuscripts in the twelfth century'.

28 Gilchrist & Sloane 2005, 79, 88–9, 91–3, 166–7, 214; for wooden examples from Scandinavia, see Sørheim 2004, 219.

29 Favreau 1999, 46; Sørheim 2004. Flixborough: Okasha 1992, 46–7 (no. 193); Blair 2005, 208–9; Brown & Okasha 2009. Kirkdale: Okasha 2004, 238–9 (no. 225); Watts et al. 1997. Okasha 2004, 228–9 (no. 212, Bawburgh) may also be relevant. The commemorative cross of Humbert, buried in St Serviatus, Maastricht in 1086, was discovered, apparently *in situ* in his coffin, propped up at the east end: Panhuysen 1988; Sørheim 2004, 219 for wooden crosses found on the chests of skeletons in Scandinavia.

30 Gilchrist & Sloane 2005, 89–91.

31 Ibid., 24, 25–6, 89, 168, 177.

32 Okasha 1996.

33 Wylie 1853; Cochet 1857a, 303–18; Favreau 1999, 54–6; Favreau & Michaud 2002, 323–30, 332 (nos 246–53, 255), figs 111–13, 115.

34 Okasha 1996; Favreau 1999, 47–53; Gilchrist & Sloane 2005, 89; Sharpe 2008. Two eleventh-century lead crosses commemorating provosts Geldulfus and Humbertus have been found in tombs in St Servatius, Maastricht: *Memo: Medieval Memoria Online*, nos 2169 and 2170. http://memo.hum.uu.nl/database/index.html (Accessed 11 July 2014).

35 Gilchrist & Sloane 2005, 91.

36 Potts 1924; Okasha 1971, 60 (no. 21); Favreau 1999, 53 for French examples of inscriptions that include the alpha and omega.

37 Okasha 1971, 60; Gilchrist & Sloane 2005, 90.

38 Ibid., 91–2.

39 Davis 1898; Page 1906, 380–1; Okasha 1971, 51–2 (no. 7); Hinton 1979, 138–40.

40 Okasha 2004, 248–9 (no. 239).

41 Okasha 1996, 68; 2004, 235–6 (no. 220).

42 Favreau 1999, 53–4.

43 Okasha 1983, 101 (no. 180); 1996, 68; Rodwell 2001, i, 147–9.

44 Favreau 1999, 48; Sørheim 2004.

45 Bouteilles: see above, n. 33. Newgate Street: Gilchrist & Sloane 2005, 92–3.

46 Okasha 2004, 229–33 (nos 213–17).

47 Doble 1937, 5; Wilson 1903, 76; London: British Library, Add. MS 57337, fol. 1r; Cambridge: Corpus Christi College MS 146, p. 66 (Gittos 2013, 232). Note that I was wrong to call it an 'antiphon' in the first hardback edition (Gittos 2013, 228–9, fig. 84). This was apparently recognised by L. Gjerlöv (cited in Sørheim 2004, 216) and, independently, by Campbell 1998, 73-4.

48 Cambridge: Corpus Christi College MS 44, p. 18; London: British Library, Cotton Vitellius MS A. vii, fol. 19v; London:

British Library, Add. MS 28188, fol. 6r; Gittos 2013, 229–30, 232, fig. 84.

49 Wordsworth 1885, 5. Bangor Cathedral, Dean and Chapter, MS 1, fol. 20v; Harper 1997.

50 For example, a search for key phrases from the Bury inscriptions in the digitised version of J.-P. Migne, *Patrologia Latina* (1844–65; now published by Chadwyck-Healey) and the CCSL (digitised version published by Brepols as the Library of Latin Texts) only turns up one reference and that is to a church consecration rite.

51 Knowles & Brooke 2002, 192–3; Gilchrist & Sloane 2005, 26. Litten 1991, 150 associates this practice with the placing of uninscribed lead crosses in tombs though he cites no supporting evidence.

52 Cochet 1857a, 308–10; Favreau 1999, 55–6; Favreau & Michaud 2002, 324–5, 330–2 (esp. nos 246, 253–5).

53 For examples associated with relic translations see Favreau 1999, 58–9.

54 The best study of burial rites, though focussed on the early Middle Ages, is Sicard 1978. Other discussion rooted in some detailed research into liturgical rites, primarily also from the early medieval period, includes Philippeau 1955; Paxton 1990; Treffort 1996; Thompson 2004, 57–91; Lauwers 2005; Paxton 2013. There is some cursory treatment in Rowell 1977.

55 Collins 1960; Salisbury 2016.

56 For especially useful lists of manuscripts associated with the Abbey, see Ker 1964, 16–22; Webber 2014, especially the appendix.

57 There are very many differences but the rites are akin to those in Collins 1960, 98–162.

58 James 1895, 89–90; Ker 1964, 20; Pfaff 2009, 194, 197; British Library Catalogue of Illuminated Manuscripts: http://www.bl.uk/catalogues/illuminatedmanuscripts/ (last accessed 2 May 2015).

59 Lambot 1931, 62: Istam crucem quam hic uides factam omni christiano quando mortuus fuerit de cera ita debes facere et ponere super pectus eius et dum sepelitur corpus crucem de cera super eum ponatur et sepulchro recondatur. Thanks to Lucy Donkin for this reference.

60 Adhibetur quoque illi crux a sacerdote, ut eam adoret, et osculetur: Paxton 2013, 90–1 and 25–7 for a summary of the historiography about this customary. There is a similar rubric at the beginning of the rite for visiting the sick in London: British Library, MS Add. 32320, fol. 11v, a fifteenth-century Sarum manual.

61 adhibetur ei unus famulus qui non habet aliud facere, nisi ut obsequatur infirmo. Sed et in nocte famuli omnes qui sunt in infirmaria diligenter excubant, ne obitus ejus improvisus eveniat. Crux est contra faciem ejus affixa, et lumen cerei usque ad claram diem non defuerit (Paxton 2013, 90–1).

62 Thompson 1902–4, i, 69 (Canterbury), ii, 5 (Westminster). The latter does not refer to the lead plaque; only Westminster refers to the placing of the cross and absolution notice on the chest.

63 Gittos 2013, 41–2.

64 Vogel & Elze 1963–72, i, 193–4 (no. LV); Orchard 2005, 31; Andrieu 1938, 288 (no. 53).

65 Philippeau 1955, 69; Sicard 1978, 233–4; Rowell 1977, 71–2; Paxton 2013, 139–45.

66 London: British Library, Add. 28188, pp 444–5: Knowles & Brooke 2002, 190–1, where it is implied by the specification that the grave should be asperged and then incensed by one of the monks standing within the grave; Henderson 1882, 98, n.

67 Deinde dicatur benedictio sepulchri (Collins 1960, 156–7).

68 Sicard 1978, 233.

69 For local practices see above, n. 46; Favreau 1999, 47; Gilchrist & Sloane 2005, 214, 217–19.

70 This is a topic to which I hope to return in future research.

References

Andrieu, M. (ed.), 1938 *Le Pontifical Romain au Moyen-Âge, 1: Le Pontifical Romain du XIIe Siècle*, Studi e Testi 86 (Vatican)

Barker, H.R., 1903 *Moyses' Hall Museum, Bury St. Edmunds, 2: Catalogue of the Specimens in the Anglo-Saxon and Mediaeval Sections* (Bury St Edmunds)

Barker, H.R., 1907 *West Suffolk Illustrated* (Bury St Edmunds)

Beloe, E.M., 1892 'The Mortuary or Absolution Cross', *Norfolk Archaeology* 11, 303–19

Blair, J., 2005 *The Church in Anglo-Saxon Society* (Oxford)

British Museum, 1907 *A Guide to the Medieval Room and to the Specimens of Mediaeval and Later Times in the Gold Ornament Room* (London)

Brown, M.P. & Okasha, E., 2009 'The Inscribed Objects' in D.H. Evans & C. Loveluck, (ed.), *Life and Economy at Early Medieval Flixborough, c. AD 600–1000: The Artefact Evidence* (Oxford), pp 138–41

Campbell, M., 1998 'Medieval Metalworking and Bury St Edmunds' in A. Gransden (ed.), *Bury St Edmunds: Medieval Art, Architecture, Archaeology and Economy* (Leeds), pp 69–80

Cochet, J.B.D., 1857a *Sépultures Gauloises, Romaines, Franques et Normandes, faisant suite à "La Normandie Souterraine"* (Paris)

Cochet, J.B.D., 1857b 'Note sur des sépultures Anglo-Normandes trouvées à Bouteilles, près Dieppe, en Mars, 1856', *Archaeologia* 37, 32–8

Collins, A.J. (ed.), 1960 *Manuale ad Vsum Percelebris Ecclesie Sarisburiensis: From the Edition Printed at Rouen in 1543*, HBS 91 (London)

Davis, C.E., 1898 *The Saxon Cross Found in Bath July 1898: A Few Notes* (Bath)

Doble, G.H. (ed.), 1937 *Pontificale Lanaletense: (Bibliothèque de la Ville de Rouen A. 27. Cat. 368.): A Pontifical Formerly in Use at St. Germans, Cornwall*, HBS 74 (London)

Favreau, R., 1999 'Les inscriptions sur plomb au Moyen Age' in W. Koch & C. Steininger (ed.), *Inschrift und Material, Inschrift und Buchschrift: Fachtagung für Mittelalterliche und Neuzeitliche Epigraphik, Ingolstadt 1997* (Munich), pp 45–63

Favreau, R. & Michaud, J., 2002 *Corpus des inscriptions de la France médiévale, 22: Calvados, Eure, Manche, Orne, Seine-Maritime* (Paris)

Gilchrist, R. & Sloane, B., 2005 *Requiem: The Medieval Monastic Cemetery in Britain* (London)

Gittos, H., 2013 *Liturgy, Architecture, and Sacred Places in Anglo-Saxon England* (Oxford)

Harper, S., 1997 'The Bangor Pontifical: A Pontifical of the Use of Salisbury', *Welsh Music History* 2, 65–89

Henderson, W.G. (ed.), 1882 *Processionale ad Usum Insignis ac Præclaræ Ecclesiæ Sarum* (Leeds)

Hinton, D., 1979 'Saxon Finds' in B. Cunliffe (ed.) *Excavations in Bath, 1950–1975* (Bristol)

James, M.R., 1895 *On the Abbey of S. Edmund at Bury, 1: The Library; 2: The Church* (Cambridge)

Ker, N.R. (ed.), 1964 *Medieval Libraries of Great Britain: a List of Surviving Books* (London)

Knowles, D. & Brooke, C.N.L. (ed.), 2002 *The Monastic Constitutions of Lanfranc* (Oxford)

Lambot, C. (ed), 1931 *North Italian Services of the Eleventh Century*, HBS 67 (London)

Lauwers, M., 2005 *Naissance du cimetière: lieux sacrés et terre des morts dans l'Occident médiéval* (Paris)

Litten, J., 1991 *The English Way of Death: The Common Funeral since 1450* (London)

Okasha, E., 1971 *Hand-List of Anglo-Saxon Non-Runic Inscriptions* (Cambridge)

Okasha, E., 1983 'A Supplement to *Hand-List of Anglo-Saxon Non-Runic Inscriptions*', *ASE* 11, 83–118

Okasha, E., 1992 'A Second Supplement to *Hand-List of Anglo-Saxon Non-Runic Inscriptions*', *ASE* 21, 37–85

Okasha, E., 1996 'The Lead Cross of Bishop Godfrey of Chichester', *Sussex Archaeological Collections* 134, 63–9

Okasha, E., 2004 'A Third Supplement to *Hand-List of Anglo-Saxon Non-Runic Inscriptions*', *ASE* 33, 225–89

Orchard, N. (ed.), 2005 *The Sacramentary of Ratoldus (Paris, Bibliothèque nationale de France, lat. 12052)*, HBS 116 (London)

Page, W. (ed.), 1906 *VCH: Somerset* 1 (London)

Panhuysen, T.A.S.M., 1988 'Humbertus, Bouwheer van de Sint-Servaaskerk te Maastricht, Overleden 2 Mei 1086', *De Maasgouw: tijdschrift voor Limburgse geschiedenis en oudheidkunde* 107(3), 159–63

Park, D., 1990 'Anglo-Saxon or Anglo-Norman? Wall Paintings at Wareham and Other Sites in Southern England' in S. Cather, D. Park & P. Williamson (ed.), *Early Medieval Wall Painting and Painted Sculpture in England: Based on the Proceedings of a Symposium at the Courtauld Institute of Art, February 1985*, BAR: British Series 216 (Oxford), pp 225–47

Paxton, F.S., 1990 *Christianizing Death: The Creation of a Ritual Process in Early Medieval Europe* (Ithaca, NY)

Paxton, F.S., 2013 *The Death Ritual at Cluny in the Central Middle Ages*, Disciplina Monastica 9 (Turnhout)

Pfaff, R.W., 2009 *The Liturgy in Medieval England: A History* (Cambridge)

Philippeau, H.R., 1955 'Textes et rubriques des Agenda Mortuorum', *Archiv für Liturgiewissenscaft* 4(1), 52–72

Potts, R.U., 1924 'An Eleventh-Century Burial Cross at St Augustine's, Canterbury', *Antiquaries J.* 4, 422–5

Rodwell, W., 2001 *Wells Cathedral: Excavations and Structural Studies, 1978–93*, 2 vols, English Heritage Archaeological Report 21 (London)

Rowell, G., 1977 *The Liturgy of Christian Burial: An Introductory Survey of the Historical Development of Christian Burial Rites* (London)

Salisbury, M.C., 2016 'Rethinking the Uses of Sarum and York: A Historiographical Essay' in H. Gittos & S. Hamilton (ed.), *Understanding Medieval Liturgy: Essays in Interpretation* (Farnham), pp 103–22

Sharpe, R., 2008 'King Harold's Daughter', *Haskins Soc. J.* 27, 1–27

Sicard, D., 1978 *La liturgie de la mort dans L'église latine des origines à la Réforme carolingienne*, Liturgiewissenschaftliche Quellen und Forschungen 63 (Münster)

Sørheim, H., 2004 'Lead Mortuary Crosses Found in Christian and Heathen Graves in Norway', *Medieval Scandinavia* 14, 195–227

Thompson, E.M. (ed.), 1902–4 *Customary of the Benedictine Monasteries of Saint Augustine, Canterbury, and Saint Peter, Westminster*, 2 vols, HBS 23, 28 (London)

Thompson, V., 2004 *Dying and Death in Later Anglo-Saxon England*, Anglo-Saxon Studies 4 (Woodbridge)

Treffort, C., 1996 *L'église Carolingienne et la mort: christianisme, rites funéraires et pratiques commémoratives*, Collection d'histoire et d'archéologie médiévales 3 (Lyon)

Tymms, S., 1855 'Note Read Thursday, March 15th, 1855', *Proc. Soc. Antiquaries of London* 3, 165–7

Tymms, S., 1856 'Quarterly Meetings: Bury St Edmund's Jan 10, 1856', *Proc. Suffolk Institute of Archaeology and History* 2, 215–17

Vogel, C. & Elze, R. (ed.), 1963–72 *Le Pontifical Romano-Germanique du dixième siècle*, 3 vols, Studi e Testi 226, 227, 269 (Vatican City)

Waterton, E., 1863 'Thursday, November 26th 1863', *Proc. Soc. Antiquaries of London*, 2 ser. 2, 301

Watts, L., Rahtz, P., Okasha, E., Bradley, S.A.J. & Higgitt, J., 1997 'Kirkdale – the Inscriptions', *Med. Arch.* 41, 51–99

Webber, T., 2014 'Books and Their Use across the Conquest' in T. Licence (ed.) *Bury St Edmunds and the Norman Conquest* (Woodbridge), pp 160–89

Wilson, H.A. (ed.), 1903 *The Benedictional of Archbishop Robert*, HBS 24 (London)

Wordsworth, C. (ed.), 1885 *Pontificale Ecclesiae S. Andreae: The Pontifical Offices Used by David De Bernham, Bishop of S. Andrews* (Edinburgh)

Wylie, W.M., 1853 'Observations on Certain Sepulchral Useages of Early Times', *Archaeologia* 35, 298–304

Part III

Settlements, sites and structures

The contributions to this, third, section of the volume pan out from the close readings of comparatively small-scale objects that characterise the preceding studies to take a broader perspective. The first three papers are all concerned with different aspects of the period which Richard Bailey has made very much his own, the Viking Age; the next two move backwards in time to consider neglected aspects of two iconic early medieval sites, Whitby in Yorkshire and the Brough of Birsay on Orkney; while the last pair reflect another area to which Richard has made a substantial contribution, that of the architectural history of churches. They are again concerned with two of the iconic places of medieval England, Brixworth in Northamptonshire and Durham Cathedral.

Deirdre O'Sullivan begins the Viking-age papers with a consideration of what it was – and is – to be 'Viking'. This leads to thought-provoking insights into the nature of the dialogue between the material remains traditionally construed as evidence of Viking settlement and the successive historiographical strategies constructed between the nineteenth century and the present day in order to understand them – a dialogue in which conventional boundaries between academic enquiry and popular preconception turn out to be disconcertingly porous. Caroline Paterson then reviews an important new series of recent excavations which are transforming our understanding of the nature of Viking-age settlement in Cumbria, revealing a much more complex series of interactions between 'native' and 'incomer' than has hitherto been supposed and suggesting that a new, more nuanced model is now required. The implications of the important collection of Viking-age sculpture recovered from Chester for the nature of the early medieval settlement there are pondered by Paul Everson and David Stocker. Their analysis leads them to propose a startling new perspective on one of the most famous and controversial events of later Anglo-Saxon history, the rowing of King Edgar on the Dee by a crew of subject kings.

In the first of two studies concerned with reinterpreting specific sites, Lorna Watts takes a long overdue fresh look at the archaeological evidence for a neglected period in the history of the famous early medieval site of Whitby, and suggests ways in which our understanding of its artefactual and settlement history prior to the emergence of the middle Saxon settlement might be developed. Christopher Morris unravels the extraordinary historiography of the discovery of a number of runic and ogham inscriptions from the Brough of Birsay, drawing out the wider implications of this epigraphic dimension of the artefactual assemblage of that famous Insular site for the interface between its late Pictish and Scandinavian phases.

The final two papers turn from settlements to architecture and suggest new approaches to understanding two of the best known architectural monuments of the English Middle Ages. David Parsons publishes for the first time the results of remote sensing surveys carried out in the churchyard of Brixworth, Northamptonshire which hint at the presence of a second, hitherto unsuspected and probably early medieval, church there. He suggests possible interpretations and contexts based on comparative evidence and sets an agenda for future investigation of the site. Eric Cambridge considers the implications of metrological analysis for a number of seeming anomalies in the design of the Romanesque cathedral at Durham. He suggests that these point to modification of the original plans during construction, considers why that might have happened, and posits a new reconstruction of the great church as first conceived.

The importance of being Viking

Deirdre O'Sullivan

Introduction

The idea of a Viking World enjoys both scholarly and popular blessing in the twenty-first century where it also serves as a marketing device for heritage, a past political entity and an alternative masculinity. Is this Viking World simply something that scholars, politicians, enthusiasts and marketers have conspired to create in the nineteenth and twentieth centuries? In any popular archaeological field it may seem superficially obvious that there is a big difference between scholarly objectives, often claimed as scientific on the one hand, and celebratory and pleasure-driven occupations on the other, the world of 'edutainment' occupying some kind of transit zone, where simplified understandings of the scientific are presented for an unlearned audience. It will be argued here that this apparent polarity between a critical and a celebratory discourse is more apparent than real.

The aims of this paper are complementary and twofold. First, I explore the idea that contemporary understandings of 'being Viking' have been created through multi-disciplinary and popular appreciations, which may have been generated in scholarly study, but can no longer be effectively segregated within it. The reason for this in the present time is not hard to find: saturated with media re-workings of all things Viking, in advertising, sports and popular culture, these understandings are no longer tested against real research or direct experience of objects and places. In modern communication theory this process is known as 'remediation'.[1] Put simply, this involves an appreciation that ideas and perspectives are formed and re-formed through encounters with multiple media representations, which are selectively retained or ignored to reinforce existing beliefs and stereotypes. Although the concept has been developed in the late twentieth century to address the way that knowledge and understanding is sustained in the super-saturated world of advertising, mass communications and social media, I will argue here for its relevance in the early development of understandings of 'being Viking'. Ideas about Viking identity were never derived from purely detached and scholarly historical endeavour; they were products of creative enterprise, experience and emotion, empathy and aesthetic appreciation.

Secondly, I ask whether there was, in fact a tangibly Viking world in the period 800–1100. 'Being Viking' at whatever level, involves a process of recognition; to what extent therefore, were people 'recognisably' Viking at this time? A great deal of fairly recent archaeological and historical debate has centred around this question, often focussed on the use of material culture in the creation of identity.

Cumbria serves as my key case study for both themes; invariably shaded in solidly when Viking activity zones are defined on maps, it is arguably the region on mainland Britain where settlers of Scandinavian origin laid their most enduring roots in the tenth century. If a real 'Viking World' existed then it must surely have been part of it, even if, unlike the Danelaw, there is no surviving historical narrative of events.

Scandinavians in Cumbria and the generation of the Old North

At the start of his engaging account of the development of enthusiasm for things Nordic in modern Britain, Andrew Wawn proposed that 'in many ways, the Victorians invented the Vikings'.[2] A key point here is the simple fact that there was no continuous tradition of 'being Viking' in Britain; throughout the Middle Ages and well into the sixteenth century, the literature of the Icelanders was simply unknown in Britain. Though the term itself was occasionally used in historic tomes, its appearance in print in Scandinavia

proved the essential precondition for dissemination, first via scholarly Latin, and later through translation into English. The process was tied into philological studies and the production of dictionaries and thesauruses; although this work began in the seventeenth century, the first substantial translations did not appear until the eve of the Victorian Age, but they ultimately gave birth to a prolific creative literature and popular culture. As Wawn demonstrates, whilst the initial audience in the nineteenth century was scholarly, the availability of 'authentic', tangible accounts of Viking activity in the early Middle Ages created a new enthusiasm for 'Old Northern' history and cultural values. The saga stories were rapidly shared when cultural figures such as Sir Walter Scott and William Morris were drawn into the dissemination process. Though it is not set in the Viking Age, Scott's 1822 novel, *The Pirate*, based in the Northern Isles, was self-consciously imbued with the Nordic past of the region. Morris's engagement with the Old North world was such that he claimed his trip to Iceland in 1871 as the most significant of his life.[3]

By no means confined to the study of literature, new affinities and values were identified in the 'Old Northern' world. These ranged from notions of a northern multi-nationality embracing the Scandinavian countries and Atlantic Isles to celebrations of regionalism by residents of the Danelaw as well as Orkney and Shetland and general understandings of chivalry and barbarity. Mapping onto contemporary political commitments, the Old North also provided grist for contemporary passions about patriarchy and female suffrage, nationalism, Unionism and democracy.[4] Wawn has argued that, by the end of the century, Vikings had made their appearance in a huge range of guises:

> they are merchant adventurers, mercenary soldiers, pioneering colonists, pitiless raiders, self-sufficient farmers, cutting-edge naval technologists, primitive democrats, psychopathic berserks, ardent lovers and complicated poets.[5]

The outputs that reflected these multiple identities were visual, textual and performative, and it is impossible to separate the serious from the social, the political from the personal, the cultural from the commercialised: individuals and groups cannot be simply classified according to their activities. For example, the Viking Society for Northern Research, originally the Orkney, Shetland and Northern Society, was founded as a social and literary grouping in 1892. Its members adopted roles, titles and Northern names, but soon moved from role-playing to more scholarly pursuits, with regular academic-led meetings and an annual journal.[6]

Matthew Townend has recently traced the development of Cumbrian awareness of its Scandinavian heritage in the nineteenth and early twentieth century. The pattern reflects the larger trends identified by Wawn; the initial spark was intellectual and philological, Thomas de Quincy first clearly identifying the link between the Danish language and the local English dialect in 1819–20.[7] A generation later, however, it was Robert Ferguson, sometime mayor and MP for Carlisle, who was the first to publish a general study, dealing with antiquities, folk customs, place-names and dialects in 1856.[8] Typical of the type of well-informed citizen who came to symbolise the British antiquarian community, he combined local loyalties with passion for the past.

The figure with the most enduring impact is undoubtedly W.G. Collingwood, still surely still one of the most under-appreciated scholars in mainstream academic discourse of the Viking Age.[9] Collingwood is best known as the amanuensis and editor of John Ruskin, but he is a more complex and interesting figure. In addition to his Ruskin-related work, he was also an enthusiastic student of geology; he also had an independent career as a painter and became an accomplished Norse linguist.

A Lake District resident since the 1880s, Collingwood's own route to Nordic studies is telling. As Townend carefully documents, his interest may have been partly sparked by the discovery of the Gokstad ship in 1880, but his enduring passion was nourished by a strong sense of localism and a love of landscape and scenery, of which he was both a careful reader and painter. His first significant venture in the field was not a scholarly treatise, but a novel, dedicated to his young son, Robin: *Thorstein of the Mere: a Saga of the Northmen in Lakeland*, which is set in Viking times.[10]

Although it never made it into the canon of Victorian literature, the book enjoyed some good reviews, and was reissued and revised on two further occasions. The project may have started with the desire to create a map of Lakeland in Viking times, but Collingwood had recently become a keen reader of medieval Icelandic literature and, as his correspondence indicates, his narrative also aimed to fill an obvious gap in this by creating a saga for the Lake District – a *Fornesinga saga*, or story of Furness folk. The characters in the novel are named after the Norse personal names embedded in the place names of the Coniston district, and the book basically consists of a set of stories that explain the naming of places. It is no coincidence that his first serious scholarly contribution to Viking studies was a paper on place names, delivered in 1894. A phenomenologist before any prehistorian, the Lake District landscape is no backdrop to his tale; the sharp cliffs and screes, ravines, becks and stretches of open water are fundamental agents, controlling and sustaining both the characters and the plot, and are vividly experienced by the reader in both luminous colour and inky night. The land-takes of the Northmen take place in a sparsely inhabited landscape, where the ruins of Roman fortifications serve only as deserted landmarks. Collingwood's Vikings have no real engagement with

them as relics of the past, encountering a mountainous and wooded world as explorers and colonisers.

The novel's content is interesting in other respects. Collingwood recognises the multilingual and multi-racial character of settlement in the district, which is peopled mostly by Northmen, carefully distinguished from Danes, but also by the English, the Welsh and a group of indigenous 'giants' with red hair; in the original edition these are called Picts. Thorstein's grandmother is Irish. Although they are clearly ready for a fight at all times, the main occupation of the Northmen is with land-taking and farming, but the men regularly take to their sails in the summer months. Thorstein and his brother seek their own fortunes in a three-year venture that takes him to Dublin, Galloway and the Clyde, the Hebrides, Orkney, Iceland and Trondheim, where he is persuaded to seek baptism by Hakon the Good. They trade in skins, collected over the preceding winter. Collingwood notes that 'the age of the vikings was over'; the Northmen 'had left being nought but rovers and robbers: they had become settlers and traders and rulers of realms on the seaboard of all the northern lands'.[11]

The next year Collingwood produced another novel, *The Bondwoman*,[12] also set in Viking-age Cumbria, in the period 970–1. This received a more critical reception, largely because of its explicit treatment of Norse concubinage, and overt engagement with sexual themes.[13] Collingwood's willingness to present a sexual morality differing from the orthodox in a fairly uncritical way indicates a degree of dispassion about his subject matter, although he incorporates criticism of 'Old Northern-ness' in more general terms.[14]

His competence as an authority on the Norse of the Lake District was assured from this point by new projects which fed a developing scholarly output. In 1896 he paired up with an Icelander, Jón Stefánsson, to produce an English translation of *Kormaks saga*,[15] and the next year Stefánsson accompanied him on a trip, half-pilgrimage, half ethnographic study, to Iceland, in the footsteps of Morris and others, to experience the places of the Icelandic sagas. On the basis of a perceived strong affinity, Collingwood anticipated the discovery of fresh insights into the Northmen of Lakeland. The principal outcome here, however, was creative: a travel book based around a set of water-colour paintings.[16] The experience proved a disillusionment; he found communication with the Icelanders difficult and could see little in common at a social level with the Northmen of his own homeland. [17]

In addition to these major outputs, Collingwood also started to produce papers and give lectures on Viking-age Cumbria, tied in to more general antiquarian research in the region. Starting with a keynote address to the Viking Society in London in 1895,[18] he went on to deliver dozens of papers on Cumbrian history and archaeology. His archaeological reputation rests mainly on his study of early medieval stone carving, into which he was drawn by his editorship of the

papers of W.S. Calverley in 1899;[19] this culminated in his monumental study of early medieval crosses in northern England, produced shortly before his death. In this work he combined his artist's sensitivity to the use of image and ornament with an archaeological appreciation of the significance of all types of carving, and a well-informed theoretical appreciation of art in society. His approach may be currently unfashionable, but as Hawkes has recently argued, it was genuinely interdisciplinary.[20]

Although Collingwood was undoubtedly a very serious scholar, it seems clear that remediation played a considerable part in his career trajectory. Moving from a creative understanding of the physical landscape and an appreciation of the literary culture of Iceland to the study of place-names and art, it is evident that he was influenced at every stage by mediated experience. His emotional as well as intellectual relationships were informed by celebratory understandings of the Old North, to which he himself contributed, though not uncritically.

The Viking World of archaeologists

An archaeological equivalent of the 'Old Northern' literary and historic discourse emerged through the work of Scandinavian scholars in the early decades of the twentieth century. Prompted by the dramatic finds at Oseberg, the identification of Viking objects, decorated in a series of distinctive styles, became a major theme of Nordic scholarship; in Britain and Ireland a Norwegian research project broke significant ground, recording a range of material in museum collections in the 1920s.[21] The research gave a clear indication of what Viking material culture should look like. Diagnostic artefact types were often retrieved from human burials, and seemed polarised around gender; distinctive sword types as well as other weapons were found with male burials,[22] and female graves often contained the oval or 'tortoise' brooches used to fasten the tube-like gowns or 'strap dresses' worn by Viking women.[23] The identification of distinctively Scandinavian runic inscriptions added an epigraphic link to the philological studies.

Questions were occasionally raised about the Scandinavian origins of elements of the decorative repertoire or the place of manufacture of artefact types, but the distribution of these 'Viking international' objects, subjected to extensive scholarship as both art objects and artefacts in the 1970s and 1980s, was seen logically to map the sphere of Viking activity, from Iceland to the Ukraine. As research developed, additional objects were added to the canon of diagnostic finds, often with more restricted but still fairly wide distributions – types of silver jewellery, for example, the deposition of hoards, or the use of boats for burial, although the latter was certainly not confined to the Viking Age. This is a very crude and over-simplified summary of an enormous amount of scholarship,[24] which has demonstrated the tangibility and

robustness of traditional classification schemes. In the English context Cumbria came out strongly here, with a relatively dense distribution of tenth-century Viking graves.[25] The 2004 discoveries at Cumwhitton illustrate the 'typical' burial identity package clearly.[26]

The uses to which this corpus of material has been put were initially rather conservative; there was a tendency to assume that a Viking must lurk behind a Viking find. In the 1990s however, in line with parallel trends in other disciplines, scholars started to focus more critically on questions of identity. Whilst some of this interest was semantic – what did the term 'Viking' mean? – most was concerned with more socially and theoretically engaged questions, such as what it meant to be a Viking, and how Vikings were externally perceived by non-Vikings. A flood of conference papers, essays and monographs debated such questions, often linked to further questions about the practices of elites, relations of power and religious conversion.[27] Although texts were clearly important here, archaeological evidence also provided a significant resource, especially in so far as it could be used to debate the distinctiveness of Viking material culture. The ethnicity and identity discussions aimed to probe beneath the surface of this archaeologically created plane and engage with deeper structures at a local or regional level.

Parallel with considerations of identity, there has also been some reframing of Viking movement and settlement. Originally loosely articulated as a colonising process, the travels of Vikings in the ninth to eleventh centuries have been gradually translated into a diaspora. Drawn from contemporary understandings of the migrations of the modern world, this concept can be understood as a fluid model of shifting individuals and families who continue to sustain a relationship with their homeland as part of their transposed cultural experience. The survival or disappearance of distinctiveness may be determined by diverse local and long-distance factors. Whether this reframing actually adds to our understanding of the Viking Age has been disputed, although Abrams has carefully argued that changing use of material culture in different parts of both homelands and overseas settlements can be legitimately interpreted in this way.[28]

Important recent research has developed this theme in a specific context. Using the information collected by the Portable Antiquities Scheme (PAS), Kershaw has recently shown that changing habits in dress can now be identified through study of the commonplace brooches, currently being retrieved in fairly large numbers by detectors from the fields of the Danelaw, especially in East Anglia.[29] In a carefully constructed set of arguments she demonstrates both the continuing use of distinctive Scandinavian-style female outfits, and the widespread transmission of Scandinavian ornamental motifs to brooches used to fasten women's 'English' style costume. As clothing represents an ideal vehicle for the signification of identity,[30] the discrete practices of 'being Scandinavian' through everyday dress which she identifies have moved the archaeological agenda into a more tangible and concrete sphere, where local and regional differences can be recognised and interpreted in context.

Most overviews define the Viking world in similar terms, to include north-west Europe and the North and West Atlantic, with an eastern arm extending down the Volga towards the Black Sea and Byzantium. The catalogue accompanying the recent exhibitions in London, Copenhagen and Berlin, for example, sets this out in a map of concentric circles, with southern Scandinavia at the centre, much of Europe, including Iceland within a larger sphere, and Greenland and the North Atlantic contained within an outer ring.[31]

There is an enormous scholarly literature on the 'Viking World' and numerous academic syntheses with this exact title, or minor variations on it, have appeared in English in the past few decades.[32] International exhibitions on the subject of Vikings proliferate; the British Museum has hosted two major shows, separated by thirty-four years. The 'Euro-isation' of Vikings, shifting the balance of their affairs to a European-centred discourse, is apparent in much of this. In 1996, funding was made available via the Council of Europe to create a cultural route – 'Follow the Vikings'.[33]

Large numbers of conferences on Vikings have catered for more elite audiences, often to commemorate specific landmarks in Viking history, and these can offer wider political opportunities. The conference held in Dublin in 1995 on the 1200th anniversary of the first Irish Viking raid, for example, was largely funded by money from Scandinavia itself, and formally addressed by the Tánaiste (deputy prime minister), Dick Spring, with a speech which overtly engaged with Norwegian involvement in the contemporary peace process in Northern Ireland.

In the twenty-first century, such enthusiasms continue unabated across a wide sector. Offering an attractively unfettered masculinity at odds with modern social constraints, Viking re-enactment and living heritage groups are thriving on both sides of the Atlantic. The 'official' co-ordinating website for such groups in the UK, called simply 'the Vikings', currently lists forty-seven groups,[34] and the equivalent North American organisation, 'Vikings NA', identifies eight member groups, but there are very many unlisted groups.[35] They are also widespread in mainland Europe; Viking re-enactments are popular in Poland, where there are several staged events, including a large annual festival at Wolin, based around a 'Village of Slavs and Vikings'.[36] The enthusiasm is by no means confined to re-enactors; in the United States, where membership of a 'descendant community' is necessarily an element of every individual identity, generic Viking iconography forms a key element in the celebration of the Scandinavian heritage of

fairly recent migrants, through organisations such as the 'Sons of Norway' – initially a mutual aid society, whose monthly magazine is called, appropriately, *Viking*.[37] Dublin's Viking origins are celebrated daily by the 'Viking Splash Tours' company, which transports visitors, decked with horned helmets, around the city sites in an amphibious bus. Originally inspired by 'Duck Tours' in Boston, the concept perfectly illustrates the remediation of the city's urban origins to a contemporary economic purpose.[38]

The extent to which an explicitly celebratory discourse of Viking origins has survived or been regenerated in Cumbria may be debatable but it is clear that it is still important to be Viking 'up North'. Taking the debate into the field of hard science, recent research by geneticists is attempting to establish a Viking basis in the DNA of people living in the North of England.

Early efforts to identify historic population movements via the DNA of modern peoples have come in for some criticism, but the development of nuanced sampling strategies is now providing more convincing results. Relying on the parallel inheritance of male chromosomes and patrilineal surnames, one such study has been carried out in the Wirral and West Lancashire.[39] This aims to identify the genetic types of men who are likely to have a long local ancestry; rare and locational patrilineal surname types, found in medieval and early modern documentation for the area, were first established. These in turn served to identify a suitable group of men for DNA analysis – 'surname-based ascertainment'. The results were then compared with studies of contemporary Scandinavian and 'Celtic' groups, and the relative degree of similarity calculated. The methodology is robust in that it builds on extensive locational analysis of contemporary surnames which have demonstrable and distinctive geographical patterning. There is no attempt to assert that these surnames necessarily denote descendants of Vikings, simply that they are likely to identify people of very local descent.

The results from the Wirral and West Lancashire are persuasive, indicating that the surname-based ascertainment strategy acts as a significant filter, identifying the relatively immobile in a population and therefore providing a narrower range of genetic types. The presence of Scandinavian genetic elements was also more clearly demonstrated. There remain a number of concerns about the process, of which geneticists themselves are perfectly well aware. The first is the over-simplification of the human groupings used – there must, for example, have been a significant Anglo-Saxon element in the population of north-west England, which does not emerge from the existing analysis. Sample size remains a concern, and there is also a lingering, underlying question about the independence of the analyses from current cultural hypotheses. Is the genetic information actually telling us something new, or is it simply an expensive way of providing additional validation of a received wisdom?

A new study is ongoing, based on *c.* 2,500 samples taken from men at a number of locations east and west of the Pennines as well as in Norway; this aims to test the specifically west Scandinavian genetic element in the population of the north of England as a whole. In their pursuit of material for genetic analysis for this, Scully et al. encountered widespread welcome for genetic recognition as a 'Viking'.[40] The nature of their research obviously restricted them to locally-based participants and the responses need to be seen in this light. The act of participation could evoke strong personal responses and enthusiasms among a group of male peers who shared the same expectations. Clearly undeterred by the fearsome reputation of their potential ancestors, Scully et al. argue that attendees were looking for a 'usable past' which would add to their own self-knowledge, confirming membership of the Viking World.

Notwithstanding this fearsome reputation, it seems that being Viking has become very positively reframed in twenty-first-century values. The cultural value of Viking heritage is about to be defined at a global level, in terms of seafaring and politics. In February 2014 the Icelandic government submitted a collection of notable sites as a formal proposal to UNESCO for consideration as World Heritage under the banner 'Viking Age sites in Northern Europe'.[41] Developed as a tentative proposal since 2008, the bid has been submitted on behalf of Iceland, Norway, Denmark, Germany and Latvia, and includes the sites of Thingvellir (Iceland) and Jelling (Denmark) which are already World Heritage sites; the others are the Vestfold boat graves and Hyllestad quernstone quarries (Norway), Grobiņa archaeological complex (Latvia), the Trelleborg fortresses (Denmark), the Danevirke and Hedeby (Germany). The proposal notes that L'Anse aux Meadows (Canada) and Birka and Hovgarden (Sweden), also already inscribed, have been excluded by their governments from the nomination, and that Garðar and Brattahlid (Denmark, Greenland) has been submitted independently, as a Norse/Eskimo cultural landscape.[42]

Outstanding Universal Value, an essential part of a successful nomination, has been identified under two different criteria. First, under criterion iii: 'to bear a unique or at least exceptional testimony to a cultural tradition or to a civilisation which is living or which has disappeared', the proposal states:

In the Viking Age, local tribal societies in Northern Europe became an integral part of the civilisation of the European Middle Ages. The development of shipbuilding technology and navigational skills for sea voyages was crucial for the political, religious, social and economic processes of this transition. In the course of this transition, the people of the Viking Age became the first to inhabit the North Atlantic islands of the Faroes and Iceland.

For criterion iv: 'to be an outstanding example of a type of building, architectural or technological ensemble or landscape which illustrates (a) significant stage(s) in human history', the proposal asserts that:

> It encompasses the archaeological remains of sites of governance with symbolic and religious monuments, assembly sites for deciding legal and political issues, defensive structures such as ring fortresses and border defences, production sites such as quarries, trading towns with harbours, burial places such as ship burials in large barrows and sites of cultural interaction. These types of archaeological sites are distinctive for the Viking Age in their specific form, architecture and layout, use and function and material expression and, as such, bear exceptional witness to this time of transition in Northern Europe.

The production of a World Heritage nomination is an expensive affair; in 2009 it was estimated that in the UK costs of *c.* £500,000 could be involved in simply preparing the bid for a single site.[43] The document produced for UNESCO in connection with 'Viking-Age Sites in Northern Europe' is a lengthy dossier of over 400 pages, backed by extensive research, which locates the significance of the sites within the scientific discipline of archaeology, as well as the national heritage of the relevant countries.

It looks as though the Viking World is growing in the twenty-first century. The bid, seizing on the expeditionary dimension of 'being Viking' (*fara i viking*), defines the core region of the Viking World in Scandinavian terms, but also a much wider sphere of interaction and expansion, reaching from Vinland to Byzantium, and including the British Isles where the Vikings established 'stable regimes at times'. It also reaches beyond the world of tangible science to embrace the intangible qualities of '*fara i viking*', proposing that Viking maritime culture defined the early Christian states of northern Europe.[44]

This boat has, quite literally, been pushed out even further. An exhibition organised at the Viking Ship Museum, Roskilde, also in 2014, sets out a much more global agenda for Viking studies.[45] Entitled *The World in the Viking Age*, here the 'Viking World' is bolted on to the much broader theme of maritime trade in the western seaways, the Indian Ocean and the Mediterranean in the early Middle Ages. The linkage is made through travellers' tales; King Alfred's well known account of Ohthere's journeys in northern seas is set against the narratives of Abhara, a Persian traveller to India and China in the tenth century, and Theodosius, an aristocratic emissary of the ninth-century Byzantine Emperor Theophilus, who made a number of visits to western rulers as part of a diplomatic strategy to strengthen the Empire's ability to resist Islamic attack. Theodosius encountered the Rus', and his activities left a visible archaeological signature in the appearance of imperial coinage in Scandinavia. The project also considers the contemporary trading networks centred in the Far East, in Indonesia and China.

Most recently, Sindbæk has picked up on this theme,[46] arguing for a Viking cultural heritage, identified as the 'historical, archaeological and literary memory' of their maritime activities, but he also explores their 'shopper' appeal, 'precursors in a world oriented to individual freedom, ideological pragmatism, consumerism and capitalism'.[47]

Conclusions

At one level it seems clear that, whatever the scale of interaction in the Viking Age itself, the 'Viking World' seems a very living thing by the twenty-first century, growing and changing with every generation. It can be simply conceived as a 'virtual' world, inhabited by a wide range of enthusiasts who bring their own agendas, knowledge and experience, without necessarily any very clear objectives. The perceived dichotomy between scholarly and popular understandings of the Viking World is misleading, as they rely on interdependent tropes which are interdisciplinary in origin and now part of mass culture.

It is hard to escape the conclusion that both the prevailing economic climate and current intellectual fashion do much more to determine understandings of the past than most scholars are prepared to concede. If 'Old-Northern' enthusiasms initially shaped understandings of the Viking past in the earlier twentieth century, it seems that trade and economics began to dominate the agenda of the 1970s, when Britain became a member of the European Economic Community, leading to increasing 'Euro-isation' of research, anticipating, and increasingly supported by, European funding. Concerns about migration, emigration and identity in the late twentieth century seem to have been rapidly translated into the Viking World and twenty-first-century enthusiasm for networks and globalisation has likewise moved onto the Viking agenda.

Moving back to the first millennium, is it possible to recognise a 'Viking World' shorn of its remediation in popular culture, contemporary aspiration and historiography? At a political level, such a world probably existed intermittently for western rulers and leaders charged with preserving the structure of their still fragile states; it is not hard to see why their minds may well have turned to thoughts of Armageddon at the latest bad news about the rise in piracy, enslavement, extortion and threats to property.

Some markers of common identity are also evident. The commonality of material culture in the archaeological record, such as the remarkable stylistic uniformity of women's costume, for example, favours the idea that Vikings might have been personally recognisable as such, in everyday domestic contexts, though this distinctiveness may not have

lasted very long into the tenth century. The dispersion and imitation of Scandinavian decorative styles persisted for longer than this, but may represent a more commoditised use of creative endeavour. There is also no reason to anticipate that such markers would involve every sphere of life.

But much of the texture of the past may be lost if there is no brake on the scale of this kind of generalisation. All understandings of both the past and the present are necessarily a product of their own intellectual context, but informed interpretations also rely on factual evidence, and this may be more productively studied at a much smaller scale. The 'big picture' is never drawn in perfect proportion; and the main interest of what survives may be local and social rather than global and economic.

The Vikings buried at Cumwhitton, self-identified through their Scandinavian dress, are surely more likely to have seen themselves as part of a small, excluded community than an international network of exchange.[48] A generation later perhaps, a faith community of Vikings and Christians at Gosforth were clearly quite literally sharing their understandings of life, death and the universe, translating these into monumental sculpture and the naming of places, tied into the local landscape. Richard Bailey opened a window onto that understanding for me and many others, and I hope he will enjoy where it has led.

Notes

1 Bolter & Grusin 1999.
2 Wawn 2000, 3.
3 Ibid., 245.
4 Wawn 2000, 30–3.
5 Ibid., 4.
6 http://www.vsnr.org/ (Accessed 1 September 2014).
7 Townend 2009, 18–24.
8 Ferguson 1856.
9 Parker 2001; Hawkes 2007; Townend 2009.
10 Collingwood 1895.
11 Collingwood 1895, 172.
12 Collingwood 1896a.
13 Townend 2009, 80–3.
14 Collingwood 1896a, 100–4.
15 Published eventually as Collingwood & Stefánsson 1902.
16 Collingwood & Stefánsson 1899.
17 Townend 2009, 96–104.
18 Collingwood 1896b; Townend 2009, 1–3.
19 Calverley & Collingwood 1899.
20 Hawkes 2007.
21 Shetelig 1940.
22 Peirce & Oakeshott 2012.
23 Kershaw 2013.
24 Graham-Campbell 1980b represents a useful 'state of play' at that time.
25 See Paterson et al. 2014, 160–9 for the most recent review.
26 Paterson et al. 2014; see also Paterson below, 149–59.
27 The literature is large; see *inter alia*, Hadley & Richards 2000; Graham-Campbell et al. 2001; Downham 2009; 2012; Phythian Adams 2011; O'Sullivan 2014.
28 Abrams 2012.
29 Kershaw 2013.
30 Hides & O'Sullivan 2000.
31 Williams et al. 2014, 12–13.
32 Graham-Campbell 1980a; Batey & Graham-Campbell 1994; Brinks & Price 2008; Hall 2007. The Centre for Viking Studies at Nottingham hosted a conference with the same title in 2016.
33 Carlsson & Owen 1996.
34 http://www.vikingsonline.org.uk/membership/groupdb/groupsearch.php (Accessed 20 July 2014).
35 http://www.vikingsna.com/vna-groups (Accessed 20 July 2014).
36 Gardela 2014.
37 http://www.sofn.com/home/index.jsp (Accessed 20 July 2014).
38 http://vikingsplash.com/about-viking-splash/history-of-viking-splash-tours (Accessed 20 August 2014).
39 Bowden et al. 2008.
40 Scully et al. 2013, 928–35.
41 Stefánsdóttir & Malück 2014.
42 Ibid.
43 DCMS 2009, 21.
44 Stefánsdóttir & Malück 2014, 66–7.
45 Sindbæk & Trakadas 2014.
46 Sindbæk 2013, 82.
47 Sindbæk 2013, 85.
48 See further Paterson below, 149–59.

References

Abrams, L., 2012 'Diaspora and Identity in the Viking Age', *Early Medieval Europe* 20(1), 17–38

Batey, C. & Graham-Campbell, J. (ed.), 1994 *Cultural Atlas of the Viking World* (Abingdon)

Bolter, J.D. & Grusin, R.A., 1999 *Remediation: Understanding New Media* (Cambridge, MA)

Bowden, G.R., Balaresque, P., King, T.E., Hansen, Z., Lee, A.C., Pergl-Wilson, G., Hurley, E., Roberts, S.J., Waite, P., Jesch, J., Jones, A.L., Thomas, M.G., Harding, S.E. & Jobling, M.A., 2008 'Excavating Past Population Structures by Surname-based Sampling: the Genetic Legacy of the Vikings in Northwest England', *Molecular Biology and Evolution* 25(2), 301–9

Brinks, S. & Price, N. (ed.), 2008 *The Viking World* (London)

Calverley, W.S. & Collingwood, W.G., 1899 *Notes on the Early Sculptured Crosses, Shrines and Monuments in the Present Diocese of Carlisle*, Cumberland and Westmorland Antiquarian and Archaeological Society extra ser. 11 (Kendal)

Carlsson, D. & Owen, O. (ed.) 1996 *Follow the Vikings* (Visby)

Collingwood, W.G., 1895 *Thorstein of the Mere: a Saga of the Northmen in Lakeland* (London, repr. 1909, 1929)

Collingwood, W.G., 1896a *The Bondwoman: a Story of the Northmen in Lakeland* (London)

Collingwood, W.G. 1896b 'The Vikings in Lakeland: their Place-names, Remains, History', *Saga Book* 1, 182–96

Collingwood, W.G. & Stefánsson, J., 1899 *A Pilgrimage to the Saga-steads of Iceland* (Ulverston)

Collingwood, W.G. & Stefánsson, J. (trans), 1902 *The Life and Death of Cormac the Skald: Being the Icelandic Kormák's Saga Rendered into English*, Viking Club Translation Series 1 (Ulverston)

DCMS 2008, *World Heritage for the Nation. Identifying, Protecting and Promoting our World Heritage: A Consultation Paper*, available online at https://www.gov.uk/government/uploads/system/uploads/attachment_data/file/78444/whconsultation_engversion.pdf (Accessed 12 April 2015)

Downham, C., 2009 '"Hiberno-Norwegians" and "Anglo-Danes": Anachronistic Ethnicities and Viking-Age England', *Medieval Scandinavia* 19, 139–69

Downham, C., 2012 'Viking Ethnicities: a Historiographic Overview', *History Compass* 10(1), 1–12

Ferguson, R., 1856 *The Northmen in Cumberland and Westmoreland* (London & Carlisle)

Gardela, L., 2014 'Vikings Reborn: Facets of Early Medieval Re-enactment in Contemporary Poland', unpublished paper presented to the conference *Translating Norse and Viking Cultures for the 21st Century*, June 2014, University of Nottingham

Graham-Campbell, J., 1980a *The Viking World* (London, repr. 2013)

Graham-Campbell, J., 1980b *Viking Artefacts: a Select Catalogue* (London)

Graham-Campbell, J., Hall, R.A., Jesch, J. & Parsons, D.N. (ed.), 2001 *Vikings and the Danelaw. Selected Papers from the Proceedings of the Thirteenth Viking Congress* (Oxford)

Hadley, D. & Richards, J. (ed.), 2000 *Cultures in Contact: Scandinavian Settlement in England in the Ninth and Tenth Centuries* (Turnhout)

Hall, R.A., 2007 *Exploring the World of the Vikings* (London)

Hawkes, J., 2007 'Collingwood and Anglo-Saxon Sculpture: Art History or Archaeology?' in R. Moss (ed.) *Making and Meaning in Insular Art* (Dublin), pp 142–52

Hides, D.S. & O'Sullivan, D.M., 2000 'Dressed to Express: Women's Dress and the Construction of Ethnicity' in M. Donald & L. Hurcombe (ed.), *Gender and Material Culture* (London), pp 79–96

Kershaw, J., 2013 *Viking Identities. Scandinavian Jewellery in England* (Oxford)

O'Sullivan, D.M., 2014 'Cumbrian Parish Origins' in K. Stringer (ed.), *North-West England from the Romans to the Tudors. Essays in Memory of John McNair Todd* (Kendal), pp 61–86

Parker, C., 2001 'W.G. Collingwood's Lake District', *Northern History* 38, 295–313

Paterson, C., Parsons, A.J., Newman, R.M., Johnson, N. & Howard-Davis, C., 2014 *Shadows in the Sand: Excavation of a Viking-age Cemetery at Cumwhitton, Cumbria* (Oxford)

Peirce, I. & Oakeshott, E., 2012 *Swords of the Viking Age* (Woodbridge)

Phythian Adams, C., 2011 'From Peoples to Regional Societies. The Problem of Early Medieval Cumbrian Identities', *Trans. Cumberland and Westmorland Antiquarian and Archaeological Soc.* 3 ser. 11, 51–64

Scully, M., King, T. & Brown, S., 2013 'Remediating Viking Origins: Genetic Code as Archival Memory of the Remote Past', *Sociology* 47(5), 921–38

Shetelig, H. (ed.) 1940 *Viking Antiquities in Britain and Ireland* (Oslo)

Sindbæk, S., 2013 'All in the Same Boat. The Vikings as European and Global Heritage' in D. Callebaut, J. Mařík & J. Maříková-Kubková (ed.), *Heritage Reinvents Europe. Proceedings of the International Conference, Ename, Belgium, 17–19 March 2011*, EAC Occasional Paper No. 7 (Ename), pp 81–97

Sindbæk, S. & Trakadas, A. (ed.), 2014 *The World in the Viking Age* (Roskilde)

Stefánsdóttir, A. & Malück, M., 2014 *Viking Age Sites in Northern Europe; A Transnational Serial Nomination to UNESCO's World Heritage List*, available online at https://www.vfk.no/Documents/vfk.no-dok/Kulturarv/Verdensarv/Nominasonsdokument.pdf (Accessed 12 April 2015)

Townend, M., 2009 *The Vikings and Victorian Lakeland: the Norse Medievalism of W.G. Collingwood and his Contemporaries*, Cumberland and Westmorland Antiquarian and Archaeological Society extra ser. 34 (Kendal)

Wawn, A., 2000 *The Vikings and the Victorians: Inventing the Old North in Nineteenth-Century Britain* (Cambridge)

Williams, G., Pentz, P. & Wemhoff, M., 2014 *Vikings: Life and Legend* (London)

A tale of two cemeteries: Viking burials at Cumwhitton and Carlisle, Cumbria

Caroline Paterson

Introduction

The evidence for Viking burials from the north-west of England prior to the recent discoveries at Carlisle Cathedral,[1] Cumwhitton[2] and St Michael's Workington,[3] has been comprehensively reviewed by Edwards[4] and more recently summarised by Redmond.[5] Both the above authors focussed their surveys on those burials with associated grave-goods the nature of which indicates a Scandinavian association. The totals, although comparatively high for mainland England, were not impressive, but approximately double in number when these recent burial finds are taken into account. If monumental funerary sculpture with Scandinavian traits, such as hogbacks, is added into the equation then the number of Viking burials in Cumbria now presents an impressive total.

The interpretation of finds associated with burials is currently a highly contentious issue,[6] particularly when assumptions are made as to the ethnicity of the interred, as embodied in the very term 'Viking burial'. This encompasses both the nature of the burial itself, be it cremation or inhumation for example, and the cultural association of any finds, which need not necessarily be of Scandinavian origin, since a taste for the exotic is well attested even within the Scandinavian homelands. The issue is made more difficult by the antiquarian nature of the existing Cumbrian finds, with frequently little or no record of the all-important burial context, which may contain information on the actual burial rite itself, not to mention the need to take account of finds that are now missing or were never recovered. So the discovery of three sites with inhumation burials of a potentially 'Viking' character in the north of Cumbria affords a welcome opportunity to re-evaluate the evidence.

Historical sources shed little light on the Viking presence in Cumbria so the position remains uncertain in many respects, but it would appear that Viking colonisation may have been a piecemeal affair largely confined to the late ninth and early tenth centuries and coming primarily from the west, though cross-Pennine influence is also apparent, and well attested through the place-names.[7] This is not to suggest however that Cumbria was some kind of political backwater during this period, as the crowning of Guthred [Guthfrith] king of the Northumbrians by Abbot Eadred of Carlisle in 883 illustrates.[8] This event, together with the evidence of fairly wealthy burials in consecrated ground at both Carlisle and Workington, suggest that political alliances between incoming Scandinavians and the Church or, more specifically, the Community of St Cuthbert, were critical to whatever power struggles were being enacted locally. As we shall see, however, there are no apparent signs of ecclesiastical influence or assimilation to Christianity reflected in the cemetery of six pagan burials from Cumwhitton.

The Cumwhitton cemetery

Scholars have consistently highlighted the low incidence of pagan Norse burials from England, and sought to explain this in terms of rapid conversion and assimilation, with one paper aptly entitled 'The Case of the Missing Vikings: Scandinavian Burial in the Danelaw'.[9] Then in 2004 a metal detector find of an oval brooch (Petersen type 51) from rural Cumbria led to the excavation of six richly furnished inhumations, comprising four male and two female burials,[10] dramatically altering the statistics. Oval brooches are a Viking brooch type associated with

female burials and generally found in pairs, as with this example. The further recovery of (Berdal type) oval brooch fragments from the plough soil at Cumwhitton now brings the English total of burials with such brooches to six, which reflects a distinct underrepresentation of women in the earliest phase of Viking settlement in England. The two female burials thus identified at Cumwhitton are the first to have been found in Cumbria and provide what may be a rare glimpse of a family of immigrants. The four male inhumations display remarkable uniformity which, with their rich array of weapons, distinctive folding knives and dress fittings (including ringed pins and waist belts), make 'band of brothers' a rather fitting description, though their relatively high status is also depicted in more individual finds including silver rings, spurs and drinking horn mounts.

Although the six graves are orientated approximately east–west with their heads to the west, this need not imply that they are Christian, for such an orientation was well established in pagan contexts from the migration period onwards.[11] With King Æthelstan's annexation of Northumbria in 926 the *Anglo-Saxon Chronicle* records a meeting with northern rulers at which 'they established peace with pledge and oaths in the place which is called Eamont, on 12 July, and renounced all idolatry and afterwards departed in peace.'[12] Eamont lies just to the south of Penrith and the renunciation of idolatry could be interpreted as a reference to pagan Norse practices within the area. The pagan ritual of burial with goods for the afterlife is well illustrated at Cumwhitton and its most likely source is Scandinavia, as reflected in the origin of several of the finds. Although recent advances in stable isotope analysis caution against making assumptions about geographic origin, the main cultural influence reflected in the Cumwhitton burials is indisputably Scandinavian, to the extent that Grave 1, with its oval brooches and maple sewing box, would not look out of place within certain areas of the Scandinavian homelands. However, the other five graves all have a strong Hiberno-Norse signature, as reflected in the ringed pins (which accompanied each of the men with the example from the plough soil coming, in all probability, from Grave 6), and in their distinctive belt fittings, which are probably of local manufacture, but with close parallels from Viking contexts around the Irish Sea. Other finds of probable Insular manufacture include the drinking horn mounts from Graves 2 and 5 and the spurs from Graves 3 and 5. The picture is complicated further by composite artefacts which may have multiple sources, as proposed for the sword from Grave 3, the hilt of which can best be ascribed to Petersen's type 'U' of Norwegian origin, yet its central inlaid cross is of Hiberno-Norse type.

The location of the Viking burials at Cumwhitton in close proximity to the River Eden accords well with the distribution of contemporary sculpture, and though there

is no surviving free-standing sculpture from the parish church, a possible Anglo-Saxon window has been noted by Edwards.[13] This was prime agricultural land not far from the trans-Pennine routes, which provided critical axes of communication between the Viking kingdoms of Dublin and York at various junctures. The grave finds are far from implying that Cumwhitton was a rural backwater; on the contrary, they reflect the cosmopolitan cultural connections typical of pagan Norse graves in the Irish Sea area. Much of the weaponry hails from Norway, some of the fine bronze artefacts are probably Irish in origin, a few exotica reflect continental connections and other finds are of probable local manufacture. Moreover, influence from the Danelaw is reflected in the spur fittings and folding knives, where their closest parallels are to be found.[14] There appears to be no concession to the established Christianity of the surrounding area, perhaps because none was needed, and the statements of power implicit in the grave-goods are typically Viking in character. Swords, as the most prestigious weapon, are the most obvious indicator of this, and were included in three of the four male graves, with the example recovered from the plough soil having almost certainly come from Grave 6. The presence of spurs (Fig. 15.1), with associated strap-ends, buckles and strap-slides, worn in two of the male burials (Graves 3 and 5), is representative of an elite mounted force, though no other riding gear is present. This is also the case in a number of Danish graves, where Pedersen considers them to be part of the deceased's dress, as distinct from his riding equipment, though retaining its symbolic value nonetheless.[15] The elevated status of Scandinavian mounted warriors was modelled on Carolingian ideals of kingship, as exemplified in a mid-ninth-century portrait of the emperor, Lothar 1, who is shown crowned, seated on a throne with sword in hand and spurs attached to his footwear, though no other riding equipment is depicted.[16] Archaeological finds, such as the gold spur from Værne Kloster, Østfold,[17] reflect the Viking adoption of this ideal, but the symbolism inherent in such objects is something about which we can now only speculate. This was more than just a taste for Carolingian equipment, though the Vikings were certainly fond of such exotic finds, as reflected in the spurs and their associated fittings from Balladoole, Isle of Man.[18] While the tinned iron spur fittings at Cumwhitton are clearly not of imperial quality, they nonetheless reflect Carolingian influence in their linear ornament and the ideal of a mounted elite. Yet their composition indicates that they were most probably made somewhere within the Danelaw, the closest parallels coming from settlements at Thetford and Coppergate, York, where there is evidence of manufacturing.[19]

There is a marked preponderance of spurs within the pagan Norse graves of northern Cumbria which, in addition to the two pairs from the Cumwhitton cemetery (Graves

Fig. 15.1 Tinned iron spur from Grave 5 Cumwhitton (897) (Drawing: Adam Parsons, Oxford Archaeology North)

3 and 5), include Hesket-in-the-Forest,[20] and Aspatria.[21] Both the latter have much in common with Cumwhitton, suggesting very close cultural links. Unlike Cumwhitton, however, the Hesket and Aspatria assemblages included other horse furnishings and were buried within apparently isolated prominent mounds, though it is probable that Grave 5 at Cumwhitton was covered by a low mound. A lost spur, which from the published engraving would appear to be of a similar type, accompanied a burial recovered from the church of St Ninian, formerly Ninekirks, at Brougham, near Penrith, in 1846.[22] Although this grave was apparently discovered beneath a thirteenth-century grave slab, the recovery of an eighth-century Insular mount in the close vicinity led Bailey to question the relationship between these features and suggest that the earlier finds may represent Viking burials.[23] Apart from these Cumbrian examples the only other finds of spurs associated with pagan Norse burials from Britain are from the aforementioned Manx burial at Balladoole, a now missing antiquarian find

from the weapon burials recovered beneath the church at Kildale, Yorkshire,[24] a single spur from a grave at Middle Harling, Norfolk,[25] a probable spur fragment from the cremation hearth in Mound 7, Heath Wood, Derbyshire,[26] and the recent discovery of a pair of spurs from the furnished grave at Auldhame, East Lothian.[27] There are some common elements linking this group of mounted warriors, and although the pair of spurs from Auldhame would appear to be an outlier, this was within the northern reaches of Northumbria, and the fine Hiberno-Norse belt set accompanying the Auldhame spear and spurs belongs to a group concentrated around the Irish Sea,[28] with related examples accompanying burials at the Carlisle Cathedral site and St Michael's Workington. One possible explanation for the Cumbrian concentration of spurs is that it reflects an organised group of mounted warriors influenced by Carolingian ideals and riding equipment, perhaps not unlike the centralised organisation which Pedersen identifies in the Danish riding gear assemblages,[29] which was based

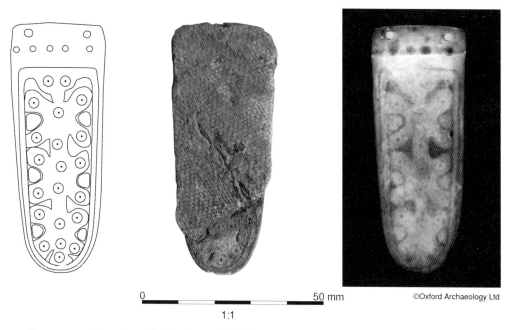

©Oxford Archaeology Ltd

0 50 mm

1:1

Fig. 15.2 Copper-alloy strap-end from Grave 2 Cumwhitton (795) (Drawing and Photograph: Adam Parsons, Oxford Archaeology North)

on the *milites,* who formed the household armies of the Carolingian nobility.[30]

Also of Carolingian derivation, though not manufacture, is an unusual strap-end recovered from Grave 2 at Cumwhitton (Fig. 15.2).[31] Here the standard decoration of stylised acanthus with a central stem and simplified florets has been reduced to its constituent parts in an almost abstract way, but its Carolingian derivation becomes clear when compared with imported parallels such as a converted baldric mount from near-by Claughton Hall, Lancashire.[32] The Cumwhitton strap-end is nearly identical to a now lost example recovered from near-by Aspatria,[33] but at Cumwhitton the belt fitting accompanied a probable female burial; this is unusual since tongue-shaped strap-ends of this form are more typically associated with masculine identity,[34] with the line of dots at its split end reminiscent of the rivets found on Carolingian baldric mounts. The low relief of the Cumwhitton strap-end, inscribed ring-and-dot motifs and other close technical details shared with its associated buckle-plate, make the set a pair which, together with the other belt fittings from Graves 4, 5 and 6, are arguably of local manufacture,[35] as is an even more debased Carolingian-derived strap-end excavated from the Carlisle Cathedral precinct (Fig. 15.5, Ae 140, confused with buckle-plate in original publication; see further below).

The Carlisle Cathedral cemetery

The early medieval finds excavated during the construction of an underground Treasury at Carlisle Cathedral in 1988 form a fascinating assemblage.[36] Unfortunately, due to the intercutting of subsequent burials, the association of

most of the early medieval finds with specific burials is far from certain, but given their nature and associated organic material it is almost certain that most accompanied inhumation burials. With the exception of a tanged leaf-shaped arrowhead,[37] and a possible scale pan fragment, the Viking-age finds could all be described as clothing accessories or small personal items which could have hung from a waist belt, including an antler comb, pendant whetstone or touchstone and some knives. This assemblage distinguishes the Carlisle Cathedral graves from more typical pagan Viking burials furnished with weapons and tools, such as those from Cumwhitton discussed above. The assemblage is also distinct from burials recovered from existing churchyards but found to include weaponry,[38] of which there are several examples from the Isle of Man,[39]

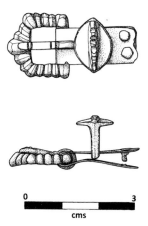

0 3

cms

Fig. 15.3 Copper-alloy strap fitting from Carlisle (Ae 5) (Drawing: Phil Cracknell)

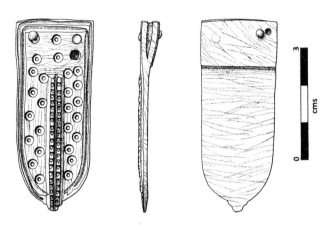

Fig. 15.4 Copper-alloy strap-end from Carlisle (Ae 183). Scale 1:1 (Drawing: Phil Cracknell)

and the north of England, including Repton, Derbyshire,[40] and Kirkdale, North Yorkshire.[41] The warrior furnished with sword and shield from Ormside churchyard in the Eden valley is a Cumbrian example.[42] The restricted nature of grave-goods at Carlisle would therefore appear to have been a deliberate act, representing a transitional stage in the abandonment of grave-goods, possibly now a precondition of burial within consecrated ground.

In a period when grave-goods had, in the main, been abandoned by the indigenous Christian population, the finds from Carlisle, restricted as they are, have a definite Viking signature. Halsall urges caution in applying the term 'Viking' to grave-goods, especially when they are not of Scandinavian origin.[43] At Carlisle there is not a single find of definite Scandinavian origin, though the water-worn antler comb is a possible candidate. The ringed pin shank with its step pattern almost certainly came from an Hiberno-Norse centre such as Dublin, and these individuals would appear to have lived within the Irish Sea milieu for some time before their deaths. This is not unexpected considering the level of cultural interchange within the Irish Sea area during this period, but the assemblage is remarkable for including an unprecedented number of small belt fittings which would appear to be Carolingian, if not in origin then at least in inspiration. These small fittings, which include Ae5 (Fig. 15.3), are distinguished by their strap-slides, paired attachment rivets, additional attachment plates and simple geometric ornament, which are all features

belonging to Carolingian spur fittings,[44] though no actual spurs were recovered. Based on the recovery of a pair of such fittings from the knees of skeleton 56 Walton Rogers identifies them as the strap fastenings for leg garters.[45] Whether attached to leggings or footwear, they would appear to have been worn at the time of burial. If they are spur fittings then they were perhaps permitted as an element of clothing, much like modern cowboy boots, and their known association with riding equipment (and, by extension, high-status Carolingian military apparel) would not have been lost on the contemporary audience at the grave side, to whom such dress fittings would have been visible in the absence of a shroud. The Viking demand for sword blades forged in the lower Rhineland is well known, and alongside this they appear to have developed a taste for other military regalia and riding equipment, coupled with the ideals of the Carolingian equestrian elite. Unlike the Cumwhitton tinned iron spur fittings which, as we have seen, were probably manufactured within the Danelaw, the copper-alloy belt fittings from Carlisle are of Carolingian type, if not manufacture, which raises the question of who was wearing them. The Carlisle burials were aligned approximately east–west but, as at Cumwhitton, this need not indicate that they were Christian, though here they were buried within consecrated ground. The number and nature of clothing accessories would suggest a recent pagan past unlike that of the indigenous population or someone of Frankish origin; individuals of Scandinavian origin therefore

seem most likely. Anglo-Saxon churchyard burials can include occasional small items associated with clothing, such as small knives,[46] but the Carlisle assemblage includes numerous finds, many of which are closely affiliated to finds from pagan Norse graves around the Irish Sea. Occasional Carolingian finds in pagan burials, such as the converted baldric mount from Claughton Hall, Lancashire,[47] indicate that the Vikings had a taste for the exotic, with many such Carolingian fittings having been converted into items of female jewellery,[48] as part of the 'military look' fashion. However, in Carlisle, as at Balladoole (Isle of Man), the fittings have not been adapted and would appear to have been used as originally intended – whether as spur or garter fittings. At Carlisle the presence of at least three small buckle sets of Carolingian type, together with another two Carolingian-derived belt fittings, may suggest a closer link with the Carolingian Empire than simply one of fashion. Wamers interprets two Carolingian spur fittings at Kaupang as representing the presence of Franks or Frisians, claiming that, since similar fittings are not found in Viking graves, they do not appear to have appealed to Viking taste.[49] The Cumbrian material presents a different picture, in which Carolingian-type spur fittings are located in probable Viking graves, indicating just such a taste for such fittings. The Carlisle finds may therefore lend support to McLeod's proposal that some of the Scandinavians who settled in England had migrated indirectly via northern Francia or Frisia,[50] bringing with them continental material culture and ideas, including a familiarity with Christian burial practices, which may help to explain this transitional burial phase within the monastic precinct at Carlisle.

A larger copper-alloy strap-end from the Carlisle cemetery (Fig. 15.4, Ae 183) also displays close Carolingian associations, and may be an early forerunner for Thomas' ribbed type.[51] Its form closely resembles that of a pair of Carolingian gilt silver foil strap-ends from the princely grave at Kolín, Bohemia,[52] with the Carlisle strap-end's 'nailhead' mid rib imitating the Kolín pair's filigree mid rib, and the inscribed ring-and-dot to either side apparently imitating Kolín's filigree ringed garnets. It is possible that the Carlisle example was an early copy of just such a Carolingian model, since its 'nailhead' mid rib and double contoured border is a feature not seen on many examples of the type, though also found on a very close parallel from the Golden Lane burial, Dublin.[53] Simpler variants of this strap-end type have been found close by at Cumwhitton,[54] Workington,[55] and Peel, Isle of Man.[56] The popularity of this ribbed series appears to have spread subsequently to the Danelaw, where simplified versions are increasingly coming to light as a result of metal detecting.[57] This may reflect demand for a belt form familiar to Scandinavian settlers who had spent time in northern Francia prior to settling in England, which would lend further support to McLeod's theory.[58] Unlike

many of the Carolingian artefacts recovered from Viking graves this strap-end form was not converted into female jewellery, but instead used as originally intended, which indicates a familiarity not just with the object, but also with the manner of wearing it.

A further Carolingian-derived strap-end in the Carlisle assemblage is Ae 133. This is actually Ae 140, confused with a buckle-plate in the original publication (Fig. 15.5), which has already been referred to in relation to the strap-end from Cumwhitton Grave 2. Its Carolingian, acanthus-based lineage is almost unrecognisable in the abstract depiction of key elements, delineated by incised semi-circles filled with ring-and-dot. Yet when compared alongside each other the association becomes clear, and a lineage from Carolingian import, through Cumwhitton Grave 2, to Carlisle can be traced. This may have chronological implications, though the time frame may be short if it relates to a single workshop in an age when experimentation with imported designs was clearly the fashion. Without comparison with the Cumwhitton find the original Carolingian inspiration for this strap-end might not have been detected, especially as it displays no reference to baldric attachment rivets, which is often helpful in diagnosing an underlying Carolingian source. The Carolingian inspiration detected in both of the above Carlisle strap-ends almost certainly extends to their respective buckle-plates, which are simply decorated with ring-and-dot. Although this is a decorative device spanning many periods and therefore regarded as rather undiagnostic, there is a distinct possibility that, when found on fittings of a form belonging to this period, it could reflect Carolingian fashion, which has important implications for the large number of such finds from the Danelaw in particular.

The Carlisle assemblage is slightly surprising considering that just a single piece of sculpture, a hammerhead cross-head recovered from the south wall of the cathedral transept,[59] is dated subsequent to the supposed subjugation of Northumbria and Strathclyde in 875.[60] Yet the role of Abbot Eadred in the inauguration of Guthfrith as King of Northumbria and in the wanderings of the Cuthbert Community presents a different picture, but one which is not necessarily rooted in Carlisle. The burial assemblage excavated in 1988 clearly reflects high-status activity at the site, which presumably involved an officiating role by members of the monastic community. The burials would appear to be of Scandinavian ethnic origin on account of the number, range and nature of their associated finds, though the interred may already have encountered Christianity during their travels, possibly in Francia, to judge from the strength of Carolingian influence. Despite the assemblage being largely restricted to items of clothing and small personal accessories, some objects are clearly of high status. The individuals buried with the

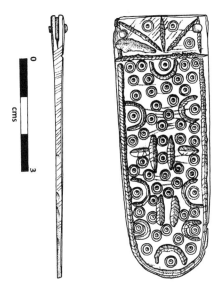

Fig. 15.5 Copper-alloy strap-end from Carlisle (Ae 140) (Drawing: Phil Cracknell)

gold toggle and the silver capped pendant whetstone,[61] arguably a touchstone for testing precious metals, were clearly wealthy, and the sets of small Carolingian-type strap fittings, whether associated with spurs or garter bindings, reflect the Carolingian military ideals of an elite, possibly mounted, force. Irrespective of personal belief it was probably expedient for the incoming Scandinavians to support the Church as a means of legitimising their power base. Assimilation of probable Scandinavian incomers within the established Church is similarly reflected in the burials with associated finds excavated from the church of St Michael, Workington in 1995,[62] which likewise had an affiliation with the Community of St Cuthbert. McLeod has recently suggested that groups of Vikings may have received estates in return for acting as mercenaries protecting certain churches,[63] a model initially proposed by Hill in relation to the Northumbrian church at Whithorn.[64] It may be that the 'transitional' burials at both Carlisle and Workington, which would appear to be predominantly male with a clear Scandinavian association, reflect just such a scenario, with small contingents of mercenaries protecting churches affiliated with the Community of St Cuthbert, which we know had close links with the Scandinavian kings of Northumbria.

Discussion

Recent evidence for Viking-age burials within Cumbria from the Carlisle Cathedral site and Cumwhitton illustrates the diversity of burial practices current in the same area at much the same time by people of Scandinavian origin.

It would be unrealistic to expect uniformity in burial rite, grave orientation and the absence or choice of grave-goods in a period of such rapid cultural assimilation, particularly when migrants were arriving from different areas of the Scandinavian world. Some scholars would question the use of the word 'Viking' as an ethnic label for the burials at both the above sites; the absence of surviving teeth at Cumwhitton and inconclusive results from Carlisle,[65] mean that techniques such as isotope analysis have not been able to resolve the question of ethnic identity scientifically. At Cumwhitton the 'Viking' label needs little justification with its pagan burial rite together with the number and range of finds of probable Scandinavian origin, Grave 1 being almost exclusively Scandinavian in character. More circumspection is required in applying the 'Viking' label to some of the early medieval graves at Carlisle, but even here, in a Christian cemetery devoid of finds of diagnostically Scandinavian origin, the reluctance to abandon grave-goods, albeit mainly dress accessories, would appear to reflect a stage in the transition from pagan burial rite to one compatible with burial within consecrated ground. The finds which were recovered are cosmopolitan in taste and best paralleled in the pagan Norse assemblages of the Irish Sea. This need not necessarily be interpreted as conversion, though that would not be out of the question in the light of the examples set by leaders, including Guthfrith and Guthrum. The literal translation of the Old Norse word for conversion, *siðaskipti*, as 'change of custom',[66] provides an appropriate paradigm for archaeologists to identify in the surviving material culture. Since there is no evidence for the use of shrouds at Carlisle, it is quite probable that clothing in all its finery, evoking associations with Carolingian military regalia of a possibly equestrian nature, would have been highly visible during the actual funeral, possibly satisfying some of the old pagan need for honouring the status of the dead. Seen in this light the Carlisle burials are not so far removed as might appear at first sight from the Cumwhitton warriors with their array of weapons and spurs.

The Vikings dominated activities within the Irish Sea area during the ninth and tenth centuries, and the cosmopolitan nature of the Cumwhitton and Carlisle grave assemblages reflects their contacts within the Irish Sea, Northumbria and as far afield as Norway and the Carolingian Empire. Both cemeteries contain material reflecting Carolingian influence, from the debased acanthus strap-end in Grave 2 at Cumwhitton to the numerous strap fittings from Carlisle. This supports Thomas' recent appraisal of the important role of Carolingian metalwork within England, with Frankish equestrian equipment and belt fittings dominating the scene,[67] and perhaps shaping Viking identity within the North West.

The contrast in location between the relatively isolated rural setting of Cumwhitton and the ecclesiastical

proto-urban one of Carlisle must have been just as dramatic a thousand years ago as today. Yet both sites housed a powerful Scandinavian elite around the end of the ninth century. Despite being from seemingly very different contexts, one pagan, the other Christian, there are some remarkably close parallels between the assemblages. The status commensurate with mounted elite warriors as reflected in the spurs at Cumwhitton may also be reflected, albeit more subtly, in the Carolingian-type strap fittings at Carlisle. For although weaponry could presumably no longer accompany the Carlisle burials within consecrated ground, the value placed on military regalia is still apparent, though only permissible through the spur-like shoe or leg bindings. The presence of folding knives at both sites is also significant, as these specialised tools, some with distinctive awl-like extensions, are not common, with their distribution being largely restricted to the north of England.[68] Although their exact function is unknown, Adam Parsons' ethnographic parallels with horse picks may have added significance if a mounted elite is represented.[69] There are also close stylistic parallels between the larger belt fittings from both sites, with the ornament on the pseudo-Carolingian strap-end from Grave 2 at Cumwhitton further deconstructed in one of the Carlisle strap-ends (Fig. 15.5), though the rather fine Carlisle strap-end characterised by its 'nailhead' mid rib (Fig. 15.4) is paralleled in a more simplified form on the baldric ties from Grave 5 at Cumwhitton.[70]

One surprising contrast between the two assemblages is that there are no finds from the Carlisle cemetery which can be ascribed with certainty to a female burial. There remains the possibility that some of the larger strap fittings could have been worn by a woman, but the belt fitting from the putative female Grave 2 at Cumwhitton is unusual in this respect. Of course several finds, such as the comb, could have accompanied either sex, and osteological sexing of burials suggests that Viking women may be less well represented in artefact assemblages than in actuality.[71] If women were indeed absent from the Carlisle cemetery, that might reflect a low number of ethnically Viking women in the area at this time, perhaps compounded by churchyard burial being restricted to the ruling elite in a time when masculine status was on the ascendancy.

Chronologically the sites are so closely connected by their assemblages that it is hard to place one earlier than the other, though Grave 1 at Cumwhitton, with its exclusively Scandinavian finds and pagan ritual, probably represents a first generation settler, whereas the other individuals at both sites had clearly spent some time integrating within the region. Burial within the monastic cemetery at Carlisle may reflect the more rapid assimilation symptomatic of an urban context. Churches appear to have been central to the exercise of lordship in ninth- and tenth-century Cumbria,

and the Scandinavian immigrants seem to have adapted to this and enthusiastically adopted burial within churchyards,[72] which Wilson gives as one of the reasons why so few Viking burials in England have been identified.[73]

Trying to gauge the relative social status of the two sites is difficult when one site is clearly pagan, whilst ecclesiastical constraints at the other have largely limited its furnishings to items of clothing. However, both Cumwhitton and Carlisle would appear to represent local elites, the former with its grandiose displays of weaponry and jewellery, the latter with its exotic clothing accessories and occasional items of precious metal. Status could clearly be conveyed after the abandonment of ostentatious grave-goods and weaponry, and even following the cessation of all grave-goods, as suggested by the fashion for tenth-century monumental stone carvings raised to commemorate local patrons. So an elite mounted force, such as that proposed for Cumbria from the finds of spurs and other horse equipment in rich pagan burials, is possibly alluded to in subsequent sculptural representations, such as the pair of mounted warriors from Sockburn, Co. Durham.[74]

The recently discovered burials at Cumwhitton and Carlisle have added greatly to our understanding of the Viking presence in Cumbria. Cumwhitton is closely associated with the prominent mound burials at Hesket and Aspatria, which housed members of an equestrian elite. Five of the graves reveal high levels of local interaction through their predominantly Hiberno-Norse assemblages, though the burial rite itself is pagan. This contrasts with the burial rites evidenced at Carlisle, where the practice of depositing grave-goods has been largely abandoned, with finds consciously restricted to clothing accessories and a few personal items. As previously noted, this change in rite was no doubt a requirement of burial within consecrated ground. Rather surprisingly, there are many close parallels between the artefacts at these contrasting cemeteries, one pagan the other Christian, which would suggest that the burials are closely linked chronologically. This reflects the range of responses on the part of different groups of migrants to their adopted country. It may also be that the proto-urban environment of Carlisle, with its established church, had a stronger influence on those who settled there than did the rural setting of Cumwhitton, illustrating how two different communities responded to the challenges of integration in different ways.

Notes

1 McCarthy 2014.
2 Paterson et al. 2014.
3 McCarthy & Paterson 2014; Zant et al. forthcoming.
4 Edwards 1992.
5 Redmond 2007.

6 Hadley 2006, 237–71.
7 Fellows-Jensen 1985, 411.
8 *Historia de Sancto Cuthberto* 13 (Johnson South 2002, 53).
9 Richards 2002.
10 Paterson et al. 2014.
11 Gräslund 1987, 83–5.
12 *Anglo-Saxon Chronicle* 'D' northern text: 7 mid wedde 7 mid aþum fryþ gefæstnodon on þær stowe þe genemned is æt Eamotum on .iiii. idus Iulii, 7 æle deofolgeld to cwædon, 7 syþþam mid sibbe tocyrdon. (Cubbin 1996, 41; trans. Whitelock et al. 1961, 69).
13 Edwards 2013, 490.
14 Paterson et al. 2014, 140–2.
15 Pedersen 1997, 126–7.
16 Wamers 2005, Abb.6, 57–61.
17 Pedersen 2014, fig. 48.
18 Bersu & Wilson 1966, 36–7.
19 Ottaway 1992, 698–704; Paterson et al. 2014, 140.
20 Hodgson 1832, pl. ii, 5a–b.
21 Rooke 1792, pl. iv:G; Abramson 2000, fig. 4:4.
22 Brougham 1847, 65.
23 Bailey 1977, 180.
24 Atkinson 1868, 52–4.
25 Rogerson 1995, 101–2.
26 Richards 2004, 38, fig. 11.
27 Heald & Paterson 2016, 64, figs 54-5.
28 Paterson 2001, 130.
29 Pedersen 1997, 132.
30 Thomas 2012, 489.
31 Paterson at al. 2014, 70–1, fig. 44.
32 Jones 1849, fig. facing 74; Kendrick 1935, pl. ii a–c.
33 Rooke 1792, pl. iv:d.
34 Thomas 2012, 508.
35 Paterson et al. 2014, 146–9.
36 Paterson & Tweddle 2014, 207–31.
37 Ottaway 2014, ill. 21 (Fe 270), 227, 230.
38 Redmond 2007, 106–18.
39 Wilson 2008, 46–51.
40 Biddle & Kjølbye-Biddle 2001, 60–7.
41 Atkinson 1868, 53–4.
42 Ferguson 1899, 379–80; see also the Viking-age sword from Morland, Cumbria (Bailey 1984).
43 Halsall 2000, 264.
44 Thomas 2012, 501.
45 Walton Rogers 2014, 223–4.
46 Hadley 2006, 246–9.
47 Kendrick 1935, pl. II a–c.
48 Thomas 2012, 502.
49 Wamers 2011, 72.
50 McLeod 2014, 132–71.
51 Thomas 2000a, 115.
52 Wamers 2005, kat. 40; 2011, 71, fig. 4.6:2.
53 O'Donovan 2008 fig. 332; fig. 119.
54 A pair of small strap-ends, possibly associated with a sword sling, found in Grave 5 (Paterson et al. 2014, fig. 91).
55 Paterson forthcoming.
56 Freke 2002, fig. 22:OL.

57 Thomas 2000b, 251, fig. 23.
58 McLeod 2014.
59 Bailey in Bailey & Cramp 1988, 87, no. 4, ills 214–7.
60 Darlington, McGurk & Bray 1995–8, 305; see recent discussion in Edmonds 2014.
61 Paterson & Tweddle 2014, 208, ill.15; 227–9, ill.22.
62 Paterson forthcoming.
63 McLeod 2015, 13, 17–18.
64 Hill 1997, 54.
65 Montgomery & Towers 2014.
66 Hadley 2000, 121.
67 Thomas 2012, 501.
68 Ottaway 2014, 229.
69 Paterson et al. 2014, 142; it is noteworthy that the grave at Middle Harling, Norfolk, contained two folding knives (Ottaway 1992, 586–8), together with a single spur.
70 Paterson 2014, fig. 91.
71 McLeod 2014, 95–6.
72 Hadley 2000, 121.
73 Wilson 1967, 44.
74 Bailey 1980, 234–5; Hadley 2008, 275.

References

Abramson, P., 2000 'A Re-examination of a Viking Age Burial at Beacon Hill, Aspatria' *Trans. Cumberland and Westmorland Antiquarian and Archaeological Soc.* new ser. 100, 79–88

Atkinson, J.C., 1868 'Proceedings Thursday, January 9th 1868', *Proc. Soc. Antiquaries of London* 2 ser. 4 (1867–70), 52–5

Bailey, R.N., 1977 'A Cup-mount from Brougham, Cumbria', *Med. Arch.* 21, 176–80

Bailey, R.N., 1980 *Viking Age Sculpture in Northern England* (London)

Bailey, R.N., 1984 'A Viking-age Sword from Morland, Cumbria', *Trans. Cumberland & Westmorland Antiquarian & Archaeological Soc.* new ser. 84 (1984), 263–6

Bailey, R.N., & R. Cramp, 1988 *Cumberland, Westmorland and Lancashire North-of-the Sands*, CASSS 2 (Oxford)

Biddle, M., & Kjølbye-Biddle, B. 2001 'Repton and the 'Great Heathen Army', 873–4' in J. Graham-Campbell, R. Hall, J. Jesch & D. Parsons (ed.), *Vikings and the Danelaw: Select Papers from the Proceedings of the Thirteenth Viking Congress* (Oxford), pp 45–96

Bersu, G. & Wilson, D.M., 1966 *Three Viking Graves in the Isle of Man*, Society for Medieval Archaeology Monograph Series 1 (London)

Brougham, W., 1847 'The Tombs of the De Broham Family, with an Account of Some Remarkable Discoveries in their Burial-place in the Church of Brougham', *Archaeological J.* 4, 59–96

Cubbin, G.P. (ed.), 1996 *The Anglo-Saxon Chronicle: a Collaborative Edition, 6. MS D* (Cambridge)

Darlington, R.R., McGurk, P. & Bray, J. (ed. and trans.), 1995–8 *The Chronicle of John of Worcester*, 3 vols (Oxford)

Edmonds, F., 2014 'The Emergence and Transformation of Medieval Cumbria', *Scottish Historical Review* 93(2), 195–216

Edwards, B.J.N., 1992 'The Vikings in North-west England: the Archaeological Evidence' in J. Graham-Campbell (ed.), *Viking Treasure from the North West: the Cuerdale Hoard and its Context* (Liverpool), pp 43–62

Edwards, B.J.N., 2013 'Cuerdale: an update from North-West England' in A. Reynolds & L. Webster (ed.), *Early Medieval Art and Archaeology in the Northern World: Studies in Honour of James Graham-Campbell* (Leiden), pp 487–99

Fellows-Jensen, G., 1985 *Scandinavian Settlement Names in the North-West* (Copenhagen)

Ferguson, R.S., 1899 'Various Finds in Ormside Churchyard', *Trans. Cumberland and Westmorland Antiquarian and Archaeological Soc.* 1 ser. 15, 377–80

Freke, D., 2002 *Excavations on St Patrick's Isle, Peel, Isle of Man: Prehistoric, Viking, Medieval and Later*, Centre for Manx Studies Monograph 2 (Liverpool)

Gräslund, A-S., 1987 'Pagan and Christian in the Age of Conversion', in J.E. Knirk (ed.), *Proceedings of the Tenth Viking Congress* (Oslo), pp 81–94

Hadley, D.M., 2000 'Burial Practices in the Northern Danelaw 650–1100', *Northern History* 36(2), 199–216

Hadley, D.M., 2006 *The Vikings in England: Settlement, Society and Culture* (Manchester)

Hadley, D.M., 2008 'Warriors, Heroes and Companions: Negotiating Masculinity in Viking-Age England', *ASSAH* 15, 270–84

Hadley, D.M. & Richards, J.D. (ed.) *Cultures in Contact: Scandinavian Settlement in England in the Ninth and Tenth Centuries* (Turnhout)

Halsall, G., 2000 'The Viking Presence in England? The Burial Evidence Reconsidered' in Hadley & Richards 2000, pp 259–76

Heald, A. & Paterson, C., 2016 'Iron Spurs with Buckles' in A. Crone & E. Hindmarch, *Living and Dying at Auldhame, East Lothian: the Excavation of an Anglian Monastic Settlement and Medieval Parish Church* (Edinburgh), p. 64

Hill, P., 1997 *Whithorn and St Ninian. The Excavation of a Monastic Town, 1984–91* (Stroud)

Hodgson, C., 1832 'An Account of some Antiquities found in a Cairn, near Hesket-in-the-Forest, in Cumberland, in a Letter from Mr Christopher Hodgson to the Rev. John Hodgson, Secretary', *Archaeologia Aeliana* 1 ser. 2, 106–9

Johnson South, T. (ed. and trans.), 2002 *Historia de Sancto Cuthberto: a History of Saint Cuthbert and a Record of his Patrimony* (Cambridge)

Jones, M., 1849 'Remains of a Viking Burial', *Archaeological J.* 6, 74–5

Keevil, G.D., 1989 'Carlisle Cathedral Excavations 1988: Interim Report' (unpublished report, Carlisle Archaeological Unit)

Keevil, G.D., 2008 'Excavations at Carlisle Cathedral in 1985', *Trans. Cumberland and Westmorland Antiquarian and Archaeological Soc.* 3 ser. 8, 37–61

Kendrick, T.D., 1935 'The Claughton Hall Brooches', *Saga Book of the Viking Society* 11(2), 117–24

McCarthy, M., 2014 'A post-Roman Sequence at Carlisle Cathedral', *Archaeological J.* 171, 185–257

McCarthy, M. & Paterson, C., 2014 'Viking-age Site at Workington, Cumbria: an Interim Statement' in S.E. Harding, D. Griffiths & E. Royles (ed.) *In Search of Vikings – Interdisciplinary approaches to the Scandinavian Heritage of North-West England* (Boca Raton, FL), pp 127–36

McLeod, S., 2014 *The Beginning of Scandinavian Settlement in England. The Viking 'Great Army' and Early Settlers, c. 865–900* (Turnhout)

McLeod, S., 2015 'The *dubh gall* in Southern Scotland: the Politics of Northumbria, Dublin, and the Community of St Cuthbert in the Viking Age, c. 870–950 CE' in P. Alessia & D. Selier (ed.), *A Festschrift in Memory of Philippa Maddern, Limina* 20(3), pp 1–21

Montgomery, J., & Towers, J., 2014 'The Isotopes' in McCarthy 2014, 233–6

O'Donovan, E., 2008 'The Irish, the Vikings, and the English: New Archaeological Evidence from Excavations at Golden Lane, Dublin' in S. Duffy (ed.), *Medieval Dublin* 8, 36–130

Ottaway, P., 1992 *Anglo-Scandinavian Ironwork from 16–22 Coppergate*, The Archaeology of York: The Small Finds 17/6 (York)

Ottaway, P., 2014 'The Ironwork' in McCarthy 2014, 224–7

Paterson, C., 2001 'Insular Belt-fittings from the Pagan Norse Graves of Scotland: a Reappraisal in the Light of Scientific and Stylistic Analysis' in M. Redknap, N. Edwards, S. Youngs, A. Lane & J. Knight (ed.), *Pattern and Purpose in Insular Art*, (Oxford & Oakville, CT), pp 125–32

Paterson, C. forthcoming 'The Early Medieval Small Finds' in Zant et al. forthcoming

Paterson, C., Parsons, A.J., Newman, R., Johnson, N. & Howard Davis, C., 2014 *Shadows in the Sand: Excavation of a Viking-age Cemetery at Cumwhitton, Cumbria* (Lancaster)

Paterson, C., & Tweddle, D., 2014 'The Gold & Silver & the Copper-alloy' in McCarthy 2014, 208–22

Pedersen, A., 1997 'Weapons and Riding Gear in Burials – Evidence of Military and Social Rank in 10th-Century Denmark?' in A. Nørgård Jørgensen & B.L. Clausen (ed.) *Military Aspects of Scandinavian Society in a European Perspective AD 1–1300* (Copenhagen), pp 123–35

Pedersen, A., 2014 'Power and Aristocracy' in G. Williams, P. Pentz & M. Wemhoff (ed.) *Vikings: Life and Legend* (London), pp 122–61

Redmond, A.Z., 2007 *Viking Burial in the North of England*, BAR: British Series 429 (Oxford)

Richards, J.D., 2002 'The Case of the Missing Vikings: Scandinavian Burial in the Danelaw' in S. Lucy & A. Reynolds (ed.), *Burial in Early Medieval England and Wales*, Soc. for Medieval Archaeology Monograph 17 (London), pp 156–70

Richards, J.D., 2004 'Excavations at the Viking Barrow Cemetery at Heath Wood, Ingleby, Derbyshire,' *Antiquaries J.* 84, 23–116

Rogerson, A., 1995 *A Late Neolithic, Saxon and Medieval Site at Middle Harling, Norfolk*, East Anglian Archaeology 74 (Dereham)

Rooke, H., 1792 'Druidical and Other British Remains in Cumberland', *Archaeologia* 10, 105–13

Thomas, G., 2000a 'A Survey of Late Saxon and Viking Age Strap-ends from Britain' (PhD, University College London)

Thomas, G., 2000b 'Anglo-Scandinavian Metalwork from the Danelaw: Exploring Social and Cultural Interaction' in Hadley & Richards 2000, pp 237–58

Thomas, G., 2012 'Carolingian Culture in the North Sea World: Rethinking the Cultural Dynamics of Personal Adornment in Viking-age England' *European J. of Archaeology* 15(3), 486–518

Walton Rogers, P., 2014 'The Textiles' in McCarthy 2014, 223–4

Wamers, E., 2005 *Die Macht des Silbers: Karolingische Schätze im Norden* (Regensburg)

Wamers, E., 2011 'Continental and Insular Metalwork' in D. Skre (ed.) *Things from the Town – Artefacts and Inhabitants in Viking-age Kaupang*, Kaupang Excavation Project Publication Series 3, Norske Oldfunn 24 (Oslo), pp 65–98

Whitelock, D. with Douglas, D.C. & Tucker, S.I. (ed. and trans.), 1961 *The Anglo-Saxon Chronicle* (London)

Wilson, D.M., 1967 'The Vikings' Relationship with Christianity in Northern England' *JBAA* 3 ser. 30, 37–46

Wilson, D.M., 2008 *The Vikings in the Isle of Man* (Aarhus)

Zant, J., Paterson, C. & Parsons, A., forthcoming *The Early Medieval Cemetery at St Michael's Church, Workington* (Lancaster)

Transactions on the Dee: the 'exceptional' collection of early sculpture from St John's, Chester

Paul Everson and David Stocker

The collection of early sculpture from St John's in Chester as catalogued by Richard Bailey numbers nine items. Two numbered additions are probably duplicates.[1] Additionally, it seems at least probable that two other carvings found close to the church originated in its graveyard.[2] An original association with St Werburgh's has been suggested for two further, unprovenanced stones from the city; Bailey himself was judiciously unconvinced but nevertheless inclined to differentiate these pieces stylistically from the collection at St John's and to suggest that they might have been produced by a second potential workshop associated with St Werburgh's, separate from that presumed to be connected with the quarrying of the cliff immediately south of St John's graveyard.[3] Admittedly, as Bailey demonstrates, their stylistic connexions are entirely different from the core St John's group (Fig. 16.1).[4] All, however, were produced in local Cheshire stone (or from reused Roman blocks from the same petrological sources); all represent modest, small-scale monuments (grave-markers and perhaps a small grave-cover in the case of the Unknown Provenance pieces). There is little doubt that such monuments marked individual graves; an important development from the major 'saintly' and 'communal' monuments of the ninth century and earlier.[5] Because of this, there is no inherent reason to believe that stylistically different monuments might not coexist in the same graveyard; and consequently it must be a possibility that they all had the same provenance at St John's, at either first or second hand. In fact the diversity of stylistic links with distant regions also relates to the maritime and trading connexions that bulk large in our account of the collection's context that follows.

Most if not all known pre-Conquest sculpture in Chester comes from St John's, then. No other church site in the city has produced any, unless the Unknown Provenance items come from St Werburgh's. Furthermore, as well as being arguably from a single site, this collection has other notable characteristics. It is of exceptional size, matched only in Cheshire by groups at Neston and West Kirby (of which more below) and best paralleled in Lancashire, perhaps, by that at Lancaster. Its monuments are not only quite uniform but also uniformly modest in scale and elaboration. Most strikingly of all, without exception they were first erected in the period between the early tenth and early eleventh century. In so far as any explanation has been offered for these characteristics it seems to have been either general – in terms of the late Saxon commercial growth of the city, still reflected most clearly in its mint, or specific – in terms of the antiquity of the church site of St John, with its proximity to the ruined Roman amphitheatre, and its eleventh-century profile and patronage.[6] With 'exceptional' collections of this type in eastern England, and especially in urban contexts, however, we have developed and tested a proposition that they and their host churches represent the ecclesiastical provision for waterborne trading communities. Typically the churches stand on or just behind the riverside hards or sea-shore beach markets, sometimes in notably prominent locations and several are close to, or above, the maximum contemporary head of the tide; and the stone funerary monuments represent the markers of deceased merchants and resident aliens. In more developed urban situations, the church, merchant community and beaching place are located clearly outside a reserved enclosure that is the locale of established secular power, with its own ecclesiastical provision and facilities such as a mint – sometimes, where the topography suits it, across the river. The proposition has been set out *in extenso* using examples in Yorkshire and Lincolnshire, but its roots lay in our earlier consideration of the 'exceptional' early sculptural collections of the

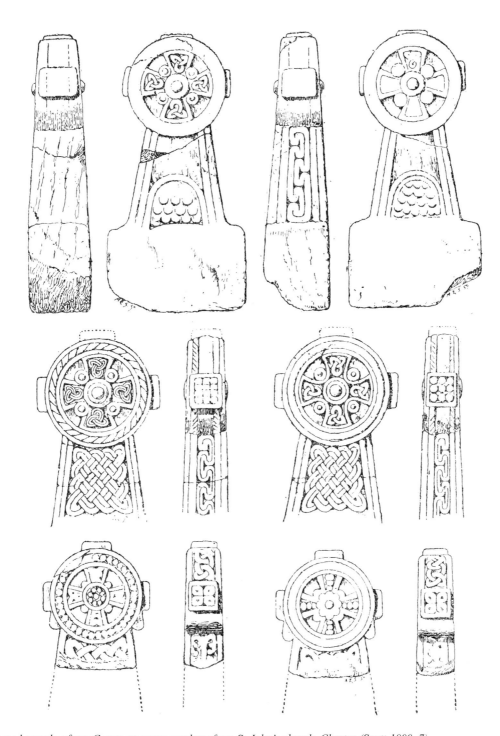

Fig. 16.1 Engraved sample of pre-Conquest grave-markers from St John's church, Chester (Scott 1899, 7)

Wigford churches of St Mary and St Mark in Lincoln and at Bicker and Marton on Trent; and we have most recently explored its relevance to the early urban centres of East Anglia at Thetford and Norwich.[7] Both the prominent siting of St John's in relation to Chester's riverside hard and its topographical location clearly outside and to the south-east of the Roman *enceinte* correspond to these characteristics (Figs. 16.2–3).

Bailey himself applied this idea that 'exceptional' collections of early sculpture might relate to trading communities to the particular concentration of Anglo-Scandinavian stone monuments in the northern Wirral and

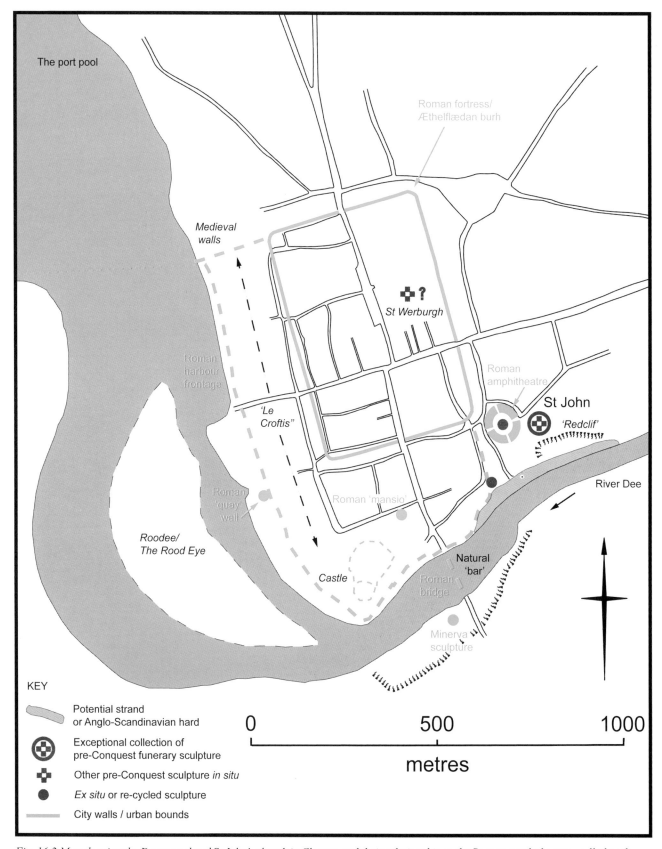

The port pool

Roman fortress/
Æthelflædan burh

Medieval
walls

Roman
harbour
frontage

'Le
Croftis''

Roman
'quay
wall'

Roodee/
The Rood Eye

St Werburgh

Roman
amphitheatre

St John

'Redclif'

River Dee

Roman 'mansio'

Natural
'bar'

Castle

Roman
bridge

Minerva
sculpture

KEY

Potential strand
or Anglo-Scandinavian hard

Exceptional collection of
pre-Conquest funerary sculpture

Other pre-Conquest sculpture *in situ*

Ex situ or re-cycled sculpture

City walls / urban bounds

0 500 1000

metres

Fig. 16.2 Map showing the Dee strand and St John's church in Chester, and their relationship to the Roman amphitheatre, walled enclosure and the river's outfall with sculpture superimposed (Drawing: P. Everson, based on Sylvester & Nulty 1958, 51)

its potential connexion with the long-established trading place at Meols.[8] Yet he was not drawn, it seems, to the more obviously 'exceptional' collection at St John's in Chester itself. To us, by contrast, both this collection and the local topography match the characteristics of eastern England's urban trading locales perfectly. The hard or strand lay below St John's and must have had at least 300m of river frontage on the north bank of the Dee, and if not the width of up to 35m that is now available, then at least sufficient for the purpose. A broad funnel of a road, Souters Lane, deeply worn into the sandstone cliff, supplies what is acknowledged to be an ancient as well as modern way up to the church and the area of the amphitheatre beside it.[9] This was *Souters Lode* in the thirteenth century, leading to a landing place on the river from the area of the city's tanneries in the later Middle Ages, and associated crafts such as shoemaking.[10] In the seventeenth century there were also paths and stairs to the Dee exiting from both the south-east and south-west corners of St John's churchyard.[11] The significance of the footprint of the Roman amphitheatre in this era and to this

grouping of facilities may have been that it was an open space, available and suitably defined for a market place. The rather miscellaneous evidence of this era in recent and earlier excavations may reflect this type of activity, rather than the high-status residential occupation conjectured; finds certainly included late Saxon ceramics and a Hiberno-Norse pin that found its way into the robbing of the eastern side of the amphitheatre in the later eleventh or twelfth century. A coin of Eadred (946–55) is recorded as found 'near the amphitheatre' in 1951.[12] The notable early tenth-century coin hoard found at St John's itself in 1862 contained one Chester penny of the so-called 'tower (or reliquary?)' type, one of the East Anglian St Edmund memorial type and no less than seven pennies of the York St Peter series out of only eighteen coins recorded. A significant reverse link for this York trading connexion is provided by the Chester customs tag, also of Eadred's reign, found in the Coppergate excavations.[13] If this Chester coin type refers to the lordly enclosure of the refurbished burh, it is tempting to identify another Chester reverse depicting a church as an image of

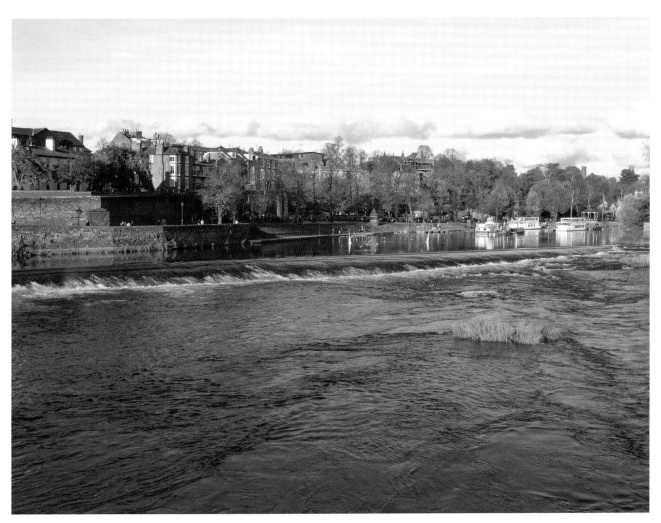

Fig. 16.3 View north-east from Dee bridge to the bar, the strand and St John's church (Photo: P. Everson)

St John's, as the church sponsoring the market here, in line with the York St Peter and Lincoln St Martin series.[14] In the twelfth century, Chester's main midsummer fair on the feast of St John Baptist was moved to the space in front of the abbey (St Werburgh's) gate; perhaps that established saintly patronage suggests that the earlier location of the city's main market had been adjacent to St John's.[15] Use of the arena of an abandoned amphitheatre for marketing has been identified at Cirencester, and may be more common than is reported.[16] At Norwich in similar circumstances, we have argued that there was a large open marketing space behind the Anglo-Scandinavian hard on the Wensum, to which the name 'Tombland' originally applied, and around and behind that, areas of manufacturing, often with specialist zones. Thetford, too, exhibits a similar arrangement.[17] By contrast, direct and contemporary evidence for manufacturing is scarce at Chester (Fig. 16.4). It all lies outside the Roman walls, to the south and south-east, however. By common consent leather-working and ancillary trades are likely to have featured strongly, and (as noted above) are well evidenced in the St John's area after the Conquest. Chester ware ceramics, which occur widely across the city and as exports to Dublin, imply kilns exploiting the local clays. None is yet located, but we may perhaps anticipate that they lay east and perhaps also north of St John's, where a later medieval ceramic industry is known north of Foregate Street and east of Frodsham Street.[18] Only on the west side of Lower Bridge Street has good evidence of dense urban activity in this era been excavated, including manufacturing involving moulding metal ingots and leather-working and contact with the distant Carolingian world.[19] The misalignment of the excavated buildings with the Roman street frontage has puzzled some commentators; but to us it signals their participation in a manufacturing zone lying behind and servicing the hard and marketing area to the east and south-east rather than the Roman alignments. The churches of this area – St Olave and St Bridget – have Hiberno-Norse dedications; and the zone east of Lower Bridge Street and extending east to the amphitheatre and St John's includes not only St Olave's, first documented in decline in 1119, but also lost street names – *Clippe Gate* and '*Ulfaldi's gate*' – both fossilising un-anglicised Norse personal names; it may, as Dodgson has supposed, have housed a distinctive Scandinavian enclave, whose origins lay in the tenth- and eleventh-century trading community.[20]

We suggest, then, that on the evidence of several parallels in eastern England St John's might be understood as a church serving a tenth-century trading community, against the backdrop of the revivification of Chester as an urban and commercial centre. This revivification was evidently brought about by the West Saxon royal dynasty in the early years of the tenth century, and presumably included the re-occupation of the city as a burh and establishment of a mint there to serve the market. Locating St John's as this

type of church goes against received and well-established academic understanding that it had earlier – if not more important – origins.[21] On examination, however, this 'importance' proves to depend largely on the evidence of a lost work of Giraldus Cambrensis, incorporated into the fourteenth-century chronicles of Chester, which claimed that St John's was founded in 689 by the Mercian king Æthelred (fl. 674–704), in association with an otherwise unknown 'St Wilfric', bishop of Chester.[22] There is clearly confusion and perhaps creative interpretation in the transmission of names, dates and roles here, and its resolution in an early date, as Thacker has proposed, depends on identifying 'St Wilfric' as St Wilfrid in the Mercian phase of his vigorous and influential career.[23] The possibility that a much earlier church was taken over by the trading community is, in practice, no stumbling block to our proposal, though no such evidence for a pre-existing church of high status has yet been brought forward in respect of any of the various eastern English comparanda for such merchants' churches. Alternative explanations of St John's might point to its later foundation. 'Wilfric' is a rare name in original pre-Conquest documents in that form, but very common as 'Wulfric', numbering 113 individuals in the PASE data-base, all – like the only Wilfric – of the mid-ninth century and later.[24] One, 'Wulfric 45' fl. 985, was both a cleric and closely associated with King Æthelred 'Unræd', whose priest he was. King's clerks were important players in the creation of pre-Conquest ecclesiastical institutions; perhaps Wulfric the clerk and King Æthelred were indeed linked in a foundation at St John's, but of the collegiate institution sometime around the millennium. Another royal Æthelred with very clear connexions with Chester was of course the *patricius* of Mercia and husband of the formidable Æthelflæd, Lady of the Mercians;[25] the period following her refortification of Chester as a burh and before his death in 911 might have been just when the merchant church of St John was founded. This would have made it coeval with the refoundation of the minster of St Werburgh within the burh, probably by Æthelflæd; and perhaps with the almost equal and complementary division of parochial rights that can be discerned as the earliest layer of ecclesiastical arrangements in the city.[26] Alternatively Sargent has suggested a confusion of place rather than uncertainty about the protagonists. He proposes that the author of the *Annales Cestriensis* (misreading *Legraceaster* as *Legaceaster*) confused Chester with Leicester, where Wilfrid as bishop of the Middle Angles – a see created by King Æthelred in 690 or 691 – had his seat, in an attempt to account for the origins of St John's as an episcopal church.[27]

St John's is otherwise first documented in connexion with King Edgar's famous visit to Chester in 973; and then in the mid-eleventh century as one of many senior Mercian churches that were patronised by Earl Leofric of Mercia and his wife Godgifu.[28] At the Conquest it was a

collegiate foundation with a dean and seven canons, who occupied eight houses exempt from customary dues; and it was situated on the small but important Lichfield episcopal manor called 'Redclif' and briefly, between 1075 and about 1087, it became the principal church of the diocese, before the see moved again to Coventry.[29]

There is little doubt that a significant factor in the attraction of an early date for St John's has been the church's proximity to the site of Chester's Roman amphitheatre. That conjuncture raises the possibility of attractive if otherwise unsubstantiated parallels with continental examples of a similar linkage, where early churches mark the site of a Christian martyrdom and a continuity of ecclesiastical presence from late Roman times.[30] Contrariwise, the pre-Conquest collegiate foundation at St John's matches in type and purpose Lichfield's collegiate foundation in Shrewsbury in the church of St Chad, staffed at Domesday by sixteen canons.[31] Indeed, Gem has seen the role of St John in the eleventh and twelfth centuries, aside from its brief service as the bishop's seat, as the mother church of the northern part of the diocese and comparable with the eleventh-century 'sub-cathedral' institutions created at Southwell, Beverley and Ripon in the diocese of York by late Saxon archbishops.[32] These York foundations colonised relatively minor churches in the ecclesiastical hierarchy; by contrast, St Chad at Shrewsbury is understood to have been an early minster church, and St Mary's church there, which also became collegiate, affords a more plausible candidate for a merchants' church, both from its location and its associated early sculpture.[33]

A more striking parallel to St John's Chester is offered by another church with an 'exceptional' collection of late Anglo-Saxon sculpture, St Mary the Great situated near the merchants' strand at Thetford. Like St John's, it was deemed fit to host the East Anglian see between 1071 and 1094, in transit from Elmham to Norwich, and subsequently to become a monastic foundation.[34] There is, nevertheless, no archaeological sign that St Mary the Great dates from any earlier than the tenth century.

The putative strand or hard at Chester is now occupied by The Groves. The weir below it is now the tidal head of the Dee (Fig. 16.3), and because of the geomorphology must always have been so. For the late Saxon trading strand to have functioned as we envisage, as the port of Chester accessible via the estuary from the open sea, then this barrier must have been negotiable on at least a part-time and predictable basis with the normal full tide.

This location, where the river debouched through the sandstone gorge into the large tidal basin that is now Chester's Roodee,[35] seems likely to have been a numinous place since prehistoric times, especially given the sacred status accorded the river itself. It remains a distinctive spot despite the reduction of the land to either side by extensive stone quarrying. Those intrusions into a numinous location are strikingly acknowledged by the famous early Roman shrine fashioned in the quarry face at Edgar's Fields on the south side of the river gorge (Fig. 16.5). Its carved tutelary figure is identified by its attendant owl as Minerva, *qua* Pallas Athene, and thought to acknowledge her patronage of skilled craftsmen, here quarrymen and masons.[36] But the deity, equipped with helmet, shield and spear in the war-like mode that is one of her core attributes, arguably represents the *genius loci* whose disturbed presence needed acknowledging and placating. In a form of naming that was a pre-Roman, pan-Celtic phenomenon, the river-name itself means 'goddess', and it gave the name *Deva* to Roman Chester. The Dee was also equated with the early Welsh war goddess, *Aerfen*, and even in the medieval period its behaviour was taken to presage the outcome of planned conflict.[37] In the circumstances, it is tempting to suggest that the unusual Roman building, with its odd associations, set high on the north side of the gorge, was part of a temple complex, rather than the *mansio* it is traditionally interpreted as.[38] Before the medieval configuration of bridge, mills and weir, there was probably some form of bar in the river at this location: 'a rocky natural feature underlying the man-made causeway or weir constructed just upstream from the Dee bridge no later than the 1090s'.[39]

The very extensive Roman port facilities, which were vital both to Chester's function as a military base and as a civil urban settlement, were situated below the gorge, lining the east side of the Roodee basin.[40] A massive masonry revetment that has traditionally been interpreted as the Roman quay wall can still be seen within the curtilage of the modern racecourse occupying the Roodee. Repeated and quite extensive excavations in the sector of the Roman suburbs between it and the city walls have revealed distinctive types of storage buildings and evidence of individuals and artefacts indicating wide-ranging trading contacts.[41] This area, however, was equally clearly not a base for early medieval trading, which required quite different facilities: strands rather than quays.[42] Rather, important investigations into relative sea levels through time have documented significant variation in sea levels in the Irish Sea basin and its major river estuaries – including the Dee – in the post-Roman period, with a marked rise from the seventh century to a peak in the later pre-Conquest era and a fall again from the thirteenth century to the present day.[43] Those falls in sea level led to well-documented, gradual impacts on the viability of Chester as a sea port in later medieval times, to the development of successively more distant down-stream alternatives at Portpool, Little Neston and Parkgate, to the silting and reclamation of the Roodee, and to major engineering and expenditure on canalising the lower reaches of the river.[44] But the early medieval sea rise, coupled with the loss of the Roman bridge serving the main road from Chester south and standing at approximately the point where its medieval successor stands, opened up the

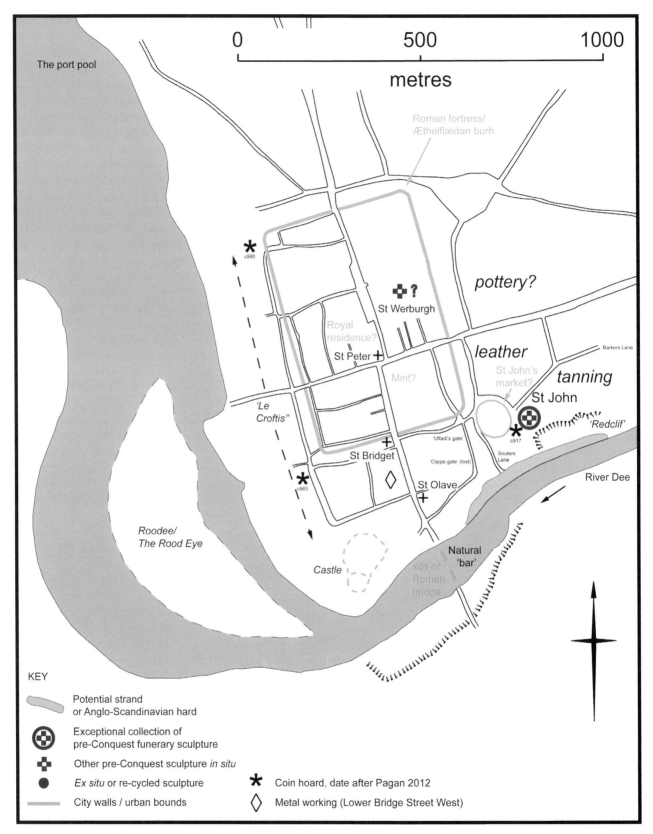

Fig. 16.4 Map showing evidence for later pre-Conquest marketing and manufacturing – outside the Roman enceinte/burh containing royal minster, mint and (unlocated) royal residence – in relation to the Dee strand and St John's church in Chester (Drawing: P. Everson, based on Sylvester & Nulty 1958, 51)

possibility of riverside landing facilities of a sort typical of the age actually further upstream and above the gorge: at the strand below St John's. The Roman bridge's survival is often presumed; but, as the VCH editors laconically note, its fate after the Roman army left Chester is uncertain. In similar circumstances, when addressing the same uncertainty about the Roman bridge over the Witham at Lincoln, modern scholarly consensus is that it did not survive, and the circumstance that both bridges were probably of the same standard Roman construction of a timber superstructure on masonry piers adds to the likelihood that they would have been lost without regular maintenance.[45] At Chester, the road south via the important settlement at Heronbridge was completely lost. The burden of bridge repair in 1066 – and presumptively for its construction? – lay with the shire as a whole; and, as at Lincoln, the sequence of medieval bridges seems to have been positioned just off line from the Roman one.[46]

This combination of circumstances – a strand and associated church, a natural bar at the river's outfall and tidal sea-levels sufficient to allow passage across that bar – gives a point and a context which has hitherto been unexplored, we suggest, to the most famous incident of Chester's early medieval history: Edgar's rowing on the Dee in 973. The extent to which it represented an act of submission by neighbouring rulers has been much discussed, and it has been noted that Chester's Roman past was a significant factor in the choice of venue in Edgar's imperial style of overlordship.[47] In brief, the sources are the spare primary account of the D and E texts of the *Anglo-Saxon Chronicle* stating that Edgar went with naval force to Chester, where six kings met him and 'with him they all pledged that they would be co-operators on sea and on land';[48] a generation later, Ælfric recalled the same event with extra details to the effect that 'all the kings of the Welsh and Scots who were in this island came to Edgar – once, on one and the same day, eight kings together – and they submitted to Edgar's rule'.[49] In the twelfth century John of Worcester gives the detail and colour that have made the incident memorable: naming the eight kings and – in a Latin version of the Chronicle account – noting their oath to be loyal to Edgar and to co-operate with him by land and sea, he adds that 'With them, on a certain day, he boarded a skiff; having set them to the oars, and having taken the helm himself, he skilfully steered it through the course [*recte* 'flow' or 'current'] of the river Dee, and with a crowd of ealdormen and nobles following in a similar boat, sailed from the palace to the monastery of St John Baptist. Having prayed there, he returned with the same pomp to the palace'.[50]

The later chroniclers presented this event as a triumph for Edgar intended to demonstrate his power and superiority over neighbouring rulers; but they, as Barrow has shrewdly pointed out, were Benedictine monks interested in lauding their patron and hero.[51] Nevertheless that simplistic agenda of 'submission' has held sway in modern scholarship until quite recently, when subtler, more nuanced understandings

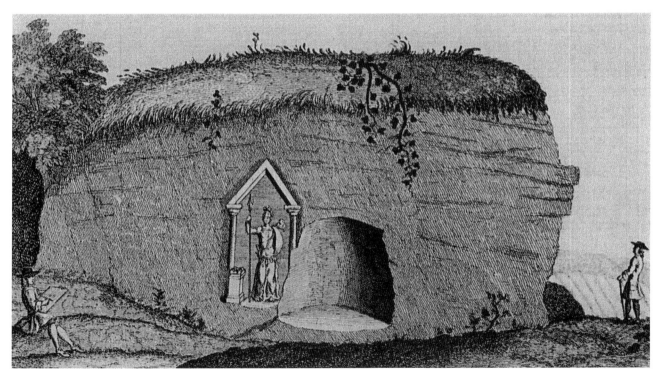

Fig. 16.5 The shrine of Minerva found in the Roman quarry in Handbridge, drawn and engraved by William Stukeley in 1725 (Stukeley 1776, pl. 67)

have emerged. The language (the words and phrases) deployed in the Chronicle account are the diplomatic standard for such contacts: there are echoes of Æthelstan's meeting with his northern and western neighbours at Eamont Bridge in 927 and both events resemble the 'submission' of the northern kings to Edward the Elder on the Pennine borders of York and Mercia in 920.[52] These were diplomatic events, designed at one level to settle spheres of interest. Characteristically they took place on borders, because there the parties – though actually unequal in power or in setting the agenda – were symbolically co-operating equals. Citing Roman, Carolingian and Ottonian instances of diplomatic meetings on boundary rivers, often on islands in, or boats on, the river – in traditions to which the Wessex kings aspired in constructing their public rituals – Julia Barrow has suggested that Chester was the chosen locale in 973 because it was generally a neutral, boundary location for the parties involved.[53] Molyneaux has gone further, tracing the extended history of such contacts and the language of titles and status surrounding them, characterising thereby a difference between 'intensive' rule and 'extensive' overlordship.[54]

It is not principally as a diplomatic event, however, that the Chester meeting is best understood or its location and details explained. Not uncommonly, such occasions had a more specific and short-term agenda woven into them. At Eamont Bridge, for example, the parties renounced all idol-worship (*deofolgeld*), presumably in response to a proposition by Æthelstan. No such agenda is explicitly recorded at Chester; but the event, as the VCH editors wisely hint, has a strong maritime flavour.[55] Edgar came with his fleet, his *sciphere* or *scipfyrd*, which is known to have been a formidable mercenary force.[56] Unless, with Matthews,[57] we set aside the straightforward sense of John of Worcester's account, he sailed around the west coast of Wales and arrived at Chester by sea; and presumably the fleet anchored in the Roodee basin. Work on the names of the eight kings listed has identified two of them – Juchil or Judethil and Huual or Hywel – as likely to have been local rulers in Brittany, whom the Wessex dynasty had patronised and supported; scarcely 'kings', they may in fact have travelled with Edgar as part of his entourage in a client relationship, but they were also practical examples of the king's maritime reach and the benefits of co-operation with him.[58] The others have variously been identified as Kenneth, king of Scots, Iago, king of Gwynedd; Maccus, son of Harold, ruler of Man and the Isles, and perhaps his brother Siferth or Giferth; Dyyfnal (alternatively Dunmail or Donald), king of Strathclyde, and Malcolm his son and heir.[59] What is striking is that the spheres of interest of this group, set alongside Edgar's own, embrace the Irish Sea on its northern, eastern and southern sides (Fig. 16.6). Strikingly, too, such mapping also correlates rather closely with the main distribution of coinage of the Chester mint, which was so prolific in

the tenth century.[60] This strongly suggests that the main purpose of the Chester meeting was a trade negotiation between equals, to which Edgar brought evidence of his naval muscle, and, by staging it there, displayed Chester's favourable facilities as a regional centre of trade and his commitment to afford that trade his royal protection. No doubt the reform of the English coinage, which Edgar instituted the same year as the meeting at Chester with the intention of establishing an unprecedented control on the quality and volume of coin in circulation, was also on the agenda, with Edgar guaranteeing the new coinage as a medium of trade in the market under his protection.[61] After 973 the already prolific Chester mint, which featured an exceptionally large number of moneyers with Scandinavian and Gaelic names, switched to the reformed coinage and again featured a similar mix in its moneyers' names before the Conquest. The facts that the numbers of moneyers fell from over twenty to five, and dies continued to be issued from Winchester even when most other mints had recovered the privilege of making their own, have been taken as signals of Chester's coin production not having the consistency or independence that might have been expected of a major trading centre, even of a 'recession' in Chester's trading development.[62] But might it not rather indicate the measure of supervision and control by the Wessex kings of England over their important, distant north-western outpost of trade and influence: a control established so memorably and with such style in 973? A century later Domesday Book reveals Chester as a lively trading entrepôt, if battered by the immediate impact of conquest; and with royal interests, ceded pragmatically to a new line of earls.[63]

Both the nature of such meetings as that at Chester in 973 and its principal documented aspects, then, suggest that its prime purpose was to promote a joint trading commitment among the principal Irish Sea parties whom Edgar could influence (i.e., excepting the Dublin Norse), with Chester – under the protection of the English king – as its focal trading place. Edgar's initiative no doubt sought to reinforce Chester merchants' exploitation or supplanting of trade that used long-established 'traditional' beach sites around the Irish Sea margins, such as that at Meols.[64] The commercial interrelationship to which the parties committed in 973 would focus here, where the mint was, and where English royal authority had been vested since the start of the century in the burghal enclosure. Edgar's own land grants to St Werburgh's, in 958, had enhanced his position as 'King of the Mercians', in an exceptional step that perhaps recognised Chester's developing commercial importance.[65] Meols, where activity increased markedly in the tenth century and especially post-973 through the eleventh century, must have formed part of these developments, but perhaps not in the way traditionally conceived. As noted above, St Bridget's church at West Kirby has an 'exceptional' collection of sculpture in its own right, by the same definition as St John's

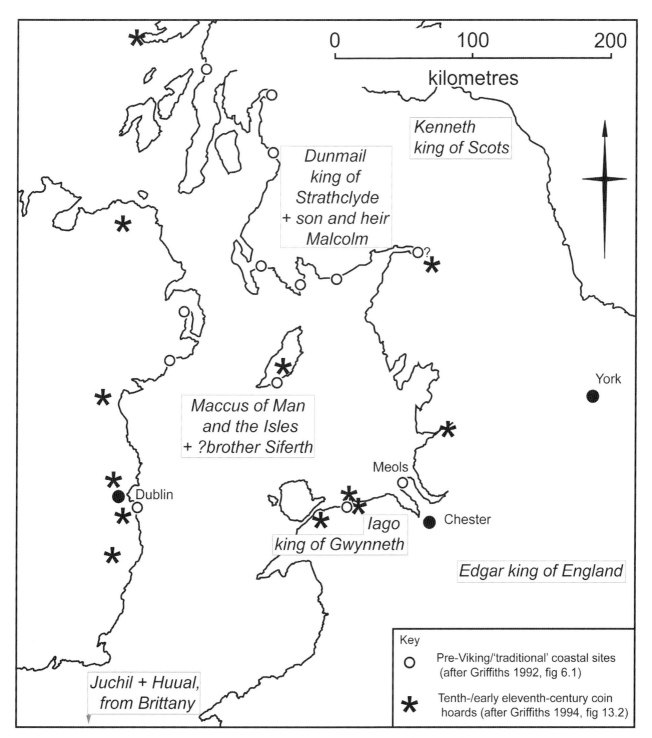

Fig. 16.6 Irish Sea maritime province, with 'traditional' coastal trading sites (after Griffiths 1994, fig. 13.2); later pre-Conquest coin-hoard distribution; and 'kings' identified at the Dee regatta (Drawing: P. Everson)

Chester does. In British Academy Corpus terms, it numbers five main catalogue pieces and a further three Appendix A items, all of tenth- or eleventh-century date: grave-markers and -covers, the monuments of individuals. The collection might be thought to include several items of similar forms and date from Hilbre Island, just off-shore from West

Kirby, where (though remote from the parish graveyard) they perhaps marked contemporary burials located on the prominent headland that, as the sea-mark at the mouth of the Dee estuary, was of particular significance to seafaring traders.[66] The trading strand of West Kirby was presumably the lost bay of Hoylake, which is well documented as an

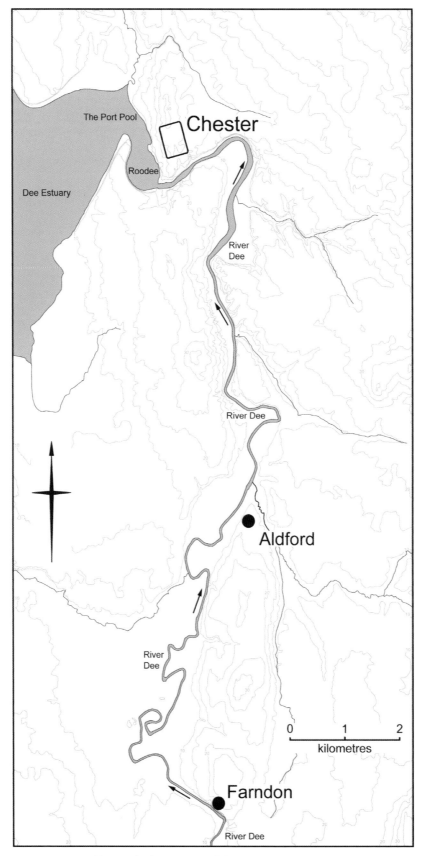

Fig. 16.7 Chester, the lower Dee and the estuary (Drawing: P. Everson)

established port of embarkation to Dublin, and the sands at Meols; both places being townships (as Little and Great Meols and Hoose) within the parish of West Kirby. The relationship between a church set back from the sea and elevated above an extensive beaching place is reminiscent of Lythe on the North Yorkshire coast and its beaching place at Sandsend Wyke.[67] What was the relationship of this north-west Wirral beach market to late pre-Conquest Chester? On the one hand, Meols has been contrasted with Chester in being considered a 'free-port', without any supervising authority, principally on the grounds that it lay outside the port of Chester's jurisdiction – considered ancient in 1354 – whose defining limit was the rocks of Arnald's Eye;[68] on the other, defined as a place under the supervision of West Kirby, it might be thought to lie topographically *within* Chester port's jurisdiction so defined, if that was relevantly ancient. More obviously, its sculpture demonstrates a clear connexion with Chester, notably in the occurrence of

Chester-type circle-headed markers at both West Kirby and Hilbre Island, as well as a hogback in a non-local stone, evidently from North Wales, which plausibly signals an alien merchant from one of the partner regions represented at 'the rowing'.[69] A tenurial interest of the king and earl is indicated by the record that West Kirby was held immediately after the Conquest by Robert of Rhuddlan, cousin of Earl Hugh, his leading tenant in Cheshire and his 'governor of the whole province'. Furthermore, Robert singled out West Kirby, its church and its associated chapel at Hilbre to grant to the abbey church of Saint-Evroul in their native Lower Normandy, in a grant confirmed by William I in 1081. This post-Conquest alien cell on Hilbre Island was transferred to St Werburgh Chester in the mid-twelfth century – perhaps recalling an earlier link – with the result that Hilbre remains ecclesiastically attached to St Oswald Chester.[70] With this evidence of links, the role of this trading place might rather have been as an 'out-port', with a relationship to Chester

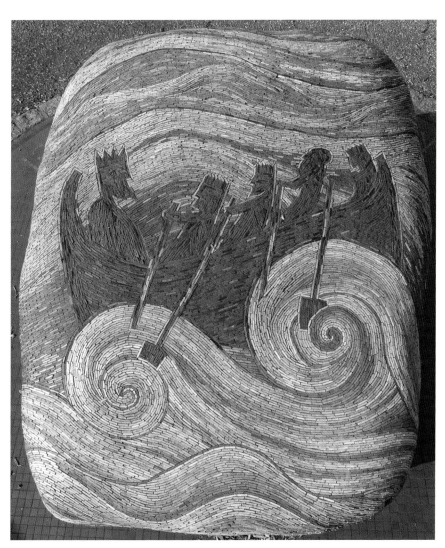

Fig. 16.8 Mosaic image of Edgar and the kings crossing the bar; modern public art in Edgar's Field Park, Chester (Photo: P. Everson)

analogous to that better documented for Torksey vis-à-vis Lincoln, and under the control of the king or earl.[71] The late medieval poetic tale of the twelfth-century constable of Chester Castle who, being unable to sail from Chester for North Wales because of adverse conditions on the Dee and its estuary, rushed with his force to Hilbre in order to do so, not only shows that he anticipated there being shipping there to commandeer in the earl's name, but also reveals the route from Chester to have been reckoned 'a royal road … night and day'.[72] The absence of Chester coinage of the period prior to 973 from the Meols collection, but its frequency afterwards, might even suggest that a negotiated trading arrangement such as we have envisaged stimulated a switch from a 'free-port' to an 'out-port'. Whatever the relationship between the Hiberno-Norse of the north Wirral and the Mercian and West Saxon kings in the period *c*. 910–*c*. 970, it changed markedly at the moment of the regatta. While the waterside facilities at Parkgate are better documented much later, the same mutually advantageous stimulus perhaps lay behind the exceptional funerary collection at Neston, half way to the open sea from Chester and overlooking an earlier strand within the estuary.[73]

We wish, furthermore, to propose that the best evidence that the purpose of the 973 meeting of parties was fundamentally commercial is to be found in the topographical detail of the show-piece incident that fixed in the chroniclers' memory: the rowing on the Dee. It has been described, and dismissed, as theatrical and a piece of improbable showmanship.[74] And indeed, whilst each modern reassessment that has accepted it as an authentic occurrence has brought out important points, no account has yet explained why a waterborne event with the characteristics reported was organised as the emblematic focus of Edgar's negotiations at Chester, or in what ways it was so appropriate to the moment that it became their most persistent image. Whether (as the chroniclers variously report) as pilot in a seat in the prow, or as *gubernator* at the rudder in the stern, the tableau presented Edgar as both leader and governor, both collaborating with, and distinguished from, the eminent oarsmen in their joint venture. Some have, with Thornton, been inclined to dismiss the whole account as late invention, rendered implausible by its failure to fit the local topography, since it plainly implies a transit from the southern end of the gorge, over the natural bar marked by the later weir and so to St John's.[75] The alternative suggestion is that John of Worcester describes a journey from a palace at Farndon, where King Edward the Elder had died in 924. But Farndon lies ten miles above St John's, along a winding river (Fig. 16.7), and such a journey, also necessitating a hard slog back against the stream, is implausible.[76] Out of public view, this voyage would have minimal symbolic content or memorable impact, and does not easily correlate with Worcester's description. Thornton is clearly correct in thinking that John of Worcester's end-

points of the rowing transit were defined in anachronistic twelfth-century terms: the 'palatium' being the castle, just as the 'abbey' of St John was the earlier, non-monastic church.[77] In this case the distance travelled would have been as little as five or six hundred metres, but the passage was full of symbolic significance: passing from the upper reach of the tidal estuary in Roodee pool, through the narrow curving sandstone gorge to the point where the estuarine waters met the sacred river. Indeed we might ask whether it was not replicating a traditional ritual journey; the successor, perhaps, to journeys made by generations of priest-kings in this place, communing with the river deity since pre-Roman times. As envisaged above, however, it required a rising tide to cross the natural bar, and even then the mingling waters probably caused a turbulence that marked the numinous spot of the river's outfall where the waters appeared to stand still (Fig. 16.8). Here Edgar's skilful helmsmanship came into play, combined with the strenuous co-operation of the oarsmen – the whole combining in an image of successful waterborne triumph over adversities, under effective direction. Furthermore, Edgar's successful negotiation with the river deity might have been seen by contemporaries not just as a feat of navigation, with commercial consequences, but also as a Christian 'appropriation' of the river deity. Their destination was the ample strand and safe beaching facilities overseen by the merchants' church that gave explicitly Christian oversight to the marketing activity. Edgar's prayers in the church aligned that divine protection with his own. The return was an easier downstream transit, perhaps with the main concern being adequate depth of water on an ebbing tide, so that Edgar took a pilot's place in the prow.

All this is slightly fanciful in detail; but it perhaps indicates how Edgar's rowing on the Dee could stand as a potent image and celebration of an Irish Sea trade agreement, focussed on the distinctive features – both practical and symbolic – of the contemporary port of Chester. What better way to symbolise this than a public show of co-operation by the kings standing in for and, giving a lead to, their people? Seen in this way, it truly qualifies as a 'form of demonstrative behaviour employed to underline political transactions and decisions'.[78] As such a ritual, it exploited an anciently numinous location and engaged with the river's reputation as pre-Christian goddess, whose current and power and dangers were skilfully negotiated. This *numen* had been formally Christianised by the foundation of St John's church upstream, and perhaps by the cross on an island – the Roodee – downstream of it. Perhaps the latter also featured, like St John's, in the arrangements we have outlined: it may have stood as a marker of the turn into the gorge giving access to the bar and the strand beyond, and perhaps it also functioned as an indicator of the state of the tide (was safe passage over the bar possible when the island was covered, for example?).[79] Having returned

safely from St John's and the strand, the righteous king of Wessex had cemented himself in the on-lookers' minds not just as a notable patron of Chester, but as guarantor of Chester's international trading facilities.[80]

In summary, our suggestion – prompted by the similarity of the 'exceptional' collection of pre-Conquest sculpture at St John's Chester to collections in churches overseeing trading places up and down eastern England – is that St John's should also be considered as a merchants' church associated with a riverside strand or hard on the north bank of the Dee below it and perhaps with a marketing space in the ruined Roman amphitheatre alongside it. This suggestion alters our thinking somewhat about the layout of the tenth-century city and it may offer some explanation for why direct archaeological evidence of the commercial re-growth of the city at this time has been so remarkably sparse:[81] the trading focus for that short period, exceptionally in Chester's history, lay away from the Roman fortress enclosure and away even from the established main access roads. This new focus, we suggest, was enabled by rising sea levels allowing access to the lower reaches of the Dee, above the natural bar at the river's outfall; it provided ample beaching and marketing facilities of a type familiar throughout the maritime regions of north-west Europe at this time and common certainly in eastern England. The bar at the river's outfall, in making the strand accessible only tidally, perhaps also provided an element of security and protection against casual piratical raids that was an asset in a still-uncertain era. Characteristically, too, the trading site featured a church to provide regulation of marketing activity, a cure of souls and a place of burial, which for the better-off merchant was marked by funerary monuments of a standardised and appropriately middling sort. Finally, the distinctive identity of the individuals commemorated by these memorials was indicated not just by the fact that they marked their graves with stone markers (at a time when this would have distinguished them from most other burials in the graveyard), but also through the distant associations of both the monument forms and the style of the sculpture with which they were decorated. These monument forms and art styles associated their obsequies with far-off places: Bailey cites parallels for various details extending from the putative nearby trading sites on the Wirral and Maen Achwyfan (Whitford) and Dyserth (both Flintshire), to the Isle of Man, the Solway basin, County Durham, Yorkshire (including York itself), Worcestershire, Gloucestershire, Somerset and Cornwall.[82] Though we cannot now explain the monuments' semiotics in detail, their decoration indicated that their owners were not only distinct in status and practice from their contemporary Cestrians, but that they belonged to a much wider, more mobile, community.

The 'exceptional' collection of sculpture at St John's, then, helps us to understand the character, location and importance of Chester's tenth-century trading heartland. Edgar's voyage on the Dee in 973 can be read as a very public confirmation of his intention both to establish Chester's market as a commercial hub for Irish Sea trade, to service that market with his reformed coinage, and to protect its alien traders as overlord of the city. Representing Chester's early merchant community, we propose that St John's 'exceptional' collection of monuments offers confirmation that Edgar's trade initiative was so much more than a whimsical regatta.

Envoi

All recently involved in the study of stones from the Anglo-Saxon period have benefited from Richard Bailey's constant presence, guiding and inspiring us to greater efforts. Both authors here experienced his wisdom as a teacher and it was at least partly through this shared interest, instilled in us both by Richard, that some thirty years ago we first started working and writing together. We have gone on to collaborate on projects ranging from the prehistoric period to the twentieth century and to explore topics from rural settlement to Renaissance painting, but in all our work together we have never been without an Anglo-Saxon sculpture project; and that enduring interest has continued to be stimulated by Richard's work. In the past we have been both flattered and further encouraged by Richard's responses to the distinctively archaeological approach we adopted in our studies of early sculpture, so one of our jointly authored papers has been offered here in Richard's honour. Typically, perhaps, it opens with a collection of pre-Conquest sculpture that he knows very well; but, not content with mere description and dating, following Richard's example we have sought additionally to locate its significance in a wider topographical, cultural and historical context, tying together other work, and offering alternative understandings of a diverse range of evidence. We know that Richard enjoys observing such activity, and that sometimes he even identifies with it.

Acknowledgements

Academic lectures stand at the beginning and end of this piece's development: first to the archaeological research seminar at the University of Chester in 2012 and secondly to the Society for Church Archaeology's conference at Chester in 2014. We are grateful respectively to Professor Howard Williams and to Dr Michael Shapland for the relevant invitations. We have benefited notably, too, from the interest and generous advice of Drs Gill Chitty, Alan Thacker and Richard Gem at different stages; and we are particularly indebted to Professor Julia Barrow for sight of sections of her then forthcoming book on secular clergy.[83]

Notes

1 Bailey 2010, 62–9, 151.

2 Ibid., 69–70 (Chester City Walls 1, and Chester Roman Amphitheatre 1).

3 Ibid., 27, 33, 70–2 (Chester Unknown Provenance 1 and 2).

4 Ibid., 39–40.

5 Everson & Stocker 1999; Stocker & Everson 2001.

6 For commerce and mint, see e.g. Dolley 1955; Thacker 1988; Ward 2001; Lewis & Thacker 2003, 17, 20–2. For these aspects of St John's, see Thacker 1982, 200–1; 2000; Blair 2005, 357, citing Darlington & McGurk 1995, 582–3.

7 Stocker 2000; Everson & Stocker 1999; 2015; see also Stocker 2013. For a consideration and definition of what might be considered 'exceptional' in such cases, see Stocker 2000, 183 and n. 2.

8 Bailey & Whalley 2006.

9 E.g. Wilmott et al. 2006, 14, 17.

10 Dodgson 1981, 77; Lewis & Thacker 2003, 215.

11 Lewis & Thacker 2005, Fig. 72; there was also a (lost) *Paynes Lode*, 'a gayte that goeth downe to the water of Dee', Dodgson 1981, 55–6.

12 Wilmott et al. 2006, 13–15; Pagan 2012, no. 270.

13 Hughes 1864; Mack 1967; Pagan 2012, 16–17; Vince 1991, 335, 340.

14 Blunt et al. 1989, 51–2, Pls 4, 14–21, 27. The association between the early memorial coinages and markets has been explored recently in Stocker 2013.

15 Lewis & Thacker 2003, 29–30; compare Strickland 1988, especially 110.

16 www.pastscape.org.uk (Accessed 8 March 2014). For example, at Lucca the arena of the amphitheatre became 'Piazza del Mercato', with shops developing in the Middle Ages in the *cavea*, which fossilised the structure in the street plan, and other examples.

17 Everson & Stocker 2015.

18 Carrington 1975; Wallace 1986; 1987; Lewis & Thacker 2003, 25, 30, 52.

19 Mason 1985; 2007, 100–8; Thacker 1987, 287.

20 Dodgson 1968, 50–3.

21 Thacker 1982, 200–1; 2000; Lewis & Thacker 2005, 125; Bailey 2010, 7.

22 Christie 1887, 11; Hawkins 1848, 86.

23 Thacker 1982, 200.

24 www.pase.ac.uk (Accessed 8 March 2014).

25 www.pase.ac.uk 'Æthelred 1' (Accessed 8 March 2014).

26 E.g. Alldridge 1981, especially 11–17; Lewis 2008, 114–15.

27 Sargent 2012, 239; see Thacker 1982, 200, n. 12.

28 Darlington & McGurk 1995, 424–5, 582–3.

29 Sawyer & Thacker 1987, 302–3, 343–4; Lewis & Thacker 2005, 125–33, 324; Gem 2000. 'Redclif' was assessed at only two-thirds of a hide, as compared with the bishop's four hides at Farndon or six at Tarvin, but he enjoyed valuable customary dues and other assets in Chester, which made it the diocese's most important Cheshire holding.

30 E.g. Matthews S. 2000–1, 73; Matthews K. 2003; Wilmott et al. 2006, 13; but the idea seems to originate in Thacker 1982, 200–1.

31 Barrow 2015, 277-8; Baker 2010, 86–7, 90–1, 94–5, 211–12.

32 Gem 2000, 32; for a discussion of this process in York's archdiocese and the buildings it created, see Everson & Stocker forthcoming.

33 Baker 2010, 92–4, 115–16, 211–12; Bryant 2012, 309–11.

34 Everson & Stocker 2015.

35 OE *rōd* (cross) + OE *ēg* (island, water-meadow): Dodgson 1981, 62–3.

36 Henig 2004, 5, Pl. 5.

37 Rivet & Smith 1979, 336–7; Dodgson 1970, 21–2; Nicolaisen 1997. Semple (2010, 30–3) anticipates 'watery' ritual deposits in the Roodee, but we suggest that the rituality of the place was more specifically focussed on the gorge itself – see below, 172–3.

38 Mason 1980; 2001, 108–9, 205–7. There is an inscribed altar to Minerva, decorated with sacrificial weapons and ritual vessels, from the southern part of the city, Henig 2004, 5–6, pl. 7.

39 Lewis & Thacker 2005, 1–2.

40 Mason 2001, 111–17; Waddelove 2001.

41 Ward 2012.

42 Milne & Hobley 1981; McGrail 1985; Hodges & Hobley 1988.

43 Tooley 1980; for a helpful digest and modelling for the Dee, see Ward 1996.

44 Lewis & Thacker 2005, 83–7; Reid 2007–8 for convenient recent summaries; Lewis & Thacker 2005, 1–2, 255–60 for the reclamation of the Roodee.

45 Jones et al. 2003, *passim* (esp. RAZ text 9.15). For the form of these bridges, see Strickland 1988, 113–14 and Lewis 2012.

46 Lewis & Thacker 2005, 76–7; Mason 2003.

47 For recent substantial comment see, e.g. Barrow 2001; Thornton 2001; Lewis & Thacker 2003, 22–3; Williams 2004a; 2004b; Matthews 2007; Breeze 2007; Woolf 2007, 207–9; Keynes 2008, 48–51; Matthews 2009; Molyneaux 2011, esp. 66–8.

48 D text: 7 þær him common ongean .vi. cyningas, 7 ealle wið him getreowsodon þæt hi woldon efen wyrhtan beon on sæ 7 on lande (Cubbin 1996, 96); E text: 7 sona æfter þam se cynig geleadde ealle his sciphere to Lægeceastre, 7 þær him common ongan .vi. cyningas, 7 ealle wið trywsodon þet hi woldon efenwyhton beon on sæ 7 on lande (Irvine 2004, 59); trans. Whitelock et al. 1961, 76.

49 Ælfric, XXI *Natale Sancti Swyðuni Episcopi*, lines 450–3: and ealle ða cyningas þe on þysum iglande wæron cumera and scotta common to eadgare hwilon anes dæges eahta cyningas and hi ealle gebugon to eadgares wissunge (Skeat 1881–1900, 469); Lapidge 2003, 606–7; Williams 2004a, 230 translates the final word as 'direction'.

50 Cum quibus die quadam scapham ascendit, illisque ad remos locatis, ipse clauum gubernaculi arripiens, eam per cursum fluminis de perite gubernauit, omnique turba ducum et procerum, simili nauigio comitante, a palatio ad monasterium sancti Iohannis baptiste nauigauit (Darlington & McGurk 1995, 422–5); William of Malmesbury similarly names the eight kings but figures Edgar as sitting in the prow of the vessel, Mynors et al. 1998, 238–41.

51 Barrow 2001, 89–93.

52 See Davidson 2001.

53 Barrow 2001.

54 Molyneaux 2011.

55 Lewis & Thacker 2003, 23.

56 Hooper 1989; Jayakumar 2001.

57 Matthews 2007, 17–20.

58 Breeze 2007.

59 Thornton 2001; Williams 2004a; Woolf 2007, 207–9; Charles-Edwards 2013, 543–5.

60 Griffiths 1994, especially Fig. 13.2; Pagan 2012.

61 Jonsson 1987; Thacker 1988, 123 notes the complete absence of portrait heads from Chester issues and suggests that it represents a concession to Norse preferences in the interest of promoting the city's Irish Sea trade.

62 Dolley & Pirie 1964; Griffiths 1994, 127–8; Lewis & Thacker 2003, 20–2.

63 Ibid., 24–5.

64 Griffiths et al. 2007, esp. 399–406; and see Griffiths 1992; Graham-Campbell 1998.

65 Lewis 2008. Edgar might have had Chester, 'the crossroads of the British Isles', in mind when he legislated – perhaps in the 970s – that measures for the organisation of sworn witnesses to supervise buying and selling were to be 'gemæne eallum leodscype, ægðer ge Englum ge Denum ge Bryttum, on ælcum ende mines anwealdes', that is 'common to the whole people, whether Englishmen or Danes or Britons, in every part of my dominion': Robertson 1925, 32; Wormald 1999, 318 (trans.), 148, 442 (date).

66 Bailey 2010, 81-2 (Hilbre Island), 133–6, 145–6 (West Kirby).

67 For the parish and its components, see Brownbill 1928, 1–6; Dodgson 1972, 282–305; for Hoylake and the evolution of the western end of the north Wirral coast, see Griffiths et al. 2007, 11–24, 355–71, 373–9, 406–11; for Lythe, Stocker 2000, 200–3, fig. 9.

68 The proposition is explored most fully in Griffiths et al. 2007, especially 406, 412–20, 433.

69 Bailey 2010, 31–3, 38.

70 Brownbill 1928, 87–9; Sawyer & Thacker 1987, 307–8, Robert was Hugh's man-in-charge in Cheshire 'princeps militiae eius et totius provinciae gubernator'; Griffiths et al. 2007, 369–71.

71 Sawyer 1998, 183–4, 196–7.

72 Hume 1863, 27 and Brownbill 1928, 29–30, both quoting Bradshaw's verse life of St Werburgh, see Horstmann 1887, 180 line 1441; it was alternatively *le Porteswaye*, Dodgson 1970, 39.

73 Bailey 2010, 85–90; Place 1996; Hartwell et al. 2011, 501, 522–3.

74 For example, Thornton 2001, 74–9; Matthews S. 2009.

75 Thornton 2001.

76 Dodgson 1972, 73–5; Bu'Lock 1972, 55; even if the royal *tun* was at Aldford, as has been suggested, that is rather more than half way.

77 Since the tenth-century *palatium* must surely have been within the Roman enclosure, the royal party perhaps exited and returned via the Westgate and took to the water on the Roodee pool, using the Roodee cross as the sea-marker and guide to the state of the tide, as suggested below.

78 Barrow 2001, 82. The formal, processional aspect of this performance at Chester – both by land and water – no doubt deserves more attention. Processions as practised in pre-Conquest England were as much a ceremonial legacy of the late antique world as important aspects of contemporary religious practice: Gittos 2013, 103–45.

79 There was a well-documented tradition of erecting stone crosses at critical points as sea-marks in Norway in the eleventh century, see Hutchinson 1994, 170–1 citing Morcken 1969. Locally, the place-name Crossens on the Lancashire coast, meaning 'headland or promontory with crosses', refers to the promontory at the mouth of the River Ribble, with sea-marks guiding access to this important estuary, see Fellows-Jensen 1985, 118.

80 Earl Ranulph II (1129–53) acted in precisely the same way – only by written charter – in pledging his peace to all who attended, when he reorganised Chester's main midsummer fair to take place before the abbey (St Werburgh's) gate; Lewis & Thacker 2003, 29–30.

81 Ward 1994.

82 Bailey 2009; 2010, 62–73. To this list we would also add the remains of what we suspect might be an encircled cross-head at Marton, Lincolnshire, not just because of the stylistic parallel but also because we believe that it too is associated with a church built on an early strand-market, see Everson and Stocker 1999, 226–8; Stocker 2000, 190–1; Stocker and Everson 2006, 215–21.

83 Barrow 2015.

References

Alldridge, N.J., 1981 'Aspects of the Topography of Early Medieval Chester', *J. Chester Archaeological Soc.* 64, 5–31

Bailey, R.N., 2009 'The Sculptural Background' in J. Graham-Campbell & R. Philpott (ed.), *The Huxley Viking Hoard: Scandinavian Settlement in the North West* (Liverpool), pp 24–8

Bailey, R.N., 2010 *Cheshire and Lancashire*, CASSS 9 (Oxford)

Bailey, R.N. & Whalley, J., 2006 'A Miniature Viking-age Hogback from the Wirral', *Antiquaries J.* 86, 345–56

Baker, N., 2010 *Shrewsbury. An Archaeological Assessment of an English Border Town* (Oxford)

Barrow, J., 2001 'Chester's Earliest Regatta? Edgar's Dee-Rowing Revisited', *Early Medieval Europe* 10, 81–93

Barrow, J., 2015 *The Clergy in the Medieval World: Secular Clerics, their Families and Careers in North-Western Europe c.800–c.1200* (Cambridge)

Blair, J., 2005 *The Church in Anglo-Saxon Society* (Oxford)

Blunt, C.E., Stewart, B.H.I.H. & Lyon, C.S.S., 1989 *Coinage in Tenth-Century England* (Oxford)

Breeze, A., 2007 'Edgar at Chester in 973: A Breton Link?', *Northern History* 44, 153–7

Brownbill, J., 1928 *West Kirby and Hilbre: a Parochial History* (Liverpool)

Bryant, R., 2012 *The Western Midlands. Gloucestershire, Herefordshire, Shropshire, Warwickshire and Worcestershire*, CASSS 10 (Oxford)

Bu'Lock, J.D., 1972 *Pre-Conquest Cheshire 383–1066*, A History of Cheshire 3 (Chester)

Carrington, P., 1975 'Some Types of Late Saxon Pottery from Chester', *Cheshire Archaeological Bulletin* 3, 3–9

Charles-Edwards, T.M., 2013 *Wales and the Britons 350–1064* (Oxford)

Christie, R.C. (ed.), 1887 *Annales Cestriensis; or Chronicle of the Abbey of St Werburgh at Chester*, Record Society of Lancashire & Cheshire 14 (London)

Cubbin, G.P. (ed.), 1996 *The Anglo-Saxon Chronicle: a Collaborative Edition, 6. MS D* (Cambridge)

Darlington, R.R. & McGurk, P. (ed. & trans.), 1995 *The Chronicle of John of Worcester* 2 (Oxford)

Davidson, M.R., 2001 'The (Non)Submission of the Northern Kings in 920' in N.J. Higham & D.H. Hill (ed.), *Edward the Elder 899-924* (London), pp 200–11

Dodgson, J.McN., 1968 'Place-Names and Street-Names at Chester', *J. Chester Archaeological Soc.* 55, 29–61

Dodgson, J.McN., 1970 *The Place-Names of Cheshire Part 1. County Name, Regional- & Forest-names, River-names, Place-names of Macclesfield Hundred*, English Place-Name Society 44 (Cambridge)

Dodgson, J.McN., 1972 *The Place-Names of Cheshire Part 4. Place-names of Broxton Hundred & Wirral Hundred*, English Place-Name Society 47 (Cambridge)

Dodgson, J.McN., 1981 *The Place-Names of Cheshire Part 5 (1:i). Place-names of the City of Chester*, English Place-Name Society 48 (Cambridge)

Dolley, R.H.M., 1955 'The Mint of Chester: Part 1 Edward the Elder to Eadgar', *J. Chester and North Wales Architectural, Archaeological and Historic Soc.* 42, 1–20

Dolley, R.H.M. & Pirie, E.J., 1964 'The Repercussions on Chester's Prosperity of the Viking Descent on Cheshire in 980', *British Numismatic J.* 34, 39–44

Everson, P. & Stocker, D., 1999 *Lincolnshire*, CASSS 5 (Oxford)

Everson, P. & Stocker, D., 2015 'Erratics and Enterprise. Lincolnshire Grave-covers in Norwich and Thetford and some Implications for Urban Development in the Tenth Century' in T.A. Heslop & H. Lunnon (ed.), *Medieval Art, Architecture and Archaeology in Norwich*, BAA Conference Transactions 38 (Leeds), pp 22–43

Everson, P. & Stocker, D., forthcoming 'Archaeology and Archiepiscopal Reform. Greater Churches in York Diocese in the Eleventh Century' in D.M. Hadley & C.D. Dyer (ed.), *The Archaeology of the Eleventh Century: Continuities and Transformations*, Society for Medieval Archaeology Monograph 38 (London), pp 240–74

Fellows-Jensen, G., 1985 *Scandinavian Settlement Names in the North-West*, Navnestudier udgivet af Institut for Navneforskning no. 25 (Copenhagen)

Gem, R., 2000 'Romanesque Architecture in Chester *c.* 1075 to 1117' in A. Thacker (ed.), *Medieval Archaeology, Art and Architecture at Chester*, BAA Conference Transactions 22 (Leeds), pp 31–44

Gittos, H., 2013 *Liturgy, Architecture, and Sacred Places in Anglo-Saxon England* (Oxford)

Graham-Campbell, J., 1998 'The Early Viking Age in the Irish Sea Area' in H.B. Clarke, M. Ní Mhaonaigh & R.Ó Floinn (ed.), *Ireland and the Early Viking Age* (Dublin), pp 104–30

Griffiths, D.W., 1992 'The Coastal Trading Ports of the Irish Sea' in J. Graham-Campbell (ed.), *Viking Treasure from the North West: the Cuerdale hoard in its Context*, National Museums & Galleries on Merseyside Occasional Papers Liverpool Museum 5 (Liverpool), pp 63–72

Griffiths, D.W., 1994 'Trade and the Port of Chester' in S. Ward, *Excavations at Chester. Saxon Occupation within the Roman Fortress: Sites Excavated 1971–1981* (Chester), pp 124–8

Griffiths, D.W., Philpott, R.A. & Egan, G., 2007 *Meols: the Archaeology of the North Wirral Coast: Discoveries and Observations in the 19th and 20th Centuries, with a Catalogue of Collections*, Oxford School of Archaeology Monograph 68 (Oxford)

Harris, B.E. & Thacker, A.T. (ed.) 1987 VCH: *Cheshire* 1 (Oxford)

Hartwell, C., Hyde, M., Hubbard, E. & Pevsner, N., 2011 *The Buildings of England, Cheshire* (New Haven, CT & London)

Hawkins, E. (ed.), 1848 *The Holy Lyfe and History of Saynt Werburge*, Chetham Society, 1 ser. 15 (Manchester)

Henig, M., 2004 *Roman Sculpture from the North West Midlands*, Corpus of Sculpture of the Roman World, Great Britain 1(9) (Oxford)

Hodges, R. & Hobley, B. (ed.), 1988 *The Rebirth of Towns in the West AD 700–1050*, CBA Research Report 68 (London)

Hooper, N., 1989 'Some Observations on the Navy in Late Anglo-Saxon England' in C. Harper-Bill, C.J. Holdsworth & J.L. Nelson (ed.), *Studies in Medieval History Presented to R. Allen Brown* (Woodbridge), pp 203–13

Horstmann, C. (ed.), 1887 *The Life of Saint Werburge by Henry Bradshaw*, EETS orig. ser. 88 (London)

Hughes, T., 1864 'On Some Anglo-Saxon Coins Discovered in the Foundations of St John's Church, Chester', *J. Chester Architectural, Archaeological and Historic Soc.* 2, 289–308

Hume, A., 1863 *Ancient Meols* (London)

Hutchinson, G., 1994 *Medieval Ships and Shipping* (Leicester)

Irvine, S.E. (ed.), 2004 *The Anglo-Saxon Chronicle: a Collaborative Edition 7. MS E* (Cambridge)

Jayakumar, S., 2001 'Some Reflections on the "Foreign Policies" of Edgar "the Peaceable"', *J. Haskins Society* 10, 17–37

Jones, M.J., Stocker, D., & Vince, A., 2003 *The City by the Pool. Assessing the Archaeology of the City of Lincoln* (Oxford)

Jonsson, K., 1987 *The New Era: the Reform of the Late Anglo-Saxon Coinage*, Commentationes de Nummis Saeculorum IX-XI in Suecia Repertis, Nova Series 1 (Stockholm & London)

Keynes, S., 2008 'Edgar, *rex admirabilis*' in D. Scragg (ed.), *Edgar, King of the English, 959–975* (Woodbridge), pp 3–59

Lapidge, M., 2003 (ed. & trans.) 'Aelfric of Winchester, "Life of St Swithun"' in *Winchester Studies 4.ii. The Anglo-Saxon Minsters of Winchester* (Oxford), pp 590–609

Lewis, C.P., 2008 'Edgar, Chester and the Mercians, 957–9' in D. Scragg (ed.), *Edgar, King of the English, 959–975* (Woodbridge), pp 104–23

Lewis, C.P. & Thacker, A.T., 2003 VCH: *Cheshire* 5(1) (Woodbridge)

Lewis, C.P. & Thacker, A.T., 2005 VCH: *Cheshire* 5(2) (Woodbridge)

Lewis, M., 2012 'Thoughts on the Roman Bridge at Lincoln', *Lincolnshire History and Archaeology* 47, 5–12

McGrail, S., 1985 'Early Landing Places' in A.E. Asbjørn (ed.), *Second Conference on Waterfront Archaeology in North European Towns* (Bergen), pp 12–18

Mack, R.P., 1967 'The St John's Church Hoard of 1862', *British Numismatic J.* 36, 36–9

Mason, D.J.P., 1980 *Excavations at Chester. 11–15 Castle Street and Neighbouring Sites 1974–8: a Possible Roman Posting House (Mansio)*, Grosvenor Museum Archaeological Excavation and Survey Report 2 (Chester)

Mason, D.J.P., 1985 *Excavations at Chester. 26–42 Lower Bridge Street 1974–6. The Dark Age and Saxon Periods*, Grosvenor Museum Archaeological Excavation and Survey Report 3 (Chester)

Mason, D.J.P., 2001 *Roman Chester. City of the Eagles* (Stroud)

Mason, D.J.P., 2003 'The Heronbridge Archaeological Research Project', *J. Chester Archaeological Soc.* 78, 49–106

Mason, D.J.P., 2007 *Chester AD 400–1066. From Roman Fortress to English Town* (Stroud)

Matthews, K.J., 2003 'Chester's Amphitheatre after Rome: a Centre of Christian Worship', *Cheshire History* 43, 12–27

Matthews, S., 2000–1 'St John's Church and the Early History of Chester', *J. Chester Archaeological Soc.* 78, 63–80

Matthews, S., 2007 'King Edgar, Wales and Chester: the Welsh Dimension of the Ceremony of 973', *Northern History* 44(2), 9–26

Matthews, S., 2009 'King Edgar and the Dee: the Ceremony of 973 in Popular History Writing', *Northern History* 46(1), 61–74

Milne, G. & Hobley, B. (ed.), 1981 *Waterfront Archaeology in North European Towns*, CBA Research Report 41 (London)

Molyneaux, G., 2011 'Why were Some Tenth-century English Kings Presented as Rulers of Britain?', *Trans. Royal Historical Soc.* 21, 59–91

Morcken, R. 1969 'Europas eldste sjømerker?', *Sjøfartshistorisk Årbok*, 7–48 (republ. in R. Morcken, *Sjøfartshistorisk artikler gjennom 20 år* (Bergen 1983), pp 67–108)

Mynors, R.A.B., Thomson, R.M. & Winterbottom, M. (ed. & trans.), 1998 *William of Malmesbury Gesta Regum Anglorum 1* (Oxford)

Nicolaisen, W.F.H. 1997 'The Dee at Chester and Aberdeen: Thoughts on Rivers and Divinities' in A.R. Rumble & A.D. Mills (ed.), *Names, Places and People. An Onomastic Miscellany in Memory of John McNeal Dodgson* (Stamford), pp 247–53

Pagan, H., 2012 *Sylloge of Coins of the British Isles, 64 Grosvenor Museum, Chester Part II, Anglo-Saxon Coins and Post-Conquest Coins to 1180* (Oxford)

Place, G., 1996 'Parkgate and Ireland' in P. Carrington (ed.), *'Where Deva Spreads Her Wizard Stream'. Trade and the Port of Chester*, Chester City Council Occasional Paper 3 (Chester), pp 72–4

Reid, M.L., 2007–8 'The Early Modern Port of Chester', *J. Chester Archaeological Soc.* new ser. 82, 1–19

Rivet, A.L.F. & Smith, C., 1979 *The Place-Names of Roman Britain* (London)

Robertson, A.J. (ed. & trans.), 1925 *The Laws of the Kings of England from Edmund to Henry I* (Cambridge)

Sargent, A.W.S., 2012 'Lichfield and the Lands of St Chad' (PhD thesis, University of Keele)

Sawyer, P., 1998 *Anglo-Saxon Lincolnshire*, A History of Lincolnshire 3 (Lincoln)

Sawyer, P.H. & Thacker, A.T., 1987 'The Cheshire Domesday' in Harris & Thacker 1987, pp 293–370

Scott, S.C., 1899 *A Guide to the Church of St John the Baptist in the City of Chester* (Chester)

Semple, S., 2010 'In the Open Air' in M. Carver, A. Sanmark & S. Semple (ed.), *Signals of Belief in Early England. Anglo-Saxon Paganism Revisited* (Oxford), pp 21–48

Stocker, D., 2000 'Monuments and Merchants: Irregularities in the Distribution of Stone Sculpture in Lincolnshire and Yorkshire in the Tenth Century' in D.M. Hadley & J.D. Richards (ed.), *Cultures in Contact. Scandinavian Settlement in England in the Ninth and Tenth Centuries* (Turnhout), pp 179–212

Stocker, D., 2013 'Aristocrats, Burghers and their Markets: Patterns in the Foundation of Lincoln's Urban Churches' in D.M. Hadley & L. ten Harkel (ed.), *Everyday Life in Viking Towns: Social Approaches to Towns in England and Ireland, c. 800–1100* (Oxford), pp 119–43

Stocker, D. & Everson, P., 2001 'Five Towns Funerals: Decoding Diversity in Danelaw Stone Sculpture' in J. Graham-Campbell, R. Hall, J. Jesch & D. Parsons (ed.), *Vikings and the Danelaw. Select Papers from the Proceedings of the Thirteenth Viking Congress, Nottingham and York, 21–30 August 1997* (Oxford), pp 223–43

Stocker, D. & Everson, P., 2006 *Summoning St Michael, Early Romanesque Towers in Lincolnshire* (Oxford)

Strickland, T.J., 1988 'The Roman Heritage of Chester: the Survival of the Buildings of *Deva* after the Roman Period' in Hodges & Hobley 1988, pp 109–18

Stukeley, W., 1776 *Itinerarium Curiosum* (2 edn London)

Sylvester, D. & Nulty, G. (ed.), 1958 *The Historical Atlas of Cheshire* (Chester)

Thacker, A., 1982 'Chester and Gloucester: Early Ecclesiastical Organization in Two Mercian Burhs', *Northern History* 18, 199–211

Thacker, A., 1987 'Anglo-Saxon Cheshire' in Harris & Thacker 1987, pp 237–92

Thacker, A., 1988 'Early Medieval Chester: the Historical Background' in Hodges & Hobley 1988, pp 119–24

Thacker, A., 2000 'The Early Medieval City and its Buildings' in A. Thacker (ed.), *Medieval Archaeology, Art and Architecture at Chester*, BAA Conference Transactions 22 (Leeds), pp 16–30

Thornton, D.E., 2001 'Edgar and the Eight Kings, AD 973; *textus et dramatis personae*', *Early Medieval Europe* 10, 49–79

Tooley, M.J., 1980 'Theories of Coastal Change in North-west England' in F.H. Thompson (ed.), *Archaeology and Coastal Change*, Society of Antiquaries Occasional Paper 1 (London), pp 74–86

Vince, A. (ed.), 1991 *Aspects of Saxo-Norman London 2. Finds and Environmental Evidence* (London)

Waddelove, A., 2001 'The River Dee and the Deva Harbour: A Reassessment' in N.J. Higham (ed.), *Archaeology of the Roman Empire. A Tribute to the Life and Works of Professor Barri Jones*, BAR: International Series 940 (Oxford), pp 131–40

Wallace, P.F., 1986 'The English Presence in Viking Dublin' in M.A.S. Blackburn (ed.), *Anglo-Saxon Monetary History* (Leicester), pp 201–21

Wallace, P.F., 1987 'The Economy and Commerce of Viking-age Dublin' in K. Düwel, H. Jankuhn, H. Siems & D. Timpe (ed.), *Der Handel der Karolinger- und Wikingzeit*, Untersuchungen zu Handel und Verkehr der vor- und frühgeschichtlichen Zeit in Mittel- und Nordeuropa 4 (Göttingen), pp 200–45

Ward, S., 1994 *Excavations at Chester. Saxon Occupation within The Roman Fortress: Sites Excavated 1971–1981*, Archaeological Service Excavation and Survey Reports 7 (Chester)

Ward, S., 1996 'The Course of the River Dee at Chester' in P. Carrington (ed.), *'Where Deva Spreads Her Wizard Stream'. Trade and the Port of Chester*, Chester City Council Occasional Paper 3 (Chester), pp 4–11

Ward, S., 2001 'Edward the Elder and the Re-establishment of Chester', in N.J. Higham & D.H. Hill (ed.), *Edward the Elder 899–924* (London), pp 160–6

Ward, S., 2012 *Excavations at Chester. The Western and Southern Roman Extramural Settlements: a Roman Community on the Edge of the World*, Chester Archaeological Excavation and Survey Report 15, BAR: British Series 553 (Oxford)

Whitelock, D., Douglas, D.C. & Tucker, S.I. (ed. and trans.), 1961 *The Anglo-Saxon Chronicle: a Revised Translation* (London)

Williams, A., 2004a 'An Outing on the Dee: King Edgar at Chester, A.D. 973', *Mediaeval Scandinavia* 14, 229–43

Williams, A., 2004b 'Edgar', *ODNB* 17, pp 698–703

Wilmott, T., Garner, D. & Ainsworth, S., 2006 'The Roman Amphitheatre at Chester: an Interim Account', *English Heritage Historical Review* 1, 7–23

Woolf, A., 2007 *From Pictland to Alba, 789–1070* (Edinburgh)

Wormald, P., 1999 *The Making of English Law: King Alfred to the Twelfth Century. Legislation and its Limits* (Oxford)

Whitby before the mid-seventh century: some ways forward[1]

Lorna Watts

Introduction

The background to Whitby before the *floruit* of the site on the headland where the well-known Middle Saxon occupation and later medieval Abbey were located has recently been brought within the context of Anglo-Saxon Yorkshire as at present understood.[2] This takes as its starting point the late Roman period, which is now acknowledged as crucial to understanding what has happened subsequently. Loveluck highlights the long-established dichotomy between East and West Yorkshire in the post-Roman period. He uses the term 'Anglo-Saxon' in inverted commas to denote the political and social evolution of the eastern part of the county, not as an ethnic but as a cultural indicator, to describe an admixture of people, the various inhabitants of late Roman Britain and incomers from the Continent, who, together, gradually developed from possible fifth-century war-bands into more coherent groups, from which an aristocracy and, finally, localised kingship emerged by the seventh century at the latest.[3] While he summarises the potentially relevant documentation (that of the late Roman period and then the backward-looking narrative of Bede), he primarily uses archaeological evidence and interpretation, centred on the themes of settlement, funerary customs and economy.

Whitby can be viewed as marginal to Loveluck's interest in the development of Yorkshire before the mid-seventh century;[4] it is also marginal to other commentators, such as Naylor, looking at the earliest coins in the area.[5] Whitby is north of the North Yorkshire Moors, a physical barrier to both settlement and to the contemporary archaeological search for habitation. It could be seen instead as more related to the wider east-coast littoral, beyond Yorkshire. Naylor's unwillingness to see Whitby as part of early Deira, implicitly placing it in a nebulous area between Bernicia and Deira,[6] may also reflect that there were times when it

was indeed 'stateless'. It was only later, possibly from the 650s, more certainly from the 680s, that that it became a central location in the greater Northumbrian kingdom that emerged when Bernicia and Deira first came under the rule of a single king, Æthelfrith (604/05–616/17).[7]

Publication of the recent extensive excavations on the headland will no doubt prompt a major reassessment of the occupation sequence of early medieval Whitby.[8] The present paper seeks to draw attention to evidence that might point to activity on the site before the Middle Saxon occupation began. It suggests ways in which further analysis of existing records and artefacts has the potential to increase our understanding of that elusive earlier and comparatively neglected period, and hence of the development of the settlement as a whole.

Location

Whitby is the most significant Yorkshire port north of the Humber. Its coastal and riverine location must always have been attractive, with access inland via the River Esk. Its seaward position facilitates contacts, north and south along the east coast of Britain, as well as eastwards to the Continent. By the Roman period, communication inland would have been by river, and also via roads and other trackways. The route along the River Esk offered a channel of communication to the north of the North Yorkshire Moors, to link up with major north-south routes as well as to routes that eventually reached the west coast.[9] There were important roads from York and Malton to the coast, including one heading in the direction of Whitby,[10] as well as additional minor roads.[11] Whitby thus had easy maritime communication but more difficult access to its hinterland.[12]

Whitby possesses other natural resources: good agricultural land,[13] access to fish (both sea and river) and

major geological assets. There is high quality stone, suitable for both building material and for sculpture; and jet, utilised over a very long period for smaller-scale ornamentation and associated with electrostatic, quasi-prophylactic qualities.[14] There may also have been sources of amber in the area around Whitby.[15]

Crucial to understanding Whitby's natural location are the degree and rate of erosion along the east coast of England.[16] At Whitby itself, this can be seen today in miniature at Saltwick Nab, to the south of the town, where there is evidence of Iron Age and Roman activity.[17] While a map surveyed in the 1920s shows this as a still-attached headland, some 300m long,[18] by 2014 it is not only detached but fragmented, so fast is the rate of erosion. Extrapolation of figures from the last 140 years might suggest general erosion of some 400m over the last 2000 years.[19] Of more than usual critical importance in the evaluation of the archaeological remains at Whitby is therefore the assessment of whether the present archaeological resource is only a fraction of what was once present.

Roman Whitby

Although Roman Whitby has little archaeological visibility in terms of identifiable sites,[20] it is known from finds from the period, such as pottery, tile, coins and jet. The pottery covers much of the Roman period, extending to Late Signal Ware.[21] Roman coins have been recorded at least since the nineteenth century, although lacking details of both location and context;[22] others 'were discovered in the lowest stratum of the Abbey site',[23] although their dates were not specified, nor whether they were considered to be in primary contexts. Coin finds from Whitby are known to include issues of the later fourth century.[24] An assessment of the coin collection held by Whitby Museum is urgently needed, in terms of chronology, where the coins were found and with what other material, the types of coinage (both present and absent) and the implications for the economy, both local and beyond.

Whether the locally-obtained sandstone, used for building and sculpture during the Middle Saxon period,[25] was also utilised earlier is not at present known. Any export of stone at this time may be anticipated to have been coastal rather than overland, but its quarry source (whether at Whitby itself or in the neighbouring area) has not yet been certainly identified: if Wade's Causeway did indeed exist at this time, Aislaby may well have been amongst these.[26]

Jet, in contrast, was easily transportable. It has already been subject to scientific as well as typological examination, so that the source can be elucidated. During the Roman period, especially during the late third and fourth century,[27] Whitby jet was 'certainly worked locally, but it was also exported to other places, notably York' and to the Wall zone, including as raw material.[28] Such exports may suggest that Whitby was linked to the Roman military infrastructure, which should be tested in terms of other commodities. Jet and related products, such as shale, are also found on many other types of Roman sites in Yorkshire, such as: the Beadlam villa in Ryedale;[29] in late Roman graves in York, including one with possible Christian connotations;[30] and in another unusual burial from Catterick.[31] At Malton, again part of the Roman military network, jet beads have been found in a grave not far from others with crossbow brooches.[32] Jet is thus found in a range of chronological and social contexts; further analysis is needed to demonstrate whether it is Whitby jet in all cases (as distinct from locally-derived jet found, for instance, on the North Yorkshire Moors). Such work may demonstrate that it was exported in the post-Roman period, as it was later, in the Anglo-Scandinavian period.[33] Evidence of wide-spread trade would indicate an organised infrastructure, both overland and by sea. This may become a 'key indicator' of activity at Whitby over a considerable time-frame.

No Roman site has yet been certainly identified in Whitby. There are, however, areas within the present Abbey grounds where further investigation of the archive may demonstrate that Roman *in situ* contexts had been encountered in the early twentieth-century excavation,[34] rather than that later contexts contained residual evidence of this period (there may be these too, with material perhaps derived from elsewhere in Whitby). One such potential area from the 1920s clearance was to the north of the north transept of the later monastic church, when tile claimed to be of Roman date was found, with loom weights, whetstones and pottery, the dating of none of which is described, together with 'thirteen pieces of timber' found '5ft [1.5m] below the surface'.[35] If this timber still exists, it may be suitable for radiocarbon determination and perhaps also for dendrochronological dating: is this a Roman context or a later one? If these timbers do prove to have been *in situ* Roman structures, the Middle Saxon buildings would not have been the first to have been built on the southern headland, above the river estuary. Perhaps, as the post-excavation stages of this ninety-year old excavation progress, we should also consider whether this could be the location of a possible Roman signal station at Whitby.

The possibility that there was formerly a Roman signal station at Whitby is a major unresolved aspect of the Roman use of the location. 'Signal station' is not a Roman designation, and the precise function of these defensive works, whether inland as well as seawards, is still subject to debate, as is their relationship to the surrounding settlements.[36] The former existence of such a site at Whitby has to be argued from negative evidence. Bell, developing a discussion that has been ongoing since the later eighteenth century at least, has cogently argued that there was a signal station on the east cliff of Whitby, to the east of the River Esk. Other signal stations are known locally at Goldsborough and Ravenscar to either side of Whitby,

also at Huntcliff, Scarborough and Filey, and suspected just south of Hartlepool and at Flamborough Head.[37] These were, Bell argues, built as a unit in the late fourth century, with 'numismatic and pottery evidence' confirming their use until at least as late as dating evidence continued, that is, to the end of the fourth century. A station at Whitby, he continues, would have been necessary to transmit signals between the known stations, Goldsborough and Ravenscar; and it could also have protected the important river access to the interior.[38] Amongst supporters of such an idea, a location for this signal station that has been lost to the sea (between the post-Roman period and the eleventh century), has long been favoured.[39] An alternative location for such a building-complex, however, could have been in the deep stratification below the present Abbey. The importance of the prominent position of this location is difficult to assess without reconstruction of the Roman-period coastline, if this is possible.[40] The recognition of such a facility in late Roman Whitby would be important in itself; it would also totally transform how we view the survival and transformation of the assumed Roman port into the Middle Saxon site.

Post-Roman Whitby

The evidence for the Roman utilisation of Whitby at present is thus primarily artefactual, without a confirmed settlement focus. Nonetheless, given its location at the mouth of a river, cessation of its use as a port on some scale at any time seems extremely unlikely; instead, it should be presumed that both habitation and use of some sort continued. How, then, could this be recognised? What would provide diagnostic archaeological material for the post-Roman period? Can material evidence be identified that might substantiate any of Loveluck's categories of settlement, funerary evidence and economy?

Excavations of sufficient depth could be expected, as at neighbouring Filey,[41] to provide sequences of occupation that might, while lacking artefactual dating, provide sufficient evidence of the passage of time to suggest either habitation or its absence. They might also contain organic material, amenable to both dendrochronological and other scientific dating methods; and also indicators of habitat. Such deposits are likely to be further located within the later Abbey grounds.[42]

There is, as in the Roman period, no certain evidence of burials in the post-Roman period, either in Whitby or the immediate area. Evidence from elsewhere in the region may, however, suggest what we should be looking for. Around Hartlepool to the north, most fifth- to sixth-century archaeological data comes from burials, where there is evidence of small groups of burials in a variety of locations, of different types, some apparently representing continuity with earlier forms of burial, with a variety of orientations; there are both plain stone-lined cist burials and other

similar cist burials that have, additionally, what are usually considered to be Anglo-Saxon artefacts; other 'diagnostic Anglo-Saxon graves of the fifth to sixth century' are mainly confined to the coast and adjacent river valleys.[43]

At Whitby, part of a cemetery has been found on the present cliff edge that includes north–south burial.[44] Whether this is the burial place of single group at a particular time is unknown. Although Lang directly assigns one of these burials to the Anglo-Saxon period because of associated sculpture,[45] north–south burial is also found in the post-Roman period. The date of burial for this group should be checked (if human bone still survives, via radiocarbon determinations) – it may be multi-period.

Negative evidence is particularly difficult to assess at Whitby, given the potential extent of coastal erosion. Likewise, discussion of another basic indicator of economic activity at any period, the indigenous pottery, is under-developed. Whitby-type ware is referred to as a pre-Conquest fabric at Hartlepool.[46] Its description later in the volume,[47] as a black micaceous handmade pottery, found in a sixth- to early seventh-century context at Norton,[48] suggests that it is another of the post-Roman fabrics to be recognised in the region.[49] Other artefacts from Whitby, including metalwork and continental pottery,[50] also at the end of the period under discussion, have been published, but again, like the coinage, most are either unstratified or have been treated as such;[51] those from the 1920s Abbey excavations had all too little stratigraphic information,[52] without which this material is likely to be deficient in details about the time of manufacture or likely length of use before deposition (either primary or secondary), information vital for a full evaluation in relation to both context and chronology. Cramp has focussed on material from the late seventh to mid-ninth century,[53] but this evidence itself is subject to re-evaluation in terms of dating,[54] and some may now be dated earlier than previously thought.

There are, nonetheless, details which suggest that much of this rich material may have been derived, directly or indirectly, from the west and north (Ireland and present-day Scotland) and from the Continent.[55] While this material may well fall at the end of the time-frame being emphasised here, such contacts need to be explored in detail and the origins of these imports investigated: do they belong to the late sixth to seventh century rather than to the fifth to early sixth century?[56] Were they part of long-established networks, where exchange between, for example, England and Ireland was long known; and where interchange may have involved not only objects of gift exchange and trade, but also ideas, including those of religious affiliations, such as Irish-derived Christianity? The latter may be hinted at by the Irish-type finials found at adjacent Lythe (the location of which may have been to guard approaches to the River Esk from the north-west); from Lastingham to the south and Heysham on the west coast, opposite Ireland.[57] Whitby was not the

only northern east-coast location to enjoy Irish contact: Portmahomack did so also, probably via the Great Glen.[58] Such details may suggest more about, for example, artefacts with clear pagan or Christian connotations; or emphasise, rather, that such religiously-based differentiations with an implied ethnic component are now outmoded and should instead be replaced by a focus on the increasingly socially-stratified population that would eventually form the population structure of medieval England.

From this later evidence, it may be possible to extrapolate backwards, to ask why it seems that all the Whitby coinage analysed so far comes from the area of the later Abbey, an area where there is deep stratification and Roman finds. One interpretation is that this marks the centre of an economic unit, where perhaps the fruits of trade were enjoyed; or from where they were primarily generated: was this the first association of royal dominance with money or did it have an earlier development? How did the elements of gift, exchange and trade interact over time?

Conclusion

It is hoped that reference to the interface between what has been conventionally termed 'Roman' and 'Anglo-Saxon' will promote much needed discussion of fifth-, sixth- and early seventh-century Whitby, a place that is little understood but which arguably had a profound influence on subsequent development.

Models for the late and post-Roman period need to be developed, like those Loveluck has applied elsewhere, seeking to elucidate who lived in and controlled Whitby – whether they were previous inhabitants (either indigenes or people brought in as a result of Roman control), of whatever ethnic origin,[59] or isolated individuals, families or groups of continental migrants, or a mixture; and whether any control was long-lasting or was, rather, constantly shifting. How and when did post-Roman occupants of Whitby interact with places known to have been significant at such times, like Catterick and York?[60] When did Whitby in fact become 'Anglo-Saxon'?[61]

Are we right to think of Whitby as a minor place throughout this period? Its years of power and influence could be argued to have been various: possibly it was already a significant place before the early seventh century, when York was not apparently powerful,[62] and when Whitby's role as a coastal port on England's east coast littoral may have been more important than its royal role. Did Whitby itself have significance in the context of markets and fairs, as neighbouring Sandsend may have done in the Anglo-Scandinavian period?[63] These are the wider considerations. In terms of prime archaeological data from Whitby itself, much has accumulated without being either fully reported or analysed. Some of the artefactual material has been subjected to fruitful comparison so that

high-level exchange and trade can be suggested, but far more remains to be reported fully. Little attention has been paid to stratigraphic data and what this can contribute to the history of Whitby, for all periods, not the Anglo-Saxon alone. The 1920s excavations have yet to be considered systematically in terms of the levels often used to report location of finds: lowest, middle, top.[64] Full consideration of this minimal information may enable deductions to be made about whether both archaeological deposits and individual finds represent material *in situ* or whether much of it was residual.

The cramped conditions around the river and the steep slopes of much of the present town are not conducive to the easy recognition of archaeological contexts, but should nevertheless be monitored. Important progress could also accrue from the bulk application of scientific techniques, especially on questions of dating and from isotope analysis to identify where the buried inhabitants of Whitby might have grown up. The firm location of Roman evidence *in situ* on the Abbey headland would indeed be a major landmark in the investigation of Whitby. Understanding of early Whitby will benefit from the addition of new data as well as from the application of the ever-changing archaeological and historical models. Whitby needs – and deserves – a major re-evaluation like that recently undertaken for Glastonbury.[65]

Notes

1 Richard Bailey has long been on the radar of the late Philip Rahtz and myself, particularly since the controversy surrounding the use of dowsing in archaeological contexts (Bailey et al. 1988; see further Parsons below, 195–6). Philip was intrigued by this phenomenon, which he considered then was beyond rational explanation, but would eventually be amenable to scientific explanation. This was the stimulus to scintillating conversation with Richard. Since then, we have benefited from his collaboration, especially in relation to the architecture and sculpture associated with Anglo-Saxon Deerhurst, Kirkdale and Lastingham.
2 Loveluck 2003.
3 Loveluck 2007; Halsall 2013.
4 Notably, it does not appear on Loveluck 2003, fig. 40 ('Location of key 5th–early 7th century Anglo-Saxon sites discussed in the text').
5 Naylor 2007.
6 Ibid., 41 n. 4; see further Loveluck 2007, 186.
7 See further, Rollason 2003, 6–7.
8 See further, *Current Archaeology* 29 (2014), 7; no author cited.
9 See further, Eastmead 1824, 453–5; Faull 1983, figs 2–3; Bell 1998, 320; Ottaway 2003, fig. 35.
10 See further, Ottaway 2003, figs 35, 126; Wilson 2003, 53.
11 Spratt & McDonnell 1989, 184.
12 See further, Stopford 2000.
13 Harrison & Roberts 1989, 74; Pickles 2016.
14 E.g. Ottaway 2013, 204; Pierce 2013.

15 Hodges 1982, 122.

16 See further, Daniels 2007, 9.

17 Possible Iron Age/Roman features comprise parts of an enclosure and ditch. Two Roman coins, of Claudius I and Marcus Aurelius, are now in the Whitby Museum collection. See report of Humber Field Archaeology 2008: http://archaeologydataservice.ac.uk/archives/view/yorksrcza_eh_2009/downloads.cfm (Accessed 23 June 2015). I would like to thank Elizabeth Marsh, Whitby Museum, for this information.

18 OS 1-inch Map 86.

19 Stopford 2000, 106.

20 See, for example, its near absence in Ottaway 2013.

21 E.g. Clark 1935, 138; Bell 1998, 305–6.

22 Sheahan & Whellan 1859, 256.

23 Clark 1935, 138–9.

24 Ibid., 139.

25 Lang 2001, 231–66.

26 Senior 1991, 14.

27 Allason-Jones & Jones 1995, 266–8, 271.

28 Hartley 1989, 52; Allason-Jones & Jones 1995.

29 Neal 1996, 50.

30 Ottaway 2013, 317.

31 Ibid., 288.

32 Ibid., 289.

33 See further, Graham-Campbell & Kidd 1980, 45; Pierce 2013, 198, 199.

34 See further, Peers & Radford 1943; Stopford 2000, 99–101.

35 Cramp 1993, 66. Was this the surface of the ground level in the 1920s?

36 See further, Ottaway 2013, 294–301.

37 E.g. Bell 1998, ill. 1 on 304; Wilson 1989; Ottaway 2013, 295.

38 Bell 1998, 304–6.

39 Bell 1998, 314; Rahtz 1995, 5.

40 For a recent attempt, see Bell 1998, ills 7 on 314, 9 on 317.

41 Ottaway 2000.

42 See further, Johnson 1992.

43 See further, Loveluck 2007, 186–9; Sherlock & Simmons 2008.

44 Rahtz 1995, 9.

45 Lang 2001, 252–3.

46 Daniels 2007, 127.

47 Loveluck 2007, 197.

48 Ibid.

49 See further, Powlesland, pers. comm., and pottery found at Kirkdale (Rahtz & Watts in prep.)

50 Dunning 1943, 80–2; Stopford 2000, 7–8.

51 See further, White 1984.

52 See further, Cramp 1976a, 223–9; 1976b; Rahtz 1976.

53 See further, Cramp 1993, 64.

54 See further, Hines & Bayliss 2013.

55 White 1984, 37; Cramp 1993, 66–7; Stopford 2000, 7–8; Boyle 2010, 453.

56 See further, Hines & Bayliss 2013.

57 Lang 1991, 171–2.

58 E.g. Carver 2008, 75.

59 See further, Halsall 2013.

60 See further, Lang 2001, 5, 7.

61 See further, Bede's indecision, *HE* IV, 23 (Colgrave & Mynors 1969, 404–15).

62 Rollason 1999, 139; Morris et al. 2006, 424.

63 The quantity of recorded early medieval coinage at Whitby, for instance, seems to far out-rival that from Hamwic, Ipswich, London and York of the same period, and so warrants investigation of its earlier productive identity (Blackburn 2003, 34–5; see further, Pestell & Ulmschneider 2003; Naylor 2007).

64 See further, Cramp 1976b; Johnson 1992.

65 Gilchrist & Green 2015.

References

Allason-Jones, L. & Jones, D., 1995 'Jet and Other Materials in Roman Artefact Studies', *Archaeologia Aeliana* 5 ser. 22, 265–72

Bailey, R., Cambridge, E. & Briggs, D., 1988 *Dowsing and Church Archaeology* (Wimborne)

Bell, T., 1998 'A Roman Signal Station at Whitby', *Archaeological J.* 155, 303–22

Blackburn, M., 2003 'Productive Sites and Pattern of Coin Loss in England, 600–1180' in Pestell & Ulmschneider 2003, pp 20–36

Boyle, E., 2010 *'Review: Anglo-Saxon/Irish Relations before the Vikings* (Proceedings of the British Academy 157), edited by James Graham-Campbell & Michael Ryan (Oxford and New York, 2009)', *Med. Arch.* 54, 452–3

Carver, M., 2008 *Portmahomack. Monastery of the Picts* (Edinburgh)

Clark, M., 1935 *A Gazetteer of Roman Remains in East Yorkshire*, Roman Malton and District Report 5 (Leeds)

Cramp, R., 1976a 'Monastic Sites' in Wilson 1976, pp 201–52

Cramp, R., 1976b 'Appendix B. Analysis of the Finds Register and Location Plan of Whitby Abbey' in Wilson 1976, pp 453–7

Cramp, R., 1993 'A Reconsideration of the Monastic Site of Whitby' in R. Spearman & J. Higgitt (ed.), *The Age of Migrating Ideas* (Edinburgh & Stroud), pp 64–73

Daniels, R., 2007 *Anglo-Saxon Hartlepool and the Foundations of English Christianity. An Archaeology of the Anglo-Saxon Monastery*, Tees Archaeology Monograph Series 3 (Hartlepool)

Dunning, G., 1943 'The Pottery' in Peers & Radford 1943, pp 75–82

Eastmead, W., 1824 *Historia Rievallensis: containing the History of Kirkby Moorside, and an Account of the most Important Places in its Vicinity ...* (London)

Faull, M., 1983 'Roman and Anglo-Saxon Settlement Patterns in Yorkshire: a Computer-generated Analysis', *Landscape History* 5, 21–31

Gilchrist, R. & Green, C., 2015 *Glastonbury Abbey: Archaeological Investigations 1904–79* (London)

Graham-Campbell, G. & Kidd, D., 1980 *The Vikings* (London)

Halsall, G., 2013 *Worlds of Arthur. Facts and Fictions of the Dark Ages* (Oxford)

Harrison, B. & Roberts, B., 1989 'The Medieval Landscape' in Spratt & Harrison 1989, pp 72–112

Hartley, B., 1989 'The Romans' in Spratt & Harrison 1989, pp 45–54

Hines, J. & Bayliss, A. (ed.), 2013 *Anglo-Saxon Graves and Grave Goods of the 6th and 7th Centuries AD: a Chronological Framework*, Society for Medieval Archaeology Monograph 33 (London)

Hodges, R., 1982 *Dark Age Economics: the Origins of Towns and Trade AD 600–1000* (London)

Johnson, M., 1992 'The Saxon Monastery at Whitby: Past, Present, Future' in M. Carver (ed.), *In Search of Cult: Archaeological Investigations in Honour of Philip Rahtz*, University of York Archaeological Papers (Woodbridge), pp 87–91

Lang, J., 1991 *York and Eastern Yorkshire*, CASSS 3 (Oxford)

Lang, J., 2001 *Northern Yorkshire*, CASSS 6 (Oxford)

Loveluck, C., 2003 'The Archaeology of post-Roman Yorkshire, AD 400–700: Overview and Future Directions' in Manby et al. 2003, pp 151–70

Loveluck, C., 2007 'Anglo-Saxon Hartlepool and the Foundation of English Identity: the Wider Context and Importance of the Monastery' in Daniels 2007, pp 186–208

Manby, T., Moorhouse, S. & Ottaway, P. (ed.), 2003 *The Archaeology of Yorkshire: an Assessment at the Beginning of the 21st Century*, Yorkshire Archaeological Society Occasional Paper 3 (Leeds)

Morris, R., Powlesland, D. & Wood, I., 2006 'Deira and York in the 7th and 8th Centuries' in B. Ariaga Bolumburu & J.A. Solorzano Telechea (ed.), *La Cuidad Medieval y su Internacionales del Medievo* (Logroño), pp 423–38

Naylor, J., 2007 'The Circulation of Early-medieval European Coinage: a Case Study from Yorkshire, *c.* 650–*c.* 867', *Med. Arch.* 51, 41–61

Neal, D., 1996 *Excavations on the Roman Villa at Beadlam, Yorkshire*, York Archaeological Report 2 (Leeds)

Ottaway, P., 2000 'Excavations on the Site of the Roman Signal Station at Carr Naze, Filey, 1993-4', *Archaeological J.* 157, 79–199

Ottaway, P., 2003, 'Roman Yorkshire: a Rapid Resources Assessment' in Manby et al. 2003, pp 125–49

Ottaway, P., 2013, *Roman Yorkshire: People, Culture and Landscape* (Pickering)

Peers, C. & Radford, C.A.R., 1943 'The Saxon Monastery of Whitby', *Archaeologia* 89, 27–88

Pestell, T. & Ulmschneider, K. (ed.), 2003 *Markets in Early Medieval Europe: Trading and 'Productive' Sites, 650–850* (Macclesfield)

Pickles, T., 2016 '*Streanaeshalch* (Whitby), its satellite churches and its estates' in T. Ó Carragáin & S. Turner (ed.), *Making Christian Landscapes in Atlantic Europe: Conversion and Consolidation in the Early Middle Ages* (Cork), 265–75; 500–4

Pierce, E., 2013 'Jet Cross Pendants from the British Isles and Beyond: Forms, Distribution and Use', *Med. Arch.* 57, 198–211

Rahtz, P., 1976 'Appendix C: the Building Plan of the Anglo-Saxon Monastery of Whitby Abbey' in Wilson 1976, pp 459–62

Rahtz, P., 1995 'Anglo-Saxon and Later Whitby' in L. Hoey (ed.), *Yorkshire Monasticism: Archaeology, Art and Architecture*, BAA Conference Transactions 16 (Leeds), pp 1–11

Rahtz, P. & Watts, L., in prep. *Kirkdale Church and Excavations in Context*

Rollason, D., 1999 'Historical Evidence for Anglian York' in D. Tweddle, J. Moulden & E. Logan (ed.), *Anglian York: a Survey of the Evidence*, The Archaeology of York: Anglian York 7/2 (York), pp 117–40

Rollason, D., 2003 *Northumbria, 500–1100: Creation and Destruction of a Kingdom* (Cambridge)

Senior, J.R., 1991 'Regional Geology' in Lang 1991, pp 7–11

Sheahan, J.J. & Whellan, T., 1859 *History and Topography of the City of York and the North Riding of Yorkshire* 2 (Beverley)

Sherlock, S. & Simmons, M., 2008 'The Lost Royal Cult of Street House Yorkshire', *British Archaeology* 100 (May–June), 30–7

Spratt, D. & Harrison, B.J.D. (ed.), 1989 *The North York Moors: Landscape Heritage* (Newton Abbot)

Spratt, D. & McDonnell, J., 1989 'Communications' in Spratt & Harrison 1989, pp 184–98

Stopford, J., 2000 'The Case for Archaeological Research at Whitby' in H. Geake & J. Kenny (ed.), *Early Deira* (Oxford & Oakville, CT), pp 99–107

White, A., 1984 'Finds from the Anglian Monastery at Whitby', *Yorkshire Archaeological J.* 56, 33–40

Wilson, D. (ed.), 1976 *The Archaeology of Anglo-Saxon England* (Cambridge)

Wilson, P., 1989 'Aspects of the Yorkshire Signal Stations' in V. Maxfield & M. Dobson (ed.), *Roman Frontier Studies 1989*, Proceedings of the XVth International Congress of Roman Frontier Studies (Exeter), pp 142–7

Wilson, P., 2003 'The Roman Period', in R. A. Butlin (ed.), *Historical Atlas of North Yorkshire* (Otley), pp 48–74

Looking at, and for, inscribed stones: a note from the Brough of Birsay, Orkney

Christopher D. Morris

The Brough of Birsay has been described as 'one of the most numinous of Scotland's sites',[1] and the preparation for final publication of both my own project there between 1974 and 1993 and that of Ralegh Radford and Stewart Cruden between 1955 and 1964 is currently my own obligation and occupation in retirement. The chapel at the centre of the site had always attracted attention and investigations in 1866 by Sir Henry Dryden and excavations and clearance undertaken on the site between 1934 and 1939 under the general supervision of Dr J.S. Richardson, Inspector of Ancient Monuments for Scotland, have now been recorded in publication.[2]

The general context for a rune-stone found by Dr Hugh Marwick in 1921 in the north wall of the chapel behind the aumbry of the chancel is therefore now clearer, as well as the record of two further rune-stones in 1934.[3] Work in the Historic Scotland archive resulted in the discovery that Richardson also recorded the finding of a stone in two parts in infilling debris on the north side of the nave with what he took to be ogham characters.[4] Curiously, neither the runic nor the putative ogham inscriptions were mentioned by Mrs Cecil Curle in her publication in 1982 of the Pictish and Norse Finds from the site, but she did include a rune-inscribed seal's tooth amulet pendant, apparently found in Area II in Passage I.[5]

Subsequently recorded by the RCAHMS based on information from Richardson,[6] the runic inscriptions have received scholarly examination and analysis on three recent occasions: by Aslak Liestøl; Katherine Holman; and Michael P. Barnes and Raymond I. Page.[7] Liestøl, in his overview of the runic inscriptions of the northern and western isles, distinguished between those of the Viking Age and later ones from the twelfth and thirteenth centuries. He firmly placed Marwick's find in the latter category and continued: 'only the name is clear, but the inscription,

filibusranru, probably was meant to say: "Philippus wrote the runes"'.[8] The other two fragmentary and split runic inscriptions found in 1934 he regarded as earlier and bearing parts of the more common formula '(NN) raised this (stone) after (NN)': 'We seem to be able to read on one of them … *x raistie* … and on the other … *ina x eftir*'.[9] He tentatively suggested that the name *ilhuki*, Illhugi or Illugi, a well-known Viking-age name in Iceland, might also be represented here and went on to speculate as follows: 'One possible link to the Isles could be the family of *Björn buna*. His great-great-great-grandsons Illugi the Black and Illugi the Red flourished in Iceland late in the tenth century, and a relative, named after a common forebear, may have stayed at Birsay.'[10]

Marwick's find, donated to the National Museum in Edinburgh, now is designated Birsay I and OR6 by both Holman and Barnes and Page.[11] For Holman it is 'the only rune-stone from the Brough with a legible text, but even so, the precise meaning of the text remains unclear', although clearly the name Philippus is a Christian name with a Latin ending, which she speculates may have belonged to 'a member of the monastic foundation that appears to have been built on the Brough in the early twelfth century', who carved the runes following the shift in the power-base of the earldom from Birsay to Kirkwall.[12] What Barnes and Page add in their rigorous description and analysis is to emphasise that the legible inscription is simply the latter part of the overall inscription, the first two parts of which cannot be transliterated, and also to raise the possibility that more than one carver (albeit that Philippus was a 'novice in the art of rune writing') might have been involved. In the latter circumstance 'Birsay I might then be viewed as a small-scale "writers' rock"… a surface on which several people had tried their hand at writing or cut inconsequential messages.'[13]

The two fragments found in 1934 were kept on site in the 'site museum' for many years and then transferred to the Tankerness House Museum in Kirkwall (now designated Birsay II and III (OR 8 and 9)).[14] Holman raises questions about Liestøl's transliteration of Birsay II, suggesting that: 'The characters may conceivably represent a form of the verb, *rista*, "to carve"', rather than *raisti*, 'raised' and thus may perhaps be a more informal inscription, rather than part of a memorial stone, and extends this to Birsay III also. But both stones have remains of framing lines.[15] Rather confusingly to non-runologists (but in tune with Richardson's observation quoted below), Barnes and Page a decade later seem to have gone back to a version of *raisti*, as per Liestøl, but have to all intents and purposes rejected his suggestion of *ilhuki*.[16] With regard to Birsay III, then, scepticism and anti-interpretation come to the fore: 'In any attempt at describing a stone in this badly worn state, there will be a strong element of interpretation. The reader is warned against this', but on balance the writers seem to come out in favour of it being part of the same stone and inscription as Birsay II, without really being able to make clear sense of either!'[17]

To this might even be added a further stone (Birsay V (OR16)) built into the south side of the church near the base of the apse. Remains of perhaps fourteen or so original runic staves can be made out, but Holman only hazards two 'u' or 'r' runes and a faint framing line as clear enough for definite record.[18] Barnes and Page have little to add beyond that: 'No useful sense can be made of this fragment. However, it is not impossible that it formed part of the same inscription as Birsay II and/or III.'[19] Nevertheless, they do add elsewhere in their monograph that: 'though fragments only, [they] seem to be firmly and professionally cut', in contrast with Birsay I which they say 'can be deemed a possible graffito'.[20] And, both they and Holman have followed Liestøl's distinction in chronological terms. Birsay II, III and V have all been found built into the walls of the later church on the site, and quite conceivably originating from the earlier period of Viking-age activity here, which Holman has linked to Curle's 'return to elegance' in the second half of the tenth century, whereas the Christianised and Latinised fragment Birsay I probably relates to the twelfth-century Christian activity on the site (albeit that the stone was found within the aumbry of the church).[21]

The final runic inscription from the Brough of Birsay (Birsay IV, OR 11) is that inscribed on what was originally designated a walrus tusk (no. 189), then a seal's tooth (253), and now apparently the canine of a brown bear – although in no case is an archaeozoological identification referred to.[22] Its archaeological context was apparently at pavement level in the passage to the west of Room VI in Area II, in what Mrs Curle (Cecil Mowbray) called the 'Lower Norse horizon'.[23] If the context is reliable, then dating would be to the ninth to tenth centuries, but the complexity of the midden deposition(s) in this area and the superimposition of later features, some apparently cutting through the Lower Norse

features,[24] has led to concern being expressed that stratigraphy was disturbed; Curle has, nevertheless, maintained that it is one of the finds from the Lower Norse horizon which is indubitably of Norse manufacture.[25] Liestøl, in his note for Mrs Curle and his later article, noted that the inscription is of the first six runes of the runic *fuþark* alphabet (together, as Holman notes, with a seventh vertical stave at the end), cut with the point of a knife, but that the forms are those used throughout the Viking Age up to about 1200. The runes are 'double-lined', which in Scandinavia and Greenland are found in the twelfth and thirteenth centuries and could suggest a late dating for this inscription.[26] However, the material might have been the result of work by more than one rune carver: 'a second one trying to tidy up and reshape the crude work of the first unpractised hand.'[27] The object is polished and perforated so the suggestion of it being a pendant is not unreasonable, although the initial suggestion of it being an amulet, perhaps with magical associations, is now being downplayed – certainly by the ever-sceptical Barnes and Page, who also conclude their dating discussion by sitting firmly on the fence: 'On somewhat uncertain archaeological and runological grounds, then OR11 could be considered among the earliest of the Scandinavian runic inscriptions from the British Isles, but it is not impossible it is from the eleventh or twelfth century'.[28]

As noted above, J.S. Richardson recorded the discovery in 1934 of a stone in two parts with what he took to be ogham letters incised upon it which, curiously, was not mentioned in either the RCAHMS *Inventory* in 1946 or Cecil Curle's work on the *Pictish and Norse Finds* published in 1982. We now know, however, from scrutiny of Ralegh Radford's archive, that he recorded in his notebook on his preliminary visit to Birsay in 1955 the existence of a 'fracture[d] slab of local brown sandstone' with an ogham inscription on its narrow edge in the end case of the 'site museum', with dimensions of 305 × 230 × 77mm (12 × 9 × 3in) thick (see Fig. 18.1a).[29] Four years later, Radford referred in the 'official' site guide-book to the 'extensive burial ground which has yielded a broken symbol stone, an early cross and a fragmentary inscription in ogam characters',[30] and we have to assume that this is a short-hand description for this same stone found in 1934 infilling debris from the north side of the nave of the church.[31] A sketch made by Radford in his 1955 *Notebook* (see Fig. 18.1b) demonstrates that it is the same stone as one later recorded by Oliver Padel as his 'Padel 2' (or 'Shore Stone').[32] It is also possible that the next year Radford made a rubbing of the stone which formed the basis of the drawing illustrated by Padel.[33] The inscription was clearly incomplete as the stone was broken across some of the characters.

In 1960, Cruden records that work was undertaken on House 4.[34] Plans of the area show this to be a room north-west of Room 6.[35] A sketch by Radford in 1961 shows internal measurements and a 'lower room' that is referred to by Cruden in 1960 in the context of the discovery of an

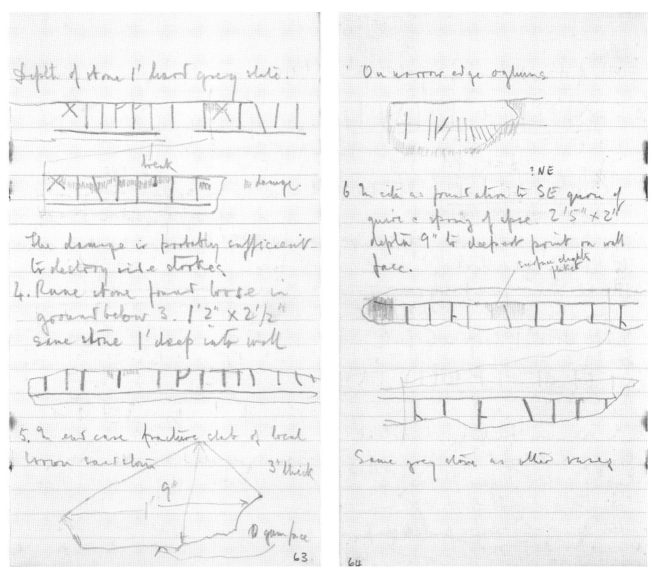

Fig. 18.1 Radford's sketches of Birsay Ogham 1 (1934): (a) Radford NB3, 32L (b) Radford NB3, 33L (Reproduced by permission of Heritage England)

ogham-inscribed stone found in the wall on the north side.[36] In fact, this investigation was remarkably fruitful in terms of artefacts, as he also records having discovered a 'bronze circular disc … probably [a] hanging bowl escutcheon, with divergent spirals',[37] as well as fragments of combs, both from deep peat deposits beneath the lower walls, i.e., the 'layer of midden material at level of floor of Thorfinn room'.[38] Cruden records that the stone 'was photographed in position and removed to hut, and replaced'.[39] In his notebook, Radford also gave details of the ogham stone (with a sketch: see Fig. 18.2):

Ogham stone found in face of inner side of NE wall of small obliquely set wall of room under Viking House Room 4. Wall bedded into midden of Viking date.

Stone reused. Inscription cut on flat bedding plane of stone. Inscribed face 2 ft by 4¼ ins. Stone triangular in flat [*recte* 'in plan'?] with maximum depth into wall of 11 ins. Length of stem line 1 ft 6 ins. Inscription apparently complete. Fractures old.[40]

This stone is clearly the same as that described by Padel as 'Birsay 1' and/or the 'Wall Stone', illustrated in his thesis by a photo of a rubbing of the stone (was this done by Radford or Cruden at the time?).[41] So, clearly, 'Padel 1' was found in 1960 and was re-used in an early Viking-period wall.[42] As the inscription occupies less than the full length of the stem line, which runs essentially parallel, and centrally, with the irregular edges of the stone, Radford's assertion that the inscription is complete seems a reasonable conclusion.

Apparently curiously, in a publication shortly after the find, Radford appears to have omitted reference to this recent find, referring only to the previous ogham inscription, i.e., Padel's 'Birsay 2'.[43] The new find was mentioned in later publications, however, such as Radford's Presidential Address to the Cambrian Archaeological Association at Dublin in 1961: 'These nameless memorials [*sc* 'with crosses'], set alongside others with inscriptions – two Oghams have been found at Birsay – illustrate the medieval Irish poem which describes the graveyard at Clonmacnois:

"Where beneath the dewy hillside sleep the noblest of the clan of Conn, Each below his stone with name in branching Ogham and the sacred knot thereon."[44]

But when it was briefly noted in other publications by Radford and Cruden in the following two years,[45] it was being somewhat misleadingly described, by implication or directly, as having been built into the walls of the 'Palace of Thorfinn'.

Also, however, in 1962 Ralegh Radford stated that: 'Two ogham inscriptions, both apparently of the Pictish type, have been found on the site, one re-used as a building stone in the Palace of Earl Thorfinn. The second is a fragment picked up on the beach below the Brough of Birsay'.[46] It is clear that the first is the 1960 stone, but also – from the account referred to above – that the latter cannot be the stone found in 1934 and located in the 'site museum'. Nevertheless, Padel described his 'Padel 2' stone also as the 'Shore Stone', which presumably relates to these later references in 1962, but is in fact incorrect. It is, however, just conceivable that there was a *third* ogham inscription found on the beach at the time – but that would require us to assume that by *c.* 1961 Radford had forgotten about the pre-war find which he appears to have studied and sketched in 1955 and possibly also in 1956.

A further curiosity of the 'case of the Birsay oghams' is that they no longer exist! When Padel came to do his work in the early 1970s he was able to inspect both stones and also could rely on a drawing and a rubbing; but when Katherine Forsyth came to do her doctoral work on this in the 1990s the original stones were not available for study, although nominally in the care of Historic Scotland.[47] There is no indication in Cruden's or Radford's notebook as to the fate of the 1960 ogham stone after the excavation, but one must presume it went back to Edinburgh. The stone from 1934 which was in the 'site museum' in the 1950s may well have been intended to have been taken back to Edinburgh (or conceivably to Tankerness House Museum in Kirkwall) as well, along with the other stones there. In Cruden's notebook, the entry at the end of 1963 season is as follows:

Implement for 1964: Make casts of all early crosses, for re-erection 1964. Also, casts required of runestones, for site museum. Originals for Edinburgh (or Kirkwall, see MacGillivray about this?).[48]

As for the putative third stone, there appears to be no other corroboration for such a 'shore stone' as its discovery is not

Fig. 18.2 Radford's sketch of Birsay Ogham 2(1960), Radford NB7 39R (Reproduced by permission of Heritage England)

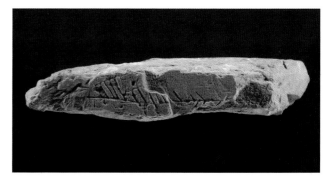

Fig. 18.3 Birsay Ogham 3 (1980), excavated by VESARP: NMRS (Photo: Crown copyright RCAHMS. DP097418. Licensor www. rcahms.gov.uk)

mentioned in any other published or archival source (such as Cruden's or Radford's own notebooks from the time), and no illustration of a third ogham stone exists from the 1960s. Significant doubt must therefore remain as to whether or not it ever existed.

It is curious that these earlier ogham stones from Birsay are not mentioned by Cecil Curle in her publication of the finds from the Brough, although she did note the recent discovery of an ogham-inscribed stone during our excavations in 1980.[49] In addition to these three ogham-inscribed slabs, a small pebble, possibly a gaming piece, was recovered by Radford from Paved passage 1, in Area II, from the Lower Norse horizon. It is incised with lines which Curle suggested might be ogham and will henceforth be listed as 'Birsay 4'.[50] It is now in Tankerness House Museum, Kirkwall.

The recently-excavated ogham stone, now called 'Birsay 3' (see Fig. 18.3),[51] was found in Site IV South, re-used in an area paved with large sandstone flags.[52] No other finds were recovered from this context which was sealed by one of the mixed rubble spreads between Structures E and S, but it was taken at the time to indicate the existence of an important pre-Norse phase in this part of the site.[53] Unfortunately the stratigraphy in this area is compressed and neither straightforward nor unambiguous, but in working it out the author has been assisted by work on radiocarbon dating by Zoe Outram of Bradford University.[54] The Phase (E1/Episode 10) from which it came comprises areas of stone flagging and deposits of clays and loams, and Phase E2 (Episode 9), which is over the ogham stone, includes clays and loamy deposits, some burnt, together with flagged areas, stone spreads and other stone features. The stone's context (APV: Phase E1/Episode 10) was not itself dated but lay on top of a context APX in Phase D2/Episode 11. Phase D was a phase made up of two episodes. Phase D1 (Episode 12) included a number of miscellaneous deposits and features, especially of loamy clay and burnt deposits. From two of these, radiocarbon determinations were able to be made on included material, both of which have given a C-14 modelled age-range at 2-sigma of cal AD 680–785, i.e., entirely within the late Pictish period. Phase D2 (Episode 11) consists of areas of clay loam, stones and features, and burning (especially, it should be noted, a charcoal spread ALX which was sampled for C-14). It should be noted that this is the episode of activity below the ogham stone and that the sample taken for C-14 has now been modelled at 2-sigma to cal AD 695–820, in other words, the late Pictish period going into the very early Viking period.

The context above the stone (ALU: Phase E2/Episode 9) was not dated, but a context (LL) in the later Phase G (Episode 7) produced a date of cal AD 735–880, implying that the stone's deposition probably occurred within the same late Pictish, possibly very early Viking, period. Despite the problems of the stratigraphy of this area, Birsay 3 is one of very few ogham inscriptions to have been discovered in an archaeologically stratified context, and the date of its deposition therefore provides a credible *terminus ante quem* for its carving. It does not, therefore, seem unreasonable on archaeological grounds to assert that this is an ogham inscription from the Pictish period.

Birsay 3 is a large triangular slab of ferric rich calcareous siltstone. The slab is intact and measures 310 × 350 × 460mm and is 650mm in height. The ogham inscription runs along the flattest edge for approximately 170mm (see Fig. 18.4). It appears unlikely that we have the entire original inscription and Katherine Forsyth has suggested that, if the ogham was indeed carved when the stone was *in situ* in a wall, it is possible that the text continued across the join and onto the neighbouring stone. The stem runs roughly parallel with the long edge, but it is not placed medially. The strokes have been sharply and fairly deeply incised with a blade, and Forsyth observes that the stem is a little more substantially carved than the letter strokes.

Of course, as far as our understanding of ogham inscriptions goes, at the time of the discovery of this stone in our excavations, the conventional understanding was that, although they represented a system of writing adopted either via Irish missionaries or from the Scots of Dalriada and could be transliterated into Latin letters, the inscriptions largely made no sense (apart from a few linguistic borrowings), since they came out of a non-Celtic, non-Indo-European background which was never a written language.[55] Indeed

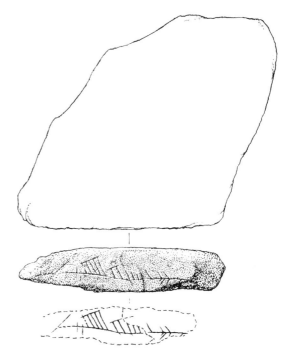

Fig. 18.4 Birsay Ogham 3 (1980), excavated by VESARP: NMRS (© RCAHMS SC147014. Iain Scott Collection. Licensor: www. rcahms.gov.uk)

this was precisely what Professor Kenneth Jackson of Edinburgh University informed us when shown pictures of the inscription on the stone.[56] Jackson's conclusion for us was as dismissive as it was to Anna Ritchie at the end of his analysis of the inscription on the spindle whorl from near-by Buckquoy: 'We must be content to write off this inscription as unintelligible, like all the other 'Pictish' inscriptions'.[57]

Even with these essentially negative messages, however, archaeologists make other connections, and both Dr Anna Ritchie and I were concerned to demonstrate that there was an unusual concentration of these ogham inscriptions in the Birsay area within Orkney – as well as drawing attention to a more general distribution of these north of the Dornoch Firth.[58] Ritchie also ventured to suggest that the one from her excavations at Buckquoy, on a sandstone spindle-whorl, while deemed a 'chattel inscription' by Padel,[59] might have had 'talismanic' or magical connotations, being related to the 'older Pictish tongue'.[60]

At this time, however, a new linguistic approach was being explored which first became evident to the wider academic community in 1996 with the publication of the journal containing Katherine Forsyth's revisionary article on the Buckquoy ogham-inscribed spindle-whorl. In this she argued for the text being in Old Irish, rather than Jackson's 'unintelligible non-Celtic Pictish', and put forward a reading of *benddact anim L* (A blessing on the soul of L …).[61] This formed part of her wider examination of the corpus of ogham inscriptions in Scotland, [62] and was followed up by her even more revisionary paper on *Language in Pictland* with the crucial sub-heading *the Case against 'non-Indo-European Pictish'*.[63] It is clear that the wider scholarly community has now rejected the earlier Jackson hypothesis, and is following Forsyth's revisionism.[64]

Padel, who is the only scholar (apart from Radford) to have actually examined the earlier ogham inscriptions from Birsay on the stones themselves, considered them both to 'have a casual, carelessly incised appearance and unlikely to have been designed as formal long-lasting monuments' and comparable in their informality with the later Maeshowe runic inscriptions, dating perhaps to the ninth century.[65] Katherine Holman extended this by observing that:

> The discovery of three ogams and five runic inscriptions from the same site is intriguing, particularly given the possibility of some kind of overlap between the two cultures that is suggested by the early date of the seal's tooth and the two ninth-century ogams.

She also suggested that the nature of the Brough of Birsay as a high-status settlement 'attracted literate residents and visitors and/or required the services of literate people in both the Pictish and Norse periods.'[66]

Barnes and Page have tended to underline this latter point, on the basis that the Brough 'was a major ecclesiastical site' and noted that, in contrast to the ogham inscriptions, only one of the runic inscriptions (Birsay 1) could be regarded as a graffito.[67] However, in her work on the Buckquoy spindle-whorl, Forsyth emphasised that, while the inscription is 'a Christian phrase written in Old Irish', it and the earlier Brough inscriptions,[68] like that from Gurness which has no ecclesiastical connotations:[69]

> share an informality which suggests that ogham literacy was not highly restricted, or reserved for solemn, formal purposes. It would be wrong, therefore, to assign an ecclesiastical interpretation to the Brough on the basis of the presence of ogham.[70]

Forsyth initially examined our excavated inscribed stone (Birsay 3) as part of her PhD work on the corpus of Scottish ogham inscriptions,[71] but we also agreed that, because of the problems associated with the previous two inscriptions, I would furnish any information to her which might emerge from my archival work on the earlier excavations.[72] Later, as the ogham-inscribed stone was one of the most iconic artefacts to have been recovered from our excavations, and the other inscriptions which had been recovered from the site before were self-evidently imperfectly understood, Historic Scotland agreed that she should re-examine them all for the final site report.[73] The brief summary that follows of salient points from her comprehensive discussion is presented as an appetiser for her comprehensive (and hopefully definitive) study.

Birsay 1, from 1934,[74] has six characters, of which only some are legible. The following tentative reading is possible, with the inversion of Radford's sketch:

—[..]Q I · A [.]—

As Padel noted, if the first letter is an A, then the reading AQI · A, for *(M)aqi A(—),* 'of the son of A—'is possible, though, of course, highly speculative.

Birsay 2, from 1960,[75] has eleven characters, of which only five can be read with confidence; three are damaged and the transliteration of a further three is uncertain. Forsyth's detailed analysis (again of Radford's sketch inverted) in the forthcoming study gives a conservative reading as follows:

| (.)*O*(.)NORRA(.)*R* R |

She states that a less cautious one would be:

| (M)*O* (N)NORRA(N)*R* R |.

There is no indication of word-division and, indeed, this could be a single word. Also Forsyth considers that the final sequence of characters 'is not phonologically possible within Celtic whether Brittonic (i.e., Pictish) or Gaelic' and she also outlines problems with a Norse interpretation, although there is an 'intriguing parallel' with the Birsay 1 rune-stone.

It is unlikely that we have the entire inscription of our own Birsay 3 from 1980. Approximately a further 60mm of stone would have been available originally, sufficient for two to three letters. Even that would be surprisingly, though not improbably, short. The tentative reading is as follows:

—[.][.] Q Q H *O* [.]—

While this is really too short for meaningful analysis, it is worth noting that, like Birsay 1, it also contains Q, a letter which Forsyth notes that elsewhere in Scotland appears only in the formula word MAQQ (and spelling variants), 'son of', which is ubiquitous in early Irish ogham inscriptions in the formula X MAQQI Y ('of X, son of Y').[76] Birsay 3 has a double Q which *might* be preceded by MA, giving: —MAQQHO— *Maqq-Ho*— 'son of Ho—', and this is discussed in the detailed study.

Birsay 4,[77] from the 1930s excavations, has been identified as a gaming piece comprising part of a diverse collection from the Brough,[78] with four ogham-like linear marks on its underside. Although not examining it directly, Forsyth is content that the likeliest explanation is that the marks are indeed ogham characters: a long straight stem and three strokes. She suggests they can be read as bab (BAB) or bmb (BMB), and speculatively related to the Old Irish interjection *babb*.[79]

Focussing on the ogham-inscribed slabs, there are some orthographic and palaeographic features noted by Forsyth which might indicate 'a unified ogham tradition, a zone of cultural interconnectedness, in the eighth and ninth centuries.'[80] It is unfortunate that all three Birsay slabs were found in secondary positions, but comparative examples discussed in the forthcoming study, although often only loosely dated, appear to belong to the late Pictish or the early Norse periods. This is consistent with the archaeological date indicated for the re-use of Birsay 3, radiocarbon dated to cal AD 695–820. As this radiocarbon date relates to the stone's re-use, it indicates that Birsay 3, at least, probably *was* carved in the Pictish period. Additionally, Forsyth notes that it is notable that Birsay 3, as well as being one of very few archaeologically datable stones, also provides an important dating point for the innovative 'bind-ogham' form of the script which it exhibits.

We have noted comments above about the concentration of both runic and ogham inscriptions in Birsay and the links to, and implications for, literacy here. But perhaps, before we push interpretation in this arena too far, it would be wise to step back and inject a degree of scepticism into the analysis, leaving the last word for the moment here with a linguist, rather than an archaeologist:

> Whether this high total reflects higher levels of literacy on and around the Brough, or merely the intense archaeological attention lavished on Birsay for over fifty years is unclear.[81]

Envoi

Between forty and forty-five years ago I first met Richard Bailey, he as an established university lecturer and I as a young college lecturer undertaking a part-time research degree under Rosemary Cramp's tutelage. What we particularly had in common then was an interest in the Anglo-Scandinavian sculpture of the north of England – he in Cumbria, I (following my undergraduate dissertation work) in Yorkshire and the Tees Valley area. This was reinforced when I moved up to join Rosemary in the University Department of Archaeology at Durham in 1972, and we were both then recruited, along with our mutual great friend the late Jim Lang, to the nascent Corpus of Anglo-Saxon Stone Sculpture project that she was getting off the ground. However, as I have described elsewhere:

> As is sometimes the way of these things, it didn't quite go to plan: some things were completed, others not, and circumstances were such that my research into the Anglo-Scandinavian impact upon northern England occupied less and less of my attention as the years went by … by the 1980s I had then diverted into aspects of Viking archaeology elsewhere in the British Isles.[82]

One of the major aspects was the investigation of key sites of the Norse Orkney earldom, and in particular those around Birsay Bay.[83]

Richard, as the Professor of Anglo-Saxon Civilisation, linking the literature, linguistics, art history and architectural history of the period, necessarily took a great interest in inscribed monuments. Within his own beloved area of Cumbria, Bewcastle received significant comments in his own works,[84] and similarly he has had critical, if often pithy, analysis to add regarding inscriptions in the Viking period:

> But if the linguist and the epigrapher offer the Viking art-historian little help in isolating Viking-age carvings this does not mean that we should ignore the few crumbs which they do make available.[85]

Or:

> … as is inevitable among runic studies, the acerbity of the discussion has been in inverse proportion to the number of characters available for debate.[86]

What I have offered here to Richard is a small interim foretaste of an aspect of the work from a project that I hope will be of interest in linking back to our earlier shared interest in stone monuments. He can now have a wry smile as he contemplates the summary of the evidence I have brought forward for the presence of both runic and ogham inscriptions on the Brough of Birsay!

Notes

1 Wilson 1982, 5.
2 Dryden 1996; Fawcett 1996; Mowbray 1996; Henderson 1996; Emery & Morris 1996.
3 Marwick 1922; Emery & Morris 1996, 217.
4 Ibid., 219.
5 Curle 1982, 59–60, 101; see ills 5, 16.
6 RCAHMS 1946, ii, 3, no. 1, 35–6, no. 120.
7 Liestøl 1984; Holman 1996; Barnes & Page 2006.
8 Liestøl 1984, 236.
9 Ibid., 225, figs 72–3, 226–7.
10 Ibid., 227.
11 The best photographic illustration remains that in RCAHMS 1946, ii, pl. 7, fig. 71; a more recent one in Barnes & Page 2006, 391, pl. 26, taken of the stone mounted in display in the Museum in Edinburgh, unfortunately has a shadow on the right-hand side.
12 Holman 1996, 233–6, 226.
13 Barnes & Page 2006, 166–72, 343; fig. 18 on 169 provides an accurate line-drawing.
14 Barnes & Page 2006 illustrate these with fine photographs taken by Anders Baeksted of the National Museum of Denmark: pls 28 and 29 on 292, with line drawings on 177, fig. 20 and 180, fig. 21. Liestøl provides annotated photographs: Liestøl 1984, 226–7, figs 72, 73.
15 Holman 1996, 236–7.
16 Barnes & Page 2006, 176–9, 343. The only illustration is a photograph by M.P. Barnes in Barnes & Page 2006, 393, pl. 30.
17 Ibid., 179–80, 343.
18 Holman 1996, 237–8.
19 Barnes & Page 2006, 180–1, 344.
20 Ibid., 92.
21 Holman 1996, 239–40; Barnes & Page 2006, 90–1.
22 The best illustrations are photographs in Curle 1982, 59, ill. 37 and Barnes & Page 2006, 395, pl. 32.
23 Mowbray 1996, 274; Curle 1982, 59, 110 and ills 5, 16; Emery & Morris 1996, ills 180, 233; Barnes & Page 2006, 187.
24 See Emery & Morris 1996, ill. 185 (Middle Norse plan) and 190 (Upper Norse plan); Curle 1982, ill. 5 (Middle and Upper Norse layers).
25 Holman 1996, 238; Barnes & Page 2006, 191; Curle 1982, 101.
26 Liestøl 1982; 1984, 232; Holman 1996, 238.
27 Barnes & Page 2006, 188–9.
28 Liestøl 1982; Curle 1982, 60; Liestøl 1984, 232; Holman 1996, 238; Barnes & Page 2006, 190–1.
29 *Radford NB3*, 32L.
30 Radford 1959, 5.
31 *JSR1934Letter;* Emery & Morris 1996, 219.
32 *Radford NB3*, 33L; Padel 1972; see further below.
33 Cf entry in *SHCNotes* for 30th [May] 1956: 'CARR took rubbings with powder black and tissue of two cross slabs in museum, and all the runes.'[I assume this may well have included the ogham stone as well – and suggest the possibility that this may be the origin of the rubbing for the drawing used by Padel for his 'Birsay 2'].

34 *SHCNotes*: Season 1960: 23 May–3 June: Viking House Room 4.
35 Curle 1982, 16, ill. 5; Emery & Morris 1996, 238, ill. 185 and 232, ill. 179.
36 *Radford NB4*, 15; *SHCNotes*: Season 1960: 23 May–3 June: Viking House Room 4.
37 Cf Curle 1982, 48.
38 *Radford NB7*, 44L & R.
39 *SHCNotes*: Season 1960: 23 May–3 June: Viking House Room 4.
40 *Radford NB7*, Birsay 1960, 39R.
41 Padel 1972.
42 This also means that, although dubbed the 'Wall Stone', it is incorrect now to link it with either pre-war work or the church and churchyard area of the site – it is clearly from Area I, i.e., east of the church, called by Radford and Cruden 'Area A' and in the pre-war and RCAHMS parlance as 'the Viking House'.
43 Radford 1962b, 174.
44 Radford 1962a, 11.
45 Radford & Cruden 1961, 311; Cruden 1965, 25; Radford 1962a, 11; 1962b, 174.
46 Radford 1962a, 11; 1962b, 174; Wainwright 1962b, 96 & 97, map, in the same publication, also refers to this stone
47 See Forsyth 1996.
48 *SHCNotes*: 1963 Season. It is quite likely that 'runestones' is a notebook-shorthand for all the inscribed stones (i.e., two rune-stones in the museum, one *in situ*, and one ogham stone).
49 Curle 1982, 86.
50 Ibid., 120, no. 595, 70, ill. 45; Forsyth forthcoming.
51 Listed as 'Birsay 3' in Katherine Forsyth's catalogue in Chapter 16 of Morris forthcoming.
52 BB 80, layer 543/APV and Recorded Find 2761.
53 As previously noted in Morris 1981, 36 and 40; Morris 1982, 52.
54 The details of the stratigraphy will be found in Chapter 14, and Zoe Outram's discussion and analysis of the radiocarbon dates (Outram forthcoming) in Chapter 16 of Morris forthcoming.
55 Jackson 1955, 138–42; Henderson 1967, 31; Ritchie 1989, 20.
56 He was not interested in examining the stone itself.
57 Jackson 1977, 222.
58 Ritchie 1985, 191–2; Morris 1995, 20.
59 Padel 1972, quoted by Ritchie 1985, 192.
60 Ritchie 1983, 53; 1985, 192.
61 Forsyth 1995a.
62 Forsyth 1996.
63 Forsyth 1997; see also Forsyth 1995b.
64 E.g. Foster 1996, 24; Carver 1999, 15.
65 Ritchie 1985, 192, with references to Padel 1972.
66 Holman 1996, 240.
67 Barnes & Page 2006, 92.
68 Forsyth 1995, 692.
69 Forsyth 1996, 321–32.
70 Forsyth 1995a, 693.
71 Forsyth 1996.

72 The material referred to earlier which I examined from the Radford and Cruden archives regarding these stones has therefore been passed on also to her and has been utilised by her in her own work.

73 Forsyth forthcoming: it will be in Chapter 16 of Morris forthcoming.

74 Re-numbered by Forsyth from Padel's 'Birsay 2' to reflect the chronology of discovery.

75 Re-numbered by Forsyth from Padel's 'Birsay 1' to reflect the chronology of discovery.

76 McManus 1991.

77 For illustration, see Curle 1982, 70, ill. 45, no. 595.

78 Hall 2007, 48–9.

79 Or, if inverted, hah (HAH) or hmh (HMH).

80 Forsyth forthcoming.

81 Forsyth forthcoming.

82 Morris 2009, 210.

83 Morris 1989; 2006.

84 E.g. Bailey 1980, 46; Bailey 1996, 42–4.

85 Bailey 1980, 52–3.

86 Bailey 1996, 24.

References

Bailey, R.N., 1980 *Viking Age Sculpture in Northern England* (London)

Bailey, R.N., 1996 *England's Earliest Sculptors*, Publications of the Dictionary of Old English 5 (Toronto)

Barnes, M.P. & Page, R.I., 2006 *The Scandinavian Runic Inscriptions of Britain* = Runrön 19, Runologiska bidrag utgivna av Institutionen för nordiska språk vid Uppsala universitet (Uppsala)

Carver, M., 1999 *Surviving in Symbols. A Visit to the Pictish Nation*, The Making of Scotland (Edinburgh)

Cruden, S.H., 1965 'Excavations at Birsay, Orkney' in A. Small (ed.), *The Fourth Viking Congress, York, August 1961*, Aberdeen University Studies 149 (Edinburgh & London), pp 22–31

Curle, C.L., 1982 *Pictish and Norse Finds from the Brough of Birsay 1934-1974*, Society of Antiquaries of Scotland Monograph Ser. 1 (Edinburgh)

Dryden, H.E.L., 1996 'The Ruined Church on the Brough of Birsay', Appendix 3 in Morris 1996, pp 267–8

Emery, N. & Morris, C.D., 1996 'The Excavations on the Brough of Birsay 1934–9' in Morris 1996, pp 209–55

Fawcett, R., 1996 'The Excavation of the Church on the Brough by Sir Henry Dryden in 1866', Section 10.2.1.2 in Morris 1996, pp 210–17

Forsyth, K., 1995a 'The Ogham-inscribed Spindle-whorl from Buckquoy: Evidence for the Irish Language in pre-Viking Orkney?', *PSAS* 125, 677–96

Forsyth, K., 1995b 'Language in Pictland, Spoken and Written' in E.H. Nicoll & K. Forsyth (ed.), *A Pictish Panorama: the Story of the Picts* (Balgavies), pp 7–10

Forsyth, K., 1996 'The Ogham Inscriptions of Scotland: an Edited Corpus' (PhD, Harvard University; microfilm copy: University of Michigan, Ann Arbor, MI)

Forsyth, K., 1997 *Language in Pictland: the Case against 'non-Indo-European-Pictish'*, Studia Hameliana 2 (Utrecht)

Forsyth, K., forthcoming 'Ogham Inscriptions from the Brough of Birsay' in Morris forthcoming

Foster, S.M., 1996 *Picts, Gaels and Scots* (London)

Hall, M.A., 2007 *Playtime in Pictland: the Material Culture of Gaming in Early Medieval Scotland*, Groam House Lecture 2006 (Rosemarkie)

Henderson, I., 1967 *The Picts* (London)

Henderson, W. [compiled by C.D. Morris], 1996 'Report on Excavations on the Brough of Birsay, 1938-9', Appendix 5 in Morris 1996, pp 278–91

Holman, K., 1996 *Scandinavian Runic Inscriptions in the British Isles: their Historical Context*, Senter for middelalderstudier, Skrifter nr. 4, Norges teknisk-naturvitenskapelige universitet (Trondheim)

Jackson, K.H., 1955 'The Pictish Language' in Wainwright 1962a, pp 129–66

Jackson, K.H., 1977 'Appendix 6. The Ogam Inscription on the Spindle Whorl from Buckquoy, Orkney' in A. Ritchie, 'Excavation of Pictish and Viking-age Farmsteads at Buckquoy, Orkney', *PSAS* 108, 174–227

Liestøl, A., 1982 [contribution to] 'Pendant from a seal's tooth', in Curle 1982, 59–60

Liestøl, A., 1984 'Runes' in A. Fenton & H. Pálsson (ed.), *The Northern and Western Isles in the Viking World. Survival, Continuity and Change* (Edinburgh), pp 224–38

Marwick, H. [M.], 1922 'A Rune-Inscribed Stone from Birsay, Orkney', *PSAS* 56, 67–71

McManus, D., 1991 *A Guide to Ogam*, Maynooth Monograph 4 (Maynooth)

Morris, C.D., 1981 'Excavations at Birsay, 1980', *Universities of Durham and Newcastle Upon Tyne Archaeological Reports for 1980* 4, 35–40

Morris, C.D., 1982 'Excavations at Birsay, Orkney', *Universities of Durham and Newcastle Upon Tyne Archaeological Reports for 1981* 5, 46–53

Morris, C.D., 1989 *The Birsay Bay Project, 1: Coastal Sites beside the Brough Road, Birsay, Orkney. Excavations, 1976–1982*, University of Durham, Department of Archaeology Monograph Series 1 (Durham) [with contributions from Colleen E. Batey, Norman Emery, D. James Rackham and others]

Morris, C.D., 1995 'Birsay: an Orcadian Centre of Political and Ecclesiastical Power: a Retrospective View on Work in the 1970s and 1980s' [O'Donnell Lecture 1993, University of Wales], *Studia Celtica* 29, 1–29

Morris, C.D., 1996 *The Birsay Bay Project, 2: Sites in Birsay Village and on the Brough of Birsay, Orkney*, University of Durham, Department of Archaeology Monograph 2 ser. (Durham) [with contributions from Beverley Ballin Smith, John W. Barber, Colleen E. Batey, Norman Emery, D. James Rackham and others]

Morris, C.D., 2009 'Revisiting Anglo-Scandinavian Settlement and Sculpture' in C.E. Karkov (ed.), *Poetry, Place and Gender. Studies in Medieval Culture in Honor of Helen Damico* (Kalamazoo, MI), pp 211–33

Morris, C.D., forthcoming *The Birsay Bay Project, 3: The Brough of Birsay, Orkney Investigations 1955–2010* [with contributions from Colleen E. Batey, David W. Griffiths, Norman Emery, Richard Fawcett, D. James Rackham, Zoe Outram, Susan Ovenden and others] (Edinburgh)

Mowbray, C.L. [= Curle, C.L.], 1996 'Report on Excavations on the Brough of Birsay, 1936–7', Appendix 4 in Morris 1996, pp 269–77

Outram, Z., forthcoming 'The Radiocarbon Dating Evidence from the Excavations carried out at the Brough of Birsay 1973–1981' in Morris forthcoming

Padel, O., 1972 'Inscriptions of Pictland' (MLitt, University of Edinburgh)

RCAHMS 1946 *Twelfth Report with an Inventory of the Ancient Monuments of Orkney and Shetland*, 3 vols (Edinburgh)

Radford, C.A.R., 1959 *The Early Christian and Norse Settlements at Birsay*, Official Guide (Edinburgh)

Radford, C.A.R., 1962a 'The Celtic Monastery in Britain', *Archaeologia Cambrensis* 111, 1–24

Radford, C.A.R., 1962b 'Art and Architecture: Celtic and Norse' in Wainwright 1962a, pp 163–87

Radford, C.A.R. & Cruden, S.H., 1961 'Orkney: Brough of Birsay' in D.M. Wilson & D.G. Hurst (ed.), 'Medieval Britain in 1960', *Med. Arch.* 5 (1961), 311

Ritchie, A., 1983 'Birsay around AD 800', *Orkney Heritage 2. Birsay: a Centre of Political and Ecclesiastical Power* (Kirkwall), pp 46–66

Ritchie, A., 1985 'Orkney in the Pictish Kingdom' in C. Renfrew (ed.), *The Prehistory of Orkney BC 4000–1000 AD* (Edinburgh), 183–204

Ritchie, A., 1989 *Picts. An Introduction to the Life of the Picts and the Carved Stones in the Care of the Secretary of State for Scotland* (Edinburgh)

Wainwright, F.T. (ed.), 1962a *The Problem of the Picts* (London & Edinburgh)

Wainwright, F.T., 1962b 'Picts and Scots' in Wainwright 1962a, pp 91–116

Wilson, D.M., 1982 'Foreword' to Curle 1982, 5

Appendix: Primary Sources

Historic Scotland

Grey/buff folder with miscellaneous Brough of Birsay papers. Copies supplied *per* P.J. Ashmore (and listed) 1983/4, to be deposited by PJA in National Monuments Record of Scotland, RCAHMS, September 2004:

- *JSR1934Letter*: Letter of 3 July 1934 from J.S. Richardson to Mr Robb.

Box file labelled 'Stewart Cruden Notebooks'. Copies supplied *per* P.J. Ashmore (and listed) 1983/4, to be deposited by PJA in National Monuments Record of Scotland, RCAHMS, September 2004.

- *SHCNotes*: Stewart H. Cruden Unpublished Notebook on 'Birsay Excavations 1956–1964'.

National Monuments Record, Swindon

C.A. Ralegh Radford Birsay Archive, now copied for National Monuments Record of Scotland in RCAHMS Edinburgh:

- *Radford NB3: Note-book 3*: Internal evidence seems to indicate that this is a note-book from Birsay 1955–6 (plus notes on visits to non-Birsay sites) with occasional later annotation.
- *Radford NB4: Note-book 4*: Sketches and measurements for various different parts of the site investigated, especially between 1957–61.
- *Radford NB7: Note-book 7*: 'Brough of Birsay' by year 1957–63 inclusive listing of sections, together with sketches, level measurements and brief descriptions of deposits in work each year.

An apsidal building in Brixworth churchyard, Northamptonshire

David Parsons

Introduction: dowsing as an archaeological technique

The publication of *Dowsing and Church Archaeology* was a bold move by our honorand.[1] In his foreword to the book Professor Charles Thomas wrote that it could be regarded as a 'brave book', while deploring that innovative work tended to attract this sort of soubriquet. He further argued:

> One cannot dismiss the practice of dowsing or divining, with any sort of instrument, for water or for subterranean anomalies just because we have no agreed explanation as to what force is involved … Nor can one discredit the practice because … people use the rod to trace ley lines, mysterious earth forces or the like.

Despite such authoritative words of support, many archaeologists have remained doubtful about the validity of the technique and tend to regard anyone employing it as part of the subject's lunatic fringe. Apart from the anticipated reviews at the time of publication, there have been few attempts to treat the subject seriously in the archaeological literature.

A notable exception to this is Martijn van Leusen's article on 'Dowsing and Archaeology', published ten years after the appearance of Bailey et al. 1988.[2] This article reviews the literature on archaeological dowsing and includes detailed coverage of the Bailey publication. It takes a critical stance on the subject, both on the general grounds that apparently successful results from dowsed surveys could be predicted on the basis of a general knowledge of the subject, and on the more scientific grounds that archaeologists do not understand scientific method and the theory of probability, that their trials of dowsing are not properly set up with double blinds, and so forth. Not only do archaeologists attract criticism but dowsers seeking sources of water are dismissed because 'in most areas one will find groundwater

fairly close to the surface wherever a well is dug',[3] although the technique is known to be used commercially for the location of sources of water and oil and the identification of lost drainage channels. The author implies that results can be 'fixed' from a knowledge of the subject: the plan typical of Norman churches is cited as illustrating the fact that 'a pattern was adhered to by the medieval architects and builders',[4] thus making survey results predictable (as though informed prediction were not in any case used as a tool in the identification of archaeological sites).

Criticism is levelled more specifically at Bailey et al. 1988 on the grounds that 'churches must count among the worst places in which to conduct dowsing tests',[5] despite the fact that *Dowsing and Church Archaeology* devotes a complete chapter to discussing the difficulties inherent in applying established geophysical techniques in and around churches,[6] and that dowsing was being investigated as an alternative means of prospection in inauspicious circumstances. Rather than being intended as an objective assessment of the technique of the sort carried out by Martin Aitken in the 1950s,[7] it was an application of last resort. Predictably, more scathing criticism is aimed at the notion of 'imprinting', which is a sitting target for dowsing sceptics. In considering the work carried out at Woodhorn, Ponteland and Hexham, van Leusen accuses the authors of 'breaking their own rules' by using documentary evidence alongside the dowser's findings. Only at Hexham was this evidence known beforehand; at Woodhorn it is implied, though not clearly stated, and at Ponteland manifestly explicit, that the documents were not consulted until after the dowsing had been carried out.

Thus this attempt by van Leusen to dismiss *Dowsing and Church Archaeology* is itself not beyond criticism and the use of dowsing cannot be regarded as discredited merely on the grounds of his objections. Doubts will always remain, however, at least until a valid scientific explanation for

the technique is forthcoming. Bailey et al. fully expected this: the present writer's copy of the book is inscribed 'For David (who won't believe a word of it)'. Scepticism notwithstanding, it seemed that nothing would be lost and something might be gained by applying the technique at All Saints', Brixworth.

The Brixworth survey

The work of the Brixworth Archaeological Research Committee has been fully reported in a monograph linked to an article in a learned journal.[8] As a framework for ground survey and possible excavation a series of base station points was established in the churchyard, from which a 10-metre grid was derived to act as the basis for all future recording.[9] Conventional geophysical survey techniques were applied to the area surrounding the church and ground-penetrating radar was used in the last stages of the project.[10] The recording of the standing fabric took place in short annual seasons from the late 1970s to the early 1990s, and was an established event at the time that the fieldwork reported in Bailey et al. 1988 was taking place. The site notebook records a visit by our honorand and his son Nigel on 30 June 1983. They took the opportunity to demonstrate the technique of dowsing in the churchyard, which generated considerable interest on site, but the Committee was reluctant to pursue this form of surveying. With the appearance of the book in 1988 further impetus was given to the idea of carrying out a dowsing experiment at Brixworth, and as a private initiative the services of a local dowser, Mrs Kay Davison, who had some experience of archaeological dowsing elsewhere in Northamptonshire, were engaged.

In the late 1980s and at intervals during the 1990s Mrs Kay Davison, with the assistance of her late husband, Eric, carried out a dowsed survey of much of the southern part of the Brixworth churchyard. In the eastern half of this area the survey revealed what appear to be small rectangular anomalies, which could be substantial tomb structures or mausolea. To the south of the nave of the church, however, a coherent group of possible structures appeared, forming a row at right angles to the axis of the church. Further to the south, and close to the southern perimeter of the churchyard, a substantial building parallel to the church was identified. It was a rectangular structure with a full-width eastern apse; its approximate external dimensions were 20 × 10.5m (Fig. 19.1).[11] In view of the interpretation of this putative building offered below, it is important to establish at the outset that:

(a) the dowser had not been given any indication of what results to expect or asked to search for any particular feature or type of feature; she was simply asked to identify any anomalies that might indicate the remains of buildings of whatever sort;

(b) in so far as the Brixworth team (in particular the present writer) was aware of the documentary evidence for a free-standing medieval chapel in the churchyard, it was not known or suspected where in the churchyard it was located or what form it might take;

(c) Mrs Davison was not aware of the existence of this documentary evidence.

The scale of the building discovered was surprising: its length is comparable with that of the nave of the church itself. Unlike some of the smaller anomalies recorded it deserves to be taken seriously and calls for a full interpretation. Another surprising feature, and one that could not have been predicted or 'invented' as van Leusen might have it, was the arrangement of small anomalies in a pentagonal pattern inside the building. It is a puzzling feature, but its central position in the body of the building, its alignment with the building's axis and the exact orientation of one of its angles on (ritual) east imply that it is not a random feature with no connexion with the building, and that it must be interpreted as some sort of internal furnishing or fitting. The slight size of the five corner indicators suggest perhaps canopy supports. Although obviously related to the surrounding building, they need not necessarily be contemporary with it; if later in date, one is tempted to suggest an association with the tomb of William de Brikelsworth – but this is to anticipate the interpretation of the building itself.

Verification

Two attempts have been made to find independent evidence for a building or buildings in the area of the churchyard concerned. In December 1992 a team from Leicester University carried out a resistivity survey in a twenty-metre square overlapping the apsidal building. High-resistance anomalies suggested the west end of a possible rectangular building, with another square feature to the west of it. These anomalies are shown in Figure 8.9 of Parsons & Sutherland 2013. A plot of the resistivity results in relation to the dowsed evidence is given here in the inset to Fig. 19.1. In December 2014 a similar area was resurveyed by the Hallaton Fieldwork Group, and the smaller anomaly recorded in 1992 was confirmed. The resistivity data do not, however, coincide closely with the dowsed evidence, though they are of similar format. This could have been the result of a setting-out error. It is noticeable that the Hallaton group's square was some two metres to the north-east of the Leicester team's original grid square, which demonstrates the difficulty of surveying around the church from the origin of the site grid at survey point C through a fairly densely-packed area of graves. This could only be overcome by the use of sophisticated electronic survey equipment, not available to the experienced fieldwork group from Hallaton, nor to Mrs Davison when she carried out the dowsing survey.

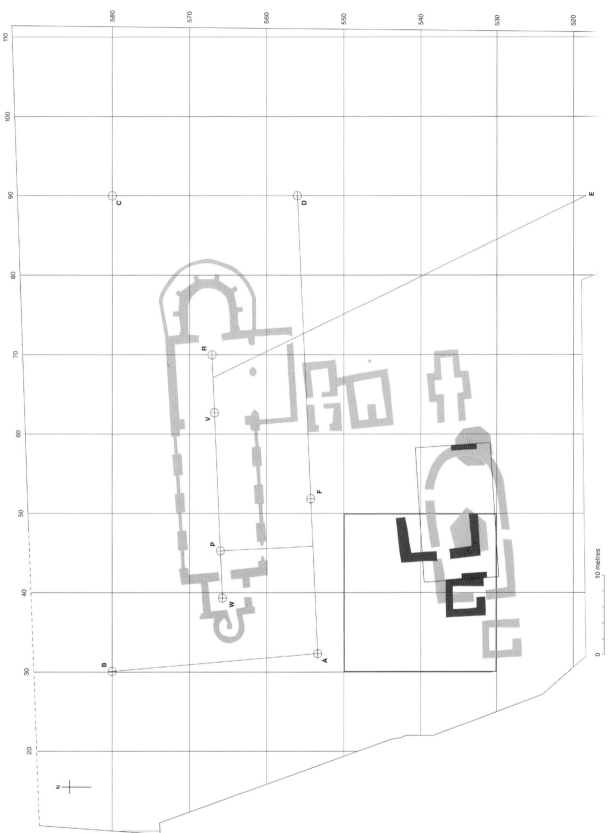

Fig. 19.1 Plan of Brixworth church and southern churchyard, showing location of survey points and 10-metre site grid; results of dowsed survey green; 20 x 20m resistivity survey area shown with select results in dark blue; GPR area 6 and possible anomalies shown in black (Drawing: Christina Unwin)

It is possible that the resistivity and dowsing evidence do coincide, but it is no longer possible to check the location of the latter. The resistivity evidence does not amount to proof of the results of the dowsing survey, but clearly indicates that there are anomalies in that area of the churchyard which would repay further investigation.

Interpretation

The apsidal east end of the building discovered suggests a liturgical rather than a domestic function. This form would be consistent either with a chapel or with a chapter house (Fernie notes that the commonest form for a chapter house was a longitudinal building with an apse).[12] There is some unreliable documentary evidence that Brixworth was 'monastic' in the pre-Conquest period, but there is no suggestion that there was any monastic community here later in the Middle Ages that would require a chapter house, particularly one of this size, though Fernie draws attention to the relative size and grandeur of major monastic examples like Durham and Norwich.[13] The Domesday record of one priest implies a church at Brixworth; it could be inferred that this was a former minster from the later establishment of Brixworth as a prebend of Salisbury Cathedral ('the last reverberation of a once powerful place'[14]), but there is nothing in the Brixworth entry comparable with Domesday references elsewhere to communities of priests continuing the Anglo-Saxon minster tradition. Further, All Saints' church itself was severely reduced in size at some time during the late Anglo-Saxon or Norman periods, with the loss of the ranges of *porticus* to the north, west and south of the main body of the church. Towards the end of this period a south door was inserted and covered by a conventional single-storey porch (demolished in 1865–6), which implies a parochial arrangement rather than use by a religious community. The chapter house interpretation therefore seems unlikely.

The interpretation of the building as a chapel is an attractive one in view of the documentary evidence from the later Middle Ages. The sixteenth-century chantry certificates refer to the chantry of Our Lady housed in a separate chapel standing in the churchyard and covered with a lead roof, one of a number of such churchyard chapels attested in medieval Northamptonshire and elsewhere.[15] Earlier evidence for this chapel is the will of William de Brikelsworth, proved in the London Husting Court in 1367, which provides for his burial in the *vetus capella* of St Mary *in cimiterio*.[16] The question is, how old was a building described as *vetus* in the fourteenth century? The building revealed by the survey is Romanesque or earlier in form and if this is the chapel referred to it would have been at least 150 years old when William made his will in the mid-fourteenth century. As a result of the suppression of the chantries St Mary's was evidently demolished: in 1550 the building materials – 'all

lead iron glass timber and stones' – were granted to Richard Heybourne and William Dalbye.[17] All traces of this building have long since disappeared.

Single-celled apsidal churches and chapels: comparative examples

Until the appearance of Fernie's *Architecture of Norman England* the study of Romanesque architecture in England relied on the synthesising publications of the 1930s, especially the seminal work of A. W. Clapham.[18] Clapham included a chapter on minor churches and chapels with a page of diagrams showing examples of plan types, in which apsidal east ends were in the majority. These by now well-known examples were highly selective, whereas the study of aisleless apsidal churches published the previous year by F. H. Fairweather aimed to be comprehensive.[19] He listed eighty-seven examples known at that time either as extant buildings or as a result of archaeological investigation including excavation. These were divided into four categories, depending on the number of cells. The dowsed ground plan of the Brixworth structure suggests that the closest comparison is with buildings of Fairweather's Type I, single-celled churches. It is nevertheless possible that the dowsed building had a dividing wall between nave and apse, but that it did not register at the time of the survey. It is also possible that the apse walls were offset in relation to the nave (i.e., that the apse was narrower) but that the building platform or foundations were continuous; dowsing, like other prospecting methods, would not necessarily pick up this subtle distinction, especially if the walls had been robbed down to foundation level. It is therefore prudent to extend the comparison to Fairweather's Type II, two-celled churches. His two sub-categories, IIa and IIb, effectively distinguish between stilted apses and those of simple semi-circular or segmental form (Fig. 19.2). In the context of the present investigation this distinction is not necessarily significant for the interpretation of the survey results. The corpus of examples consists, then, of fifteen Type I and twenty Type II churches, a total of thirty-five.

Since Fairweather wrote, further examples have been discovered, in many cases as a result of archaeological excavation. With the establishment of the journal *Medieval Archaeology* in 1957, such discoveries have been included in the annual review of the preceding year's work (since 1982 entitled 'Medieval Britain and Ireland' and hereafter referred to as 'MBI'). Since 2007 only highlighted entries have been printed in the journal; the remainder are available electronically on a website hosted by Archaeological Data Service. MBI entries are very variable, with some giving the barest details and not followed up by definitive publication. Possible and probable sites of apsidal churches extracted from this source are given in Appendix A, but this list should be regarded as indicative rather than exhaustive,

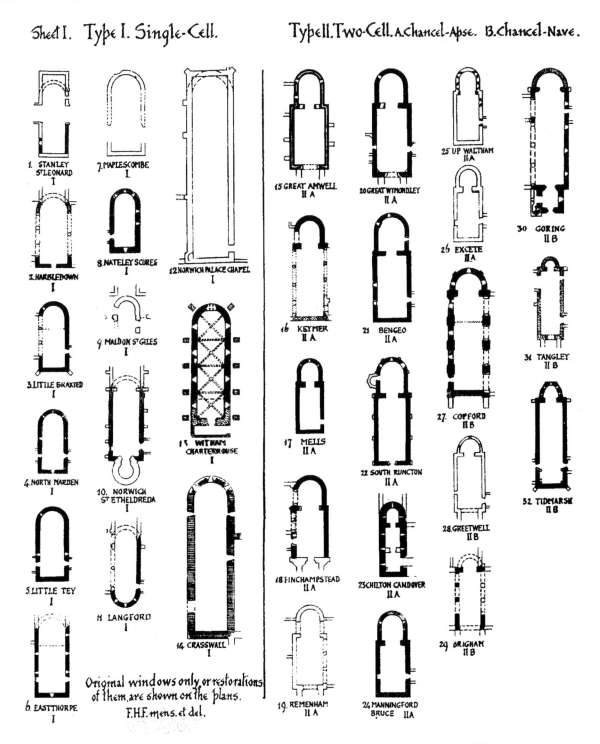

Sheet I. Type I. Single-Cell. Type II. Two-Cell. A. Chancel-Apse. B. Chancel-Nave.

1. STANLEY ST LEONARD I
7. MAPLESCOMBE I
12. NORWICH PALACE CHAPEL I
15 GREAT AMWELL II A
20 GREAT WYMONDLEY II A
25 UP WALTHAM II.A

2. HARBLEDOWN I
8. NATELEY SCURES I
16 KEYMER II A
21 BENGEO II A
26 EXCETE II A
30 GORING II B

3. LITTLE BRAXTED I
9. MALDON ST GILES I
17 MELLS II A
22 SOUTH RUNCTON II A
27 COPFORD II B
31 TANGLEY II B

4. NORTH MARDEN I
10. NORWICH ST ETHELDREDA I
13 WITHAM CHARTERHOUSE I
18 FINCHAMPSTEAD II A
23 CHILTON CANDOVER II A
28 GREETWELL II B
32 TIDMARSH II B

5. LITTLE TEY I
11 LANGFORD I
14 CRASSWALL I
19 REMENHAM II A
24 MANNINGFORD BRUCE IIA
29 BRIGHAM II B

6. EASTTHORPE I

Original windows only, or restorations of them, are shown on the plans. F.H.F. mens. et del.

Fig. 19.2 Plans of apsidal churches of Types I and II (After Fairweather 1933)

since churches described in MBI simply as 'nave and chancel' without specific reference to the form of the east end have been excluded; this group, however, could contain further relevant examples. There is a number of cases where the complete extent of the building was not available for excavation, so that comparative dimensions cannot be obtained. Examples in the recent past are Aberdeen,

St Nicholas, where an apse was excavated in the East Kirk, while the remainder of the building lies under the West Kirk, and its form and extent are unknown.[20] At Dulas Court (Herefordshire) part of the apse of the former church of St Michael was excavated, but the overall dimensions of the building were not ascertainable; what appear to be the remains of a clergy bench running concentrically inside the

apse suggest an early date.[21] Other sites have been reported, but appear not to belong to Fairweather's Types I and II.

As it stands, the list adds another thirty-one examples to Fairweather's corpus. Of these nearly half (fourteen) clearly belong to Fairweather's Type II, and another three may possibly do so. On the basis of the brief descriptions a further ten could belong to either category. Only one clear example of a Type I building was reported, though there are three further possible examples, one of which (Foxley) was a timber building. Adding these to Fairweather's examples, there is thus a potential corpus of nineteen instances of Type I and thirty-seven examples of Type II, a total of fifty-six, with a further ten that cannot with confidence be allocated to a category and four dubious examples. The simple apsidal church of one or two cells is therefore something of a rarity, and in particular there are very few examples of the apsed single-celled variety.

In addition to his main classifications Fairweather noted a number of examples which he characterised as Anglo-Saxon. These he showed on his map, with entries in the appropriate county lists in his gazetteer. Some of these were subsequently included in the Taylors' corpus, which gives further examples apparently not known to Fairweather.[22] All of these sites are listed in Appendix B below, which also includes those items in the list of additional examples (Appendix A) where the excavators claimed an Anglo-Saxon or Saxo-Norman date. This gives a further fourteen examples, excluding Stanley St Leonard, already included in Fairweather's Type I list (Fig. 19.3).

Dimensions

Fairweather's corpus does not provide dimensions for any of the quoted examples, and the plans are reproduced at such a small scale to facilitate comparison that scaling off does not yield reliable results. In extreme cases dimensions derived from his plans, where they can be verified from other sources, can be shown to be wildly inaccurate, for example the church at Great Wymondley, Hertfordshire: scaling from Fairweather's plan produces dimensions of 22.86 × 8.53m (75 × 28ft), whereas the measurements recorded in the Victoria County History are 19.81 × 5.94m (65 × 19ft 6in).[23] In other cases the plan dimensions are close to the actual values: the chapel in the bailey of Colchester Castle appears to be about 15.24m (50ft) long and between 6.1–7.62m (20–25ft) wide; on the basis of the published excavation plan the measurements are fractionally over 15 × 7.08m (49 × 23ft).[24]

It is possible – with due caution – to make some general observations on the basis of Fairweather's plans, subject to further checking. Of his fifteen Type I examples, seven appear to be about 15.25m in length, four about 18.25m and three (all rather special cases) greater than 18.25m; the longest examples are Crasswall Priory, Herefordshire, at 32m and Norwich Palace Chapel, *c.* 42.5m. As a class the Type II churches

are slightly longer. Where dimensions can be ascertained (or estimated from Fairweather's plans), the bulk of the examples fall in the range 16.75–22.8m, with widths almost universally between 6 and 8.5m, the sole exception being Copford at 9.5m. Among the additional examples, two of the probable Type I churches measure approximately 13.4m and 18.25m respectively. The Type II examples the dimensions of which can be ascertained range from about 10.95m to about 27.5m; more of these fall outside the 16.75–22.8m range than those on Fairweather's original list. Their widths are similarly variable. The Anglo-Saxon and Saxo-Norman list includes the tiny east chapel at Hexham, only 8.84m long, but half the churches have length dimensions in the 18.5–21m range, with Canterbury St Pancras measuring 23.75m.

Very few Type I churches have dimensions at all similar to the Brixworth building. Maplescombe (Kent) and Easthorpe (Essex) are around 18.25m long, but narrower than Brixworth (8.84m and 6.1m respectively). The chapels at Witham (Somerset), Crasswall (Herefordshire) and the bishop's palace at Norwich are much longer and range from about 27.5–42.5m; Norwich alone is comparable in width at 10.7m. Type IIa churches, with their stilted apses, tend to be longer overall, with three examples around 18.25m and five between 21m and 23m. At their greatest width (i.e., the width of the nave) all these examples fall between 7.6m and 8.7m, again narrower than the Brixworth building. The few Type IIb churches are either considerably shorter or considerably longer than Brixworth; only Tidmarsh (Berkshire), at around 22.9m, is a possible contender for comparison, but with a width of only just over 6.1m is of very different proportions. The additional list of mainly excavated examples provides little in the way of comparative material. Where dimensions are readily ascertainable, they prove to be smaller than Brixworth in most cases. Only Wharram Percy (North Yorkshire) has a comparable width (9.68m), but with its heavily stilted apse is much longer at 28.06m. Several examples on the Anglo-Saxon/Saxo-Norman list come close to Brixworth, however: West Bergholt (Essex), Hascombe (Surrey), Barrow (South Humberside), Rochester (Kent) and St Paul in the Bail, Lincoln, measure between 18.6m and 21m in length with widths of 7.9m and above. A further example, the chapel of St John's Abbey in Colchester, is 9m wide, though its length is a mere 14.5m. The recently-discovered church at Great Whip Street, Ipswich, which has a full-width apse and may belong to Type I, despite the continuous east nave wall, has dimensions similar to those of this group.

The closest comparison in terms of both dimensions is the excavated building under the west end of Rochester Cathedral (20.42m × 9.91m). Not only the gross size but the overall proportions of this building are nearest to Brixworth: both are approximately twice as long as they are wide. In the case of Brixworth the actual length to width ratio is 1:0.53, while at Rochester it is 1:0.49. Another early church with the same ratio as Rochester is Stoke d'Abernon (Surrey), though it is

about 4m shorter and 2m narrower than Brixworth. Out of fifty churches both of whose dimensions are known, a small group of ten (20%) clusters around Rochester and Stoke with proportions falling between 1:0.45 and 1:0.50. This group includes another early example, Cressing All Saints (Essex) at 1:0.45, six Type I churches (one from the additional list) and only one Type II example, Finchampstead (Berkshire). Apart from this one case, many of the Type II churches fall between 1:0.38 and 1:0.44, along with several Type I and Anglo-Saxon/Saxo-Norman examples – twenty altogether (40%). A remarkable number of mainly Type II churches have the value 1:0.36; together with the neighbouring values of 1:0.35 and 1:0.37 there are eleven examples (22%). In all of this, Brixworth stands as an isolated example between 1:0.50 and 1:0.55, but too much significance should not be read into this, since precise dimensions cannot be expected from any kind of remote sensing and the dowsing probably indicates foundations rather than standing walling: the actual dimensions of the building could be different by a few metres in either direction.

Distribution (Fig. 19.3)

The distribution of the examples cited by Fairweather shows some notable concentrations. As his map makes clear, Type I churches occur principally in Essex (a very heavy concentration), north Kent and south Berkshire/south Oxfordshire. Of the few additional examples only Foxley in Wiltshire lies outside this core area. Type II churches have a slightly more central and southern distribution; only one (Copford) occurs in Essex and none in Kent, while there are examples in Hertfordshire, West Sussex and northern Hampshire in addition to Berkshire and Oxfordshire. This distribution is confirmed by the list of additional examples, which also extends the area into Suffolk and Norfolk and provides a number of far-flung outliers in Wales (two), North Yorkshire, and southern Scotland. It is worth noting the distant example (from a southern perspective) at Brigham in Cumbria on Fairweather's original map. The Anglo-Saxon/Saxo-Norman list, rather more substantial than Fairweather's, has examples in Essex (four) Kent (three), Surrey (two), Lincolnshire/south Humberside (two) and Hampshire and Northumberland (one each). With the exception of Hexham in Northumberland this is very similar to Fairweather's Type I distribution. Apart from the western and northern examples just noted, the overall distribution is restricted to the south and east of the limestone belt, indicated on Fairweather's map by the 'west limit of Cretaceous and Tertiary Strata'.

Discussion

The easy comparisons with Romanesque apsidal buildings which were the initial basis for this paper seem on closer investigation to be less apposite than they appeared. The small number of single-celled apsidal churches does not offer convincing parallels in terms of gross size, though six or seven examples come close to matching the proportions of the Brixworth building. Because of their extended length, the two-celled buildings, especially those with stilted apses, come closer to matching the Brixworth dimensions, though as a class they are consistently narrower than the Brixworth building and fail the proportion test. The closest and most consistent parallels are with the Anglo-Saxon/Saxo-Norman churches (Appendix B). Of fifteen examples six match at least one dimension of the Brixworth building and three are very close in terms of the length:breadth ratio; the excavated church at Rochester provides the closest match of all the comparanda. Regardless of date, however, there is the problem that Brixworth lies at the very edge of the main area in which apsidal buildings can be shown to occur. Nevertheless there are pre-Conquest examples farther north in Lincolnshire and Humberside, while at Brixworth itself the Anglo-Saxon church of All Saints is well known for its eastern apse.

The possibility that the dowsed structure may be of pre-Romanesque origin in terms of its apparent building plan opens up further avenues of interpretation. It is potentially significant that it has the same alignment as the main church, to which it seems to be linked by a series of smaller rectangular structures at right angles to the axis of All Saints' (Fig. 19.1). This invites an interpretation of the building as part of the original Anglo-Saxon monastic complex, perhaps a subsidiary chapel. Its position vis-à-vis the main church is comparable to that of the chapel of St Mary to the south of monastic church at Saint-Riquier, Picardy, the site of which has been verified by excavation; the famous engraving shows the chapel connected to the main church by a gallery.[25] The comparison is all the closer by virtue of the dedication of the chapel in either case to St Mary (assuming that the identification of the Brixworth building with the *vetus capella* of the fourteenth-century will can be substantiated). This is a common dedication for one of the churches in a complex of two or more places of worship on the same site, often, but not necessarily, not the principal church; unlike Brixworth, however, many of the examples of multiple churches were arranged in a linear sequence.[26]

As to the status of the possible chapel, it has been suggested that all apsidal places of worship were of less than parochial rank.[27] This proposition requires further investigation, though it is fair to say that Fairweather's original list of examples includes a high proportion of buildings that were hospital or castle chapels and the like. Although the proposition is likely to be true of post-Conquest examples, those from the Anglo-Saxon period are less easy to define. The little building at Hexham is almost certainly subsidiary to the main monastic church, but St Mary in Tanner Street presumably fulfilled a quasi-parochial function in relation to a small area of urban settlement in early medieval Winchester. The late- or sub-

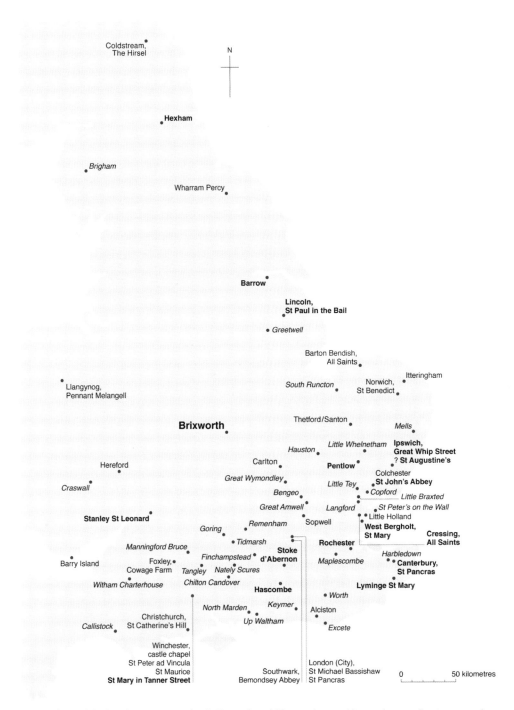

Fig. 19.3 Distribution of apsidal churches; Fairweather's Types I and II in italics; additional examples in normal type; Saxo-Norman examples in bold type (Drawing: Christina Unwin)

Roman, or early Anglo-Saxon, church of St Paul in the Bail in Lincoln, built across the courtyard of the forum of the Roman town, must have been a significant public monument; whatever its exact status, it can hardly count as a minor place of worship. The functional status of other examples is also not clear. If the excavated church at Rochester was not itself the Anglo-Saxon cathedral, what was its relation to the cathedral? And what precisely was the nature of St Pancras in Canterbury: did it form part of St Augustine's monastery, and if so what was its function? During the period before the development of the parish the status of churches is very difficult to define except for the small number of attested minsters, and this is further obscured in many cases by their assumption of parochial status after the Conquest. A change

in status during the period cannot be ruled out. The apsidal building at Brixworth may possibly have been the original church of the monastery, later superseded by the existing church, and reduced to the role of subsidiary chapel, which may also have been the case at Rochester. This is a line of enquiry that needs to be further pursued.

The apsidal building is the most significant and intriguing evidence to come out of the dowsed survey. Its potential importance makes it imperative to verify the findings by alternative means, and ultimately the opportunity to excavate part or all of the area concerned would be the only sure way to prove the building's existence and to establish details such as its building materials, its surviving floor levels and its internal fittings. If nothing else, it should contain the grave of William de Brikelsworth, if the interpretation of it as the old chapel of St Mary is to be substantiated.

Acknowledgements

I am grateful to the Hallaton Fieldwork Group in Leicestershire for carrying out a resistivity survey in part of Brixworth chuchyard in November 2014, to Leslie Sims DipArch, RIBA, for checking measurements on site in January 2015, and to the following for kindly supplying me with information before full publication about excavated churches in their remit: Mike Kimber (Headland Archaeology), Richard Brown (Oxford Archaeology South) and Märit Gaimster (Pre-Construct Archaeology); and to Märit Gaimster and Tiziana Vitali for access to recent editions of MBI.

Notes

1 Bailey et al. 1988.
2 van Leusen 1998.
3 Ibid., 126.
4 Ibid., 136.
5 Ibid., 128.
6 Bailey et al. 1988, 23–6.
7 Aitken 1959.
8 Parsons & Sutherland 2013; Parsons 2013.
9 Parsons & Sutherland 2013; Parsons 2013.
10 Parsons & Sutherland 2013, 127–33.
11 When this paper was first drafted, imperial dimensions were used throughout, since much of the published source material gives measurements in feet and inches. More recently published excavation data, especially those in *Med. Arch.* used for Appendix A, are normally metric; the original imperial dimensions have been converted to metric for the purposes of this publication and are given in round brackets following their metric equivalent.
12 Fernie 2000, 201.
13 Ibid.
14 Barnwell in Parsons & Sutherland 2013, 229; the prebend is discussed on 224–5, the importance of Brixworth generally at Domesday on 223–4.

15 Thompson 1911–12, 117 & 149 (Brixworth); 115 & 141–2 (Bulwick). See also Serjeantson & Longden 1913, 292 (Bulwick), 303 (Cottingham), 337 (Harringworth), 377 (Northampton), 437–8 (Woodford Halse); Parsons 2003, 19–22. Examples occur elsewhere, for instance at Arlington, East Sussex, see Garraway Rice 1935, 37–8.
16 Serjeantson & Longden 1913, 288.
17 PRO 1924–9, iv, 24–5; Salzman 1937, 157.
18 Fernie 2000; Clapham 1934.
19 Fairweather 1933.
20 *Med. Arch.* 51 (2007), MBI no. 215.
21 *Med. Arch.* 56 (2012), MBI no. 111.
22 Taylor & Taylor 1965.
23 Page 1912, 185.
24 Drury 1982, fig. 2.
25 Heitz 1980, 51–60.
26 Blair 1992, 246–58.
27 Dr Carol Davidson Cragoe, pers. comm.

References

Aitken, M.J., 1959 'Test for Correlation Between Dowsing Response and Magnetic Disturbance', *Archaeometry* 2, 58–9

Bailey, R.N., Cambridge, E., & Briggs, H.D., 1988 *Dowsing and Church Archaeology* (Wimborne)

Bell, R.D., Beresford, M.W., Hurst, J.G. & Rahtz, P.A, 1987 *Wharram: a Study of Settlement on the Yorkshire Wolds, III: Wharram Percy: the Church of St Martin* (London)

Biddle, M., 1972 'Excavations at Winchester, 1970', *Antiquaries J.* 52, 93–131

Blair, J., 1991 *Early Medieval Surrey: Landholding, Church and Settlement before 1300* (Stroud)

Blair, J., 1992 'Anglo-Saxon minsters: a topographical review' in J. Blair & R. Sharpe (ed.), *Pastoral Care before the Parish* (Leicester, London & New York), pp 226–66

Clapham, A.W., 1934 *English Romanesque Architecture after the Conquest* (Oxford)

Cramp, R., 2014 *The Hirsel Excavations*, Society for Medieval Archaeology Monograph 36 (London)

Drury, P.J., 1982 'Aspects of the Development of Colchester Castle', *Archaeological J.* 139, 302–419

Fairweather, F.H., 1933 *Aisleless Apsidal Churches of Great Britain* (Colchester)

Fernie, E., 2000 *The Architecture of Norman England* (Oxford)

Garraway Rice, R. (ed. W.H. Godfrey), 1935 *Transcripts of Sussex Wills as Far as They Relate to Ecclesiological and Parochial Subjects, Up to the Year 1560*, 1, Sussex Record Society 41 (Lewes)

Heitz, C., 1980 *L'Architecture religieuse carolingienne: les formes et leurs fonctions* (Paris)

Leach, P.E., 1987 'Excavations at Alciston, 1984', *Sussex Archaeological Collections* 125, 91–8

Milton, B. et al., 1984 *Four Church Excavations in Essex*, Essex County Council Occasional Paper 4 (Chelmsford)

Page, W. (ed.), 1912 VCH: *Hertford* 3 (London)

Parsons, D. & Sutherland, D.S., 2013 *The Anglo-Saxon Church of All Saints, Brixworth, Northamptonshire: Survey, Excavation and Analysis 1972–2010* (Oxford)

Parsons, D., 2003 *Lost Chantries and Chapels of Medieval Northamptonshire*, Eighteenth Brixworth Lecture 2000, Brixworth Lectures 2 ser. 3 (Brixworth)

Parsons, D., 2013 'All Saints' Church, Brixworth, Northamptonshire: the Development of the Fabric *c*.1100 to 1865', *JBAA* 166, 1–30

PRO, 1924–9 *Calendar of the Patent Rolls preserved in the Public Record Office: Edward VI*, 6 vols (London)

Roberts, J.P. (with M. Atkin), 1982 'St Benedict's Church' in A. Carter (ed.), *Excavations in Norwich, 1971–1978, Part I*, East Anglian Archaeology Report 15 (Norwich), pp 11–29

Salzman, L.F. (ed.), 1937 VCH*: Northampton* 4 (London)

Serjeantson, R.M., & Longden, H.I., 1913 'The Parish Churches and Religious Houses of Northamptonshire: their Dedications, Altars, Images and Lights', *Archaeological J.* 70, 217–452

Taylor, H.M., & Taylor, J., 1965 *Anglo-Saxon Architecture*, 2 vols (Cambridge)

Thompson, A.H., 1911–12 'The Chantry Certificates of Northamptonshire', *Associated Architectural Societies' Reports and Papers* 31, 87–178

van Leusen, M., 1998, 'Dowsing and Archaeology', *Archaeological Prospection* 5, 123–38

Appendix A: examples additional to Fairweather's list

KEY: *MA* refers to the journal *Medieval Archaeology*; F = Fairweather 1933; T&T= Taylor & Taylor 1965; dimensions given in the texts cited are often internal, and overall lengths and widths have been calculated by adding three or two wall thicknesses respectively.

F type	Place	County	Status/date	Dimensions	Source	Refs
?	Carlton	Bedfordshire	Anglo-Saxon; 2-celled; apsidal?			*MA* 15 (1971), 124;
	Christchurch, St Catherine's Hill	Dorset (formerly Hampshire)	series of chapels in earthwork; no details			*MA* 12 (1968), 174
?	Colchester	Essex	leper hospital, chapel C12; excavated 1989; unclear whether apsidal			*MA* 40 (1996), 253
?	Hereford, Castle Green		mid-C12; nave + chancel			*MA* 5 (1961), 317
I/II?	Alciston, (dedication unknown)	E. Sussex	Anglo-Saxon?; excavation revealed substantial remains of apse of hitherto unknown church	nave reconstruction based on later chancel dimensions		*MA* 29 (1985), 201; Leach 1987
I/II?	Barrow	S. Humberside	pre-Conquest?	19.5 × *c*.8.5m	*MA* text (metric conversion)	*MA* 22 (1978), 147
IIa	Barry Island	Glamorgan	C12	11.34 × 4.66m	Scaled from *MA* plan	*MA* 13 (1969), 254
I/II?	Barton Bendish, All Saints	Norfolk	mid-C11; nave plus same width apsidal chancel	16.6 × 6.6m	*MA* text	*MA* 26 (1982), 195
II	Colchester, St John's Abbey	Essex	Anglo-Saxon?	*c*.14.5 × 9m	Scaled from *MA* plan, fig. 55	*MA* 17 (1973), 140
II	Coldstream, The Hirsel		Date uncertain, but possibly C11; in phase 2, apse added to single-celled church	10.7 × 7.3m	Cramp 2014	*MA* 29 (1985), 219–20; Cramp 2014, 51–2
I	Cressing, All Saints	Essex	Saxo-Norman church with nave + apse on rubble footings	*c.* 18.23 × 8.06m	Scaled from conjectural plan in Hope's report (Milton et al. 1984, fig. 24)	*MA* 41 (1997), 252; Milton et al. 1984, 28–42

(Continued)

F type	Place	County	Status/date	Dimensions	Source	Refs
I?	Foxley, Cowage Farm	Wiltshire	timber building with E apse excavated; church?			*MA* 28 (1984), 246
II?	Hascombe	Surrey	pre-Conquest? (demolished)	19.2 × 8.23m	Blair plan	Blair 1991, 119
II	Ipswich, Great Whip Street, St Augustine(?)	Suffolk	Two-celled church with full-width apse; probably C11	18.5 × 7.84m	Richard Brown, OAS, pers. comm.	Stoke Quay Ipswich, Pt.I: Post Excavation Assessment and Updated Project Design, (OAS/PCA, Dec. 2013)
I/II?	Itteringham	Norfolk	Aerial photographic evidence for apsidal church	17.1 × 6.1m	Metric conversion from *MA* text	*MA* 31 (1987), 151
II	Lincoln, St Paul in the Bail	Lincolnshire	Late-/sub-Roman or Anglo-Saxon?; phase 1 nave plus apse	21 × 9m	*MA* text	*MA* 23 (1979), 214–17, 241
I	Little Holland	Essex	Excavated church phase 1 apsidal single cell	13.4 × 6m	*MA* text	*MA* 33 (1989), 177
I/II?	Llangynog, Pennant Melangell	Powys	Excavated E apse mentioned, no further details			*MA* 34 (1990), 252
II	London (City), St Michael Bassishaw		first church nave + apse; 'not earlier than C12'	length not known, width *c.* 5.49m	Scaled from *MA* plan	*MA* 10 (1966), 186 & fig. 78 on 188
II	London (City), St Pancras			nave 5.89m wide with apsidal chancel	Metric conversion from *MA* text	*MA* 9 (1965), 185
II	Norwich, St Benedict	Norfolk	Excavated nave + full-width apse with chancel arch responds; W end irregular; late C11	*c.* 14m × 6m	Scaled from Roberts 1982	*MA* 17 (1973), 157; Roberts 1982
I/II?	Sopwell	Hertfordshire	Part of apse and S wall of earlier church	Length not determined, but at least 12m × 4.6m wide	Scaled from *MA* plan (metric conversion)	*MA* 10 (1966), 178 & fig. 73a on 179
I/II?	Southwark, Bemondsey abbey		Infirmary chapel; C11/ C12	*c.* 24m long and apsidal in C11, extended to *c.*36m in C12	*MA* text	*MA* 32 (1988), 251
I	Stanley St Leonard	Gloucestershire	Chapel of priory	16.64 × 6.81m	Conversion from T&T text	See F no.1
II?	Stoke d'Abernon	Surrey	pre-Conquest?	14.93 × 7.92m	Blair plan	Blair 1991, 116; T&T 573
I/II?	Thetford/Santon	Norfolk	?	apsidal about 27.4m long	*MA* text (metric conversion)	*MA* 6–7 (1962–3), 320

(Continued)

F type	Place	County	Status/date	Dimensions	Source	Refs
I	West Bergholt, St Mary	Essex	Excavation of 'continuous nave and apsidal chancel'; Turner's report claims Saxo-Norman and plan shows Type I quite clearly	18 × 7.6m	Scaled from Milton et al. 1984, fig 35	*MA* 23 (1979), 257; Milton et al. 1984, 43–63
II	Wharram Percy, St Martin	Yorkshire	Early C12	28.06 × 9.68m	Bell plans + text	Bell et al. 1987, fig. 7, & 61, 70
II	Winchester, Castle chapel	Hampshire	Nave + apse; late C11			*MA* 15 (1971), 147
I/II?	Winchester, Cathedral Close, St Mary	Hampshire	Identified by excavation; no details			*MA* 35 (1991), 161
IIa	Winchester, St Mary in Tanner Street	Hampshire	Phase J apse ended; stilted apse added to nave at some date before the Conquest, extended to rectangular E end by *c.* 1100	*c.* 10.1 × 6.1m	Biddle fig. 4	Biddle 1972; *MA* 14 (1970), 173; *MA* 15 (1971), 153
IIa	Winchester, St Maurice	Hampshire	'Norman'	nave 15.24m × ?, with stilted apse (included in length dimension?)	*MA* text (metric conversion)	*MA* 4 (1960), 143

Appendix B: Anglo-Saxon and Saxo-Norman examples

KEY: T&T refers to Taylor & Taylor 1965; F = Fairweather 1933; dimensions given in the texts cited are often internal, and overall lengths and widths have been calculated by adding three or two wall thicknesses respectively.

F type	Place	County	Status	Dimensions	Source	Refs
I/II?	Barrow	S. Humberside	pre-Conquest?	19.5 × *c.*8.5m	*MA* text	*MA* 22 (1978), 147
II	Canterbury, St Pancras	Kent	Phase 1	23.78 × 9.22m	Conversion from T&T text	T&T, 148
II	Colchester, St John's Abbey	Essex	Anglo-Saxon?	*c.*14.33 × 9.98m	Scaled from *MA* plan (fig. 55)	*MA* 16 (1972), 140
I	Cressing, All Saints	Essex	Saxo-Norman church with nave + apse on rubble footings	*c.*18.23 × 8.06m	Scaled from conjectural plan in Hope's report (Milton et al. 1984, fig. 24)	*MA* 41 (1997), 252; Milton et al. 1984, 28–42
II	Hascombe	Surrey	pre-Conquest? (demolished)	19.2 × 8.23m	Scaled from Blair plan	Blair 1991, 119
I	Hexham	Northumberland	E chapel	8.84 × 5.18m	Conversion from T&T text	T&T, 312

(Continued)

F type	Place	County	Status	Dimensions	Source	Refs
II	Ipswich, Great Whip Street, St Augustine(?)	Suffolk	Two-celled church with full-width apse; probably C11	18.5 × 7.84m	Richard Brown, OAS, personal communication	Stoke Quay Ipswich, Pt. I: Post Excavation Assessment and Updated Project Design, (OAS/ PCA, Dec. 2013)
II	Lincoln, St Paul in the Bail	Lincolnshire	Late-/sub-Roman or Anglo-Saxon?; phase 1 nave plus apse	21 × 9m	*MA* text	*MA* 23 (1979), 214–17 + 241
II	Lyminge St Mary	Kent		L unknown × 6.71m	Conversion from T&T text	T&T, 409
II	Norwich, St Benedict	Norfolk	Excavated nave & full-width apse with chancel arch responds; W end irregular; late C11	*c.* 14 × 6m	Scaled from Roberts 1982	*MA* 17 (1973), 157; Roberts 1982
II	Pentlow	Essex		13.94 × 8.43m	Conversion from T&T text	T&T, 491
II	Rochester	Kent		20.42 × 9.91m	Conversion from T&T text	T&T, 518–19
I	Stanley St Leonard	Gloucestershire	Chapel of priory	16.64 × 6.81m	Conversion from T&T text	See F no.1
II	Stoke d'Abernon	Surrey	pre-Conquest?	14.93 × 7.92m; 16.2 × 7.92m	Scaled from Blair plan; conversion from T&T text	Blair 1991, 116; T&T, 573
I	West Bergholt, St Mary	Essex	Excavation of 'continuous nave and apsidal chancel'; Turner's report claims Saxo-Norman and plan shows Type I quite clearly	18 × 7.6m	Scaled from Milton et al. 1984, fig. 35	*MA* 23 (1979), 257; Milton et al. 1984, 43–63
II	Winchester, St Mary in Tanner Street	Hampshire	Phase J apse ended; stilted apse added to nave at some date before the Conquest, extended to rectangular E end by *c.* 1100	*c.*10.1 × 6.1m	Scaled from Biddle fig. 4	Biddle 1972; *MA* 14 (1970), 173; *MA* 15 (1971), 153

Designing and redesigning Durham Cathedral

Eric Cambridge

Introduction

In 1843 Robert Billings, with characteristic acuity, first drew attention to the marked variation in the bay lengths of Durham Cathedral, describing it as 'the principal singularity in the plan';[1] having recently completed his meticulously accurate survey, he was uniquely well placed to know. Admittedly, two features of the original design of Durham, the plans of the crossing piers and of the choir aisle bays, must have ensured that its bay lengths were characterised by a significant degree of variability from the outset, for both features are significantly longer east–west than north–south. In the former case, accommodating this additional length probably accounts for the reduced spans of the adjoining bays (at the west end of the choir and east end of the nave), which are shorter than any others in their respective arcades;[2] likewise, in the latter, it explains why (measuring from pier centre to pier centre) the eastern three bays of the choir arcade are each nearly 50% longer than the inner bays of the transept arcades.[3] Yet this cannot be the whole explanation for the phenomenon which Billings had observed, for the degree of variation at Durham is greater, and its occurrence more frequent, than can be accounted for by these features. Thus the longest bays, at the west end of the nave, are no less than 144% longer than the shortest, at the extremities of the transepts (Fig. 20.1);[4] and (in the three western limbs at least), significant changes in bay length are the norm rather than the exception. Recent analyses of contemporary Anglo-Norman great churches elsewhere underline the anomalous position of Durham in both respects. For example, at Norwich, though the overall variation is some 58%,[5] substantial differences are confined to the transepts, the fourteen nave bays and four western choir bays taken together varying by only some 8%.[6] At Ely the longest bays in the church exceeded the shortest by no more than 25%.[7] The maximum variation found at Durham is thus about two and a half times that at Norwich and nearly

six times that at Ely; and in marked contrast to the continual changes in bay length that characterise the western limbs of Durham, in both the latter churches most of the variation is accounted for by a few exceptional bays. But if subsequent research has vindicated Billings' observation, an explanation continues to prove elusive.[8]

The plan of the transepts

The transepts of Durham are aisled on the east side only. Their arcades each comprise two double bays with alternating compound and cylindrical piers, a leitmotif of the design of Durham which, as has long been recognised, derived from two other churches (themselves intimately related) of the preceding generation, the abbeys of Jumièges and Westminster.[9] Their bay lengths reduce the further removed they are from the crossing, the inner bay being the longest, the middle two shorter, and the outermost significantly shorter still. As the spans narrow the arcade arches become more stilted, producing an uncomfortably congested appearance at the extremities (Fig. 20.2). It has recently been suggested that this phenomenon is a consequence of the underlying geometrical framework of the design, in which the total length of each transept was conceived as two units of a module defined by the (presumably north–south) length of the crossing square measured from pier centre to pier centre.[10] The inner module approximates to the first double bay of each arcade, while the outer one accommodates not only the second double bay, but also the thickness of the terminal walls and the projection of the stair turrets (Fig. 20.3a);[11] the markedly shorter outer bays are thus explained by the need to accommodate these elements within the second module. Persuasive though this hypothesis is in itself, the approximate correspondence between the inner module and the first double bay of each arcade prompts the question why the outer module differs – why, that is, the terminal walls and

Fig. 20.1 Durham Cathedral, elevations of (left) west bay of north nave arcade, and (right) north bay of north transept arcade (From Billings 1843, pls. x, xv)

stair turrets were not located beyond rather than within it, so that the double module would then have defined the internal length of each transept and not its absolute length. Had that been so, the total length of each main vessel would then have been some 23.04m (75ft 7in), about 3.91m (12ft 10in) longer than as built,[12] implying an arcade length of approximately 22.40m (73ft 6in) (Fig. 20.3b).

The length of the inner bay of each transept arcade (and hence the span of its arch) must have been fixed at the outset, for it reflects the width of the adjacent choir aisle which is part of the earliest phase of construction. If we suppose that the arches in all four bays were originally

intended to match that span, we can estimate the resulting total arcade length on the further assumptions that the sizes of the arcade piers remained as originally designed (the dimensions of the cylindrical piers at least hardly vary throughout the choir and transepts) and that (taking the north transept as an example) the shallower north respond would have been intended to be as deep as its southern counterpart. The aggregated arcade length would then be some 22.07m (72ft 5in),[13] and the consequent total length of the main vessel 22.81m (74ft 10in); while, if the double module had originally been intended to fix the location of the inner face of the north wall of the aisle rather than the

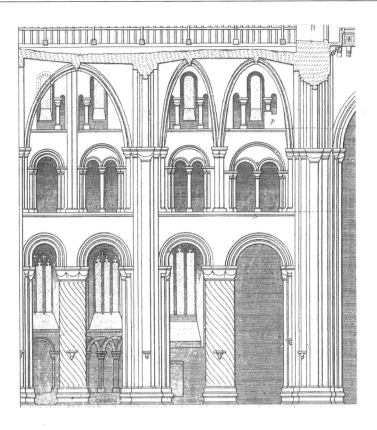

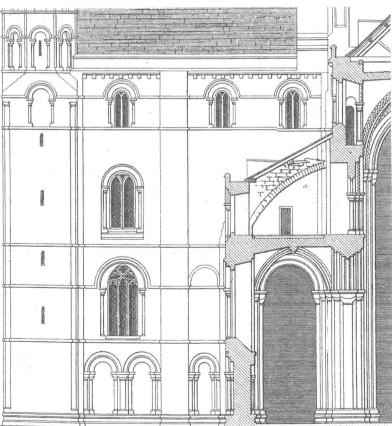

Fig. 20.2 Durham Cathedral, elevations of north transept (above) arcade, (below) exterior of west wall (From Billings 1843, pls. xv, xiii)

main vessel (which, since its walls are thinner, projects slightly farther north than the latter), the total length would increase to 23.09m (75ft 9in) (Fig. 20.3b).

Taken in isolation the apparent convergence between the length of the transept arcades implied by the underlying geometry and that implied by assuming that all four arcade bays were originally meant to be the same length as the innermost ones might be dismissed as insufficiently close to be significant. Yet seemingly anomalous features of the transepts as built would also make sense as consequences of the compression of a design originally intended to have been longer. Thus, the large stair turrets at the north-west and south-west corners now encroach upon the interior space by some 2.08m (6ft 10in) (Fig. 20.3a); but if that were the result of fitting them within the outer module,[14] they, like the terminal walls, may originally have been intended to stand outside it. In turn, that would explain why the east and west elevations of the transepts are so incompatible, the latter being articulated as three bays as against the four of the arcades (Fig. 20.2),[15] for the existing footprint is too short to accommodate four-bay elevations in the west walls, the intrusive stair turrets occupying almost all of the available space opposite the shortest, outer arcade bays (Fig. 20.3a); but if the turrets had originally been intended to project externally, that would have left room to articulate the west walls in four roughly equal bays, matching the longer, more evenly spaced arcades postulated above. And given that the east–west position of the transept aisle walls must also have been fixed as part of the original design, it would further imply that the bays of the transept aisles were originally intended to be square (Fig. 20.3b). A somewhat similar arrangement to the suggested original form of the Durham transepts (though utilising a different underlying geometrical framework) was adopted a generation later at Peterborough Abbey, where the transepts are also of four bays and aisled on the east side only. The arcades are notably shorter than their counterparts in the choir, and not only are they of comparatively even length but the arcade bays and those of the west walls march in tandem, producing an even and coherent overall effect,[16] all exactly as here proposed for Durham.

The relationship between the new cathedral at Durham and the existing east claustral range may also suggest that the position of its east–west axis was fixed with the longer transepts suggested above in mind. The slype is located in what became the standard position for such a cross-passage, between the south transept and the chapter house. Despite heavy restoration, its detailing indicates that it was constructed contemporaneously with the rebuilding of the latter (complete by 1141),[17] the western portion of which occupies (at least approximately) the same footprint as its late eleventh-century predecessor.[18] In functional terms, however, the twelfth-century slype was a superfluity, for the pre-1093 east range was already provided with a cross-

passage further south (Fig. 20.4),[19] an arrangement which, though less common, can be found in contemporary layouts elsewhere.[20] What was intended in 1093 to occupy the space where the later slype was erected is therefore a nice question. The transepts as built may, of course, have been shortened so as to allow for the future relocation of the slype; but that seems an unlikely priority, and one more easily achieved by positioning the central axis of the church slightly further north from the beginning. It seems more likely that the twelfth-century slype should rather be seen as a rationalisation of space that had become redundant, and had remained unoccupied, following a decision to shorten the transepts. Again Peterborough may provide a pertinent analogy, for the sacristy which adjoins the west wall of its south transept has been convincingly interpreted as reflecting a similarly opportunistic use of space left vacant by the abandonment of the original scheme, which had provided for western as well as eastern aisles, though only the latter were built.[21] The space occupied by the twelfth-century slype at Durham would not only have accommodated the longer transepts suggested here,[22] but also the south-west turret if that had originally been intended to project southwards from the transept façade (Fig. 20.4a).[23]

If the transepts had indeed once been intended to be significantly longer, why might that plan have been abandoned? Thurlby suggests that, in the case of the south transept, there may have been a need to take account of the position of the pre-Conquest cathedral, the greater part of which probably remained in use until the translation of 1104,[24] so would likely still have been standing when the transept foundations were set out; the north transept would then presumably have been designed as a mirror image of the south.[25] The precise location of the earlier cathedral remains unidentified, though it is generally agreed to have lain south of its successor; but while it might have obstructed the building of the new church, it seems inherently unlikely that the design of the latter would have taken account of a structure the demolition of which had already been decided upon.[26] Nor can the presence of standing buildings south of the church begun in 1093 have caused its east–west axis to be erroneously located further south than intended (thereby reducing the space available for the south transept), for the buildings of the pre-1093 south and east claustral ranges were clearly always intended to be retained, and the enlarged cloister connecting them to the new church is laid out with sufficient accuracy to imply that the surveyors must have successfully negotiated whatever obstacles they may have encountered in the intervening space.

Shorter transepts may have resulted from a mistake, a line (whether on a diagrammatic plan not showing wall thicknesses or actually marked out on the ground) intended to define the internal space of one at least of the ends of the transepts being misinterpreted as delimiting its exterior; once foundations had been laid on the wrong side of the

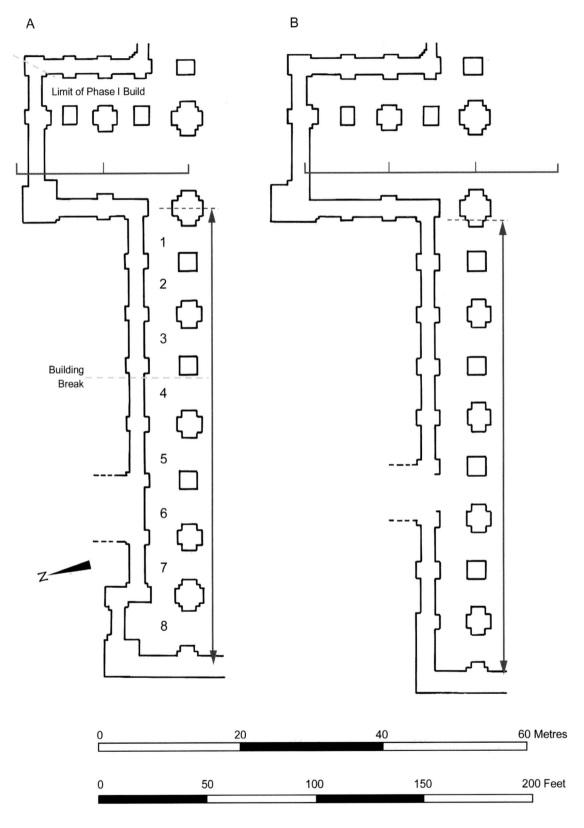

Fig. 20.3 Durham Cathedral, plan of north transept and north nave arcade: (a) as built, showing bay numbering and building phases in green (After Billings 1843); (b) suggested original design; hypothetical underlying geometrical framework of north transept, and (arrowed) $\sqrt{2}$ × cloister north walk shown in red (Drawing: Alan Williams)

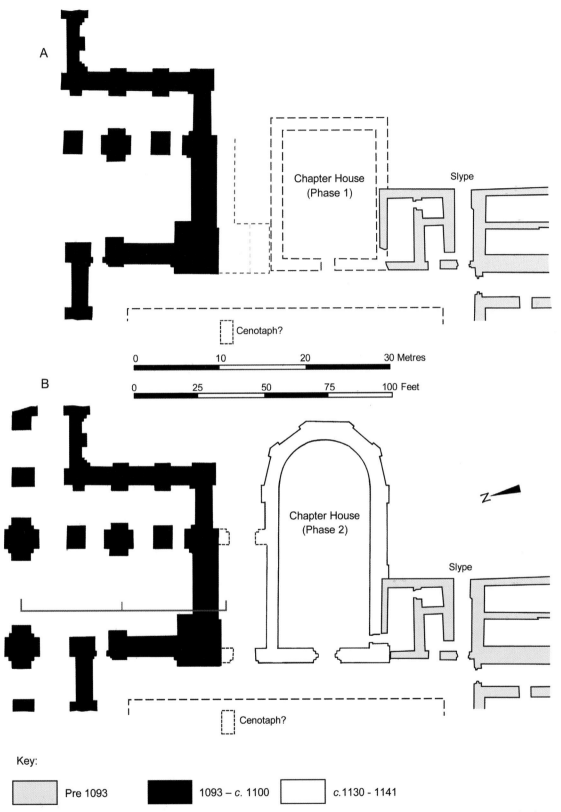

Fig. 20.4 Durham Cathedral, plans of south transept and east claustral range (after Billings 1843 and Markuson 1980), showing probable location of cloister cenotaph and (a), eleventh-century chapter house and hypothetical original southward extent of south transept in broken line, arrangement of stair turret reconstructed (i) projecting internally, in green, (ii) projecting externally (cf Fig. 20.3b), in red; (b), twelfth-century chapter house and additional slype, underlying geometrical framework of south transept in red (Drawing: Alan Williams)

line, it might have seemed more expedient to adapt the design to what had already been done that to begin afresh. Yet, as we shall see, the pattern of curtailment appears to have been repeated in the nave, which suggests deliberate strategy rather than simple error.[27]

Two further, not mutually exclusive, possibilities may be advanced. Curtailment may reflect a decision to reduce of the number of bays in the transepts by one, for the existing footprint would comfortably accommodate three comparatively evenly spaced bays. The death of the cathedral's founder and patron, Bishop William of St Calais, in early January 1096,[28] within two and a half years of the start of work, might provide a possible context, for thereafter conduct of the work fell to the convent under Prior Turgot, who were obliged to fund it from their own resources.[29] Any such revision must have been soon abandoned, however,[30] for the responds of the transept aisles match the bay lengths of the existing four-bay arcades, and those aisle walls form the westernmost extent of the *first* phase of the church to be erected (Fig. 20.3a).[31] What was actually built would then have to be seen as a rapid reversion to the original four-bay scheme, only now shoe-horned into the reduced footprint, with the anomalous consequences noted above. This hypothesis may seem needlessly over-complicated; yet similar vacillation – or controversy – demonstrably attended the later stages of construction of the transepts with regard to whether they should be vaulted in stone.[32] Further or alternatively, shortening the south transept at least may have reflected a concern to facilitate access to the place where St Cuthbert's shrine had stood until 1104. Already in the twelfth century it was marked by a cenotaph in the cloister garth,[33] later believed to have been located opposite where the twelfth-century slype was built (Fig. 20.4).[34] Anomalous though such an arrangement may seem, the cenotaph was then evidently regarded as a location, in addition to the shrine itself, to which lay access for the purpose of seeking cures was permitted, at least on an occasional basis.[35] If the cenotaph did become a cult focus (albeit a short-lived one), that would indeed seem most likely when the previous location of Cuthbert's relics would still have been a recent memory, and when his cult was at the height of its popularity.[36] It is thus possible that interest in that location had already manifested itself – or had been anticipated – at precisely the period when key architectural decisions about the form of the transepts were taken.[37] If so the convent may have been more predisposed than its diocesan to factor it into those decisions, the high priority that it accorded to memorialising earlier *loci* being eloquently demonstrated by its substantial investment a generation later in a new church (perhaps deliberately evoking Durham in its appearance) at the original site of Cuthbert's cult on Lindisfarne.[38]

However the existing form of the transepts came about, the result was to introduce significant incompatibility between the bay articulation of their east and west walls,

and probably also a significant degree of improvisation into the design of their arcades, the uneven bay lengths presumably being deemed the least obtrusive way of fitting in two double bays while also accommodating inner bays of a size determined by the earlier work. More importantly for present purposes, telescoping four-bay arcades into the existing footprint within those design constraints was only achieved at the cost of introducing significant disparity into their bay lengths.

The plan of the nave

The only scholar to have considered the issue of variability in bay lengths of the nave of Durham in print, Eric Fernie, has noted that its setting out exemplifies a common design principle of Romanesque monastic plans whereby the length of the nave equates to the side of the adjacent cloister multiplied by $\sqrt{2}$. He interprets the variation in the lengths of the nave bays as a consequence of the position of its west wall having been fixed by that underlying geometry, entailing a progressive increase in their lengths in order to make the arcade fit the predetermined overall length.[39] This is a perfectly coherent explanation of the evidence and, indeed, may well be the correct one. Nevertheless, in the light of the above interpretation of the transepts, a possible alternative explanation may also be worth consideration.

The pattern of variability in the bay lengths (Fig. 20.3) of the nave arcades bears close scrutiny. Disregarding the easternmost bay,[40] the remaining seven fall into three groups: bays 2 and 3, which are of exactly equal length;[41] bays 4–6, again almost exactly the same length as one another (within a tolerance of 50mm (2in);[42] and the two westernmost bays, which are more irregular. Bay 8, the westernmost, is the longest of all, presumably reflecting the dimensions of the western towers, which are appreciably wider than the nave aisles,[43] while bay 7 (though the shortest of the seven in terms of clear span owing to the presence of compound piers on both sides) is, when measured from centre to centre, intermediate in length between bay 8 and bays 4–6.[44] In at least two places (bays 2–3 and bays 4–6), a standard bay length seems to have been adopted, albeit not adhered to for long. That is worth stressing because one might have supposed that the least visually obtrusive way of dealing with increases in bay length would have been to introduce them gradually rather than in marked steps between groups of bays of equal length.

The construction of the nave of Durham falls into two principal phases with a building break occurring (in the lowest stage of the elevation at least) west of the third bay of the nave (Fig. 20.3a).[45] The break is associated with significant changes in architectural detailing, implying a major revision of the design and, probably, the resumption of work after a significant interval.[46] It also coincides with one of the changes in bay length noted above, between

bays 2–3 and 4–6 (Fig. 20.5). Might that imply that all bays were initially intended to be the same length as bays 2 and 3?[47] If so we would also need to account for two other pieces of evidence: the geometrical relationship between the length of the nave and the diagonal of the cloister square already noted; and the eventual location of its west wall. Eight bays of that length would result in a total internal length (measuring from the west side of the crossing) that falls far short (by some 7.315m (24ft)) of the length of the diagonal of the cloister as calculated from the length of the north cloister walk.[48] But if the nave were originally intended to comprise nine bays rather than eight (Fig. 20.3b), the hypothetical total internal length would then be 62.61m

(205ft 5in);[49] this is as close an approximation to the diagonal of the cloister as Fernie's measurement (62.89m (206ft 4in), which is taken from the mid-point of the west crossing arch to the centre of the present west wall.[50] As contemporary building practice varied it is difficult to know how to decide between these alternative measuring points. Yet the reconstruction proposed here may make better sense in the context of the design as a whole, for the total internal length of the church that it entails would have been almost exactly twice the total original internal length of the transept as reconstructed above.[51]

If the initial intention at Durham was indeed to provide a nave both some 2.77m (9ft 1in) longer than as built,[52] and

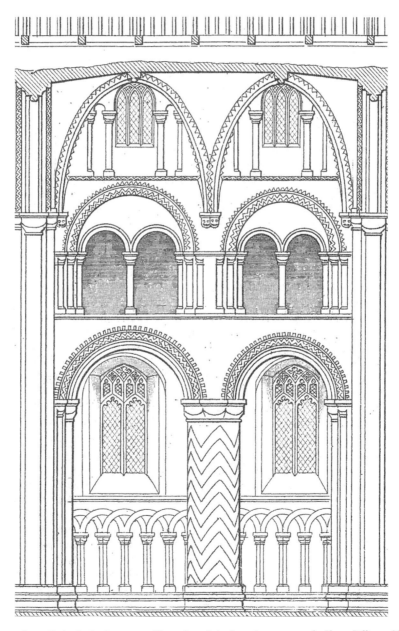

Fig. 20.5 Durham Cathedral, elevation of bays 3 and 4 of north nave arcade (from Billings 1843, pl. x)

comprising an additional bay, it would then have had to be articulated as four double bays plus a single westernmost bay (Fig. 20.3b). That arrangement most readily makes sense if we suppose that the latter was intended to accommodate twin western towers. Westminster Abbey (already noted as a likely source of the double-bay system of Durham), provides a close parallel, its western bay with flanking towers reading as an addition to the sequence of double bays preceding it (Fig. 20.6a), though there it also sits outside the 1:$\sqrt{2}$ framework and not, as argued here for Durham, within it.[53] If the length of the posited western bay at Durham matched those to the east, any associated towers would have been significantly smaller than those of Westminster (or, indeed, those later erected at Durham itself), with dimensions closer to those of Christ Church Canterbury.[54] This more modest form of twin-tower façade continued to be deployed into the early twelfth century, for something similar was once intended at Peterborough,[55] and (on a smaller scale) actually built at Southwell.[56] Smaller western towers at Durham would, moreover, have closely matched the dimensions of the pair of towers which were designed (and probably actually built) at the east ends of the choir aisles, flanking the main apse.[57] The external profile of the cathedral as initially conceived would thus have entailed a much greater degree of symmetry between the eastern and western pairs of façade towers than obtained in what was ultimately constructed.

Why might an initial design of the form posited above have been modified in execution? One practical consideration, given the precipitous site, might have been the additional structural stability to be gained by even such a comparatively modest retreat from the cliff edge, especially if the size of the western towers was significantly increased in the revised design. Another, less immediately obvious, motive might have been the provision of a more appropriately located south-west door. Fernie has demonstrated that a common consequence of the 1:$\sqrt{2}$ geometrical relationship between nave and cloister was to place the west perimeter wall of the latter in an irrational relationship to the bay divisions of the nave,[58] thereby displacing any south-west door from what would soon become its standard position, at the head of the west cloister walk. Despite being set markedly west of centre in its aisle bay internally, the existing doorway at Durham still exemplifies this phenomenon on the cloister side (Fig. 20.6b (i)), a feature which it may have shared with Westminster (Fig. 20.6a) among other places. If, as is likely, the Romanesque cloister walks were somewhat narrower than their later medieval replacements the effect would have been more pronounced still. But in the original layout as reconstructed here, the spacing of the bays would have displaced a doorway in this position even further east, completely beyond the west walk (Fig. 20.6b(ii)). Where (as, perhaps, originally intended at Durham) the south-west door was comparatively small and utilitarian this would have been only a minor inconvenience;

but it might have become a significantly greater concern once it had been decided to rebuild the chapter house on a much grander scale, for that entailed moving the dormitory from its original position above the east range into the west range; the south-west door might then have assumed an enhanced significance if it were to become the Durham monks' principal route between their new dormitory and the church. While uncertainties remain over the precise dates of execution of these projects,[59] the revised design for the nave, the new chapter house, and the relocated dormitory, may all have been conceived together. If so, the revised design would not only have incorporated a much grander and more elaborate south-west doorway, but also (and more importantly for present purposes) have entailed adjusting the spacing of the western arcade bays so as to minimise its eastward displacement, retaining, so far as practicable, its association with the west cloister walk and proximity to the dormitory door (Fig. 20.6b (i)). The arrangement of monumental north-west and south-west nave doorways directly opposite one another may also date from this revision.

Changing the position of the west wall of the nave would have had far more radical implications for the design of its western bays than would have been the case in the transepts, for there it would only have involved relocating foundations, whereas in the nave the designer was further constrained by having to include larger façade towers while also accommodating what had already been built at the eastern end, a legacy that included the main divisions of the elevation, their heights marked by prominent string courses. If the overall coherence of the design were to be preserved those divisions would need to be retained and a glance at the junction of the two phases of work in the nave immediately reveals that room for manoeuvre was severely restricted (Fig. 20.5). The spans of the arches could only be increased without disturbing the levels of the string courses above by making their supports shorter or the arches themselves segmental rather than truly semi-circular. Both techniques had already been employed, the former in the choir and transept galleries and the latter in the three eastern bays of the choir arcades and the inner bays of the transepts (Fig. 20.2); but varying the heights of the supports was a device never used in the nave, and segmental arches were effectively eliminated in its eastern bays, suggesting that both solutions were later considered aesthetically undesirable. Nevertheless, segmental arches were reintroduced in the revised design of the western bays, perhaps indicating the extent of the practical difficulties confronting the designer (Fig. 20.1).[60]

It will never be possible to prove that the original plan of the nave of Durham differed significantly from what was actually built. Yet, if a comparable revision had already taken place in the design of the transepts, there would have been a precedent; and the hypothesis would be compatible with the underlying geometrical framework of the design.

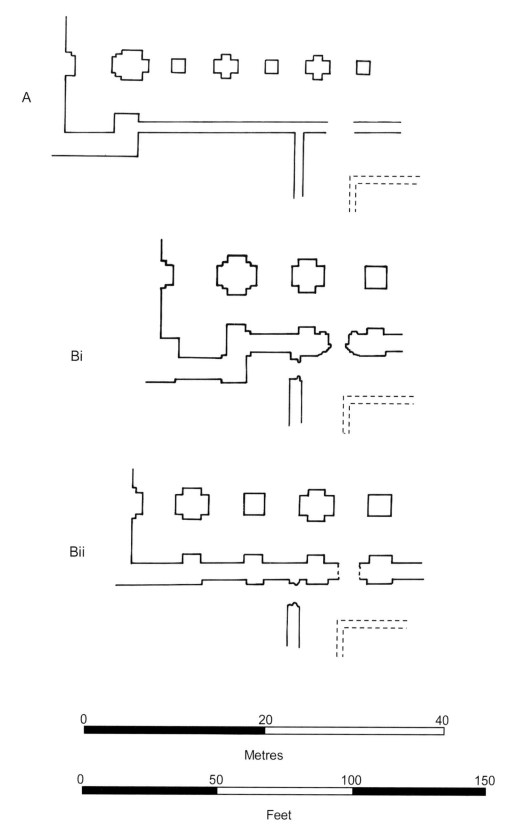

0 20 40

Metres

0 50 100 150

Feet

Fig. 20.6 (a) Westminster Abbey, west end of nave and junction with west perimeter wall of cloister (after Fernie 1995 and Gem & Ball 1981); (b) Durham Cathedral, west bays of nave and junction with west perimeter wall of cloister, and position of south-west door, (i) as built, (ii) suggested original design (Drawing: Alan Williams)

It would also explain why the proposed original design was modified and why that modification resulted in the more disparate bay lengths of the existing structure, the lengths of the five western bays (and, by implication, the eventual position of the west wall) being apparently determined pragmatically. In plan, they enabled larger western towers and a more appropriately located south-west doorway to be accommodated; and in elevation they caused the apexes of the arches to be brought generally closer to the supervening string courses than had been the case in the eastern bays while also introducing (with the exception of the narrower clear span of bay 7) varying degrees of segmentality into their elevations. The proposed original design would also not have been out of place in the context of recent architectural developments in Anglo-Norman England. Most significantly for present purposes, its bay lengths would have been much more regular than as eventually built.

It is increasingly widely accepted that some key dimensions of a number of Anglo-Norman great church plans, including that of Durham, incorporated references to those of Old St Peter's in Rome.[61] If the nave of Durham were originally intended to be *c.* 2.77m (9ft 1in) longer than as actually constructed,[62] the suggested initial design of the church would then just have surpassed the generally accepted internal length of Old St Peter's,[63] whereas the church as built falls slightly short of it by about the same amount.[64] The significance of that variation (if any) is unclear: if approximate parity were the intention, it is presumably neutral in its implications; if, however, the original objective had been specifically to outdo Old St Peter's, that ambition would appear to have been sacrificed in favour of the other benefits of the revised design already noted.

If the proposed modification of the design of the transepts might be associated with the period when the convent under Prior Turgot was responsible for the day-to-day conduct of the work after St Calais' death,[65] the adoption of a revised design for the nave might then be seen as reflecting the resumption of effective episcopal control of the project by his successor, Ranulph Flambard. Though provided to the see in May 1099, the new bishop spent most of the early years of his episcopate in Normandy,[66] so was unlikely to have been in a position to effect a radical revision to the design of his cathedral until after his permanent return to England in the autumn of 1106.[67] A date towards the end of the first decade of the twelfth century for the formulation of the revised design would be consonant with the structural and stylistic evidence of the fabric itself.

Conclusion

This discussion has suggested ways in which the question that so perplexed Billings long ago, as to why the bay lengths of Durham Cathedral as built are so variable, might be answered. The original scheme reconstructed here, with much more

regular bay lengths than as built, would then have conformed in that respect (as it clearly did in so many others) to the general conventions of Anglo-Norman great church design. It follows that the transformation of that initial design in the course of execution must have been more radical, and have begun earlier, than has hitherto been supposed. From this perspective the well-rehearsed changes of mind over the extent of the provision of stone vaulting, and the form that those vaults were to take, emerge as the concluding stages in a much more protracted process of debate that had shaped the appearance of the building virtually from its inception. Further, it reveals something of the practical challenges that those in charge of the project must have faced in the course of construction, and perhaps also affords tantalising glimpses of the design of the cathedral as it might have been originally conceived for its first patron, Bishop St Calais. Finally, it poses a number of questions about how plans were devised, revised and preserved at the highest levels of Anglo-Norman masonic practice.

Acknowledgements

I am most grateful to Eric Fernie for the expert Socratic midwifery that eventually induced this paper and to Alan Williams for his accustomed skill and infinite patience in producing the drawings.

Notes

1 Billings 1843, 10–11.
2 I am grateful to Eric Fernie for drawing this to my attention.
3 Billings 1843, pl. iv.
4 Ibid., pls iii–iv.
5 Repton 1965, pl. ii.
6 Fernie 1993a, 205–6.
7 Fernie 1979, fig. 1.
8 Exploring this issue is a particularly appropriate offering in a volume honouring Richard Bailey for, as his *alma mater*, Durham has long retained a special place in his affections, and he has himself published pioneering work in the study of the metrology and planning of early medieval buildings (Bailey 1991).
9 Fernie 2000, 16, 18, 96–8, 138. Other aspects of the design of Durham were indebted to that of Winchester Cathedral (Thurlby 1994, 167–9; 2014, 22–5).
10 Appendix, (a). Each transept is in fact some 0.61m (2ft) shorter than this notional total length.
11 Thurlby 2014, 30, citing unpublished research by Hugh McCague.
12 Appendix, $((a) \times 2) - (b)$.
13 Appendix, $((d) \times 4) + ((e) \times 2) + (f) + ((g) \times 2)$.
14 This feature became fossilised in the design of the west tower stairs (where, however, outward displacement would have contravened the underlying geometry of the façade) and in Durham-derived designs elsewhere.
15 Thurlby 2014, 29.
16 Plan by Peers in Bateson 1906, facing 440.

17 Snape 1980, 22.

18 Hope 1909, 420.

19 Markuson 1980, 41–3.

20 For example, at Thetford Priory (Gilyard-Beer 1976, fig. 12).

21 Fernie 2000, 152.

22 Appendix, (h).

23 The precise northward limit of the eleventh-century chapter house is uncertain, but its centre line coincides with another unit of the module, while the south perimeter wall of the cloister lies 1.5 units south of that. The implications are presumably that the first cloister was intended to be 3 × 3 such units with the chapter house centred in its east range, and that the module itself originated in that 1083 design.

24 Cambridge 1983, 91–3; Crook 2000, 168.

25 Thurlby 2014, 30.

26 Rollason 2000, 244–5; Snape 1980, 21.

27 Below, 215–16.

28 Greenway 1971, 29; Barlow 2004, 594.

29 Rollason 2000, 276–7.

30 See further below, 218.

31 Bony 1990, 20–1, fig. 4a.

32 Fernie 2000, 135–6; cf Thurlby 2014, 30–4.

33 Reginald of Durham, writing in the late 1160s (Tudor 1989, 449) refers to it (Raine 1835, 100) in a miracle datable to 1144 x 52 if its reference to 'Bishop William' can be identified with William of Ste Barbe.

34 Cambridge 1983; Crook 2000, 168–9.

35 Raine 1835, 100–1.

36 Tudor 1989, 466–7.

37 The (otherwise unexplained) blocked doorway in the south transept west wall (Fig. 20.4) may also originally have been intended to provide public access to the cenotaph from the cathedral.

38 Piper 1989, 444–5.

39 Fernie 1993b, 89.

40 See above, 208.

41 Appendix, (j).

42 Appendix, (l) – (n).

43 Appendix, (p).

44 Appendix, (o).

45 The cylindrical columns on the west side of bay 3 were set out (and probably partly built) during the first phase

46 Bilson 1922, 111–14; James 1983, 136–7; Thurlby 2014, 35–6.

47 Appendix, (j).

48 Appendix, (aa) – (s); Fernie 1993b, 89. The lengths of the cloister walks vary (Billings 1843, pl. v), but the north walk is likeliest to be relevant as it is contiguous with the nave, so was presumably set out together with it.

49 Appendix, (u).

50 Fernie 1993b, 89.

51 Appendix, (a) × 5 = 60.39m (198 ft 1.5in); (y) × 0.5 = 60.49m (198ft 5.5in).

52 Appendix, (v).

53 Fernie 2000, 97, fig. 75.

54 Blockley et al. 1997, figs 16, 20.

55 Bateson 1906, 440, fig. on 441.

56 Fernie 2000, 182, figs 141–2.

57 Thurlby 1994, 169–72, pl. 20.

58 Fernie 1995, 234–5, pl. 2.

59 Snape 1980, 22–3.

60 Billings 1843, pls x–xi.

61 Thurlby 1994, 161–5; Thurlby 2014, 22.

62 Appendix, (v).

63 Appendix, (v), (y), (w).

64 Appendix, (x), (y), (w).

65 Above, 214.

66 For cautionary comments against construing this as a period of exile, see Sharpe 2006, 33, n. 75.

67 Mason 2004, 982. The only other period when Flambard might have influenced the design, between his consecration in June 1099 and departure for Normandy in August 1100, seems too early to be associated with the western parts of the nave, yet perhaps not too late for him to have had some input into the final plan of the transepts.

References

Bailey, R.N., 1991 'St Wilfrid, Ripon and Hexham' in C. Karkov & R. Farrell (ed.), *Studies in Insular Art and Archaeology* (Oxford, OH), pp 3–25

Barlow, F., 2004 'St Calais, William of' in H.C.G. Matthew & B. Harrison (ed.) *ODNB* 48 (Oxford), pp 592–4

Bateson, M., 1906 'Peterborough Minster' in R.M. Serjeantson & R.W. Adkins (ed.), VCH: *County of Northampton* 2 (London), pp 431–56

Billings, R.W., 1843 *Architectural Illustrations and Description of the Cathedral Church at Durham* (London)

Bilson, J., 1922 'Durham Cathedral: the Chronology of its Vaults', *Archaeological J. 79*, 101–60

Blockley, K., Sparks, M. & Tatton-Brown, T., 1997 *Canterbury Cathedral Nave Archaeology, History and Architecture*, The Archaeology of Canterbury new ser. 1 (Canterbury)

Bonner, G., Rollason, D. & Stancliffe, C. (ed.), 1989 *St Cuthbert, his Cult and his Community to AD 1200* (Woodbridge)

Bony, J., 1990 'The Stonework Planning of the First Durham Master' in E. Fernie & P. Crossley (ed.), *Medieval Architecture in its Intellectual Context. Studies in Honour of Peter Kidson* (London & Ronceverte), pp 19–34

Cambridge, E., 1983 'The Anglo-Saxon Cathedral at Durham' in H.D. Briggs, E. Cambridge & R.N. Bailey, 'A new Approach to Church Archaeology: Dowsing, Excavation and Documentary Work at Woodhorn, Ponteland and the pre-Norman Cathedral at Durham', *Archaeologia Aeliana* 5 ser. 11, 91–7

Coldstream, N. & Draper, P. (ed.), 1980 *Medieval Architecture at Durham Cathedral*, BAA Conference Transactions for the Year 1977 (London)

Crook, J., 1994 'The Architectural Setting of the Cult of St Cuthbert in Durham Cathedral (1093–1200)', in Rollason et al. 1994, pp 235–50

Crook, J., 2000 *The Architectural Setting of the Cult of Saints in the Early Christian West, c. 300–c. 1200* (Oxford)

Fernie, E., 1979 'Observations on the Norman Plan of Ely Cathedral' in N. Coldstream & P. Draper (ed.), *Medieval Architecture at Ely Cathedral*, BAA Conference Transactions for the Year 1979 (London), pp 1–7

Fernie. E., 1993a *An Architectural History of Norwich Cathedral*, Clarendon Studies in the History of Art (Oxford)

Fernie, E., 1993b 'Design Principles of Early Medieval Architecture as Exemplified at Durham Cathedral' in M.J. Jackson (ed.), *Engineering a Cathedral* (London), pp 146–56

Fernie, E., 1995 'Reconstructing Edward's Abbey at Westminster' in E. Fernie, *Romanesque Architecture: Design, Meaning and Metrology* (London), pp 233–9

Fernie, E., 2000 *The Architecture of Norman England* (Oxford)

Gem, R., 1981, 'The Romanesque Rebuilding of Westminster Abbey (with a Reconstruction by W.T. Ball)' in R.A. Brown (ed.), *Proceedings of the Battle Conference on Anglo-Norman Studies III (1980)* (Woodbridge), pp 33–60

Gilyard-Beer, R., 1976 *Abbeys: an Illustrated Guide to the Abbeys of England and Wales* (London)

Greenway, D., 1971 *John Le Neve Fasti Ecclesiae Anglicanae 1066–1300, 2: Monastic Cathedrals (Northern and Southern Provinces)* (London)

Hope, W.H.StJ., 1909 [untitled] in *Proc. Soc. of Antiquaries* 2 ser. 22, 416–23

James, J., 1983 'The Rib Vaults of Durham Cathedral', *Gesta* 22(2), 135–45

Krautheimer, R., Corbett, S., & Frazer, A.K., 1977 *Corpus Basilicarum Christianarum Romae: the Early Christian Basilicas of Rome (IV–IX Cent.)*, 5 (Vatican City)

Markuson, K.W., 1980 'Recent Investigations in the East Range of the Cathedral Monastery, Durham' in Coldstream & Draper 1980, pp 37–48

Mason, J.F.A., 2004 'Flambard, Ranulph' in H.C.G. Matthew & B. Harrison (ed.) *ODNB* 19 (Oxford), pp 980–4

Piper, A.J., 1989 'The First Generations of Durham Monks and the Cult of St Cuthbert' in Bonner et al. 1989, pp 437–46

Raine, J. (ed.), 1835 Reginald of Durham, *Libellus de Admirandis beati Cuthberti Virtutibus quae novellis patratae sunt Temporibus*, Surtees Society I (Durham)

Repton, J.A., 1965 *Norwich Cathedral at the End of the Eighteenth Century* (Farnborough)

Rollason, D., Harvey, M. & Prestwich, M. (ed.), 1994 *Anglo-Norman Durham 1093–1193* (Woodbridge and Rochester, NY)

Rollason, D.W. (ed. & trans.), 2000 *Symeon of Durham, Libellvs de Exordio atqve Procvrsv istivs hoc est Dvnhelmensis Ecclesie* (Oxford)

Sharpe, R., 2006 *Norman Rule in Cumbria 1092–1136*, Cumberland and Westmorland Antiquarian and Archaeological Society Tract Ser. 21

Snape, M.G., 1980 'Documentary Evidence for the Building of Durham Cathedral and its Monastic Buildings' in Coldstream & Draper 1980, pp 20–36

Thurlby, M., 1994 'The Roles of the Patron and the Master Mason in the First Design of the Romanesque Cathedral of Durham' in Rollason et al. 1994, pp 161–84

Thurlby, M., 2014 'The Building of the Cathedral: the Romanesque and Early Gothic Fabric' in D. Pocock, M. Thurlby, D. Park & I. Curry, *Durham Cathedral an Architectural Appreciation* (Durham), pp 19–45

Tudor, V., 1989 'The Cult of St Cuthbert in the Twelfth Century: the Evidence of Reginald of Durham' in Bonner et al. 1989, pp 447–67

Appendix: Key measurements and calculations used

	Measurement	Quantum	Source
a	Base module of transepts (= N–S distance between W crossing piers from centre to centre)	12.08m (39ft 7.5in)	Billings 1843, pl. iv
b	Distance between centre of NE crossing pier and shaft carrying formeret	1.12m (3ft 8in)	Billings 1843, pl. iv
c	Internal length of N transept as built	18.90m (62ft 9in)	Billings 1843, pl. iv
d	N Transept, inner bay, interval between responds (at floor level)	3.06m (10ft 0.5in)	Measured on site
e	N Transept, average N–S length of base of cylindrical pier	2.26m (7ft 5in)	Measured on site
f	N Transept, N–S length of compound pier	3.53m (11ft 7in)	Measured on site
g	N Transept arcade, depth of S respond	0.89m (2ft 11in)	Measured on site
h	Internal width of twelfth-century slype	5.0m (16ft 5in)	Billings 1843, pl. xiv
i	Nave arcade, bay 1	5.61m (18ft 5in)	Billings 1843, pl. iv
j	Nave arcade, bays 2 & 3	each 7.125m (23ft 4.5in)	Billings 1843, pl. iii (marked dimensions)
k	Nave arcade, bays 1–3	19.86m (65ft 3in)	(i) + (j)
l	Nave arcade, bay 4	7.81m (25ft 7.5in)	Billings 1843, pl. iii (marked dimensions)
m	Nave arcade, bay 5	7.76m (25ft 5.5in)	Billings 1843, pl. iii (marked dimensions)
n	Nave arcade, bay 6	7.77m (25ft 6 in)	Billings 1843, pl. iii (marked dimensions)
o	Nave arcade, bay 7	8.03m (26ft 4.25in)	Billings 1843, pl. iii (marked dimensions)
p	Nave arcade, bay 8	8.57m (28ft 1.25in)	Billings 1843, pl. iii (marked dimensions)

(Continued)

	Measurement	Quantum	Source
q	Nave arcade, total internal length	59.84m (196ft 4in)	Billings 1843, pls iii and iv (inside of W wall to junction of E nave responds and W crossing piers)
r	Nave arcade, bays 4–8	40.03m (131ft 4in)	(q) – (k)
s	Nave arcade (extrapolating length of bay 2 or 3 × 7)	55.44m (181ft 10.5in)	(k) + ((j) × 5)
t	Difference in length between nave (extrapolating bay 2 or 3 × 7) and as built	– 4.41m (14ft 5.5in)	(q) – (s)
u	Nave arcade (extrapolating length of bay 2 or 3 × 8)	62.61m (205ft 5in)	(k) + ((j) × 6)
v	Difference in length between nave (extrapolated as length of bay 2 or 3 × 8) and as built	+ 2.77m (9ft 1in)	(u) – (q)
w	Total Internal length of Romanesque church as built	118.21m (387ft 10in)	Billings 1843, pls iii and iv (inside of W wall to inside edge of feretory platform, less 58mm (20in) (= distance between the latter and the inside of E wall as marked on feretory floor))
x	Rome, Old St Peter's, internal length (from inner face of E wall to inner face of W apse)	119.48m (392ft 0in)	Measurements marked on Fernie 2000, 9, fig. 9; Krautheimer et al. 1977, 243–5 pl. v
y	Projected total internal length of Romanesque church assuming nave length as in (u)	120.98m (396ft 11in)	(v) + (w)
z	Cloister, N walk	44.35m (145ft 6in)	Billings 1843, pl. v
aa	$\sqrt{2}$ × cloister, N walk	62.71m (205ft 9in)	

Part IV

Constructing meanings

The final section of this volume shifts the focus from material culture to text-based studies. Given Richard Bailey's substantial contribution to advancing our understanding of the material culture of the Middle Ages it is easy to overlook his abiding interest in texts and their interpretation; yet his initial training was linguistic and literary, and that remained at the core of his teaching throughout his career. The chronological focus of the contributions ranges widely in date from Bede in the early eighth century to lawyers arguing over the interpretation of a medieval charter a thousand years later. This span reflects something of the breadth of Richard Bailey's own interest in texts, extending as it does from Bede to the writings of nineteenth-century antiquarians. Yet, underlying that apparent diversity, common themes of interpreting and reinterpreting evidence inherited from the past start to emerge.

We begin with Bede. Colm O'Brien's deconstruction of Bede's famous account of Edwin's dream in his *Ecclesiastical History* reveals the great scholar's ingenuity in drawing on a wide range of narrative techniques to construct a past which, though already chronologically remote, was still ideologically charged and replete with resonances for his own time. Gale Owen-Crocker then considers an aspect of the compositional technique of an equally famous (though, alas, anonymous) early medieval author, the *Beowulf* poet. She examines the evidence for the visual appearance of the interior of Hrothgar's halls, revealing in the process the poet's remarkable technical skill in deploying the art of allusion rather than overt description to evoke the physical settings of his great narrative.

The second pair of papers examines issues of reinterpretation of very different kinds. First, Ian Doyle considers the way in which a traditional miracle story of St Hilda, originally devised to explain the origin of fossilised ammonites from the cliffs at Whitby, was transformed by an anonymous late medieval preacher into a solemn warning against the insidious power of sin. Secondly, Lindsay Allason-Jones and David Heslop trace how the boundary clauses of an early twelfth-century charter of Bishop Ranulph Flambard of Durham also came to have a wholly unexpected (and hotly contested) afterlife as evidence in a litigated boundary dispute some 600 years after the charter was written.

In the next two contributions, by John Frankis and Hermann Moisl, we turn from issues of composition and construction to the actual art of writing: both observe medieval scribes struggling to transcend the boundaries of mother tongue and indigenous training to record unfamiliar languages in orthographic systems not designed to accommodate them. Moisl records Irish scribes' attempts to capture the name of a recently deceased Frankish king, while Frankis traces the efforts of their Anglo-Saxon counterparts, using the full range of graphic resources at their disposal, to reproduce written versions of, *inter alia*, Old High German and the earliest surviving example of Old Netherlandic.

The concluding paper of the volume moves from texts to consider the oral heritage of place names. Diana Whaley invites us to walk with her along a short section of the coast in Richard Bailey's adopted county of Northumberland, in the course of which we encounter an astonishing variety of local place names. She makes a powerful case for the potential of this comparatively neglected category of names to illuminate the landscape and history of a locality.

The hero's journey in Bede's *Ecclesiastical History*: the case of King Edwin

Colm O'Brien

I wish to propose a way of reading a chapter of the *Ecclesiastical History* (*HE*) where Bede adopts a story-telling model which has received little commentary. My chapter is Book II, Chapter 12, the incident, recounted as a flashback, in which the young Edwin, a refugee in the court of King Rædwald and pursued by agents of King Æthelfrith, alone in the night receives a visit from a mysterious stranger who, in a question-and-answer session, challenges him with decisions as to his future. It comes as the turning point in a drama which Bede has developed in a narrative arc from the point he introduced Edwin at the beginning of Book II, Chapter 9 through to the end of Chapter 17. My argument is that Bede places this scene beyond time to present Edwin within the mythic idea of the hero's journey whose structure and elements Joseph Campbell elucidated.[1]

In an editors' footnote on Book II, Chapter 13, the debate among Edwin's councillors at which at which they accepted Christianity, Colgrave and Mynors judged that Bede's account of Edwin's conversion was 'somewhat confused':[2] I disagree. They thought that three episodes, the assassination attempt (Chapter 9), the stranger in the night (Chapter 12) and the debate in council (Chapter 13) came from three different traditions current at the time of Bede's writing. If so, it seems to me that he has brought them together with great skill, achieving a unified narrative with shape, clarity and direction. Bede did not begin at the beginning. When we meet Edwin at the opening of Chapter 9 he is already a great king, the increase in his earthly power being a sign that he was preordained to accept the faith and the heavenly kingdom.[3] Thus a journey is mapped out: it is Edwin's coming to God; and in Bede's hands, this journey has real dramatic quality. It works as a drama in three acts, with a prologue, intermezzo and epilogue, carefully shaped and balanced, during which he draws from a repertoire of narrative techniques in a bravura

and masterly performance to carry the reader along. Here is my reading of the dramatic structure:

PROLOGUE (*HE* II, 9)
As above, the sign of God's intent is in place; the journey begins.

ACT 1: THE CALL TO GOD
SCENE 1: MARRIAGE (*HE* II, 9)
Inciting Incident 1: Marriage brings Paulinus into the drama
Edwin's Conditional Promise 1
Edwin seeks a marriage with Æthelburh of Kent, a Christian princess, and so a pre-nuptial agreement is proposed for her to practise her religion. Edwin agrees and gives the first hint that he might join her with a gem of conditional procrastination: 'Nor did he deny the possibility that he might accept the same religion himself if, on examination, it was judged by his wise men to be a holier worship and more worthy God'.[4] The sentence opens with a double negative (*neque abnegauit*), followed by a conditional clause (*si tamen ... posset inueniri*), referral of the whole matter to a committee (*examinata a prudentibus*), with a threshold level specified of evidence to be achieved (*sanctior ac Deo dignior*) before a decision to recommend Edwin to convert (*se etiam eandam subiturum esse religionem*) could be made. Any senior manager of a university could be proud of such a formulation!

Caution is to be the theme of the journey and this is the first of two conditional undertakings Edwin will give before his eventual unconditional acceptance. But the marriage has brought Paulinus into Edwin's court as the queen's chaplain

and he sets the actions in motion, yet despite his best efforts caution prevails and he is getting nowhere.

SCENE 2: ENTER THE ASSASSIN (*HE* II, 9)

Inciting Incident 2: Assassination Attempt
Edwin's Conditional Promise 2
Edwin narrowly survives death when a supposed ambassador from the king of Wessex proves to be an assassin. Bede has scripted the scene in a single paragraph, conveying the dramatic intensity with a masterly economy of detail, stripped of anything superfluous. We see the setting in a king's hall somewhere by the River Derwent; the characters – king, assassin, the thegns Lilla and Forthhere; the unfolding action – the approach of the faux ambassador, his lunge with the poison-tipped sword, Lilla's swift reaction to put himself in the way of the blade, the ensuing mêlée in which the assassin and Forthhere are killed. This is reportage of the highest standard, and a gift to any cinema scriptwriter who might wish to take on Edwin.

The trauma throws the pregnant queen into premature labour and Eanflæd is born. Edwin thanks his gods but this gives Paulinus the opening he needs to attribute the safe delivery to God. Edwin is responsive and Paulinus draws from him his second statement of commitment. It is still conditional: 'if God would grant him life, and victory over the king who had sent the assassin who wounded him, he would renounce his idols and serve Christ'.[5] No double negative now – instead, as a pledge of his intent, Edwin gives his daughter to be baptised. But first there is business to be settled.

SCENE 3: RETRIBUTION (*HE* II, 9)

Edwin Prevaricating 1
The assassination attempt cannot go unpunished and Edwin leads his army to Wessex to take retribution. The condition he had specified for coming to Christ has been met, but after returning home victorious Edwin delays. A man of 'great natural sagacity' (*uir natura sagacissimus*), he needs to learn more and to consult his counsellors. Act 1 closes with Edwin sitting alone and in silent thought.

INTERMEZZO: *PAPAL PERSUASION*
(*HE* II, 10–11)

Bede the dramatist gives way now to the documentary historian as he brings in two letters from Pope Boniface, one addressed Edwin and one to Æthelburh, to encourage Edwin to convert: powerful support for Paulinus.

ACT 2: TO THE WATERS OF BAPTISM

SCENE 1: STALEMATE (*HE* II, 12)

Edwin Prevaricating 2
Act 2 opens with Edwin in the same state. Despite all that has happened, he is still prevaricating. Paulinus is about to take the action which will move events rapidly to their climax. But first Bede sets this up with a flashback scene.

SCENE 2: FLASHBACK TO YOUTH (*HE* II, 12)
Stranger in the Night and Three Promises
The whole scene, set in the darkness of night, has an otherworldly quality. It is a drama within the drama, its structure formal and tight.

INTRODUCTION: THE SETTING

Back to the days of Edwin's youth as a refugee in the court of King Rædwald, his life in danger as Rædwald is tempted by the bribes of King Æthelfrith's agents to betray the trust Edwin has placed in him and hand him over to be murdered.

Edwin is alone.

EPISODE 1: ENTER THE FRIEND

The Friend offers Edwin the chance to escape. Edwin choses the hero's course, to face whatever the future holds.

The Friend leaves. Edwin is alone.

EPISODE 2: ENTER THE STRANGER

The Stranger asks three questions as to the future, each a what-if question, each one drawing a commitment from Edwin in reply: 'What if someone could get you out of this danger?' 'I would give him whatever I could in return.' 'What if this person could win you a kingdom?' 'I would be suitably grateful.' 'What if this person could give you better advice as to your salvation than anyone of your kinsmen has received?' 'I would follow his teachings in every particular.' The Stranger gives a sign, bidding Edwin to remember his promises when next he should receive this same sign.

The Stranger disappears; Edwin realises he has been visited by a spirit. Edwin is alone.

EPISODE 3: RE-ENTER THE FRIEND

The Friend brings the news that the present danger has past: Rædwald's wife has persuaded him to do the decent thing by Edwin. Edwin is not alone; he has a protector.

The Stranger's first what-if question has been answered.

EPILOGUE: FAST-FORWARD TO THE PRESENT

In the fast-forward to the present, we are given a glimpse of the battle of the River Idle in which Rædwald's army wins the kingship for Edwin.

The Stranger's second what-if question is answered. Now only the third remains.

SCENE 3: PAULINUS CALLS IN THE DEBT
(*HE* II, 12–13)
Back to the present
Edwin Prevaricating 3
Inciting Incident 3: Paulinus gives the sign
Before the flashback, Bede left Edwin prevaricating; he is still prevaricating. Paulinus acts by giving to Edwin the same sign which the mysterious Stranger had given all those years ago. Edwin is jolted into remembering the

promises of his youth. It is time for him to deliver on the third and final what-if question and now, at last, he makes an unconditional undertaking: he is both 'willing and bound' to receive the faith.[6]

SCENE 4: DEBATE IN COUNCIL (*HE* II, 13)

From the beginning, Edwin had said he would have to consult his advisors. Now Bede gives us the debate in council, in which the issue moves to its resolution through three speeches. Bede used the model of the set-piece debate to great effect with the Synod of Whitby (*HE* III, 25); this debate, while on a smaller scale, is no less forceful in its encounter between the two priests, Paulinus and Coifi, with the un-named councillor's image of the sparrow in the hall presented as the hinge on which the debate turns. In a dramatic gesture, Coifi then destroys the temple to his own gods.

SCENE 5: BAPTISM: THE CULMINATION (*HE* II, 14)

That which was foreseen in the Prologue (*HE* II, 9) comes to pass as those who were preordained to eternal life (*quotquot erant praeordinati ad uitam aeternam*) receive baptism. Paulinus then takes his mission out into Bernicia and Deira.

ACT 3: CHRISTIAN KINGSHIP

SCENE 1: A DEBT REPAID (*HE* II, 15)

As Rædwald had served Edwin by protecting his mortal life and winning for him his kingship (the first two what-if questions), so Edwin now returns the gift by ensuring heavenly life for Rædwald's apostate son Eorpwald (the third what-if question) by bringing him back to Christ.

SCENE 2: BISHOP AND KING TRIUMPHANT (*HE* II, 16)

Paulinus, who has been God's agent in bringing Edwin to God, is triumphant in extending the Christian realm beyond the Humber where Edwin's *imperium* of peace and majesty is established in a model of Christian kingship.

EPILOGUE (*HE* II, 17)

Again Bede the documentary historian comes to the fore, this time showing the second papal letter to Edwin, affirming attainment of the aspirations of the first (*HE* II, 10).

Discussion

I am arguing, then, that Bede conceived the whole narrative of Edwin in dramatic terms and as a unity, placing the flashback scene as the centrepiece around which the drama revolves. We do not know how and in what form elements of the story had reached Bede, whether his raw material was disconnected fragments, as Colgrave and Mynors suggest, or whether (or, if so, to what extent) any of it had been shaped already in

storytelling. Henry Mayr-Harting saw characteristics of saga in the assassination attempt.[7] Reviewing the matter recently, Victoria Gunn considered that Bede's references to eyewitness and oral accounts are part of the rhetorical strategies he developed to convince his readers of his historical accuracy, a point which she applies to *HE* II, 12.[8] I would not take such an instrumentalist approach in reading a work of providential history: Edwin, as we have seen, was preordained to eternal life; and, as I read it, Bede has placed the flashback scene beyond normal historical time.

By chance, the stranger-in-the-night flashback is one of a few scenes in the *Ecclesiastical History* which we can directly compare with another writer's treatment and so gain some insight into what Bede himself has brought to the telling of it. The other writer is the anonymous author from the monastery of Whitby who composed a *Life* of Pope Gregory the Great, including within it (Chapters 12–19) a section on Edwin as king and posthumous miracle worker, with the stranger-in-the-night scene treated in Chapter 16.[9] Bertram Colgrave, editor and translator of the Whitby text, judged that it had been written between 704 and 714,[10] at least seventeen years earlier than Bede's text, yet 'it is very unlikely' to quote Colgrave, 'that Bede had ever seen the Whitby Life'.[11] So if the two texts are independent of one another, this suggests the story was in general circulation, as the Whitby writer implied when he referred to ancient tradition (*quomodo antiquitus traditur*).[12]

The Whitby account is much briefer than Bede's, despite its author's claim not to be writing in the 'condensed form in which we have heard it',[13] and it is introduced into the text as a throw-away: since we are mentioning Edwin we should include this, with none of Bede's careful positioning within a larger narrative structure. The context is established of Edwin in Rædwald's court, under threat and in fear of his life, when one day 'a certain man, lovely to look upon, appeared to him crowned with the cross of Christ'.[14] The man does not ask questions of Edwin; rather he makes conditional promises of a happy life and restoration of his kingdom if Edwin will obey him. Edwin replies that he will do so if the man can prove the truth of what he says. The man answers that Edwin himself will prove this and gives the instruction that Edwin must obey the first man he sees with this appearance and sign. The man is then identified as Paulinus.[15]

The Whitby author does not use the narrative device of flashback and so misses a powerful story-telling technique first encountered in literature as far back as the *Odyssey*. There is no attempt to paint the scene with Edwin alone and pensive in the night, in the way that Bede did to integrate his flashback with the main narrative. There is no friend to offer Edwin a way out of his predicament and draw him into making the heroic decision to face his fate. The encounter between Edwin and the stranger is heavy-handed as compared with Bede's, in which the questioning technique will lead Edwin to attain awareness for himself, and the laying on of a hand prepares us, the readers, also

for the shock of Edwin's moment of truth in the next scene. The most telling point of difference is that only the Whitby author identifies the stranger as Paulinus.

Charles Plummer's comment on *HE* II, 12 supposes that Bede's stranger was in fact Paulinus, sent on a mission to East Anglia.[16] This is plausible as history and recently Max Adams has followed this in his reconstruction of Edwin's reign;[17] and Michael Wallace-Hadrill appears to have taken his cue from Plummer in suggesting that Bede's version derived from a tradition emanating from Paulinus himself.[18] This may be so, but surely there is more to it. If Bede wished to identify an individual but was unsure who he was, he could have called him *ignotus*, but he did not to this. When the stranger had departed, he writes, Edwin recognised that he was not a man but a spirit. Bede is comfortable with the idea that spirits should engage with humanity: one such appeared at Coldingham (*HE* IV, 25).

The two key points in my reading of Bede's scene of Edwin and the stranger are, first, that he has placed it out of its strict chronological context: flashback is a storytelling technique, not normal historical narrative; and, secondly, that, having detached the scene from its time in history, he placed it in darkness beyond time to turn it into an other-world encounter. Bede has modelled Edwin as a mythic hero in a mythic setting.

I draw my interpretation from Joseph Campbell's exposition of the hero's journey, first published in 1949, later re-published and still a landmark in literary studies.[19] The path of the hero's mythic journey follows the three stages in rites of passage: initiation; separation; return.

> A hero ventures forth from the world of common day into a region of supernatural wonder: fabulous forces are there encountered and a decisive victory is won: the hero comes back from this mysterious adventure with the power to bestow boons on his fellow man.[20]

This model is seen in stories in many societies from the earliest literature known to us: Odysseus' journey is one such, with his descent into Hades being the liminal second stage of separation. In his fuller exposition Campbell identifies seventeen episodes in the three stages of the hero's journey, by no means all of which are necessarily present in any particular version of the myth. We can map Edwin's journey on to Campbell's model as set out in Table 21.1 (I use Campbell's headings and retain his numbering of the episodes,[21] and I cross-refer to the scenes of my scheme above in italics within square brackets.)

Richard North was of the view that Bede knew a version of the flashback scene which had come down from Edwin,

Table 21.1 Edwin's journey according to Campbell's model

Campbell Model (select elements only, reproducing Campbell numbering)	Corresponding Elements of the Dramatic Structure of HE II, 9-17
I: SEPARATION OR DEPARTURE	
1. The Call to Adventure	Paulinus calls Edwin to God *[Act 1, Scenes 1 and 2]*
2. Refusal of the Call	Despite his promises to Paulinus, Edwin prevaricates after his victorious return from Wessex. *[Act 1, Scene 3; Act 2, Scene 1]*
4: The Crossing of the First Threshold	The flashback takes Edwin across the threshold from historical time into an other-worldly state. *[Act 2, Scene 2, Introduction: the Setting]*
5: The Belly of the Whale	By rejecting his friend's invitation to escape, Edwin confronts the other-worldly dangers. *[Act 2, Scene 2, Episode 1]*
II: THE TRIALS AND VICTORIES OF INITIATION	
1. The Road of Trials	Edwin is tested by the spirit (who can be understood as a trickster) who confronts him with three questions. *[Act 2, Scene 2, Episode 2]*
2. The Meeting with the Goddess	An indirect meeting; Edwin's friend brings news that Rædwald's wife has intervened to save him. *[Act 2, Scene 2, Episode 3]*
III: THE RETURN AND REINTEGRATION WITH SOCIETY	
1. Refusal of the Return	Despite his promises to Paulinus, Edwin prevaricates after his victorious return from Wessex. *[Act 1, Scene 3; Act 2, Scene 1]*
3. Rescue from Without	Paulinus gives the sign and Edwin remembers his commitments; his councillors and Coifi assent. *[Act 2, Scenes 3 and 4]*
4. The Crossing of the Return Threshold 5. Master of the Two Worlds	Edwin accepts the Catholic faith and receives baptism from Paulinus. He now has both temporal and spiritual power. *[Act 2, Scene 5]*
6. Freedom to Live	Within Edwin's newly Christian realm, Paulinus is able to bring the boon of Catholic baptism to the people. *[Act 3, Scenes 1 and 2]*

who had identified the spirit as being Woden, and that, when later reminded of his promises, Edwin rationalised Paulinus as Woden; then when the people saw Coifi destroying his temple in an apparent fit of madness,[22] they also thought they were seeing Woden.[23] This reading too places Edwin in a mythic setting and one within a pre-Christian understanding of his identity. It is not unconvincing to suggest that Bede and other church leaders were in touch with the pre-Christian roots of English culture and with secular forms of entertainment, if only to warn against them. Bede himself, in Chapter 15 of his *De Temporum Ratione*, gave the old names for the months of the year and explained something of the beliefs and cult practices lying behind these, while giving thanks that Jesus had turned us away from such things.[24] At the end of the eighth century, Alcuin warned bishop Speratus that there was not room for both Ingeld and Christ at his dinner table, where God's words should be heard, not a harpist and pagan songs.[25] In this he was echoing protests that Bede had made in a letter to his former pupil, by then bishop, Ecgbert, about laughter, jokes, storytelling, eating, drinking and other seductions in episcopal households.[26] Such practices were, no doubt, the reason why the Council of *Clovesho* in 747 felt the need to forbid priests to chatter in church in the manner of secular poets and to castigate poets, harpists, musicians and buffoons.[27]

Perhaps the biggest surprise in all of this is that, in describing how the first of his model Northumbrian kings came to God, Bede did not trumpet the Old Testament to announce the providential significance of the events. He had, after all, already likened Edwin's pagan predecessor and enemy Æthelfrith to King Saul of the Israelites (*HE* I, 34), and, as Judith McClure has shown, he built his understandings of kings more generally on Old Testament models,[28] in a work permeated with insights drawn from scriptural exegesis.[29] It may be that the Scriptures are present obliquely, as Julia Barrow suggests in her reading of *HE* II, 12–13,[30] with Coifi's spear piercing his own temple deliberately evoking the lance from the Crucifixion piercing the temple of Christ's body; and her thought that the spirit who visited Edwin in the night is to be understood as the promises of the Old Testament awaiting fulfillment in the New is consistent with Bede's understanding of the relationship between the two Testaments.[31] But it would take an erudite scriptural scholar among Bede's readers to spot these allusions; they are well disguised. The flashback of *HE* II, 12 is not there for such a reader. Instead, Bede presents Edwin as a mythic archetype of the hero in a narrative structure closer to forms of storytelling which he criticised when writing to Ecgbert but which were deep-rooted in clerical and lay society. Why should he have done this? Hermann Moisl some time ago made the case that Anglo-Saxon kingdoms maintained orally transmitted traditions of kingly descent from heathen gods.[32] Was Edwin so widely known in stories associated with Woden that, in

order to make of him a model Christian king and to displace Woden, Bede realised that he would have to address the mythology on its own terms and in its own forms?

Edwin is certainly the hero of this journey, but focus on the role of Paulinus affords another insight into Bede's narrative construct. In a structural sense, Paulinus' role is to bring together the inner flashback story and the main outer narrative. By giving the sign to Edwin he collapses the space between the mythic time of the inner story and the historical time of the main conversion narrative to initiate the end game, despite the fact that he was not the stranger in the night and not present in the flashback scene. The other-world encounter of that night is not only mythic, it is also miraculous. Benedicta Ward has observed that Bede is not naïve in his use of miracle stories; his primary concern is with the moral truth and inner meaning of the events, and then with their significance within the story he is writing.[33] In this case, we have two interlocking miracles. In the inner story there is the appearance in the night of the prophetic spirit whose functional significance is to set the stage for Edwin's encounter with Paulinus in the outer narrative; the moral truth of this miracle is that Edwin is destined to come to Christ. In the outer narrative, Paulinus is placed in a similar position to that of Cædmon (*HE* IV, 24), visited in a dream by a spirit who reveals truth to him. In a functional sense, this miraculously conveyed knowledge enables Paulinus to act to bring Edwin to a state of self-realisation; the moral truth underlying this is that Paulinus is God's appointed agent, one of the much more worthy heralds (*HE* I, 22), for the conversion of the English people. In this way, Bede has not only moved Edwin from the realm of the everyday into a mythic dimension, but also Paulinus, in a specifically Christian way. This is not his only use of the hero's journey in a miraculous context. The out-of-body experiences of both Fursa (*HE* III, 19) and Dryhthelm (*HE* V, 12) are of this type, though neither case is so well developed as Edwin's.

I suggest that this reading of Paulinus' role offers a new perspective on the claim in *Historia Brittonum* and the *Annales Cambriae* of the ninth to tenth centuries that Rhun son of Urien of Rheged participated in Edwin's baptism.[34] Whether this was indeed the case has divided scholarly opinion. David Rollason, for instance, is doubtful, while Clare Stancliffe takes the view that British collaboration in Paulinus' mission and a jointly conducted baptism may well have been the case.[35] Of more immediate concern here is whether Bede knew of this claim and, if so, what was his attitude to it; neither he nor the Whitby writer refers to it. Wallace-Hadrill thought that, had Bede known, 'he would have paused to rebut it'.[36] While there can be no certainty on this point, it is clear that Bede had access to, and used material from, British sources: Chapters 12–16 and 22 of Book 1 are derived from Gildas; Augustine's stand-off with the British church leaders at Augustine's Oak (*HE* II, 2) is written in part from a British perspective; and Bede knew of

the internal structuring of the monastery of Bangor (*HE* II, 2). But if we suppose, for the sake of argument, that Bede did know of the story of Rhun's involvement, it is striking that he neither referred to it nor rebutted it.

Bede had a deep-seated antipathy towards the Britons and Clare Stancliffe has shown how he contrived, through careful structuring of the text of the *Ecclesiastical History*, to present them in a consistently unfavourable way. The hardening of attitudes in the 670s, under the influence of Theodore and Wilfrid, against those not accepting the Roman date of Easter provides a reason, Stancliffe suggests, why no Anglo-Saxon sources would have admitted to an event such as Rhun's involvement in Edwin's baptism; their silence is no evidence that the story was either untrue or unknown.[37] Thomas Charles-Edwards has suggested that the claim that Rhun baptised Edwin 'may have been widespread among the Britons as a counter to the depreciation of their Christianity after the Synod of Whitby'.[38] If so, this places the story's circulation in a contested context central to Bede's interests. Why, then, did he not respond?

I suggest that Bede did know of this tradition, and responded to it, but in a way which was oblique and implicit. In the preface to the *Ecclesiastical History*, he invoked the idea of *uera lex historiae*, ('a [or 'the'] true law of history') which, deriving from *fama uulgans* ('common report'), admits of error.[39] This text has attracted much commentary on several points;[40] but Plummer was first to compare it with Bede's commentary on St Luke's Gospel (2:33–4), itself derived, as C.W. Jones recognised, from Jerome, concerning the birth of Christ.[41] Bede comments that the evangelist, despite the theological truth that Mary conceived by the Holy Spirit and remained a virgin, was 'expressing the common belief, which is the true law of history' when he called Joseph the father of Christ.[42] Thus Bede drew a distinction between theological truth and a, possibly flawed, historical knowledge; the evangelist acknowledged the unsound common belief while affirming the theological truth. I suggest that this distinction may also apply in the case of Rhun. By drawing Paulinus into the sphere of the miraculous in *HE* II, 12, Bede makes him part of the theological truth that Edwin was 'foreordained to eternal life' (*HE* II, 14). Whether Rhun was associated with his baptism is a question of *fama uulgans*, a different order of knowledge. So his treatment of events in *HE* II, 12, being both mythic and miraculous and set beyond historical time, removed from Bede the need for explicit rebuttal, for the Britons who had failed to preach to the pagan English incomers were not the heralds destined to bring that people to the faith (*HE* I, 22).

Michael Lapidge and Walter Berschin have shown us how Bede, in re-working the life story of St Cuthbert for his treatments first in verse and then in prose, stripped out from the Anonymous *Life* points of specific circumstantial detail to focus on the figural meaning of the events, removing them 'from the temporal and the local and to situate them

in a timeless, placeless framework';[43] and how, through a structuring in forty-six chapters, referring to the forty-six years of the building of the Temple and the forty-six days in the forming of the human body and soul, he made of Cuthbert 'a perfect temple of God'.[44] When, later, he came to write the *Ecclesiastical History*, Bede already had in mind, from the time he wrote the *Greater Chronicle*, an historical model of the conversion of the English by Pope Gregory's missionaries in two stages, first in Kent and then in Edwin's Northumbria, and an understanding that Edwin's early power was a portent of what was to come.[45] He brought this model forward into the *History*, treating it according to an epistemology that privileged theological truth over what was said to have been the case. And having learned from his writings on St Cuthbert how a reality can be created through literary construct, he drew on a mythological archetype and a Christian understanding of the miraculous to show the inevitability of Edwin's conversion at the hands of God's agent, Paulinus, thereby removing any suggestion of a Woden-inspired reading of Edwin or of any British involvement in his baptism. The conceit is breath-taking; its written realisation brilliant.

Notes

1 Campbell 1993.
2 Colgrave & Mynors 1969, 182–3.
3 in auspicium suscipiendae fidei et regni caelestis, potestas etiam terreni creuerat imperii (Colgrave & Mynors 1969, 162–3).
4 Neque abnegauit se etiam eandem subiturum esse religionem, si tamen examinata a prudentibus sanctior ac Deo dignior posset inueniri (ibid.).
5 promisit se abrenuntiatis idolis Christo seruiturum, si uitam sibi et uictoriam donaret pugnanti aduersus regem, a quo homicida ille, qui eum uulnerauerat, missus est (Colgrave & Mynors 1969, 166–7).
6 *HE* II, 13: rex suscipere quidem se fidem, … et uelle et debere respondebat (Colgrave & Mynors 1969, 182–3).
7 Mayr-Harting 1972, 224.
8 Gunn 2009, 146–52.
9 Colgrave 1968, 94–105.
10 Colgrave 1968, 46–9.
11 Ibid., 56–9.
12 Chapter 16 (ibid., 98–9).
13 Quod non tam condenso quomodo audivimus verbo (ibid.).
14 quadam die quidam pulchre visionis, cum cruce Christi coronatus apparens (ibid., 100–1).
15 Ibid.
16 Plummer 1896, ii, 93.
17 Adams 2013, 81–4.
18 Wallace-Hadrill 1988, 71.
19 Campbell 1993; Epstein 2004.
20 Campbell 1993, 30.
21 Ibid., 36–7.
22 *HE* II, 13: Quod aspiciens uulgus aestimabat eum insanire (Colgrave & Mynors 1969, 184–5).
23 North 1997, 304–42.

24 Jones 1977, 329–32; Wallis 1999, 53–4.

25 Alcuin, *Epistolae* (Dümmler 1895, 183 (no. 124)); Bullough 1993, 124.

26 Bede, *Epistola ad Ecgbertum Episcopum* 4 (Grocock & Wood 2013, 128–9).

27 Haddan & Stubbs 1871, 364, 369; Wormald 1978, 42–8; Cubitt 1995, 100–1.

28 McClure 1983.

29 Thacker 2010.

30 Barrow 2011, 699–704.

31 Ibid., 697.

32 Moisl 1981.

33 Ward 1976, 72–3.

34 Nennius, *Historia Brittonum* 63 (Morris 1980, 38, 79); *Annales Cambriae, s.a.* 626 (Morris 1980, 46, 86).

35 Rollason 2003, 88; Stancliffe 2010, 77–8.

36 Wallace-Hadrill 1988, 65.

37 Stancliffe 2007, 11–16.

38 Charles-Edwards 2013, 354–5.

39 *quod uera lex historiae est, simpliciter ea quae fama uulgante collegimus ad instructionem posteritatis litteris mandare studuimus.* ('For, in accordance with the principles of true history, I have simply sought to commit to writing what I have collected from common report, for the instruction of posterity.': Colgrave & Mynors 1969, 6–7).

40 See Goffart 2005 for a review of the topic.

41 Plummer 1896, ii, 3–4; Jones 1947, Chapter 5, especially p. 83.

42 *opinionem uulgi exprimens quae uera historiae lex est* (Hurst 1960, 67).

43 Lapidge 1989, 91.

44 Berschin 1989.

45 Jones 1977, 523, 525; Wallace 1999, 226–8.

References

Adams, M., 2013 *The King in the North* (London)

Barrow, J., 2011 'How Coifi Pierced Christ's Side: A Re-Examination of Bede's Ecclesiastical History, II, Chapter 13', *J. of Ecclesiastical History* 62(4), 693–706

Berschin, W., 1989 '*Opus deliberatum ac perfectum*: Why Did the Venerable Bede Write a Second Prose Life of St Cuthbert?' in Bonner et al. 1989, pp 95–102

Bonner, G., Stancliffe, C. & Rollason, D. (ed.), 1989 *St Cuthbert, his Cult and his Community to A.D. 1200* (Woodbridge)

Bullough, D.A., 1993 'What has Ingeld to do with Lindisfarne?', *ASE* 22, 93–125

Campbell, J., 1993 *The Hero with A Thousand Faces* (London)

Charles-Edwards, T., 2013 *Wales and the Britons 350–1064* (Oxford)

Colgrave, B. (ed. and trans.), 1968 *The Earliest Life of Gregory the Great* (Cambridge)

Cubitt, C., 1995 *Anglo-Saxon Church Councils c. 650–c. 850* London

DeGregorio, S. (ed.), 2010 *The Cambridge Companion to Bede* (Cambridge)

Dümmler, E. (ed.), 1895 *Epistolae Karolini Aevi, Tomvs II*, MGH: Epistolarum Tomvs 4 (Berlin)

Epstein, L.E., (ed.), 2004 *Mythic Worlds, Modern Worlds: on the Art of Joseph Campbell/James Joyce* (Novata, CA)

Goffart, W.A., 2005 *The Narrators of Barbarian History (AD 530-800): Jordanes, Gregory of Tours, Bede and Paul the Deacon* (Notre Dame, IN)

Grocock, C., and I.N. Wood (ed. & trans.), 2013 *Abbots of Wearmouth and Jarrow...* (Oxford)

Gunn, V., 2009 *Bede's Historiae: Genre, Rhetoric and the Construction of Anglo-Saxon Church History* (Woodbridge)

Haddan, A.W. & Stubbs, W. (ed.), 1871 *Councils and Ecclesiastical Documents Relating to Great Britain and Ireland* 3 (Oxford)

Hurst, D. (ed.), 1960 *In Lucae Evangelium Expositio, Bedae Venerabilis Opera, Pars II, Opera Exegetica 3*, CCSL 120 (Turnhout), pp 1–425

Jones, C.W., 1947 *Saints' Lives and Chronicles in Early England.* (Ithaca, NY)

Jones, C.W. (ed.), 1977 *De Temporum Ratione Liber, Bedae Venerabilis Opera, Pars VI, Opera Didascalica 2*, CCSL 123B (Turnhout)

Lapidge, M., 1989 'Bede's Metrical *Vita S. Cuthberti*' in Bonner et al., 77–93

Mayr-Harting, H., 1972 *The Coming of Christianity to Anglo-Saxon England* (London)

McClure, J., 1983 'Bede's Old Testament Kings' in P. Wormald with D. Bullough & R. Collins (ed.), *Ideal and Reality in Frankish and Anglo-Saxon Society* (Oxford), pp 76–97

Moisl, H., 1981 'Anglo-Saxon Royal Genealogies and Germanic Oral Tradition', *J. of Medieval History* 7, 215–248

Morris, J. (ed. and trans.), 1980 *Nennius, British History and the Welsh Annals* (London & Chichester)

North, R., 1997 *Heathen Gods in Old English Literature* (Cambridge)

Plummer, C. (ed.), 1896 *Venerabilis Baedae Opera Historica*, 2 vols (Oxford)

Rollason, D., 2003 *Northumbria, 500–1000: Creation and Destruction of a Kingdom* (Cambridge)

Stancliffe, C., 2007 *Bede and the Britons*, Whithorn Lecture (Whithorn)

Stancliffe, C., 2010 'British and Irish Contexts' in DeGregorio 2010, 69–83

Thacker, A., 2010 'Bede and History' in DeGregorio 2010, 170–89

Wallace-Hadrill, J.M., 1988 *Bede's Ecclesiastical History of the English People, a Historical Commentary* (Oxford)

Wallis, F. (trans.), 1999 *Bede: The Reckoning of Time* (Liverpool)

Ward, B., 1976 'Miracles and History: a Reconsideration of the Miracle Stories used by Bede' in G. Bonner (ed.), *Famulus Christi: Essays in Commemoration of the Thirteenth Centenary of the Birth of the Venerable Bede* (London), pp 70–6

Wormald, P., 1978 'Bede, "Beowulf" and the Conversion of the Anglo-Saxon Aristocracy' in R.T. Farrell (ed.), *Bede and Anglo-Saxon England* (Oxford), pp 32–95

Furnishing Heorot

Gale R. Owen-Crocker

Introduction

Scholarly work about the physical nature of Heorot has tended to focus on architecture, comparing the fictional hall to archaeological finds from England, and to the Danish royal occupation site at Lejre,[1] with particular attention to the implausibility or moral significance of Heorot's golden roof, 'an architecturally incongruous feature in a timbered Germanic long-hall'.[2] Films and video games depicting early medieval habitations seem to rely heavily on dark interiors lit partially by flaming torches in sconces on the walls, with carved wooden posts reminiscent of Norwegian stave churches such as the mid-twelfth-century building at Urnes, Norway;[3] dress accessories and furnishings are recreated combining iconic artefacts from different periods and regions, such as the Zemeckis film's use of some sixth-century brooches, the seventh-century Desborough necklace and the tenth-century Jellinge cup.[4]

The *Beowulf*-poet is, admittedly, restrained when it comes to describing the interior of Heorot; but the few hints that are given in the poem about hall life, combined with the evidence of archaeology, particularly burials that were furnished as rooms, make it possible to develop the picture a little. We can assume that the walls were wooden, since wooden architecture was normal for domestic buildings and for many churches both in Anglo-Saxon England and later in Scandinavia; this is consistent with the threat of fire which will eventually destroy Heorot (lines 82–3, 781–2) and the fact that the hall reverberates with the violence of Beowulf's fight with Grendel: *Dryhtsele dynede* (line 767).[5] The walls are reinforced outside with iron bands, however, perhaps as a special precaution against the monster. The door is also reinforced with iron and we can imagine it as a stout, solid, wood door with wrought iron fittings like that out of which an angel conducts Adam and Eve from Eden in the Junius manuscript.[6] The floor is more problematic: as Grendel steps onto it, the poet describes it as *fāgne flōr*

(line 725). *Fāg* is generally interpreted as 'decorated', but whether the imagined decoration takes the form of polished wood, paving, Roman mosaic or patterned tiling of the kind found in early medieval churches is not agreed.[7] The adjective can also mean 'stained'[8] and the possibility that it refers to the blood stains from Grendel's previous murders should not be dismissed.

Round the walls

Both archaeological evidence and the text itself suggest that portable wealth might have been hung round the walls as decoration. There is evidence of this from the Prittlewell, Essex, chamber grave, which John Hines has called 'a version of a lived-in building'.[9] The Prittlewell burial, when discovered in 2003, was undisturbed, since grains of sandy soil had infiltrated between the planks slowly and gently, filling the chamber without moving the contents. Vessels were still attached to hooks on the wooden walls when it was excavated. The hanging bowl, which would have been prized for its foreignness, its antiquity and its rich decoration, was not suspended by its four rings in a horizontal position so that it could be filled and used, but hung vertically from a single hook on the wall so that the ornaments on its outer sides and base would be exhibited.[10] Shiny vessels, gilded, silver, copper and tinned, would have contributed to the gleaming appearance of the hall interior. Weapons, too, would almost certainly have been hung on walls: Beowulf seizes the gigantic sword with which he despatches Grendel's mother and decapitates Grendel from *on searwum* (among the treasure, line 1557), and one cannot imagine that this treasure was just a jumbled heap in her lair since Beowulf is able opportunistically to seize its decorated hilt without fumbling (line 1563) and strike a fatal blow. He later turns *be wealle* (by, or near the wall, line 1573) to strike Grendel's lifeless body. The custom of

hanging swords and other weapons in display on the walls has persisted and they can be seen in many medieval and later buildings which are open to the public today, swords sometimes crossed and other weapons often fanned out round a shield in deliberately ornamental arrangements that are almost certainly traditional. In early medieval times this display might have extended to protective armour. Objects had almost certainly been hung up in the wooden funerary structure which was built on the Sutton Hoo ship, although, unlike the Prittlewell chamber, this one had collapsed violently, smashing some of the objects. Among the treasures thought to have been hung up was the helmet. The Sutton Hoo helmet was tinned, and a mount found among the Staffordshire hoard and believed to be from a helmet was silver;[11] such objects would have gleamed *hwīt* (shining), like the helmet Beowulf wears for his plunge into the mere (line 1448).

The funeral pyre at Finnesburg is furnished with treasures *āhæfen of horde* (brought up, or extracted from, the hoard, line 1108) which suggests a store of treasures kept not in the hall but elsewhere, possibly in a subterranean room if we take literally the statement that they are 'brought up'. Certainly Beowulf's retainers are able to furnish his pyre with helmets, shields and mailcoats (lines 3139–40) which must have been kept somewhere other than his royal hall, since that had been burnt down by the dragon (lines 2325–7). It seems reasonable to suppose, however, that a king and his *comitatus* would have lived surrounded by chosen treasures, which could be taken down, admired and polished in any idle moment. These would include certain ancestral items which could become the source of tales about previous owners, their exploits with weapons and the biographies of the objects themselves. The poet gives hints of such artefact life-stories in his allusions to Unferth's sword, Wiglaf's sword, the legendary neck-ring of the Brosings (lines 1197–1201) and Beowulf's own neck-ring which is given to him by Wealhtheow, re-gifted by Beowulf to Hygd, passed to her husband Hygelac and lost by him in his fatal Frisian raid. Perhaps the ancestral treasures given to Beowulf by Hrothgar were not suddenly produced from an unseen store, but were well known to the protagonists since they had been displayed in full view: the famous, ornamented sword which had belonged to Hrothgar's father (*brand Healfdenes ... Mære māðþumsweord*, lines 1020, 1023);[12] a golden standard (*segen gyldenne ... hildecumbor*, lines 1021–2), a crested helmet (lines 1030–4); the mail coat of Hrothgar's late brother, King Heorogar (lines 2155–62) and the king's own *sadol searwum fāh ... hildesetl* (saddle decorated with treasures ... war saddle, lines 1038–9).

After Beowulf's victory over Grendel, men and women decorate Heorot for festivities (*gestsele gyredon*, line 994). The only adornment specified is gold-ornamented textile which is hung along the walls (*Goldfāg scinon / web æfter wāgum*, lines 994–5). As the poet immediately afterwards

mentions the structural damage caused by the fight with Grendel – *Wæs þæt beorhte bold tōbrocen swīðe / eal inneweard īrenbendum fæst, / heorras tōhlidene* (The bright building was much broken, all fastened inside with iron bands, the hinges sprung apart, lines 997–9) – it is natural for the modern critic to see the installation of the wall hangings as a device to cover up the damage and potentially as a kind of metaphor for the behaviour of the Danes who both plaster over the cracks in royal family relationships and choose to ignore the existence of another monster lurking in the darkness in order to return to their rather decadent hall life.

On this occasion I prefer to consider the wall hanging more literally. This kind of furnishing may already have been a feature of luxury-class living by the early seventh century since there were fragments of what was probably a hanging in the funeral chamber on the Sutton Hoo ship. This textile was wool soumak weave on linen, attested by fragments SH5 and SH7.[13] Hall hangings and other curtains – variously called *heallreaf* (hall curtain), *wahrift* (hanging) and *burreaf* (curtain for a small room or building) – are well attested for the late Anglo-Saxon period, since they are bequeathed by wealthy women, and in one case by a man (a bishop), in tenth- and eleventh-century wills. People owned hangings of different lengths and qualities and probably had a stock of such things which were kept in chests and brought out when required.[14] Textile draperies may have been a particularly English tradition, since the Flemish scholar Goscelin was very impressed with the soft furnishings (curtains, hangings and seat covers) provided when a filthy hovel was transformed into a desirable home for him on his arrival at Potterne (Bishop's Canning), Wiltshire, in 1058.[15] The Bayeux Tapestry, which probably dates to the 1070s or 1080s, measuring 68.58m in its present incomplete state, must have been one of the longest wall hangings of its day, made for the interior of a very large room, probably a royal dwelling. It is almost certainly English work.[16] The Icelandic *Saga Gísla Súrsonnar*, which, typically for the genre, deals with lower status characters than *Beowulf*, mentions hangings which are prestigious in their world, being 27.43m long. The text is thirteenth-century but the subject matter is tenth-century.[17] Possibly the hangings in this story were also of English manufacture, since Vestein, who gives this tapestry to his sister Aud and her husband Gisli, had previously sailed to England, the last of his voyages before he was killed; though there was also a Scandinavian medieval tradition of wall hangings (see below).

There is no information that either the *Beowulf* hangings or the *Saga Gísla Súrsonnar* tapestry were pictorial, and the Sutton Hoo remains are too fragmentary to establish the form of the pattern, but there was evidently a tradition of pictorial hangings in England and Scandinavia from at least the ninth century. The Oseberg, Norway, ship burial, dated by dendrochronology to 834, contained a hanging in soumak

(wrapped) weave, which depicts figures and vehicles.[18] The widow of Byrhtnoth, the ealdorman of Essex who died at the Battle of Maldon in 991, presented a curtain depicting her husband's deeds to the church at Ely, though it is not known whether this was tapestry, embroidery or other craftwork, such as a painted textile.[19] Parts of a composite tapestry, again of soumak weave, from Overhogdal, now Sweden, but in Norway in medieval times, have been C-14 dated to 800–1100, and were probably once wall hangings, their decoration possibly combining a Christian theme with Norse mythology.[20] The twelfth-century Skog Tapestry, now in the National Museum of Sweden in Stockholm, is a further example of a pictorial hanging.[21]

The *Beowulf*-poet, typically, is more interested in commenting that people marvelled at the shining gold of the wall hanging in Heorot than in describing its woven ornament. At first sight this impression of a gold-adorned weaving would appear to be hyperbolic, since cloth-of-gold (fabric, usually silk, woven with a gold filé weft) was only commercially produced in Europe from the fifteenth century. Gold-adorned textiles appear north of the Alps as rare luxury dress items from the fifth century, however. All are relatively small things: gartering, head-bands, edges of head veils or garment borders. These early gold textiles were made by cutting strips of thin gold foil, either with a knife or shears, and brocading it into textile – often a tablet-woven band – while it was still being woven, then flattening and burnishing it. Some of the earliest, belonging to the early sixth century, were found in two rich female graves at Unterhaching, Bavaria, Germany and must have been a mark of particularly high status.[22] Gold-decorated textiles became more common in Merovingian Francia, and it was probably from there that the fashion reached England in the later sixth century, manifested most often at the heads of richly-equipped female skeletons, occasionally worn as a single wrist-band. They are mostly found in Kent, and in other areas influenced by Kentish, ultimately Frankish, culture.[23] They appear in seventh-century, high-status male graves at Taplow, Buckinghamshire, where the gold-brocaded textile may have edged a cloak or decorated a baldric (Fig. 22.1),[24] and at Prittlewell, where the gold, which has not yet been fully investigated, clearly edged a neck-line.[25] By the mid-Saxon period techniques had advanced to the point where strips of foil were replaced by filé thread (thin gold spun round a fibre core). A small skein of this was found in an eighth- or ninth-century location in Southampton, Hampshire.[26] This spun gold made possible the gold embroidery which was greatly prized in later Anglo-Saxon England[27] and is well known from the tenth-century Winchester-style examples deposited in the tomb of St Cuthbert in Durham.[28] This type of embroidered decoration would develop into the famous *opus anglicanum* of the later Middle Ages.[29] While most of the surviving examples of Anglo-Saxon gold textile are from items of dress, the Maaseik, Belgium, embroideries, thought

to be English work of the eighth or ninth century, which are accompanied by gold-brocaded tablet-woven bands, may once have belonged to ecclesiastical hangings. They are now part of a composite 'vestment' called a *casula*, but have obviously been recycled.[30] The only possible evidence of a gold secular hanging from the period is suggested by what are described on the website of the Museum of Cultural History in Oslo as 'scraps of silk interwoven with gold thread' which were 'stuck between the joists of the roof' of the Gokstad Ship, a funeral vessel for a wealthy man deposited *c*. 900. They have been interpreted as the remains of wall hangings.[31]

Gold wall hangings for Heorot are therefore not implausible. It is more likely, perhaps, that a poet would have imagined them in the tenth century or later, when spun gold was making gold textiles a more familiar luxury than before, but even at the earliest dates discussed for the poem, gold-adorned cloth was in existence in England.

Furniture

The most important piece of furniture in Heorot is Hrothgar's seat. An early example of a seat for a distinguished head of a household is provided by a wooden chair found in the early

Fig. 22.1 Gold brocade from a male grave at Taplow, Buckinghamshire, seventh century (Photo: Trustees of the British Museum)

fifth-century boat grave of a Roman officer at Fallward, near Wremen, Cuxhaven, Lower Saxony, Germany. Made from the trunk of an alder tree, and still retaining the rounded shape of the tree trunk, the chair is 0.65m high, providing some support for the lower back. It is ornamented with geometric decoration in chip-carved technique. It was accompanied by a footstool.[32] Another early chair carved from a solid block is the sandstone *frithstol* (peace-seat) in Hexham Abbey, Northumberland, which may be the seventh-century throne of the founder-bishop, Wilfrid (Fig. 22.2).[33] Perhaps this stone seat could have been a skeuomorph of a

timber prototype. Similar simple chairs, draped with covers, appear in the Old English illustrated Hexateuch (Fig. 22.3).[34] Perhaps surprisingly for modern observers, backless seats seem to have been the norm in the late Anglo-Saxon period

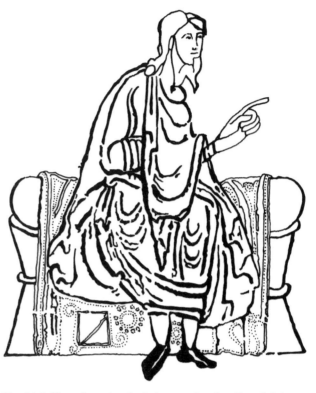

Fig. 22.2 Frithstol, *Hexham Abbey, Northumberland, probably late seventh century (Photo: Tom Middlemass, © Corpus of Anglo-Saxon Stone Sculpture)*

Fig. 22.3 Chair draped with cloth cover. London: British Library, Cotton MS Claudius B. iv, fol. 48r, eleventh century (Drawing: Maggie Kneen)

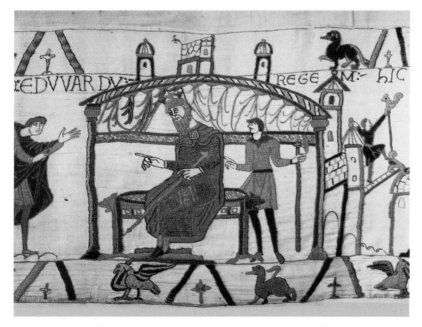

Fig. 22.4 King Edward the Confessor seated on a zoomorphic bench, the Bayeux Tapestry, eleventh century (Photo: by special permission of the City of Bayeux)

even for the royal and the elderly, though the comfort of a footstool was generally provided. Queen Ælfgifu/Emma pictured as dowager queen in British Library MS Add. 33241 (fol. 1v), dating to the 1040s, when she would have been about fifty-five, quite old by Anglo-Saxon standards, sits on a backless but wide seat with a matching footstool, both carved with a number of arched openings like the windows and doors on images of buildings.[35] In the Bayeux Tapestry King Edward the Confessor sits on backless benches with carved animal heads and feet; even when he is so elderly that his beard is greying and he carries a walking stick, and must have been aged at least fifty-nine, he is given no support for his back (Fig. 22.4).[36] Other ruler figures in the Tapestry (Guy of Ponthieu and William of Normandy) sit on similar zoomorphic seats usually carved with arches[37] but the only seat that is given a back and decorative finials is King Harold's coronation chair. Even here, though there is clearly a seat back and decorative bird heads in the scene where Harold is told about Halley's Comet and what it may presage,[38] in the earlier scene where he is crowned there may be no seat back, though there are uprights on either side of the king's body with knob terminals.[39] Clearly Anglo-Saxon leaders were expected to sit up unsupported, even though thrones with backs are sometimes shown in evangelist portraits such as St Luke in the Gospels of St Augustine (fol. 129v),[40] or images of King David playing the harp, as in the Durham Cassiodorus (fol.181v).[41] The former, with its square-backed seat, is a late antique portrait, originating in Italy; the latter, with its animal-headed finials, seems to reflect an Insular type of chair, with stone analogues for the finials in Monkwearmouth 16 and Lastingham 10, and a gilded wooden finial from tenth-century Dublin.[42]

Medieval chairs were, however, well cushioned. A seated figure rarely appears in Anglo-Saxon art without a fat, often decorated, cushion peeping out at the sides, even when the subject is pictured as a hard-working scribe (as, for example, St Matthew in the Lindisfarne Gospels (fol. 25v)),[43] or, like Aldhelm in Lambeth Palace Library MS 200 (fol. 68v), is seated on a folding chair (Fig. 22.5). Cushions or pillows evidently played a major part in furnishing wealthy Anglo-Saxon homes. There are remains of them from Sutton Hoo and a grave from Great Chesterford, Essex, and they are mentioned along with seat covers in Anglo-Saxon wills.[44] They could have been stuffed with feathers (sorting and storing plucked feathers of fowl was probably a normal habit of medieval life),[45] or with tow (the short fibres of flax that were not fit to be spun), or even with straw. That the *Beowulf*-poet chooses not to mention cushioned seats is consistent with the heroic subject matter. The Scyldings have nothing soft about their image except at night when they pull out bolsters and other bedding – and that, of course, is when they are most vulnerable.

In art we generally find one seated figure holding audience with others standing before or around him. Heorot,

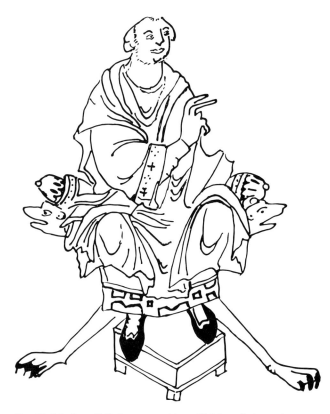

Fig. 22.5 Bishop Aldhelm on a cushioned folding chair, tenth century (Drawn by the author after Lambeth Palace Library MS 200 fol. 68v)

in contrast, is depicted as a residence, where retainers and guests are feasted and entertained, and as such seats are provided for all. At different points in the text Hrothgar is joined by his wife Wealhtheow,[46] and his nephew Hrothulf.[47] In the Bayeux Tapestry when Duke William and his brother Bishop Odo are addressed by a messenger, the artist gives them similar, individual seats, though Odo's is placed behind the Duke's, using the Bayeux convention of foregrounding the most important figure in a scene.[48] However, although Wealhtheow and Hrothulf may sit beside the king they may not have been provided with permanent thrones. The Fallward cemetery gives examples of easily movable alternative seats in the form of three-legged stools, both high and low, and a solid stool made from a tree-trunk.[49] Folding chairs of various kinds were certainly a feature of Anglo-Saxon life: there was one in the seventh-century grave of the Prittlewell Prince,[50] and examples are depicted in the Old English illustrated Hexateuch (fol. 23v),[51] and the Bayeux Tapestry,[52] as well as the one on which Aldhelm sits (see above) which, since it is drawn with only two legs, appears precarious, though its animal heads and feet make it rather grand.

From the opening of *Beowulf* the poet uses mead benches metaphorically as a symbol of security: Scyld Scefing deprives his enemy nations of their mead benches (line 5),

a periphrasis for subjugating them. The evidence of *Hrolf's Saga Kraka*, where Bothvar bodily removes three retainers in order to occupy, with his companion, a better place, nearer to the king, than he had been assigned,[53] suggests that in the heroic world each man had his physical position on the mead bench which indicated his status in relation to his lord and his peers. Beowulf's choice, after his victories, of a seat on the bench among the *giogoð* (youth), actually between the two royal sons (lines 1188–91) suggests his relative modesty and his appreciation of a bit of hero worship from the children. It also reflects, in the watching queen, the mixed emotions of fear that he will displace her sons from their heritage and hope that he could make a powerful protector for them if he so chose. All this circumstantial evidence suggests that mead benches occupied established positions in the hall, and were possibly fixed in place, an impression that is confirmed when we are told that the violence of Beowulf's fight with Grendel uprooted many mead benches from the floor (*Þær fram sylle ābēag /medubenċ moniġ*, lines 775–6). In consistency with this, the actions of the Danes (*Benċþelu beredon*, line 1239, literally 'they cleared the bench planks') as they prepare for sleep just before the attack of Grendel's mother should not be interpreted, as it has sometimes been, that the men move the benches away so that they can sleep on the floor, but that they cleared the planks – the seat parts – of the benches: they may have vacated their seats so as to use the benches as repositories for the shields, helmets and mail coats which they had been holding and wearing; or they may have slept on the cushioned bench seats, hanging their equipment on the wall, or the bench ends and uprights, above. The poet explains:

> hit ġeondbrǣded wearð
> beddum ond bolstrum …
> Setton him tō hēafdon hilderandas,
> bordwudu beorhtan; þǣr on benċe wæs
> ofer æþelinge ȳþġesēne
> heaþostēapa helm, hrinġed byrne,
> þrecwudu þrymliċ. Wæs þēaw hyra,
> þæt hīe oft wǣron anwīġġearwe …[54]

Possibly 'moving the bench planks' means that the seats of the mead benches were lifted, being effectively the lids of boxes inside which the bedding – blankets and pillows – was kept.

The essential feature of the poetic mead bench is its communality. Communal seats are occasionally shown in art. William and his two brothers share a padded bench adjacent to the feast at Hastings in the Bayeux Tapestry.[55] They sit under a temporary-looking shelter and are not themselves eating or drinking but evidently discussing the forthcoming battle. However the illustration for the month of April in the calendar in London: British Library, Cotton Tiberius B. v (fol. 4v),[56] shows three men drinking on a

splendid communal bench, attended by servants (Fig. 22.6). At each end the heads and forequarters of animals form massive terminals. The men sit on a decorated cushion with a cloth draped over it. The seat back rises above their heads, decorated with rectangular apertures, and a communal footstool with carved arches supports their feet; but the costume of the drinkers is Roman, and the bench perhaps follows a late antique model rather than depicting Anglo-Saxon furniture. The *Beowulf*-poet entirely eschews the animal-carved benches beloved of Anglo-Saxon artists. In keeping with the splendour of Heorot, its mead benches are decorated with gold (line 777) and no other decoration is of interest to the poet.

Strangely absent from Heorot are tables. If, as we might suppose, a communal hall was for feasting, surely tables would be required; but nobody eats in Heorot, except the monster, who eats the members of the *comitatus*! The eight horses which are gifted to Beowulf (lines 1035–7) could not have been paraded round a hall filled with tables. The floor space must have been clear, allowing space for those horses to be brought in. The interior of a great hall must have provided open space for activities which are unmentioned in the poem, entertainment such as jugglers, for practising moves with weapons, for cleaning and polishing armour, as well as things which are mentioned: performances by minstrels (lines 89–90; 1063–7), training a bird of prey (lines 2263–4) and the ceremonial gift-giving which was the *raison d'être* of Hrothgar's Heorot (lines 71–3).

The Fallward graves[57] provide evidence of little individual tables which might have been set up for the lord and his immediate companions from which to eat. People might have lounged on floor cushions (shown several times in the Old English illustrated Hexateuch)[58] to play on similar low tables the games which are attested by ivory gaming pieces from high-status male graves. Larger food tables were probably collapsible and erected only when needed; but possibly people apart from the ruler and his immediate family did not sit down to eat. There are no chairs depicted at the two feasts in the Bayeux Tapestry[59] and most of the diners are visible above the table top to below the waist, indicating that they are standing up. Fixed tables were uncommon even by the late fourteenth century, since in introducing the Franklin, the *bon viveur* among Chaucer's Canterbury pilgrims, as 'Epicurus owene son', the narrator mentions as an unusual fact about him that:

> His table dormant in the halle alway
> Stood redy covered al the longe day.[60]

The table for the feast in the Luttrell Psalter,[61] at which Sir Geoffrey Luttrell dines with his household, consists of a rectangular board resting on two trestles. The legendary King Arthur did not invent the round table. Curved or circular tables appear in Anglo-Saxon art: the Old English illustrated

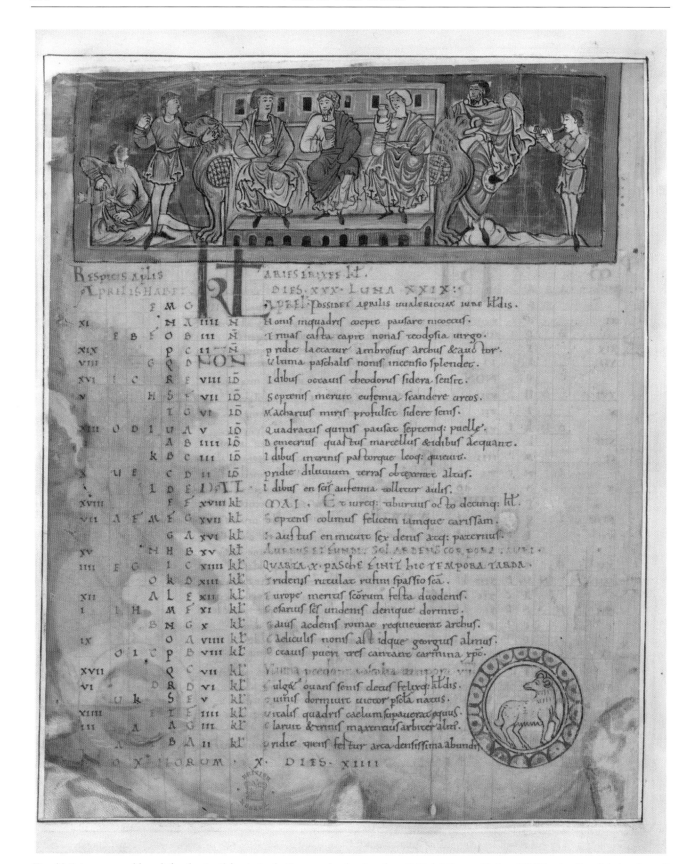

Fig. 22.6 A communal bench for the April feast, Anglo-Saxon calendar. London: British Library, Cotton MS Tiberius B. v, fol. 4v, eleventh century (Photo: © The British Library Board, all rights reserved)

Hexateuch (fol. 102r),[62] an illustration of Prudentius' *Psychomachia* (fol. 18r),[63] and the Bayeux Tapestry,[64] though in all three instances the contexts are rather decadent and the round tables may be indicative of disapprobation.[65] They might not, therefore, be out of place for Hrothgar's splendid but self-indulgent courtiers. Manuscript illustrations show that tables could be draped with cloths and they were furnished with knives, plates and bowls. Drinking vessels, such an important part of Germanic culture as attested by literature, art and archaeology, were carried round and held in the hand by the drinkers.

Darkness and light

The *Beowulf*-poet makes much of the contrast between the darkness out of which Grendel comes and the brightness of the hall, but never mentions any artificial source of light, choosing rather to focus on the gold:

> Đā cōm of mōre under misthleoþum
> Grendel gongan …
> Wōd under wol(*c*)num tō þæs þe hē wīnreċed,
> goldsele gumena ġearwost wisse
> fǣ*t*um fāhne.[66]

Metal in its solid state does not, of course, project light, but only reflects it, though the poet chooses to ignore this fact.[67] In practice Anglo-Saxon secular buildings were lit by lamps. In the Sutton Hoo ship burial, a lamp had been placed in isolation (Fig. 22.7). It consisted of an iron bowl, 140mm in

diameter and 70mm deep, still containing beeswax, mounted on a three-legged iron stand, the whole thing being 189mm high.[68] A similar lamp, 160mm high, on four legs, was found in Broomfield Barrow, Essex,[69] and the bowl of another, with a diameter of 150mm, was found in laboratory investigation of material from Prittlewell.[70] A three-legged stand found at Boughton Aluph, Kent, in 1902 may have supported a wooden, rather than an iron, bowl, leading Bruce-Mitford to suggest that 'the ordinary house lamp' may have been of wood.[71] The Sutton Hoo lamp had been placed directly in contact with the bottom boards of the boat, which suggests that in domestic contexts such lights were placed on the floor.

Conclusions

The dating of *Beowulf* is a complex matter. The few historical characters mentioned in the poem lived in the Migration Age. Certain details of material culture (helmets, funeral practices) suggest that the poet was particularly evoking the late sixth to seventh century as a kind of Golden Age.[72] The only manuscript of the poem is very broadly dated on palaeographical grounds to 950–1050. Every century from the Anglo-Saxon conversion period of the seventh century to the eleventh has been suggested for the poem's composition,[73] and it is possible that some of the subject matter is even older if pre-literate, oral traditions have been integrated into a later composite structure. The poet may have been a conscious antiquarian and archaiser; or it may be that old features of material culture are fossilised in the final version, just as early spellings are.

This investigation has not truly shed any light on the dating of the composition of *Beowulf*. Gold cloth is more likely from the tenth century but not impossible in the seventh. Otherwise the way in which we mentally furnish Heorot is dependent on where we stand as regards date, rather than *vice versa*: for example, if we favour an early date we might visualise Hrothgar's throne as like the Fallward chair or the Hexham stone seat; if a later date we might picture the king on a lion-headed bench like Edward the Confessor.

What is clear is the poet's lack of interest in practical detail. Drinking vessels in the poem are plated (*fǣted wǣge*, line 2253) presumably with gold or silver gilt, but the poet never mentions the foundation material to which the plating is attached, be it wood, horn or base metal, all of which are attested as vessel material from archaeology. There is no reference to glass, one of the most luxurious materials for drinking vessels known to the Anglo-Saxons. None of these substances functions as furnishings in the hall as the poet describes it. The protagonists live off mead, beer and glory. Seemingly they have no food and no tables to eat it from. Being of noble stock, attached to a generous lord, they have benches on which to sit; but the decoration of those

Fig. 22.7 Lamp from the Sutton Hoo Ship Burial, seventh century (Photo: © Trustees of the British Museum)

seats bears no resemblance to the elaborately carved seats of Anglo-Saxon art. The poet is only interested in their gold adornment and their symbolic value.

I have observed that undergraduates discussing *Beowulf* often mention the light and warmth of the hall; but the students are deceived. I do not deny that the *effects* of light and warmth are present, but they are metaphorical only, created by the comradeship of the retainers and their king's affection for them, the sense of Heorot as a centre of human refinement surrounded by an uncivilised outside world. The poet's Heorot has no fire and no lamps.

This study has demonstrated that anyone wishing to illustrate or dramatise *Beowulf* has plenty of material in surviving examples of early medieval artefacts to flesh out the architectural detail provided by excavation. It also shows how little the poet helps us in our imaginative exercise. His version of the protagonists' physical surroundings is startlingly minimalist. The poet's Heorot is an ideal, described only in terms of what was considered prestigious. Alternatively we might see Heorot as evidence of sinful preoccupation with worldly pomp: towering architecture, gold ornament, alcoholic drink, soft bedding and seating for everybody.

Envoi

Richard Bailey arrived at Newcastle University when I was an undergraduate there. His inspirational course on *Beowulf* illustrated and exemplified the text in terms of excavated material, and proved an effective trailer for his final year special subject course Anglo-Saxon Art and Archaeology. When I was planning doctoral research the suggestion that I study Anglo-Saxon clothing was Richard's. In 1971 I was employed at Manchester University with the specific brief that I was to teach *Beowulf* and Anglo-Saxon art and archaeology. I continued to teach and research the former for the rest of my career, and ran courses on the latter for over thirty years. Everything I have written is interdisciplinary. Richard's teaching provided the foundation of all I have done in academic life.

Notes

1 Cramp 1957; Niles 2007; 2011, 43–5.
2 Wentersdorf 2007, 425.
3 Urnes (Electronic Resource).
4 Zemeckis 2007.
5 All references to *Beowulf* are taken from Fulk et al. 2008; all translations are my own.
6 Oxford: Bodleian, MS Junius 11, p. 46 (Ohlgren 1992, 548).
7 *Dictionary of Old English* fāh², fāg² 1. Particoloured, variegated 3. Bright, shining, gleaming; adorned (Online reference; thus: Klaeber 1950, 155 n. to line 725; Swanton 1997, 69; Coatsworth 2007, 3).

8 *Dictionary of Old English* fāh², fāg² 2. Discoloured, stained, marked; only in poetry 2.a. specifically: stained with blood.
9 Hines 2011, 25.
10 Prittlewell 1 (Electronic Resource); MOLA 2004; Dr Susan Youngs, unpublished lecture to the Manchester Centre for Anglo-Saxon Studies, 11 November 2013.
11 Information from Dr Susan Youngs; also Dr Kevin Leahy.
12 I am not sympathetic to the suggestion that *brand Healfdene* is a kenning for Hrothgar himself; see the discussion on 'lines 1020ff. brand' in Fulk et al. 2008, 177–8.
13 Inv. 180 and Inv. 182 (Crowfoot 1983, 433, 438, 458).
14 Owen 1979, 197, 221–2; Coatsworth 2007, 5–9.
15 Ibid., 5–6.
16 Brown 2013, xxi.
17 Gislason 1849, 21, 27–8; Johnston 1963. I am grateful to Hanna Steinunn Thorleifsdottir for this reference and to the late Helen S. Maclean for discussing it.
18 Krafft 1956.
19 Budny 1991.
20 Oscarsson & Rydquist 1981; Horneij 1991.
21 Oscarsson & Rydquist 1981, 9.
22 Haas-Gebhard & Nowak-Böck 2012, 12–17.
23 Crowfoot & Hawkes 1967; Owen-Crocker 2004, 96–7.
24 Ibid., 196.
25 Coatsworth & Owen-Crocker 2007, 9, fig. 3.
26 Walton Rogers 2005.
27 Clegg Hyer 2012.
28 Plenderleith 1956; Coatsworth 2001.
29 Christie 1938.
30 Budny & Tweddle 1984; 1985.
31 Gokstad (Electronic Resource).
32 Schön 1999, 80–1 (chair), 82–3 (footstool); also Hanson 2010, 90; Hanson confuses BC and AD at one point.
33 Cramp 1984, 9, 192, no. 41, ills 186–7.
34 London: British Library, Cotton MS Claudius B. iv (e.g. fol. 8v); Hexateuch (Electronic Resource).
35 Campbell 1949.
36 Wilson 1985, pls 1, 28.
37 Ibid., pls 10, 13, 16, 34–5.
38 Ibid., pls 32–3.
39 Ibid., pl. 31.
40 Cambridge: Corpus Christi College, MS 286.
41 Durham: Cathedral Library, MS B. II. 30.
42 Respectively Cramp 1984, p. 139, pls 124, 673–6; Lang 1991, 172–3, pls 614–17, 623–6; and Lang 1988, 53–4, cat. DW12.
43 London: British Library, MS Cotton Nero D. iv, fol. 25v.
44 Coatsworth 2012.
45 The seventh-century Wollaston, Northamptonshire, helmet, found in a grave, had been in contact with feathers (Meadows 1997).
46 ēode … tō hire frēan sittan (she went to sit by her lord; lines 640-1).
47 Mentioned with him as the company moves to sit down (lines 1012–17) and approached by the queen (lines 1162–4): Þā cwōm Wealhþēo forð … þǣr þā gōdan twēġen /sǣton suhterġefæderan (Then Wealhtheow came forward to where the two good men, uncle and nephew, sat).
48 Wilson 1985, pls 34–5.

49 Schön 1999, 44–5, 70–1, 74–5 respectively.
50 Prittlewell 1 (Electronic Resource).
51 Hexateuch (Electronic Resource).
52 Wilson 1985, pl. 19, upper border.
53 Garmonsway & Simpson 1968, 105.
54 It [the *reċed*, 'building' mentioned in line 1237] was spread with bedding and pillows … They set at their heads the battle circles, bright wooden shields; there on the bench, over the nobleman was easily seen the battle-tall helmet, the ringed mailcoat, the mighty, powerful spear. It was their custom that they were always prepared for attack. (lines 1239–47).
55 Wilson 1985, pl. 48.
56 McGurk et al. 1983.
57 Schön 1999.
58 Coatsworth 2012, 529.
59 Wilson 1985, pls 3, 48.
60 *Canterbury Tales* lines 336, 353–4; Benson 1987, 28–9 and 813, note to line 353 'table dormant: A table left in place and thus differentiated from a table set up in the hall and taken down after use', paraphrasing the original note on the line in Robinson 1957, 660.
61 London: British Library, Add. MS 42130, fol. 208v, *c.* 1325–35; Luttrell Psalter (Electronic Resource).
62 Hexateuch (Electronic Resource).
63 London: British Library, Cotton MS Cleopatra C. viii (Ohlgren 1992, 497).
64 Wilson 1985, pl. 48.
65 Respectively, the Israelites feasting and playing after worshipping the Golden Calf; an illustration of *Luxuria*; a parodic portrayal of the Augustine's Gospel 'Last Supper scene', with Odo replacing Christ and one diner lounging across the table (Owen-Crocker 2005, 120).
66 Then came Grendel, going from the moor under the cover of mist … He advanced under the clouds until he could most clearly see the wine building, the gold hall of men, shining with [gold] plates. (lines 710–16).
67 When Wiglaf enters the dragon's lair he sees a golden standard (*seġn eall gylden*; line 2767) which radiates light (of *ðām lēoma stōd*; line 2769).
68 Bruce-Mitford 1983, 844.
69 Ibid., 846 citing C.W. Phillips.
70 Prittlewell 2 (Electronic Resource).
71 Bruce-Mitford 1983, 851.
72 Owen-Crocker 2000.
73 Chase 1997; Neidorf 2014.

References

Benson, L. (ed.), 1987 *The Riverside Chaucer*, 3 edn (Oxford)

Brown, S.A., 2013 *The Bayeux Tapestry. Bayeux, Médiathèque Municipale: MS. 1. A Sourcebook*, Publications of the Journal of Medieval Latin 9 (Turnhout)

Bruce-Mitford, R., 1983 (ed. A. Care Evans) *The Sutton Hoo Ship Burial, 3: Late Byzantine and Roman Silver, Hanging-bowls, Drinking Vessels, Cauldrons and Other Containers, Textiles, the Lyre, Pottery Bottle and Other Items*, 2 parts (London)

Budny, M., 1991 'The Byrhtnoth Tapestry or Embroidery' in D.G. Scragg (ed.), *The Battle of Maldon AD 991* (Oxford), pp 263–78

Budny, M. & Tweddle, D., 1984 'The Maaseik Embroideries', *ASE* 13, 65–96

Budny, M. & Tweddle, D., 1985 'The Early Medieval Textiles at Maaseik, Belgium', *Antiquaries J.* 65(2), 353–89

Campbell, A., 1949 *Encomium Emmae Reginae*, Royal Historical Soc. Camden 3 ser. 72 (London)

Chase, C. (ed.), 1997 *The Dating of Beowulf* (Toronto & London)

Christie, A.G.I., 1938 *English Medieval Embroidery* (Oxford)

Clegg Hyer, M., 2012 'Reduce, Reuse, Recycle: Imagined and Reimagined Textiles in Anglo-Saxon England', *Medieval Clothing and Textiles* 8, 49–62

Coatsworth, E., 2001 'The Embroideries from the Tomb of St Cuthbert' in N.J. Higham & D.H. Hill (ed.), *Edward the Elder 899-924* (London), pp 292–306

Coatsworth, E., 2007 'Cushioning Medieval Life: Domestic Textiles in Anglo-Saxon England', *Medieval Clothing and Textiles* 3, 1–12

Coatsworth, E., 2012 'Soft Furnishings and Textiles ante-1100' in G.R. Owen-Crocker, E. Coatsworth & M. Hayward (ed.), *Encyclopedia of Medieval Dress and Textiles of the British Isles c. 450–1450* (Leiden & Boston), pp 526–30

Coatsworth, E. & Owen-Crocker, G.R., 2007 *Medieval Textiles of the British Isles AD 450–1100: an Annotated Bibliography*, BAR: British Series 445 (Oxford)

Cramp, R., 1957 'Beowulf and Archaeology', *Med. Arch.* 1, 57–77

Cramp, R., 1984 *County Durham and Northumberland*, CASSS 1 (Oxford)

Crowfoot, E., 1983 'Chapter IV The Textiles' in Bruce-Mitford 1983, i, pp 409–79

Crowfoot, E. & Chadwick Hawkes, S., 1967 'Early Anglo-Saxon Gold Braids', *Med. Arch.* 11, 42–86

Fulk, R.D., Bjork, R.E. & Niles, J.D. (ed.), 2008 *Klaeber's Beowulf and the Fight at Finnsburg*, 4 edn (Toronto, Buffalo & New York)

Garmonsway, G.N. & Simpson, J. (trans), 1968 *Beowulf and its Analogues* (London & New York)

Gislason, K. (ed.), 1849 *Saga Gísla Súrsonnar* (Copenhagen)

Haas-Gebhard, B. & Nowak-Böck, B., 2012 'The Unterhaching Grave Finds: Richly-Dressed Burials from Sixth-Century Bavaria', *Medieval Clothing and Textiles* 8, 1–23

Hines, J., 2011 'No Place Like Home? The Anglo-Saxon Social Landscape from Within and Without' in Sauer et al. 2011, pp 21–40

Horneij, R., 1991 *Bonaderna från Överhogdal*, English summary pp 188–203, trans. D. Bell (Jämtland)

Johnston, G. (trans.), 1963 *The Saga of Gisli* (Toronto)

Klaeber, F. (ed.), 1950 *Beowulf and the Fight at Finnsburg*, 3 edn (Boston, MA & London)

Krafft, S., 1956 *Pictorial Weavings from the Viking Age: Drawings and Patterns of Textiles from the Oseberg Finds*, traduction française par M. Lesoil; trans. R.I. Christophersen (Oslo)

Lang, J.T., 1988 *Viking-Age Decorated Wood: a Study of its Ornament and Style* (Dublin)

Lang, J.T., 1991 *York and Eastern Yorkshire*, CASSS 3 (Oxford)

McGurk, P., D.N. Dumville, M.R. Godden & A. Knock (ed.), 1983 *An Eleventh-Century Illustrated Miscellany*, EEMF 21 (Copenhagen)

Meadows, I., 1997 'Wollaston: The "Pioneer" Burial', *Current Archaeology* 154, 391–5

MOLA 2004 *The Prittlewell Prince: the Discovery of a Rich Anglo-Saxon Burial in Essex* (London)

Neidorf, L., 2014 *The Dating of Beowulf: a Reassessment* (Woodbridge)

Niles, J.D., 2007 *Beowulf and Lejre* (Tempe, AZ)

Niles, J.D., 2011 'On the Danish Origins of the *Beowulf* Story' in Sauer et al. 2011, pp 41–62

Ohlgren, T.H. (ed.), 1992 *Anglo-Saxon Textual Illustration: Photographs of Sixteen Manuscripts with Descriptions and Index* (Kalamazoo, MI)

Oscarsson, U. & Rydquist, A.-M., 1981 *La Tapisserie d'Överhogdal court présentation par la Musée régional de Jämtland, Östersund*, trans. [into French] O. Ekwall (Östersund)

Owen, G.R., 1979 'Wynflæd's Wardrobe', *ASE* 8, 195–222

Owen-Crocker, G.R., 2000 *The Four Funerals in Beowulf: and the Structure of the Poem* (Manchester)

Owen-Crocker, G.R., 2004a *Dress in Anglo-Saxon England: Revised and Enlarged Edition* (Woodbridge)

Owen-Crocker, G.R., 2004b 'Brothers, Rivals and the Geometry of the Bayeux Tapestry' in G.R. Owen-Crocker (ed.), *King Harold II and the Bayeux Tapestry* (Woodbridge), pp 109–23; repr. in G.R. Owen-Crocker, *The Bayeux Tapestry: Collected Papers* (Farnham, 2012), Chapter 8

Plenderleith, E., 1956 'The Stole and Maniples. (a) The Technique' in C.F. Battiscombe (ed.), *The Relics of St Cuthbert* (Oxford), pp 375–96

Robinson, F.N. (ed.), 1957 *The Works of Geoffrey Chaucer*, 2 edn (London)

Sauer, H. & Story, J. with Waxenberger, G. (ed.), 2011 *Anglo-Saxon England and the Continent*, Medieval and Renaissance Texts and Studies 394, Essays in Anglo-Saxon Studies 3 (Tempe, AZ)

Schön, M.D., 1999 *Feddersen Wierde Fallward Flögeln*, Archäologie im Museum Burg Bederkesa, Landkreis Cuxhaven (Bad Bederkesa)

Swanton, M.J. (ed. and trans.), 1997 *Beowulf*, rev. edn (Manchester)

Walton Rogers, P., 2005 'Gold Thread' in V. Birbeck, R.J.C. Smith, P. Andrews & N. Stoodley, *The Origins of Mid-Saxon Southampton: Excavations at the Friends Provident St Mary's Stadium 1998–2000* (Salisbury), pp 68–9

Wentersdorf, K.P., 2007 'The Beowulf Poet's Vision of Heorot', *Studies in Philology* 104, 409–26

Wilson, D.M., 1985 *The Bayeux Tapestry* (London)

Electronic resources

Dictionary of Old English A-G on CD-ROM Version 2.0 2008 (Toronto)

Gokstad: http://www.khm.uio.no/english/visit-us/viking-ship-museum/exhibitions/gokstad/ (Accessed 30 Sept 2013)

Hanson, S., 2010 *Archaeological Finds from Germany; Booklet to the Photographic Exhibition*, Berlin, Deutsches Archäologisches Institut Eurasien-Abteilung, http://www.dainst.org/sites/default/files/media/abteilungen/eurasien/event/archacologische_funde_englisch.pdf (Accessed 30 July 2014). The exhibition was held in Baku, Azerbaijan

Hexateuch: http://www.bl.uk/manuscripts/FullDisplay.aspx?ref=Cotton_MS_Claudius_B_IV (Accessed 30 July 2014)

Luttrell Psalter: http://www.bl.uk/onlinegallery/ttp/luttrell/accessible/images/page30full.jpg (Accessed 30 July 2014)

Prittlewell 1: http://www.museumoflondonarchaeology.org.uk/Services/PCaseStudies/UK-projects/Prittlewell-Prince/PrittlewellPrincelyBurial.htm (Accessed 30 July 2014)

Prittlewell 2: http://www.archaeologyuk.org/ba/ba83/news.shtml (Accessed 30 July 2014)

Urnes: http://www.visitnorway.com/uk/where-to-go-uk/fjord-norway/sognefjorden/what-to-do-in-the-sognefjord-area/attractions-in-the-sognefjord-area/urnes-stave-church/ (Accessed 30 July 2014)

Film

Robert Zemeckis, 2007 *Beowulf*, Paramount/Warner Bros.

A miracle of St Hilda in a migrating manuscript

A.I. Doyle

This miracle attributed to St Hilda (foundress and abbess of the double monastery at *Streanæshalch*, later identified with a site on the hill top above the present town of Whitby, in the North Riding of Yorkshire) is well known in its gist,[1] but its origin is uncertain. It is an example of a common type of folkloric aetiology of observed geological and palaeontological phenomena, here obviously an explanation of the fossil molluscs called ammonites which abound in the strata exposed in the cliffs adjoining the site (Fig. 23.1).[2] It is not mentioned by Bede in his *Historia Ecclesiastica Gentis Anglorum*, the main source for our knowledge of Hilda.[3] Though there has been recent speculation that it may be early medieval in origin,[4] I do not know of it in writing before its appearance in the *Nova Legenda Angliae*, a collection of saints' lives most reliably ascribed to John (vicar) of Tynemouth (active in the mid-fourteenth century), where (in Horstmann's printed edition at least) it occurs in many of the same words but not as extensively as in the version appended below.[5] There is no life of Hilda in the *Legenda Aurea* of Jacobus of Voragine or its English derivatives that I know of, and the story is not in the three lections for her feast (17 November) in the York liturgical Breviary.[6] Three ammonites, each with a snake's head, were the arms recorded for the medieval abbey of Whitby, and were afterwards adopted by the town of Whitby.[7]

Durham University Library Cosin MS V.iv.9 is a small volume (160 × 115mm) comprising over 100 parchment leaves written by a single expert 'Anglicana Formata' of the first half of the fifteenth century,[8] with conventional English decoration of the larger initial letters in blue and red. It contains chiefly a copy of the *Historia Trium Regum* by John of Hildesheim (d. 1375), the legend of the (traditionally three) magi of St Matthew's Gospel, whose remains were (and are) supposed to be enshrined in Cologne Cathedral, a work widely spread all over Europe, including England, and frequently translated into the vernacular.[9] Following

this copy is a separate shorter text (fols 108v–111v) in the same hand, without title though with a space of two lines left for one, a Latin account of the miracle attributed to St Hilda of Whitby.

But after the extensive and elevating narrative of the event there is a sudden switch, via an unusual expression of scepticism, to an abrupt application of its spiritual significance for an audience of male religious addressed by

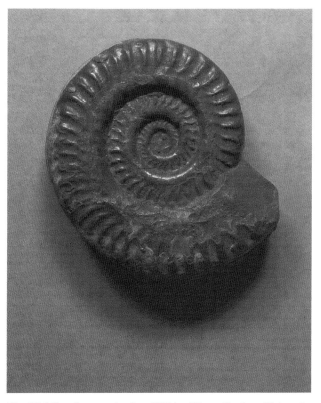

Fig. 23.1 Fossil ammonite from Whitby (Photo: Durham University Collections)

a homilist, against self-indulgence in the comforts of their life. That they were not the Benedictine monks of Whitby is implied by the placing of the miracle 'in provincia illa'. One may wonder who this preacher was and when and where he took up the tale, in broadly the same words as used by John of Tynemouth. And why was it all copied in this manuscript? Did its first owner or compiler have a personal or local interest? The original provenance of the book is not known, though it was certainly written in England and by a skilled scribe. Yet there is a lot of evidence of its later history.

At its end (fol. 114v) in a hand differing in style from the preceding texts is 'Nomen scriptoris Iohannes plenus amoris forte sic' but this is a conventional formula of little significance. On folio 115 however by another hand of the fifteenth century is 'Henricus Percy Alienora Percy Chandos Miser'. One Eleanor was the wife of Henry Percy, third Earl of Northumberland (1455–61), and the name of his daughter, and also of a daughter of the fourth Earl (also Henry). The re-founder of Whitby Abbey in the late eleventh century had been William de Percy.[10] Chandos was the name of a herald (in Ireland?) who composed a French life of the Black Prince (d. 1399), so it may have been a successor.

At the beginning of the volume (fol. 1) is 'Memorandum quod codex iste [an irrecoverable name erased] Armigeri' and 'Peto vt codex iste restituatur predicto <domino Ricardo>', erased but read by ultra-violet light, both of the later fifteenth century. Other jottings include a reference to the penitentiary of the bishop of London, to John Pond of Chelmsford and William Pond, OFM, whose ordination as sub-deacon in 1522 is in Archbishop Warham's (Canterbury) register.[11] The date 1526 is added by a different hand at the end of the miracle and at the end of one chapter of the preceding text for no obvious reason.

However at the end (fol. 114v) is a formally signed claim of ownership by John Grethed, Registrar of Carlisle diocese, mid-sixteenth century, over an earlier one (mostly erased) of purchase at Stourbridge Fair (i.e. Cambridge) by Nicholas Johnson. The name of Bernard Aglionby, Registrar (1561–76) follows, and the name of Richard Harrison (also on fol. 81v) of 'Edmonde' (*recte* 'Eamonde') Bridge, parish of Penrith, 1564, and 'Thomas Tutins', official of the same diocese in the same year,[12] 'Thomas Foster' (repeated in Greek and Hebrew script) 16 July 1640, and again on folio 48. He is not identifiable with any of the name (or Forster) as an alumnus of Oxford or Cambridge, nor in the late C.R. Huddleston's indexes of northern clergy.[13]

Penultimately, on folio 2v is the inscription 'Geo Davenport. Donum Johannes Tempest Armigeri.1668' in the hand of the former. The latter (of Old Durham, d. 1697) also gave Davenport Cosin MSS V.iii.17 (1665), V.iv.2 (1665), and V.iv.5, of various provenances, amongst the seventy codices (most of its medieval manuscripts) given by him to Cosin's Library in 1670.[14] But, unlike the others, this one did not receive the ex-libris inscription and shelf and item number in the hand of Thomas Rud, Librarian at the beginning of the eighteenth century, nor did he include it in his catalogue of them. The absence is partly explained by another inscription 'Amissum reperit restituit R. Harrison 1778' though not indicating where or how. Harrison was effectively Cosin Librarian in the late eighteenth century and notes in his hand appear in a number of books.[15] When Rud's catalogue was printed (from a transcript) by James Raine in 1838 it did not include this item, which was only later given the number V.iv.9, at the end of a shelf, probably by the Rev. J.T. Fowler, Cosin Librarian (d. 1924). It is only getting a full description in the new catalogue of the medieval manuscripts of Durham University Library by myself and the late Alan J. Piper.[16]

Acknowledgements

I owe thanks to Henry Emeleus, Francis Gotto, Richard Higgins, Jan Rhodes, and Paul Taylor for various help in the preparation of this piece.

Notes

1 E.g. in a poem on St Hilda by Robert Surtees (Taylor 1852, 258–61).

2 Charlton (1779, 32–3, 353) says that the story was well known to the common people, and to William Camden; Anon. 1851[?], 67, 96 (geology). For an up-to-date survey, see Taylor & Sendino forthcoming.

3 Bede, *HE* IV, 23 (Colgrave & Mynors 1969, 404–15); Thacker 2004.

4 Kracher 2012, 63–4.

5 Horstmann 1901, ii, 30–1, often mis-attributed to John Capgrave (d. 1464). For the probable author, see Sharpe 1997, nos 949, 1655; Görlach 1994, 7–11 and (for St Hilda's miracle), 113. For a fuller account of John of Tynemouth's work, the relationship of the manuscripts, and the manuscript basis of Horstmann's edition, see Lapidge 2003, 745–52. A brief mention is made of the miracle by John Leland under the heading 'Ex vita S. Hildae' in his *Collectanea* (Hearne 1774, IV, 39), and 'ut monachi ferunt' on his visit in *c*.1534 according to the dating in Carley 2010 (lxxxv–vi); cf Sharpe et al. 1996, 643.

6 Lawley 1883, cols 507–8.

7 Longstaffe 1863, with illustration on 22. The context and full content of the present piece are somewhat surprising yet may appeal to Richard Bailey's antecedents and interests.

8 For this and other nomenclature of scripts, see Derolez 2003, 135–41, pls 81, 84–6.

9 *Bibliotheca Hagiographica Latina*, no. 5137; Horstmann 1886, 206–312 (Latin text); cf Schaer 2000, 17–26.

10 Fallow 1913, 101–2.

11 Reported by the late Bishop John Moorman from his index of English medieval Franciscans, now deposited in the Franciscan Study Centre, Canterbury.

12 Doyle 1966, with (facing 468) plate of Grethed's signed ex libris.

13 Available in the Archives & Special Collections, Durham University Library.
14 See Doyle 2000.
15 For Robert Harrison (1744–1802), Cosin Librarian 1779–96, see Stephenson 2004.
16 Available in the Search Room of the Palace Green Library.
17 I have converted consonantal 'u' to 'v', a colon for the punctus elevatus, but I have not corrected grammatical anomalies nor solved some verbal puzzles. I have introduced a fresh paragraph at the beginning of the unexpected homilist's contribution. Editorial interventions are in square brackets. I have also provided a literal translation to assist the reader.

References

Anon., 1851[?] *Reed's Illustrated Guide to Whitby*, 4 edn (Whitby)
Bibliotheca Hagiographica Latina Antiquae et Mediae Aetatis, 1898–1911, 3 vols (Brussels)
Carley, J., 2010 *John Leland de viris illustribus* (Toronto)
Charlton, L., 1779 *The History of Whitby* (York)
Derolez, A., 2003 *The Palaeography of Gothic Manuscript Books* (Cambridge)
Doyle, A.I., 1966 'A Durham Manuscript and its Inscriptions', *Trans. Cumberland and Westmorland Antiquarian and Archaeological Soc.* 66, 468–70
Doyle, A.I., 2000 'The Cosin Manuscripts and George Davenport', *The Book Collector* 53, 32–45
Fallow, T.M., 1913 'The Abbey of Whitby' in W. Page (ed.), VCH: *County of York* 3 (London), pp 101–5
Görlach, M. (ed.), 1994 *The Kalendre of the Newe Legende of Englande, ed. from Pynson's printed edition, 1516*, Middle English Texts 27 (Heidelberg)
Hearne, T. (ed.), 1774 *Johannis Lelandi Antiquarii de Rebus Britannicis Collectanea*, 6 vols (London)
Horstmann, C. (ed.), 1886 *The Three Kings of Cologne: an early English Translation of the 'Historia Trium Regum' by John of Hildesheim*, EETS orig. ser. 85 (London)
Horstmann, C. (ed.), 1901 *Nova Legenda Anglie: as collected by John of Tynemouth, John Capgrave, and others, and first printed, with New Lives, by Wynkyn de Worde a.d. mdxui*, 2 vols (Oxford)
Kracher, A., 2012 'Ammonites, Legends, and Politics the Snakestones of Hilda of Whitby', *European J. of Science and Theology* 8(4), 51–66
Lapidge, M., 2003 *Winchester Studies 4.ii The Anglo-Saxon Minsters of Winchester: The Cult of St Swithun* (Oxford)
Lawley, S. (ed.), 1883 *Breviarium ad Usum Insignis Ecclesie Eboracensis* 2, Surtees Society 75 (Durham)
Longstaffe, W.H.D. (ed.), 1863 *Heraldic Visitation of the Northern Counties in 1530, by Thomas Tonge, Norroy King of Arms*, Surtees Society 41 (Durham)
Schaer, F. (ed.), 2000 *The Three Kings of Cologne Edited from London, Lambeth Palace MS 491*, Middle English Texts 31 (Heidelberg)
Sharpe, R., 1997 *A Handlist of the Latin Writers of Great Britain and Ireland before 1540*, Publications of the Journal of Medieval Latin 1 (Turnhout)
Sharpe, R., et al., 1996 *English Benedictine Libraries: the Shorter Catalogues*, Corpus of British Medieval Library Catalogues 4 (London)
Stephenson, F.R., 2004, 'Harrison, Robert (1714/15–1802)' in H.G.C. Matthew & B. Harrison (ed.), *ODNB* 25 (Oxford), pp 525–6
Taylor, G., 1852 *A Memoir of Robert Surtees, Esq., M.A., F.S.A.* (new edn with additions by J. Raine, Surtees Society 24 (Durham))
Taylor, P.D., & Sendino, C., forthcoming 'Historical Background: Fossil Folklore' in A. Lord & M. Munt (ed.), *Fossils of the Yorkshire Lias*, Palaeontological Association, Field Guide to Fossils (Hoboken, NJ)
Thacker, A., 2004 'Hild [St Hild, Hilda] (614-680)' in H.G.C. Matthew & B. Harrison (ed.), *ODNB* 27 (Oxford), pp 90–1

Appendix: Text (from Cosin MS V.iv.9 fols 108v–111v)[17] and Translation

In primordio itaque cum beata virgo Hilda Whitbiense cenobium quod tunc vocabatur Streneshalc cepit construere: tanta ibidem multitudo serpencium propter densitatem veprium & solitudine heremi fertur fuisse: ut vix quisquam illis diebus in prefato loco. ob virulenta serpencium impedimenta posset habitare. Sunt enim huiusmodi reptilia abruptis minorum semper amica. Presertim ubi queant colere fruticum umbras. Unde eciam quidam dicuntur colubri quia colunt umbras: Horum vero terrore deo devote virgines. que cum dei famula Hilda cohabitaverant praeterite: & plurimum illorum horribilibus sibulis consternate. adeo ut extra cellam uspiam egredi non audebant. Nec eciam ad cotidiani victus subsidia aquam haurire. Hac ergo inquietudine aliquandum fluctuantes: quo se verterent. quidne agerent penitus ignorabant: Tandem [fol. 109r] salubre adepte consilium: illud sibi expedire putabant refugium. ut super ingruenti molestia convenirent Abbatissam Hildam matre illarum omnium. Quatinus eius intercessionibus amoveretur ab eis imminens periculum. Quod cum beate Hilde cermia [*recte* vermia] satis suggestione exposuissent: respondens ait. Karissime filie habete fidem dei in vobis. Licet enim me viderim impotentem in huiusmodi opere. novi tamen quia divina clementia maiora solet concedere. quam humana fragilitas presumit petere: Igitur beatissima virgo Hilda se in terram prostravit & oravit dominum dicens. Jesu Christe fili dei vivi. qui discipulis suis dixisti. quicumque dixerit huic monti tollere & mittere in mari & non hesitaverit in corde suo quin fiat: fiet ei. Peto te per omnipotentiam divine maiestatis tue ut si acceptaveris nos tibi in hoc loco servire: exosam infestacionem serpencium hinc digneris amovere. Iubeasque eas maritibus rupis perpetuo inherere. Nec cuiquam illorum ultra [fol. 109v] sit fas quemquam ledere. nec in perniciem cuiusquam hominum vel bestiarum virus effundere. Sed quicumque eos amodo viderit seu manibus attrectaverit: non serpencium doleat astuciam: sed lapidum

perpendat innocenciam. Optineat serpens rigorem lapidis. sed lapis nesciat maliciam serpentis. Sit igitur effigies in lapidem. sed venenum non sit in serpente. Neque difficile tibi est domine rex regum hoc transmutare in illo: qui omnia creasti ex nichilo. Converte ergo queso serpentes. qui huius loci incolunt confinia. in solidissimum lapidum natura. quatinus nos deinceps illorum non metuentes insolenciam: cum pace & tranquillitate tibi soli domino liberis mentibus serviamus qui es super omnia benedictus in secula seculorum. Cumque omnes respondissent amen: mirum dictu: videres circumquaque sepentes ex rivulis terre confluere & apud litora maris. que satis noscuntur contigua certatim serpere. Ibi sese sine more per devexa mon[fol. 110] tis precipitavere [*recte* precipitare]. ubi mox velut lapides diriguere. Ex illa vero die & in posterum in provincia illa nemo se unquam hac clade se sensit lesum. quia supradictus locus ubi degebat beata Hilda cum devota deo turba virginum adeo immunis existit [*recte* exstitit] & mundus ab hoc genere vermium. ut nulli sit cura ibidem illorum. quia non sinit vitare progressum. Huius autem portenti talia usque in presenti signa incolis terre relinquuntur: quod in cavernis saxorum ubi serpentes corruere lapilli inveniuntur. in quibus ita proprie exprimuntur eorum figure. ut nil penitus conformitati serpentis quantam ad expressam speciam desit vel nature: Lapillos quasi ad ymaginem serpentinam expressos inspicis. sed nulla arte humani ingenii sic posse insculpi facile advertis. Lapis manibus palpitatur [*recte* palpatur]. Sed nichil nisi serpens cogitatur.

O preclara virginis Hilde virtutum merita pro cuius amore supernus artifex in terris operatur mirabilia quorum profecto spectacula: explicare non sufficit [fol. 110v] mens humana vel lingua. O specialis virginitatis puritas. que quia suo ineffabiliter militavit creatori sine querela: ideo ei obtemperabat mirabiliter creatura. Unde ad ostendendum sanctitatis eius meritum. plerique ferunt. quod pulvis predictorum lapidum minutatim tritus benedictaque acqua conspersus: viperei morsus dolorem mitigat. & a corpore hominis omne venenum effugat. Quod quidem si verum fuerit: ipsi melius noverunt qui experti sunt. Nos autem nolumus dubia certis inserere. unde manifestam testem non valemus inducere. vel evidentem racionem ostendere. Sed licet fratres per dei misericordiam forinsecus ab hac peste tuti sumus. tum ne interior homo noster amaritudinis poculo corrumpatur: sollicite attendamus. Unusquisque sibi omni diligencia provideat ne serpenti. qui in cordibus reproborum serpere solet accessum prebeat. Relinquamus egipto debita spolia. Ut expeditius in heremo nudi cernere possimus vermium iacula. Fertur enim quid serpens hominem nudum non ausus sit [fol. 111r] contingere. Ut igitur fortes & muniti simus in prelio: denudemus nos ab omni contagione. non efficiamur cupidi super aliena possessione. ne inveniat inimicus noster quo se teneat in congressione. Nunc itaque dilectissimi istis finem imponere volo, sed prius omni industria vos commoneo. ne consensu impio.

vosmetipsos exponatis antiquo serpenti & lubrico: Ipse enim semper post quedam dulcia & suavia que incautis suggerendo promittere non cessat: letales gustus amarissimi poculi pro falso pollicitis supponendo propinat. & post multa mollia & blanda que ymaginaria representacione in posterum fingit: mille dura & aspera apud inferorum inquinamenta: ubi cuncta fetent miserabiliter super sequaces suos inducit. Cuius nanque stipendia universa sunt horrida & penalia in fetore. Nec potest aliud suis concaptivis erogare emolumentum nisi quod ipse sine quietis vicissitudine pa[fol. 111v]titur in dolore. A quo nos liberet Jesus Christus. Qui nobis sit ubique propicius. Amen. Explicit. [added:] anno domini 1526

And so in the beginning when the blessed virgin Hilda began to build the monastery of Whitby which then was called Streneshalc, there is said to have been so great a multitude of snakes there on account of the thickness of thorn-bushes and the isolation of the desert place, that scarcely anyone in those days could live in the aforesaid place because of the virulent hindrance of the snakes. For reptiles of this sort are always fond of rocky steeps, especially where they can enjoy the shade of vegetation, whence some are also named serpents [*colubri*] because they seek [*colunt*] shade. So for fear of them the virgins pledged to God, who meanwhile had taken up residence with God's handmaid St Hilda, were terrified and exceedingly frightened by the horrible hissing, so that they dared not ever go out of the cell, not even to draw water to provide their daily sustenance. Thus wavering for some time in disquiet where they should turn, they inwardly did not know what to do. At last [fol. 109] having adopted wise counsel they decided to seek recourse, that they would consult Abbess Hilda, common mother of them all, about the growing harm, that by her intercessions the imminent danger might be removed from them. When they had sufficiently explained about the pests, she replied: 'Dearest daughters keep your trust in God. Although I may seem helpless in a matter of this kind, I have, however, known that divine clemency is accustomed to grant greater things than human weakness dares to beg.' Therefore the most blessed virgin Hilda prostrated herself on the ground and prayed to the Lord saying 'Jesus Christ son of the Living God, who said to his disciples "Whoever will say to this mountain remove and sink into the sea, and will not hesitate in his heart that it will happen, it will be done for him" I beg thee by the omnipotence of thy divine majesty that if you shall have accepted us to serve thee in this place, you would deign to remove the hateful infestation of snakes hence, and bid them forever to inhabit the seaside cliffs and none of them further [fol. 109v] to do harm to anyone nor injury to any man or beast by ejecting poison. But henceforth whoever merely will see them or touch them with hands may not suffer pain from the cunning of the snakes but consider the harmlessness of the stones. May the snake get the stiffness of stone but

the stone not know the malice of the snake. Therefore may its likeness be in the stone but let there not be poison in the snake. Nor is it difficult for you Lord king of kings to change this to that, who created everything from nothing. So change, I ask, the snakes which inhabit the neighbourhood of this place to the nature of the most solid stone, in so far that, we henceforth not fearing their insolence, in peace and tranquillity with free minds may serve thee our holy Lord, who is blessed above all things for endless ages.' And when they had all responded 'Amen', wonderful to say, you would see everywhere snakes flowing from the streams of the earth and on the adjacent shores of the sea, where they are known to creep, and rushing there without delay down the slopes of the hill [fol. 110], where soon they stiffened like stones. Indeed, from that day, and afterwards in that area, no one ever felt himself harmed by that hurt, for the aforesaid place where blessed Hilda dwelled with the band of virgins pledged to God remained unharmed and clear of that kind of pest, and no worry thereof there, because there is no possibility of it going on. But of this wonder such signs remain for the present for the inhabitants of the area, for in those rocky caves where the snakes used to run little stones are found in which are so shown their proper shapes that nothing of the inward similarity of a snake is lacking, either so far as its likeness is concerned or of its nature. You see the little stones shaped in the snakes' appearance, but you see it could not thus be easily carved by any skill of human ingenuity. The stone is fondled in the hands and nothing but the snake is thought of.

O the outstanding merits of the virtues of the virgin Hilda for whose love the supreme creator effected wonders whose appearances the human mind or tongue is not adequate to explain! O special purity of virginity which, since it moved inexplicably for its creator, his creation submitted to him without demur! Whence, in order to show the merit of her sanctity, many say the ground-up dust of the foresaid stones dispersed bit by bit sprinkled in holy water mitigates the pain of snake bite and drives all poison from human bodies. Which indeed, if it is true, they know better who have experienced it. But we do not wish to introduce doubts into certainties, for which we cannot produce public witness, or demonstrate plain reason. But though, brethren, by the mercy of God we have been freed outwardly from this pest, however, let us carefully watch lest our inner man is corrupted by a drink of bitterness. Let everyone take care for himself with all diligence lest he should give access to the snake which creeps in the hearts of the wicked. Let us leave to Egypt what we had earned so that we more speedily may be seen naked in the desert [*sc.* 'free'] from attacks of pests. For it is said that the snake does not dare [fol. 111] to touch a naked man. That therefore we may be strong and protected in the battle, let us strip ourselves of all contagion, let us not become greedy of others' possessions, lest our enemy should find wherewith he may hold sway. And therefore, most beloved, I want to put an end to these things, but firstly with all earnestness I warn you, lest with an evil consent you expose yourselves to the old and slippery serpent. For always, after some sweet and soft things which by suggesting to the unwary he does not cease to promise, [he] follows on with deadly draughts of a most bitter cup, by way of falsely substituting for his promises; and after many soft and smooth things which by imagination he invents in future, yet leads to a thousand hard and sharp judgments in hell where all things stink miserably on his followers. For the universal wages are horrid and painful in stink. Nor can anything occasion relief for his fellow captives unless he suffers in grief. From which free us Jesus Christ who is always favourable to us. Amen.+

A dastardly deed? Bishop Ranulph Flambard and the Ravensworth Estate

Lindsay Allason-Jones and David Heslop

Introduction

In 1938 Lord Ravensworth presented the Society of Antiquaries of Newcastle upon Tyne (hereafter 'SANT') with a collection of eighty-two deeds relating to lands in Co. Durham.[1] The earliest of these, a charter of Ranulph Flambard, Bishop of Durham (1099–1128), was displayed in the exhibition *Tales of Antiquarian Adventure,* which was held in the Great North Museum: Hancock to celebrate SANT's bicentenary in 2013, and attracted a great deal of curiosity as to its significance.

The document (Fig. 24.1), on parchment, measures 220mm × 152mm.[2] The remnants of a wax seal, which was first wrapped in wool then stored in a linen bag, is attached to the document with a parchment seal tag through a fold at the foot. The seal was identified by Richard Bailey's predecessor as editor for SANT, Charles Hunter Blair, as a genuine seal of Ranulph Flambard, catalogued as DS 3110.[3] The text is arranged in sixteen ruled lines. At the bottom of the text, on the right side, in a very small hand, is the annotation 'iiii° Aug 1716 lect[a] in curi[a]' and signed 'TH'; that is, the deed was read in court, 4 August 1716.[4]

The charter is unusual in a number of ways compared to Flambard's other surviving charters. For example, Offler commented that the script, elements of the form of address, and the use of the phrase *Huius donationis testes sunt isti* to introduce the witness list, are not encountered elsewhere in Bishop Ranulph's charters, while its grammatical and syntactical errors, and the occurrence of the name of the bishop in full (elsewhere usually abbreviated to 'R.' or 'Ranñ'), are atypical of them.[5] The seal is genuine but the way in which it is attached by a tag folded through a small, irregular hole at the foot of the document is unusual, as most of Ranulph's grants were sealed on a tongue cut from right to left from the foot of the document.[6] These anomalies led Offler to believe that the charter was probably not the original but a 'later rehandling'.[7]

When the donation of the charter to SANT was reported in *Archaeologia Aeliana* in 1939 it was calendared by H.E. Bell in the following terms:[8]

Grant by Ranulph, bishop of Durham, to Richard his nephew of Hectona, Raueneswrthe and Blaikestona, by these boundaries, pertaining to Hectona and Raueneswrthe, to wit, from Scadneslaue upon the east by the issue of the spring under Scadneslaue as it falls into Tame, by Tame to where Mereburne falls into Tame, by Mereburne to Aldrethesdene, by Aldrethesdene to Tame, by Tame to where Beccleiburne falls into Tame, by Beccleiburne to the river that falls from Felfordesfen, by Felsfordesfen to Auescheburne, by Aueskesburne to Blakesburne, by Blakesburne upon the east to where it falls into Tame, by Tame to where Choldene falls into Tame, by Choldene to Semer, and from Semer by the high road to Scadneslaue. To hold at service of half a knight.

Witnesses: Ranulph the archdeacon, Papamonus, Osbert, nephew of the bishop, Robert his brother, William, son of Ranulph, Urricus, Richard de Untedune, Payne, nephew of Ranulph'.

The full text, as edited by Offler, reads:[9]

Ranulfus dei gratia Dunelmensis episcopus omnibus hominibus francis et anglis, salutem et ueram benedictionem. Sciatis me bonorum hominum meorum et amicorum meorum consilio dedisse et concessisse et hac presenti carta mea confirmasse Ricar[do] nepoti meo et heredibus suis in feudo et in hereditate pro humagio et seruicio suo Hectona et Rauenswrthe et Blaikestona cum omnibus rebus

et pertinentibus et per has diuisas quas pertinent ad Hecton[am] et Rauenswrthe, scilicet de Scadneslaue apud orientem per exitum fontis sub Scadneslaue sicut descendit in Tame, et per Tame usque Mereburne descendit in Tame, et per Mereburne usque Aldrethesdene, et per Aldrethesdene usque in Tame, et per Tame usque Beccleiburne cadit in Tame, et per Beccleiburne usque riuam que descendit de Felfordesfen, et per Felfordesfen usque ad Auescheburne, et per Aueskesburne usque ad Blakesburne, et per Blakesburne apud orientem usque cadit in Tame, et per Tame usque Choldene descendit in Tame, et per Choldene usque Semer, et de Semer per altum iter usque ad Scadneslaue. Habendas et tenendas de me et de successoribus meis sibi et heredibus suis libere et quiete et honorifice per seruicium dimidii unius militis pro omni alio seruicio auxilio consuetudine et exaccione faciendo forinsecum seruicium quando per episcopatum euenerit quantum pertinet dim[idio] militis. Volo et concedo ut predictus R[icardus] et heredes ejus habeant et teneant predictas terras per predictum seruicium libere et quiete et honorifice cum nullus homo in episcopatu Dunel[mensi] tenet, in boscho in plano in pratis in pascuis in moris et in maricis in aquis et stangnis in molendinis in terris cultis et incultis et inter has diuisas edificare et cultificare et in omnibus aliis aisiamentis. Huius donationis testes sunt isti : Rann[ulfus] archid[iaconus], Papa mon[achus], Osbertus nepos episcopi, Robertus frater ejus, Willelmus filius Rann[ulfi], Vrricus, Ricardus de Vntedune et Paganus nepos Rann[ulfi] et plures alii.

A number of very interesting questions arise from this document. Where are the properties referred to in the text? To what extent is it typical of episcopal charters of its time? What is the date of the document? And lastly, why was the charter produced in a court of law in 1716, nearly six hundred years after it was written?

The place-names and the boundaries of the estate

Offler found it difficult to plot the place-names on a modern map and produce a clear outline of the estate in question.[10] A transcription, also in the SANT collection, dated to 1716 and presumably prepared for the court case of that year, implies that there was certainty at the time about matching the twelfth- and eighteenth-century place-names but this has not proved to be so.[11] The suggestion of certainty, of course, may well be due to the intended use of the transcript, that is, to support the case of Sir Henry Liddell, one of the parties. There is also a copy of the deed in the notebooks of Thomas Randall, 'late of the City of Durham, Clerk', in Durham Cathedral Library.[12] This must have been copied in the eighteenth century as Randall died in 1774, but,

unfortunately, there are many discrepancies between his transcription and the Society's 1716 copy. This may be due to Randall's local knowledge, but as there are several misspellings throughout Randall's copy it is likely that he was merely an inaccurate transcriber; it is also unclear whether he was transcribing the SANT document itself or another version prepared for the 1716 court case. Research on the place-names mentioned in the charter published since Offler's edition is summarised in Table 24.1.

Offler started plotting the place-names with 'Scadneslaue',[13] which is attested as 'Schedeneslawe' in 1305,[14] was referred to as 'Scadneslande' by Randall,[15] and identified as Sheddon's Hill on the 1898 Ordnance Survey Map; it is more commonly referred to today as Shadons Hill (NZ 282575). He then suggested that the estate boundary ran westwards to the River Team ('Tame') along the Leyburnhold Gill, running through ground now occupied by the northern outskirts of Birtley, before heading north down the Team to the Coltspool Burn, which is how he interpreted the 'Mereburne' of the charter. The boundary can then be followed west along the Coltspool Burn and south-west to its source south of Ouslaw, the highest point in the watershed on Hedley Fell. Offler could not discern the line of 'Aldrethesdene', transcribed as 'Aldrechesdene' by Randall,[16] and now called Hedley, but identified 'Auescheburne' as the stream referred to in the 1716 transcription as the 'Avishburn'. He further

Table 24.1 Place-names mentioned in the Charter

Name form appearing in charter	Modern equivalent
Hectona	Eighton (Watts 2002, 39)
Raueneswrthe	Ravensworth (Watts 2002, 102)
Blaikestona	Blakiston (or Blackeston) (Watts 2002, 13 (*sub* Blackeston Hall); Watts 2007, 155)
Scadneslaue	Sheddon's Hill/ Shadons Hill (Watts 2002, 111)
Tame	[river] Team (Watts 2002, 123)
Mereburne	Coltspool Burn (presumed by Offler 1968, 103)
Aldrethesdene	Hedley ((cf Watts 2002, 57, *sub* Hedley (2))
Beccleiburne	(unidentified; probably Bobgin(s) Burn (Watts 2002, 6 (*sub* Beckley))
Felfordesfen	(unidentified; perhaps part of Andrew's House Gill, Hedley)
Auescheburne (Aueskesburne)	(unidentified; perhaps part of Andrew's House Gill, Hedley)
Blakesburne	Blackburn (Watts 2002, 12)
Choldene	Chowdene (Watts 2002, 26)
Semer	(unidentified)

postulated that the line of 'Auescheburne' and 'Felfordesfen' referred to in the charter may have approximated to that of Andrew's House Gill which runs into Wheatley Burn and then Bobgin Burn, the stream which Offler associated with the 'Beccleiburne' of the charter and the 'Beckley Burn' of the 1716 transcript. The old Andrew's House Farm has been identified as being at grid reference NZ 2041 5711. Offler was confident that the north and north-western boundaries ran along the Blackburn 'from about 100 yards

west of Fen House until it flowed into the Team some 100 yards north of Tileshed Wood; then continued east of the river up Chowdene'.[17] This section is easily identified on modern maps. Offler was then baffled as to how the boundary returned to Shadons Hill nor was he sure as to the identification of the *altum iter* ('high road') of the charter.[18] He appears to have concluded that the road now known as Longbank and Old Durham Road was the eastern boundary; despite Offler's reservations it is, however, more likely that

Fig. 24.1 Charter of Ranulph Flambard, Newcastle upon Tyne: Society of Antiquaries of Newcastle Collection, MS SANT/DEE/8/3/1 (Photo: © Woodhorn Archives)

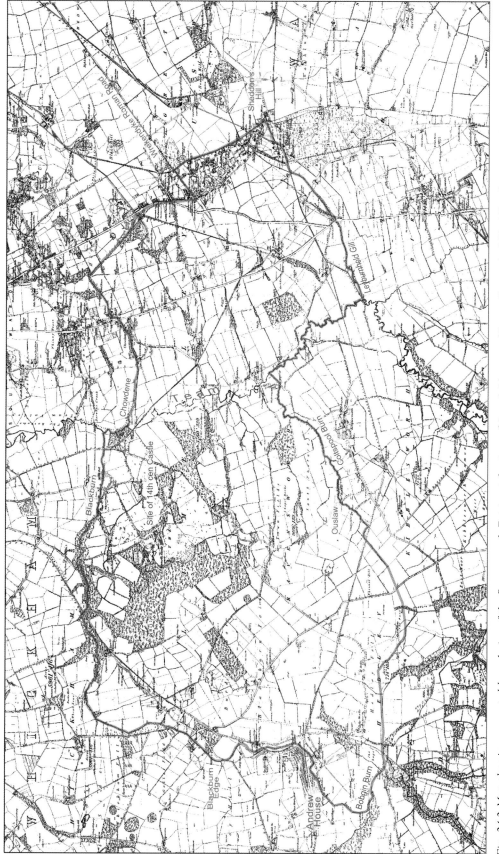

Fig. 24.2 Map showing suggested boundaries of the Ravensworth Estate at the time of Ranulph's grant (Crown Copyright 209. All rights reserved. Ordnance Survey License Number 100019569)

the highway referred to was the old Roman road known as the Wrekendyke, a route which in the twelfth century would have been a prominent feature as it wended its way across the marsh lands towards the River Tyne. It is noticeable that the resulting outline of the estate, as shown in Fig. 24.2, is reflected by the later civil parish boundaries,[19] which seems to confirm the hypothesis that the *altum iter* was indeed the Wrekendyke, as does Thomas Moule's 1837 description of the area as 'a wide, spongy, dark moor' which was bounded on the east by the Roman causeway.[20]

By tracing the boundary using landscape indicators and a more precise understanding of its later history, the estate is now revealed to have been smaller than Offler calculated: 7.25km from east to west and 4.3km north to south, and to have constituted a viable, indeed choice, estate, including water meadows, arable and upland grazing.[21] It included Lamesley, Hedley, Eighton and Ravensworth, but excluded Kibblesworth. It may not, however, have included all of Eighton if that vill is to be identified with the *Hectona* for which John de Amundeville owned ten marks to the Crown for seisin of his father's land at *Hectona* and *Hasteleia* in 1130–1.[22] Hedley civil parish was carved out of the Ravensworth estate before 1851.[23] Hedley Fell was enclosed in 1881, removing it from the Ravensworth estate.[24]

Blakiston, the other component of Flambard's grant, was not part of the Ravensworth estate but was in the parish of Norton, near Billingham. Though Durham Priory had already successfully reasserted its claim to the superior lordship of this part of the grant before Flambard's death in 1128, Blackiston remained in the hands of the descendants of the original beneficiary of the grant, Flambard's nephew Richard, until it was quitclaimed to the monks in the later thirteenth century.[25]

The charter in its twelfth-century context

Offler established that the witness list of this charter is of particular interest, largely because the individuals named are not the usual witnesses to a Flambard deed but most appear to be related to him in some way.[26] Two, Osbert and his brother Robert, are stated in the charter itself to have been (like Richard, the beneficiary of the grant, himself) Flambard's nephews; Ranulph the archdeacon was probably another nephew (though he may have been Flambard's illegitimate son by his mistress Alveva).[27] William, son of Ranulph, probably to be identified with the William Fitz Ranulph who was enfeoffed by Flambard with Houghall, Harraton, the two Herringtons and Hawthorn,[28] was probably the son of Ranulph the archdeacon rather than, as suggested by Davis, the bishop's own son.[29] Pain (*Paganus*), possibly to be identified with the Pain of Silksworth who later held Richard's fee,[30] may have been yet another nephew of Bishop Ranulph or, as Offler suggested, the nephew of Ranulph the archdeacon.[31] Papa the monk was also very

likely a relative, perhaps the bishop's brother in law or brother.[32] In addition, assuming that *Untedune* refers to Huntingdon, where Bishop Ranulph's mistress Alveva lived, it may be inferred that Richard de Untedune was related to or associated with her in some way.[33]

Given the overwhelming preponderance of members of Bishop Ranulph's family in the witness list of the charter, Offler went on to speculate that its formal peculiarities might be explained in part by supposing that the beneficiary, Richard (and, perhaps, other members of the Flambard family) played an active role in producing it. This is, if anything, supported by recent research on other English episcopal archives, which has emphasised the proactive role of beneficiaries, at least in the case of documents dating from the earlier twelfth century.[34] Viewed from that perspective, what may prove to be exceptional is not so much the idiosyncrasies of this document as the (perhaps rather precocious) degree of uniformity exhibited by the other surviving Flambard charters. It is also apparent that the presence of a substantial family component in the entourages of early twelfth-century diocesans, for which they were expected to make suitable provision, was not unusual. The Flambard clan may have been distinguished by its size, though the occurrence of a brother and perhaps as many as ten *nepotes* in the witness lists of charters of Flambard's younger contemporary, Bishop Everard of Norwich (1121–45) suggests that it was not unique in that regard.[35] It is also possible that the scale on which Flambard enfeoffed his relatives was unusually extensive; we know that Richard was by no means the only member of the clan to benefit in this way, for a second charter in favour of William, son of Ranulph, survives,[36] and there is evidence of a third, now lost, to Osbert, *nepos episcopi*.[37] Nor can the bishop's zeal and lack of scruple in promoting his family's interests be in any doubt.[38] Assessing whether Flambard went beyond the limits of acceptable behaviour by the standards of the early twelfth-century English episcopate in this respect (and, if so, how far beyond) is hampered by the comparative infrequency with which charters evidencing the enfeoffment of relatives have survived among episcopal *acta* elsewhere. That what still exists may significantly underrepresent the original position is suggested by the way in which our charter (together with its associated royal confirmation, see further below) was preserved in the hands of the successors in title of the original recipient,[39] for that appears to be a comparatively uncommon route to survival.[40] It is also possible that Offler was right to suspect that the amount of knight service (half a knight) owed in respect of this fee may reflect unusually favourable treatment on Flambard's part,[41] though the absence of detailed boundaries of the Blackiston component of the grant makes evaluation difficult while, if our proposed reconstruction of the extent of the Ravensworth estate is correct, it implies that it was rather smaller than Offler supposed.

Finally, it may be worth considering why the fee comprised two such widely separated estates, some 35km apart. There is, of course, nothing unusual about its geographically disparate character as such, but the locations of its component estates are, nevertheless, suggestive, since Blackiston sits on the north-western edge of an important ancient episcopal manor the *caput* of which was, by the later twelfth century at least, located at Stockton on Tees;[42] perhaps the Ravensworth estate bore a similar peripheral relationship to the bishops' manor of Gateshead on the Tyne,[43] for it borders on its south-western edge. If this is correct it would recall the topographical relationships between other estate centres and the fees granted to important administrative officials associated with them at much the same time: compare, for example, Flambard's enfeoffment of Papedy (the sheriff of Flambard's new castle of Norham) with Ancroft, on the south-eastern border of that episcopal demesne;[44] or that of Embleton, held by the sheriffs of the royal castle of Bamburgh, bordering the southern limit of the royal demesne.[45] This suggests that such arrangements may once have been more widespread.

The date of the charter

The date of this document has given rise to some debate, though Offler's work at least enables the attempts of antiquarians to assign it to the early years of Flambard's episcopate to be discounted.[46] SANT also holds within its collection an undoubtedly genuine charter of Henry I which confirms the grant to Richard, nephew of Ranulph (Fig. 24.3); this probably dates to late August 1127,[47] which thus provides a *terminus ante quem* for our charter (or, strictly, for the charter of which ours may be a reworking).[48] The only potential assistance provided by the witness list is the date at which Ranulph the archdeacon was appointed to that office. Unfortunately, however, the chronology of the early archdeacons of Durham is uncertain.[49] If, as seems likely, the Ranulph, nephew of the bishop, who witnesses Flambard's grant of Hallowstell fishery to the monks of St Cuthbert, dated by Offler to *c.* 1122–27, can be identified with the Ranulph who later became archdeacon,[50] it suggests that his appointment had not yet taken place, so must have happened late in Flambard's episcopate, as Offler supposed.[51] It also seems unlikely that much time elapsed between the date of the original grant and that of Henry I's charter. The evidence, such as it is, thus tends to confirm Offler's suggestion that our charter probably played a part in Flambard's tidying of his affairs in the last two years of his life.[52]

Later history of the estate

In 1166 the Ravensworth estate formed part of the holding of Richard's son, Geoffrey.[53] It then passed to Richard's

grandson, Marmaduke de Horden, whose son and grandson both assumed the name of Fitz Marmaduke. The Fitz Marmadukes were to have a long history among the minor aristocracy in the north of England. A direct line then continued as superior lords of the lands included in this estate until Richard Fitz John Fitz Marmaduke, fifth in descent, was killed by Robert Neville on Framwellgate Bridge in 1318 (as Offler noted, a great irony given that the bridge had been built by his ancestor Bishop Ranulph).[54] Exactly how the land came to the Lumleys is unclear; according to Surtees,[55] it was Richard's sister Eleanor who married into a younger branch of the family, but Offler doubted that Richard had a sister or a daughter called Eleanor, stating: 'As propounded in the 1380s, the Lumleys' title … came from the marriage of Mary, Richard's sister and heir, to Sir Robert Lumley' but goes on to say that 'there seem grave weaknesses in this descent'.[56] Howsoever the estate passed to the Lumleys, it is clear the family held it until late in the fifteenth century when Isabel, daughter and heir of Bertram Lumley, married Henry Boynton of Sebury; their sole daughter, also called Isabel, married Sir Henry Gascoigne. Towards the end of the reign of Elizabeth I Sir William Gascoigne was forced by financial difficulties to lease the castle to his brother-in-law Thomas Liddell, who then bought it outright sixteen years later.[57] By this date the estate included the manor of Lamesley as well as land at Eighton, Longacres, Northend, Ravensworth and Pockerley. As can be seen in the attached line of descent (Fig. 24.4), the property continued to be owned by a Thomas Liddell until the Third Baronet died without issue in 1700 and was succeeded by his brother Henry.

The 1716 court case

Randall's copy of King Henry I's charter confirming Flambard's grant to Richard is annotated: 'This charter was given in evidence at York Assizes 1716 G.I. a[nn]o 2do by S[i]r Hen. Liddell ag[ains]t Nathaniel (Crew) B[isho]p. of Durham touching a part of Gateside [*sic*] Fell'.[58] The case established the boundaries of the manor of Ravensworth with Lamseley and Eighton. The descent of the property (Fig. 24.4) was not then in doubt, but the ambiguities of the topographical detail in the charter left scope for disputation as to which parts of south Gateshead were within the Bishop's manor and which lay within the estate of Ravensworth. In particular Chowdene, on the southern margin of Gateshead Fell, may have been mostly poor quality agricultural land but it was on the edge of the expanding Tyneside coalfield. Previously unworkable, the deeper seams south of Felling were becoming economically viable by the time of the 1716 litigation as drainage technology improved and Sir Henry was able to recover flooded levels in his Ravensworth colliery by means of a three-wheel water-pumping mill.[59] Developments in mining

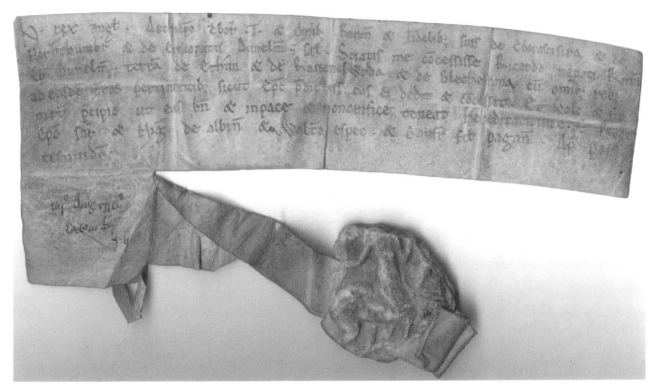

Fig. 24.3 Ratification of Ranulph's charter by Henry 1, Newcastle upon Tyne: Society of Antiquaries of Newcastle Collection, MS SANT/ DEE/8/3/2 (Photo: © Woodhorn Archives)

technology thus explain why this hitherto marginal and comparatively unproductive land suddenly became worth a lawsuit.

The territorial dispute was also interlaced with deeper, political and religious antipathies between the arch-Whig, Sir Henry, and the Jacobite-leaning High Tory in the palace at Durham. Although the Bishop lost the York case – and the fact that the historic civil parish boundary places Chowdene within Sir Henry's demesne suggests the Bishop's claim was always weak – one of his final acts before his death in 1721 was to incorporate the town of Sunderland, the growing sea-coal rival of Newcastle,[60] to full parish status, much to the annoyance of the Tyne coal magnates such as the Liddells.[61] Crewe's successor, Bishop Talbot (1722–30), however, nominated Sir Henry for the office of sheriff, showing that the Chowdene dispute had not caused any long-term rift between the Liddells and the bishops.

The first Liddell to live in the twelfth-century Ravensworth Castle, then still consisting largely of four towers and a curtain wall, was Sir Thomas Liddell III, second baronet. In 1724 Sir Henry Liddell, using the profits from the coal mines which the 1716 court case had confirmed as his to exploit, built a mansion within the castle walls. The income from the mines continued to enrich the family, allowing later generations of Liddells to enlarge and embellish Ravensworth Castle until it could be described by Pevsner as

'the nearest approach to the thrills of Fonthill which, in the C20, one could experience anywhere'.[62] The improvements to the family's fortunes and the increasing splendour of Ravensworth, however, were disrupted when the sixth baronet moved to Eslington Park in Northumberland. The seventh baronet planned to demolish the castle and it was revealed, after a public outcry against this decision, that working the 30-acre coalfield beneath the estate, which the Liddells had fought so hard for, had resulted in the foundations sinking and the building becoming unsafe. It was demolished in 1953.[63]

Conclusion

This deed has often attracted the attention of historians and for many the charter simply confirms that Flambard sailed very close to the wind in his activities.[64] However, it should be remembered that he became bishop after a period of chaos during which one of his predecessors, Walcher, had been murdered outside Gateshead church, and when the first two Norman kings found the earldom of Northumbria, in Brindle's colourful phrase, a 'revolving door succession',[65] which both failed to consolidate English control of the north and encouraged Scottish territorial ambitions until decisively checked at the Battle of the Standard at Northallerton in August 1138. Flambard's career as bishop lasted twenty-nine

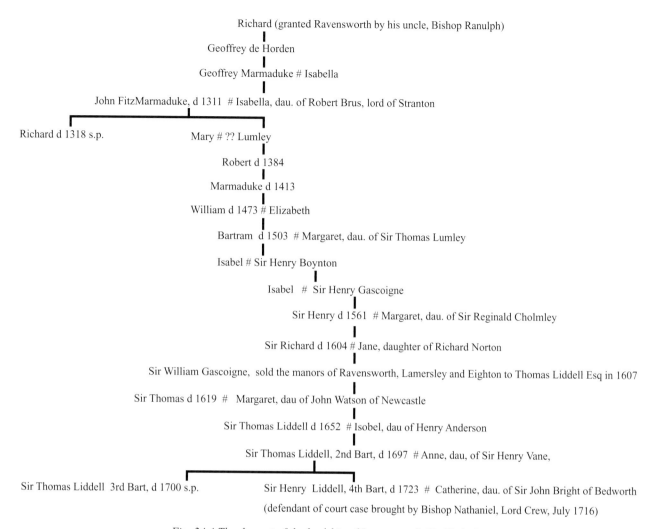

Richard (granted Ravensworth by his uncle, Bishop Ranulph)

Geoffrey de Horden

Geoffrey Marmaduke # Isabella

John FitzMarmaduke, d 1311 # Isabella, dau. of Robert Brus, lord of Stranton

Richard d 1318 s.p. Mary # ?? Lumley

Robert d 1384

Marmaduke d 1413

William d 1473 # Elizabeth

Bartram d 1503 # Margaret, dau. of Sir Thomas Lumley

Isabel # Sir Henry Boynton

Isabel # Sir Henry Gascoigne

Sir Henry d 1561 # Margaret, dau. of Sir Reginald Cholmley

Sir Richard d 1604 # Jane, daughter of Richard Norton

Sir William Gascoigne, sold the manors of Ravensworth, Lamersley and Eighton to Thomas Liddell Esq in 1607

Sir Thomas d 1619 # Margaret, dau of John Watson of Newcastle

Sir Thomas Liddell d 1652 # Isobel, dau of Henry Anderson

Sir Thomas Liddell, 2nd Bart, d 1697 # Anne, dau, of Sir Henry Vane,

Sir Thomas Liddell 3rd Bart, d 1700 s.p. Sir Henry Liddell, 4th Bart, d 1723 # Catherine, dau. of Sir John Bright of Bedworth

(defendant of court case brought by Bishop Nathaniel, Lord Crew, July 1716)

Fig. 24.4 The descent of the lordship of Ravensworth (D. Heslop)

years and, despite his various disputes with the king, once reconciled to the crown he would have represented stability; having the confidence to build a castle at Norham could be taken as evidence for the extent to which Flambard enjoyed royal support at that time. Putting his various relatives in positions of importance in the north of England would have strengthened his hold over the region.

Collections, such as that of SANT, contain many fascinating documents, most of which have been published many times over the years. This example, its oldest document on parchment, may have survived to the present day simply because it was valued by all the estate's owners through the centuries as evidence for their boundaries and continually referred to, the 1716 court case simply being the only such recorded event. It also reveals insights into twelfth-century century ecclesiastical life and shows that reassessing documentary evidence whenever new historical and archaeological work is published can shed new light on old landscapes.

Acknowledgements

The authors are grateful to Roger Norris for his initial input and to the staff at Woodhorn Museum and Northumberland Archives for preparing the Figs. 24.1 and 24.3.

Notes

1 The collection is held with the rest of SANT's archives at Woodhorn Museum and Northumberland Archives: SANT/DEE/8/3.
2 SANT/DEE/8/3/1.
3 Bell 1939, 44 (n. 3), 45, pl. iv, fig. 2.
4 Who the scribe TH was is not known; but cf n. 58.
5 Offler 1968, 102.
6 Ibid., 102.
7 Ibid., 103.
8 Bell 1939, 44–5.
9 Offler 1968, 100–1, reproduced by kind permission of the Surtees Society.
10 Ibid., 103–4.

11 SANT/DEE/8/3/3.

12 Dean and Chapter of Durham (hereafter 'DCD') Randall MS 3.

13 Surtees (1820, 211) also recorded the boundaries of the grant but for some reason (perhaps relying upon documents generated in the 1716 litigation) started at Chowdene and used different versions of the place-names.

14 Fraser 1953, 112 (no. 106).

15 Randall MS 3.

16 Randall MS 3.

17 Offler 1968, 103.

18 Ibid., 103–4.

19 Based on the 1851 census: Southall and Burton 2004.

20 Moule 1837, ii, 310.

21 Offler's calculation that it was 7.25 × 6.5km (4.5 × 4 miles) requires the inclusion of Kibblesworth, although he avers that Kibblesworth was not included: Offler 1968, 104.

22 Pipe Roll, 31 Henry I [1130–1] (Hunter 1833, 36; Hodgson 1835, xii).

23 Southall and Burton 2004.

24 Durham County Record Office: D/CG 32/8.

25 For the later tenurial history of Blackiston, see Offler 1968, 104–5.

26 For fuller details, see Offler 1968; 1971; Aird 1998, 203–4; Archer 1887. Conversely, William the Chamberlain, not related, is conspicuous by his absence, even though he witnesses several other approximately contemporary Flambard charters (Offler 1968, 81).

27 Ibid., 94.

28 Ibid., 72–83 (nos 11–13).

29 Ibid., 74, following Surtees 1816, xx; Davis 1956, 221 (no. 1564).

30 Greenwell 1872, note on 125.

31 Offler 1968, 105.

32 Offler 1962, 201; cf Piper 2007, 140.

33 Talbot 1959, 40.

34 Offler 1968, 105–6; Brett & Gribbin 2004, xxv.

35 Harper-Bill 1990, xxxii, xliii.

36 In several versions: Offler 1968, 72–83 (nos 11–13); see above, n. 29.

37 Offler 1968, 115, no. 26b. For surveys of the evidence for Flambard's family enfeoffments whilst he was Bishop of Durham, see Offler 1971, 22–3; Aird 1998, 201–7, Fig. 5.3.

38 For example, as early as 1101 Flambard gained the vacant see of Lisieux for his brother Fulcher and when Fulcher died the following year, secured the position for his son, even though it was reported that the boy was barely twelve years of age (*Orderici Vitalis Historia Æcclesiastica* X; Chibnall 1975, 320–3).

39 For the royal charter, see below, n. 47.

40 For possible comparable examples, see Barrow 1993, 1–3 (no. 2) (though for a different view, see lxiii, n. 2); Harper-Bill 1990, 44–6 (nos 49 and 50).

41 Offler 1971, 22.

42 Brownbill 1928, 351 (n. 80), 353.

43 Hope Dodds 1915, 92.

44 Offler 1968, 91–3, no. 19.

45 Sharpe 2006, 19–20.

46 Hutchinson 1785, i, 149.

47 SANT/DEE/8/3/2; Bell 1939, 45; Davis 1956, 231 (no. 1603); Offler 1968, 106–7 (no. 23a), who sets out the dating evidence.

48 Offler 1968, 107.

49 Offler 1962; Greenway 1971, 39–40. Boutflower (1926, 105, 154) provided two contradictory dates, neither of which takes into account the evidence that Ranulph's appointment as archdeacon pre-dated Flambard's death.

50 Offler 1968, 94 (no. 20).

51 Offler 1962, 200.

52 Offler 1968, 105–6.

53 Ibid., 103.

54 Offler 1988, 203.

55 Surtees 1820, 208.

56 Offler 2002.

57 Surtees 1820, 209.

58 Randall MS 3. The reference to the second regnal year of George I dates its production in court to before 31 July 1716.

59 Tyne and Wear Historic Environment Record 1663. But cf above, 248.

60 Sea-coal can be understood as coal suitable for export.

61 Meikle & Newman 2007, 179.

62 Pevsner & Williamson 1983, 389.

63 Meadows & Waterson 1993, 16–19, which also shows photographs of both the interior and exterior of the Castle.

64 Offler 1968, 103, 105–6.

65 Brindle 2013, 92.

References

Aird, W.M., 1998 *St Cuthbert and the Normans: the Church of Durham, 1071–1153* (Woodbridge)

Archer, T.A., 1887 'Ranulf Flambard and his Sons' *English Historical Review* 2(5), 103–12

Barrow, J., 1993 *English Episcopal Acta 7: Hereford 1079–1234* (Oxford)

Bell, H.E., 1939 'Calendar of Deeds given to the Society by Lord Ravensworth', *Archaeologia Aeliana*, 4 ser. 16, 43–70

Boutflower, D.S., 1926 *Fasti Dunelmenses – A record of the Beneficed Clergy of the Diocese of Durham down to the Dissolution of the Monastic and Collegiate Churches*, Surtees Society 139 (Durham)

Brett, M. & Gribbin, J.A., 2004 *English Episcopal Acta 28: Canterbury 1070–1136* (Oxford)

Brindle, S., 2011 'Henry II, Anglo-Scots Relations and the Building of the Castle Keep, Newcastle upon Tyne' in J. Ashbee & J. Luxford (ed.) *Newcastle and Northumberland: Roman and Medieval Architecture and Art*. BAA Conference Proc. 36 (Leeds), pp 90–114

Brownbill, J., 1928 'Stockton on Tees' in W. Page (ed.) *VCH: County of Durham* 3 (London), pp 348–65

Chibnall, M. (ed. & trans.), 1975 *The Ecclesiastical History of Orderic Vitalis*, Vol. V, Books IX and X (Oxford)

Davis, H.W.C. (ed. C. Johnson & H.A. Cronne), 1956 *Regesta Regum Anglo-Normannorum 1066–1154, 2: Regesta Henrici Primi 1100–1135* (Oxford)

Fraser, C.M., 1953 *Records of Antony Bek, Bishop and Patriarch 1283–1311*, Surtees Society 162 (Durham and London)

Greenway, D.A., 1971 *Jon Le Neve, Fasti Ecclesiae Anglicanae 1066–1300, 2: Monastic Cathedrals (Northern and Southern Provinces)* (London)

Greenwell, W., 1872 *Feodarium Prioratus Dunelmensis*, Surtees Society 58 (Durham, London and Edinburgh)

Harper-Bill, C. (ed.), 1990 *English Episcopal Acta VI: Norwich 1070–1214* (Oxford)

Hodgson, J., 1835 *Magnus Rotulus Pipae, or the Great Roll of the Exchequer, for Northumberland, from 1130 to 1272*, A History of Northumberland in Three Parts 3 (Newcastle upon Tyne)

Hope Dodds, M., 1915 'The Bishop's Boroughs', *Archaeologia Aeliana* 3 ser. 12, 81–185

Hunter, J. (ed.), 1833 *Magnum Rotulum Scaccarii, vel Magnum Rotulum Pipae, de Anno Tricesimo Primo Regni Henrici Primi …* (London)

Hutchinson, W., 1785 *The History and Antiquities of the County Palatine of Durham* (Newcastle upon Tyne)

Meadows, P. & Waterson, E., 1993 *Lost Houses of County Durham* (York)

Meikle, M.M. & Newman, C.M., 2007 *Sunderland and its Origins: Monks to Mariners* (Chichester)

Moule, T., 1837 *The English Counties Delineated* 2 (London)

Offler, H.S., 1962 'The Early Archdeacons in the Diocese of Durham', *Trans. Architectural and Archaeological Soc. of Durham and Northumberland* 11(3–4), 189–207; repr. Offler 1996, no. 3

Offler, H.S., 1968 *Durham Episcopal Charters 1071–1152*, Surtees Society 179 (Gateshead)

Offler, H.S., 1971 'Ranulph Flambard as Bishop of Durham 1099–1128', *Durham University J. 14*–25; repr. Offler 1996, no. 7

Offler, H.S., 1988 'Murder on Framwellgate Bridge', *Archaeologia Aeliana* 5 ser. 16, 193–211; repr. Offler 1996, no. 14

Offler, H.S. (ed. A.J. Piper & A.I. Doyle), 1996 *North of the Tees: Studies in Medieval British History* (Aldershot)

Offler, H.S., 2002 'Addenda and Corrigenda to Durham Episcopal Charters' in Snape 2002, pp 149–70

Pevsner, N. & Williamson, E., 1983, *The Buildings of England: County Durham* (2 edn, London)

Piper, A.J. (with L. Rollason), 2007 'Durham Monks: Biographical Register of Durham Cathedral Priory (1083–1539)' in D. & L. Rollason (ed.), *The Durham Liber Vitae: London, British Library, MS Cotton Domitian A. VII*, vol. 3 (London), pp 129–436

Randall, T., [undated] *Collectanea ad Statum Civilem et Ecclesiasticum Comitatus Dunelmensis. Spectantia, ex variis Codicibus tam Manuscriptis quam Impressis sine Ordine Congesta* [DCD, Randall MS, 3]

Sharpe, R., 2006 *Norman Rule in Cumbria 1092–1136*, Cumberland and Westmorland Antiquarian and Archaeological Soc. Tract Series 21 (Kendal)

Snape, M.G., (ed.) 2002 *English Episcopal Acta 24: Durham, 1153–1195* (Oxford)

Southall, H.R. & Burton, N., 2004 *GIS of the Ancient Parishes of England and Wales, 1500–1850* [computer file]. Colchester, Essex: UK Data Archive [distributor], March 2004. SN: 4828, http://www.dx.doi.org/10.5255/UKDA-SN-4928-1

Surtees, R., 1816 *History and Antiquities of the County Palatine of Durham* 1 (Durham)

Surtees, R., 1820 *History and Antiquities of the County Palatine of Durham* 2 (Durham)

Talbot, C.H., 1959 *Life of Christina of Markyate* (Oxford)

Watts, V., 2007 *The Place-Names of County Durham, The Survey of English Place-Names, 83: Part One Stockton Ward* (Nottingham)

Watts, V. (with J. Insley) 2002 *A Dictionary of County Durham Place-Names* (Nottingham)

Varieties of language-contact in Anglo-Saxon manuscripts

John Frankis

Nearly all, probably all, surviving manuscripts compiled and circulated in Anglo-Saxon England use either or both of two languages, Latin and Old English, and the interaction of these languages underlies a substantial part of Old English literature and, indeed, Anglo-Saxon civilisation; but when, rarely, some other language appears, it obviously raises questions about comprehensibility and motivation; sometimes there may be some evidence in the manuscript to explain the difference in language use, sometimes one can make reasonable conjectures, but sometimes the motivation of the scribes involved may remain unclear. I do not attempt here to consider manuscript entries in Greek (though they are an important part of the history of scholarship in England), or Irish or Welsh (which are of obvious interest to anyone concerned with Anglo-Saxon civilisation but are not within my competence); my concern is with a number of European vernaculars that occasionally appear in surviving manuscripts compiled in Anglo-Saxon England before the end of the twelfth century.[1]

For the purpose of this study, the first example of a bilingual manuscript is London, British Library, Cotton MS Caligula A. vii, s. x², the manuscript of the Old Saxon poem *Heliand*, to which was added in s. xi¹ a charm in Old English verse:[2] both Ker and Gneuss agree that the Old Saxon text was copied in England. Unlike other examples discussed below, in this case the non-English text is the most substantial work in the manuscript and the English text is a minor addition to it. Ker points out that the additional leaves containing the charm (fols 176–8) resemble the manuscript to which they are attached and 'are not likely to be ... an independent fragment bound up here by Cotton'.[3] Why the extra leaves were added here can best be explained by the assumption that they were needed in order to make a new entry as an addition to *Heliand*, perhaps the missing end of the poem. Since these leaves contain nothing but the charm, the implication must be that the scribe who copied

the English text felt strongly that the charm (intended to improve land, sometimes given a modern title *Æcerbot*, deduced from the phrase *æceras betan* in the opening line) needed to be associated with the preceding Old Saxon text, though the nature of the two texts does not suggest any obvious connection.[4] This problem has recently been discussed by Ciaran Arthur, who suggests a range of possible connections between *Heliand* and the charm to motivate their juxtaposition;[5] whether or not one accepts Arthur's arguments in detail (and I have no alternative to offer), the most probable implication of the linguistic juxtaposition is that an early to mid-eleventh-century Anglo-Saxon (probably a monk, to have had access to the manuscript and to have been able to add to it in this way) was able to read, understand and value the Old Saxon text that had been written down (in England, as Ker and Gneuss agree) some half century earlier and he evidently thought that some supplement to it was appropriate. Understanding both texts presumably involved no great linguistic problems: written Old English and Old Saxon in the tenth century look as if there must have been a high degree of mutual literary intelligibility, even allowing for the specialised nature of the forms of language that appear in verse, though the extant portions of the Old Saxon and Old English versions of *Genesis*, a long-familiar topic among scholars of early Germanic languages, throw little light on the process of translating the former into the latter.[6] Whatever connection the Anglo-Saxon scribe perceived between *Heliand* and *Æcerbot* remains unclear to us today; it may well have been like that expounded by Arthur, but linguistic difference was presumably not part of the issue.

My second example conforms to the pattern of a brief 'foreign-language' entry among texts in an otherwise predominant language, but the latter, in this case, is not Old English but Latin; the manuscript is again well known and much discussed, Cambridge, University Library, MS

Gg.5.35, s.xi med, from St Augustine's, Canterbury,[7] which contains a wide selection of Latin texts of religious and literary interest, probably arranged with a pedagogical function, followed by the famous *Cambridge Songs*, which are also in Latin but include two macaronic poems in Latin and German. The manuscript is generally agreed to have been copied in England from a German exemplar, probably at St Augustine's Abbey, Canterbury, where its presence is attested from the twelfth century onwards.[8] Many of the Latin poems of the *Carmina Cantabrigiensia* refer to German places and people (emperors, archbishops and abbots) and the two vernacular texts show mixed High and Low German forms of language. As was normal in England,[9] the Latin texts are copied in a caroline script, but it is striking that here the scribe occasionally uses insular script for the German text. In the Latin text he regularly uses the short caroline <r> but has the insular long <r> (with a descender) in some German words (*riche*, 19.1.4). In the German text, while he often uses caroline <g> in an initial position before a back-vowel (*guodo*, 19.2.2), in a medial position he may sometimes use insular <g> (*kuniglich*, 19.2.3), apparently anticipating a distinction (probably between plosive and fricative consonants) that is regularly observed in numerous Old English manuscripts of later date.[10] Assuming that the German exemplar used caroline script throughout, as was normal on the Continent, the implication of this occasional use of insular letter-forms is that the scribe evidently recognised the German language as being akin to English to the extent of being partly subject to Anglo-Saxon scribal conventions for distinguishing between Latin and vernacular. This suggests that the scribe (if he were English) had some understanding of the German lines he copied and recognised the similarity of cognate English forms, but it is highly unlikely that he would have used (or even known) insular script if he had been a German scribe working in eleventh-century Canterbury.

The next example falls into the category of short non-English texts inserted into a manuscript predominantly in English: this is in Oxford, Bodleian Library, MS Bodley 340, s. xi in-med, from Rochester Cathedral Priory, a manuscript of homilies by Ælfric.[11] At the end of the volume is a blank page (fol. 169v) on which in s. xi² several hands (again, presumably monks) wrote various phrases and verses in Latin under the heading *probatio penne* ('pen trial'); these were discussed by Sisam and among them is a line of what Sisam identified as a Netherlandic text, preceded by a Latin version of the same text.[12] I cannot find anything on this page that shows any connection with the English homilies immediately preceding it and any motivation for this use of a blank page remains unexplained, other than for trying out a pen. Since the Netherlandic language is not well attested at this date, this brief text has attracted a good deal of attention, particularly among Netherlandic scholars. Since Sisam's discovery a few more words have

been tentatively distinguished and the full text of the Latin and Netherlandic is now:

> Abent omnes uolucres nidos inceptos nisi ego et tu / quid expectamus nu[nc].
> Hebban olla uogala nesta hagunnan hinase hi[c] / anda thu [uuat unbidan we nu].
> ('All the birds have begun their nests, but not you and I. What are we waiting for now?')

Each of these two lines is a word-for-word translation of the other. The last three words of the Latin text are written above the preceding text; the last four words of the Netherlandic text are unclear (Sisam did not print them) and are partly conjectured on the basis of the Latin text; the verbal stem *–bid-* is apparently written *–b(i)ad-* with superscript *–i-*, but this has not as far as I know been explained: it may merely be a correction. The version printed by some scholars, *uuat unbidat ghe nu* (what are you waiting for now?), is probably closer to what can be distinguished of this unclear text but does not match the Latin text (having the second person plural instead of the first person plural of pronoun and verb). The confused layout of this page suggests at first glance that the Netherlandic text may be a translation of the Latin phrase that precedes it. However, most commentators see the Netherlandic text as part of a secular poem or song, in which case the Latin may have been written above it as a gloss, though the scribe's motive in supplying a Latin translation is unclear since there could hardly have been much expectation of readers for the entries on this page. It is, however, obviously possible that the scribe received the Latin text and, for whatever reason, made a translation into his own language.

From among the many commentaries on this text, one may be taken as a starting-point for further consideration: discussing the language, Maaike Hogenhout-Mulder[13] compares the vowels in unstressed syllables with those in later Middle Dutch texts, pointing out that later texts show the loss of distinctive vowel sounds in unstressed syllables and their replacement by a generalised vowel, presumably a schwa, spelled <e> (a well-known development seen also in the transition from Old English to Middle English and in fact common to all West Germanic languages).[13] Surprisingly, however, the early text here does not show any vocalic variety in unstressed syllables, in every case the unstressed vowel is spelled with <a>, which can hardly be a retention of an earlier pattern: rather it suggests a levelling of unstressed vowels into a sound that the scribe thought was best represented by the spelling <a> (the exact nature of this sound, whether a schwa or something else, being uncertain). This would suggest that the scribe was not familiar with any accepted spelling system, which would perhaps not be surprising at this date in this language. The unstressed prefix of *hagunnan* (past participle) is problematic: it looks like

Old English *agunnen,* past participle of *aginnan,* a late Old English reduction of *onginnan,* to which the corresponding Middle Dutch form is *ontginnen,* past participle *ontgunnen,* which could hardly be the form intended by the scribe (he probably intended to write **bagunnan,* for *begunnen*). The spelling of *hinase,* 'except', is odd because it shows a loss of the final consonant of *hit/het* when compared with the later form quoted by Hogenhout-Mulders from a thirteenth-century text, *het ne si.*[14] The final syllable, *-se,* is also unexpected for the present subjunctive (third person singular) of 'be', *si(e)* (the same in Old English and Old/Middle Dutch). Here again the scribe seems to be extemporising rather than using any kind of established spelling system, perhaps even being confused by the corresponding Latin *nisi* that he had written in the line above. This, like the spelling of unstressed vowels, could possibly identify the scribe as an Englishman struggling with a foreign language, but perhaps rather as a Fleming who did not know an accepted system for writing down his own language. In any case *hinase / het ne si* (except or unless) is apparently an idiom peculiar to Dutch (also Middle Dutch *het en si,* modern Dutch *tenzij*); I know of no equivalent usage in English.

Because of its apparent lack of any connection with Ælfric's homilies in the preceding pages, this odd line of a continental language in an Anglo-Saxon manuscript does not illustrate the kinds of language-contact discussed above: the entries on this page look unmotivated and unrelated to the preceding texts; but the Netherlandic text may be taken to illustrate the problems that arise when someone trained to literacy in a language other than his native tongue (in this case perhaps a Fleming trained to write Latin but not Flemish), attempts to devise a system, presumably based on Latin but possibly taking Old English conventions into account, for writing his own language. Obviously, writing on this page, he must have had some awareness of written Old English, and the contents of this manuscript may even have made the writer aware of possibilities for his own language that he had not previously envisaged, but his choice of this text is still surprising.

Recent considerations of the Netherlandic text have moved away from these rather basic considerations of language and spelling: eighty years ago Sisam glanced briefly[15] at a range of English contacts with the Low Countries which he thought might lie behind the presence of this text in an Anglo-Saxon manuscript,[15] and this subject has been taken up by a number of scholars in order to amplify the continental background to this text in countries around the lower Rhine, and to relate the text to the origins of European lyric poetry, making comparisons with early lyrics from many parts of Europe.[16] A closer comparison, linguistically and geographically, for the final phrase of the lines in the Bodleian manuscript, *quid expectamus nunc / uuat unbidan we nu* (what are we waiting for now?), would be with the refrain allegedly sung in the early eleventh century by the Dancers of Kölbigk, *Quid stamus, cur non imus* (what are we standing still for, why don't we get going?); the vernacular original of this Latin version has not been preserved.[17] In both songs a stanza refers obliquely to human courtship and leads to a refrain invoking participation ('why don't we do it too?'). The events of the legend of the Cursed Dancers were said to have occurred in 1021, and although, as Schröder points out, the legend had its origins in the region of Saxony in eastern Germany, it spread rapidly westwards and references to it occur in western Germany, the Low Countries, France and England from 1100 onwards; the legend was thus probably becoming well known in Flanders and England about the time when the pen-trials were being entered into the Bodleian manuscript. All the accounts of the Cursed Dancers are preserved in manuscripts later than 1100, though some draw on eleventh-century sources; but one text that includes the story was certainly composed before 1100 and that is a Latin work written in England about 1080, the *Life of Saint Edith* by the Flemish monk Goscelin of Saint-Bertin, which tells how one of the dancers was finally cured at the shrine of St Edith at Wilton.[18] This version is the first to give details of the song allegedly sung by the dancers and later versions that repeat these details apparently derive from it: what form Goscelin's source had is unknown, but when one compares other versions of the story in Schröder's collection it seems likely that the words of the song may possibly be Goscelin's own addition. Goscelin is famous of course for his many Latin lives of English saints, and the composition of these took him to a large number of English monasteries in the second half of the eleventh century: unfortunately there is no record of his ever having visited Rochester, where the annotations in MS Bodley 340 were presumably made, but he spent his later life not far away at St Augustine's Abbey in Canterbury.[19] Nothing is known with certainty about the origins of the legend of the Cursed Dancers and about the song the dancers were alleged to have sung (apart from the Latin verses quoted, and perhaps elaborated, by Goscelin): it could well be that the Flemish lines in the Bodleian manuscript are as close as we shall ever get to whatever popular dance-song may underlie the legend.

The manuscripts discussed so far are all reasonably well known and have in fact been referred to in discussions of English contacts with the Continent,[20] but their linguistic implications considered in the light of their manuscript context (as attempted here) have been less explored. However, West Germanic languages are not the only contemporary vernaculars that appear in Anglo-Saxon manuscripts. Because of the prolonged Scandinavian incursions into England in the ninth and tenth centuries, and again in the late tenth and early eleventh centuries, one might expect some record, however fragmentary, of the Old Norse language, but the major factor inhibiting this is the fact that no system for writing down the Old Norse language with the Latin alphabet

had been developed before the end of the Anglo-Saxon period. It is thus inevitable that the one Old Norse text preserved in an Anglo-Saxon manuscript should use runic letters, the only form of writing developed at that time for a Scandinavian language. This is the runic charm preserved in London, British Library MS Cotton Caligula A. xv,[21] a post-Conquest manuscript from Canterbury Cathedral Priory with computistic and other typically monastic texts, which I have already discussed elsewhere in some detail.[22] As in the case of the Old English charm added to the *Heliand*, it is difficult to see any connection between the charm and the context into which it has been inserted: Arthur's suggested solution implies, quite plausibly, that there was no great linguistic problem involved in comparing an Old Saxon and an Old English text, but my own comments on the Old Norse charm suggest that the Anglo-Saxon scribe probably had only a partial understanding of the Old Norse text that he copied into a monastic manuscript and his motivation remains uncertain. But both manuscripts, Cotton Caligula A. vii and Cotton Caligula A. xv, testify to some connection between charms and Christian religious texts, without much illuminating the kind of connection that the scribes may have envisaged.

My final example of a foreign-language text in an Old English manuscript is Cambridge, University Library MS Ii.1.33, a collection of homiles by Ælfric;[23] this too I have already discussed elsewhere.[24] In this case we have some late twelfth-century Anglo-Norman and English annotations in an earlier homiletic manuscript (the inscriptions are noted by Ker), and we may assume that the writers of the annotations each understood both languages: in fact, in one case the Anglo-Norman note seems to evoke a response in English from another annotater, almost as if two late twelfth-century readers of Ælfric's homilies were engaged in a bilingual conversation (the situation was perhaps not quite as clear-cut as this, but there was obviously some interlingual contact). At any rate, with this last example from just before 1200 we are moving away from the world of Anglo-Saxon manuscripts towards the medieval world of bilingual (English and French) manuscripts (like British Library MS Cotton Caligula A. ix and Oxford, Jesus College MS 29, both s.xiii²) and trilingual (English, French and Latin) manuscripts (like Oxford, Bodleian MS Digby 68, s.xiii², and London, British Library MS Harley 2253, s.xiv¹) in all of which issues of language contact take a different and apparently unproblematic form: the kind of issues discussed here with reference to Anglo-Saxon manuscripts no longer arise in the thirteenth and fourteenth centuries.

Notes

1 This brief survey rests on two fundamental reference works: Ker 1957 and Gneuss 2001. Dates of manuscripts are all quoted from Ker. For manuscript entries in Greek, Irish and Welsh see the Index in Gneuss 2001.

2 Ker 1957, no. 137; Gneuss 2001, no. 308.

3 Ker 1957, no. 137.

4 The charm is printed in Dobbie 1942, 116–18; on cxxx Dobbie repeats the older view (rejected by Ker) that the two texts, *Heliand* and the charm, were first bound together in the seventeenth century; also edited in Storms 1948, 172–86; for the Old Saxon text see Behaghel 1948.

5 Arthur 2014.

6 For an account of the Old Saxon and Old English *Genesis* see Bremmer 2001, 382–4; texts in Behaghel 1948, 211–48. The wider connections between Old Saxon and Old English poetry have been much discussed but are not relevant here.

7 Ker 1957, no. 16; Gneuss 2001, no. 12.

8 Edited by Bulst 1950; edited with translation by Ziolkowski 1998; my references are to Bulst.

9 See, for example, Ker 1957, xxv–xxvi.

10 Ker 1957, xxvii.

11 Ker 1957, no. 309 and Gneuss 2001, no. 569. For further information on this manuscript see Clemoes 1997, 7–10, and Godden 1979, xxv–xxviii. The page in MS Bodley 340 with the Latin and Netherlandic notes follows after the end of Godden 1979, 176–9, no. 18, 'Eodem die Sanctorum Alexandri, Euentii et Theodoli'.

12 Sisam 1933; 1953, 196–7, who also prints some of the Latin notes.

13 Hogenhout-Mulder 1983, 12, who prints *uuat unbidat ghe*.

14 Ibid., 82; the phrase appears in its context on 186, line 33.

15 Sisam 1953, 197.

16 van Houts 2006 cites several studies on this theme, most authoritatively Dronke 2005.

17 The materials on this subject were published by Schröder (1896, 127–8 (song text in Latin)). Later studies include most recently Kleinschmidt 2005, 42–7 and Rohmann 2013. The story is now best known in England in a fourteenth-century version: *Robert of Brunne's Handlyng Synne* (Furnivall 1901, 283–90, lines 8987–9252, which quotes the same Latin verses, lines 9045–7).

18 Wilmart 1938, 285–92.

19 On Goscelin and St Edith see most recently, Otter 2004; Hollis 2005, 82–85. The version of the story written in the hand of Orderic Vitalis to which Schröder 1896, 123, gives priority (followed by Dronke 2005, n. 17) is an almost verbatim copy of Goscelin's *Translatio Edithe*, cap. 17.

20 See van Houts 2006, 3–4.

21 Ker 1957, no. 139; Gneuss 2001, no. 411: neither mentions the runic inscription.

22 Frankis 2000.

23 Ker 1957, no. 18, post-1100 so not in Gneuss 2001.

24 Frankis 2007.

References

Arthur, C., 2014 'Ploughing through Cotton Caligula A. vii: reading the sacred words of the *Heliand* and the *Æcerbot*', *Review of English Studies* new ser. 65, 1–17

Behaghel, O. (ed.), 1948 *Heliand und Genesis* (Halle)

Bremmer, R., 2001 'Continental Germanic Influences', in Pulsiano & Treharne 2001, pp 375–87

Bulst, W. (ed.), 1950 *Carmina Cantabrigiensia* (Heidelberg)

Clemoes, P. (ed.), 1997 *Ælfric's Catholic Homilies, the First Series, Text*, EETS supp. ser. 17 (Oxford)

Dobbie, E. van K. (ed.), 1942 *Anglo-Saxon Minor Poems*, ASPR 6 (New York)

Dronke, P., 2005 'Latin and Vernacular Love-lyrics: Rochester and St Augustine's, Canterbury', *Revue Bénédictine* 115, 400–10

Frankis, J., 2000 'Sidelights on post-Conquest Canterbury: Towards a Context for an Old Norse Runic Charm (*DR* 419)', *Nottingham Medieval Studies* 44, 1–27

Frankis, J., 2007 'Languages and Cultures in Contact: Vernacular Lives of St Giles and Anglo-Norman Annotations in an Anglo-Saxon Manuscript', *Leeds Studies in English* new ser. 38, 101–33

Furnivall, F.J. (ed.), 1901–3 *Robert of Brunne's "Handlyng Synne" A.D 1303*, EETS orig. ser. 119 (1901) and 123 (1903) (London): reissued as one volume (Oxford, 1991)

Gneuss, H., 2001 *Handlist of Anglo-Saxon Manuscripts: a List of Manuscripts and, Manuscript Fragments Written or Owned in England up to 1100*, Medieval and Renaissance Texts and Studies 241 (Tempe, AZ); republ. as Gneuss, H. & Lapidge, M. (ed.), 2014 *Anglo-Saxon Manuscripts: a Bibliographical Handlist of Manuscripts and Manuscript Fragments Written or Owned in England up to 1100* (Toronto, Buffalo & London)

Godden, M. (ed.), 1979 *Ælfric's Catholic Homilies, the Second Series, Text*, EETS supp. ser. 5 (Oxford)

Hogenhout-Mulder, M., 1983 *Cursus Middelnederlands* (Groningen)

Hollis, S., 2005 *Writing the Wilton Women* (Turnhout)

Ker, N.R., 1957 *Catalogue of Manuscripts containing Anglo-Saxon* (Oxford)

Kleinschmidt, H., 2005 *Perception and Action in Medieval Europe* (Woodbridge)

Otter, M., 2004 *Goscelin of St Bertin Liber Confortatorius: the Book of Encouragement and Consolation* (Cambridge)

Pulsiano, P. & Treharne, E. (ed.), 2001 *A Companion to Anglo-Saxon Literature* (Oxford)

Rohmann, G., 2013 *Tanzwut. Kosmos, Kirche und Mensch in der Bedeutungsgeschichte eines mittelalterlichen Krankheitskonzepts* (Göttingen)

Schröder, E., 1896 'Die Tänzer von Kölbigk', *Zeitschrift für Kirchengeschichte* 17, 94–164 (now available as a Kessinger Reprint, no date)

Storms, G., 1948 *Anglo-Saxon Magic* (The Hague)

Sisam, K., 1933 'MSS Bodley 340 and 342: Ælfric's Catholic Homilies', *Review of English Studies* 9, 1–12, repr. (as part of a series of articles) in K. Sisam, *Studies in the History of Old English Literature* (Oxford, 1953), pp 148–98

van Houts, E., 2006 'Neighbours of Nascent Dutch Writing: the English, Normans and Flemish (*c.*1000–1200)', *Queeste. Tijdschrift over middeleeuwse letterkunde in de Nederlanden* 13, 3–11

Wilmart, A., 1938 'La légende de Ste Édithe en prose et vers par le moine Goscelin', *Analecta Bollandiana* 56, 5–101, 265–307

Ziolkowski, J.M., 1998 *Cambridge Songs*, Medieval and Renaissance Texts and Studies 192 (Tempe, AZ)

Flodibor rex Francorum

Hermann Moisl

Introduction

From the later sixth century onwards there was a complex web of secular and ecclesiastical interaction linking Merovingian Francia, Anglo-Saxon England and Ireland.[1] One episode in this interaction was the exile of the Merovingian prince Dagobert to Ireland not long after the death of Sigibert III in 656 (or possibly 651),[2] and his return and reinstatement as Dagobert II, king of Austrasia in 675 or 676.[3] This episode is reported in the *Liber Historiae Francorum*, completed in 727 by an unknown author working in a Neustrian monastery:

> Pippin having died, Sigibert king of Austrasia established Grimoald, Pippin's son, as mayor of the palace. As time passed and King Sigibert died, Grimoald had Sigibert's little son Dagobert tonsured and instructed Dido, the bishop of the city of Poitiers, to take him on pilgrimage to Ireland, making his own son king.[4]

While not doubting the fact of Dagobert's exile to Ireland, historians have found the labyrinthine Merovingian political context in which this episode is embedded problematic. Various reconstructions of that context have been proposed,[5] one of which, that of Picard,[6] includes an entry taken from the Irish *Annals of Ulster* (hereafter 'AU') for the year 659, the date of which needs to be corrected to 658:[7] 'The killing of Orc Doth mac Sechnusaigh and of Concu mac Laidhgnein and Flodubuir king of the Franks'.[8] No Merovingian king Flodubuir is known,[9] and the name does not look very Merovingian in any case.[10] Assuming that 'Flodubuir' is not a figment of the annalist's imagination but rather a corruption of the name of an historical figure, the question is: who of the possible candidates among known Merovingian kings was Flodubuir? Various views have been expressed. In their edition of the *Annals of Ulster*, Hennessy

and MacCarthy suggested that he was Chlothar III,[11] and Moody et al. followed them in this.[12] Picard proposed an identification of Flodubuir with one of two Merovingian kings, the Austrasian Childebert II or the Neustrian Clovis II, and thought Childebert the more likely of the two.

The aim of the present discussion is to attempt to settle the matter. On the basis of evidence different from that used by existing commentators, the argument is that Flodubuir was in fact Clovis II. The discussion is in two main parts. The first part reviews Picard's argument and the second presents my own attempt at identification.

Flodubuir: Picard's identification

Picard prefaced his attempt at identification of Flodubuir with the observation that there is a syntactic ambiguity in the annal entry. At first glance the passage appears to mean 'The slaying of Orc Doth mac Sechnusaigh and of Concu mac Laidhgnein and of Flodubuir king of the Franks': 'Orcdoith' and 'Concenn' are Irish genitive proper noun forms,[13] and 'Flodubuir' looks like the genitive form of 'Flodubur' comparable to, for example, the genitive form 'Conchobuir' of 'Conchobur', the king of the Ulstermen in the vernacular Irish Ulster Cycle texts. On this interpretation, however, one would expect *Flodubuir regis Francorum*, with *rex* in the genitive rather than in the nominative singular. The alternative is to take *Flodubuir rex Francorum* as syntactically independent of the preceding part of the entry, with 'Flodubuir' a nominative form agreeing with 'rex', and to read the entry as meaning that Flodubuir became king of the Franks in that year.[14] To identify Flodubur/Flodubuir we are, therefore, looking for a Frankish king who was either killed or acceded to the Frankish throne in or about 658.

Picard assumed that 'Flodubuir' is a corruption of a Merovingian name and attempted to identify possible candidates by looking at Frankish history in the mid-

seventh century. The chronology of Merovingian kings at this time has been controversial, but according to Wood the sequence was as follows:[15] Sigibert III, king of Austrasia, had appointed Grimoald as his mayor of the palace; on Sigibert's death in 656, Grimoald placed his own son on the throne under the Merovingian name Childebert II, but this went down badly with the Neustrian nobility – Grimoald was seized, taken before Clovis II king of Neustria for trial and executed on Clovis' orders; Childebert managed to hold onto power in Austrasia until 662, however; in 657 Clovis II died and was succeeded by his son Chlothar III in late 657 or early 658.[16] There are, therefore, four candidates for identification with 'Flodubur'/'Flodubuir': Sigibert III; Childebert II; Clovis II; and Chlothar III, all of whom either died or acceded to kingship at about the time of the AU entry.

Picard points out that there are only two other references to Frankish kings in the Irish annals, the deaths of Charlemagne and Louis the Pious, and that none of our four candidates had anything approaching the pan-European stature of these two kings. Inclusion of Flodubur/Flodubuir must therefore be an artefact of some particular connection between Ireland and Francia. As already noted, Picard argues that this connection had to do with the despatch of the Merovingian prince Dagobert to Ireland. Confirmation comes from Stephen's early eighth-century *Life of Wilfrid*,[17] which says that Dagobert had been in Irish exile in his youth, and that, after some years, had returned from Ireland 'well supplied with weapons',[18] with the help of everyone's favourite fixer, Wilfrid,[19] to be installed on the Austrasian throne; this happened in 675 or 676. Given Stephen's corroboration, therefore, we can take it as certain that a major Frankish cleric and a Merovingian prince arrived in Ireland around 651/6, and that the prince remained there for two decades or so. If one assumes that (i) Dagobert, who was only a child in 651/6, had a Frankish retinue with him, (ii) the Franks were staying in some important place in Ireland, like a royal court or a monastery, and (iii) the Franks would have kept in touch with events back home, then we have a good explanation for the insertion of the Flodubur/Flodubuir entry: the death or accession of a Merovingian king would have been noteworthy for the Franks, and its importance would have been conveyed to their Irish hosts and duly noted in the Irish annals for that year.

This gives a plausible explanation for the inclusion of Flodubur/Flodubuir in AU, but gets one no further with identification. Picard goes on to argue that the involvement of the monastic *familia* of St Fursey in the Dagobert affair makes it possible to narrow identification of Flodubur/Flodubuir to two of the four possible contenders.[20] The argument is as follows. The Irish monk Fursey and his brothers Foillan and Ultan founded a group of monasteries in Francia during the mid-seventh century under the patronage of Merovingian kings and the Frankish

aristocracy. They also retained contact with their home monasteries of Louth and Slane. Ultan, in particular, was involved in arranging the exile of Dagobert, harbouring him in a Fursean monastery in Ireland – most likely Slane – and then arranging for his return. The Fursean *familia* was, in short, deeply involved in Frankish politics, and had its own monastic interests to protect. As such, it would have had reason to note the accession of Childebert II or the death of Clovis II, its patrons in Austrasia and Neustria respectively, but no particular reason to note the death of Sigibert III or the accession of Chlothar III. 'Flodubur'/'Flodubuir' is, consequently, to be identified with either Childebert or Clovis, with Childebert the more likely, as already noted.[21]

Flodubuir: proposed identification

In attempting to relate AU's 'Flodubuir' to the candidate Frankish name forms, two possible types of source for the entry have to be reckoned with. On the one hand is the possibility that a documentary source was brought to Ireland at some stage and then used by the annalist; Bishop Dido is a plausible provider, but others are, of course, possible because the entry is not necessarily contemporary – monks returning to Ireland from one of the Fursean monasteries in Francia could have brought a documentary source with them, for example. On the other hand, the source might have been reported to the Irish annalist orally. Dido is the obvious medium, but again this is not necessary; it could have come from an English intermediary rather than directly from a Frankish speaker.[22]

If one postulates a documentary source for the entry, then the first step must be to determine what the putative basis for 'Flodubuir' might have looked like. This can be established by a survey of the relevant name-forms in Frankish documents covering the Merovingian period. Three documents are here selected for this purpose: Gregory of Tours' late sixth-century *Historia Francorum*;[23] the later seventh-century *Chronicle of Fredegar*;[24] and the *Liber Historiae Francorum*,[25] completed in 727 as already noted. Together these give a good random sample of Merovingian name spellings from the late sixth to the early eighth century. There are three caveats, however. Firstly, there is no guarantee that the three texts chosen exhaust all spelling possibilities. Secondly, seventh-century Frankish orthography was not standardised. At this early stage in the development of post-classical scriptoria in Europe individual writing centres developed their own house styles, and these were often at variance with classical Latin orthography.[26] There is, in other words, always the possibility that the spelling in the supposed documentary source underlying 'Flodubuir' was different from that in the above sample texts. Finally, most of the manuscript copies of these sample texts date from Carolingian (and later) times, when there was a conscious policy of correcting what was perceived

to be the faulty Latinity and orthography of Merovingian-period texts. This policy is, moreover, known to have been unevenly applied across texts and even within individual documents.[27] One cannot, therefore, be certain whether a given name-form is contemporary with the date of the text or a Carolingian correction.

The following forms are attested in the sample texts for our four candidate Merovingians (Table 26.1).

The only orthographic forms even remotely similar to 'Flodubuir' are the forms 'Flodoveus' and 'Flodovechus' for Clovis, which, given the foregoing range of candidates, indicates that Flodubuir was Clovis II. It has, however, to be noted that all the names, without exception, end in the Latin suffix '-us'. Any documentary source for the AU entry is therefore very likely to have had that suffix, but 'Flodubuir' does not. One might argue that the annalist was sufficiently

Table 26.1 Spellings of the names of the candidate kings in the sample Frankish documents

Clovis

Historia Francorum	Chlodovechus, Flodovechus
Chronicle of Fredegar	Chlodovechus, Chlodoveus, Chlodovius, Clodoveus, Clodovius, Ghlodoveus, Glodoveus, Glodovius, Flodoveus, Hludowius, Hludowicus, Ludovicus
Liber Historiae Francorum	Chlodovechus, Chlodoveus, Chlodovius, Clodoveus, Clodovius, Ghlodoveus, Glodoveus, Glodovius, Flodoveus, Hludowius, Hludowicus, Ludovicus

Chlothar

Historia Francorum	Chlothachiarius, Chlotcharius, Chlotharius
Chronicle of Fredegar	Clotacharius, Chlotharius, Chlotarius, Clotharius, Lotharius
Liber Historiae Francorum	Clotacharius, Chlotharius, Chlotarius, Clotharius, Lotharius

Childebert

Historia Francorum	Childeberthus, Childiberthus, Childebertus
Chronicle of Fredegar	Childebertus
Liber Historiae Francorum	Childebertus

Sigibert

Historia Francorum	Sigiberthus, Sigyberthus, Sygiberthus, Syghiberthus, Syghibertus, Sigibertus
Chronicle of Fredegar	Sigobertus, Sygibertus, Sigibertus
Liber Historiae Francorum	Sigibertus

Latinate to have understood that the '-us' suffix had to be removed in order to arrive at the name in common usage; a less speculative alternative is to consider the possibility that the Irish annalist's source was oral, and this is addressed in what follows.

Any attempt to relate 'Flodubuir' to orally-transmitted forms of possibly-corresponding Frankish names has to address the following two issues: first, how did native Frankish Romance or possibly Germanic speakers of the mid seventh century pronounce the Merovingian names in question? And secondly, how would a native Irish speaker hearing the Germanic name pronounced have perceived it, and how would he have rendered his perception of it orthographically? Definitive resolution of these issues requires a conjunction of competences in late Latin, early medieval French, early medieval continental Germanic, Old Irish, and possibly Old English phonetics. This conjunction must be exceedingly rare in any one individual, and I can claim only a subset, but using that subset a few relevant observations can be made.

[F]lodubuir

Historically, three of the four candidate names began with a voiceless velar fricative [χ], as in the Scottish pronunciation of 'loch' or the German pronunciation of the composer's name 'Bach': the first element of Childerich's name comes from the Indo-European (hereafter 'IE') root [*kelǝdh- / *klād-'], 'Kampf, Krieg',[28] which became [χild] in Germanic,[29] and the first element in the names Chlodowech (modern 'Clovis') and Chlothar corresponds to IE [*kʰ^lu-], 'hören, Ruhm',[30] with *-to-* suffix, which became [χloð] in Germanic.[31] Most of the name forms in Table 26.1 spell this sound 'ch', but there are several examples of spelling as 'f'– 'Flodovechus' as against 'Chlodovechus', for example. These are not random spelling errors but are rather symptomatic of general Frankish scribal practice from the late sixth century, where alternation between initial 'F' and 'Ch'/'C' in the spelling of royal names was, if not frequent, then at least attested often enough to show that it was not accidental. Table 26.2 gives a selection of examples.

My layman's view is that this alternation in scribal practice probably reflects phonetic usage, but that is for a Romance specialist to decide.

In Old Irish [f], [χ], and [s] were phonemic in initial position and were kept distinct in the orthography.[32] If the above scribal 'ch'/'f' alternation does indeed reflect early medieval Romance phonetics, therefore, an Irish scribe hearing one of the names 'Flodowech', 'Flothar', or 'Fildebert' would have written 'f', making 'Flodubuir' compatible in this respect with contemporary pronunciations of 'Chlodowech', 'Chlothar', and 'Childebert'. Sigibert is, however, ruled out on this criterion.

Table 26.2 'F' spellings of initial [χ] in Frankish documents

Gregory of Tours, *Historia Francorum*[1]	Alternation of 'Chlodomer' and 'Flodumir'
A letter of Desiderius, bishop of Cahors *c.* 630–655[2]	'Flothari principis' for 'Chlothari principis'
Vita Fursei,[3] later seventh century	Variants 'Chlodoveus' and 'Flodoveus' depending on manuscript (ninth–eleventh century)
Vita Desiderii,[4] eighth–ninth century	'Flotarius' and 'Flodoveus for 'Chlotarius' and 'Chlodoveus' throughout

Notes: [1]Krusch & Levison 1951, 94, 95; [2]Arndt 1892, i, 9; [3]Krusch 1902, 423–51; [4]ibid., 546–602, at 563ff and 592

F[l]odubuir

Chlodowech (Clovis) and Chlothar both have the liquid [l] in second position, represented in all spellings in Table 26.1 and corresponding to the 'l' in 'Flodubuir', but Childebert and Sigibert are ruled out.

Fl[o]dubuir

Chlodowech and Chlothar both have the back vowel [o] in second position, represented in all spellings in Table 26.1 and corresponding to the 'o' in 'Flodubuir', but Childebert and Sigibert both have front vowels, also represented in the spellings, and are again ruled out.

Flo[d]ubuir

The IE voiceless stop [t] became the Germanic voiceless fricative [Þ] by the Germanic consonant shift, and by Verner's law this was voiced to [ð] in voiced surroundings,[33] yielding [χloð] as the first component of the names Chlodowech and Chlothar, as above. In the orthography of the Old Irish period, intervocalic 'd' represents a voiced fricative,[34] and therefore accurately represents what the Irish scribe would in principle have heard in the Germanic name. In practice, this voiced fricative is variously spelled 'd', 't', and 'th' in Table 26.1, and this might well represent a Romance pronunciation. The Childebert examples also have the 'd' spelling, though with a preceding 'l' which is absent from 'Flodubuir', and Sigibert does not have this segment, so both are once again ruled out.

Flod[u]buir

The spellings of the back vowel in unstressed position for Chlodowech are consistently 'o' in Table 26.1 and consistently 'a' or null for Chlothar, which may or may

not reflect a phonetic difference; if so, Chlodowech has the advantage relative to 'Flodubuir'. The spellings for Childebert and Sigibert are consistently front vowels, ruling them out.

Flodu[buir]

The '-vech-' and similar in the spellings of Chlodowech represents IE [*weik-], 'energetic, specifically hostile display of strength',[35] where the IE voiced continuant [w] remains in Germanic in initial and medial intervocalic positions,[36] the IE diphthong [ei] became Germanic [ī],[37] and the IE voiceless stop [k] became a voiceless velar fricative [χ] in early Germanic, which in the historical period was weakened to an unvoiced glottal fricative.[38] In Old Irish orthography 'b' represents a voiced fricative in intervocalic position,[39] and 'ui' represents a raised and fronted schwa in unstressed position.[40] Thus far, therefore, 'bui' represents the Germanic name well. The Germanic form does not, however, have a final 'r', either in the putative Germanic form or in the orthographical representations of Table 26.1, so in this respect 'Flodubuir' is against Chlodowech.

The '-ar-'/ '-char-' and similar in the spellings for Chlothar comes from IE [*korjo-], 'war, war band' (Krieg, Kriegsheer),[41] where the IE voiceless velar stop [k] became a voiceless velar fricative [χ] in early Germanic, which tended to disappear in medial position in dialects of the historical period;[42] in the spellings listed in Table 26.1 it is sometimes represented ('Clothacharius') and sometimes not ('Chlotharius'), which suggests that this was happening in the Frankish of our period. IE [o] becomes Germanic [a],[43] and IE [r] remained in Germanic.[44] In Old Irish orthography the voiceless velar fricative was written as 'ch' or 'c' in intervocalic position,[45] not 'b' as in 'Flodubuir', which counts against Chlothar as a candidate. On the other hand, the putative form of the Germanic name and spellings of Chlothar all have final 'r', as does 'Flodubuir'.

Finally, the spellings of Childebert and Sigibert have both the 'b' and the 'r' of 'Flodubuir', but add a final 't' which is missing in the Irish form.

Childebert and Sigibert have too much against them to be viable as the names underlying 'Flodubuir'. Of the remaining two, Chlodowech and Chlothar are both good but not perfect fits, and both therefore remain candidates, but no more. To summarise, the assumption of an oral source for the Irish annal entry indicates that 'Flodubuir' could have been Clovis II or Chlothar III, and the assumption of a documentary source that he was Clovis II, but there are problems with both. One further piece of evidence remains.

There is a version of the AU 'Flodubuir' entry for the year 658 in another set of early Irish annals, the *Annals of Tigernach* (hereafter 'AT'), to which none of the earlier commentators on the entry, including Picard, referred: 'The killing of Ercdot mac Sechnusaigh and

of Conchu mac Laidhgnen. Flodibor king of the Franks died.'[46] The AT entry resolves the syntactic irregularity and attendant ambiguity of AU: 'Flodibor' died in 658, and so 'Flodubuir'/'Flodibor' was Clovis rather than Chlothar. The AT editor, moreover, suggested an emended reading 'leg. Flodobuis i.e. Clovis II?', which seems reasonable given the probable unfamilarity of the Frankish name to the Irish annalist and the similarity of the graphs for 'r' and 's' in insular minuscule, and would resolve both the orthographic and phonetic problems discussed above. Why should one trust AT over AU, however?

The answer involves looking briefly at the development of the medieval Irish annals.[47] The Chronicle of Ireland is a hypothetical record of Irish events from the late sixth to the early tenth century which is reconstructed using a variety of still-extant annals; what follows adopts Charles-Edwards' reconstruction.[48] Its earliest component was the Iona Chronicle begun in the monastery of that name in the second half of the sixth century and continued there. Another set of annals begun no later than 642 at a monastery associated with the Iona confederation was incorporated into the Iona Chronicle in the second half of the seventh century. Around 740 the Iona Chronicle was brought to an unidentified monastery in the Irish east midlands and maintained there, with a particular interest in the affairs of the Armagh monastic confederation, until 911; this is the Chronicle of Ireland proper. After 911 the Chronicle of Ireland split into two branches, one represented by the extant AU and the other by a group of annals which includes the AT.

In reconstructing the Chronicle of Ireland, a fundamental principle is that entries which occur both in AU and AT were very probably in the Chronicle.[49] The Flodubuir/Flodibor entry is in both AU and AT, so in accordance with that principle it was in one of (i) the original Iona Chronicle, or (ii) in the composite chronicle incorporated into the Iona Chronicle in the second half of the seventh century, or (iii) added retrospectively to the Chronicle of Ireland after *c.* 740 on the basis of a now-unknown source. There is some reason to favour (iii). Picard argues that, given the Fursean connection with Frankish events surrounding Dagobert's tonsure and transportation, Dagobert would have stayed in a monastery with Fursean associations such as Slane or Louth in the Irish east midlands; the 'Flodubuir'/'Flodibor' information would have come from a locally maintained record of Frankish events connected with Dagobert's presence, and the occurrence of the Flodubuir/Flodibor reference at the end of the AU and AT entries is consistent with this. Be that as it may, though, the main reason for adopting the AT rather than the AU reading is that the latter is syntactically anomalous and looks like a corruption of the syntactically correct original in the Chronicle of Ireland, which AT preserves.

On balance, therefore, it looks like the 'Flodubuir'/'Flodibor' entry in the Chronicle of Ireland recorded the death of Clovis II in 658. This is why the AT version of the name is used in the title of the present discussion.

Conclusion

The proposal is that AU 'Flodubuir'/AT 'Flodibor' was Clovis II. What are the consequences of this result? First, there may be implications for reconstruction of the events surrounding the exile of Dagobert in Ireland and the involvement of the community of Fursey in them. Second, it injects what is very probably a contemporary date which is independent of Frankish documentary sources into the controversial chronology of Merovingian politics in the mid to later seventh century. And lastly, it adds another tessera to the slowly emerging mosaic of Irish interaction with the Continent in the early Middle Ages.

Notes

1 Löwe 1982; Picard 1991a; Richter 1999.
2 Wood 1994, 222.
3 Ibid., 231–4; Cubitt 2013, 343.
4 Post haec autem Sighibertus rex Auster, Pippino defuncto, Grimoaldo, filio eius, in maiorum domato instituit. Decedente vero tempore, defuncto Sighiberto rege, Grimoaldus filium eius parvolum nomine Daygobertum totundit Didonemque Pectavensem urbis episcopum in Scocia peregrinandum eum direxit, filium suum in regno constituens. (*Liber Historiae Francorum*, 43: Krusch 1888b, 315–16; my translation).
5 Picard 1991a; Wood 1994, 221–34; Fouracre 2008; Wood 2013, 206–7.
6 Picard 1991b; but see now, Fouracre 2008; 2013; Wood 2013.
7 McCarthy 1998, 2008.
8 Iugulatio Orcdoith mc. Sechnusaigh & Concenn m. Laidhgnein & Flodubuir rex Francorum (McCarthy 1998, 2008); cf Charles-Edwards 2006, i, 151.
9 James 1983; Wood 1994; Fouracre & Gerberding 1996; Ewig 2006.
10 Ewig 1991.
11 Hennessy & MacCarthy 1887–1901, i, 115.
12 Moody et al. 1982, 25.
13 Thurneysen 1946, 176–217.
14 Picard 1991b, 41.
15 Wood 1994, Chapter 13, esp. 222–4.
16 Krusch & Lebecq 2015, 149, n. 337.
17 Stephen, *Vita Wilfridi* 28 (Colgrave 1927, 54–5).
18 per arma ditatum.
19 For Wilfrid's involvement see Wood 1994, 231–2; Fouracre 2008; 2013; Wood 2013; Cubitt 2013.
20 On this involvement, see further Wood 2013, 207.
21 Picard 1991b, 41–2.
22 Cf Wood 2013, 207.
23 Krusch & Levison 1951.
24 Krusch 1888a.
25 Krusch 1888b.
26 Keller 1978; Fouracre & Gerberding 1996, 58–78.
27 Ibid, 58–78.

28 Pokorny 1959, 546–7.
29 Prokosch 1939, 37–45, 59; Krahe & Meid 1969, 83, 98–9.
30 Pokorny 1959, 605–7.
31 Prokosch 1939, 90–2; Krahe & Meid 1969, 96.
32 Thurneysen 1946, 21; Russell 2005.
33 Prokosch 1939, 60–4; Krahe & Meid 1969, 85–6.
34 Thurneysen 1946, 21–2 and 25–9; Russell 2005.
35 energische, bes. feindselige Kraftäusserung; Pokorny 1959, 1128–9.
36 Ibid., 90–2; Krahe & Meid 1969, 95–6.
37 Prokosch 1939, 96, 100; Krahe & Meid 1969, 53–4, 64.
38 Prokosch 1939, 37–45, 59; Krahe & Meid 1969, 83, 98–9.
39 Thurneysen 1946, 21–2 and 25–9.
40 Ibid., 63–7; Russell 2005.
41 Pokorny 1959, 615–16.
42 Prokosch 1939, 59.
43 Krahe & Meid 1969, 51.
44 Prokosch 1939, 85, 95.
45 Thurneysen 1946, 21–4.
46 Guin Ercdoít maic Sechnusaigh & Conchínd maic Laidhgnen. Flodibor rex Frangcorum obit (Stokes 1895–7, 195).
47 Smyth 1972; MacNiocaill 1975; Grabowski & Dumville 1984; McCarthy 1998, 2008; Charles-Edwards 2006, i, 1–58.
48 Ibid.
49 Ibid., i, 7.

References

Arndt, W. (ed.), 1892 'Desiderii episcopi Cadurcensis epistolae' in W. Gundlach & E. Dümmler (ed.), *Epistolae Merowingici et Karolini aevi (I)*, MGH: Epistolarum 3 (Berlin)

Charles-Edwards, T.M., 2006 *The Chronicle of Ireland*, Translated Texts for Historians 44, 2 vols (Liverpool)

Colgrave, B. (ed.), 1927 *The Life of Bishop Wilfrid by Eddius Stephanus* (Cambridge)

Cubitt, C., 2013 'Appendix 2: the Chronology of Stephen's Life of Wilfrid' in Higham 2013, pp 340–7

Ewig, E., 1991 'Die Namengebung bei den ältesten Frankenkönigen und im merowingischen Königshaus', *Francia* 18, 21–69

Ewig, E., 2006 *Die Merowinger und das Frankenreich* (Stuttgart)

Fouracre, P. & Gerberding, R. 1996 *Late Merovingian France. History and Hagiography 640-720* (Manchester)

Fouracre, P., 2008 'Forgetting and Remembering Dagobert II: the English Connection' in D. Ganz & P. Fouracre (ed.), *Frankland: the Franks and the Worlds of the Early Middle Ages* (Manchester), pp 70–89

Fouracre, P., 2013 'Wilfrid on the Continent' in Higham 2013, pp 186–99

Gerberding, R., 1987 *The Rise of the Carolingians and the Liber Historiae Francorum* (Oxford)

Grabowski, K. & Dumville, D., 1984 *Chronicles and Annals of Mediaeval Ireland and Wales* (Woodbridge)

Hennessy, W. & MacCarthy, B., 1887–1901 *Annala Uladh: Annals of Ulster*, 4 vols (Dublin)

Higham, N.J. (ed.), 2013 *Wilfrid, Abbot, Bishop, Saint: Papers from the 1300th Anniversary Conferences* (Donington)

James, E., 1982 *The Origins of France* (London)

Keller, R., 1978 *The German Language* (London & Boston, MA)

Krahe, H. & Meid, W., 1969 *Germanische Sprachwissenschaft* (Berlin)

Krusch, B. (ed.), 1888a *Fredegarii et aliorum Chronica*, MGH: Scriptores Rerum Merovingicarum 2 (Hannover), pp 1–193

Krusch, B. (ed.), 1888b *Liber Historiae Francorum*, MGH: Scriptores Rerum Merovingicarum 2 (Hannover), pp 215–328

Krusch, B. (ed.), 1902 *Passiones vitaeque sanctorum aevi Merovingici (II)*, MGH: Scriptores Rerum Merovingicarum 4 (Hannover & Leipzig)

Krusch, B. & Lebecq, S. (ed. & trans.) 2015 *La geste des rois des Francs* (Paris)

Krusch, B. & Levison, W. (ed.) 1951 *Gregorii episcopi Turonensis. Libri Historiarum*, MGH: Scriptores Rerum Merovingicarum 1 (Hannover)

Löwe, H., 1982 *Die Iren und Europa im früheren Mittelalter* (Stuttgart)

MacAirt, S. & MacNiocaill, G. 1983 *The Annals of Ulster (to A.D. 1131)* (Dublin)

MacNiocaill, G., 1975 *The Medieval Irish Annals* (Dublin)

McCarthy, D., 1998 'The Chronology of the Irish Annals', *Proc. Royal Irish Academy* 98, 203–55

McCarthy, D., 2008 *The Irish Annals: their Genesis, Evolution and History* (Dublin)

Moody, T., Martin, F. & Byrne, F.J., 1982 *A New History of Ireland, 8: A Chronology of Irish History to 1976* (Oxford)

Picard, M., 1991a *Ireland and Northern France AD 600–850* (Dublin)

Picard, J.-M., 1991b 'Church and Politics in the Seventh Century: the Irish Exile of King Dagobert II' in J.-M. Picard (ed.) *Ireland and Northern France* (Dublin), pp 27–52

Pokorny, J., 1959 *Indogermanisches etymologisches Wörterbuch* 1 (Bern & Munich)

Prokosch, E., 1939 *A Comparative Germanic Grammar* (Philadelphia, PA)

Richter, M., 1999 *Ireland and her Neighbours in the Seventh Century* (London & New York)

Russell, P., 2005 'What was Best of Every Language: the Early History of the English Language' in D. Ó Cróinin (ed.) *A New History of Ireland, 1: Prehistoric and Early Ireland* (Oxford)

Smyth, A., 1972 'The Earliest Irish Annals', *Proc. Royal Irish Academy* 70, 1–48

Stokes, W., 1895–7 'The Annals of Tigernach', *Revue Celtique* 16, 374–419, *Revue Celtique* 17, 6–33, 119–263, 337–420, *Revue Celtique* 18, 9–59, 150–97, 267–303

Thurneysen, R., 1946 *A Grammar of Old Irish* (Dublin)

Wood, I.N., 1994 *The Merovingian Kingdoms 450–751* (London)

Wood, I.N., 2013 'The Continental Journeys of Wilfrid and Biscop' in Higham 2013, pp 200–11

Lexical heritage in Northumberland: a toponymic field-walk

Diana Whaley

Introduction

If we stand on any one of the splendid vantage points offered by England's northernmost county – say Dunstanburgh Castle (Fig. 27.1), perched on a spectacular whinstone headland – we can view landscapes whose many phases of human settlement and activity are inscribed on the ground itself, but inscribed also in the place-names. These names are cultural artefacts, handed down in everyday speech or in documents and maps, and their value, both in themselves and as part of a whole array of evidence for reconstructing the past, has long been recognised, not least by the dedicatee of this volume.[1] This paper takes its cue from Richard Bailey's philological and toponymic interests and expertise, and his fondness for walking the shores, moors and hills of his adopted county of Northumberland. It offers thoughts on place-names as we take an imagined walk, heading approximately east from Embleton (NU 230225) to the coast, then south-east to Dunstanburgh Castle, and south to Craster. Though less than six kilometres, the route passes through a changing landscape where the drama of rock and hewn stone is set off against the tranquillity of sandy shore, dunes and pasture. It is unspoilt by road access and protected by multiple designations including Area of Outstanding Natural Beauty, Site of Special Scientific Interest and Heritage Coast, and is in the care of the National Trust; it is full of archaeology.[2] Along the way are smaller, less well-known features bearing minor names such as Rumble Churn, Scrog Hill and Big Shaird. The names chosen for comment are mainly found both on the first edition six-inch Ordnance Survey map of 1867 (henceforth 'OS 1867') and on the current 1:25,000 Explorer map. Below I consider the etymology of the names, and how they reflect the history, topography, and above all the local dialect of the area. The enquiry is also methodological, exploring how names of this sort, especially the neglected minor ones, can be investigated, and what they can tell us.

Investigating Northumberland place-names

The place-names of Northumberland, fifth largest of the historic English counties, are seriously under-researched. The county is one of only three for which no full-scale survey by the English Place-Name Society (EPNS) is published, in progress or in prospect, though a single-volume dictionary is under way.[3] Meanwhile, Mawer, Ekwall and Watts are invaluable sources for the early spellings on which interpretation crucially depends,[4] though, as for other northern counties, 'early' generally means post-Conquest, several centuries after the presumed coining of most major names in the Anglian period.

With some minor exceptions the standard dictionaries understandably restrict their coverage to the names of major settlements and landscape features recorded in medieval documents. This leaves thousands of minor Northumberland names uncollected and unexplained, despite sterling work such as that by Beckensall on field-names and Nurminen on hill-terms,[5] and indeed minor names are less well researched nationally. Nevertheless, as I hope to show, they are full of interest. Even where the spellings (found in sources such as Surveys, Parish Registers (PR), Tithe Awards (TA), and early maps and guidebooks) are fairly stable and etymologies seemingly obvious, questions remain about the names' exact reference, the motivation for their coining and the distribution and rarity or frequency of their elements. In pursuing those questions below I make use of standard and dialect dictionaries, the evidence of landscape and history, and potential parallels to place-name elements accessed via the Digital Survey of English Place-Names (DSEPN), a digitised version of the first eighty EPNS volumes,[6] and the OS 1:50,000 Place-names Gazetteer (PNG) of England, Scotland and Wales. Except where place-name elements are explicitly identified in DSEPN/EPNS, search results from DSEPN and PNG require great caution even after manual

sifting, and ideally the names on larger scale maps would also be searched. Nevertheless, these are useful tools. Finally, light on local names is often shed by the nineteenth-century Ordnance Survey Name Books or Original Object Name Books (OSNB) which, taking evidence from local informants as well as written sources, represent oral history on a grand scale. Recent oral tradition from the Craster area, some concerning names, has also been captured by Porteous.[7]

Embleton (Fig. 27.2)

The place-name Embleton neatly exemplifies a number of recurring features in the development and interpretation of English toponyms. The earliest known spellings are: *Emlesdune c.* 1200, *Emlesdone, Emelesdona* 1212, *Emildon* 1242, *Emeldon* 1255, *Embledon* 1350,[8] *Emylton* 1538. The meaning is probably 'Æmele's hill'. The medieval spellings unanimously point to Old English (OE) *dūn* 'hill' as the generic or second element; as in many -*dūn* names, this

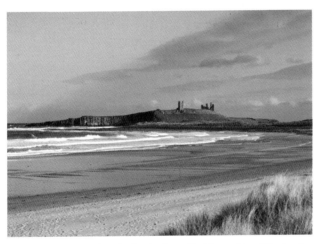

Fig. 27.1 Dunstanburgh Castle from Embleton Bay (Photo: Ian Whaley)

Fig. 27.2 Embleton – a dūn – from Embleton Bay (Photo: Ian Whaley)

was replaced by -*ton* in or about the sixteenth century. The specific or first element is less certain. A personal name such as *Æmele/Emele* is likely: it accounts well for the spellings; *Æmele* is recorded in Old English, albeit only once;[9] OE *dūn* is frequently qualified by a personal name;[10] and the possessive -*s*- seen in the earliest spellings is most often found with personal names, though it can also occur with common nouns. An alternative possibility for the specific is OE *emel/æmel* 'caterpillar', as a man's nickname (unrecorded) or conceivably referring to the insect, though, as often, the more picturesque explanation is the less likely.

As well as showing that Embleton's situation on a hill and its association with a man called Æmele were at one time perceived as essential to its identity, the name can potentially tell us more, despite the documentary and archaeological silence that surrounds it. As famously demonstrated by Gelling and Cole,[11] the Anglo-Saxons used their ample topographical vocabulary in subtle, precise and consistent ways, and *dūn* tends to refer not just to any hill but particularly to one with a level, open top suitable for habitation.[12] This is borne out reasonably well by the corpus of Northumberland place-names collected from the 1:50,000 maps by Nurminen, where *dūn* is the most frequently used Old English hill-term.[13] Further, while *dūn* continued in use for the coining of place-names over many centuries (and survives as *down* as in North and South Downs), it is among the topographical terms that are characteristic of early Anglo-Saxon naming, *c.* 400–*c.* 730,[14] and can therefore be used, with caution and alongside other evidence, as an indicator of settlement chronology. Embleton additionally has what Wood terms 'earliness indicators':[15] the place is of relatively high status (see below), and the presumed specific *Æmele/Emele* is a monothematic personal name with suffix, a type characteristic of the earlier Anglo-Saxon centuries, whereas compound names predominated later.[16] It seems likely, therefore, though far from proven, that Embleton was settled relatively early in the period that saw widespread territorial takeover and the ascendancy of Germanic (English) speakers over speakers of the Celtic language of Brittonic.

Embleton became the centre of an ecclesiastical parish comprising eleven townships and of a barony whose chain of owners included Simon de Montfort and John of Gaunt, while the advowson of the church belonged to Merton College Oxford from 1274. It is not possible to linger over the history that emerges from the documents, nor the field-names preserved there, which afford glimpses of the workings of the medieval and post-medieval manor,[17] but as a single example, tithe from six acres was assigned in 1313–14 to the hospital in *Spitaldene* – perhaps a leper hospital, to match those at Bamburgh and Warenford.[18] Its location is unknown but is hinted at by Spitalford on the Embleton Burn (*Spittleford* 1838 Greenwood Map; cf *Spital House(s)* 1748 PR).

The Skaith (Fig. 27.3)

Striking east-north-east from Embleton, past Dunstanburgh Castle Golf Club, we walk warily across the course. The view of the sea is blocked by dunes, and between dunes and golf-links a flattish expanse of rough grass stretches northwards: The Skaith. The definite article suggests a word *skaith* known locally (at least in the past), but it is not a familiar word, and it looks Scandinavian, though occurring in an area where Scandinavian linguistic influence, even indirect, appears very sparse – so encountering this name is almost as surprising as finding a Borre-style brooch on the beach. The initial sequence *sk-/sc-* is not native to English and would usually reflect the influence of Old Scandinavian, as in Skegness or Scargill, or else of French, as in the post-Conquest Scremerston. More specifically, *skaith* looks remarkably like the Old Scandinavian (OScand) *skeið* n. (where '*ð*' = '*th*') 'course, race, stretch of time or place',[19] and would be its normal reflex or linguistic descendant. *Skeið* occurs in the compound *hestaskeið* 'horses' course, racecourse' in numerous Heskets or Heskeths in Cumbria, Lancashire and Yorkshire, and in

Wickham Skaith (Suffolk), another putative racecourse.[20] For The Skaith, Embleton, OSNB is splendidly helpful, unwittingly explaining its meaning and supporting an ultimately Scandinavian etymology, as it notes, 'The Games, which take place at Embleton Feast, are carried on here'.[21] By adding '(origin of name unknown)' OSNB suggests that the word *skaith* was unknown locally by 1861, and it does not appear in the dictionaries.[22] Nevertheless, the Embleton name, together with other Northern English examples,[23] would suggest that OScand *skeið* survived for some time as a dialect word, as Taylor has suggested for Scots.[24] Although further investigation is needed, then, this illustrates the contribution that toponymy can make to lexicography, and The Skaith contributes a small nugget of evidence to a much-needed investigation of vocabulary of Scandinavian origin in Northumberland.

Embleton Bay, Bathing Rock (OS 6in only)

The Embleton Burn (1769 Armstrong Map) flows through a gap in the dunes and empties gently into the North Sea (*German Ocean* 1841 TA) at Embletonburn Mouth.

Fig. 27.3 The Skaith (Photo: Ian Whaley)

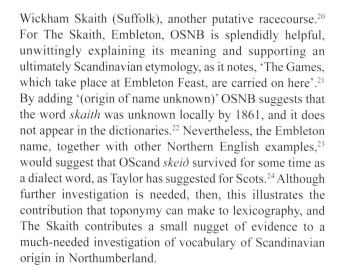

Fig. 27.5 The Due, with Cushat Knock (L) and Scrog Hill (R) behind (Photo: Ian Whaley)

Fig. 27.4 Bathing Rock, around low tide (Photo: Ian Whaley)

Fig. 27.6 Greymare Rock (Photo: Ian Whaley)

Following the burn, we enter Embleton Bay (where the element *bay* must be sixteenth-century or later) – beautiful, especially in the low sunlight of winter or twilight, whether we look north across golden sands or south to the boulder-strewn beach topped by a basalt precipice and the craggy ruins of Dunstanburgh Castle. Bathing Rock (Fig. 27.4), immediately to the north-east, lies between high and low water, and 'Bathers are in the habit of leaving their clothes on the Rock, while bathing, hence the name' – this on the authority of Messrs Ralph Pringle, Robert Sheel and James Patterson, fishermen of Newton Seahouses in 1861.[25]

Dunstanstead Links, Dunstan Square, Dunstan Steads, Dunstan, The Due

From Embletonburn Mouth, a sandy footpath heads south-east along the dune-tops towards Dunstanburgh, with the golf-course on the right. This stretch of dunes is Dunstanstead Links, one of a cluster of places named by reference to Dunstan, having belonged to Dunstan township before it was absorbed into Craster Civil Parish. Only the Links are on the walking route to Craster, though if the walk is circular Dunstan, Dunstan Square and Dunstan Steads can be taken in on the return. Dunstan, already spelt *Dunstan* in 1242, appears to mean 'hill-rock', from OE *dūn* + OE *stān*, and is usually taken as a reference to Dunstanburgh. If correct the two place-names mutually cross-refer, though the nucleus of Dunstan is 2km from Dunstanburgh, and the great headland is not visible from it.

The name Dunstanstead Links is doubly appropriate, though by coincidence. *Link(s)*, from OE *hlinc* 'ridge, bank', must here have its Scots and Northern English sense, 'sandy, grass-covered ground by the sea-shore'. 'Golf-links' is also apt, but the golf-course (opened 1900) post-dates the name (recorded 1861).[26] A small metalled road leads right (south-west) from the Links to Dunstan Steads (recorded 1682 PR). The word *stead* goes back to OE *stede* 'place, site', common in pre-Conquest place-names, especially in south-east England.[27] There are Northumberland examples probably coined after the Conquest, such as Barneystead (*Bernerstede* 1373), but it is later that *stead* becomes extremely productive, often added to an existing hamlet- or village-name to designate an outlier. Heslop counted forty-three place-names in *-stead*,[28] which is thus a Northumberland hallmark, if a rather unobtrusive one. Similarly with Dunstan Square (*Dunston Square* 1783 PR) to the south: rural examples of the structure 'place-name + *square*' are more frequent in Northumberland than elsewhere, though generally uncommon, to judge from PNG.

The hamlets of Dunstan Steads and Dunstan Square are mentioned throughout the Embleton Parish Registers, and for a few decades from 1691 'Dunstanburgh Steads' also appears. It is unclear from the pattern of residents' names whether this is the same place as Dunstan Steads (simply *Steeds* Armstrong Map and occasionally PR) or a short-lived outpost of Dunstan township, which was quite populous,

judging from the parish Registers, the 1841 Tithe Award and widely visible ridge and furrow marks.[29] It is tempting, but perhaps hazardous, to link the enigmatic Dunstanburgh Steads with the remains of a 'small late medieval, or post-medieval, farmstead' south-west of the castle.[30]

A little further along the dune-top path and away to the right (west) is a rock-inlaid hillock named The Due, 'a well known land mark to the fishermen along the Coast' (Fig. 27.5).[31] As with The Skaith, the definite article creates the expectation of a recognisable word, yet *due* 'that which is due', a loan-word from French first recorded *c.* 1430,[32] seems improbable, and no other explanation or useful toponymic parallels present themselves.

Greymare Rock (Fig. 27.6)

The tussocky dunes continue south-east, but the sandy beach below gives way to rocks, both boulders and slabs, the most dramatic of which is the undulating outcrop jutting out into the waves like a natural pier – an excellent perch for a picnic. This is Greymare Rock, known locally as Saddle Rock, while to fishermen it is The Whale's Belly.[33] Grey mares in place-names can deceive, some evidently deriving from OE *(ge)mǣre* 'boundary', e.g. Greymare Hill, Shotley (*Graymare* 1307), which abuts a boundary. Others, however, including this instance, the waterfall Grey Mare's Tail (Dumfries and Galloway) and the long barrow The Grey Mare and her Colts (Dorset), are what they seem: fanciful comparisons.

Castle Point, Thorns Carr, Gull Crag (OS 6in only), *Rumble Churn, Queen Margaret's Cove*

Continuing south, we skirt right (west) past the Great Whin Sill headland topped by Dunstanburgh Castle. The names around the headland are mainly transparent. Castle Point is certainly so (and probably sixteenth-century or later), while *thorns* remains unexplained – possibly a surname – and *carr* is discussed below. Gull Crag is a curving rampart of sandstone, shales and whin (basalt),[34] streaked white with the guano of the hundreds of kittiwake pairs who nest on its narrow ledges every spring (Figs. 27.7–8). DSEPN yields no place-names containing *gull* (first recorded in English *c.* 1430, possibly as an adoption from Welsh),[35] though PNG has several probable instances, including multiple Gull Rocks in Devon and Cornwall. *Crag*, for which *OED*'s first citation is pre-1375, though there are pre-datings in place-names,[36] is assumed to originate in Gaelic *creag*. It is extremely common in Cumbria, and also in southern Scotland and northern England, including Northumberland (with 119 instances in Nurminen's corpus).[37]

Rumble Churn (Fig. 27.7), like the castle towering above, has inspired awe, legend and poetry.[38] The name is a dialect compound *rumble-kirn* 'a gully on a wild rocky shore', seemingly with Standard English *churn* replacing *kirn/kern*, cf Rumbling Kern just to the south (NU 262172').[39] A curious feature of Rumble Churn is that the name has

Fig. 27.7 Gull Crag and Rumble Churn (Photo: Ian Whaley)

Fig. 27.10 Dunstanburgh Castle (Lilburn Tower) and site of meres after rain (Photo: Ian Whaley)

Fig. 27.8 Kittiwakes on Gull Crag (Photo: Ian Whaley)

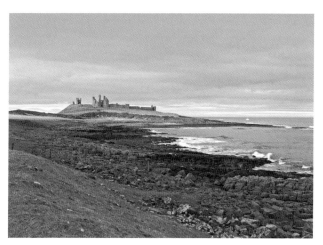

Fig. 27.11 Dunstanburgh from the south, with Nova Scotia below (Photo: Ian Whaley)

Fig. 27.9 Queen Margaret's Cove, formerly Rumble Churn (Photo: Ian Whaley)

Fig. 27.12 Nova Scotia from the north-west (Photo: Ian Whaley)

moved. For eighteenth-century writers it was the gully south-east of the castle, below Egyncleugh Tower,[40] where 'the noise of the disturbed waters, and the groan which echo returns through the desolated towers, are noble, though tremendous'.[41] This is the location on OS 1867 and on plans from the 1890s,[42] and the identification is still known locally today.[43] Meanwhile, 'Queen's Cove' is noted in 1861, on the authority of Revd Mr Rooke, as an alternative to the better-attested Rumble Churn,[44] and since OS 1899 the south-east gully has been named Queen Margaret's Cove (Fig. 27.9), or locally Margaret's Gut (cf Margaret Tower, an alternative to Egyncleugh Tower),[45] while 'Rumble Churn' has been fixed cartographically north of the castle, below Gull Crag. The 'Margaret' names reflect a local tradition that during the Wars of the Roses the Lancastrian Queen Margaret of Anjou (1430–82) 'landed, or embarked here, during one of the Sieges of the Castle'.[46] However, the evidence relates to Bamburgh,[47] not Dunstanburgh. Cadwallader Bates saw both 'Rumble Churn' and 'Queen Margaret's Cove' as erroneous names for the south-eastern chasm of 'Eggingclough' and favoured the present northern location of Rumble Churn and this view (conveyed to a Newcastle Antiquaries' excursion in 1885) may have been influential.[48]

Dunstanburgh Castle (Figs 27.10–11)

Built by Thomas, Earl of Lancaster, cousin and rival of Edward II (reg. 1307–27), the castle is now a splendid, jagged ruin in the keeping of Historic England. The earliest spelling given in standard place-name dictionaries is *Dunstanburgh* 1321, but *castri de Dunstanburgh(e)* appears in a document of 1313–14, contemporary with the castle's construction.[49] Dunstanburgh seems to contain the place-name Dunstan compounded with OE *burh* 'fortified place' or its reflex. The site provides some evidence for an Iron Age promontory fort,[50] and Roman finds in the castle bailey have prompted tentative suggestions of a second-century military presence here, perhaps a signal station.[51] Old English *burh* could have referred to these or to hitherto undetected Anglian defences. However, *bur(g)h* continues to be extremely productive in the naming of manors, boroughs and towns, and of castles of the twelfth century and later, such as Skipsea Brough and Scarborough (both Yorkshire East Riding).[52] It is conceivable that the naming of Dunstanburgh was a 'fourteenth-century concoction' partly designed, like the fabric, to rival the royal castle at Bamburgh, and if so it symbolises tensions between king and barons.[53] The fourteenth-century landscape of defence and display included three freshwater pools forming a moat, pragmatically named North, West and South Mere in archaeological plans.[54]

Scrog Hill, Cushat Knock, Cushat Stiel

As we face south from the castle and head towards Craster a new landscape opens up as the track follows a verdant, level stretch of sheep-grazed pasture, fringed to the left (east) by the low rocky shore and to the right (west) by the long, low ridge called The Heughs (see below). Nearest to us at the north end of The Heughs is the rather unkempt low eminence of Scrog Hill. Unsurprisingly, the name makes no reference to the small Bronze-age cairn found there,[55] but uses the Scots and Northern dialect word *scrog/shrog* to denote stunted trees, bushes, brushwood or the ground on which they grow; the description is still apt. The earliest attestation of *scrog/ shrog* in *OED* is late fourteenth century and the earliest Scots record is in a place-name *c.* 1208.[56] Just east of Scrog Hill sits Cushat Knock, recorded in 1861 as a fishermen's landmark, pronounced as 'Cushy Knock'.[57] *Knock* is rather uncommon but found in hill-names from Kent to Scotland and assumed to go back to OE **cnocc* or Old Irish/Scots Gaelic *cnoc(c)* 'hillock'.[58] *Cushat* or *cushie/cushy*, from OE *cūsc(e)ote*, of uncertain origin, is a word for the wood-pigeon (*Columba palumbus*) or related species recorded in Scots and in Midland and Northern English dialects, though it is little known in Northumberland now.[59] Only seven place-names containing *cushat* appear in PNG: two in Northumberland and five in Scotland, and most refer to hills or woods; DSEPN yields none. Cushat Knock seems to have given rise to the name Cushat Stiel. The dialect profile of *cushat* is repeated in *stiel*, seemingly a reflex of OE *stigol*, *stigel* 'stile, steps' and a variant of dialect *steel*, Standard English *stile*. It is recorded especially in Scots and Northumbrian and is applied to tongues of land and (here) to coastal rocks.[60] Of place-names in PNG over forty, mainly Northern or Scottish, contain the spelling *steel* and may contain this word; there are also five instances of *stiel* (DSEPN has none of this spelling).

Nova Scotia (Figs 27.11–13)

The small bay beside Cushat Stiel is sometimes called The Square Haven by local fishermen, while the beach is known as Cusha.[61] The name on the map is Nova Scotia, and has been since OS 1867:[62] something of a surprise, not because it is also the name of a Canadian province, established in its founding charter of 1621,[63] but because most Nova Scotias in England are farms or fields. Like other transferred names reflecting colonial expansion (Philadelphia, Botany Bay, etc.), Nova Scotia is usually regarded as a 'remoteness' name.[64] Of fourteen places so called,[65] most are remote from other settlements, within 1km of a current civil parish boundary, and situated in northern England.

Nova Scotia south of Dunstanburgh was once a small settlement. It appears as two small black rectangles on Armstrong's map of 1769 and as crouching cottages in evocative pictures of Dunstanburgh by J.M.W. Turner, who visited in 1797.[66] The footings of buildings can still be seen on and beside the track from Dunstanburgh to Craster.[67] Two families are associated with Nova Scotia in Embleton Parish Registers: Facus and Bohill(s). The 1760 baptismal entry for Robert, son of Patrick and Elizabeth Facus of Nova Scotia,

provides the first record of the place-name known to me, but their next son, Edward, was born in 1761 at Newton (-by-the-Sea), and individuals called Facus (and variants) are usually located at Newton or Craster. Nova Scotia is next mentioned in 1780 on the baptism of George, first son of George and Catherine (alias Christian) Bohills. Their abode is given as Dunstan Steads at their marriage in 1779, and again in the entries for sons baptised in 1781 and 1783, but a further five sons (including twins) and one daughter were born at Nova Scotia between 1788 and 1796 – the bay must have resounded with young voices. Archaeological evidence also indicates use of the bay, whether occupied or not, as a haven for fishing boats and as the probable site of the castle harbour.[68] The silence that descends on Nova Scotia in the Parish Registers tallies with its absence from the maps of Fryer (1820) and Greenwood (1828), and the patchwork of fields around Nova Scotia belonged to Dunstan Square in 1841 (Dunstan TA). That the name Nova Scotia hints at Scottish immigration[69] cannot be ruled out, given the long history of north–south movement,[70] but it owes more to North America and a Northern English naming fashion than to Scotland, and the Fa(u)cuses of Embleton parish, if all one family, were firmly local.[71]

The Heughs, Big Shaird (OS 6in only), *Little Shaird* (OS 6in only), *Hares Nick* (OS 6in only)

Running north–south and parallel with the track to Craster is the low ridge of The Heughs, whose archaeological record encompasses mesolithic flints and a World War II radar station.[72] *Heugh* is the reflex of OE *hōh*, which in place-names denotes a 'heel, heel-shaped ridge, ridge or spur of land', typically 'ris[ing] to a point and hav[ing] a concave end'.[73] Ingoe and Shaftoe are classic Northumbrian examples. Its Scots and Northern dialect reflex *heugh/heuch* is extremely frequent in the names of low ridges, above all in Northumberland, with fifty certain or possible instances, but also in adjacent Scottish and English counties.[74] Both within and outside place-names it can also refer to ravines and steep descents.[75] The modest barrier of The Heughs is pierced through to the north by Little Shaird, carrying a track to Dunstan Square, and to the south by Big Shaird (Fig. 27.14). The dialect word *sha(i)rd* 'a gap or broken place in a hedge, wall, &c.'[76] is rare in place-names, though its etymon OE *sceard* 'notch, gap' is modestly prolific.[77] The spelling *shaird* is also rare, lexicographically unrecognised except in sixteenth- and seventeenth-century Scots,[78] and occurring only once in PNG (West Shaird, Orkney). *Nick* in Hares Nick is another rare term for a similar feature. The sense 'a narrow gap or pass between two hills' is recorded from 1606,[79] but PNG contains only twelve instances of *nick* as the final word in a place-name, all in southern Scotland or northern England. OSNB explains that 'hares wh[en] started Contiguous to this, frequ[ently] make for this place, to cross The Heughs'[80] – perhaps referring to hare-coursing.

Oxberry Law (OS 6in only), *Oxberrylaw Holes, Liverpool Hole*

Oxberry Law (Fig. 27.15), a five-metre eminence close to the sea, must be the smallest of over 168 names in Northumberland containing OE *hlāw* or its reflexes Middle English (ME) *loue*, Modern English (ModnE) *law* or *low*; its frequency in the North East is exceeded only by OE *hyll*, ME, ModnE *hill*.[81] *Oxberry* finds a single match in DSEPN (Oxbury Wood, Hertfordshire). It is a dialect name for black bryony (*Tamus communis*) or the fruit of the cuckoo pint (*Arum maculatum*),[82] but these are woodland plants, and black bryony is virtually unrecorded in Northumberland.[83] *Oxberry* could perhaps be a surname; it is concentrated in Northumberland in the census of 1991 though not in that of 1881.[84] The use of *hole* to name a small bay or gully, here the wave-battered basalt chasms of Oxberry Holes and Liverpool Hole, is rather rare and not widely recognised (Fig. 27.16).[85] The specific *Liverpool* tempts one to imagine the wreck of a ship so named, and OSNB confirms that, without giving details.[86] This is a coast of many wrecks.[87]

Little Carr, Muckle Carr, Hurlbuck

Little and Muckle Carr (*North Scar, South Scar* 1769 Armstrong Map, *Little Carr, Great Carr* 1828 Greenwood Map, *Great Carr* 1841 TA) are limestone skerries off Craster harbour, treacherous in high seas (Fig. 27.17). *Muckle*, now mainly Northern English and Scots,[88] has prevailed over Standard English *great*. The word *carr* is of two main origins in the minor names of England: OScand *kjarr*, ME *ker* 'bog, marsh', not relevant here, and OE *carr* 'rock',[89] believed to be an adoption from Celtic. Early evidence for OE *carr* is (occasional place-names aside) restricted to the tenth-century Northumbrian glosses to the Lindisfarne and Rushworth Gospels, where it translates Latin *petrus* (rock).[90] The distribution is wider, generally Northern, in later English, but the element is still favoured in Northumberland (Embleton parish has Out Carr and Jenny Bell's Carr, Ice Carr and Lobster Carr as well as Thorns Carr). Hurlbuck, the name of a small rock, is completely unexplained, beyond the fact that it exists as a rare surname.[91]

Craster (Fig. 27.18)

This (*Craucestr'* 1242, *Craister* 1460, *Craster* 1550) is 'the fort frequented by crows', from OE *crāwe* 'crow' and OE *ceaster* '(Roman) fort'. An OE personal name *Crāwa* (male) or *Crāwe* (female) is also possible as the specific, though both are rare.[92] As with Dunstanburgh, it is less than certain what stronghold the name refers to. Although *ceaster* commonly denotes Roman sites, there is no clear evidence of one at Craster, whose name is usually explained as referring to the Iron-age defended site south of the present village on Craster Heugh.[93] The medieval village is believed to have centred farther inland (west) than the harbour area,

Fig. 27.13 Nova Scotia, traces of footings (Photo: Ian Whaley)

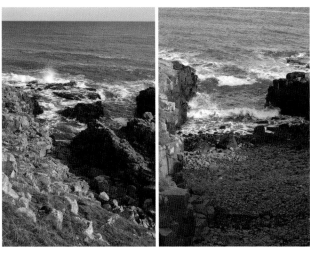

Fig. 27.16 Oxberrylaw Holes and Liverpool Hole (Photo: Ian Whaley)

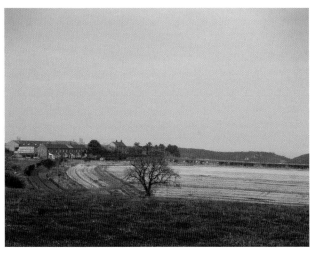

Fig. 27.14 Dunstan Square from the south-west, with The Heughs and Little Shaird (R) (Photo: Ian Whaley)

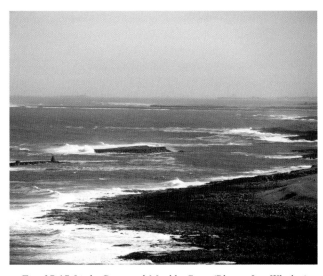

Fig. 27.17 Little Carr and Muckle Carr (Photo: Ian Whaley)

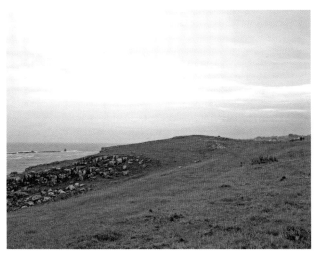

Fig. 27.15 Oxberry Law (Photo: Ian Whaley)

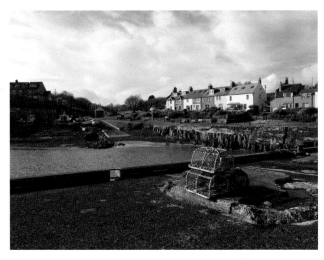

Fig. 27.18 Craster (Photo: Ian Whaley)

which was known as Craster Seahouses (e.g. 1754 PR). Space does not allow discussion of the minor names around Craster here, interesting though they are, or were – the farm-names Beggar my Neighbour (1769 Armstrong Map) and Pinch-me-Near (1721 PR, 1769 Armstrong Map) have been replaced. However, if we should repair to The Jolly Fisherman on arrival in Craster we could reflect that the name has been in use at least since the Tithe Award of 1841.

Conclusions

This exercise in toponymic field-walking has, I hope, indicated the lexical treasure-trove that may be found in even a small area, the analysis being aided by resources such as OSNB, DSEPN and PNG as well as standard dictionaries. Habitation terms are *square* and *stead*, while OE/ME *bur(g)h* (with *castel/castle* added later) and OE *ceaster* reflect the visual impact of strongholds commanding the coast. The rich topographical vocabulary comprises five different terms for hill (OE *dūn*, and *heugh*, *hill*, *knock*, *law* in presumably later names), four for rocks and skerries (OE *stān*, later *carr*, *rock*, *stiel*), four for inlets or gullies (*bay*, *churn*, *cove*, *hole*), two for natural gaps (*nick*, *shaird*), as well as *burn*, *crag*, *links*, *mouth*, *point* and the striking rarity *skaith*. *Cushat, gull* and the crow hiding in Craster specify birds that are readily recognisable and were perhaps welcome as dietary supplements; a distinctive rock is imagined as a *grey mare*, and *rumble churn* domesticates wild nature through metaphor. *Scrog* refers to vegetation; *oxberry* and *thorns* are baffling as potential plant-names and more likely surnames, as *hurlbuck* could be. One Anglo-Saxon individual, Æmele, lives on in Embleton, while Queen Margaret may be an imaginative mistake. Other names give glimpses of later lives: village games played on The Skaith, swimming from Bathing Rock, perhaps hare-coursing at Hares Nick, and the wreck of the *Liverpool*. The Due remains a mystery, at least for the present. As with archaeological small finds, context makes all the difference, and in the case of Nova Scotia documentary, toponymic and archaeological evidence combine to help our understanding of this deserted settlement.

Within the material studied here the interest and local distinctiveness of the minor names shine out, as well as their variability. While the historically important names (Embleton, Dunstan(burgh), Craster) exemplify naming patterns found widely throughout England and south-east Scotland, names such as Scrog Hill, Cushat Stiel, The Heughs, Little Shaird, Muckle Carr and Oxberry Law have a strongly Northumberland tang, often sharing more with Scots than with other English dialects. *Stead* and *square*, though not dialect words, are characteristic of Northumberland place-names.

Dating the names – identifying which part of the past they speak for – is extremely problematic, though the date

of first record of the names and their constituent elements can help, together with comparative and historical evidence. Further investigation could improve the situation – for instance a full study of farm names ending in *-stead(s)* might reveal meaningful patterns of distribution in time and space, as it does for the *ground* and *place* names in Cumbria.[94] Meanwhile, it is at least clear that the place-names have been given and then transmitted, modified, moved or forgotten over at least one-and-a-half millennia, by Anglo-Saxon and post-Conquest magnates and bureaucrats, local farmers and fishermen, ordnance surveyors and antiquarians. They reflect diverse features of ecology and human activity in the past, and preserve a rich verbal legacy much of which would otherwise be lost.[95]

Abbreviations

Armstrong Map: Armstrong 1769

DSEPN: Digital Survey of English Place-Names (formerly DEEP, Digital Exposure of English Place-Names), at https://epns.nottingham.ac.uk/ (Accessed April 2014)

DSL: *Dictionary of the Scots Language*, comprising *Dictionary of the Older Scottish Tongue* (*DOST*) and *Scottish National Dictionary* (*SND*), at http://www.dsl.ac.uk/ (Accessed 10 April 2014)

EDD: *English Dialect Dictionary* (Wright 1898–1905)

EPNS: English Place-Name Society

Greenwood Map: Greenwood & Greenwood 1828

MED: *Middle English Dictionary* at http://www.uod.lib.umich.edu/m/med/ (Accessed 10 April 2014)

NCH: *Northumberland County History* (Bateson et al. 1895–1940)

OED: *Oxford English Dictionary Online* at http://www.oed.com/ (Accessed 10 April 2014)

OSNB: Ordnance Survey Name Book, 1861 (Original Object Name Book for Parish of Embleton, OS 34/366, National Archives)

PNG: OS 1: 50,000 Place Names Gazetteer, via Digimap (Gazetteer Plus) at http://digimap.edina.ac.uk/ (Accessed 10 April 2014)

PR: Parish Registers for Embleton Parish, EP/170/1-2, Northumberland Archives

TA: Tithe Award for Dunston [*sic*] township, 1841, EP/170/37, Northumberland Archives

TNA: The National Archives (formerly PRO, Public Record Office)

VEPN: *Vocabulary of English Place-Names* (Parsons et al. 1997–)

Notes

1 E.g. Bailey 1980, 33–6, *passim*; Fellows-Jensen 1985, 401–9.
2 See Oswald et al. 2006; Middleton & Hardie 2009.
3 Whaley, in preparation.
4 Mawer 1920; Ekwall 1960; Watts 2004. Unless otherwise specified, they have supplied the spellings for Embleton, Dunstan, Dunstanburgh and Craster below.
5 Beckensall 2006; Nurminen 2012.
6 I am indebted to Dr Jayne Carroll (Institute for Name Studies, University of Nottingham) for access to a test version in Spring 2014.
7 In Oswald et al. 2006, esp. 21–8.

8 Oliver 1924, 154; and see n. 4 above.

9 PASE.

10 Gelling & Cole 2000, 167.

11 Gelling 1984; Gelling & Cole 2000.

12 Ibid., 164.

13 Nurminen 2012, 34, 139–58.

14 Cox 1975–6, 66.

15 See, e.g.,Wood 2007, 386.

16 Kitson 2002, 96.

17 *NCH* ii, 8–82.

18 Ibid., 23–4.

19 Fritzner 1883–96: *skeið* n., senses 1–5. Other explanations such as OScand *skeið* f. '(war)ship', Brittonic *skath* 'large boat', sometimes applied to coastal rocks (Padel 1985, 205), or a dialect spelling of *scathe* 'harm, injury', can be ruled out. See Smith 1956, 2, 124 on OScand *skeið* in English place-names.

20 E.g. Watts 2004, 677.

21 OSNB 30.

22 Not in *OED*, *MED*, *EDD* or Heslop 1892–4.

23 E.g. The Skaithe (Yorkshire West Riding), Scarth of Scaiths (Westmorland), perhaps cf Skaith (Dumfries and Galloway) and Skaith (Orkney).

24 Taylor 2006–12, v, 499–500.

25 OSNB 29.

26 Middleton & Hardie 2009, 15, 33–4; OSNB 52. See *OED*: *link* n.[1], senses b, c; *EDD*: *link* sb.2, sense 2.

27 Smith 1956, ii, 148.

28 Heslop 1892–4: *steed*.

29 Middleton & Hardie 2009, 45–7.

30 Oswald et al. 2006, 84–5.

31 OSNB 44.

32 *OED*: *due* n. 1, senses 1, 2a.

33 Porteous in Oswald et al. 2006, 5. *NCH* ii, 3, 7 (but not OSNB 53) mentions Saddle Rock as an alternative.

34 *NCH* ii, 4.

35 *OED*: *gull* n.[1].

36 *OED*: *crag* n.[1]; Whaley 2006, 395.

37 Nurminen 2012, 133–9.

38 See e.g., Porteous in Oswald et al. 2006, 21–6.

39 *EDD*: *rumble* v. and sb., sense 1(6); cf Scots *rummle kirn*, *rummling-kirn* (*DSL-SND*: *rummle* v. n.[1]).

40 *Elgyntour* 1459, *Tower called Egyng cloughe* 1543 (Bates 1891, 192, n. 85).

41 Wallis 1769, ii, 395; Hutchinson 1778, 189 (quoted).

42 Plan of 1893 by Hodges, reproduced in Oswald et al. 2006, 11; *NCH* ii, 196–7.

43 Pers. comm. Jonathan Mitchell of English Heritage, whom I also thank for guidance to Nova Scotia.

44 OSNB 54.

45 Porteous in Oswald et al. 2006, 27–8.

46 OSNB 54.

47 Oswald et al. 2006, 20.

48 Bates 1885–6, 81; 1891, 193–4 and n. 86. He did not promote the 'Margaret' legend, as tentatively hinted by Porteous (Oswald et al. 2006, 28).

49 TNA: DL29/1/3 roll 2.

50 Oswald et al. 2006, 17, 30–3.

51 Ibid., 14.

52 Smith 1956, i, 59; *VEPN* ii, 74–9.

53 Oswald et al. 2006, 17, 31, acknowledging Henry Summerson.

54 E.g. Oswald et al. 2006, 29.

55 Oswald et al. 2006, 33.

56 *OED*: *scrog* n., *shrog* n.; *DSL-DOST*: *scrog(g)*, *skrog(g)*.

57 OSNB 55.

58 Smith 1956, i, 103; *VEPN* iii, 135–6; Taylor 2006–12, v, 335.

59 *EDD*: *cushat*; Simmelbauer 2000, 57–8.

60 Heslop 1892–4: *steel*[3]; *EDD*: *steel* sb.2; *DSL-SND*: *steel* n.[2]; not in this sense in *OED*: *stile* n.[1]. More specific suggestions for *stiel* and Square Haven (Oswald et al. 2006, 77) seem less convincing.

61 Porteous in Oswald et al. 2006, 77.

62 Cf OSNB 55: 'an opening between the rocks at Cushat Stiel'.

63 Fraser 1922, 12–13, 44–5.

64 Cameron et al. 1985–, iii, 106, 174.

65 Six in DSEPN, twelve in PNG, four of these in both.

66 Hill 1996, 72, 76.

67 Middleton & Hardie 2009, 79–80.

68 See Oswald et al. 2006, 76–80.

69 Oswald et al. 2006, 85, acknowledging Craster.

70 See e.g., *NCH* ii, 35 for Scottish-born residents taxed in 1440.

71 Robert Faucus is named in 1538 (*NCH* ii, 38); a Faucus Rock allegedly commemorated a drowning (OSNB 2).

72 Middleton & Hardie 2009, 72, 88.

73 Gelling & Cole 2000, 186.

74 Nurminen 2012, 170; PNG.

75 *OED*: *heugh/heuch*; *MED*: *hough* n. 1, n. 2; *EDD*: *heugh*; *DSL-DOST*: *heuch/hewch*.

76 *EDD*: *shard* sb.2 and v.2; cf *OED*: *shard*, *sherd* n.[1], sense 1.

77 Smith 1956, ii, 101.

78 *OED*; not in *EDD* or *DSL*.

79 *OED*: *nick* n.[1], sense 4, 'orig[inally] Sc[ottish]'.

80 OSNB 99.

81 Nurminen 2012, 30, 66.

82 *OED*: *ox* n.[1] Compounds C2.b.; not in Heslop 1892–4 or *EDD*.

83 Flora of North-East England at www.floranortheast.org.uk (Accessed 10 April 2014).

84 publicprofiler—gbnames at http://gbnames.publicprofiler.org/ (Accessed 10 April 2014).

85 DSL-SND: *hole* n., v., sense 3, and see Taylor (2006–12, v, 405) for Fife examples denoting good fishing-spots; not in *OED* or *EDD*.

86 OSNB 78.

87 See Collings [no date].

88 OED: *mickle* adj.; EDD: *muckle*; DSL-SND: *muckle*.

89 *VEPN* iii, 3, 143; *DSL-SND*: *karr* n.[2].

90 Dictionary of Old English Web Corpus at http://www.doe.utoronto.ca/pages/pub/web-corpus.html (Accessed 10 April 2014): *carr*.

91 Ancestry at http://www.ancestry.co.uk/ (Accessed 10/4/2014).

92 PASE.

93 E.g. Watts 2004, 166.

94 Whaley 2006, 402, 414.

95 It is a pleasure to thank Simon Taylor for helpful feedback on a draft of this paper, and Ian Whaley for photography.

References

Armstrong, A., 1769 *A Map of the County of Northumberland* (London)

Bailey, R.N., 1980 *Viking Age Sculpture in Northern England* (London)

Bates, C.J., 1885–6 'Dunstanburgh', *Proc. Soc. Antiquaries of Newcastle upon Tyne* 1885–6, 73–83

Bates, C.J., 1891 *The Border Holds of Northumberland* 1 (Newcastle upon Tyne)

Bateson, E. et al. (ed.), 1895–1940 *A History of Northumberland*, 15 vols (Newcastle upon Tyne)

Beckensall, S., 2006 *Place Names and Field Names of Northumberland* (Stroud)

Cameron, K., with Field, J. & Insley J., 1985– *The Place-Names of Lincolnshire*, EPNS 58, 64–5, 66, 71, 73, 77, 85, 7 vols (Nottingham)

Collings, P., [no date] *The Illustrated Dictionary of North-East Shipwrecks* (Chester-le-Street)

Cox, B., 1975–6 'The Place-Names of the earliest English Records', *J. EPNS* 8, 12–66

Ekwall, E., 1960 *Concise Oxford Dictionary of English Place-Names*, 4 edn (Oxford)

Fellows-Jensen, G., 1985 *Scandinavian Settlement Names in the North-West* (Copenhagen)

Fraser, A., 1922 *Nova Scotia: The Royal Charter of 1621* (Toronto)

Fritzner 1883–96 *Ordbog over det gamle norske sprog*, 3 vols (Kristiania/Oslo)

Fryer, J., 1820 *Map of the County of Northumberland* (Newcastle)

Gelling, M., 1984 *Place-Names in the Landscape* (London)

Gelling, M. & Cole, A., 2000 *The Landscape of Place-Names* (Stamford)

Greenwood, C. & Greenwood, J., 1828 *Map of Northumberland* (London)

Heslop, O., 1892–4 *Northumberland Words* (London)

Hill, D., 1996 *Turner in the North* (New Haven, CT & London)

Hutchinson, W., 1778 *A View of Northumberland* (Newcastle)

Kitson, P.R., 2002 'How Anglo-Saxon Personal Names Work', *Nomina* 25, 91–131

Mawer, A., 1920 *Place-Names of Northumberland and Durham* (Cambridge)

Middleton, P. & Hardie, C., 2009 *Historic Environment Survey ...: Dunstanburgh and Embleton Bay* (Barnard Castle)

Nurminen, T.J., 2012 'Hill-Terms in the Place-Names of Northumberland and County Durham' (PhD, Newcastle University)

Oliver, A.M. (ed.), 1924 *Early Deeds Relating to Newcastle upon Tyne*, Surtees Society 137 (Durham)

Oswald, A., Ashbee, J., Porteous, K. & Huntley, J., 2006 *Dunstanburgh Castle, Northumberland: Archaeological, Architectural and Historical Investigations* [Portsmouth]

Padel, O.J., 1985 *Cornish Place-Name Elements*, EPNS 56–7 (Nottingham)

Parsons, D.N., Styles, T. & Hough, C., 1997– *Vocabulary of English Place-Names*, 3 vols (Nottingham)

Simmelbauer, A., 2000 *The Dialect of Northumberland: A Lexical Investigation* (Heidelberg)

Smith, A.H., 1956 *English Place-Name Elements*, EPNS 25–6, 2 vols (Cambridge)

Taylor, S. with Márkus, G., 2006–12 *The Place-Names of Fife*, 5 vols (Donington)

Wallis, J., 1769 *The Natural History and Antiquities of Northumberland*, 2 vols (London)

Watts, V.E., 2004 *The Cambridge Dictionary of English Place-Names* (Cambridge)

Whaley, D., 2006 *A Dictionary of Lake District Place-Names* (Nottingham)

Whaley, D., in preparation *A Dictionary of Northumberland Place-Names*

Wood, M., 2007 'Bernician Narratives: Place-Names, Archaeology and History' (PhD, 2 vols, University of Newcastle upon Tyne)

Wright, J., 1898–1905 *English Dialect Dictionary*, 6 vols (London)

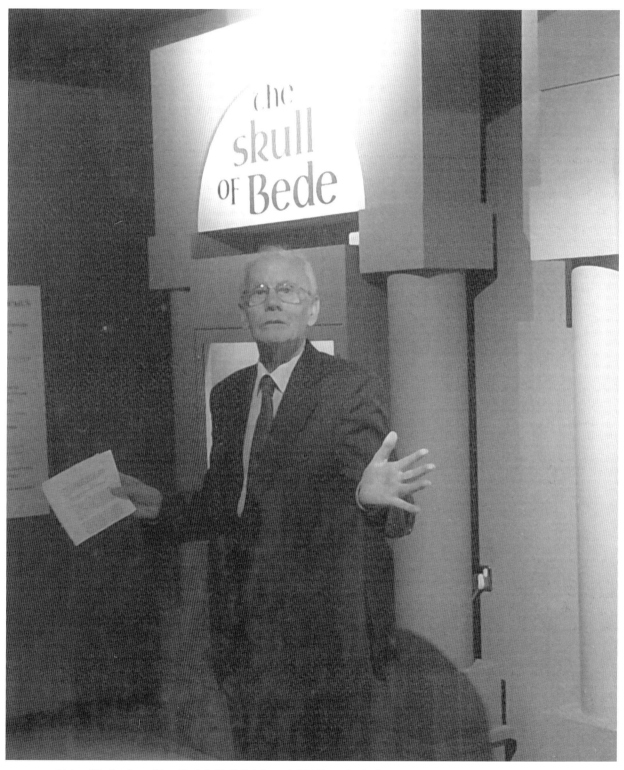

Richard Bailey launching 'Bede's Skull Exhibition' (2015), at the Bede Museum, Jarrow (Photo: Matt Storey)

Richard N. Bailey's Publications

Compiled by Derek Craig[1]

Articles and Books

'The Addingham Cross-incised Slab', *Trans. Cumberland & Westmorland Antiquarian & Archaeological Soc.* new ser. 60 (1960), 37–41

'An Anglian Cross-shaft Fragment from Brigham', *Trans. Cumberland & Westmorland Antiquarian & Archaeological Soc.* new ser. 60 (1960), 42–5

'Manx Patterns on Sculpture of the Norse Period at Stanwix and Millom', *Trans. Cumberland & Westmorland Antiquarian & Archaeological Soc.* new ser. 60 (1960), 187–8

'The Clogher Crucifixion: a Northumbrian Parallel and its Implications', *J. Royal Soc. of Antiquaries of Ireland* 93(1) (1963), 187–8

'Pre-Norman Sculpture from Brigham', *Trans. Cumberland & Westmorland Antiquarian & Archaeological Soc.* new ser. 63 (1963), 155–9

'The Sandbach Crosses', *Proceedings of the 113th Annual Meeting of the Cambrian Archaeological Association at Chester* (Bangor: Cambrian Archaeological Association, 1966), 14–16

(with F.J. Frankis) 'A Runic Forgery from Cullercoats', *Archaeologia Aeliana* 4 ser. 47 (1969), 43–6

'An Anglo-Saxon Pin from Pontefract', *Yorkshire Archaeological J. 42*(4) (1970), 405–6

'Another Lyre', *Antiquity* 46 (182) (1972), 145–6

'Museum Notes, 1972. 1. A Carpenter's Axe from the College Valley', *Archaeologia Aeliana* 4 ser. 50 (1972), 277–80

'Pre-Viking Sculpture from Lowther and Kirkby Stephen, Westmorland', *Archaeological Newsbulletin for Northumberland, Cumberland and Westmorland* no. 13 (January 1972), 14–15

'The Development of English' in D. Daiches & A. Thorlby (eds.), *The Mediaeval World: Literature and Western Civilisation* (London: Aldus Books, 1973), pp 127–62

'The Sculpture of Cumberland, Westmorland and Lancashire-North-of-the-Sands in the Viking Period' (PhD thesis, 3 vols, University of Durham, 1974)

'The Anglo-Saxon Metalwork from Hexham' in D.P. Kirby (ed.), *Saint Wilfrid at Hexham* (Newcastle upon Tyne: Oriel Press, 1974), pp 141–67

'Three Cheerful Notes on Anglo-Saxon and Viking Sculpture in the North-west', *Archaeological Newsbulletin for C.B.A. Regional*

Group 3: Northumberland, Cumberland, Durham, Westmorland and Lancashire-North-of-the-Sands no. 6 (January 1974), 14–15

(with J.T. Lang) 'The Date of the Gosforth Sculptures', *Antiquity* 49 (196) (1975), 290–3

'The Anglo-Saxon Church at Hexham', *Archaeologia Aeliana* 5 ser. 4 (1976), 47–67

'The Abbey Church of St Andrew, Hexham (NY 935641): the Medieval Works' in 'Report of the Summer Meeting ... at Newcastle upon Tyne in 1976', *Archaeological J.* 133 (1977 for 1976), 197–201

'Bywell and its Two Churches (NZ 048615)' in 'Report of the Summer Meeting ... at Newcastle upon Tyne in 1976', *Archaeological J.* 133 (1977 for 1976), 203–4

'Church of St Mary, Ovingham (NZ 085637)' in 'Report of the Summer Meeting ... at Newcastle upon Tyne in 1976', *Archaeological J.* 133 (1977 for 1976), 205

'A Cup-mount from Brougham, Cumbria', *Med. Arch.* 21 (1977), 176–80

'The Meaning of the Viking-age Shaft at Dacre', *Trans. Cumberland & Westmorland Antiquarian & Archaeological Soc.* new ser. 77 (1977), 61–74

The Durham Cassiodorus, Jarrow Lecture 1978 (Jarrow: Parish of Jarrow, n.d.); repr. as 'The Durham Cassiodorus' in M. Lapidge (ed.), *Bede and His World, 1: The Jarrow Lectures 1958–1978* (Aldershot: Variorum, 1994), pp 463–90

'The Chronology of Viking-age Sculpture in Northumbria' in J. Lang (ed.), *Anglo-Saxon and Viking Age Sculpture and its Context: Papers from the Collingwood Symposium on Insular Sculpture from 800 to 1066*, BAR: British Series 49 (Oxford: BAR, 1978), pp 173–203

'Hexham Abbey', *Bulletin of the CBA Churches Committee* 11 (1979), 4–6

(with D. O'Sullivan) 'Excavations over St Wilfrid's Crypt at Hexham, 1978', *Archaeologia Aeliana* 5 ser. 7 (1979), 144–57

The Early Christian Church in Leicester and its Region, Vaughan Paper 25 (Leicester: University of Leicester, Department of Adult Education, 1980)

Viking Age Sculpture in Northern England, Collins Archaeology 1 (London: Collins, 1980)

'The Hammer and the Cross' in E. Roesdahl, J. Graham-Campbell, P. Connor & K. Pearson (ed.), *The Vikings in England and in*

their Danish Homeland (London: The Anglo-Danish Viking Project, 1981), pp 83–94

'Apotropaic Figures in Milan and North-West England', *Folklore* 94(1) (1983), 113–17

'Bede's Text of Cassiodorus' Commentary on the Psalms', *J. Theological Studies* new ser. 34(1) (1983), 189–93

'Dowsing for Medieval Churches', *Popular Archaeology* 4(8) (February 1983), 33–7

'Excavations at Woodhorn Church', *Universities of Durham & Newcastle Archaeological Reports for 1982* (1983), 61–3

'Ledsham', *Bulletin of the CBA Churches Committee* 18 (1983), 6–8

(with R. Handley) 'Early English Manuscripts of Cassiodorus' *Expositio Psalmorum'*, *Classical Philology* 78(1) (1983), 51–5

(with H.D. Briggs & E. Cambridge) 'A New Approach to Church Archaeology: Excavation and Documentary Work at Woodhorn, Ponteland and the pre-Norman Cathedral at Durham', *Archaeologia Aeliana* 5 ser. 11 (1983), 79–100 [R.N.B.: '1. Introduction', 79–82; '3. Excavations in the Chancel of Woodhorn Church', 85–8; '4. Excavations at Ponteland', 88–90; '5. The Phenomenon of "Imprint"', 90–1; '7. Conclusion', 97]

'Dowsing Surveys in North-east England and Associated Excavations at St Mary's Church, Ponteland and St Oswald's Church, Durham', *Universities of Durham & Newcastle Archaeological Reports for 1983* (1984), 67–8

'Irish Sea Contacts in the Viking Period – the Sculptural Evidence', in G. Fellows-Jensen & N. Lund (ed.), *Tedie Tvaerfaglige Vikingesymposium: Kobenhavns Universitet 14. maj 1984* (Copenhagen: Forlaget hikuin og Afdeling for middelalder-arkaeologi, 1984), pp 6–36

'A Viking-age Sword from Morland, Cumbria', *Trans. Cumberland & Westmorland Antiquarian & Archaeological Soc.* new. ser. 84 (1984), 263–6

'Aspects of Viking-age Sculpture in Cumbria' in J.R. Baldwin & I.D. Whyte (ed.), *The Scandinavians in Cumbria* (Edinburgh: Scottish Society for Northern Studies, 1985), pp 53–64

'Celtic Influence on the English Tradition of Stone Sculpture' (abstract from the Twentieth International Congress on Medieval Studies, Kalamazoo), *Old English Newsletter* 18(2) (1985), A-12 (appendix)

(with H.D. Briggs & E. Cambridge) 'A New Approach to Church Archaeology, II: Dowsing and Excavations at Ponteland and St Oswald's, Durham', *Archaeologia Aeliana* 5 ser. 13 (1985), 133–46 [R.N.B.: 'Introduction', 133; 'Excavations at Ponteland', 133–40; 'Conclusions', 143]

'Anglo-Scandinavian Sculpture' in L.A.S. Butler, 'All Saints Church, Harewood', *Yorkshire Archaeological J.* 58 (1986), 85–108, at 97–9

'A Crucifixion Plaque from Cumbria' in J. Higgitt (ed.), *Early Medieval Sculpture in Britain and Ireland*, BAR: British Series 152 (Oxford: BAR, 1986), pp 5–21

(with R. Cramp) *Cumberland, Westmorland and Lancashire North-of-the-Sands*, CASSS 2 (Oxford: Oxford University Press for the British Academy, 1988)

(with H.D. Briggs & E. Cambridge) *Dowsing and Church Archaeology* (Wimborne: Intercept, 1988)

'A Bibliography of Barbara Strang' in G. Nixon & J. Honey (ed.), *An Historic Tongue: Studies in English Linguistics in Memory of Barbara Strang* (London & New York: Routledge, 1988), pp 242–7

'Early Medieval Britain: the Cultural and Social Setting' in B. Ford (ed.), *The Cambridge Guide to the Arts in Britain, 1: Prehistoric, Roman and Early Medieval* (Cambridge: Cambridge University Press, 1988), pp 100–20; repr. with abbreviated bibliography as 'Early Medieval Britain: the Cultural and Social Setting' in B. Ford (ed.), *The Cambridge Cultural History of Britain, 1: Early Britain* (Cambridge: Cambridge University Press, 1992), pp 100–20

'St Cuthbert's Relics: Some Neglected Evidence' in G. Bonner, D. Rollason & C. Stancliffe (ed.), *St Cuthbert, His Cult and His Community to AD 1200* (Woodbridge: Boydell Press, 1989), pp 231–46

The Meaning of Mercian Sculpture: Sixth Brixworth Lecture, 1988, Vaughan Paper 34 (Leicester: University of Leicester, Department of Adult Education, 1990)

'An Early Irish Carved Stone in Northern England', *J. Royal Soc. Antiquaries of Ireland* 120 (1990), 126–8

'Gold Plaque' in L. Webster & J. Backhouse (ed.), *The Making of England: Anglo-Saxon Art and Culture AD 600–900* (London: The British Museum, 1991), p. 59, cat. 45

'St Wilfrid, Ripon and Hexham' in C. Karkov & R. Farrell (ed.), *Studies in Insular Art and Archaeology*, American Early Medieval Studies 1 (Oxford, OH: Miami University, Department of Art, 1991), pp 3–25

'Sutton Hoo and Seventh-century Art' in R. Farrell & C. Neuman de Vegvar (ed.), *Sutton Hoo: Fifty Years After*, American Early Medieval Studies 2 (Oxford, OH: Miami University, Department of Art, 1992), pp 31–41

Saint Wilfrid's Crypts at Ripon and Hexham: a Visitor's Guide (Newcastle upon Tyne: Society of Antiquaries of Newcastle upon Tyne, 1993)

'An Anglo-Saxon Strap-end from Wooperton', *Archaeologia Aeliana* 5 ser. 21 (1993), 87–91

'The Ruthwell Cross: a Non-problem', *Antiquaries J.* 73 (1993), 141–8

'Govan and Irish Sea Sculpture' in A. Ritchie (ed.), *Govan and its Early Medieval Sculpture* (Stroud: Alan Sutton Publishing, 1994), pp 113–21

'Cross-shaft Fragment' in E. Cambridge & A. Williams, 'Hexham Abbey: a Review of Recent Work and its Implications', *Archaeologia Aeliana* 5 ser. 23 (1995), 51–138 at 112–13

'St Oswald's Heads' in C.E. Stancliffe & E. Cambridge (ed.), *Oswald: Northumbrian King to European Saint* (Stamford: Paul Watkins, 1995), pp 195–209

Ambiguous Birds and Beasts: Three Sculptural Puzzles in Southwest Scotland, Fourth Whithorn Lecture, 16 September 1995 (Whithorn: Friends of the Whithorn Trust, 1996)

England's Earliest Sculptors, Publications of the Dictionary of Old English 5 (Toronto: Pontifical Institute of Mediaeval Studies, 1996)

'Seventh-century Work at Ripon and Hexham' in T. Tatton-Brown & J. Munby (ed.), *The Archaeology of Cathedrals*, OUCA Monograph 42 (Oxford: Oxford University Committee for Archaeology, 1996), pp 9–18

'"What mean these stones?" Some Aspects of pre-Norman Sculpture in Cheshire and Lancashire', *Bulletin of the John Rylands University Library of Manchester* 78(1) (1996),

21–46; repr. with additions as '"What Mean these Stones?" Some Aspects of pre-Norman Sculpture in Cheshire and Lancashire' in D. Scragg (ed.), *Textual and Material Culture in Anglo-Saxon England: Thomas Northcote Toller and the Toller Memorial Lectures* (Cambridge: Cambridge University Press, 2003), pp 213–39

'Bewcastle'; 'Crosses, Stone'; 'Gosforth Cross'; 'Grave-markers'; 'Hexham'; 'Hogbacks'; 'Ripon'; 'Sandbach'; 'Scandinavian Influence on English Art'; 'Sculpture, Stone' in M. Lapidge with J. Blair, S. Keynes & D. Scragg (ed.), *The Blackwell Encyclopaedia of Anglo-Saxon England* (Oxford: Blackwell, 1999), pp 64, 129–30, 213–14, 220, 237, 240–1, 394, 405, 406–7, 411–13

'The Gandersheim Casket and Anglo-Saxon Stone Sculpture' in R. Marth (ed.), *Das Gandersheimer Runenkästchen: Internationales Kolloquium, Herzog Anton Ulrich-Museum, Braunschweig, 24.–26. März 1999* (Brunswick: Herzog Anton Ulrich-Museum, 2000), pp 43–52

'Scandinavian Myth on Viking-period Stone Sculpture in England' in G. Barnes & M.C. Ross (ed.), *Old Norse Myths, Literature and Society: Proceedings of the 11th International Saga Conference, 2–7 July 2000, University of Sydney* (Sydney, NSW: Centre for Medieval Studies, University of Sydney, 2000), pp 15–23; also available online at: <http://sydney.edu.au/arts/medieval/saga/pdf/015-bailey.pdf>

'Bede's Bones' in P. Binski & W. Noel (ed.), *New Offerings, Ancient Treasures: Studies in Medieval Art for George Henderson* (Stroud: Sutton Publishing, 2001), pp 165–86

'Preface' in H. Hamerow & A. MacGregor (ed.), *Image and Power in the Archaeology of Early Medieval Britain: Essays in Honour of Rosemary Cramp* (Oxford: Oxbow Books, 2001), pp ix–xii

'The Rey Cross: Background' in B. Vyner (ed.), *Stainmore, the Archaeology of a North Pennine Pass: an Archaeological Survey of Bowes Moor, Co. Durham, Undertaken in Conjunction with the Improvement of the A66 Trans-Pennine Trunk Road*, Tees Archaeology Monograph Ser. 1 (Hartlepool & London: Tees Archaeology & English Heritage, 2001), pp 118–20

'Introduction' in C.E. Karkov & F. Orton (ed.), *Theorizing Anglo-Saxon Stone Sculpture*, Medieval European Studies 4 (Morgantown, WV: West Virginia University Press, 2003), pp 1–4

'"Innocent from the Great Offence"' in C.E. Karkov & F. Orton (ed.), *Theorizing Anglo-Saxon Stone Sculpture*, Medieval European Studies 4 (Morgantown, WV: West Virginia University Press, 2003), pp 93–103

Anglo-Saxon Sculptures at Deerhurst, Deerhurst Lecture 2002 (Deerhurst: The Friends of Deerhurst Church, 2005)

(with J. Whalley) 'A Miniature Viking-age Hogback from the Wirral', *Antiquaries J.* 86 (2006), 345–56

'Richard Harbottle, 1934–2005', *Archaeologia Aeliana* 5 ser. 35 (2006), 121–2

'The Winwick Cross and a Suspended Sentence' in A. Minnis & J. Roberts (ed.), *Text, Image, Interpretation: Studies in Anglo-Saxon Literature and its Insular Context in Honour of Éamonn Ó Carragáin*, Studies in the Early Middle Ages 18 (Turnhout: Brepols, 2007), pp 449–72

'The Beast-headed Stone' in R.A. Hall, T. Kendall & C. Briden, 'St Helen's Church, Skipwith, North Yorkshire', *Archaeological J.* 165 (2008), 399–470 at 455–7

(with G. McCombie) 'Enid Hart, 1926–2007', *Archaeologia Aeliana* 5 ser. 37 (2008), 243

'Anglo-Saxon Art: Some Forms, Orderings and their Meanings' in S. Crawford & H. Hamerow, with L. Webster (ed.), *Form and Order in the Anglo-Saxon World, AD 400–1100*, ASSAH 16 (Oxford: Oxford University School of Archaeology, 2009), pp 18–30

'The Sculptural Background' in J. Graham-Campbell & R. Philpott (ed.), *The Huxley Viking Hoard: Scandinavian Settlement in the North West* (Liverpool: National Museums Liverpool, 2009), pp 24–8

'Appendix: a Viking Hoard from Sandbach, Cheshire?' in J. Graham-Campbell & R. Philpott (ed.), *The Huxley Viking Hoard: Scandinavian Settlement in the North West* (Liverpool: National Museums Liverpool, 2009), p. 84

Cheshire and Lancashire, CASSS 9 (Oxford: Oxford University Press for the British Academy, 2010)

'*In medio duorum animalium*: Habakkuk, the Ruthwell Cross and Bede's Life of St Cuthbert' in E. Mullins & D. Scully (ed.), *Listen O Isles, unto Me: Studies in Medieval Word and Image in Honour of Jennifer O'Reilly* (Cork: Cork University Press, 2011), pp 243–52, 379–82

(with R. Cramp) 'The Stone Sculptures of Anglo-Saxon England', *British Academy Review*, issue 17 (March 2011), 40–2

(with V. Oakden & E. Okasha) 'Two pre-Conquest Stones from Milnrow', *Trans. Lancashire & Cheshire Antiquarian Soc.* 106 (2011), 128–37

'The Acklington "Warriors Stone": Medieval or Modern?', *Archaeologia Aeliana* 5 ser. 41 (2012), 279–83

(with V. Oakden & E. Okasha) 'A pre-Conquest Latin Inscription from North-west England', *Medieval Archaeology* 56 (2012), 260–7

'St Wilfrid – a European Anglo-Saxon' in N.J. Higham (ed.), *Wilfrid: Abbot, Bishop, Saint. Papers from the 1300th Anniversary Conferences* (Donington: Shaun Tyas, 2013), pp 112–23

(with E. Cambridge), 'St Cuthbert's Posthumous Biography: a Revised Edition', *Peritia* 26 (2015), 13–28

(with J. Story) 'The Skull of Bede', *Antiquaries Journal* 95 (2015), 1–26

(with E. Cambridge). 'Dating the Old English poem "Durham"', *Medium Ævum* 85(1) (2015), 1–14

Forthcoming. 'Roman or Anglo-Saxon Stone Carvings?' in R. Hall (ed.), *Ripon Cathedral Crossing Excavations*

Reviews

P.G. Foote & D.M. Wilson, *The Viking Achievement: the Society and Culture of Early Medieval Scandinavia* (London, 1970), *Antiquity* 45 (177) (1971), 64–5

O. Klindt-Jensen, *The World of the Vikings* (London, 1970), *Antiquity* 45 (179) (1971), 233–4

E. Munksgaard, *Denmark: an Archaeological Guide* (Faber & Faber, 1970), *Notes & Queries* 18(2) (1971), 69–70

P.V. Glob (trans. J. Bulman), *Danish Prehistoric Monuments: Denmark from the Stone Age to the Vikings* (Faber & Faber, 1971), *Notes & Queries* 18(9) (1971), 346–7

G. Watson, *Goodwife Hot and Others: Northumberland's Past in its Place-names* (Oriel Press, 1970), *Archaeological Newsbulletin*

for Northumberland, Cumberland and Westmorland no. 11 (May 1971), 16–17

P. Addyman & R. Morris (ed.), *The Archaeological Study of Churches*, CBA Research Report 13 (London, 1976), *Archaeologia Aeliana* 5 ser. 5 (1977), 211

R.J. Cramp & J.T. Lang, *A Century of Anglo-Saxon Sculpture* (Newcastle upon Tyne, 1977), *Archaeologia Aeliana* 5 ser. 6 (1978), 181–2

R.A. Hall (ed.), *Viking Age York and the North*, CBA Research Report 27 (London, 1978), *Archaeologia Aeliana* 5 ser. 7 (1979), 248–9

B. Hope-Taylor, *Yeavering: an Anglo-British Centre of Early Northumbria* (London, 1977), *Archaeologia Aeliana* 5 ser. 8 (1980), 169–71

R. Cramp & R. Miket, *Catalogue of the Anglo-Saxon and Viking Antiquities in the Museum of Antiquities, Newcastle upon Tyne* (Newcastle upon Tyne, 1982), *Archaeologia Aeliana* 5 ser. 11 (1983), 317–18

E.W.F. Tomlin, *In Search of St. Piran: an Account of his Monastic Foundation at Perranzabuloe, Cornwall, and its Place in the Western or Celtic Church and Society* (Padstow: Lodenek Press, 1982), *Notes & Queries* 31(2) (1984), 255–6

P. Hunter Blair (ed. M. Lapidge & P. Hunter Blair), *Anglo-Saxon Northumbria* (London, 1984), *Archaeologia Aeliana* 5 ser. 13 (1985), 221

J.M. Cronyn & C.V. Horie, *St Cuthbert's Coffin: the History, Technology and Conservation* (Durham, 1985), *Antiquaries J.* 66(2) (1986), 446–7

S. Cruden, *Scottish Medieval Churches* (Edinburgh: John Donald, 1986), *Notes & Queries* 35(2) (1988), 206–7

J.T. Lang, *Viking-Age Decorated Wood: a Study of its Ornament and Style*, National Museum of Ireland & Royal Irish Academy: Medieval Dublin Excavations 1962–81, ser. B, vol. 1 (Dublin, 1988), *Medieval Archaeology* 34 (1990), 304–5

B. Cassidy (ed.), *The Ruthwell Cross*, Index of Christian Art, Department of Art and Archaeology (Princeton, 1992), *English Historical Review* 111 (440) (1996), 139–40

S.M. Foster (ed.), *The St Andrews Sarcophagus: a Pictish Masterpiece and its International Connections* (Dublin & Portland, 1998), *Antiquity* 74 (283) (2000), 246–7

N. Cookson, *Archaeological Heritage Law* (Chichester, 2000), *Ecclesiastical Law J.* 6 (28) (2001), 64–5

M. Redknap, *Vikings in Wales: an Archaeological Quest* (Cardiff, 2000), *Archaeoleg yng Nghymru / Archaeology in Wales* 41 (2001), 180

J. Graham-Campbell, R. Hall, J. Jesch & D.N. Parsons (ed.), *Vikings and the Danelaw: Select Papers from the Proceedings of the Thirteenth Viking Congress, Nottingham and York, 21–30 August 1997* (Oxford & Oakville, 2001), *Archaeologia Aeliana* 5 ser. 30 (2002), 189–90

R. Colls & W. Lancaster (ed.), *Newcastle upon Tyne: a Modern History* (Chichester, 2001); and G.L. Dodds, *A History of Sunderland*, 2 edn (Sunderland, 2001), *Archaeologia Aeliana* 5 ser. 30 (2002), 192–3

M. Redknap, N. Edwards, S. Youngs, A. Lane & J. Knight (ed.), *Pattern and Purpose in Insular Art, Proceedings of the Fourth International Conference on Insular Art Held at the National Museum & Gallery, Cardiff 3–6 September 1998* (Oxford & Oakville, CT, 2001)*, Archaeoleg yng Nghymru / Archaeology in Wales* 42 (2002), 184

'Book Notices, 2005', *Archaeologia Aeliana* 5 ser. 34 (2005), 175

P. Frodsham & C. O'Brien, *Yeavering: People, Power and Place* (Stroud, 2005), *Archaeologia Aeliana* 5 ser. 35 (2006), 113–14

'Book Notices, 2006', *Archaeologia Aeliana* 5 ser. 35 (2006), 119

'Book Notices, 2007', *Archaeologia Aeliana* 5 ser. 36 (2007), 379–80

'Book Notices, 2008', *Archaeologia Aeliana* 5 ser. 37 (2008), 241–2

F. Orton & I. Wood, I., with C.A. Lees, *Fragments of History: Rethinking the Ruthwell and Bewcastle Monuments* (Manchester & New York, 2007), *J. Ecclesiastical History* 59(3) (2008), 537–8

M.M. Meikle & C. Newman, *Sunderland and its Origins: Monks to Mariners* (Chichester, 2007), *Archaeologia Aeliana* 5 ser. 38 (2009), 162

M. Townend, *The Vikings and Victorian Lakeland: the Norse Medievalism of W.G. Collingwood and his Contemporaries*, Cumberland & Westmorland Antiquarian & Archaeological Soc. extra ser. 34 (Kendal, 2009), *Archaeologia Aeliana* 5 ser. 39 (2010), 442–3

D. Petts & S. Turner (ed.), *Early Medieval Northumbria: Kingdoms and Communities, AD 400–1100* (Turnhout, 2012), *Archaeologia Aeliana* 5 ser. 41 (2012), 294–6

C. Maddern, *Raising the Dead: Early Medieval Name Stones in Northumbria* (Turnhout, 2013), *Archaeologia Aeliana* 5 ser. 43 (2014), 262

Note

1 Many thanks to the people who have helped me out in this vain attempt at a complete listing, particularly Eric Cambridge (and through him, John Frankis). Also Richard himself, for regularly sending me copies of his new publications.

Index

Page numbers in italics indicate pages with images or tables